PENGUIN BOOKS

LEONARDO

Serge Bramly, who spent five years researching this biography, has an outstanding reputation in France as a prize-winning author of fiction and non-fiction. In 1983 he won the Booksellers' Prize for *La Danse du Loup* (*Dance of the Wolf*), and *Leonardo* was first published in France in 1988 to great critical and popular acclaim. He lives in New York.

Siân Reynolds, who translated this book, is also the highly acclaimed translator of *The Mediterranean* and other works by Fernand Braudel. She is Professor of French at Stirling University.

SERGE BRAMLY

—————

LEONARDO
THE ARTIST AND THE MAN

TRANSLATED BY SIAN REYNOLDS

PENGUIN BOOKS

PENGUIN BOOKS

Published by the Penguin Group

Penguin Putnam Inc., 375 Hudson Street, New York, New York 10014, U.S.A.

Penguin Books Ltd, 80 Strand, London WC2R 0RL, England

Penguin Books Australia Ltd, 250 Camberwell Road, Camberwell, Victoria 3124, Australia

Penguin Books Canada Ltd, 10 Alcorn Avenue, Toronto, Ontario, Canada M4V 3B2

Penguin Books India (P) Ltd, 11 Community Centre,

Panchsheel Park, New Delhi – 110 017, India

Penguin Books (NZ) Ltd, Cnr Rosedale and Airborne Roads,

Albany, Auckland, New Zealand

Penguin Books (South Africa) (Pty) Ltd, 24 Sturdee Avenue,

Rosebank, Johannesburg 2196, South Africa

Penguin Books Ltd, Registered Offices:

Harmondsworth, Middlesex, England

Leonardo: The Artist and the Man was originally published in France in 1988
by Éditions Jean-Claude Lattès under the title *Léonardo de Vinci*.
It was translated and published in the United States in an edited version
by arrangement with Éditions Jean-Claude Lattès

First published in Great Britain by HarperCollins Publishers 1992
Published by Penguin Books 1994

15 17 19 20 18 16 14

ISBN 0 14 02.3175 7

Printed in the United States of America

For Nour

———

For Virgile

Contents

CONTENTS

VIII
The Absolute Man 253

IX
Laurels and Tempests 303

X
Like a Well-Filled Day 351

XI
The Traces 409

Illustrations follow page 238

Acknowledgments

THE AUTHOR WOULD PARTICULARLY like to thank for their help the archivists and librarians of the Elmer Belt Library, Los Angeles; the Biblioteca Leonardiano in Vinci; the Biblioteca Ambrosiana and the Biblioteca Trivulziana in Milan; the library of the Institut de France and the Bibliothèque Doucet in Paris. He also thanks M. André Chastel for his valuable advice; Mlle Laura Lombardi for corrections to the manuscript.

Above all, thanks to Mme Jacqueline Raoul-Duval, who saw the book through from beginning to end.

Chronology

1450 Ser Piero da Vinci recorded as a notary in Pistoia.

1451 Birth of Christopher Columbus and Ludovico Sforza.

1452 Birth of Leonardo on 15 April in Vinci, to Caterina.

Ser Piero marries sixteen-year-old Albiera Amadori.

1456 A hurricane ravages Tuscany.

1457 Leonardo appears on the tax declaration of his grandfather, who is living on the Piazzetta Guazzesi (now the Via Roma) in Vinci.

Verrocchio, on his tax declaration, says he is no longer a goldsmith.

1464 Death of Albiera, Ser Piero's first wife.

1466 Flooding of the Arno in Florence and surrounding districts.

Death of Donatello.

1468 Verrocchio employed on installing the ball on the cathedral dome.

1469 Leonardo registered on the tax declaration of his grandmother in Vinci.

Death of Piero de' Medici. The new leaders of the city are Lorenzo and Giuliano de' Medici.

Birth of Machiavelli.

1470 Leonardo registered on the tax declaration of his father, Ser Piero, who is now established in Florence.

1472 Leonardo becomes a member of the *arte* of painters in Florence, along with Perugino and Botticelli.

Sack of Volterra.

First published edition of Dante's *Divine Comedy*.

Death of Alberti.

Birth of Copernicus.

1473 Death of Ser Piero's second wife.

First known drawing by Leonardo: the landscape painted on the Feast of Santa Maria delle Neve.

Verrocchio paints the *Baptism of Christ* at about this date.

1475 Ser Piero marries Margherita di Francesco.

Birth of Michelangelo.

Death of Uccello.

1476 Birth of Antonio, Ser Piero's first legitimate child, on 26 February.

On 9 April, Leonardo is charged with sodomy; the case is dismissed on 16 June.

Verrocchio finishes his statue of David.

Lorenzo de' Medici sets up the Platonist Academy.

1477 Verrocchio works on the Forteguerri monument in Pistoia.

Botticelli paints *Primavera*.

1478 Pazzi conspiracy. Terrible floods in Florence. Outbreak of plague.

Leonardo writes: "I have begun the two Virgin Marys." His best friend is one Fioravante.

Leonardo receives his first personal commission to be recorded in an official document (but the work never materializes).

1480 Ser Piero moves from the house he was renting on the Via della Prestanza to one on the Via Ghibellina.

Lorenzo de' Medici allies himself with Naples and makes peace with the Pope.

Verrocchio is working on the Colleoni statue.

Ludovico the Moor takes power in Milan.

1481 In March, Leonardo is commissioned to paint the *Adoration of the Magi.* (The last mention of his name in the accounts of his patrons, the friars of San Donato, is on 28 September.) Botticelli, Perugino, Piero di Cosimo, Signorelli, Antonio Pollaiuolo, and Ghirlandaio leave for Rome in reply to a request by the Pope.

1482 Leonardo goes to live in Milan.

Death of Toscanelli.

1483 On 25 April, Leonardo is commissioned, along with the de Predis brothers, to paint the *Virgin of the Rocks.*

Birth of Raphael.

Charles VIII is anointed king of France.

1484 Botticelli paints the *Birth of Venus.*

Pope Innocent VIII elected.

1485 Plague ravages Milan.

Hieronymus Bosch paints the *Garden of Earthly Delights.*

Birth of Titian.

1486 Pico della Mirandola publishes his *Conclusions.*

First sermons by Savonarola.

1487 Competition for the *tiburio* of Milan Cathedral.

The first Inquisition tribunal is set up in Sicily, on the Spanish pattern.

1488 Death of Verrocchio.

1489 Leonardo studies anatomy *(Libro titolato de figura umana)* and architecture.

1490 Leonardo visits Pavia with Francesco di Giorgio Martini, for the *fabbrica del Duomo.* Begins treatise on landscape and hydraulic works.

He makes a fresh start on the bronze horse and organizes the Masque of the Planets for the marriage of Isabella of Aragon to the young duke Gian Galeazzo Sforza.

In July, Salai comes to live with him.

1492 Death of Piero della Francesca.

Bramante builds the choir of Santa Maria delle Grazie.

Christopher Columbus's voyage to America.

Death of Lorenzo de' Medici.

Election of Pope Alexander VI (Borgia).

Jews expelled from Spain.

1493 Leonardo's clay model for the *cavallo* is put on display in Milan.

In July, a woman called Caterina (possibly his mother) joins his household.

The New World is divided between Spain and Portugal.

1494 Beginning of the Italian wars. Charles VIII of France, allied to the Moor, occupies Naples. In Florence, Piero de' Medici is removed from power and Savonarola takes over. Pisa becomes independent.

Luca Pacioli publishes his *Summa de arithmetica*.

1495 Leonardo begins *The Last Supper* in the refectory of the convent of Santa Maria delle Grazie.

1496 Leonardo does the drawings for Pacioli's *De divina proportione*. Production of *Danaë*.

Death of Beatrice d'Este.

Emperor Maximilian enters Italy at request of the Pope.

1498 Leonardo decorates the Sala delle Asse.

Possible first attempt at a flying machine.

In France, Louis XII succeeds Charles VIII.

Savonarola burned at the stake.

1499 Second Italian war. Ludovico Sforza forced to flee.

Leonardo leaves Milan, now occupied by French troops.

Cesare Borgia becomes duke of Valentinois. Venice threatened by Turks.

Signorelli paints the frescoes in Orvieto.

1500 Leonardo accompanies Pacioli to Mantua, where he draws the *Portrait in Profile of Isabelle d'Este*.

They go on to Venice, and Leonardo visits Friuli.

He returns to Florence and is offered hospitality by the monks of the Annunziata, for whom he paints the *Virgin and Child with Saint Anne*.

Ludovico the Moor is taken prisoner by the French.

Diet of Augsburg.

1501 Leonardo preoccupied by mathematics.

Paints *Madonna with a Yarn-Winder* for Florimond Robertet.

French occupy Rome.

1502 Order by Cesare Borgia appoints Leonardo military engineer to his armies. Leonardo inspects fortresses and sees the Romagna campaign, engages in cartography, and meets Machiavelli.

Soderini appointed *gonfaloniere* (chief magistrate) of Florence for life.

1503 Leonardo returns to Florence.

In the war with Pisa, the Florentines try to divert the Arno.

Leonardo begins the *Battle of Anghiari*.

1504 9 July, death of Ser Piero, Leonardo's father, who leaves ten sons and two daughters.

Francesco da Vinci, Leonardo's uncle, makes him his heir.

Leonardo occupied with fortifications of Piombino and hydraulic works.

Michelangelo does the cartoon for the *Battle of Cascina*. A committee of artists, including Leonardo, decides on the site for Michelangelo's *David*.

1505 Leonardo studies the flight of birds. Second unsuccessful attempt to fly.

Last payments for the *Battle of Anghiari* made at the end of this year.

Raphael makes sketches based on the *Mona Lisa* and *Leda*.

1506 In May, Leonardo leaves Florence for Milan, having been summoned there by Charles d'Amboise, the French governor.

Louis XII is greatly impressed by his small painting of a Madonna (possibly the one with a yarn-winder).

Bramante starts work on St. Peter's in Rome.

1507 Leonardo is appointed painter and engineer to Louis XII. He supervises the painting of a second version of the *Virgin of the Rocks,* and meets Francesco Melzi.

He goes to law against his stepbrothers over his inheritance from his uncle Francesco, who died in 1506, but recovers the vineyard given him by Ludovico Sforza.

In September, he returns on a six-month visit to Florence, staying at the Casa Martelli.

1508 Leonardo divides his time between Milan and Florence.

He carries out studies of waterworks and designs the Trivulzio monument.

Michelangelo begins work on the frescoes in the Sistine Chapel.

League of Cambrai formed against Venice.

1509 Leonardo pursues his studies of anatomy (with Marcantonio della Torre?) and continues with hydraulics.

De divina proportione, by Pacioli and Leonardo, is published in Venice.

1510 Death of Botticelli.

Melzi draws the profile of a man in Leonardo's notebooks, dated this year.

1511 Erasmus writes his *Praise of Folly*.

Death of Charles d'Amboise. Swiss troops reach outskirts of Milan. Pope Julius II forms Holy League against the French, who evacuate their troops from Milan after the battle of Ravenna.

Birth of Vasari.

1512 The Medici take power again in Florence.

1513 Leo X (Medici) elected Pope.

In October, Leonardo moves to Rome, where he lives in the Belvedere with Melzi and Salai. Work on mirrors and possibly the Turin self-portrait.

1514 Death of Bramante.

Leonardo visits Parma and Florence.

Plans to drain Pontine marshes.

1515 Death of Louis XII. François I reconquers the Milanese region at the battle of Marignano.

Leonardo's letter to Giuliano de' Medici.

Deluge drawings. *John the Baptist* (?). Automatic lion for king of France.

Machiavelli writes *The Prince*.

1516 Death of Giuliano de' Medici.

Leonardo, who may have met François I at the Bologna peace talks, definitively leaves Italy for France toward the end of the year.

1517 Leonardo, Melzi, and Salai move into the château of Cloux near Amboise.

Romorantin plans. Geometrical games. Visit by cardinal of Aragon.

1518 Leonardo organizes festivities for the baptism of the Dauphin and the marriage of Lorenzo di Piero de' Medici at Amboise.

1519 On 23 April, Leonardo makes his will.

On 2 May, he dies at Cloux.

Introduction

Toward the middle of the sixteenth century, the prolific Giorgio Vasari, a mediocre painter but a respectable architect (he designed the Uffizi in Florence), began to document the lives of the greatest Italian artists. The idea came to him in Rome, during a conversation with the historian Paolo Giovio. Giovio had begun to write in Latin some "eulogies" of famous artists, but since he knew little about painting, he hesitated about continuing. Vasari immediately undertook the task in his place. He had already amassed a quantity of notes on his illustrious contemporaries and had collected anecdotes, drawn up lists of works, and purchased sketches and drawings, which he kept in bulging portfolios. He extended his research, drew on new sources, and expanded his catalogue; a few years later, in 1550, Torrentino published Vasari's *Vite de' più eccellenti architettori, pittori e scultori italiani,* containing one hundred twenty biographies.[1] It told of the great adventure of Italian art, from the primitives to the "moderns," and sought to distinguish three styles and three periods: the age of emancipation (of which the foremost representative was Giotto); the age of maturity (attained with Masaccio); and the age of perfection (begun by Leonardo and completed, according to Vasari, by Michelangelo). He was inventing art history.

The book's success was such that in 1564, Vasari, by then a sort of superintendent of fine arts for the Grand Duke Cosimo de' Medici, brought out a second edition of the *Lives.* The new version

was enlarged, illustrated with portraits, and now included himself as a subject. "Your paintings won't last," Giovio said to him with brutal frankness, "but time will not consume this writing."

The debt we owe Vasari cannot be overstated. The essentials of what we know about Italian artists from the thirteenth to the sixteenth centuries derive from his monumental work. Despite inaccuracies and mistakes, despite his prejudices and often blind Florentine nationalism, despite an annoying tendency toward moralizing or hagiography and a definite penchant for legend, Vasari remains the first indispensable reference for anyone fascinated by the Italian Renaissance.

Vasari was only eight years old when Leonardo died, but he later studied in Florentine workshops where the memory of the master with the white beard was still fresh, among people who had had some acquaintance with him and who continued to talk about his doings. Vasari approached some of Leonardo's former pupils, who enabled him to verify, complete, and expand the information he had collected. Most notably, he consulted Francesco Melzi, da Vinci's friend, executor, and heir, who had carefully preserved, along with the manuscripts, a drawing of his master. Finally, Vasari was able to acquire some charcoal and pen-and-ink studies by Leonardo— many of whose works he knew only by hearsay—to add to his personal collection.

His "Life of Leonardo da Vinci, Florentine Painter and Sculptor," is not, therefore, an eyewitness account, but it draws on a number of personal contacts, and we have no more complete firsthand testimony.

Reading the twenty or so pages of this biography, one feels that Vasari is both fascinated and disconcerted; his subject is so ambiguous, so unlike his fellow artists.

A great deal has been guessed, supposed, imagined, or made up about Leonardo. Kenneth Clark, who devoted much of his life to studying him, writes: "Leonardo is the Hamlet of art history, whom each of us must recreate for himself, and although I have tried to interpret his work as impersonally as possible, I recognize that the result is largely subjective."[2]

Leonardo explored the most diverse of areas, reached out to the extreme frontiers of knowledge, dreamed up extravagant schemes,

and went into prolonged pursuit of fantasies. He rarely finished the works he began, and there were, in any case, very few of them. There were other men who combined the skills of painter, sculptor, architect, and engineer, or became famous for works comparable to his in worth, or led even more eccentric lives, but no other personality was so intimidating, no other career so difficult to encompass. So Vasari often resorts, in lieu of analysis, to the assumption that Leonardo embodied some superhuman quality: *il divino*. The imposing figure of the sage with the long white beard seems to have cast a shadow that partially concealed the real man of flesh and blood.

"Celestial influences," Vasari writes, "may shower extraordinary gifts on certain human beings, which is an effect of nature; but there is something supernatural in the accumulation in one individual of so much beauty, grace, and might."

This was not mere rhetoric. According to Vasari, Leonardo possessed every gift, every noble quality. The biographer speaks of his prodigious physical skill and strength: "He could contain the most violent forces. With his right hand he could twist a horseshoe or the iron ring of a doorbell as if they were made of lead." He praises Leonardo's generosity ("in his liberality, he welcomed and gave food to any friend, rich or poor"), his kindness, his sweet nature, his eloquence ("his speech could bend in any direction the most obdurate of wills"), his "regal magnanimity," his sense of humor, his love of wild creatures ("passing the places where birds were sold, he would pay the price asked for them, take them from their cages, and let them fly off into the air, giving them back their lost freedom"), his "terrible strength in argument, sustained by intelligence and memory," the subtlety of his mind, "which never ceased to devise inventions," his aptitude for mathematics, science, music, poetry. What was more, Leonardo was a man of "physical beauty beyond compare."

To what extent can we believe this portrait? The legend of Leonardo started early, in the artist's own lifetime. His unique silhouette was famous in the streets of both Florence and Milan, and his contemporaries, who were usually very sparing with physical descriptions, never failed to allude to his appearance whenever they mentioned him. One anonymous writer (who is usually referred to as the Anonimo Gaddiano) tells us that the beard, "combed and

curled," reached the middle of his chest and that he wore a "rose-colored garment, which reached only to the knee, although the fashion of the time was for longer clothes."[3] The Milanese painter Giovanni Paolo Lomazzo also noted the length of Leonardo's hair and beard and his thick eyebrows, declaring him "the true model of the dignity of knowledge, like Hermes Trismegistus and Prometheus in antiquity."[4]

Pompeo Gaurico, in his *De sculptura* (published in 1504), compares Leonardo to Archimedes; the humanist Giovanni Nesi, who knew da Vinci in Florence in about 1500, speaks of his "venerable image" and refers to Delos, Crete, and Samos, the native land of Pythagoras.[5] But Leonardo most reminded his learned contemporaries of Plato. The artist's venerable appearance, his scientific interests, his even temper, reputation for eccentricity (he was left-handed and vegetarian), which the rose-colored garment could only enhance, as well as the court of handsome young pupils surrounding him, made irresistible the comparison with the "philosopher of princes and the prince of philosophers."[6] The great Plato, who was at that time seen as something of a magician and physician, was described as the "master of the divine" and the father of all mysteries, prefiguring the Trinity.

In 1509 Raphael painted his great fresco *The School of Athens* in the Vatican, in the room known as the Stanza della Signatura. This preeminent work, summing up the tastes and aspirations of the period, puts the thinkers of antiquity on the same footing as the fathers of the Church. In the center, under marble porticoes whose harmoniously repeated arches seem to be an architectural projection of supreme reason, two figures stand out against the sky, one holding the *Timaeus,* the other the *Ethics:* Plato and Aristotle dominate the respectful company of sages, who open their ranks to allow them through. Draped in a rose-colored toga, Plato's index finger is raised in a gesture typical of Leonardo.[7]

Following the custom of the day, Raphael peopled *The School of Athens* with contemporary figures, such as Francesco Maria of Urbino, the young Federico of Mantua, Perugino, and himself. It is thought that he gave to certain sages of antiquity the features of artists whom he admired, in order to promote the plastic arts to the rank of philosophy. Traditionally, Michelangelo is identified with

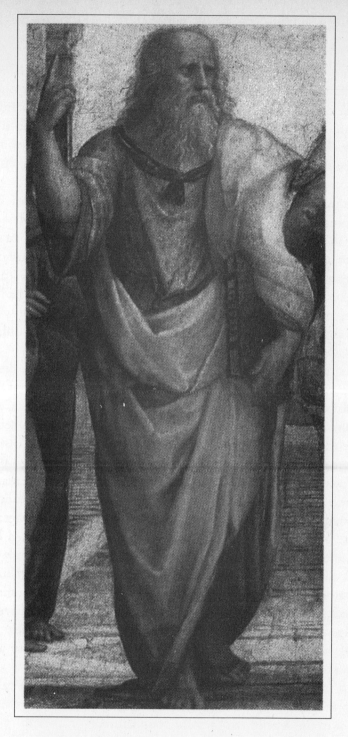

Raphael, *The School of Athens,* detail showing Plato.

the somber Heraclitus in the foreground, and the architect Bramante (friend of Leonardo, compatriot of Raphael, and possibly collaborator on the background of the fresco) with the "ingenious Euclid," who is holding a pair of compasses. If tradition is to be trusted, Raphael paid greatest homage to Leonardo da Vinci—choosing him to represent the man then thought to be the greatest thinker of all time.[8]

Leonardo was remembered in the court of François I of France as a philosopher (a word used in this period in the broadest sense: a "man of learning") as much as if not more than as an artist. Benvenuto Cellini writes in his *Discorsi sull'Arte:* "I must repeat what the king told me personally, in the presence of the cardinal of Ferrara and the king of Navarre. He said that never had there been a man who knew as many things as Leonardo, not only about sculpture, painting, and architecture but also about philosophy, for he was a very great philosopher."[9]

Cellini is no doubt exaggerating, carried away by the desire to glorify a compatriot. But other sixteenth-century texts confirm the idea of Leonardo as "philosopher." For example, in *The Courtier,* written between 1508 and 1516, Baldassare Castiglione refers to Leonardo's love for philosophy, only to deplore it, since it distracted him from painting.[10] And Geoffroy Tory, the French king's printer, in 1530 repeats almost word for word François I's remarks to Cellini: "Leonardo da Vinci was not only an excellent painter but a veritable Archimedes, and he was also a great philosopher." The qualities lent to the artist define the ideal man as imagined by the age: affable, a good horseman, one who was skilled at playing a musical instrument or improvising verses, generous, a brilliant conversationalist, cultivated—and good at sports. Apologias for Lorenzo de' Medici or Francesco Sforza abound in superlatives very similar to those used to praise Leonardo. In *The Courtier,* Castiglione calls for similar talents and virtues from the prince and his entourage.

All the same, other sources confirm the portrait in a general sense; the prodigious traits described by Vasari do seem to have existed in real life; the legend had a solid foundation.

In his brief "Eulogy,"[11] composed at Ischia, where he retired after

the sack of Rome, Paolo Giovio, who had known Leonardo at the court of Pope Leo X, had noted before Vasari that Leonardo's "charm, generosity, and brilliant mind were not inferior to the beauty of his person. His inventive genius was amazing, and he was the arbiter of all questions pertaining to beauty and elegance, in particular all those relating to ceremonial spectacle. He sang admirably, accompanying himself on the *lira,* and the entire court was delighted." Leonardo died at the age of sixty-seven, Giovio concluded, "to the great affliction of his friends."

Much has been written about the enigmatic Leonardo (more than on any other painter) and in every vein; we always see through the filter of our own preoccupations.

In the century or so after his death, since his notebooks—the only evidence of his philosophy and learning—were hidden away in private collections and since little or nothing survived of his sculpture or engineering works, he was for many years seen only as a painter. The publication of his *Treatise on Painting* in 1651, when the academies were at the height of their powers, reinforced the view that above all he was the artist of the *Mona Lisa* and *The Last Supper,* pictures that were endlessly copied and from which much could be learned. The eighteenth century rediscovered Leonardo's caricatures. Where previously they had been regarded as curiosities, the new age found in them a deep study of character. They provoked discussion of the effect of the passions on the human physique;[12] it was a time when the word "psychology" was taking on meaning. But it was not until the nineteenth century, the age of the industrial revolution, that serious attention was given to the writings, by now scattered all over the world. Through them, the personality of Leonardo and his nonartistic pursuits, in particular his scientific research, emerged once more.

One of his short treatises, *Del moto e misura dell'acqua,*[13] was published in 1826 in a collection of essays on hydraulics. Then plans were begun for the complete publication of the notebooks. Each new publication inspired numerous studies and commentaries, partial and often contradictory—and the subject is far from exhausted even now.

The thematic index of an anthology of the notebooks gives some idea of Leonardo's preoccupations. That provided by the MacCurdy edition[14] falls under fifty headings. Leaving aside, for the sake of brevity, all the writings on art, and the philosophical and personal notes, one can find: Geology, Optics, Acoustics, Music, Mathematics, Anatomy, Hydraulics, Ballistics, Naval Armaments, Botany, Movement, Weight, etc. Leonardo, as if he had infinite time at his disposal, embarked on a rational inspection of all the spheres of knowledge, and in each of them, it seems, he made amazingly modern discoveries and, what was more, devised inventions. He imagined a flying machine propelled by great wings, and another that could take off vertically by means of a kind of screw, prefiguring the helicopter; a machine to raise and move monuments; a kind of tank, and even a bicycle.

He was said to have grasped the principle of gravity before Newton, the principle of erosion before Cuvier; he explained the twinkling of stars before Kepler, the trade winds before Halley. He apparently worked out the circulation of the blood and had known and described the internal workings of the human body better than all the anatomists of his day; he anticipated Bacon, Galileo, Pascal, and Huygens.

In 1902, the eminent French chemist and politician Marcellin Berthelot, weary of hearing colleagues in the ultraserious Academy of Sciences exaggerating the importance of da Vinci as engineer and scientist, was one of the first to suggest that all the discoveries and inventions credited to Leonardo were in fact already available in his time, as indeed they had been in the age of Archimedes. Berthelot claimed that Leonardo's writings were for the most part visions, intellectual games, and that this was not in any case the place to look for his genius. "Berthelot's views," a critic recalls, "made no stir and in no way shook the reputation of Leonardo da Vinci in any area of his fame."[15] A few years later, the physicist and philosopher Pierre Duhem, who had no more belief in scientific prophecy than he had in spontaneous generation, clarified some of Leonardo's sources, which made it easier to evaluate his work.[16] Everything has its root, as Victor Hugo wrote. Leonardo did have precursors and masters, whose thoughts he pursued or revived. Many of his works

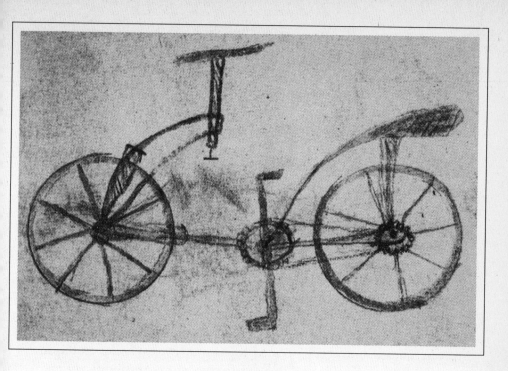

Bicycle,

were directly inspired by those of his contemporaries, often without significant improvements. His engines of war had already been designed by the German engineer Konrad Keyser, his ships and his "automobile" by the Sienese Francesco di Giorgio Martini. And a careful study of his "discoveries" showed that while Leonardo had come close to formulating certain scientific laws and technical innovations, he had rarely followed them through. His flying machine would have been unable to fly. These revelations interested specialists, but the general public was unmoved. The legend of the unique, fertile universal genius, isolated in a century incapable of understanding him, remained intact. And since this was the age of Jules Verne as well as Nietzsche and his Superman, the age of the Universal Exhibition and the Eiffel Tower, the legend kept on growing. It has continued gathering strength into our own time; Italy under Mussolini made a major contribution in 1939 with the great exhibi-

tion of Milan, which had several rooms full of models constructed from the designs for Leonardo's machines.[17]

Viewed from another angle, Leonardo's degree of omniscience, his extraordinary obsessions (arising from man's eternal dreams: flying through the air, exploring the ocean bed) and the mysteriously futuristic research they inspired could hardly fail to arouse suspicions. The same individual had also fashioned, in paint or in clay, angels with perfect smiles, living creatures realistic in every detail; and the artist himself was close to perfection. The excessive is never far from the monstrous. The longer the list of his "discoveries," the more Leonardo appeared to move dangerously beyond all human measure, coming to seem a kind of magician, a fantastic sorcerer, a visionary whose means were not of the world. A sentence from his notebooks, which has persistently been taken out of context to inflate its meaning, *"Facil cosa e farsi universale"* (It's easy to make oneself universal), seemed to suggest overweening ambition and a degree of pride and self-satisfaction at once magnificent and deliciously blasphemous. In the first edition of his *Lives,* Vasari had written that Leonardo "formed in his mind a doctrine so heretical that he depended no more on any religion, perhaps placing scientific knowledge higher than Christian faith." No doubt fearing the passage might damage the master's reputation (the Congregation of the Supreme Inquisition had been created in Rome in 1542), the biographer suppressed it in the definitive edition of the book. Vasari's statement, which suggested atheism or perhaps deism, was later resurrected and twisted; Michelet, for example, in a flight of lyric romanticism, called Leonardo "Faust's Italian brother."

The parallel was suggestive. Leonardo must have made a pact with the devil; there was a whiff of sulfur about him. In order to make accurate anatomical paintings, Leonardo used to "dissect the corpses of criminals in the medical schools, remaining impassive in the face of this inhuman and repulsive work."[18] His contemporaries were well aware of this pursuit (indeed, Leonardo boasted of it as if to provoke people; in 1517, he told the cardinal of Aragon that he had "dissected the corpses of more than thirty men and women of all ages.")[19] One wonders what his fellows thought of this impeccable dandy when they imagined him dissecting dead flesh by

candlelight, sawing up bones, or plunging his well-manicured hands (he devised a method to keep his fingernails clean) into evil-smelling viscera.

The anatomist bordered on the necromancer. What was more, Leonardo wrote *backward,* from right to left, with inverted characters, so his manuscripts have to be read with a mirror. This is in fact a trait commonly found in left-handed people, but some chose to interpret his unusual handwriting—like the hermetic signs used by the alchemist—as a means of concealing studies too discreditable to confess.

Finally, Freud in 1910 offered estimations of a thoroughly abnormal mind.[20] The artist was a case study; the man whom Baudelaire compared to a "deep and dark mirror"[21] was an easy, almost obvious target for the father of psychoanalysis. Freud turned him into a patient—underlining his weaknesses, denouncing his homosexuality (as "passive and idea-bound"), stressing his inhibitions, his neuroses, the difficulty he had in finishing his works, and discovering evidence of sadistic drives.

Leonardo consequently entered the twentieth century trailing clouds of glory, but of a shifting, sometimes ambiguous kind. Today he is seen as one of the most famous figures in the history of art; no painting in the world has been reproduced as often as the *Mona Lisa,* no other attracts so many visitors, or has been "borrowed" by so many other artists. (Marcel Duchamp gave the Mona Lisa a mustache, Fernand Léger, who must have read Freud, linked her to a bunch of keys, Kazimir Malevich included her in a collage, and Andy Warhol printed the image thirty times over by silk screen.) Yet Leonardo is among the least well represented by his works; not a single sculpture survives, and the fewer than fifteen paintings that remain include several that are unfinished and some in which his is not the only hand. Contemporary criticism is still engaged in cutting down to size the catalogue of paintings claimed as his, a list encrusted with all kinds of additions in the nineteenth century. At the same time, he is seen as one of the most ingenious and prolific of minds. Set against the small number of paintings is the extraordinary (sometimes overwhelming) number of notebooks, revealing the dazzling activity of the man of science, the engineer, the writer (indeed, the term "Leonardo complex" has recently been coined).[22]

Finally, he must be numbered one of the most enigmatic figures in the human pantheon. Everything we know about Leonardo and his life has been submerged under what people have wanted to believe about his art and his science.

Like Athens in the age of Pericles, Renaissance Italy is a summit in human history. Today, no name better seems to symbolize that age than Leonardo da Vinci.

I

A Circle
of Mirrors

That figure whose attitude best expresses the passion that moves it is most worthy of praise.

—LEONARDO DA VINCI[1]

Man in a Circle of Mirrors.

NOT FAR FROM THE Turin Cathedral, which houses the famous but now disputed Shroud, there is, in the Biblioteca Reale, the least contested self-portrait of Leonardo da Vinci. It is a drawing in red chalk on a medium-sized sheet of paper (33.3 by 21.4 centimeters), highly detailed and finished. Below the portrait, an unknown hand—but certainly one from the sixteenth century—has written, also in red chalk, the painter's name: Leonardus Vincius, with a further notation, in black: "portrait of himself in fairly old age" *(ritratto di se stesso assai vecchio).* [2] The words have become almost illegible, and the paper is covered with red blotches. Like the Shroud this self-portrait is rarely exhibited in public: ravaged by time, it is stored away from the harmful effects of air and light.

One might say it is Leonardo's destiny, or at any rate it comes close to his spirit, to remain both celebrated and secret, a legendary jewel, buried in the dark. One of his notebooks contains the following sentence from Ovid's *Metamorphoses:* "I doubt, O Greeks, that my exploits can be written down, although you know of them, for I accomplished them without witnesses, with the shades of night as my accomplice." [3]

The Turin self-portrait has been reproduced and published many times; the curious thing is that depending on the way the original was photographed, or the method used by the photoengraver, depending, too, on the size of the reproduction, the expression seems to change—the man looks different. Sometimes reproductions

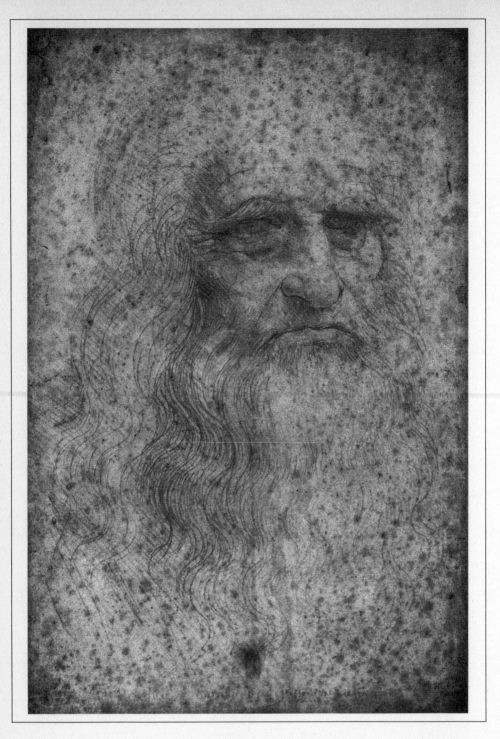

Self-portrait.

18

heighten the contrasts: deepen the wrinkles, introduce a bitter, disillusioned line around the mouth, or accentuate the profile of the nose (which some experts think has been retouched).[4] The eyebrows seem to show irritation, a sort of haughty impatience. In other versions, the ink seems to blur, the eyes become misty, the lips less distinct, and one finds oneself looking at an indecisive old man, fragile and melancholy. In others again, the lines are finer and more delicate, the background is lighter, the red smudges disappear, the cheekbones stand out, the nostrils flare, the beard swells—and the portrait becomes a patriarch, solid and energetic. Looking at one version, I detect an anxious sadness; another seems to portray a mixture of strength and goodness; a third offers ennui, fatalism, and a resigned pessimism; a fourth a hint of malice, if not irony.

It is very strange, especially since in the original drawing all these features seem somehow to mingle and coexist without contradiction. The rich subtlety of this drawing is enough to prove it is not the work of a pupil; indeed, it should be ranked one of Leonardo's masterpieces.

Leonardo was one of the great pioneers in the use of red chalk, a ferruginous, crumbly material remarkably suitable for depicting flesh. It can achieve a delicacy that is impossible to convey by most reproduction techniques. If the paper is slightly tinted, the line seems to well up out of the background, the shading melts into it, and a texture can be achieved comparable to that of oil paint. Leonardo manages to create a soft image without losing any precision of line or form; every hair is there, yet there is no dry academicism in the detail. (Da Vinci's "touch" was also something inimitable; the nineteenth-century engraver Calamatta took no fewer than twenty years to transpose the *Mona Lisa* to copper; by his own account, he never succeeded in perfectly reproducing all its nuances.[5])

The self-portrait is not dated, but most critics agree it was drawn in about 1512, either in Milan or on the way to Rome. Leonardo was about sixty years old; the greater part of his life lay behind him, and what he had done with it (his notebooks tell us) far from satisfied him. His health was failing, age and long study had weakened his eyes, he would soon need spectacles for working, and under the light mustache, the shrunken upper lip reveals that his teeth had gone. His French patrons were being driven out of Italy; just as his

star was fading, he had to start looking for a new protector. Many of his friends were dead. To whom could he turn?

As surprising as the self-portrait's many moods is the fact that the eyes, under the long bushy brows, are looking not ahead but rather slightly to the side and downward. Most of Rembrandt's self-portraits look the viewer straight in the eye. Raphael, Dürer, Rubens, Velázquez, Ingres, Corot, Delacroix, Van Gogh, all painters of self-portraits, look out directly and horizontally, as if into the mirror from which they were taking their image.

At a period of uncertainty, having to start all over again (at his age!), Leonardo wanted to see his face as he did not habitually see it: obliquely, at work. He probably used an ingenious arrangement of mirrors, at least three: one facing him, one three quarters on, one behind him.[6] (Looking glasses were preoccupying him just then; in Rome in 1513, he spent a great deal of time and energy building parabolic mirrors.) In this portrait, there would be no self-deception; rather, he was studying himself scientifically, catching himself unawares, so to speak. He scrutinized the worn features of the old man he had become, as if they were those of a stranger. The mysterious power of the drawing may derive from this: Leonardo is summing up his life with a crayon.

He is searching for himself, interrogating himself, *thinking* himself. He is analyzing the marks left on him by the years: his childhood in Vinci, his apprenticeship in Florence, the happy years of his first stay in Milan, uncertainty and wandering, the mercenary travels in the pay of Cesare Borgia. All the feelings that ran through him as his hand moved over the paper, passing across his face as clouds pass across the sky, are there in the portrait.

It is interesting to compare the Turin self-portrait with portraits made of him by his pupils: the profile in the Royal Library at Windsor[7] and its replica in the Ambrosiana,[8] attributed to either Francesco Melzi or Ambrogio de Predis.

The Windsor profile shows a Leonardo younger by some years than the self-portrait. Time has not yet made the hair recede from the brow, the eyes are less deeply circled, the lines are less marked, the beard is fuller and even glossier. But there are differences between the two works that have nothing to do with age: the pupil

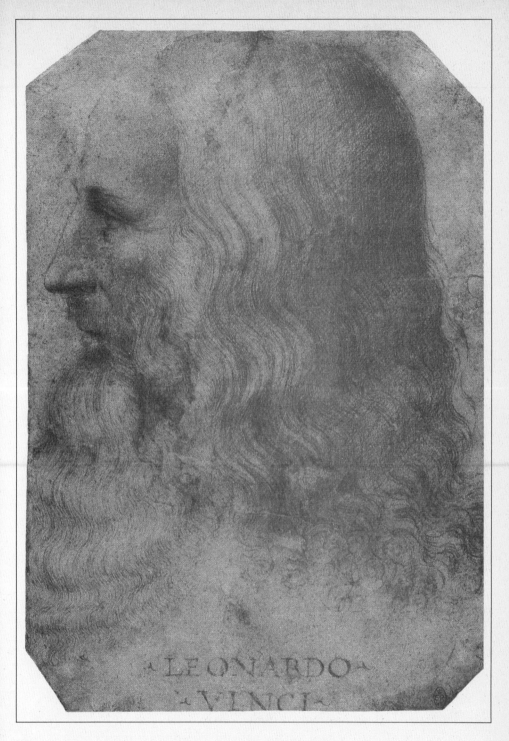

School of Leonardo da Vinci, Portrait of Leonardo da Vinci.

ROYAL LIBRARY, WINDSOR.

21

has corrected the line of the master's nose, making it finer and more narrow, as if to approximate the ancient Greek ideal; and he has left out the thick eyebrows. The pose of the profile reminds one of the effigy on a medal: the disillusioned, melancholy expression, heavy with regret for all that has been left undone, haunted by disappointment, failure, and the approach of death, is here smoothed away and refined, leaving only a limpid serenity. Hiding from others the anguish gnawing at his soul, but revealing its inexorable progress in his notebooks, Leonardo presented in public a clear-eyed and luminous mask, shining with goodness, mildness, and gentleness.

Leonardo "had such great presence," writes Vasari, "that one only had to see him for all sadness to vanish." Yet were it not for these literary descriptions, one might never suspect that Leonardo had been a man of striking beauty. The Turin portrait has directly or indirectly shaped the entire iconography of the artist, imposing on it a reductive but ineradicable idea of the man. It is impossible now to conceive him other than with the white beard; impossible to imagine him with another, younger face. Significantly, whenever his life is retold in pictures, he is always depicted as bearded and long-haired; the illustrator merely makes the younger man's hair thicker and darker.[9]

Cristoforo Coriolano, the Venetian engraver to whom Vasari had recourse for the illustrations to the second edition of his *Lives,* was the first to popularize this simplified version of Leonardo. Inspired (I feel sure[10]) by the Turin portrait, he engraved a vigorous profile, where one finds once more the wrinkles, the strong nose, and the lofty, preoccupied forehead. The only addition is a traveling cap, something like a beret. In slightly modified form, the Coriolano engraving was reproduced in Antwerp in 1611, Amsterdam in 1682, and Paris in 1745.[11] Vasari uses the image in his fresco *The Court of Leo X* in the Palazzo Vecchio in Florence. The detail of the features did not matter so much; thenceforward the characteristic signs (beard, hair, curious little cap) would serve as immediate identification of Leonardo, just as the mustache, the cane, and the bowler hat identify Charlie Chaplin. Leonardo became a type, a silhouette. The sad monument in the Piazza della Scala in Milan by the sculptor Pietro Magni, or the pathetic painting by Ingres show-

From Vasari's *Lives,* 1568.

———

ing Leonardo dying in the arms of a distraught François I, were both inspired by the *idea* of how he looked.

There is a painting in the Uffizi in Florence that was long considered to be a self-portrait in oils of the master; here Leonardo appears as a mature man, bearded but with an animated expression, and this time wearing a large floppy cap. But in about 1935, connoisseurs, made suspicious by the work's mediocre quality, finally subjected it to scientific analysis. X-rays showed that it had been painted over a *Penitent Mary Magdalene,* itself a work of little interest, probably by a German artist of the seventeenth century.[12] It was withdrawn from the Uffizi, but it had already become fixed in people's minds: the hat it depicted had taken its place in Leonardo's iconography. It figures, for instance, in the sculpture at La Scala as well as in the majority of paintings or engravings of Leonardo done at this time. There are a few other presumed por-

traits, notably a rather crude profile, also in the Uffizi, attributed to a pupil and based on the Windsor profile; and a three-quarters portrait in the Cherbourg Museum, vaguely resembling the Turin portrait but looking a few years younger. None of these is convincing, nor does any of them contribute any new or precise information about the physical appearance (or psychology) of da Vinci.[13]

However, there once existed a portrait, not without talent, of Leonardo as a young man, according to the lines written by the Florentine poet Giovanni Nesi at the end of the quattrocento:

> *I have already seen, drawn in charcoal with perfect art,*
> *The venerable image of my Vinci . . .*

And the poem goes on:

> *It is such that if you trace his portrait with a brush,*
> *Whoever you are, whatever your colors,*
> *You will never surpass his image or do better than he.*
> *For his art is more worthy and of greater value,*
> *That art in which he seems to be absorbed,*
> *Whereas his greatest value*
> *Resides in himself.* [14]

This charcoal drawing that was, according to Nesi, beyond compare has not survived, as is the case with so many of Leonardo's works. The poet does not dwell on a description of it but uses it as a pretext to write a clever homage in the form of Chinese boxes: no painter, even if he uses oil or tempera instead of a stick of charcoal, will be able to rival da Vinci, whose art is nevertheless surpassed by his person. There is no greater artist than he, yet the artist conceals a man who is even more admirable.

Nesi's ingenious game is in a way the equivalent of Vasari's *divino;* Leonardo's works and personality are so impossible to analyze, apparently, that this is the only way to deal with them.

Certain historians[15] of the late nineteenth century searched through the oeuvres of Leonardo's contemporaries hoping to uncover some unknown portrait of the master. Their efforts brought

only idealized representations to light (such as Plato in *The School of Athens*). Most, in any case, are disputed. Practically every time historians came across an image of an old man with white hair and a long beard, preferably wearing some kind of cap, they fell over themselves to prove that this was da Vinci.[16]

Yet even if we accept these as actual portraits, none can be considered a portrait from life, a "speaking likeness," enabling us to glimpse something of the model's personality, as the Turin drawing does. They always tell us less about the subject than about the author, or rather the author's attitude toward the subject.

Other historians went further and examined the works of the *young* Leonardo's colleagues seeking possible portraits of him before the white hair and beard.[17] These seekers have claimed that Verrocchio, Leonardo's teacher, used him as a model for the *David* (National Museum, Florence). Such an identification is certainly possible—the ages and dates more or less tally; the shape of the nose and the brow, the eyelids, the melancholy sweetness of the eyes, the regular line of the lips, the wavy hair, all anticipate to some extent the Turin portrait. Moreover, if Leonardo was as beautiful as people said, it would have been natural for Verrocchio or fellow students to ask him to pose.

Historians have also looked for Leonardo in his own works. Surely he used himself as a model, studied and represented himself more than we think. Observers have noticed in his unfinished *Adoration of the Magi* (Uffizi) a young man of slender bearing, with that characteristically bony, slightly aquiline nose, standing on the right as if, unconcerned with the mystery of the Epiphany, he were talking to someone outside the frame. Large ceremonial paintings (Adorations, for instance, or Virgins in Majesty) allowed artists to slip in among the characters of the Holy Scripture depictions of patrons, people they wished to honor, friends, or sometimes, as a kind of signature, themselves.[18] These self-portraits within larger paintings usually give themselves away by their location (mostly in one of the painting's lower corners) or by some attitude or expression completely at odds with those of the other characters. This is the case in Botticelli's *Adoration of the Magi;* one recognizes the painter himself in the figure draped in a flowing yellow cloak, looking boldly out at the spectator. The young man in Leonardo's

Detail from *Adoration of the Magi.*
GALLERIA DEGLI UFFIZI, FLORENCE.

Adoration has much in common with Botticelli's self-portrait: the position, the peripheral situation,[19] the subject of the painting, the date of execution. It is all the more the pity, then, that the da Vinci is unfinished. It has outlines and hints at the light, but there is no color, no flesh, no precise detail, merely a certain spirit, elegant and relaxed. The young man with the indifferent air barely emerges from the surrounding shadows to which he belongs.[20]

The search for Leonardo's image extended to his own drawings and notebooks. He liked to draw old men and beardless youths at all periods of his life, and often the worn or terrifying faces resemble each other, evoking or prefiguring the Turin portrait. When still under thirty, he was drawing profiles of older men[21] that look like premonitory self-portraits (some critics[22] claim them to be portraits

of his father, Ser Piero da Vinci, with no evidence other than "family resemblance"). The broad brow, the powerful nose, the sharp or pensive eye, the mouth with drooping corners, the rather heavy chin, occur time and time again in the pages of the notebooks, sometimes in caricature, as if Leonardo was haunted by his own features, or rather by those that his own resembled, a physiognomy to which he continually returned, a canon from which he could not escape. He tended, for example, to give his male faces a fleshy and prominent lower lip, which becomes a thrusting deformity in the most exaggerated instances. Echo of self is the most probable explanation, as he himself suggests in his notes: "The painter who has rough hands will draw the same in his works," or "if you have a bestial face, so, too, will the faces you draw be lacking in grace, and similarly, any quality you possess, good or bad, will be partly displayed in the figures you produce."[23] And again: "Apply yourself to copying the agreeable parts of fair faces whose beauties are consecrated by renown rather than by your own judgment, else you run the risk of erring by choosing faces too like your own, for similarity seems to seduce us; if you were ugly, you would not linger over fair faces but would create ugly ones, like so many painters *whose types often resemble their author.*"[24]

Though given to artists with unprepossessing looks, the advice applies to all (as one can see by comparing the figures created by Botticelli and Raphael with their self-portraits). It holds for Leonardo too. Even if he tried to follow his own advice,[25] would we not look for some reflection of his own looks in all his works—his saints, angels, and even women? Perhaps when he smiled, it was with the bewitching smile of John the Baptist or Mona Lisa.[26]

Some think at least two[27] of Leonardo's drawings are as surely self-portraits as the sketch in Turin. These are both of a man without a beard, his head shaved, full face and in profile, with the center of the face squared off and a grid superimposed, so as to calculate the proportions. The drawings represent a fine Mediterranean head, reminiscent of some consul of ancient Rome. Here again, one finds all the characteristics of the Turin portrait; adding the long hair and beard, one discovers the man from the chalk sketch, seen from different angles. These drawings date from the 1490s, when he was about forty years old, yet they depict a much older man (especially

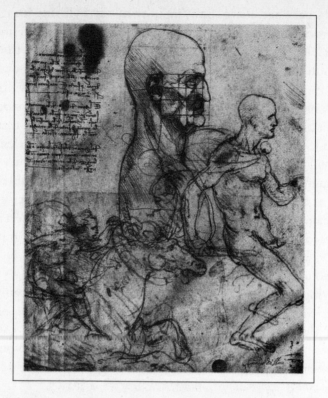

Profile of Man and Studies of Riders.
ACCADEMIA, VENICE.

the profile),[28] with sunken cheeks and deep circles under the eyes, a man who is well over sixty. Was Leonardo caricaturing himself, altering the reality of his features in the drawing just as in life he hid himself, from some point on, behind his long beard?

One should spend a long time observing the Turin self-portrait— it is inexhaustible, which is why it reproduces so badly. Do so and you will see passing before you, through imperceptible changes in your own perspective, all the faces Leonardo could embody. One can see him playing countless roles, expressing an infinite variety of sentiments. Ultimately, one sees his own perplexity, touched by weariness and irritation, when faced with the multiple being reflected in the set of mirrors.

I want to understand how, by what process, the fresh-faced Leonardo of childhood—an unformed being in front of whom every path lay open—came to have this face at the end of his life. To do so, I shall try not to construct too much (constructing means having in mind from the start what one will find at the end). I shall attempt as far as possible to reconstitute things (without neglecting any clue or hypothesis), beginning the search from scratch and trying to follow Leonardo's movements in time, examining sources and motives almost as if I were a detective.

When I look once more at the face in the red-chalk drawing in Turin, I see now in the corners of the eyes and the curve of the lips a mixture of indifference and mockery, as if Leonardo had unwillingly deigned to take up the pose.

II

Lovable as a Love Child

He was the natural child of Ser Piero, notary of the Republic, and as lovable as a love child.

—STENDHAL

Sketch for a Madonna

LOUVRE, PARIS.

A CRUCIAL MOMENT came in Leonardo's life when, as an adolescent, he arrived in Florence from his native village of Vinci.

The normal route would have been down the southern side of Monte Albano, joining the river Arno at Empoli and following it along the valley to Montelupo, La Gola della Gonfalina, Malmantile, La Lastra, and finally Florence. If this was indeed the route he took, he would have entered the city, after a journey of forty to forty-five kilometers, by the Porta San Friano.

Over the high, ocher-colored wall bristling with towers that surrounded the city, he would have seen the roof of a fortified house, a pointed bell tower, the pale ribs of the great dome. He probably had to contain his impatience; at every gate, all baggage and the load of every cart had to be inspected by the salt-tax officers.

Once past the customs barrier, he would have come in past Santa Maria di Verzaia. The cart track, with its deep ruts, here gave way to a paved street on which the hooves of the mules clattered; now there were no more trees. Leonardo would have crossed the Ponte alla Carraia and then plunged, via the Borgo Ognissanti, into the noisy heart of the city, making his way to the Via della Prestanza, near the Piazza San Firenze, where his father, Ser Piero da Vinci, had rented rooms.

No doubt Leonardo had been to Florence before with his father, who, as an active notary, had built up a solid practice over the years. But this time Leonardo was not on a pleasure trip. He had left Vinci to live in the capital of Tuscany.

"Going to town" meant very different things for father and son. For the father, it represented a kind of triumph. For young Leonardo it meant separation from his mother and from the hills and mountains, woods and fields, where he had spent his early years. It was the end of childhood. Thenceforward, he would have to deal with the real world and try to find his place in society. He was old enough to be apprenticed.

The Tuscan archives make it possible to trace Leonardo's family as far back as the 1300s. The earliest ancestor on record is his paternal great-great-great-grandfather, Ser Michele, who had taken as a patronym the name of his native village, Vinci, and was a notary. He emigrated to Florence, taking his family with him. His son, Ser Guido,[1] succeeded him; he, too, lived in Florence as a notary. Michele's grandson Ser Piero continued the family tradition; he married into the respectable Florentine bourgeoisie and became a notary and chancellor of the Republic, obtaining the honor of state office.[2]

Here were three generations of men of the law, making names for themselves in the capital. Then suddenly the sequence is interrupted. Leonardo's grandfather Antonio, breaking with family tradition, returned to the small estate of his forefathers in Vinci and led the quiet life of a country squire. He married the daughter of a notary, Lucia di Ser Piero Zosi di Bacchereto.[3] Perhaps out of respect for his progenitors, he was addressed as "Ser," the title of a notary, but it is not bestowed in any official document; everything suggests he had no qualifications and that he never practiced any profession.[4] Neither did he have a true peasant's mentality, for he made little effort to enlarge the estate. He farmed it out to sharecroppers and lived a quiet life as a landowner with modest tastes. Antonio married very late in life, as if out of duty; at the time of the birth of his first child, Piero, he was over fifty, and he had reached eighty by the time Leonardo was born.

The contrast between Leonardo's grandfather and his father is striking. Active, ambitious, oft married, Ser Piero seemed determined to pick up where his grandfather, after whom he was named, had left off. He became a notary at a young age. He began his career

The village of Vinci.

in Pisa and Pistoia, but very soon started looking for a practice in Florence. Eventually, he built up a clientele there—a convent and certain private customers. Thanks to his efforts, the da Vinci family regained some of its former luster and emerged once more from anonymity. The windows of the apartment Ser Piero rented[5] opened onto the back of the Palazzo della Signoria, the seat of government. All manner of hopes might flourish in the shadow of its bell tower: that the Republic would soon be calling for his services on a regular basis; that soon he would have another son, who could become a notary and aim higher still.

Another son it would have to be, for his firstborn, Leonardo, was a bastard. The statutes of the guild of magistrates and notaries refused illegitimate children (as well as gravediggers, priests, and criminals) entry to this noble profession.[6] Nor could Leonardo

become a doctor or an apothecary. He would not go to the university for the same reason. When he arrived in the city, all careers of any consequence were closed to him.[7]

Many authors[8] have tried to minimize the role played by illegitimacy in Leonardo's life. The word "bastard," they argue, was not at all dishonorable in Renaissance Italy.[9]

While it is true that the situation of illegitimate children seems to have been noticeably better in Italy than in other parts of Europe, easier, too, in the fifteenth than in later centuries, it differed considerably according to whether the child's father belonged to the nobility, to the common people, or to what today would be called the middle class.

King Ferrante of Naples did not, it seems, greatly suffer from his irregular parentage; neither did Filippino Lippi, a painter and the son of a painter.[10] But matters were always more complicated in bourgeois families—the class in between. In order to maintain its prerogatives, to distinguish and protect itself, the bourgeoisie made up a multitude of rules. Hence the system of guilds, companies, or corporations, known in Florence as the *arti*. Before long, since the bourgeoisie was readily imitated by those below, a distinction grew up between the *arti maggiori* (or "noble professions"), which included cloth merchants, bankers, and notaries among others, and the *arti minori*. Variable in number, and conferring no notable social benefits, these humbler guilds included craftsmen and artisans.

A bastard would have to belong to one of the great Florentine dynasties—the Albizzi, Gondi, or Rucellai—to have hopes of finding a place of any status in this bourgeois republic. As the illegitimate child of a small-time notary, unable to overcome the usual prohibitions and prejudices by family influence, Leonardo could have no hope of a traditional career (a sad fate in a city where it was said that "he who possesses nothing is worth no more than a beast"). He would have to search for fortune in some unconventional way: in the army (many *condottieri*—mercenaries—were bastards), in literature, or in the arts.

If Leonardo had been his legitimate heir, Ser Piero most likely would have obliged him to follow his own footsteps into the law, or at least would have directed him toward one of the *arti maggiori*.

Leonardo, from what we know of him, might not have been unwilling to become a doctor. It was rare to find the son of a bourgeois among the painters and sculptors: Mantegna was the son of a peasant, Paolo Uccello's father was a butcher, Botticelli's a tanner, Giuliano di Maiano's a stonemason. Some came from backgrounds of grinding poverty, like the Pollaiuolo brothers, sons of a poultry seller, hence their name, or Perugino, who learned the elements of the trade while working as a domestic servant to an artist. Many were themselves sons of painters or goldsmiths: Ghiberti, Raphael, Piero di Cosimo. Few were like Alesso Baldovinetti, who turned his back on his father's lucrative trade in order to pursue a career in painting. Michelangelo had to defy his family—at the cost of punishments and beatings—to embrace a condition regarded as dishonorable by relatives.

Ser Piero did not stand in Leonardo's way; the boy was not his "proper" son. As soon as he arrived in Florence, Ser Piero sent him to be apprenticed; what else was there to do with him?

Leonardo was about fourteen or fifteen at the time. He must have shown early promise at drawing. Perhaps he began, like Giotto, the shepherd boy, by sketching animals and flowers on flat stones; then, since paper would have been plentiful in the house of a notary, he may have drawn portraits of those around him. Ser Piero, a sensible man of the law, collected the best drawings and took them to his friend Andrea del Verrocchio, painter by appointment to the Medicis, to have an expert's opinion of the boy's talents.

Verrocchio, Vasari tells us, "was amazed by such promising beginnings and urged Piero to have the lad study the subject." It is unlikely Ser Piero hesitated long. If Verrocchio was willing to take the boy on, why not send him straight away to the workshop?

Leonardo was born in 1452—on Saturday, April 15, at 10:30 P.M., to be precise. Antonio, his grandfather, noted the event at the bottom of the last page in the notarial book that had belonged to Leonardo's great-great-grandfather. The entry reads: "1452: there was born to me a grandson, the child of Ser Piero my son." As was usual in the case of an illegitimate child, the mother's name was not

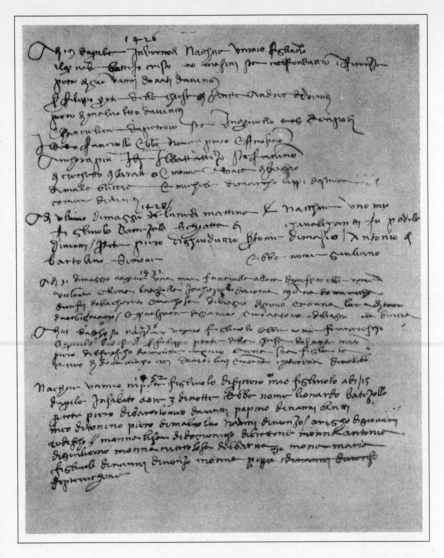

The last page from
Ser Antonio's notorial book.

recorded, but the name of the priest who baptized Leonardo appears—Piero di Bartolomeo di Pagneca—as well as the names of five men and five women from the village who acted as witnesses to the ceremony.[11]

The few lines penned by Antonio tell us nothing at all about the house in which the child was born, the circumstances of his birth, or the way the birth was received. Nor do we know who took custody of the child—the paternal family or his mother. And who was this woman, whose surname is unknown?[12] The Anonimo Gaddiano claims, unreliably, that Caterina "was of good blood and Guelph origin," which only confuses the picture.

What can be said with certainty is that from the start, Leonardo's life did not follow an ordinary course. When he was born, his paternal family consisted of the grandparents, Antonio and Monna Lucia, aged eighty and fifty-nine, respectively, and their three children: Piero, then twenty-five, already a notary and often away in Pisa, Pistoia, or Florence on business; Violante, his younger sister, who had married and moved away from Vinci; and the sixteen-year-old Francesco, who, like his father, had no professional ambition and though registered in the silk guild was in fact content to stay home and run the estate.

In the very year of Leonardo's birth, Ser Piero married advantageously—to a girl from the Florentine bourgeoisie, Albiera di Giovanni Amadori. Did this occasion mark his break with Caterina, or did he have a wife in town and keep a mistress in Vinci?

This seems improbable, and even if such an arrangement existed, it cannot have lasted long. Caterina, who was about twenty-two years old, most likely the daughter of peasants and employed either on the land or perhaps as a servant at an inn, was herself married not long thereafter, to a certain Antonio di Piero di Andrea di Giovanni Buti, nicknamed Accattabriga—the Quarreler. They settled at his home in Campo Zeppi, just over two kilometers from Vinci. They soon had a daughter, Piera, followed by three more daughters and a son.

So in addition to unmarried parents who quickly split up, Leonardo soon had both a stepmother and a stepfather, and then, on his mother's side, several half-sisters and a half-brother.

As for the events preceding Leonardo's birth, only hypotheses are possible. Since by custom Tuscan girls married at a young age, it is possible that Caterina had met and become involved with Piero many years before bearing his son. We may also imagine that the

Leonardo's Family Tree

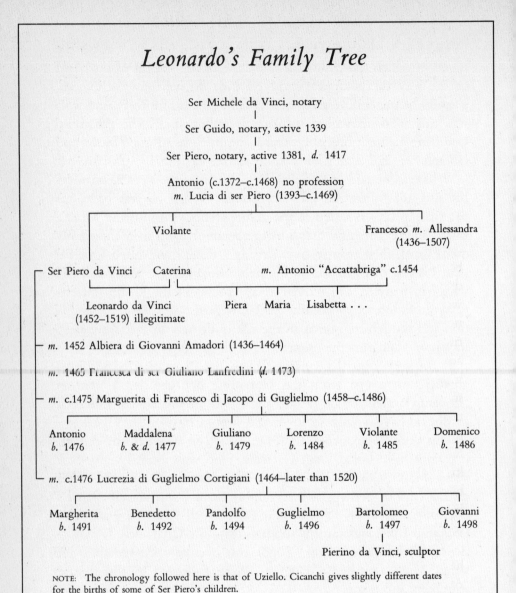

Ser Michele da Vinci, notary
|
Ser Guido, notary, active 1339
|
Ser Piero, notary, active 1381, *d.* 1417
|
Antonio (c.1372–c.1468) no profession
m. Lucia di ser Piero (1393–c.1469)

Violante Francesco *m.* Allessandra
(1436–1507)

Ser Piero da Vinci Caterina *m.* Antonio "Accattabriga" c.1454

Leonardo da Vinci Piera Maria Lisabetta . . .
(1452–1519) illegitimate

m. 1452 Albiera di Giovanni Amadori (1436–1464)

m. 1465 Francesca di ser Giuliano Lanfredini (*d.* 1473)

m. c.1475 Marguerita di Francesco di Jacopo di Guglielmo (1458–c.1486)

Antonio	Maddalena	Giuliano	Lorenzo	Violante	Domenico
b. 1476	*b.* & *d.* 1477	*b.* 1479	*b.* 1484	*b.* 1485	*b.* 1486

m. c.1476 Lucrezia di Guglielmo Cortigiani (1464–later than 1520)

Margherita	Benedetto	Pandolfo	Guglielmo	Bartolomeo	Giovanni
b. 1491	*b.* 1492	*b.* 1494	*b.* 1496	*b.* 1497	*b.* 1498

Pierino da Vinci, sculptor

NOTE: The chronology followed here is that of Uziello. Cicanchi gives slightly different dates for the births of some of Ser Piero's children.

child inherited his beauty from her. (Leonardo later wrote in one of his notebooks: "Have you not seen peasant girls in the mountains, clad in their poor rags, bereft of all ornament, yet surpassing in beauty women covered with adornments?"[13] Ser Piero was not accused of "kidnapping," and there was no fine for rape (Italian

archives are otherwise full of such charges). Was he in love with Caterina? And was his love requited? In his notebooks, Leonardo penned another observation, as intriguing as it is unscientific: "The man who accomplishes intercourse with reluctance and disdain sires children who are irritable and unworthy of confidence, but if intercourse is entered upon with great love and desire on both sides, the child will be of great intelligence, full of wit, liveliness, and grace."[14] Was this an allusion to illegitimate children, the fruit not of arranged marriages but of passion? Perhaps he was told in his youth tales of his parents' great love, hence this proud conclusion.

But grand passion or no, the relationship ended. Ser Piero may have tired of Caterina or abandoned her after the birth of their son, because she did not fit into his plans, because his prospering business drew him to Florence, or because he had met a young woman who would provide a dowry and whose parents could help establish him in the city. Self-interest, which ruled the lives of most men at the time, would explain why the child remained illegitimate. If we accept that Ser Piero sacrificed Caterina to his career, we might also imagine that either out of remorse, or for fear of a scandal, he subsequently sought a husband for his mistress in the village, if necessary paying the dowry out of his own pocket, in order to make up for his conduct. This would explain why Caterina found a match fairly quickly, despite her age and her child. Accattabriga was known to the da Vincis; he had been a lime burner near the village between 1449 and 1453, and the land of his family at Campo Zeppi bordered on the property of Antonio di Lionardo, a man with ties to one of Leonardo's grandfathers.[15]

This arrangement, which would appeal to the notarial mind, may have been suggested by the grandparents. For a couple as elderly as Antonio and Monna Lucia, the arrival of a first grandson, even illegitimate and born to a woman of lower status, would have been a happy event: a child to enliven their declining years. Antonio was not ashamed to record the birth in his family papers, and the number of witnesses he mentions attending the baptism tells us that he fully recognized the child and wanted him to be completely integrated into the village community.

But even if they so desired, the grandparents could not take sole responsibility for the baby. He had to be breast-fed, and while wet

nursing was widespread during the Renaissance, it was essentially a practice among the rich. The Vincis were not particularly wealthy. Ser Piero was just beginning his career, and the small family estate, planted with olive trees, wheat, and buckwheat, provided only a modest income. A single servant woman did the housekeeping, at a wage of eight florins a year. Why go to unnecessary trouble and expense to hire a wet nurse?[16] In all probability, Leonardo was entrusted to his mother, possibly even in exchange for her keep. She would have lived only a few hundred yards from the Vincis, and he would have remained with her until he was weaned—normally about eighteen months. It was roughly after this interval that Caterina married Accattabriga and went to live in Campo Zeppi. This may be coincidence, but one's impression is of an orderly procedure, planned in advance and possibly drawn up by contract: Caterina delivered Leonardo back to his father's family once he was weaned. She was then free to marry Accattabriga, who, in spite of his nickname,[17] seems not to have been too bad a match; his father owned a farm and some land, which brought in a decent income.

The traditional chronology of Leonardo's youth is based on three tax declarations[18] by the da Vinci family: one filed by the grandfather in 1457; one by Monna Lucia in 1469; and one by Ser Piero dating from 1470 and registered in Florence, not Vinci.

To the researcher, the registers containing these detailed accounts are a magnificent source of information. The accuracy of the data they contain is, however, less than complete, first because in Renaissance Italy people were just as anxious to avoid paying taxes as they are today, and second because the census was carried out at irregular intervals, arbitrarily chosen. The 1457 document is the first after Leonardo's birth and the first official record bearing his name.

In it, Antonio declared that the child was living with him; he registered him on the tax census as a *bocca*—a mouth to feed. In order to convince the authorities of the bona fide nature of his request, he spelled out that the child was born to "Caterina now the wife of Accattabriga." The authorities granted tax reductions for illegitimate children only after special consideration; the reduction was in fact refused in this case, as the accounts that follow the

A Rush and a Sedge.

ROYAL LIBRARY, WINDSOR.

declaration show. The same happened in 1469. There was no *automatic* right to a reduction, so, contrary to the opinion of some historians, the Vincis did not take in the child with the aim of

A Small Oak Branch with a Spray of Dyer's Greenweed.
ROYAL LIBRARY, WINDSOR.

reducing their taxes. They may have been parsimonious, but self-interest did not exclude a sense of family obligation.

At any rate, by 1457 Leonardo was living with his grandparents. Did that mean he stopped seeing his mother altogether? And who supervised his day-to-day life?

44

Ser Piero and his lawfully wedded wife spent most of their time in Florence, at least a day's journey away. The notary probably came home only for feast days, special occasions, or on summer holidays to escape the city heat. While there seem to have been some links between the child and his stepmother,[19] her visits in Vinci were probably too short and episodic to allow for any determining influence over the child's development.

So it seems responsibility for the boy rested almost entirely with Piero's aged parents and his younger brother, Francesco. In fact, the latter must have been the person closest to the growing boy. Only sixteen years older than his nephew, Francesco took his pleasure from the land, from which he was never long away. When Antonio was no longer able to go out in the fields, it was Francesco who would have supervised the olive harvest, inspected the grapevines, and negotiated with the sharecroppers. The child would have grown up alongside this gentle and contemplative man of independent character, who surely knew the names and qualities of plants (the region is rich in medicinal herbs), the signs of bad weather, the habits of the wild creatures, and the superstitious legends that govern country people's acts. Leonardo would have acquired in his company a love of the outdoors and a curiosity about the natural world. Francesco planted mulberry trees and dabbled in silk production; was it for his benefit that Leonardo later devised a mill for crushing dyestuffs?[20] The close bond between them does not seem to have slackened with time. When Francesco died childless in 1506, it was to Leonardo and not to his legitimate nephews that, contrary to custom, he left his possessions.

Oddly enough, in the first edition of Vasari's *Lives,* Ser Piero is described (possibly by scribal error, by misinformation, or by a deliberate attempt to conceal Leonardo's illegitimacy) as the artist's uncle. Vasari rectified this in the next edition, but perhaps the initial mistake is closer to the truth.

We have no idea how often Leonardo met his mother, but it is not unreasonable to suppose that they saw each other quite frequently. From Vinci to Campo Zeppi is not far—a healthy boy could walk there in half an hour. The "Accattabrigas" would have attended church in nearby San Pantaleone, but for everything else

they depended on Vinci. This is a confined region, hemmed in by high hills, and all the inhabitants would have been bound by links of one kind or another. There was no shortage of occasions—feast days, baptisms, fairs—that would also bring them together.[21]

What evidence remains of Leonardo's feelings about his real mother? "Tell me how things are back there, and can you tell me what la Caterina wishes to do," we read in one of his notebooks.[22] If this incomplete sentence does concern his mother (which is probable but not certain), one might conclude that he thought of her with some disrespect: "la Caterina." Referring to his father, he invariably writes "Ser Piero, my father." Was it perhaps painful to refer to Caterina as "my mother"? Did he save this form of address for Ser Piero's legitimate wives? Did he subconsciously think Caterina did not deserve it?

The first child of the Accattabriga household was born when Leonardo was two or three years old; the others followed fairly quickly. So in his early childhood, Leonardo would always have seen his mother encumbered by a young child demanding her attention—an intruder, usurping his rights and taking his place in his mother's heart. How could he fail to compare his own situation with that of his half-sisters and half-brother, who had both their rightful parents living with them all the time? How, on the other hand, could he have avoided comparing the brilliant (but distant) Ser Piero, whose success must have been the subject of village talk, and Accattabriga, a man who was most likely illiterate, who worked at the kiln and farmed by the sweat of his brow?

Leonardo, who later spent much time studying the mechanisms of childbirth and the development of the fetus, wrote and repeated that "a single soul governs the two bodies" (of mother and unborn child). He considered—in an astonishingly modern insight—that "desires, fears, and suffering are common to this creature as to all the other animate parts of the body, so that something desired by the mother will be imprinted on the members of the child within her when she experiences the desire, and a sudden terror may kill both mother and child." Ser Piero married Albiera in Florence the same year that Leonardo was born. Did he abandon Caterina, or tell her of his engagement, while she was pregnant? One may imagine

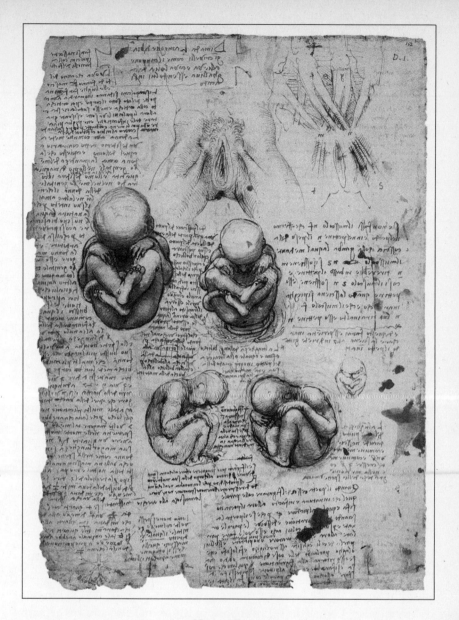

Human Fetus.

the distress the news would have caused the young woman. Else-where, Leonardo wonders whether the unborn fetus can cry and make sounds, and writes, "How the same spirit governs two bodies:

47

in that the desires, fears, and sorrows of the mother are one with the sorrows, that is to say the physical sufferings and wants, of the child lodged in the maternal womb."[23]

In the last years of the fifteenth century, Leonardo noted down a series of prophecies in the form of riddles, a fashionable genre at the time, which amused him and with which he may have entertained the court of Milan.[24] Among the riddles he records, the number that turn on the identification of children may reflect wounds suffered from illegitimacy and his parents' separation. "The time of Herod will return," he writes, "for innocent children will be snatched from nursing mothers and will die of great wounds inflicted by cruel men." The bathetic answer is "baby goats," but there is a warmth of feeling here and the theme turns up again. He writes elsewhere that "Many children will be torn from the arms of their mother, with pitiless blows, and thrown to the ground to be mutilated." Here the answer is "walnuts, acorns, and olives." And we read these words in a riddle to which the answer is "donkeys": "A tender and kind mother to some of your children, you are a cruel and implacable stepmother to others. . . . I see your sons sold into slavery and their lives serving the oppressor." Most tellingly, there is this one: "We will see fathers and mothers take more care of their stepchildren than of their own son." The answer: trees, which allow their sap to nourish grafts. I could quote more examples. The obsessive return to this theme, more disturbing than a straightforward lament, seems to point to the importance of the trauma.

It was in 1909, when treating a patient "with the same constitution as Leonardo but without his genius,"[25] that Sigmund Freud thought of applying his own method to da Vinci: to try, as he put it, "to explain Leonardo's inhibitions in his sexual life and his artistic activity." Why did Leonardo leave so many works unfinished? Freud took as his point of departure a curious memory recorded by Leonardo in one of his notebooks and interpreted it in the light of similar information given him by his patients, going on to draw conclusions about the artist's childhood. Proceeding rather like a paleontologist who uses a jawbone or tibia to reconstruct a whole dinosaur, he set out to reconstitute certain obscure events in the artist's life and certain facets of his personality. In 1910, Freud

published *A Childhood Memory of Leonardo da Vinci,* into which he had put much passion and which he later considered "the only pretty thing" he had ever written.

Leonardo had noted, on the back of a page covered with observations about birds' flight: "I seem to have been destined to write in such a detailed manner on the subject of the kite, for in one of my earliest childhood memories, it seems to me that when I was in my cradle, a kite flew down and opened my mouth with its tail and struck me many times with the tail on the inside of my lips."[26]

Freud interpreted the bird's tail as the maternal breast. When he then ventured to explain why Leonardo had chosen that particular species of bird, he unfortunately committed an error for which historians have never forgiven him. In the German version of the *Notebooks* from which he was working, the word *nibbio* used by Leonardo was translated incorrectly as "vulture" *(Geier).* So Freud's bold conclusions, reached in part by reference to Egyptian mythology about vultures, could hardly be taken seriously.[27]

Nonetheless, Freud was the first to bring into the open the crucial problem of Leonardo's illegitimacy and his parents' separation. He drew a picture of the conflicts that raged inside the artist, deciphered the ambivalent feelings he had toward his mother. According to the analyst, Leonardo unwittingly held her responsible for having abandoned him (hence the idea of the "hostile mother"). Freud then went on to show that this contributed to the development of Leonardo's sexual inhibitions, to his homosexuality, and eventually to his refusal of all sexual activity. Thanks to the phenomenon of sublimation, this also fueled his intellectual curiosity and reinforced his "instinct of investigation" to the detriment, according to Freud (and this is perhaps the greatest aberration in the essay), of his artistic creativity.

One might reproach Freud, apart from the kite-vulture confusion, for the unwarranted reduction of various events that afflicted Leonardo's childhood into one alone: the moment of leaving a tenderly loving mother. In fact, the trauma of separation must have been reawakened every time the boy saw Caterina, and there would have been other exacerbating circumstances over the years, in particular the birth of his half-sisters and -brother.

One could mention other sources of disturbance and psychologi-

cal wounds unknown to Freud or unmentioned by him: the practical consequences of illegitimacy; the marriage of his uncle Francesco (who was something like an adoptive father to him); the death of Albiera, followed by Ser Piero's immediate remarriage; the death in about 1468 of his grandfather; the death of his grandmother shortly afterward; and finally—perhaps most importantly—leav g Vinci and going to live in Florence, where a new life in a new milieu awaited.

He had to become an adult and learn a trade, a manual trade rather than the noble profession of his father, and more than ever before, he was obliged to experience and take full measure of the millstone of his illegitimate birth.

III

Artium Mater

This century, being truly a golden age,
has brought back to light the liberal arts,
which had almost been destroyed: grammar, poetry, rhetoric,
painting, sculpture, architecture,
singing to the Orphic lyre—and all in Florence.

—MARSILIO FICINO

When the morning stars sang together
and all the sons of God shouted for joy . . .

—BOOK OF JOB

Santa Maria del Fiore,
the Cathedral of Florence.

I N LEONARDO'S YOUTH, Florence was a turntable of trade and one of the most enterprising, prosperous, and lively cities in Italy. The area it controlled barely covered Tuscany, its population was scarcely more than 150,000, yet this "London of the Middle Ages," as Stendhal called it, had recovered from the crises of the fourteenth century and had set up trading posts throughout the known world. Florence stood on an equal footing with the great powers—France, the Holy Roman Empire, and England, whose kings had been in debt to the city—and had become in many respects the focal point and leading light of Europe. Highly conscious of its success, possessed of a powerful sense of history, Florence throve on the notion of its own value.

The Florentines were proud of their city and readily said as much.[1] They were proud of the stability of its currency (the florin, a coin stamped on one side with a lily, the city's emblem, and on the other with Saint John, the city's patron saint); its institutions; its republican government; its liberty; its language (Tuscan, from which Italian was to grow); its past (Roman and Etruscan); of the great men who brought the city fame (above all, Dante); of the beauty of its monuments (especially the cathedral and baptistery). Most of all, they were proud of Florence's "modernity."

The city's appearance closely reflected its aspirations. If one compares the solid and homogeneous Florence of the *Carta della Catena*,[2] dating from 1470, with the chaotic townscape depicted in the

53

Anonymous, detail from fresco, *Madonna della Misericordia.*

Misericordia fresco in the Bigallo orphanage, dating from more than a century earlier (1352), one sees the transformations the city had experienced or deliberately engineered. By the later date, the urban landscape has mellowed and become comparatively organized; it is bathed in a more serene light.

Formerly, internecine feuds ravaged the city, first the Guelphs (supporters of the pope and opposed to all foreign powers) against the Ghibellines (supporters of the emperor), then the Whites against the Blacks.[3] Factions had fought openly in the streets, families or whole districts fortified themselves militarily; the facades of the houses were elevated and strengthened, and every important mansion was built like a citadel. Those who could afford to added towers to their dwellings, in order to keep an eye on the enemy (often a neighbor) and protect themselves with deluges of arrows or boiling pitch. Battlemented, foursquare, close-packed, vying with one another in their enormous height, these impregnable tow-

ers formed a chaotic and threatening skyline—reflecting the political struggles that led to bloodshed in the streets.

In the early fourteenth century, there were still about one hundred fifty towers; the adjective *spinoso* (bristling) often figured in descriptions of the city.[4] When Leonardo arrived in Florence, some of these towers were still standing, but most had been reduced in height or demolished.

Likewise, the unhealthiest districts, such as the dyers' quarter, had been cleaned up; measures had been taken to control new building, and a municipal service had been created, rather like a miniature ministry of public works.[5] The narrow and twisting streets of the old town center, previously described as *sordidae, turpes et faetidae* and much ravaged by the Black Death, had been widened and straightened wherever possible. Roads through the newly built districts were designed according to the prevailing criteria of sanitation, convenience, and beauty.

Walking in front of the Medici Palace, Leonardo would have encountered a marvelously straight road, with houses lined up regularly on each side, a broad and airy thoroughfare, wide enough for several carts side by side (and its name reflected this rare quality: the Via Larga[6]). Compared with the village of Vinci, which consisted of about fifty low buildings huddled on a hilltop around a little fortress,[7] the great city where Leonardo had come to live must have seemed like the pinnacle of civilization.

And the Florentines went on building and beautifying their city in every direction. On the banks of the Arno, which was already spanned by four bridges, building sites resounded to the blows of hammers on wood or on *pietra serena,* the gray stone of Tuscany. (Significantly, there were more marble masons and carpenters in town than butchers' shops.) These were not the great collective construction ventures of the previous century, although some of the latter, like the cathedral, were not yet finished. The new buildings were, for the most part, private initiatives. The bourgeoisie, made wealthy from textiles or finance, feverishly built great houses they called palaces: "Thirty *palazzi* built between 1450 and 1478 alone!" as the chronicler Benedetto Dei proudly stated. And to make way for these magnificent dwellings, with their noble living quarters,

Buonsignori, *Carta della Catena*.

their storehouses, offices, stables, and gardens, the past had to be wiped out, old districts razed to the ground and broad new avenues opened up.

Severe lines were emblematic of the Florentine *palazzo* of the fifteenth century; fantasy and extravagance were out of style. The new architecture obeyed the simple rules of symmetry and rigor. Ser Piero's house on the Via della Prestanza eventually fell to the building craze that was changing the face of Florence; the Gondi family bought it, demolished it, and erected on the site the elegant

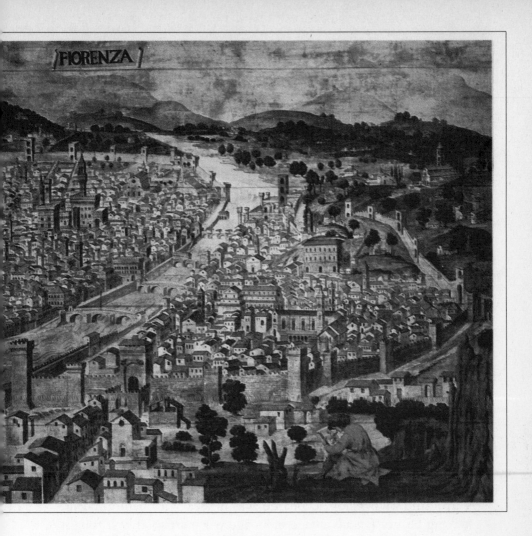

palace that still bears the family name, designed by Giuliano da Sangallo, with whom Leonardo was on good terms.

The date when Leonardo left Vinci is even less certain than the date on which he left his mother's care. Once more, we must resort to guesswork, with a little help from the tax records.

In 1469, Monna Lucia listed Leonardo on her tax declaration in Vinci. The following year, Ser Piero listed Leonardo on his own declaration in Florence. Taken at face value, this indicates that Leonardo did not go to the city until he was seventeen or eighteen years old—very late to be embarking on an apprenticeship.

In fact, the tax register required a list from the head of the family

that included *all* family members, whether resident at home or not.[8]

On Monna Lucia's 1469 declaration (drawn up in her name since Leonardo's grandfather had died a few years earlier) we find listed not only Leonardo, his uncle Francesco, and the latter's wife, but also Ser Piero and his second wife, Francesca de Ser Giuliano. By this time, Piero and his wife were living more or less permanently in Florence. Leonardo could perfectly well have joined them there earlier and still figured on the tax registers back home in Vinci.

Monna Lucia died in 1469 or 1470. Ser Piero, as the oldest son, became the head of the family and was legally obliged to register at his own place of residence as a taxpayer, listing his entire family. This explains the first mention of his son in an official *Florentine* document.

At the time, the normal age to embark on an apprenticeship was twelve or thirteen—or even earlier. As a son of a bourgeois, Leonardo might have remained in the country a year or two longer—which brings us to 1465 or 1466 at latest. The decision to send him to Florence might in fact have been prompted by the death of his grandfather, or by the marriage of his uncle Francesco, or by the second marriage of Ser Piero. One pivotal moment in family life often leads to another.

When he presented himself for the first time at the door of Verrocchio's workshop, Leonardo was blessed with natural talent, striking beauty (an advantage in an age when artists always sought handsome models), and, one assumes, plenty of charm—but very little else. His intellectual and artistic baggage was extremely light.

In a village as remote as Vinci, the level of schooling would not have been high, but for an illegitimate child, it would have been deemed sufficient. Even his "bad habit" of writing left-handed remained uncorrected.

But Leonardo could read and write. The *parroco,* or parish priest, had probably taught him the rudiments of grammar and arithmetic and shown him how to use an abacus. His grandfather and his uncle Francesco, neither of whom attended a university as far as we know, would have done their best to complete his education, or Leonardo would have sought to complete it himself, in their company. He had no Latin (he began learning it when he was over forty). His Italian

was colored by the local Vinci dialect (of which traces survive in the notebooks). His spelling was somewhat erratic, and he may have spoken with an accent.

What would he have read, besides the Bible? Not much, one imagines. Were there nonreligious books in the village? Books were expensive; printing had only recently been invented and was not yet being practiced in Italy. For Leonardo, poetry and literature more likely would have meant Sunday canticles and the folk songs sung at weddings, at grape harvests, or during long winter evenings; stories, perhaps from Boccaccio or Sacchetti, narrated by a traveling storyteller; and Dante, the most popular of writers, whose verses were explained to the congregation in church and whose language was very simple, so that almost everyone could recite a few lines.[9] But it would not have meant Cicero, Virgil, or Homer.

Such literary ignorance was probably common among Leonardo's fellow apprentices. The relative poverty of his artistic education, however, would have been more of a handicap.

The eye is trained by what it beholds. Taste is formed and refined by acquaintance with works of art. In the quattrocento, when there were no museums to speak of, nor any kind of mass reproduction, art was a living thing. One was initiated into painting, sculpture, or architecture by visiting churches, inside or outside, and by looking at public monuments.

Besides the paintings proudly displayed in official or religious buildings, there were in Florence many external facades painted with frescoes: San Tommaso, San Giuliano, Santa Maria Maggiore. An intersection would often be the site of a shrine, and the candles flickering in front of it might illumine a madonna by Fra Filippo Lippi or Antonio Veneziano. The walls of the Hospital of the Innocents were decorated with ceramic medallions in the limpid blue of Della Robbia. Sculpture by Ghiberti, Donatello, and Michelozzo was displayed outside the church of Or San Michele, the baptistery, and the bell tower. Even the art of antiquity might be encountered as one strolled through the city, in the form of a sarcophagus serving as a horse trough, or a Roman capital crowning a stone column. A Florentine lived in his city like a princely collector among his possessions.

But what if one had grown up in Vinci?

Lorenzo Ghiberti, *Flagellation.*
MUSEO DELL'OPERA DEL DUOMO, FLORENCE.

In front of which picture or statue had Leonardo's vocation declared itself? What had he *seen* before coming to Florence?

His grandfather might have had some pious image in his bed-chamber, perhaps a Virgin or an austere female saint, hanging in a conspicuous place, where her golden halo and dark eyes would make an impression on a child. Or there might have been a painted wooden crucifix, a Christ with an agonized smile. Or the family might have owned a childbed panel *(disco di parto)* or a marriage chest *(cassone),* brightly colored and decorated with figures likely to interest and inspire a child's imagination. Possibly the Vincis inherited some object from Leonardo's great-grandfather, the first Ser Piero, a wealthy man who was probably cultivated too. But since works of art were still found rarely in humble interiors,

especially in the countryside, it is more likely that Leonardo was first affected by the sight of a sculpture or painting in the little village church where he had been baptized. Odds are against its being a masterpiece; it was probably some looming, crudely carved statue in the Gothic or Byzantine style.

But before leaving for Florence, Leonardo may have accompanied his father or uncle to Empoli or Pistoia. In the cathedrals of these towns he would have seen works that were more modern and of higher quality: a fresco by Masolino or an altarpiece by Fra Filippo Lippi. Perhaps he even saw a painter at work there.

If he went with his father to Pisa, he could have admired not only the Campo, with its famous leaning tower, but also the important painting by Masaccio in the church of Santa Maria del Carmine. Later in life, Leonardo would cite Masaccio as one of the most significant artists in history. The panels making up this monumental work have been dispersed; some are in the national museum in Pisa, others in the National Gallery in London, and some have disappeared altogether. Vasari's detailed description mentions "some horses drawn from nature, so fine that one could not wish for better"; they figure in the panel now in the Dahlem Museum in Berlin. When we remember Leonardo's passion for horses, it is tempting to imagine him as a child looking wide-eyed at this painting by Masaccio and to venture that his life was launched on its course by this very picture. This panel, well lit by candles, was situated at a child's eye level. His gaze would be caught by the whinnying, restive horses: alarmed by the mystery of the Epiphany, they were saluting in their own way the birth of the son of God. Moving leftward, the eye would travel from the martyrdom of Saint John to that of Saint Peter. Masaccio's Saint Peter is a very strange figure, suspended upside down within a terribly geometrical space; naked but for a loincloth, arms outstretched and legs apart, the founder of the Church seems to be illustrating some theorem by Euclid. This image curiously prefigures one of da Vinci's most famous drawings: the male figure inscribed within a square and a circle, limbs outstretched to indicate proportions.

If he did go to Pisa, Pistoia, or Empoli (or if he had already visited Florence), Leonardo could not have stayed more than a few days; he might have seen the works of art the town possessed, but

he would have had no chance to become familiar with them.

Was there any other way in which he might have been initiated into the art world or become acquainted with works of art? Vasari, describing how Ser Piero went one day to show his son's drawings to Verrocchio, calls the latter "his great friend." Was Ser Piero something more than the blinkered notary, solely concerned with respectability and money, depicted by most biographers of Leonardo? If Vasari is to be believed, Ser Piero kept company with artists.

In about 1465, the merchant company for which Ser Piero worked and from which he rented his rooms had commissioned from Verrocchio a bronze representing the *Incredulity of Saint Thomas* (the patron saint of lawyers, because of his prudence), which was intended to fill one of the niches on the facade of Or San Michele.[10] At the time, any important commission would be signed before a notary. Did artist and notary meet on the signing of this contract?

Ser Piero, whose clientele seems to have consisted largely of confraternities and convents[11]—major patrons of the arts—surely met Verrocchio for the first time on some such occasion. But Vasari's claims notwithstanding, I believe their acquaintance remained primarily professional; there is no sign that it was of particular benefit to Leonardo in the early days. The notary would have known the artist well enough to greet him in the street and no doubt respected his work. Verrocchio had a first-class workshop and was a serious person from every point of view; there was no bohemianism about him. But to imagine regular contact or close friendship is probably going too far. It seems Vasari, either knowing little about Ser Piero or embarrassed by the child's illegitimate birth, let himself be carried away here and added a sentimental and misleading touch, intended to suggest a life dedicated from the start to sculpture and paintbrush.

Whether or not he knew the art world well, Ser Piero certainly showed extraordinary perspicacity, or else was very happily inspired, when he chose to send his son to Verrocchio rather than to some other master. No other would have suited the boy so perfectly. We may reproach Ser Piero with many things, but we cannot accuse him of lack of judgment. While he had not hitherto given his son

the good education called for by the boy's intellectual potential, this one choice entirely redeems him. Verrocchio was a sort of one-man university of the arts. With a teacher like this, Leonardo would quickly make up for lost time.

Four men had already made an impression on Leonardo's youth: his father, stepfather, adoptive father (Uncle Francesco), and grandfather. A fifth must now be added: his spiritual father, Andrea del Verrocchio.

The same age as Uncle Francesco, Verrocchio was only about seventeen years older than Leonardo. A tragic accident set the course of his life.[12] As a youth, he was walking one evening with some friends outside the city walls between the Porta alla Croce and the Porta a Pinti. They began amusing themselves by throwing stones. Unfortunately, one thrown by Andrea struck the temple of a certain Antonio di Domenico, a woolworker, aged fourteen. The injured boy died a fortnight later. Andrea was arrested, imprisoned, and tried for involuntary manslaughter. The magistrates, inured to stone-throwing cases (there were many complaints about this in Florence), released him shortly afterward. But the damage was done; he had killed, and it weighed upon him for the rest of his life.

Andrea's father, a tax collector, died that same year, leaving a widow, Nannina, six children, and more debts than property. The two daughters each received a small house as a dowry. Andrea's inheritance was the burden of supporting his family. This proved to be his salvation, and he threw himself into study and work.

When Leonardo arrived at his workshop, Verrocchio was still providing some financial help to his siblings. He also ungrudgingly helped establish his nieces and nephews rather than enriching himself. He remained unmarried, either from the pressure of work or because it was not to his taste.

Some of Andrea's tax returns make plaintive reading: neither I nor my brother have any shoes, he writes. (True, he may have learned this formula, calculated to soften the heart of the tax officials, from his father, who knew the system from the inside.) But even when his order books were full, Verrocchio pleaded poverty.

The portrait painted of him in 1485 and attributed to Lorenzo di Credi shows a man with a square-set, rather fleshy face and a determined expression, enlivened by a pair of large, dark, penetrat-

Lorenzo di Credi, *Portrait of Verrocchio.*
GALLERIA DEGLI UFFIZI, FLORENCE.

ing, and relentless eyes. Below the broad nose, thin lips betray no emotion; they do not seem capable of doing so. There is no hint of softness in this bourgeois countenance, except perhaps in the

chin—small, nervous, and rather feminine. In the lower part of the portrait, the hands seem to be fidgety, as if impatient at holding the pose for so long. One senses that they are anxious to get back to work. Indeed, Master Verrocchio was never idle; he was, Vasari says, indefatigable and always had something in hand, "as if to avoid getting rusty."

Verrocchio had apprenticed with the goldsmith Giuliano de' Verrocchio and had respectfully adopted his name, a practice that went back to the Middle Ages. Goldsmithing was then considered a fully rounded art; it combined the skills of drawing, engraving, and modeling or carving figures in three dimensions, and it called for the most varied of techniques, from polishing precious stones to working with molten metals. It was excellent training. Paolo Uccello, Brunelleschi, Ghiberti, and Ghirlandaio had all begun as goldsmiths.[13]

Verrocchio had chiseled clasps for the copes of the cathedral clergy; he had made silver cups decorated with friezes of animals or children dancing,[14] which had elicited general admiration. But owing either to a lack of commissions (as he claimed in his tax declarations for 1457) or because he had other ambitions, he eventually turned to sculpture.

He followed in the steps of Donatello,[15] possibly as a pupil and later as a collaborator. It seems that in old age, Donatello referred customers to the younger man. In 1464, Verrocchio was commissioned to make the tombstone for the "father of the state," Cosimo de' Medici. From that point on, he replaced Donatello as sculptor by appointment to the Medici family.

This important commission probably made his name. Orders began pouring in. Verrocchio extended his activities once more, advertising himself as a painter and decorator as well as a sculptor and goldsmith. His workshop on the Via de Agnolo[16] could handle all kinds of requests.

We should not picture this workshop—in which Leonardo was to spend twelve or thirteen years of his life—as anything like the studio of a nineteenth- or twentieth-century painter. This was a *bottega,* a shop—just like that of the shoemaker, butcher, or tailor—a set of ground-floor premises opening directly onto the street, where children played and dogs, pigs, and chickens freely wandered.

Miniatures and frescoes of the time[17] give some idea of the artist's *bottega,* usually a single, basic room with whitewashed walls; an awning was pulled down to act as a door or shutter. The living quarters would be at the back or upstairs. Artists' materials would be hanging on the walls, alongside sketches, plans, or models of work in progress, while ranged around the room would be a collection of sculptor's turntables, workbenches, and easels; a grindstone might stand alongside a firing kiln. Several people, including the young apprentices and assistants (who generally lived under the same roof as the master and ate at his table), would be working away at different tasks.

Outside the shop, a few modest samples, typical of the shop's everyday production, might be hung as advertisements. Even the most famous Florentine workshops accepted orders for "bread-and-butter" work; the *botteghe* were like small-scale factories, commercial enterprises that exploited all possible means to stay in business. Donatello, Vasari tells us, turned his hand to everything, "regardless of whether it was cheap or costly." At Ghirlandaio's workshop, baskets were gilded, while Botticelli worked on "banners and other fabrics," having invented a technique for stabilizing dyestuffs. A painter would gladly decorate wooden chests or china for weddings, coats of arms, headboards, caparisons for horses or weddings, canvas for tents; he designed patterns for embroiderers, weavers, and ceramicists. The goldsmith or sculptor (who might double as an architect) welcomed opportunities to manufacture pieces of armor, candelabras, bells, capitals for pillars, or pieces of furniture.

In his flexibility, circumstances, and life-style, the Tuscan artist of the mid-fifteenth century was scarcely distinguishable from a simple artisan. Even when he produced a work of high quality and originality that could bring "great honor and gain," he rarely bothered to sign it.[18] He did not yet have the "creative artist's complex." He almost always worked as part of a team; he did not think it beneath him to finish a fresco started by someone else, and he readily left a pupil to finish a painting to which he had devoted months of work. He did, of course, "seek to remain in men's mouths for all future time," as Marsilio Ficino put it; but he did not yet display obsessive vanity about his reputation.

Similarly, the teaching provided in the *bottega* followed a pattern not unlike an artisan's training. Apprentices, taken on primarily as cheap labor or because they were paying for their tuition, began with the humblest tasks: running errands, sweeping the floor, cleaning the paintbrushes, tempering the plaster, supervising the heating of varnish and glue. They learned their skills and gradually rose to higher status by imitating the work of their elders and by obeying traditional formulas.

In his famous *Book of Art or Treatise on Painting,* [19] written in the 1430s, the painter Cennino Cennini advises the "young man inflamed with the love of art" to give total obedience to his chosen master. He speaks unambiguously of "placing oneself in servitude" for the longest possible period.

Cennini thought thirteen years the appropriate length of time for an artist to move from the stage of apprentice *(discepolo)* to that of journeyman *(garzone)* and then to master craftsman *(maestro).* The first year was devoted to "drawing on tablets," the next six to familiarizing himself with all the materials, which could not be bought ready-made but had to be put together by the artist on the spot. The apprentice would learn to make paintbrushes, to prepare glazes, to stretch canvas onto lime or willow panels, to recognize and prepare pigments, which had to be freshly ground and mixed every day, since at that time there were no tubes or binding agents. He would apply gold to backgrounds, he would "dust, scrape, assemble, and carve." The last six years were spent learning to color, to "decorate with mordants," to make cloth-of-gold, to work directly on a wall—all this while "drawing the whole time, never stopping work neither on weekdays or holidays."

The 189 chapters of Cennini's painstaking book (written in the Stinche prison, where he found himself for debt) prove conclusively how close art then was to a skilled trade. The treatise reads like a manual of joinery or an encyclopedia of gardening. Cennini remains firmly within the realm of techniques, which are described in detail. He explains how to darken a vellum panel, how one ought to paint an old man's face, or the Virgin Mary's blue cloak, or the waters of a river (with or without fish). Point after point, he reveals all his knowledge, the fruit of his experience as a conscientious artisan.

He interrupts his recital only to introduce some advice about personal habits or morality: addressing his imaginary pupil, he says: "Your life should be as well ordered as if you were a student of theology. . . . You will eat and drink in moderation, at least twice a day, taking light pasta, carefully prepared, and modest wines." Deeply pious, Cennini never began anything without some prayers, invoking God the Father, the Virgin Mary, Saint John, Saint Luke, and more. When he ventures to discuss proportions, he gives those of the male body, never the female, on the pretext that "no perfect measure can be found" for the latter.

Leonardo entered Verrocchio's studio in 1466 or 1467, thirty years after this treatise was written. The profession remained essentially the same. To be persuaded of this, one has only to look through the notes on painting, metalworking, or architecture that Leonardo later jotted down in his notebooks. Addressing either himself or some imaginary pupil, Leonardo also sets down recipes: "Take oil of cypress, which you will then distill; have ready a large vase in which you put the distilled oil, with enough water to give it an amber color. Cover it well, so that it does not evaporate . . ."[20] and so on. Some of his recipes are pretty odd: "Salts can be made from human excrement, burned, calcified, stored, and dried over a low fire; any excrement will yield salt in this manner, and once distilled, these salts are very caustic."[21] Did he really try this out? And like Cennini, Leonardo gives himself advice on living habits. He warns against abuse of food and drink; "Wine is good," he says, "but at table, water is preferable."[22] Nor is he averse to invoking the name of God: "May it please the Lord, light of all things, to show me the way, so that I shall paint light worthily."[23]

It is true that from Cennini's time to that of Verrocchio there were tremendous changes in taste, sensibility, and technique. The fashion for plaster relief in painting had vanished, as had that for gold ornament. Under the influence of the Northern School, painters were experimenting with oils. Above all, perspective had been discovered and mathematics was all the rage; indeed, it was behind the new movement in art to understand space. But the foundation remained that of the trecento. However great Verrocchio's pedagogical skills and however talented Leonardo was when he arrived, the apprentice still had to learn in a fairly mechanical way, within

the context of the *bottega,* to bend humbly to the discipline and spirit of the master.

Once he had assimilated the rudiments of the trade by watching how the master worked, the apprentice would gradually take greater part in the production of the *bottega.* He perfected his skills while contributing to the "firm's" output: transferring the master's drawing to a panel or a wall, laying down the first colors, rough-hewing the stone, or polishing the bronze. Then he became a journeyman, and the degree of his participation increased. Gradually, the master would entrust him with decoration or backgrounds; he might allow him to handle the architectural sections if he showed skill in this area, or plants if that was what appealed to him, then perhaps garments and background figures, and finally whole sections of a work.

To some extent, the output of a given workshop enables us to deduce the "study program" of those who trained there. If we wish to find out about Leonardo's life during his apprentice years, or at any rate what he was doing and learning under Verrocchio's tuition, we have only to look at the works produced by the shop during these years.

Leonardo seems to have been a perfectly docile student. Not only did he complete a normal training program but he remained alongside Verrocchio as a collaborator for several years after becoming a master craftsman.

"The pupil who does not outstrip his master is mediocre,"[24] Leonardo would later declare. He was hardly inferior to Verrocchio, but perhaps he was not yet fully aware of his abilities. One does not idly pen a sentence like that. The quasi-paternal authority of his master must have exerted considerable sway, strong enough to keep Leonardo in the *bottega* for a longer than usual period. (Perhaps he found it difficult to move out of the comfortable shadow of his master—who was much more like Leonardo than has been thought—without some painful internal struggle. Is this why the name of Andrea del Verrocchio does not figure once in the thousands of pages of the notebooks?)

In 1467, Verrocchio installed the commissioned tombstone for Cosimo de' Medici in the church of San Lorenzo. Then his workshop cast the great bronze globe that was to surmount the lantern

Cigoli, Drawing of Brunelleschi's Design
for the Cupola of Santa Maria del Fiore.

GALLERIA DEGLI UFFIZI, FLORENCE.

on the Duomo, the city's cathedral. This was probably the first
project Leonardo could witness from start to finish.

Cathedrals took several centuries to build. After work was begun
on Santa Maria del Fiore, the cathedral of Florence, by Arnolfo di

Cambio (at some point before 1300), construction was abandoned and recommenced again and again. Giotto, who designed the bell tower, Andrea Pisano, Francesco Talenti, Ghiberti, and Brunelleschi had all worked on it in turn. Filippo Brunelleschi astounded the world when he erected the dome, the greatest since antiquity, without any of the buttresses or external supports usually necessary for this kind of structure. When he died, in 1446, the building was still waiting for its crowning glory; the cupola had nothing on top. Eventually, the decision was made and the costs were approved; the marble lantern, already partially constructed, would be completed and attached to the summit. After much more hesitation and discussion, in which the goldsmiths, metalworkers, and sculptors of the city all took part, it was decided to crown the lantern with the ball and cross specified by Brunelleschi.

Since the latter had prepared the designs before his death, the work asked of Verrocchio was essentially that of an engineer and contractor.[25] He had to cast the metal, assemble the sphere, and hoist the enormous object (it was six meters across and weighed over two tons) to a height of about 107 meters, then attach it firmly to the pointed tip of the lantern. I find it interesting that the first important work in which Leonardo may have had some hand was not creative or artistic in nature; from the start, he witnessed the harnessing of artistry to skilled engineering.

Before Verrocchio could attach his sphere, he had to figure out how to secure it to the lantern, devise a support mechanism, decide where to strengthen it to withstand strong winds, and where to attach the chains holding it in position—in other words, he had to sit down with pen and paper and make all kinds of elaborate calculations. According to Vasari, in his youth Verrocchio had "devoted himself to sciences, especially geometry." A natural inclination drew him to this kind of study, and no doubt he involved the whole workshop in his research—possibly also calling on noted scientists.[26]

On 27 May 1471, a Monday, all of Florence gathered to watch the hoisting of the great gilded ball to the top of the marble lantern. The next day, at 3:00 P.M., after a fanfare of trumpets and to the sounds of a *Te Deum,* it was secured to the plinth. The event was recorded by chroniclers and historians.[27] Leonardo, looking on from

the front row, must have sensed for the first time the glory to which an artist-engineer might aspire.

Clearly, this enterprise left a deep mark on him, both because of the special place it occupied in his career, and because of its spectacular nature. It acquainted him with most of the technical problems of his time, and exposed him to physics, mechanics, metallurgy, and architecture. We find references in his notes both to the construction and to the installation of this great bronze sphere. The cupola shape haunts all his church designs. He drew a detailed sketch of the crane running on circular rails that Brunelleschi had devised to hoist large weights to the summit of the dome,[28] and which was probably used by Verrocchio. Leonardo imagined variants on it. In about 1515, half a century later, when confronted with a similar problem (the building of large parabolic mirrors), he was still writing in Rome: "Remember how the ball on Santa Maria del Fiore was soldered."[29]

Verrocchio handled other orders alongside this commission. Among the most important (that we know about) were the tomb for Giovanni and Piero de' Medici and a large bronze candelabra for the Palace of the Signoria (it is now in the Rijksmuseum in Amsterdam). These works prove that Verrocchio remained deeply wedded to goldsmithing. The amazing tomb, made of bronze, serpentine, and porphyry, brings to mind an elaborate Renaissance jewelry box or saltcellar. It bears no effigy or religious emblem; the accent is on the elegant bronze ornaments at which Verrocchio excelled: a tracery of interwoven cords and lifelike foliage cascading in wreaths and garlands, all arranged in perfect symmetry.

Until about 1475, Verrocchio seems to have spent much of his time serving the Medici family; he produced decorative objects, painted ceremonial coats of arms, ornamented a banner, and restored an antique marble sculpture, *The Flaying of Marsyas,* destined for the gardens of the palace on the Via Larga.[30] The Medici also commissioned two sculptures: the *Putto with Dolphin*[31] and the magnificent *David* in the Bargello. According to a persistent legend, the model for the latter was the young Leonardo.

These works were begun after Leonardo finished his apprenticeship. Oddly enough, during these long years no major sculpture, statue, or bas-relief, no painting or fresco of note, seems to have been produced by Verrocchio's workshop. One has the impression

that throughout this period the master was preoccupied by various commercial projects of a technical or decorative nature, as if he lacked the confidence to venture onto more difficult paths or tackle the life-size human form. He took years to get around to the bronze *Incredulity of Saint Thomas* commissioned by the merchant guild in 1465, delivering this group sculpture only in the 1480s. As far as we know, the only animate creatures he depicted during the fifteen-year interim are lions, children *(putti),* and winged monsters, which he used as decorative elements.

Examining Verrocchio's work (or what survives of it) from a chronological point of view, we see that the bulk of his creative activity is concentrated in the years from the middle 1470s until his death, in 1488—that is, after the Medici ceased to overwhelm him with commissions for their villas, houses, and numerous celebrations. The Medici launched Verrocchio; did their continued patronage inhibit his development?

It is true that Verrocchio occupies an extremely awkward place in art history. He belongs to the very end of the early Renaissance— on the cusp of two ages. He came after the awe-inspiring generation of Donatello, Masaccio, and Brunelleschi, and had as pupils artists who were themselves exceptional. Verrocchio's art has suffered by its proximity to that of his predecessors and disciples. He appears to many to be a minor link in art history—a marginal figure.

This was certainly how Vasari saw him. He dismisses the master, presenting him as a hack, and puts his successes down to studious application and dogged persistence. Was Verrocchio no more than a *potential* creative artist during Leonardo's apprenticeship, content to decorate marble plaques, carve candlesticks, or weld together bronze leaves? If so, how do we explain his celebrity, the importance of his workshop, the number and quality of his pupils *before* 1470, and, above all, the influence he appears to have exerted on all around him, in painting as well as in sculpture?

Among the painters trained in or influenced by his workshop were artists of outstanding reputation: Leonardo, Perugino, Lorenzo di Credi, Botticelli, and to some extent a whole generation of artists born in about 1450—possibly down to Ghirlandaio and Luca Signorelli. Drawing up, in about 1490, a list of the greatest Florentine artists, the writer Ugolino Verino went on to say: "Verrocchio had

as disciples almost all those whose names now fly about the cities of Italy."[32]

When Leonardo became his apprentice, Andrea's workshop was in the process of becoming a meeting place of all the artistic youth in Florence—it was a crucible in which the principles of the new "modernity" were being hammered out. Here everything that went on in the city was subject for discussion. There was talk about dissection, antiquities, philosophy (Marsilio Ficino was at the time translating and commenting on Plato); artists exchanged models, plans, sketches, recipes for varnish or binding agents; and it was a place of recreation, where music was played. (According to Vasari, Verrocchio was also a musician; perhaps he taught Leonardo music.)

Sandro Botticelli, eight years Leonardo's senior, had begun his apprenticeship with a goldsmith, then learned painting with Fra Filippo Lippi. In about 1465, when his master left to work in Spoleto, Botticelli drew closer to the Verrocchio circle. His education was already complete, but he spent some time there to perfect his art, to breathe the spirit of the new age.

A few years later, Perugino arrived at the workshop. He too was past the age of apprenticeship; he too possessed the essentials of the art. He was drawn from his native Umbria to Florence, the "mother of the arts"; perhaps the rumor had reached him that in Verrocchio's workshop all kinds of innovations were being experimented with, including the "Flemish technique," whereby paints were crushed and mixed with oil (instead of water), allowing smooth and harmonious gradations as the colors melted miraculously into one another.

The first individual works by both these men bear unquestionable traces of "Verrocchismo."[33] They date from 1470 and 1471, suggesting that even before this time (therefore during Leonardo's apprenticeship), the painting activities of the shop were well developed and that Verrocchio himself, although historians attribute no important painting to him during these years, was already equal or superior to his principal rivals, in the eyes of other painters. The suggestion is certainly that his workshop could hold its own, as regards painting, with the *bottega* of the Pollaiuolo brothers, Antonio and Piero—the other pole of the Florentine "avant-garde"—with which it is always compared.

Verrocchio in fact had the soul of a pioneer. He was not content to apply and pass on automatically the lessons of his predecessors; he experimented, improved, challenged, extended, and innovated.

By so doing, he exerted a certain fascination over his younger colleagues and helped fulfill the essential ambition of his age: the rational and scientific mastery of method. Art was not, at this stage, a goal, an end in itself; the word was not yet being written with a capital *A* but rather in the plural: "the apprenticeship of the arts," wrote Leon Battista Alberti, "is acquired by reason and method; and one passes master by dint of practice."[34]

When one examines the preoccupations of the artists of the quattrocento, when one considers the incredible desire for progress that drove these "artist-artisans"—who had everything to discover and who in less than a century indeed *discovered everything* by themselves (the principles of perspective, the science of anatomy, the laws of light)—one realizes how different this age was from any other and why every one of its works of art is, so to speak, a trophy, the mark of a conquest.

It is generally agreed that this great conquest resulted from a return to nature—that is, to the real. Leonardo in some sense completed this idea with his desire not to repeat what had already been done.

Along with his contemporaries, he believed that art had been brought to its highest pinnacle during that vague and idealized period known as Antiquity and that it had been in constant decline since the days of the Romans. Giotto—who was to the plastic arts what Dante was to literature—had revived it, inventing the "modern" way of painting. Giotto, Leonardo writes, grew up in the solitude of the Tuscan hills (rather as he had himself); he began by drawing the goats he was tending and then all the animals in the neighborhood: he "went directly from nature to his art." Thus, always drawing inspiration from what was before his eyes, he surpassed "not only the painters of his time but also those of many former centuries."[35]

Leonardo was here repeating the classic account of Giotto's life, which was handed down through the studios of Florence and would be reproduced by Vasari. But he introduces a personal note, a little

parenthesis that seems to be crucial and to reveal something of himself: Giotto, he points out, "was not satisfied with imitating the works of his master, Cimabue."

One has to look hard to find these words in the manuscript: Leonardo, symptomatically, has crossed them out, for no obvious reason, as if they were inappropriate, as if for fear of having gone too far—whereas the text to which they belong develops exactly the same idea: "How painting declines and is lost from age to age, when painters have as their only model the paintings of their predecessors."[36]

The painters and sculptors of the Middle Ages were working for the glorification of God and the edification of men. Their faith inspired them; tradition showed them the way. They exercised their talents (Leonardo would have said that they wasted them) by repeating preordained forms, which they had not devised themselves but had learned in the workshop. Leonardo says that Giotto was the first to break with this practice of copying one's master's work, and he goes on to say that after Giotto, painting declined once more, since painters had not learned the lesson, and instead of setting out on a voyage of discovery, exploring boldly in the natural world, they began to imitate Giotto in slavish fashion.[37] And so it was, "until the day that Tommaso of Florence, known as Masaccio, showed by the perfection of his work how those who are inspired by a model other than nature, a mistress above all masters, are laboring in vain."

As an illegitimate child, who almost certainly suffered in his relations with his father, Leonardo could not envisage with complete equanimity, as something quite neutral, the relationship of pupil and teacher, especially since the latter lodged his disciples under his roof, fed them, beat them if he thought fit—and was in short a legal guardian.

"Not satisfied with imitating the works of his master . . ." These scored-out words reveal more than a personal point of view: they constitute a virtual definition of the artist—of the artist as he was gradually emerging in the quattrocento in Italy and in Florence.

Skill was no longer enough. The artist might copy—but now it was in order to understand, to assimilate the discoveries made by another. "The painter will produce mediocre pictures if he is in-

spired by the work of others,"[38] as Leonardo also wrote. Merit would from now on be measured very largely by one's inventiveness; or rather inventiveness was beginning to become a condition *sine qua non* of merit.

Invention was not the same thing as originality at all costs (which Vasari called *terribilità*). It should be not gratuitous but practical, useful—technical. "Avoid [excessive] study," says Leonardo; "it will give rise to a work destined to die with the workman."[39] Invention ought to be able to serve the inventors of the future; it should play a generous part in the victorious march of progress.

The quattrocento was a time of ventures into the unknown. Christopher Columbus, born a few months before Leonardo, was to discover America in the last years of the century. Nature was yielding up her secrets, slowly giving way: she was a treasure chest full of riches, just beginning to open. The unknown, those infinite spaces which so awed Pascal, beckoned from every perspective, in exciting ways, inspiring healthy desires and immense hopes.

Of all the men of the quattrocento, it was the artists—and Florentine artists in particular—who most believed in progress, for they always had before their eyes the works of preceding generations. These works revealed to them the progress already accomplished, the road already traveled.

The artist of the quattrocento also "measured himself against nature." In about 1410, in order to verify the results of his research into perspective, Filippo Brunelleschi (known to his friends as Pippo)—who was a sculptor and an architect—painted on a small panel a scene that was well known to all Florentines: the Piazza San Giovanni, seen from the cathedral doorway. In the painting, on either side of the massive octagon of the Baptistery, he included the house of the Misericordia, "with the Wafer seller's shop," the vault of the Pecori, and the column of San Zanobi. When the painting was complete, he pierced a hole in the center and exhibited it on the very spot from which it had been painted. He asked the viewer to hold the panel up with its blank side toward him, to put his cheek against it and look at the piazza through the hole; then he held up a mirror between the viewer and the scene before him. By raising or lowering the mirror, the viewer could judge how *faithful* the picture was, how perfect the illusion—and appreciate the method

that made such accuracy possible.[40] The experiment was so success-
ful that Brunelleschi soon repeated it, choosing another very famil-
iar scene for Florentines, the Piazza della Signoria.

The scientific spirit that inspired Pippo Brunelleschi was also
found in Verrocchio's studio. Leonardo inherited it: his art and all
his knowledge stem from its principles. Observation, analysis, de-
duction, experiment: "Science is the captain, practice the soldier,"
he wrote.[41] Or again: "Those who are obsessed with practice, but
have no science, are like a pilot setting out with no tiller or compass,
who will never know for certain where he is going."[42] Among the
various mottoes Leonardo chose for himself in his mature years, I
am especially struck by this one: *"ostinato rigore"*—obstinate rigor.[43]

At Verrocchio's, Vasari tells us, one learned to draw from nature;
the approximate was not tolerated. In order always to have precise
models in front of the pupils, plaster casts were taken of hands, feet,
legs, and torsos.[44] (Master Andrea made death masks, which must
have provided a substantial part of his income: he was an expert
worker in plaster.) Models were also fashioned out of clay and then
draped with "fabrics that had been dampened and smeared with
clay" to make them heavier, so that the folds fell more convinc-
ingly[45]—then the pupils set about making meticulous reproductions
of them, with the paintbrush, in monochrome, on canvas or on
paper. Several of Leonardo's studies of draperies, done on this
principle and of admirable accuracy and relief, have come down to
us.[46] These methods were new; otherwise Vasari would not have
noted them in such detail.

To learn to see; to reproduce everything that enters through that
"window of the soul," the eye; to make judgments; to return
untiringly toward the real; to draw from the real "a subtle specula-
tion"[47]: Leonardo would later repeat these same precepts to his own
pupils. He would say: "The painter must strive to be universal"—in
other words, capable of representing the countless forms contained
in the world. "The spirit of the painter will be like a mirror, which
always takes on the color of the thing reflected, and contains as
many images as there are things placed before it. Know, O painter,
that you will never succeed if you do not have the universal power
to represent by your art all the varieties of form present in nature—

Drapery Study.

and indeed, you will find this impossible unless you can first see them and hold them in your mind."[48]

The Florentine artist of the quattrocento was no longer satisfied by symbolic representation, as conventional as a stage set: he wanted

the infant Jesus to be a real child, not a miniature adult; he wanted John the Baptist in the desert to be something more than a giant set against pasteboard mountains; if he painted Saint Sebastian pierced with arrows, he wanted to show real muscles contorted in pain; he wanted clouds to be more than white shapes dotted in a clear blue sky, and hair no longer to be a set of wavy lines plastered against the skull. He wanted the viewer to feel the texture and weight of every lock and the shape of the cranium; he wanted the eye to plunge into the depths of a landscape or sky, to see the wind driving the clouds, and in order to achieve this, the artist had to understand what a cloud was.

He still believed in the feelings he was expressing—art was still essentially religious—but he was giving increasing importance to the means of expression.

IV

Fear and Desire

The greater the sensibility,
the greater the suffering—much suffering.

—LEONARDO[1]

Landscape with Aquatic Birds.

ROYAL LIBRARY, WINDSOR.

D O NOT TELL LIES about the past,"[2] Leonardo writes, but in fact he rarely mentions the past. His notebooks constitute neither a private journal nor memoirs. When, at about thirty, he began to keep a systematic record of his thoughts—writing down observations and reflections in the little notebooks he carried everywhere—he did not imagine he was leaving a record of himself. The thousands of pages covered with his reverse, left-handed script, some of it illegible, amount, some have said, to the raw material for a huge encyclopedia.[3] All too rarely does one discover—scribbled between plans, observations, descriptions, or calculations—some item of personal detail: a moral reflection, a note of expenditure, the draft of a letter, someone's name, a maxim, a list of books to be borrowed or of things not to forget. And even these echoes of life seem to be there by accident. For example, at the bottom of one page devoted to descriptive geometry and the canalization of rivers are the words: "Tuesday: bread, meat, wine, fruit, *minestra,* salad."[4] There are very few confidences in these pages. Leonardo reveals his innermost feelings indirectly. Valéry said of him: "He is innocent of the weakness for confession and the boastfulness that fill so many so-called intimate writings."[5] But then writing down one's emotional experiences was not common practice in Renaissance Italy. To find Leonardo the man, one has to read between the lines.

Apart from the story of the kite forcing open his lips in the cradle, Leonardo tells no personal stories—at least none that have sur-

vived—about his childhood, adolescence, or formative years. His native village, the hills where he grew up, rarely figure in the notebooks except in maps, or in the "aerial views" he sketched when describing a mill for grinding the local pigments,[6] or when in about 1503 he devised an ambitious project to divert the river Arno.[7] But while he never mentioned it, he never lost sight of the land where he had his roots.

Among Leonardo's first known drawings are two landscapes of the wild Tuscan countryside of his birth. The more detailed of the two[8] shows a valley with sharply twisting contours, where rocks mingle with the vegetation; high on the left stand the square battlements of a castle. Was this the Castello di Poppiano, between Vinci and Pistoia?[9] The experts are divided. Leonardo was twenty-one when he made this sensitively penned sketch. It is still slightly academic, but it captures well the slight trembling of the shadows in the wind. The scene must have had some special significance for him, since he dated the work—5 August 1473—an extremely rare phenomenon at the time.[10] I do not think this is an imaginary landscape, as is sometimes suggested.[11] In early August, Leonardo would surely have left Verrocchio's studio and the stifling heat of Florence to go back home, as many people did, for a summer holiday. Perhaps he returned to see his mother after a long separation. The reverse side of the drawing shows a hasty sketch of a hill and a stone arch among trees; a male nude appears in the sky; and above a smiling face there is this sentence penned normally—that is, from left to right: "I, stopping [or staying] at Antonio's, am content" *(jo. morando. dant. sono. chontento.).* Leonardo's cheerfulness shows itself, moreover, in the fanciful lettering. By 1473, his grandfather Antonio had been dead for several years; was the Antonio with whom he was staying perhaps Accattabriga (Antonio di Piero)? This drawing—which has been described as the first true landscape drawing in Western art[12]—shows the scene in vivid detail, as if to etch it forever in memory, as if it represented in the artist's secret heart the setting for some moment of great emotion.

Moments of tranquillity, of pure happiness, such as corresponded to the landscape drawn on a visit home, when Leonardo perhaps saw his mother, cannot have been very frequent. Where else do we find him exclaiming with the same innocent happiness, "I am content"?

Landscape dated August 5, 1473.
GALLERIA DEGLI UFFIZI, FLORENCE.

Around the same time he drew this landscape (as we know because of similar paper, ink, and style), when he was about twenty years old, Leonardo made a drawing of a rocky outcrop with a pool at its foot;[13] on the lower right, an angry swan is flapping its wings to scare off a plump duck, which disdainfully swims away. In the background, tumbled rocks mark the bed of a dried-up stream; here it is also summer, and here, too, we have something like a "vacation project." The artist has gone for a walk, perhaps near his mother's village, or accompanying Uncle Francesco on the family estate. With time on his hands, he follows a path through the woods, alone and carrying pen and paper in his haversack.

All around the village of Vinci, on the Campo Zeppi side, looking toward Vitolino, Toiano, or San Ansano, the vineyards are interspersed with waterfalls, long outcrops of rock, or chaotic screes crowned by tangled roots. This is not the rich and gentle

Tuscan countryside, the landscape of lazily rolling hills south of Florence, but an inhospitable region, surrounded by dense forests where wild beasts once roamed—indeed, it remains a hunter's paradise, and wild boar is a specialty of the region.

The rocks, mountain streams, and escarpments of his childhood made up Leonardo's private landscape, his mental furniture. His interest in geology, botany, hydraulic engineering—and everything to do with natural science—was prompted by this early contact. Most of his adult preoccupations seem, more than is the case with most people, to have their origins in his childhood. We find these scenes, magnified by the double lens of art and memory, in the shadowy backgrounds of most of his paintings, whether the *Virgin of the Rocks,* the *Virgin with Saint Anne,* or the *Mona Lisa.* These are the same scenes that were the subject of his earliest personal drawings.

There is a text that dates from about the same period[14] as these drawings, these "visions" obsessed by masses of rock and swift-flowing streams. It is among the most revealing Leonardo ever wrote. Preceded by a few short sentences about the roaring of the sea and of volcanoes, it continues as follows:

> Driven by an ardent desire and anxious to view the abundance of varied and strange forms created by nature the artificer, having traveled a certain distance through overhanging rocks, I came to the entrance to a large cave and stopped for a moment, struck with amazement, for I had not suspected its existence. Stooping down, my left hand around my knee, while with the right I shaded my frowning eyes to peer in, I leaned this way and that, trying to see if there was anything inside, despite the darkness that reigned there; after I had remained thus for a moment, two emotions suddenly awoke in me: fear and desire—fear of the dark, threatening cave and desire to see if it contained some miraculous thing.[15]

Alcuna miracholosa chosa. The words stop short here. Leonardo indicates by a symbol (like the number 6) that the passage continues further on, but the back of the sheet is devoted to metaphysico-scientific problems; the end of the story about the cave has never

been found.[16] Leonardo never reveals whether he overcame his fear or gave in to it, although his word order seems to suggest that curiosity got the better of him, that he did eventually explore the subterranean darkness.

One has to admire Leonardo's incredible precision in describing the scene, savoring the words as he conveys an attitude, an expression, a movement; we can picture him as he kneels outside the cave, steadying himself on the uneven rocks, hesitating, narrowing his eyes as he shades them with his hand. His writing shows exactly the same verve and confidence as his drawing. No literary pretensions clutter the straightforward reporting—he simply conveys the essentials.

Yet the experience does not seem to be contemporary with its transcription. The absence of circumstantial detail (date, place), the highly symbolic aspect of the narrative, the generalizing introduction ("Driven by an ardent desire," and so on), the unfinished sentences preceding this passage—which are poetic, somber, and grandiose—suggest the writing down of an old memory, or perhaps a daydream.

Fear and desire, the two emotions provoked by the yawning dark mouth of the cave (whose sexual connotations need little underlining), are not unlike the emotions Dante describes as he comes to the mouth of hell. Similarly "struck with amazement," Dante is afraid yet wishes to enter, he tries to see inside without endangering himself, and at last he takes the risk because his curiosity (or destiny) has already taken him too far for him to go back.

We must consider Leonardo's words in their context. The preceding sentences talk of raging oceans, a hurricane, "the sulfurous flames of Etna and Stromboli," and the back of the page describes the Flood, fossils, death, reproduction, the (cruel) nature of the universe, a shipwreck, a tidal wave, terrified animals fleeing in vain before an unleashed nature: tearing one another apart, they perish, and the human race eventually dies out; all that remains is a landscape of ashes. Leonardo's tone here is apocalyptic; in order to perpetuate itself, the universe feeds on corpses.[17]

What nightmares resided in the depths of the cave? He was not afraid of physical danger—breaking a limb or invading the lair of a wild beast. Leonardo imagined perils terrifying in other ways,

forces that were disturbing, brutal, primitive, and irrational. He imagined as some kind of dragon the obscene power governing the body and the instincts, as well as the bowels of the earth. In his vision, he is suddenly at the very edge of the shadowy zone where life is created and destroyed; a short step separates him from the solution to some great mystery. The cave irresistibly attracts, but the mere fact of having found it unexpectedly is what upsets him most of all. If he leaves the narrative unfinished, it is not because he is recounting some real-life climbing or caving expedition (as his biographers have too often assumed) but because he is evoking the terrible moment when he discovered in himself a window opening onto the demons and marvels of the night.

What Leonardo has left us is a number of involuntary confidences, at best oblique and metaphorical: an anecdote explaining a drawing; an occasional quotation; a story that slipped into the notebooks because Leonardo never dreamed that anyone would ever see them, let alone scrutinize them in detail.[18] These fragments reveal piecemeal some aspect of his character, giving clues to things that preoccupied him, his feelings, and his state of mind at a given moment in his life.

They also leave us with great dark stretches, scarcely illuminated by the very few scraps of evidence we possess.

Before Leonardo left Florence for Milan—that is, during the first thirty years of his life—all we know for certain about his career and his itinerary are a few dates, a few facts, often questionable ones. Yet the mystery seems a reasonable reflection of the uncertainties surrounding him as he tried to find his place in the world.

In the late 1460s and the 1470s, Florence was the scene of much pleasure-seeking; morals had relaxed, and the great families seemed to throw themselves headlong into amusements, with the Medici in the lead. During these years, writes the poet Angelo Poliziano, Florentines led a life of "blithe enjoyment," a delirium of tournaments, triumphs, and public and private feasting.[19]

Himself a courtier, Poliziano fails to point out that there were underlying political motives for the festivities. But it was no exaggeration that anything could be a pretext for grandiose parties; as

one entertainment led to another and then still more, the city seemed to be celebrating all year round.

Betrothals, marriages, birthdays, or visits by foreign princes were all occasions for incredible displays of pomp. Traditional feast days, governed by the calendar of the Church, lost their pious character and increasingly tended to become pure spectacle. Carnival, the Lenten break, May Day, and the feast of Saint John (the patron saint of Florence) were constantly enlivened with dances, games, "promotional" exhibitions (not unlike modern trade shows) including allegorical floats, triumphal arches, *tableaux vivants,* horse races (the *palio*), and fights between wild beasts. All required costumes, decor, complex machinery, and stage management—which gave scholars a chance to show off their culture and artists their skills.

Verrocchio's workshop was, of course, involved in most of these festivities. As soon as Leonardo came back from the austerity of the countryside, he was plunged into an atmosphere of luxury and pleasure-seeking.

The workshop, with its many talents, probably played a major part in the spectacles and festivities; it turned out carnival masks, disguises, and stage sets, and was particularly concerned with jousts—a fashion inherited from the Middle Ages that was reaching the peak of popularity at this time. Unfortunately, none of the studio's artifacts, to which Leonardo's inventiveness no doubt contributed, has survived; we can get an idea of them only from similar productions or from descriptions.

The first memorable festivities in which Leonardo was surely involved were those held in 1469 by Lorenzo de' Medici for his muse, Lucrezia Donati.

The Medici family of merchants and bankers, who had lived in Florence since the twelfth century, were probably doctors originally, hence the name and the six disks (resembling pills) on their coat of arms. They had held the reins of Tuscan political life for almost fifty years, without any formally defined status in the government. Cosimo the Elder, described on his death as "Father of the State," placed his most devoted partisans in key posts in the magistracy; he never occupied public office himself. As a private citizen, he owed his dominance to his immense wealth, his skill in deploying it, and his influence both inside and outside the city. He pulled all

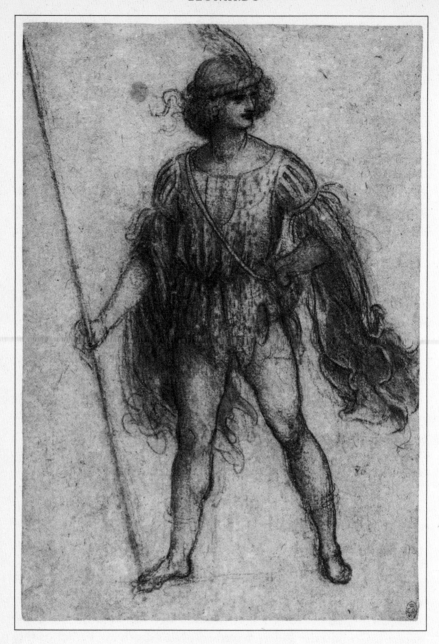

Figure in Masquerade Costume.

ROYAL LIBRARY, WINDSOR.

strings and was indispensable to the public weal without anyone knowing exactly how. His son, Piero the Gouty, and the latter's children, Giuliano and Lorenzo (later called "the Magnificent"), inherited his curious prerogatives, still with no official sanction. The Medici behaved less and less like businessmen and more and more like princes, becoming the avowed masters of a city that remained a republic in name only.

In the late 1460s, an epidemic of plague and a costly war against Venice that ended in a disappointing treaty had caused unrest among the people. At the end of 1468, when Piero's health was in decline, Lorenzo suggested holding celebrations such as Florence had never seen, in order to divert the populace and reassert the might of the dynasty. These were the celebrations dedicated to Lucrezia Donati, one of the beauties of the city, the wife of a certain Niccolò Ardinghelli and the recipient of passionate verses from Lorenzo. (The evidence suggests that she never succumbed to his pleas and that this remained an unrequited, platonic, and, of necessity, literary love affair.[20])

Lorenzo was generous with both his energy and his money in preparing for the festivities. His grooms procured for him some of the best horses in Italy—from Rome, Milan, and Naples (where his own mounts Fals'amico and Abruzze were acquired). His shield was embossed with a huge diamond. From Verrocchio he ordered a banner bearing a sun, a rainbow, the motto "The time has returned," and a female figure weaving a garland made of laurel leaves, his own emblem (Lorenzo = laurel). He also ordered from Verrocchio a portrait of Lucrezia, the queen of the day. When he saw it, he fell into ecstasy.[21] In all, by Lorenzo's own admission, he spent ten thousand gold florins and considered it money well spent—such terrifying prodigality was extremely flattering to his fellow citizens.

The celebration took the form of a tournament, held on the seventh of February in the Piazza Santa Croce.

Imagine what Florence was like on carnival days: the wooden bars still to be seen above some windows were used for hanging drapes, tapestries, and garlands of flowers to brighten the gray stone walls; every facade was decorated. The church bells, each with its own name and its own special tone, pealed continuously. Banners

in the city's colors, red and white, flapped in the wind. The towns-people wore their Sunday best, and spectators crowded the balconies and massed on the roofs. Trumpet fanfares sounded constantly.

Santa Croce was one of the largest piazzas in the city. Preceded by heralds, each competitor rode into the arena, accompanied by gentlemen and a page carrying a banner emblazoned with a device. Both rider and horse were decked with costly fabrics. Antonio Pollaiuolo, Verrocchio's rival, had chiseled pure silver bridles for the mounts ridden by Benedetto Salutati, one of the richest men in town.[22] The jousting began at noon and went on all day long. Lorenzo was, of course, declared the winner.

Leonardo, lost in the crowd, no doubt watched with his friends these fashionable and magnificent duels between members of the city's gilded youth. He may have felt some jealousy. It cannot have been easy for a proud provincial boy of illegitimate birth to witness all this luxury while excluded from taking part—standing aside like a tradesman.

Such feelings may explain Leonardo's later desire to live extrava-gantly: to wear brocade doublets, to have impeccably dressed ser-vants, and to parade about on fast horses.

Other festivities further acquainted him with the extravagance of Florentine high society: the marriage of Lorenzo de' Medici to Clarice Orsini in June the same year (with three days of dancing and banqueting); the tournament of January 1471; the triumphal welcome offered to Cardinal Francesco Gonzaga the following July, and, eclipsing all others in grandeur, the entertainment offered to Galeazzo Maria Sforza, duke of Milan, in March 1471.

This was a matter not only of impressing the Florentines but of rivaling in magnificence (for extremely political reasons) the tyrant of a powerful state. The Medici were measuring themselves against Lombardy.[23]

Galeazzo could put numbers and ostentation on display; the Sforzas, of only recent nobility, had the reflexes of the nouveau riche. They were still, it was said, "uncouth soldiers who lacked sophistication." A hundred horsemen and five hundred foot soldiers escorted the twelve carriages, draped with gold cloth, that bore the duke and his young bride, Bona of Savoy, sister-in-law of the king of France. Fifty lackeys, clad in silks and velvets, surrounded the

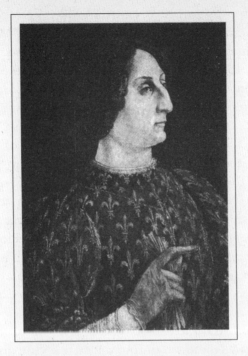

Pollaiuolo, *Portrait of Galeazzo Maria Sforza.*

ducal couple; then came fifty pikemen leading five hundred pairs of hunting dogs, and a corps of falconers, their hawks on their wrists. Then there were the duke's five hundred thoroughbred horses, half for his own use and half for the duchess, all splendidly caparisoned; finally, two thousand courtiers accompanied the noble guests.

The Milanese entered Florence on March 15, to general amazement.

Lorenzo received Galeazzo Maria in his palace on the Via Larga, in apartments decorated by Verrocchio. His costume was modest compared to the trappings of his visitors. He had decided to compete with weapons other than brocades and precious stones, namely Tuscan culture as a whole, all the works of art that graced his own house and the city. The duke of Milan supposedly owned to being deeply impressed by the refinements on view (though that information comes from a Florentine witness).[24]

Leonardo was by this time something like Verrocchio's second-in-command. He thus had the chance to see the Medici at close quarters; he entered their palaces, saw how they lived. Like the duke of Milan, he looked with respect and envy at the antiques, the sculptures, paintings, tapestries, manuscripts, jewels, and all the fabulous collections amassed by three generations of lovers and patrons of the arts.

Verrocchio's workshop had never before been offered so much work: besides the decoration of the ducal apartments, Lorenzo had ordered from the sculptor a "Roman-style" suit of arms and helmet for his guest. These works can be imagined from the workshop's bas-reliefs, such as the marble *Scipio* in the Louvre; the *Beheading of John the Baptist* in the cathedral museum in Florence; or the drawing of a warrior in profile, by Leonardo, which is in the British Museum. The gifts would have been true examples of the goldsmith's art, the metal decorated with lions' claws and teeth and eagles' wings as well as wreaths and scrolls.

It is possible that the *bottega* was also asked to help with the religious pageants mounted during the duke's visit: an *Annunciation* in the church of San Felice, an *Ascension of Christ* in Santa Maria del Carmine, a *Descent of the Holy Ghost to the Apostles* in Santo Spirito. These *sacre rappresentazioni* (in which the Italian theater originated) were rarely put on without "special effects": machines, or *ingegni,* commissioned from artists. Brunelleschi was famous for this: Vasari tells us that he could construct skies "crowded with living creatures and lights that flashed on and off as swiftly as lightning," wooden mountains with angels flying over them, and trompe l'oeil temples, each pillar of which bore a gold or silver statue.[25] Similarly, Leonardo designed an articulated dove that could go up and down on a string.[26]

During the night of March 21–22, the last of these pageants ended in disaster. A fire, probably started by one of the many torches used in the spectacle, broke out and destroyed the church. The next morning, all the talk was of dire omens and divine retribution. Public opinion condemned the Milanese for not observing Lent, for having feasted rather than fasted, and for openly indulging in pleasures every day. In reaction, sumptuary laws were devised to control dress, feasting, and funerals. They were voted in but never observed.

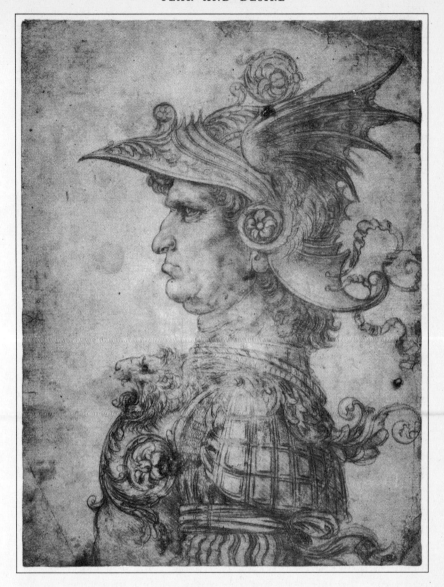

Profile of a Warrior.
BRITISH MUSEUM, LONDON.

On the period as a whole and on these festivities in particular, Niccolò Machiavelli pronounced: "There now appeared disorders commonly witnessed in times of peace: the city's youth, being more

independent, spent excessive sums on clothing, feasting, and debauchery. Living in idleness, it consumed its time and money on gaming and women; its only care was to seek to outshine others by luxury in costume, fine speaking, and wit. . . . These unfortunate habits became even worse with the arrival of the courtiers of the duke of Milan. . . . If the duke already found the city corrupted by effeminate manners worthy of courts and quite contrary to those of a republic, he left it in an even more deplorable state of corruption."[27]

It is hardly surprising that Leonardo engaged in rather frivolous pursuits, or for some years led a life that could be described as dissolute. He was simply conforming to the spirit of the age.

Kenneth Clark suggests[28] that Leonardo's chief concerns were probably "dressing up, taming horses, and learning the lute."

At the same time, of course, he was working. He finished his apprenticeship and became master of his trade in 1472, at the age of twenty. That year his name appears alongside the names of Perugino and Botticelli in the "Red book of the debtors and creditors of Saint Luke"—the register of the painters' guild. (Saint Luke was its patron since he was supposed to have painted a portrait of the Virgin Mary.)[29]

A subsection of the company of physicians, apothecaries, and grocers, the painters' guild did not have much power, since it was not a fully fledged company or *arte*, more a confraternity of ethicoreligious character. Little is known of its statutes. It met in the church of Santa Maria Nuova, took part in religious processions, had its special day on October 18. Sometimes it took on disciplinary functions, at least in theory—it was supposed to ensure that its members didn't substitute cheap Prussian blue for expensive ultramarine, for instance. But the guild seldom intervened in the drawing up of contracts binding an artist to a customer; what it seemed to ask above all was exemplary piety and fiscal regularity from its members. It delivered no diplomas and pronounced no disbarments.

Enrolling in the confraternity (which cost one florin) was supposed to be a prerequisite for opening one's own studio and taking

commissions. But it seems the rule was not respected. Botticelli had a *bottega* in his own name in 1470, two years before his enrollment in the guild register.[30] Apparently, registering was a formality few in Florence observed.

Leonardo's "mastership" did not mean a great deal. He was not yet pursuing individual glory but continued to work alongside Verrocchio. This seems to have satisfied him, perhaps because he had more free time and no responsibilities.

He continued to draw, still learning and perfecting his skills. He modeled some clay "heads of women smiling and children's faces,"[31] but it was toward painting that he leaned. Vasari tells the story of one of his first painted works as if the tale were already a legend.

One day, he says, Leonardo's father was in the country and received a visit from one of his sharecroppers, who had a favor to ask. He had carved from the wood of a fig tree a round shield, which he wished to have decorated by a painter from Florence. He promised to pay in fish and game, so Ser Piero was only too happy to oblige. Understandably, the notary passed the commission to his son. Leonardo set to work. The shield was crudely carved and badly warped. Leonardo reshaped it under heat, sent it to be polished, and then covered it with his own special varnish. What to paint on it? The picture on the shield should be like a Gorgon's head, he reasoned, the better to frighten one's enemies. So he collected, in some shed transformed into a studio, "lizards great and small, crickets, snakes, grasshoppers, bats, and other strange creatures." He dissected them and combined their limbs rather like an early Frankenstein, in order to create a perfect spine-chilling monster. He depicted this biological nightmare "emerging from a cleft in a dark rock, vomiting fire from its gaping jaws, its eyes blazing, and poisonous vapors emanating from its nostrils." When at last it was ready, Leonardo asked his father to come for it. On hearing Ser Piero's knock at the door, the artist adjusted the shutters so that only a dramatic ray of light fell on the shield, which was propped on his easel. As the notary walked in, he had a terrible shock: in the gloom, he thought he was in the presence of some limb of the devil. He started and shrank back, whereupon Leonardo stopped him. "That is what a shield ought to do," he said. "Take it." According

to Vasari, he added: "That is what one expects from a work of art." Ser Piero, impressed as much by the argument as by the artwork, went straight to the market, bought an ordinary shield decorated with a heart pierced by an arrow, and gave that to the sharecropper, who was perfectly happy with it. Then Ser Piero secretly sold the shield painted by his son for one hundred ducats to merchants in Florence, who soon afterward sold it to the duke of Milan for three hundred.[32]

Vasari is the only source for this story, but it is thought to be based on a true incident. No trace of the shield survives.

In his *Trattato della pittura (Treatise on Painting),* Leonardo advises the painter to construct a fantastic animal from real elements. To paint a dragon, for instance, he advises taking "the head of a mastiff or a pointer, the eyes of a cat, the ears of a porcupine, the muzzle of a greyhound, the brow of a lion, the crest of an old rooster, and the neck of a tortoise."[33] The idea was not new; Verrocchio had applied it to the decoration of ceremonial helmets. What Leonardo did was to set it out in words.

The anecdote about the shield—in which Ser Piero does not appear in the best light—also illustrates Leonardo's innate sense of theater (the arrangement of the shutters), his taste for the bizarre, for special effects, indeed for farce, as well as his conception of art. In his eyes, art should not merely be ornamental; it ought also to act upon people, to disturb and influence them.

Finally, the horrible monster, fruit of a morbid imagination, so lifelike that Ser Piero was taken in, seems revealing about the demons that haunted Leonardo. I am tempted to think the creature's lair was the dark cave that inspired in Leonardo both desire and anguish.[34]

Leonardo was not confined to Verrocchio's circle. Workshops opened their doors to any member of the profession. He would have frequented other *botteghe,* notably that of Antonio and Piero Pollaiuolo, who were humanist scholars—and who flayed cadavers to study the anatomy and function of the muscles (the famous *Battle of the Nude Men* engraved by Antonio in about 1470 demonstrates the interest this studio took in both antiquity and anatomy).[35] Nor

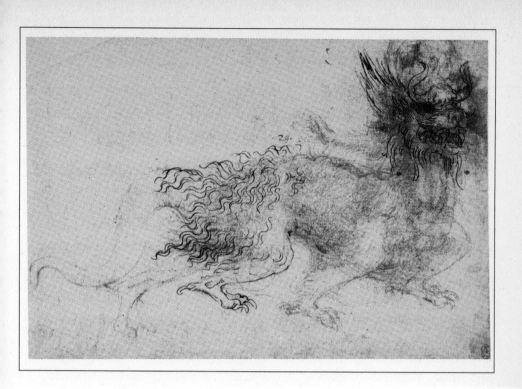

Dragon.
ROYAL LIBRARY, WINDSOR.

would Leonardo have been a stranger to the *bottega* of the elderly
Paolo Uccello. Painter, mosaicist, marquetry artist, and decorator,
Uccello was passionately interested in geometry and perspective.
Love of this science, Vasari tells us, kept him awake night after
night. When his wife begged him to come to bed, he merely
muttered, "Ah, what a sweet thing perspective is." In many ways,
Leonardo resembled this master; they had in common a love of
mathematics, of curious shapes, of the natural world, of animals
(horses in particular—I think of Uccello's hunting and battle scenes
and his equestrian portrait of Sir John Hawkwood[36]). They both
had a slightly maniacal precision, a tendency to favor monochrome
and the darker end of the spectrum, to bring out values against a
terra verde background. But in the 1470s, the works of Uccello, who
was still going in for what is known as "international Gothic," must
have looked a little out-of-date. Vasari mistakenly places him in the
same generation as Brunelleschi and Masaccio, giving his date of

99

death as 1432 instead of 1475, but Vasari's slips often contain a certain truth. Although Leonardo may have sympathized with this gaunt and eccentric old man with a long white beard,[37] he did not spend much time following his teaching. Outside marquetry workshops, Uccello had few imitators left in Florence.

Someone like Alberti would have had much more influence.

Born in 1404, Leon Battista Alberti was of the same generation as Uccello, but his research had kept pace with the times.[38] The epitome of the *uomo universale,* he seems a perfect precursor to Leonardo and may well have been a model. He, too, was illegitimate and of uncommon beauty and physical strength (with his feet together, it was claimed, he could jump over a grown man; he could throw a coin up inside the Duomo so high that it reached the top of the cupola, etc.). A skilled horseman and a brilliant musician, Alberti had made a name for himself both in arts and in sciences. Poliziano describes him as a "miraculous mind," and his epitaph reads: "prince of erudition." Philosopher, architect, amateur painter and sculptor, engineer, mathematician,[39] he was one of the great intellectual influences of the age.

His self-portrait, sculpted on a medal[40] in about 1450, shows a long, bony face in profile, a proud face with a very straight nose. Born into the upper bourgeoisie, Alberti was an intimate friend of Pope Nicholas V as well as of Federico da Montefeltro, duke of Urbino. He had the casual manner of a grandee: he merely delivered to the foreman the plans for the buildings he designed, never deigning to go on site himself. Leonardo probably would not have had frequent occasions to meet him, since the elegant Alberti divided his time between Florence and Rome (where he died in 1472), but it seems clear that Leonardo was fascinated and durably influenced by him. Leonardo certainly read him avidly, commented on his writings, and imitated him in his life and works, before coming to criticize him.[41]

Leonardo must also have known Alesso Baldovinetti, the painter and mosaic artist. Alesso painted in minute detail broad landscapes that pointed the way toward Leonardo's own research.[42] But I imagine he went to Baldovinetti above all for information about chemistry—"recipes for paints." Alesso had a

Leon Battista Alberti, Self-Portrait.

———————

furnace where he prepared an original mixture of egg yolk and resin. Applied as a varnish, it gave frescoes the brilliance and freshness of an oil painting.

The story of the introduction of oil paint to Florence is a curious one. A revolutionary invention, it is thought to have been the brainchild of the Flemish painter Jan van Eyck. According to Vasari, some of the Flemish master's paintings reached Naples and Urbino during the first third of the quattrocento and caused a sensation. They had a glossy surface, with shades of color and transparent effects that could not be achieved with traditional pigments. The Italians tried to discover the secret of the northern painters. Still according to Vasari, the Sicilian Antonello da Messina, after various unsuccessful experiments, traveled to Flanders, to be initiated into van Eyck's technique on the spot. Afterward, he settled in Venice and taught it to his friends, in particular to Domenico Veneziano, who in turn introduced it to the workshops of Florence. Veneziano was hired to paint one third of the apse of Santa Maria Nuova, with the other two thirds commissioned from Baldovinetti and Andrea del Castagno. The latter was, Vasari tells us, unable to bear the success his colleague enjoyed thanks to the new

technique. But Castagno pretended to be friendly. Every night the two men would go out together, playing the lute and serenading pretty girls. Lulled into confidence, Domenico gradually revealed everything he knew about oils. Once Castagno had learned what he needed, he murdered his informant with an iron bar so as to have no rival. The cowardly murder went unpunished, for the assassin "only revealed the truth in confession at the very end of his life."

At about this time, Vasari further informs us, Andrea del Castagno painted a portrait of himself as Judas Iscariot, "who was like him a traitor in soul and deed."

The whole thing makes for a splendid story but is pure fiction. In fact, Antonello da Messina first went to Venice fourteen years after the death of Domenico, who himself died four years after Castagno, his presumed assassin.

What probably happened was that the Italians learned about oil painting techniques from northern artists living in Italy, that the secrets were discovered in Naples and Venice before they reached Florence, and that either Domenico or Antonello da Messina himself introduced them to the latter city—without skulduggery or violence. The fact that rumor—in other words, the collective unconscious—saw fit to link the new discovery to a bloody murder underlines, it seems, the capital importance attached to it. The new techniques would help put an end to traditional practice.

But around 1470, when Leonardo was taking his first steps as a painter, the Tuscan artists had not yet fully mastered the technique of oils. Some were content simply to imitate its effects; they finished off their works by coating them with a sort of tinted varnish. It seems certain that it was in Verrocchio's workshop that "the oil paint revolution" bore most fruit, in the work of Leonardo, then of Perugino, who passed on the torch to Raphael.

The advantages of oil over water are many: it is possible to put one layer of paint over another without blurring the color, to mix paints as much as one wants, to go back over work indefinitely (so long as one respects the time it takes to dry). In practice, it creates much greater facility in rendering relief and giving the impression of space with nuances of color, and by enabling the artist to soften outlines, escaping hard-edged drawing, it makes possible a much

smoother and deeper finish—the *morbidezza* and *sfumato* that the new aesthetic was starting to demand.

Perugino took this smooth finish to excess, falling into sentimentality in the end. The trait had probably been inherited from fellow Umbrian painters like Giovanni Boccati, Bonfigli, or Caporali. Perugino arrived in Verrocchio's workshop in about 1470, some years after Leonardo. By then, his style had probably already found its principal characteristics; all that remained was for him to become "modernized" by contact with Florence. In exchange for this modernity, Perugino transmitted to Verrocchio's *bottega* a little of the suavity and elegant sensitivity of the artists of his homeland.[43]

Leonardo and Perugino, possibly helped by the young Lorenzo di Credi, would have attempted to perfect recipes for preparing oil paints—which had to be fluid yet quick-drying, and not too strongly pigmented. Leonardo notes several of these recipes in his papers, trying them out and experimenting, as he was to continue to do all his life, sometimes with disastrous consequences. This was basic research, going hand in hand with a better understanding of the medium. Thus he mixed oil with more or less purified turpentine;[44] he crushed mustard seed with linseed oil,[45] then put the mixture through a press;[46] he distilled juniper and with the essence obtained dissolved the resin from the same plant;[47] he thought that amber was "the latex of the cypress" and stated that it had to be collected and treated in April or May in order to obtain a "perfect varnish";[48] he also tried walnut oil, noting that if one did not carefully clean the nuts first, the skins might stain the paint;[49] and he noted a method of rescuing oil paint once it had hardened, with the aid of soap.[50]

At about the time his name appears in the red book of the guild in 1472, Leonardo was assisting Verrocchio in the execution of a large painting, the *Baptism of Christ,* commissioned by the monks of San Salvi, a monastery outside the city walls near the Porta alla Croce. This is the oldest surviving trace of Leonardo's painting.[51]

Verrocchio painted Christ in a loincloth, hands together and eyes lowered, standing barefoot in the clear waters of the Jordan while Saint John administers the baptism with a copper bowl. The Holy Ghost, in the form of a dove, descends from heaven. Since Christ

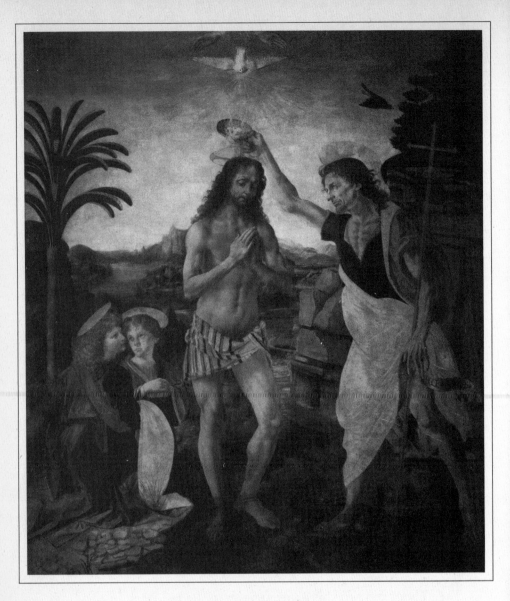

Verrocchio, *Baptism of Christ.*

GALLERIA DEGLI UFFIZI, FLORENCE.

occupies the center of the panel, Verrocchio included two angels on the riverbank to balance the composition; he painted the one nearest the center and left the other to Leonardo, who also completed the background.

Verrocchio surpassed himself in this work, which is full of harmony and emotion. The ascetic figures, painted with faultless anatomical detail, are a fine mixture of realism and grandeur. He resolved very well—in the Flemish manner—the representation of the transparent water bathing the feet of Christ and John the Baptist (the Italians usually avoided the problem entirely, depicting baptisms on dry land). But when Verrocchio saw the angel carrying Christ's garment, painted by his pupil,[52] he was—according to the irrepressible Vasari—dumbstruck. Humiliated to discover that for all his youth, Leonardo already knew more than his master, Verrocchio swore never to touch a paintbrush again.

In fact, Verrocchio accepted commissions for other paintings. The quality of Leonardo's work must simply have convinced him that he could increasingly delegate responsibility for the "painting department" of the workshop, so as to devote himself to what he personally preferred: sculpture and goldsmithing. It seems likely that at this point Leonardo was promoted from first assistant to partner.

According to John Ruskin, the angel carrying the garment is not superior to the figures painted by Verrocchio "in religious or major respects. . . . But the difference is great in terms of painterliness."[53] The first part of this remark is debatable; the second is not. In this painting Leonardo accomplished the first of many tours de force. He chose the most difficult of angles, portraying his angel in three-quarter profile from the back, in order to depict a "turning figure." The drapery still has something of the artificial stiffness of his master's (no doubt the dampened and weighted fabrics described by Vasari), but the face shines with a luminous light quite unknown in Florence before this. The hair, eyes, and smile have a new vivacity and presence—so much so that they almost unbalance the unity of the whole. Walter Pater wrote: "this angel is a space of light in the cold, labored old painting."[54]

This precocious, extraordinary achievement by Leonardo can, I think, be attributed both to his special conception of volume and space and to the progress he had made in mixing paints with oil. When the *Baptism of Christ* is X-rayed, the difference between his technique and Verrocchio's emerges quite staggeringly.[55] Whereas

his master still indicated relief by highlighting contours with white lead (which blocks the X-rays and therefore shows up clearly on them), Leonardo superimposes very thin layers of paint, unmixed with white; his application is so smooth and fluid there are no brush strokes to be seen. The X-rays go straight through his section; the angel's face shows up completely blank.

Leonardo, who never used tempera in any of his paintings, always painted on undercoats first, so thinly that the wooden panel itself can be seen on the X-ray.[56] Then he applied very fine layers of paint, the lightest of coats, gradually darkening to provide the contour of the flesh. The light passes through his painting as if through stained glass, straight on to the primed surface beneath, which reflects it back, thus creating the impression that it emanates from the figures themselves.[57] The emulsions used in Leonardo's last painting, *John the Baptist,* are so thin that X-rays reveal nothing except a uniform mist.[58]

In Leonardo's *Treatise on Painting,* we read: "Painters who wish to represent the relief of things they paint must cover the surface with a half-tint, then paint in the darkest shadows and lastly the main lights."[59]

This sentence reveals the chief outlines of Leonardo's "manner." Elsewhere, asking himself which is the more difficult—distributing light and shade or drawing—Leonardo makes his meaning clearer. Relief, he writes, is the very soul of painting.[60]

By this he means the reproduction of three-dimensional objects on a two-dimensional surface.[61] He was to write a great deal about relief, about its nature and function and about the different ways of rendering it. He nowhere says, however, how he sensed its importance, or how he formed the idea that painting should be not a linear representation of the world but rather a representation *in terms of volume.*

A clue to the origin of this fundamental axiom can, I think, be found in the passage already mentioned in which Leonardo succinctly summarizes the history of painting: first came Giotto; then Masaccio led the great revival of art from the Dark Ages. To my mind, no account of Leonardo's training is complete unless it evaluates the debt he owed to Masaccio.

A country boy like Giotto and Leonardo, Masaccio arrived in Florence in about 1417. Perhaps because he had never experienced the culture of the city, he looked at things with a new, almost iconoclastic eye. He worked with Masolino da Panicale, and in about 1424, the two men began to paint a cycle of frescoes, representing various episodes from the Scriptures, in the Brancacci chapel of Santa Maria del Carmine. In 1428, Masaccio left for Rome, where he died that autumn, aged only twenty-seven (but he was not, as legend has it, poisoned—Renaissance Italians did not really kill each other right and left). The frescoes remained unfinished, and eventually Filippino Lippi completed them to the best of his ability.

Public taste did not appreciate Masaccio during his lifetime. It was to take almost half a century for his teaching to bear fruit. Vasari describes his achievements as follows: "He discovered beautiful poses, noble movements, proud and animated stances, and a way of rendering relief that was truly natural, something no painter ever achieved before him."[62] He further adds that Masaccio was one of the first to apply the rules of perspective and to paint foreshortened figures;[63] he speaks of his simplicity, fluidity, naturalness, grace, and blending of colors, all combining to create an extraordinary "power of truth."

One might add to this that Masaccio eschewed bright colors, gold paint, and seductive detail in order to give priority to expressiveness. Above all, he was the first painter to unite all the elements of his compositions into a fixed geometry, with consistent lighting proceeding from a single organizing principle. One has the impression that air is circulating between his figures. Leonardo would be ruled by this principle all his life.

When Leonardo was not drawing or painting, when he was not mixing pigments or experimenting with new recipes for oils or varnishes on a little palette, when Verrocchio was not calling on his services—what was he up to? How did he spend his time?

Whereas Masaccio was so dedicated to his work that he took no interest in the affairs of this world, to the point of being slovenly in his dress, Leonardo was never satisfied with a single activity. There is a sheet of paper in Windsor covered with pen-and-ink

Study of Cats.

sketches of cats in various degrees of detail, obviously done from life.[64] Sometimes the cat is drawn from behind, with its tail in the shape of a question mark; sometimes crouching low as it stalks an

invisible prey; in other sketches it is asleep, curled up in a ball, or washing itself, or biting at its leg, or drawing itself up on its four legs, fur standing on end, or fighting other cats. There are twenty drawings on the same page, evidence of remarkable powers of observation and rapidity of execution. But in the middle of all these cats appears a little dragon (one does not notice it at first, because of its feline pose). Leonardo could not resist the urge, at some point, to let the pen run away with him for a few minutes. On another sheet of drawings,[65] a cat (looking a bit like a tiger) has strayed in among some studies of horses. Elsewhere, alongside a drawing of stallions rearing their heads, Leonardo has allowed himself to be distracted into sketching the jaws of a furious lion, then the leonine face of an angry man.[66] In a study of a cranium in section, he sketches the larynx, the esophagus, and the thyroid, five or six times over, then, on the same sheet, two columns (Florentine, not spinal) with bases and capitals.[67] Rarely does he forgo the pleasure of a little side trip.

Similarly, while learning his trade, he was devoting time to various sciences—as though they were a hobby. He was fascinated by everything: "The desire to know is natural to good men," he wrote.[68] And he also justified himself by repeating the words of Alberti: the painter ought to possess all the forms of knowledge useful to his art. But whereas Alberti was thinking only of history, literature, and mathematics,[69] Leonardo lengthens the list enormously, depending on circumstances and including forms of knowledge that (to us at least) seem to have little to do with painting—such as astronomy.

A series of names, jotted down in the notebooks, helps us reconstruct his interests.[70] Among them, we encounter *"maestro Pagolo medico"* (Paolo del Pozzo Toscanelli, a physician but also a philosopher, man of science, geographer, and mathematician) and *"Benedetto dell'abbaco"* (the *abbaco* was a portable calculating table: Benedetto taught arithmetic in Florence).

It is impossible to discover whether Leonardo assiduously attended the lectures of these eminent professors or merely admired them timidly from afar. Certain coincidences do suggest that the elderly Toscanelli (well known in artistic circles, a close friend of Brunelleschi and in touch with Verrocchio) may have guided Leo-

Studies of Horses, with the Heads of Horses, a Lion, and a Man.
ROYAL LIBRARY, WINDSOR.

nardo's first steps into the sphere of science. Leonardo would already have met him during the installation of the ball on the cathedral. In January 1472, a comet, referred to by contemporary chroniclers as "horrible and terrifying,"[71] passed over the Tuscan sky, its long tail clearly visible even in daylight. In 1478, an eclipse of the sun once more alarmed the townspeople and excited speculation among scholars. In Leonardo's papers, it so happens that the sketches of elementary mechanisms intended for astronomical demonstrations date from this period—and in the margin of one of them, a little caricature might well be of Master Paolo.[72]

Toscanelli was at this time the most famous astronomer and geographer in Florence. His theories contributed to the major discovery of the century: it was apparently a copy of a letter he had written in 1474, stating that China could be reached by sailing westward, that convinced Christopher Columbus to set off across the Atlantic.[73] Leonardo, who all his life showed great curiosity about celestial phenomena, about the peculiarities of the earth (he would later own a *mappamondo*), and about exotic countries, may have heard Toscanelli's descriptions, his all too rare "lectures," may

have asked him questions, borrowed ideas and even books and instruments from him. Perhaps it was from him that he learned mapmaking (Leonardo drew some very handsome maps) and the basic elements of Ptolemaic geography.[74]

It seems quite likely that Leonardo gravitated around Benedetto, Paolo Toscanelli, and indeed most of the city's leading lights in the sciences and the arts.[75] Intellectual Florence was, after all, no more than a large village. But at twenty or twenty-five years of age, he would not have been content solely with the company of venerable old men.

Above a drawing of an alert adolescent and a dour old man, whose features seem to spring from the accidental ink stains on the paper, Leonardo has written: "Fioravante di Domenico is my dearest friend in Florence. I love him like a brother."[76]

This is one of his all-too-rare records of his feelings. Who was Fioravante—whose name figures nowhere else? Did he have the sharp-featured and rather tormented face of the boy in the sketch? One would dearly like to have a list of the youthful Leonardo's friends.[77]

Did he keep company, outside business hours, with fellow artists from the studio? He does mention Botticelli several times with a kind of affection. *"Il nostro Botticelli,"*[78] as he calls him, was a great joker, whose pranks delighted all the *botteghe* in town. But Leonardo has little good to say about his fellow painter's work. In fact, Leonardo criticizes him for neglecting perspective: "Sandro, you do not say why the second things [i.e., objects in the middle ground] appear lower than the third ones."[79] Leonardo also felt Botticelli put little effort into his landscapes,[80] treating them as mere backdrops, in front of which characters appear but with which they have nothing to do. He was not wrong in this respect: the feet of the nymphs in Botticelli's *Primavera* do not seem to be touching the ground, and the trees in the *Birth of Venus* appear to be made of cardboard. Botticelli had not completely mastered Masaccio's teaching.

Da Vinci says nothing about Perugino. Yet consider his remarks about the need for a painter to strive toward universality: "It is extremely unworthy to succeed very well in one thing and to do

badly in another, as many do who only study the measures and proportions of the body without seeking to discover how these vary: for individuals may be short and fat, or tall and thin, or average; he who takes no note of these differences will always produce figures that look the same; they will all resemble each other like sisters, and this practice should be severely condemned."[81] When he wrote these words, was he thinking of Perugino, who could indeed be criticized on this score?

A poem by Raphael's father, Giovanni Santi, links the names of Leonardo and Perugino ("Two adolescents, of the same age and fired by the same passions"[82]), but it seems likely they were driven apart by differences in their characters and ambitions. Perugino had suffered from deprivation, and the specter of poverty haunted him; he desired honors and fortune and set out to acquire them as quickly as possible, producing many paintings, seizing on the most commercial formulas, and seeking to please with an almost indecent determination. Michelangelo publicly described him as a *goffo* (oaf),[83] and no doubt da Vinci was of the same mind.

Leonardo also says nothing about Lorenzo di Credi, his junior by seven years. The grandson of a goldsmith, modest Lorenzo assisted Verrocchio, absorbing and copying the master's style. Largely because of the difference in ages, and despite the affection and benevolence Lorenzo may have inspired in Leonardo, it is not likely they were close companions.

Like today's art students, the trainee artists of Florence devoted a great deal of their time and energy to amusement. They loved parties, liked to distinguish themselves from respectable citizens and indeed to shock them. Leonardo, too, was not above amusing himself at others' expense. He invented (or claimed as his own) riddles, charades, puns, and funny stories (whose appeal sometimes escapes us nowadays). Examples: "If Petrarch liked bay leaves [*laura*], it was because they are good served with sausages and thrushes."[84] Someone asked a painter why his children were so ugly, when the faces he painted were so beautiful. He replied that "the paintings were made by day and the children by night."[85] Leonardo was rather addicted to conjuring tricks—springing perhaps from his scientific turn of mind. He would make multicolored flames jump from a cup of boiling oil by throwing red wine into it; he would break a stick

balanced on two glasses without cracking them; he would moisten a pen with saliva and then write black letters on paper with it. He manufactured all sorts of stinkballs from the remains of fish or animals allowed to decompose in a vessel—and so on.[86]

His taste for tricks, jokes, and deceptions of all kinds later brought him into contact with some odd people, of doubtful morals, such as Tommaso di Giovanni Masini, the son of a gardener from outside town, who claimed to be the bastard son of one of the great Rucellai family. Mechanic, goldsmith, self-styled magician, and expert in the occult sciences, Masini adopted the nom de guerre Zoroastre de Peretola and went to extravagant lengths. He was suspected of various crimes. Leonardo accepted him as both friend and assistant.

In the 1470s, the custom did not yet exist whereby Florentine artists formed grotesque confraternities (the Companies of the Trowel or the Cauldron, some of whose exploits are recorded, seem to have belonged to the next generation). Young artists of earlier days did not institutionalize their activities, but they were just as lively.

In Verrocchio's workshop there was singing, and various musical instruments were played. Leonardo was said to have a fine voice and to have been a virtuoso on the *lira da braccio*. Contrary to what most translators have assumed, this was neither a lute nor an antique lyre, nor was it the "plaintive guitar" spoken of by Stendhal.[87] Rather, it was a sort of viol for accompanying a song: it could be held in various positions and was played with a bow. Impromptu concerts might become rowdy affairs, especially if wine was available.

In those days, fashionable young men had long hair, curled with tongs, and bangs. They wore caps or turbans, often of bright colors, and close-fitting doublets and hose, sometimes with exaggerated codpieces. Did Leonardo and his friends follow the vagaries of fashion? Their means would not have allowed them to wear the lace and embroidery ("painting with the needle," as Alberti called it) that decorated the clothes of the rich. We do not know what Leonardo earned, but Lorenzo di Credi received one florin a month from Verrocchio—about the same as a domestic servant. And I cannot see Ser Piero spoiling his son unduly. But they may have found cheap ways of introducing striking features to their costume.

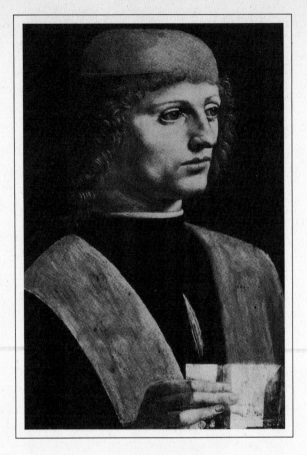

Portrait of a Musician.
AMBROSIANA, MILAN.

In his notebooks, Leonardo mocks those who "have eternally for counselor their mirror and comb" and remarks on those who use gum arabic imported at great expense from the East to plaster down their hair: "Their greatest enemy is the wind, for it ruffles their sleek locks." And in the same passage he disapproves of the "excessive ornaments" worn by young people,[88] praising instead sweet simplicity. He also writes: "I remember seeing in my childhood men both great and small who wore the ends of their garments slashed all over, from head to foot and down the sides. Not content with this brilliant invention, they even slashed the slashes. . . . Later, sleeves

grew so long and full that each one was larger than a coat. Then collars grew so tall that they hid people's heads. And people wore their clothes so tight that it became torture: many died of this; their feet were so constricted by their shoes that their toes were cramped on top of each other."[89]

Yet, as the carefully curled hair and beard and rose-colored garment described by the Anonimo Gaddiano suggest, he allowed himself refinements. Others show through, directly or indirectly, at various points in his writing. In the middle of a recipe for mixing pigments, for instance, he suddenly feels an urge to talk about perfumes and writes: "take some fresh rose water and moisten your hands with it; then some lavender flowers and rub them between your palms: it will be agreeable."[90] He perfumed and colored alcohol with cornflower or poppy petals.[91] He invented a depilatory based on lime and yellow arsenic.[92] I imagine him being fanatical about cleanliness: "He who wishes to see how the soul inhabits the body should look to see how that body uses its daily surroundings," he writes emphatically. "If the dwelling is dirty and neglected, the body will be kept by its soul in the same condition, dirty and neglected."[93] Since certain oils he prepared, notably walnut oil, gave off a strong smell that offended him, he devised methods of neutralizing the fumes—by boiling the oil with vinegar, for example.[94] And he seems to have been very fond of jewels, especially intaglios (he may have engraved semiprecious stones himself).[95]

With Leonardo, everything seems to have two sides. He jumps continually from high seriousness to triviality. There is method and rigor in his practical jokes, while some element of lightheartedness and game playing creeps into his most abstruse investigations. He is both changeable and obstinate; worldly and solitary ("the painter or sketcher must be solitary," he writes, "so that the well-being of his body does not affect the vigor of his mind"[96]); active and sluggish; humble and proud; obedient and rebellious; fantastical and practical. He wanted to be of service to mankind but aimed too high: most of his inventions were not really practicable. He indulged himself imagining engines of destruction, while inveighing against the folly of war; he sought after the canon of ideal beauty, while at the same time pursuing in slums and hospitals examples of the grotesque and deformed—the canon of ugliness. In his genius

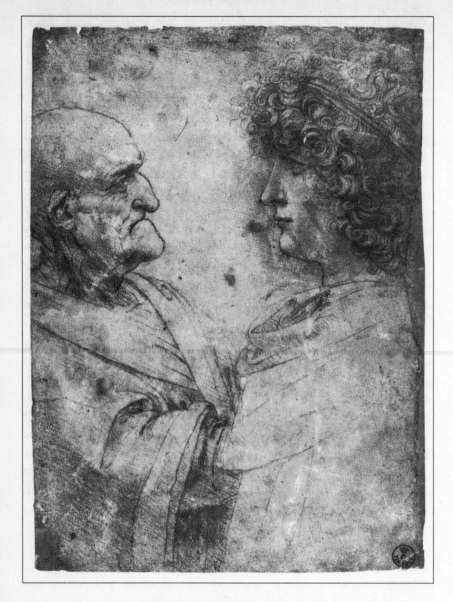

Profiles of an Old Man and a Youth.

he sometimes leaps ahead of his contemporaries—only to repeat himself or change his mind. Both serenity and youth attracted him: yet madness and old age haunted his mind. How often on the same

page does he balance a profile of a graceful and innocent boy with that of a father figure, imposing and glowering. It is a sort of leitmotif of the notebooks. And he never feels desire without fear immediately gripping him like remorse.

In order to make sense of Leonardo's years with Verrocchio, they must be seen in light of the conflicts to which he was prey. Florence, for instance, was home of the arts, knowledge, and pleasure, but it was also the city where Leonardo was *obliged* to live, his place of exile. His career was cramped by his condition, in particular his illegitimate status. What was his opinion of himself? It seems to me that he had little self-love in these years, that he was less than satisfied with the person he had become at the hands of chance, necessity, and circumstance.

Francesca Lanfredini, Leonardo's second stepmother, died childless in 1473—the same year that he wrote on the back of his summer landscape, "I am happy."

Ser Piero observed a proper period of mourning; placed a marble plaque on the family vault; and waited some two years before trying his luck again. This time he married the young Margherita di Francesco di Jacopo di Guglielmo, who brought him a dowry of 365 florins.

The notary's reputation was now firmly established, his business thriving. The poet Bernardo Cambini composed the flattering lines "If destiny bids you take the best man of law / Look no further than da Vinci, Piero."[97] Ser Piero's resources enabled him to buy several properties, in particular in his native village. To crown this general felicity, his third wife presented him in 1476 with his first legitimate child, a boy, who was baptized with great ceremony in the name of his grandfather Antonio.

Schopenhauer maintains that nothing in our lives happens by chance. Early in 1476, Leonardo was summoned to appear in a court of justice on a charge of sodomy. He was twenty-four years old.

His biographers, understandably shy about this embarrassing incident, have long tended to draw a discreet veil over it. Yet it is the only "uncoded" clue to Leonardo's emotional life; and the facts are after all there.

The accusation was anonymous. Florence in those days had spe-

cial letter boxes known as *tamburi* (drums), from their cylindrical shape, or *buchi della Verità* (mouths of Truth), which enabled "virtuous citizens" to speak out without risk. They made it very easy to denounce a neighbor suspected of being a crook, a conspirator, a murderer, or merely an adulterer. Once the complaint was registered, an inquiry was opened by the appropriate authority. In the case of homosexuality, this was the Officers of the Night and Monasteries—the night watch—who oversaw community life like a present-day vice squad.

Leonardo was accused, with three other youths, of having practiced sodomy on the person of one Jacopo Saltarelli, aged seventeen. Jacopo wore black (the charge sheet tells us), was the brother of a goldsmith in the Via Vaccereccia, was himself an apprentice goldsmith, and, it seems, was a notorious prostitute. The fellow accused were Bartolomeo di Pasquino, another goldsmith from the Via Vaccereccia; Baccino, a tailor and doublet maker from Orto San Michele, and Lionardo de' Tornabuoni, who also wore black. Theoretically, the penalty could have been death at the stake.

The first hearing was held on 9 April 1476 and produced no result. The law, more just than is sometimes claimed, required firm evidence and signed statements from witnesses. None were forthcoming, so the affair was postponed until 7 June. The accused were *"absoluti cum conditione ut retamburentur"*—discharged on condition the case be heard again ("brought back to the drum" was the idiom). There was another inquiry and a fresh hearing, where once again the prosecution failed to come up with anything. The judge dismissed the case, and the charges were dropped for good.

Who was the real target of the accusation? Was it the painter, the doublet maker, or the goldsmith? Was it Saltarelli himself, whose guilty doings were exposed in some detail; or, possibly, Lionardo de' Tornabuoni, for whom neither fixed address nor any useful information is given, as if none were needed. Who did not know this family? Lorenzo de' Medici's mother had been a Tornabuoni. Through this young man, the whole Medici clan was being attacked, and perhaps Lorenzo brought pressure to bear to get an acquittal, from which Leonardo also benefited. I am inclined to think that politics, some sexual jealousy, or the virtuous indignation of some neighbor about Saltarelli's notorious "trade" is behind the

whole affair. Why should anyone want to attack an obscure young painter at the outset of his career? The accuser probably included his name to augment the lineup.

Since the charge was anonymous, its value has long been challenged. "This alone should serve to condemn it," writes Gabriel Séailles.[98] Yet while no definite proof has ever been produced of Leonardo's homosexuality, there are plenty of indications, in his drawings as well as in his writings, that he was attracted to males, and it is, as Freud puts it, "doubtful whether he ever embraced a woman with love."

There is no record of any woman in his life—not even a female friendship. On the other hand, he was soon surrounding himself with a constantly renewed court of remarkably beautiful young men. No doubt they posed for him: he drew—apparently for the pleasure of drawing—large numbers of male nudes. Whereas his interest in women seems confined to the face, the hands, the movements of the bust, when it comes to young men, he pays more attention to thighs, buttocks, and in general everything from the navel downward.[99] During the period when he was most interested in anatomy, he depicted in detail the male genitourinary system, drawing the penis in a variety of ways, whereas only twice did he draw the private parts of a woman (not counting sections). And in the first of these, his drawing is coarse and inaccurate—a menacing dark opening as disturbing as the entry to the cave, one might venture, and most unscientific as well, since while it includes the urethra, it omits the clitoris and labia minora.[100] On the same sheet of paper, he makes several attempts to draw the muscular mechanism of the anal sphincter, dilated and contracted. The subject seems to engage him, but as usual, he allows himself to become distracted, and the five muscles he identifies in the sphincter turn into the petals of a flower, perhaps a fleur-de-lis, then into the plan of a pentagonal fortress surrounded by a moat. Leonardo writes a few notes about these muscles; then, on coming out of his reverie, he simply writes the word "False" across the whole thing.

There is a later drawing of a vulva on a page devoted to embryology that is more accurate, though the labia are exaggerated.[101] Leonardo thought that the private parts of a woman were disproportionate to those of her partner. On the same page he writes: "In

The External Genitalia and Vagina.

ROYAL LIBRARY, WINDSOR.

general, woman's desire is the opposite of man's. She wishes the size of the man's member to be as large as possible, while the man desires the opposite for the woman's genital parts, so that neither ever

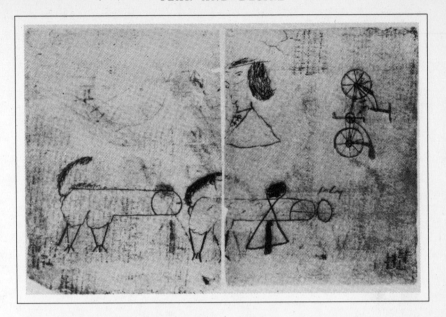

School of Leonardo da Vinci, Graffiti.

CODEX ATLANTICUS.

attains what is desired. . . . Compared to the size of the womb, woman has larger genital organs than any other species of animal."

On another page,[102] mostly concerned with machines, he draws a man and a woman in the sexual act: there seem to be two penises in contact with each other. In another drawing, a penis is directed straight at a pair of masculine buttocks, spotted with ink.[103] In a third, figuring the extraordinary bicycle that Leonardo is said to have designed,[104] the coarse hand of an assistant has drawn an obscene caricature: a penis with legs and a tail is approaching a round orifice above which is scrawled the name of Leonardo's favorite pupil, Salai. Each of these "clues" means little taken separately, but they add up.

It would take a tome to exhaust the possibilities of Leonardo's complex sexuality. One could go on indefinitely analyzing and dissecting his writings and his drawings, in which sexual feelings often seem to lurk just beneath the surface; one can patiently attempt to decipher the symbols behind which he seems to hide, or draw up a catalogue of his favorite themes—or obsessions. One constantly

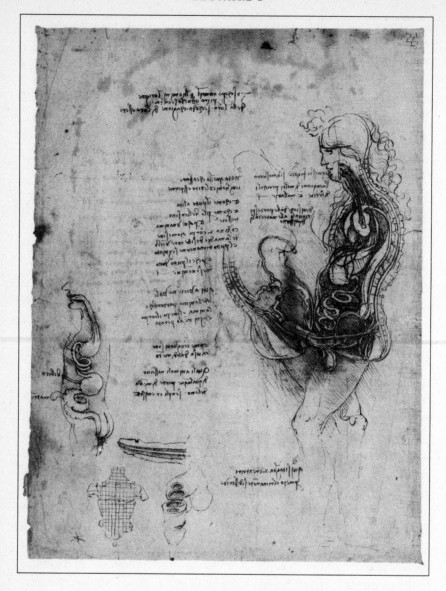

Coition of Man and Woman in Section.
ROYAL LIBRARY, WINDSOR.

feels on the verge of discovering some vital clue or reflex, and yet one can always see an alternative explanation. So it is hard to say anything definite. Leonardo seems forever on the brink of confes-

sion, then draws back as if deliberately covering his tracks. All the same, I propose a few points for consideration.

On several occasions, Leonardo made drawings, always in section, of a man and a woman engaged in sexual intercourse. The couple is always upright, but the anatomy of the male is invariably more detailed than that of his partner. At the foot of the most finished of these sketches (in which the man is provided with a curiously abundant head of hair), Leonardo has written: "Thanks to these figures, the cause of many ulcers and diseases will be demonstrated."[105]

Human or animal copulation—he does not seem to make much real distinction between them—seems to inspire in Leonardo curiosity mingled with disgust. Borges has written: "Copulation and mirrors are both equally abominable, since they increase the number of human beings." Leonardo wrote: "The act of coupling and the members engaged in it are so ugly that if it were not for the faces and adornments of the actors, and the impulses sustained, the human race would die out."[106] This eventuality would not, it seems, greatly distress him; many years later, when one of his half-brothers informed him of the birth of a son, Leonardo replied, with surprising brutality: "I learn from your letter that you have an heir, an event which I understand has given you great pleasure. To the extent that I had formerly judged you to be endowed with prudence, I am now convinced that I was as far from being a perspicacious observer as you from being prudent. For you are congratulating yourself on having engendered a vigilant enemy, all of whose energy will be directed toward achieving a freedom he will acquire only on your death."[107]

It is hard to know to what degree Leonardo may have been speaking from experience or basing his conclusion on observation. Did he detest Ser Piero to this extent? How far did the overpowering personality of a man who in 1476 had already abandoned one mistress and buried two wives determine or stimulate Leonardo's own sexual tendencies?

"Avoid lustfulness," Leonardo repeats,[108] and not only in the sense meant by Cennino Cennini, who said sexual pleasures made the painter's hand as unsteady "as a leaf in the wind."[109] Leonardo says: "He who does not restrain his lustful appetites places himself

on the same level as the beasts."[110] On this somewhat flimsy basis, there are those who maintain that Leonardo had no more sexual experience with men than with women; that his undeniable taste for pretty youths was of a purely aesthetic nature, translated into platonic affection; that he led a monastic existence—in short, that he died a virgin. Freud writes: "He appears to us as a man whose sexual drives and activity were extraordinarily low, as if some higher aspiration lifted him above ordinary animal necessity." Going even further, others have alleged as an explanation that the beautiful and delicate Leonardo displayed all the classic symptoms of impotence.

Arguments advanced in favor of this claim do not lack weight or ingenuity. But they do not stand up to detailed examination; there are too many counterindications. Leonardo did, it is true, appreciate thoroughbred horses, which were the quattrocento equivalent of fast sports cars, and he wore jewels and a sword, which are also aggressive symbols of power. But these could be symptoms of a social rather than a sexual malaise. Some have maintained that Leonardo was prudish on the subject, that he avoided writing about erotic matters and eschewed sexual jokes. But as a collector of witticisms, he noted several frankly pornographic jokes, such as one about "a woman crossing a treacherous and muddy place, who lifts up her dress both before and behind; therefore, as she touches both anus and vagina, she tells the truth three times when she says 'This is a difficult passage.' "[111] Elsewhere, there is a story hardly possible to misinterpret, where a man compares the vigor of his lance to the difficult target proposed to him by a woman. Or one in which a prostitute deceives a priest by offering him the back end of a goat.[112] What is more, in the execution of his anatomical studies, Leonardo shows no reticence in his perfectly natural, objective studies of the male organ—whether erect ("long, thick, and heavy") or in repose ("short, narrow, and soft").[113] The same is true of the testicles, which he describes as "witnesses to coition," and of his diagrams of the formation and transfer of sperm. This is not the attitude of a man incapable of enjoying the pleasures of the flesh.

Inspired by Galen, he also wrote a sort of apologia for the penis: "It has dealings with human intelligence and sometimes displays an intelligence of its own; where a man may desire it to be stimulated, it remains obstinate and follows its own course; and sometimes it

moves on its own without permission or any thought by its owner. Whether one is awake or asleep, it does what it pleases; often the man is asleep and it is awake; often the man is awake and it is asleep; or the man would like it to be in action but it refuses; often it desires action and the man forbids it. That is why it seems that this creature often has a life and an intelligence separate from that of the man, and it seems that man is wrong to be ashamed of giving it a name or showing it; that which he seeks to cover and hide he ought to expose solemnly like a priest at mass."[114]

In fact, Leonardo considered the pleasures of the flesh dangerous only if abused: then they were responsible not only for the absurd multiplication of human beings[115] but also for various "diseases" in both the figurative and the physical senses—sicknesses of the mind as well as venereal complaints. Syphilis, or "the French disease," as it was called, reached Italy in about 1495, and these words were written in about 1500. Leonardo believed that sensuality harmed true love, that it slowed down intellectual activity, and that disappointments and sorrows were its inevitable product—but this was an opinion widely held at the time. "I love in spite of myself, under duress, in sadness and tears," Petrarch had written in the previous century, adding that love is a "hell of which fools make their heaven," a "poison with a sweet taste," a "torment that attracts," a "death having the appearance of life."[116] Cardinal Bembo, the eminent Latinist, noted in his *Gli Azolani,* composed in about 1497, that the verb *amare* (to love) and the adjective *amare* (bitter) were identical in Italian, "surely so that men may learn from its name what love is like."

Leonardo sums up this point of view in an allegorical drawing representing two men springing from a common trunk.[117] One is old and seems to hold a branch of oak, accompanied by flames; the other, young and handsome, holds a reed and some gold coins, which he is carelessly letting fall. They represent Pain and Pleasure. Leonardo himself provides a commentary:

Pleasure and Pain are shown as if they were twins, joined together, for one never comes without the other; and they are turning their backs on each other because they are opposed to each other.

Allegorical Composition.

COLLECTION OF CHRIST CHURCH COLLEGE, OXFORD.

If you choose Pleasure, know that behind him is someone who will bring you nothing but tribulation and repentance.

Such are Pleasure and Pain. . . . They are represented back to back, as if opposed to each other, but springing from a common trunk because they have one and the same foundation, for fatigue and pain are the foundation of pleasure, and vain and lascivious pleasures the foundation of pain.

[Pleasure] is thus shown here holding in his right hand a reed, a weak and futile thing, which inflicts poisoned wounds. In Tuscany, reeds are put in the beds as a base, to indicate that this is where one has vain dreams and that a great deal of one's life is consumed there. Useful time is wasted there in the morning, when, since the mind is fresh and alert, the body is ready to undertake a new task. It is there, too, that many an illusory pleasure is tasted, whether in the mind, by pursuing fantasies, or in the body, given up to pleasures that sometimes shorten one's life. So the reed is held to be a symbol of these foundations.

I must break off here with two parentheses: first, the idea that pain and pleasure being linked like Siamese twins is already to be found in Plato.[118] More prosaically, Leonardo seems to have found it hard to get out of bed in the morning. He was used to lying awake, daydreaming—and perhaps wanted to cure himself of the habit: "Lying on a feather mattress or quilt will not bring you renown,"[119] he writes under another drawing. We do not know whether he was given to "solitary pleasures."

When he condemned the ugliness of the "act of coupling," he was no doubt thinking of heterosexual relations—for which he may indeed have felt revulsion. But he was not unaware of the attractions and benefits of sexual contact and did not underestimate the pleasure people derived from it. He wondered (and one remembers again the trauma of his birth): "For what motive do beasts who sow their seed sow it with pleasure, and why does she who awaits it receive it with pleasure and bring forth young in pain?"[120] He also writes these words, which must have signified more to him than a mere echo of Neoplatonist theory: "If the lover is attuned to the object with whom he would be united, the result is delight, pleasure, and satisfaction. When the lover is united with the one he loves, he finds peace; relieved of his burden, he finds rest."[121] What he deplored above all were liaisons with mediocre people—the mercenary relations into which he may sometimes have lapsed. "If the object of love is worthless, the lover cheapens himself," he writes.[122]

The fact that Leonardo warns against lustfulness certainly need not mean that he himself was chaste. He preaches not abstinence but moderation. Could his fear of debauchery indicate that he had personally suffered on that account, that he had indeed indulged and was still indulging in unwise liaisons or practices? One only tries to control appetites that are out of hand.

And we should not lose sight of the lawsuit and the terms of the charge.

Just as he placed back-to-back pleasure and pain, or fear and desire, Leonardo made a connection between envy (in the sense of jealousy, *invidia*) and virtue: "The moment that virtue is born, it gives birth to the envy it provokes; and a body may more readily be separated from its shadow than virtue from envy."[123]

This is how he represents Envy: "She wears a mask over her fair face. Her eye is wounded by the palm and the olive branch, her ear by the laurel and myrtle, for triumph and truth offend her. Lightning flashes from her to symbolize the wickedness of her language. She is gaunt and wrinkled, for perpetual desire consumes her; a fiery serpent gnaws at her heart. She carries a quiver with tongues for arrows, for she often wounds with the tongue. . . . She carries in her hands a vase of flowers in which lie concealed scorpions, toads, and other venomous beasts. She rides astride death, over which she triumphs, for she is immortal. . . . She is laden with diverse weapons, and all are weapons of destruction."[124]

Above all other things, Leonardo feared jealousy and the malicious gossip it gave rise to, the bad reputation that scandal could create. He complains of it in near-paranoid fashion. He believes he has never done any wrong; yet he is pursued, attacked, persecuted. Falsehood, scandal, ingratitude, lies, hatred, insults, ill repute—all these words recur insistently in his writings. And it seems that all the rumors, the malicious or malevolent talk that provoked such a bitter reaction from him, referred back to the Saltarelli affair, or perhaps to some similar mishap.

The acquittal did not mean very much and certainly did not erase the smear. As Fred Bérence rightly remarks, what was so alarming was not the probable outcome of the case but that Leonardo could be implicated in it in the first place.[125] "The greater the sensibility, the greater the suffering," as he said. One has to imagine the sudden arrest, the feelings of shame it provoked, the humiliating interrogation, the brutal questions of the night watch. Then there was the cruel anxiety of a two-month wait between the hearings, days filled with remorse and fear that this might be an irremediable disaster.

"You put me in prison," Leonardo wrote years later.[126] But it does not appear that he was ever imprisoned: if he did see the inside of a cell, it was most likely when he was held for questioning in the early stages of the case. But that fear "which appears before everything,"[127] probably suggested the worst to him: a few hours in custody, and he was imagining the rest of his life in a dungeon. Just as he feared injustice, he feared for his liberty and was ready to do anything to defend it. In about 1480, perhaps at the time he considered leaving for Milan (and finally escaping from Florence),

he drew plans for a contraption to pull the bars off a window[128] and another "to open a prison from the inside"[129]—indeed, these were practically his first inventions.[130]

Leonardo was not really in much danger from the law. Homosexuality was so widespread in Florence at the time that the legal penalties were never enforced. In spite of the threat of divine punishment imagined by Dante in cantos XV and XVI of the *Inferno,* in spite of repeated fulminations from preachers like Bernardino of Siena, and in spite of an attempt in 1403 to reduce homosexuality by encouraging the opening of brothels, the practice had become so common throughout Tuscany that in Germany the word *Florenzer* was applied to homosexuals. Unable to eradicate it, the authorities were resigned to turning a blind eye to it. Although the humanist Giulio Pomponio Leto, founder of a Platonic Academy, was imprisoned in Rome for having praised too highly the physical charms of a Venetian youth, there are few examples in Florence in the 1470s of great severity toward homosexuals. The poet Angelo Poliziano and the banker Filippo Strozzi, another relative of the Medici, were not discreet about their preferences, and Ariosto openly advised the would-be writer to have a love affair with someone of his own sex once in his life. Mary McCarthy, in her book *The Stones of Florence,* wonders whether Verrocchio himself was not homosexual, but there is no evidence for this. The fact that Andrea was a bachelor proves nothing: many artists remained unmarried.[131] Early in the next century, homosexuals do not seem to have been any more inclined to concealment. The painter Giovanni Antonio Bazzi, who was working alongside Leonardo in about 1500, openly acknowledged his nickname, Il Sodoma. Later still, Aretino, who did not disdain the opposite sex, nevertheless dared ask the duke of Mantua among other things for a pretty boy in return for services rendered.

The painter-writer Lomazzo did not hesitate to attribute to Leonardo (whom he admired above all others) a long apology for homosexuality. In about 1560, he imagined a dialogue in the artists' paradise between Leonardo and Phidias, the most renowned sculptor of antiquity. The conversation is entirely invented and trivial, but the sense is crystal clear: Phidias asks Leonardo, apropos one of his favorite pupils, if he ever played with him "that backside game that

Florentines love so much." "Many times!" Leonardo replies. "You should know that he was a very fair young man, especially around the age of fifteen." "And you are not ashamed to say so?" "No, why should I be ashamed? Among men of worth, there is scarcely greater cause for pride."

There follows a long tirade of several pages, in which the painter justifies himself by quoting illustrious examples and employing arguments extremely derogatory toward women. "What is more," he concludes, "all of Tuscany has attached much worth to this ornament, and in particular the learned men of my homeland, Florence, where thanks to such practices, and by fleeing the useless chatter of women, so many exceptional minds have been produced in the realm of the arts."[132]

To be recognized as homosexual, as can be seen from this text written forty years after Leonardo's death, was no more dishonorable during the Renaissance than it is today—at least in intellectual circles. Indeed (since women were much more closely supervised and therefore less accessible), it is possible that homosexuality was more socially acceptable and perhaps easier to come to terms with.

So it was not the accusation of sodomy that would have distressed Leonardo so much as the scandal it aroused—all the more sensational since a relative of the Medici was involved. The authorities were prepared to turn a blind eye to various sexual misdemeanors—homosexuality, incest, bigamy: fairly common forms of behavior, after all—on the condition that public order was not disturbed and that a minimum of discretion was observed. No doubt such affairs embarrassed the authorities as much as the parties involved and their families.

The greatest source of shame for Leonardo, I therefore believe, was to have attracted public attention in unfortunate circumstances, to become the subject of the gossip this pitiful incident occasioned—in marketplaces, church porches, on all the *piazze* of Florence. The city adored such scandals. And Leonardo was probably most concerned about those around him: Verrocchio, under whose roof he was living; his mild uncle Francesco; his highly respectable father; and, of course, his mother.

We do not know how Ser Piero reacted to the news, or whether he made any attempt to intervene, as his position might have

allowed him to. One imagines he was not overjoyed to see the name that he had worked hard to make for himself in Florence dragged through the mud. I would guess that there was some violent and unpleasant scene between father and son.

Leonardo says nothing about this, but he may be alluding to it (unconsciously) in several passages in a kind of bestiary composed in about 1493, in Lombardy, in the little notebook known as manuscript H. They call for little comment.

Envy: It is said of the kite that when it sees its nestlings grow too fat, it pecks their sides out of envy and leaves them without food.[133]

Sorrow: Sorrow can be compared to the crow, which, seeing that its chicks are white, abandons them in distress and only resolves to feed them when a few black feathers appear.[134]

The eagle: The eagle, when it is old, flies so high that it burns its feathers, then by the grace of nature plunges into shallow water and recovers its youth. If its young cannot similarly bear the sight of the sun, it deprives them of food.[135]

Perhaps these examples merely reflect Ser Piero's general attitude toward his son or—much the same thing—Leonardo's perception of his father's feelings. Take what he says of the partridge: "It is transformed from a female into a male and forgets its first sex. Being envious, it steals the eggs of other birds and sits on them, but the young always return to their true mother."[136] Perhaps Leonardo found sympathy and understanding, during these dark times, with Caterina, in the house of his stepfather. Writing of the lion and the lioness, he declares that the male, a terrifying creature, fears nothing so much as the "sound of empty wagons and the crowing of cocks" (symbols of gossip).[137] "The sight of them troubles him greatly, he looks at their crests with terror, falling prey to strange distress, even if his face is covered"; whereas the female is ready for any sacrifice to defend her cubs and prevent their being captured.[138]

Finally, there is this remark: "the goldfinch brings spurge [a poisonous plant] to its young when they are imprisoned in a cage. It is better to die than to lose one's freedom."[139]

And this passage might refer to himself: "Peace: It is said of the beaver that when it is pursued, knowing that it is being hunted for the medicinal properties of its testicles, if it cannot escape, it stops and in order to be left in peace by its assailants bites off its testicles with its sharp teeth and abandons them to the enemy."[140]

It is my impression that Leonardo—just as he was beginning to be successful in his profession and could boast of friends in Florentine high society (like Tornabuoni, who was related to the Medici)—saw himself being rejected once more by his father. At the same time, he felt terribly guilty of having failed in Ser Piero's eyes—hence his distress, his anguish, quite disproportionate to the crime that had prompted it, and his desire to punish himself, to repent and mend his ways.

Did he succeed? Under the heading "Vices that are hard to eradicate," he writes (without saying precisely to what he is referring): "I know that I shall make myself enemies now, for no one will believe what I may say about him. In fact, one's vices only offend a few people: those who feel an instinctive repugnance. Many men hate their father and lose their friends when the latter upbraid them for their faults; contrary examples have no effect on them, nor does any human advice."[141]

Like many of his remarks, this could be read several ways. Once more, Leonardo is not baring his soul but simply jotting down observations as they come to him, in no apparent logical order. I do not claim that mine is the only correct interpretation: I have simply reached it by arbitrarily relating isolated sentences from his notebooks to the few concrete details we have of his life. The method is debatable; but Leonardo practices it himself, when he plays the game of analogy or free association—using a mode of thought typical of what Lévi-Strauss would call the "savage" mind.

It is an empirical and primitive method, but it does produce results. If we are prepared to accept the principle, we can construct the following schema: Ser Piero has no compassion for his son. Like the eagle, the crow, or the kite of manuscript H, he "deprives [him] of food"—closing his door and his purse to him. Of all the punishments suffered by Leonardo, this is the worst. Whereas he longed to shine in his father's eyes, instead he has failed. He remained long obsessed by the image of the old male (his father was by now about

fifty)—powerful, unbending, hostile to the child that did not resemble him. At the same time, Leonardo blamed his misfortune not only on the "lustful" behavior into which he had lapsed but also on gossip born of envy. (In the same manuscript H occurs the remark: "nothing is more to be feared than a bad reputation. This bad reputation is the result of vice.") Being unable to change his nature and give up his "vices" but at the same time despising them, he would from now on approve not only of fear, which "protects from danger,"[142] but also of duplicity and concealment. By so doing, he would be exposed to less misfortune. "He who does not always travel in fear," he writes, "suffers many insults and often repents"; and again: "He who journeys in fear of dangers will not be their victim."[143]

Leonardo was left-handed. He could in fact write with both hands and in either direction, but as is commonly the case in left-handed people, it was easier for him to do mirror writing, from right to left—his shading is always from right to left, unlike that of right-handed artists. He had learned to write like this not out of fear of some improbable Inquisition, as some have claimed, or to conceal his scientific discoveries from an indiscreet or envious gaze: his extraordinary handwriting came naturally. But it did suit very well his taste for secrecy. That taste, while it may not have shaped his handwriting, did by contrast influence his style: his deliberately elliptical sentences, allegorical and enigmatic, often remind one of riddles.

Emotions were essential to Leonardo; they were the driving force of everything, in everyday life as well as in art. There was nothing more precious; but there was nothing more frightening—if other people knew about them. From now on, he would conduct his life secretly, "with only the darkness of the night for witness." He wrote the following singular sentence: "If freedom is dear to you, do not reveal that my face is the prison house of love."[144] Later still, he would decide to hide his beauty under a long beard, as others might a harelip or a scar.

V

Dispero

If you are alone, you will be your own man.

—LEONARDO[1]

Sketch for a Masquerade Costume.
ROYAL LIBRARY, WINDSOR.

Lorenzo de' Medici was twenty years old when he agreed—without enthusiasm, he claimed—to take over the government of Florence. The task seemed an overwhelming responsibility for so young a man, and full of risk. He would have preferred to spend his time on poetry, parties, and hunting, far from the din of the city, on his fine estates in Carreggi, Mugello, or Poggio a Caiano. But he was obliged to accept, he said, in order to ensure the protection of his friends and of his fortune, "because in Florence, when one is rich, it is not easy to survive unless one controls the state."[2]

The temptation of *dolce far niente*—in other words, a peaceful country life—was a powerful one at the time. Almost any banker or merchant—but also any doctor, tanner, or joiner—would have a country retreat, appropriate to his means, where he could spend weekends or holidays and to which he dreamed of retiring. Leonardo, too, dreamed of this in moments of depression, as is suggested by the little fable he composed in Milan:

A stone of good size, washed bare by the rain, once stood in a high place, surrounded by flowers of many colors, at the edge of a grove overlooking a rock-strewn road. After looking for so long at the stones on the path, it was overcome with desire to let itself fall down among them. "What am I doing here among plants?" it asked itself. "I ought to be down there, with my own

kind." So it rolled to the bottom of the slope and joined the others. But the wheels of carts, the hooves of horses, and the feet of passersby had before long reduced it to a state of perpetual distress. Everything seemed to roll over it or kick it. Sometimes, when it was soiled with mud or the dung of animals, it would look up a little—in vain—at the place it had left: that place of solitude and peaceful happiness. That is what happens to anyone who seeks to abandon the solitary and contemplative life to come and live in town, among people of infinite wickedness.[3]

Lorenzo de' Medici was no more able than Leonardo to escape to the soothing shade of a tree, though for different reasons. The citizens had no sooner entrusted Lorenzo with the government than he had to levy troops and call for an alliance with both Milan and Naples (that is, he had to win over two experienced tyrants) in order to thwart various threats of war.

The political situation in Italy—of which Leonardo says next to nothing, although his life was seriously affected by it—was at this time as confusing as it was unstable. Five great powers—Florence, Venice, Milan, Rome, and Naples—and such smaller principalities as Ferrara, Urbino, Genoa, Siena, and Mantua were constantly intriguing and uniting against each other in order to expand, enrich themselves, and protect their interests. Fifteenth-century Italy was like a miniature continent, in which "nations" the size of a province or even a county fought as fiercely as great empires.

And within each state, various factions were on permanent alert to challenge the established ruler. Young Lorenzo knew that he was being watched: one false move or sign of weakness could be fatal to his party.

His father died in December 1469. The following April, conspirators tried to capture the town of Prato, which was under Florence's protection, with the aim of rousing all Tuscany to arms. The attempt failed, and eighteen of the plotters were beheaded. Lorenzo, despite his inexperience, had the wisdom and courage to pardon the rest.

A few months later, when the Turks had almost conquered Greece, Lorenzo had to stand up to the Pope, who was anxious to launch a crusade. (In Florence's view, trade came before religion.)

At the same time, he consolidated his control of the government, restructured the family holdings, banks, and trading houses, and attempted to reorganize the Medici branches in Lyon, Avignon, Venice, and Naples.

His hard line in these and other affairs established his authority and inspired respect. He regaled Florence with amusements in the manner of a Roman emperor—an expensive policy, with the economy in rather poor health, but this, too, contributed to a lull in the series of plots against him.

In foreign affairs, alliances were made and unmade: with Venice; against Naples; against Siena; and against Rome, which thereupon confiscated from the Medici both the administration of the papal finances and their monopoly of alum, ceding them instead to another family of Florentine bankers, the Pazzi.

Inevitably there were reprisals: Lorenzo accused one of the Pazzi of treason and thwarted another over a legacy. With the support of the Pope (and of Siena), the Pazzi clan planned revenge. The idea matured, and ambitions grew to match—why not simply seize power?

On Sunday, 26 April 1478, Lorenzo and his brother Giuliano were attending high mass in the cathedral church of Santa Maria del Fiore. The bell sounded for the end of the service. It was the signal for attack. Swords flashed from under cloaks as the conspirators sprang forward, hurling themselves on Giuliano's body and stabbing him in the heart. Lorenzo, although wounded in the throat, managed to defend himself and took refuge in the sacristy, behind the double bronze door; from there, aided by his friends, he made his way to his palace on the Via Larga.

The news quickly ran through the city, but slogans of liberation roused little echo. Above the clangor of the church bells was heard the Medici rallying cry: *Palle!*[4] Far from rebelling against their ruler, the townspeople unanimously took his side, acclaimed him, and pursued the conspirators, who included a number of priests. They were hunted down to their houses, and before long corpses were dangling outside the law courts and paraded on the ends of pikes, hideously mutilated. The crackdown continued in the following weeks, with the judges passing a hundred or so death sentences. The Pazzi name was banned by decree; the family's coat of arms was

removed from all public and private buildings. Finally, as was sometimes done in cases of high treason against the state, a painter was commissioned to depict on the facade of the Bargello prison (just around the corner from Ser Piero's house) the execution of the guilty men, so as to punish them in effigy and frighten any remaining supporters.

If, as I believe, Leonardo was hoping to receive this commission, he was disappointed—it went to his friend Botticelli, who was then more fashionable. Leonardo may also have been passed over because of his association with Verrocchio. The latter had been asked to make ex-votos in wax (to thank Heaven for sparing Lorenzo),[5] and it may have been thought wise to distribute the work equitably among different workshops.

We do not know how the charming Botticelli (fresh from completing his allegorical painting *Primavera*) depicted the victims. His fresco, for which he received forty gold florins, was destroyed in 1494, when the Medici were overthrown.[6]

A drawing, preserved in the Musée Bonnat in Bayonne, enables us to see how Leonardo might have treated the subject. It is an uncompromising pen-and-ink sketch, dating from the end of 1479,[7] depicting one of the conspirators, Bernardo di Bandini Baroncelli. He had succeeded in escaping after striking the fatal blow at Giuliano and wounding one of Lorenzo's companions. At first he hid inside the cathedral, then he galloped away over the frontier, to take ship for Turkey. But he was mistaken in thinking himself safe inside the walls of ancient Constantinople. Lorenzo wanted him dead or alive. The Medici had "special" (that is, financial) contacts with the Sublime Porte. Arrested and extradited, the assassin was hanged in Florence in December 1479. Leonardo was certainly present at the execution and drew exactly what he saw, taking care to note the details of the costume in case he was asked to do a painting: "Small brown cap," he writes in the margin, "black serge jerkin, lined woolen singlet; blue cloak lined with fox fur, collar trimmed with red and black velvet bands; Bernardo di Bandino [*sic*] Baroncelli; black hose."

At the foot of the page, he did another sketch of the head, to rectify the angle of the jaw against the neck. There is no evidence

Hanging Body of
Bernardo di Bandino Baroncelli.

MUSÉE BONNAT, BAYONNE.

that Leonardo did more than a preliminary study of this subject.

As for Lorenzo, he was now openly at war with Pope Sixtus IV, whose nephew he had imprisoned. He resolved this situation by an act of great audacity. Putting himself in the lion's den, when all

seemed lost, he won over to his cause King Ferrante of Naples, depriving the Pope of his strongest ally. Following his return to Florence, he would ever after be known as Lorenzo the Magnificent.

In the latter half of the 1470s, as if to help himself recover from the sodomy charges, Leonardo seems to have settled seriously to his art.

What had he painted before the Saltarelli affair? Apart from the angel in the *Baptism of Christ,* the only possibility is the large *Annunciation* in Florence, which may date from 1474 or 1475. No doubt this was another studio production, which explains disparities in execution. Before it was acquired by the Uffizi in 1867, the picture was in the convent of Monte Oliveto and was attributed to Ghirlandaio. Some critics have, more convincingly, seen signs of Verrocchio's hand. Ruskin alone declared it an early Leonardo, "one of the most authentic, and of great interest; the scholars who have questioned this are—well, never mind what they are." A pen-and-ink study of the sleeve of the angel Gabriel,[8] which was published only in 1907, confirmed this confident judgment, which most art historians have since come to accept.

If one compares this *Annunciation* with the angel in the *Baptism,* or with other paintings from Verrocchio's workshop, one realizes what progress Leonardo had made. His master's influence, above all his sense of molding, is still there, for example in the slightly mannered pose of the Virgin's long fingers and in the ornamented chest in the center of the picture, which faithfully reproduces the porphyry sarcophagus of the Medici tomb. There is some clumsiness of execution, especially in the perspective (the lectern is in a different plane from the hand resting on it). But the painting as a whole, despite its poor state of preservation, radiates a sweetness, unity, depth, light, and general atmosphere, that are quite original, unknown at the time, and that already point to the masterpieces of Leonardo's maturity. All his scientific observation is displayed in the flower bed in the foreground, with its many botanical specimens, as well as in the wings of the celestial messenger. As a rule, angels' wings in paintings are gaudy and awkwardly attached: they look like theatrical accessories, decorative but cumbersome. Leonardo, wishing to make his wings as realistic as possible, clearly used real

birds' wings as inspiration. He has them grow from the shoulder blades (an indication he already had some notion of human and animal anatomy), so that they naturally prolong the line of the arm. Soberly colored, discreet, and logical, exactly proportioned to the rest of the body, they look as though they could really fly. Their scrupulous realism (and it was quite new: one only has to think of the very unaerial wings of Fra Angelico, Lippi, or even Piero della Francesca) must have been seen as iconoclastic. A later hand lengthened them to canonical dimensions: it is an unhappy alteration, cutting across two trees in the background and rendering the wings less natural by making them half as big again.[9]

What came next?

In 1477, only a few months after the the final dismissal of the Saltarelli case, Master Andrea took some of his team to Pistoia, a hill town about forty kilometers from Florence. He was supposed to be making a marble monument in memory of Cardinal Niccolò Forteguerri. The local authorities apparently took advantage of his presence to commission a large altar painting, a *Virgin and Child*. Leonardo was included in the party, as we know from a note made in 1478.[10] No doubt he was glad to escape the capital for a while. We do not know how long he stayed in Pistoia, but it cannot have been long. He seems to have contributed little to the studio's work there. I am inclined to see this as a sign of his increasing emancipation: a hint that he was neglecting his subordinate role as collaborator and seeking to work at last on his own. Lorenzo di Credi, whom he had helped to train, was now sufficiently competent and experienced to take his place as chief assistant to the master. One recognizes Lorenzo's careful but uninspired brush strokes in the Pistoia *Madonna;* at no point does this painting display the fluid touch of Leonardo, who seems to have provided the *bottega* with a few drawings and little else. A terra-cotta model for the Forteguerri memorial (now in the Louvre) may be by him: it shows a fairly conventional angel greeting either Christ or the Virgin.[11] This may have been the very last item he produced in Verrocchio's service.

At the age of twenty-five (and it must have been especially true in those days), one's hopes begin to seem burdensome, reality has tarnished a few illusions, and it becomes unbearable to remain simply a "promising talent." I imagine that this was a turning point

in Leonardo's life. He had not yet accomplished anything that was entirely his own, he had little to show for himself, and his only claim to fame was to have been cited in a notorious criminal case. At his age, Masaccio had accomplished most of his life's work. Leonardo, starting to feel himself a failure, was discovering how quickly time flies. "Nothing," he wrote, "flows faster than the years, daughters of time."[12]

With Lorenzo di Credi ready to replace him in the studio, he could start to detach himself without guilt; indeed, everything encouraged him to do so.

It was a gradual process. He stayed a while longer with Verrocchio, whose paternal benevolence seems not to have been affected by the trial. (After all, he himself had been tried for murder; so heavy did the fateful stone thrown in his youth weigh on his conscience that when he sculpted David, he could not bear to put a sling in the hands of this other stone thrower and instead depicted him with a cutlass.) When Leonardo announced that he wanted to set up on his own, Verrocchio understood and surely gave his blessing, if not more concrete assistance.

There have been more brilliant debuts.

The first personal commission came from the government. On 1 January 1478, Master Leonardo da Vinci was requested in writing to paint a picture for the altar of Saint Bernard's chapel in the Signoria. On 16 March, he received a respectable advance of twenty-five florins. For some reason, he never fulfilled the contract, but he was not the first to fail. The work had originally been ordered from Piero Pollaiuolo, without result; Ghirlandaio inherited it and similarly gave up; eventually it fell to Filippino Lippi, who completed it—seven years later—from a cartoon by Leonardo, if we are to believe the Anonimo Gaddiano.[13]

It was in July that Botticelli won the contract for painting the execution of the Pazzi. But in the last months of that year—a tragic one, since it witnessed not only political problems but also floods and an epidemic of plague—Leonardo must have found work, since he notes on the corner of a page: "I have begun the two Virgin Marys."[14]

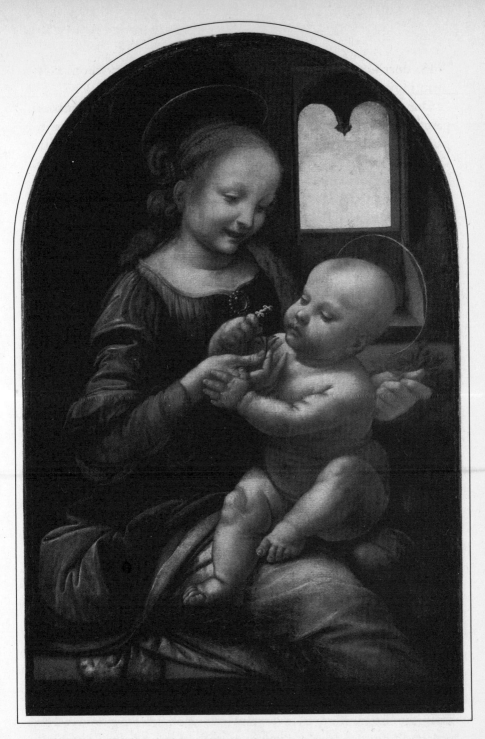

Benois Madonna.

HERMITAGE, LENINGRAD.

———

145

He does not say what paintings these were, nor for whom they were intended.

One seems to have been the *Benois Madonna*. An old master painting normally has a history and references; one can follow its path down the centuries, since it is mentioned in inventories, wills, and books on art or travel. But not this one. It turns up out of the blue, where one would least expect it: In the early nineteenth century, at Astrakhan, in Tartary, a traveling Italian musician produced it by some miracle from his bags and sold it, without explanation of its provenance or any of the usual sales patter, to a certain Sapojnikov. It was this man's granddaughter, by then the widow of the Russian painter Léon Benois (hence the name), who bequeathed it in 1914 to the Hermitage in Saint Petersburg, where it now hangs.[15]

The painting must have suffered a good deal in its travels to the mouth of the Volga. Being transferred to canvas (Leonardo painted on wooden panels) did not help it. Badly restored and further damaged over the years, as well as overpainted by sacrilegious hands, the *Benois Madonna* is only a shadow of its original self. Berenson unkindly speaks of a "woman with a bald forehead and puffed cheek, a toothless smile, blear eyes, and furrowed throat."[16] In fact, the Virgin's teeth are still there under the discolored varnish, and the quality of the skin is the result of overpainting in a manner quite foreign to Leonardo.

Whatever efforts are made now, the painting will never be restored to its original state and will remain a disappointment. But its historical importance is undeniable, and it is from this perspective that one should approach it. Most previous paintings of the Virgin make her a hieratic figure, truly sublime but by the same token rather stiff and unbending, like those early photographic sitters who had to "hold the pose." Filippo Lippi tried to render her more human, to paint her as a woman rather than as an article of faith, to bring her down from the pedestal and present her in a more familiar pose. The artists of the late quattrocento tend the same way—but none goes quite so far as the *Benois Madonna*. Leonardo decided to symbolize the divine mystery by simple maternal love, as if the latter were an everyday reflection of the former. He depicted a domestic scene: a young woman of quite ordinary beauty, playing with a baby. The baby is fascinated by a flower and reaches

out for it. The mother, amused by his clumsy attempt and his solemn and important expression, is not displaying her son for the admiration of the crowd. Neither mother nor child is looking at the spectator; the scene is enacted between the two of them and the flower. One does not even sense the presence of the artist. The *Benois Madonna* marks the discovery of the principle that a literal illustration is not as effective as a metaphor; in Carlo Pedretti's term, a "fiction." Leonardo strips the Virgin of her gold ornaments, removes for good the marble throne, the columns, the angel musicians, all the signs of majesty, goodness, and purity with which she was habitually surrounded. And he replaces them with the simple representation of feeling. The bond between mother and child no doubt had a special place in his heart, but he was not looking for a pretext. This was still a religious painting, though transposed into another mode to make the spectator think, or rather feel. Leonardo was composing a visual parable. Instead of painting a crown, he showed why the Virgin deserved a crown. To represent and provoke emotion was later his principal aim. Soon he would attempt to translate the entire confusing mystery of life through mere gesture of the hand or an enigmatic smile.

I do not know whether the fifteenth-century public appreciated this painting at its true worth. I imagine the *Benois Madonna* was too far ahead of its time to be really popular. But we can judge the reaction of Leonardo's fellow artists by the large number of imitations it provoked: from Lorenzo di Credi to Raphael, a whole generation of painters would take up this new image of the Madonna.[17]

"Two Virgin Marys," he says in his notes.

It is more difficult to identify the second. It might be the *Madonna with a Cat,* now lost, which is known only through sketches and preliminary studies[18] (it is along the same lines as the *Benois Madonna,* with a cat replacing the flower). There are those who think it is the *Madonna with a Flower* in the Pinakothek of Munich.[19] I do not believe that the latter work, which is in even worse condition than the Hermitage painting, is completely attributable to Leonardo. The general conception of the picture, the blue mountains, the transparent vase, and the intricate hairstyle of the Virgin do, it is true, irresistibly suggest Leonardo. But the fat baby with a vacant

expression, perched uncomfortably on a cushion, does not look at all like his work. And what of the stiff attitude of the figures, the infinite complications of the drapery? The painting could as readily be by Verrocchio or Lorenzo di Credi. It was probably one more of the workshop's joint productions.

There is little documentary evidence, but it seems that by 1479 (the year when Ser Piero's second legitimate child was born), Leonardo was living *in casa sua propria*—in his own lodgings. Among the works that gained him his independence was the cartoon for a tapestry destined for the king of Portugal: *Adam and Eve in Paradise,* at the moment of the Fall. Vasari describes it in part: "Leonardo drew with a brush, in chiaroscuro, highlighted with white lead, a meadow with various plants and animals. Truly no other genius could have rendered these more carefully and naturally: one sees a fig tree with its foreshortened leaves and the detail of the branches treated so lovingly that the mind stands amazed at such meticulousness. And there is a palm tree, whose crown of fronds is rendered with that marvelous artistry of which only Leonardo's talent and patience were capable."

For some reason, the tapestry, which was supposed to be woven in Flanders in silks and thread of gold, was not executed. The cartoon never left Florence. The Anonimo Gaddiano devotes one line to it, and Vasari thought that in the mid-sixteenth century it was in the house of Ottaviano de' Medici, a distant relative of Lorenzo. We know no more about it, for like so many of Leonardo's works, it later disappeared.

It is from about the same period that one can date the *Portrait of Ginevra de' Benci.* (This was sold in 1967 to the National Gallery of Washington, for a record sum of over a million dollars, by the Liechtenstein Collection in Vienna. It is the only picture by Leonardo now in the United States.)[20]

The bad luck that seems to have attended da Vinci's paintings did not overlook this one. At some time, the portrait lost a strip of about twenty centimeters from the lower half, hence its odd proportions. On the back of the panel is drawn a branch of juniper surrounded by a garland of palm and laurel, with the inscription *Virtutem forma decorat* (Beauty adorns virtue). The bottom of the garland is missing: completing it would bring the picture back to the classic

dimensions of 3 by 4. So the missing section of the portrait ought to contain the model's hands. Fortunately, the preparatory study for them (in silverpoint on pink paper) has survived in the Windsor collection.[21]

Originally, the fingers of the right hand were playing with the lacing of the bodice (the bottom of the garment has been over-painted); and they may have been holding a flower. Thus reconstituted, the painting—which already suggests the *Mona Lisa*—would be introducing a revolutionary formula. I do not know of any previous example of a portrait with hands. (Traditionally, portraits were of the bust only, and in the case of women, a bust in profile.) The new formula had in fact been worked out by Verrocchio in his marble *Lady with a Bunch of Violets* in the Bargello Museum. But Leonardo was the first to apply it in a painting: it was ideally suited to his desire for expressiveness (and was quickly adopted by others: notably Botticelli in his *Young Man with a Medallion,* in the Uffizi).[22]

This is once more a "fiction," not simply a flat representation of appearances. "Give your figures an attitude that reveals the thoughts your characters have in their minds," Leonardo wrote. "Otherwise your work will not deserve praise."[23]

Ginevra, whose name is symbolized by the dark juniper bush (*ginepro* in Italian) against which she is pictured, was the daughter of the rich banker Amerigo de' Benci and had married in 1474 a certain Luigi di Bernardo Niccolini. A writer of poetry, she is herself celebrated in many verses, notably two sonnets by Lorenzo de' Medici, as much for her beauty as for not yielding to the courtship of a Venetian ambassador. No doubt this was what Leonardo wanted to indicate by the language of the hands. But he put something else into this portrait, which goes beyond the anecdotal.

The spiky leaves of the emblematic juniper, the twilight sky, the alternation of dark and light, the disturbing flicker on the waters of a lake or river, the blue distance—the whole landscape seems in every detail to be a part of the portrait, bringing nuances and complexities to it, enriching the subject's expression. The young woman is not simply viewed with her back to a neutral background of trees and mountains: she secretes and develops around her her own atmosphere, full of unspoken meanings, like a spider spinning

her web. And this projection of her mood hints, obscurely, at what the closed lips, the melancholy gaze, and the lofty marble brow cannot say. Figure and landscape—and this is another major innovation—are so intimately linked that they merge into each other through the play of shadow. Until this time, no doubt because of the demands of fresco technique, painters composed distinct and continuous masses: elements of a picture were conceived separately, surrounded by a firm outline that made them stand out against a background. Leonardo is here experimenting with a sort of discontinuity of matter: the shape is broken up; here and there, the contours disappear; landscape and figure merge at their darkest points, melting into a single deep black. André Malraux, in *La Psychologie de l'art,* writes that Leonardo created "a kind of space that had never been seen in Europe before, one that not merely was a location for the figures but drew characters and spectators together, as time does, plunging into immensity." Leonardo was here beginning to approach the *sfumato* effect—a melting, a merging of shades, literally an "evaporating into smoke"—that would appear in the *Mona Lisa.* Eventually, he would be doing to light what in this portrait he did only to shade.

According to the Anonimo Gaddiano, "he painted the portrait from life of Ginevra d'Amerigo Benci, a work of such finish that it appeared not to be a portrait but Ginevra in person." But it was a representation at many levels: the juniper, as in a riddle, represented the chaste Ginevra; but the thick crown of leaves like spines, their pattern reflected in the water as it catches the last rays of the dying light, helps to evoke a mood in very romantic fashion. At the same time, while the portrait is that of an individual, it tends toward the portrait of an ideal, of Woman. Further, it conveys a likeness of its author, for above all it reveals Leonardo himself.

Many writers have reproached Leonardo for producing a cold, ungenerous art, overreflective and abstract, like an algebraic equation. It lacks "the tears and music of love," according to André Suarès.[24] Such critics find little of the man in the works—as if he painted them with his intellect alone. These seem to me very superficial judgments, by people who have made no effort to steep themselves in Leonardo's works or to decipher them; consequently they fail to see the emotion that lies behind every form. In Leo-

nardo's view, it is true, the intellect sublimated and transcended all feeling, like the philosopher's stone. Starting from the Platonic postulate that all human emotions are but shadows of one parent emotion, or, more simply, that at their peak of intensity all emotions (whether inspired by love, pain, religion, or the beauty of a stormy sky) unite and dissolve into a single emotion embracing them all, Leonardo was at this time seeking to set down *pure feeling*. It is possible to distinguish two kinds of artists or writers: those who say everything openly, bare their hearts and inflict on the spectator or reader a complete picture of their sorrows and desires; and others, more rarely encountered, who hang back, set up screens, suggest instead of describing, and make the spectator look for things. The first would, for example, say straightforwardly: I am afraid. The others would never use the word, but their work, the "fiction" they are creating, would provoke fear. These artists do not spare the public the effort; instead, they call on it to participate. They run the risk of not being understood (or rather that the spectator will never advance beyond a literal reading of the work). For on every subject they tackle—perhaps because they have taken the time to reflect— they cannot resist trying to express the indefinable that is within everything.

After the pale Ginevra de' Benci, musing pensively under a dramatic sky, Leonardo's next picture, in 1480 or 1481—no documentary evidence tells us exactly when—was of the tormented figure of Saint Jerome in the desert: another "disguised self-portrait," this time of a full-length emaciated nude, crouching before the mouth of a cave as if before a crucifix, watched over by a lion.

The history of this unfinished painting is no less mysterious and surprising than that of the *Benois Madonna*. We do not know its provenance or who commissioned it. Like the *Madonna*, it turned up quite by accident in the early nineteenth century. Cardinal Fesch, an uncle of Napoleon Bonaparte, was walking one day through the streets of Rome when he saw in the back of a secondhand shop a little cupboard, with what looked like an extraordinary door panel. On closer inspection, he recognized it as a Renaissance masterpiece. It was the head of Leonardo's *Saint Jerome,* extracted to fit the dimensions of the cupboard. Fesch bought it and set about finding the missing portion of the panel in the same part of the city. Months

Saint Jerome.
VATICAN MUSEUM, ROME.

later, he found it in the shop of a shoemaker, who had nailed it to his bench. Restored, the joins covered over with thick varnish, the picture was acquired by the Vatican in 1845, six years after the death of the sharp-eyed cardinal.[25]

Saint Jerome lived in Rome, in Gaul, and in the Chalcidian desert, in Syria, before retiring to Bethlehem. It is to him that we owe the critical edition of the Bible that he translated into Latin with a commentary. Legend (which on this point confuses him with Saint Gerasimo) tells that he won the friendship of a lion in the desert by pulling a thorn out of its foot. Painters usually represent him as a scholar in his cell (Carpaccio, Antonello da Messina) or as an anchorite (Cosimo Tura). Leonardo has chosen the second approach. He makes him an ageless figure, with sunken eyes, skele-

tally thin, beating his breast with a stone. The open mouth is imploring divine mercy; the prayer is accompanied by the roaring of the lion. In the *Benois Madonna,* the Virgin was looking at the Child, who was looking at a flower. Here we have the same movement in zigzag form: the beast is looking at the saint, who is looking at an invisible image of the Savior. Hence the impression that we are eavesdropping on an intimate scene.

Once more, Leonardo commits himself to great anatomical precision. Despite the picture's incompletion, all the tendons of the saint's neck, all the protruding ribs, are visible; and the lion is probably the first real lion in the history of painting. Leonardo almost certainly drew it from nature: the Medici, like many Italian princes, owned a menagerie (which even contained a giraffe, the gift of an Egyptian ambassador).

One could point, too, to the bold and elegant sweep of the lion's tail, corresponding to the saint's gesture of mortification; or to the dark outline of the rocks, blocking the background in a great cruciform mass. But the most important aspect of the picture seems to be the ardent and painful supplication on the lips of this man, who is chastising himself severely with blows from a stone. It would later be said of Caravaggio that he painted "the poetry of the cry." But such poetry finds infinitely more dramatic and more disturbing expression in this *Saint Jerome*—to my mind the most despairing work of the century.

Under the heading "How to represent despair," Leonardo wrote in his notebooks: "give the desperate man a knife, let him tear at his garments with his hands, and let him be tearing at his wound with one of them."[26] The attitude and mode of penitence in this picture are much more effective. The ascetic, the lion crouching and roaring, the desolate site, all cry out the pessimism, the disgust with life (and the flesh), of the artist himself. The unfinished state of the painting, the fact that it is in monochrome, far from diminishing its effect, give an extra intensity to this throbbing portrayal of anguish.

Leonardo, now aged about twenty-nine or thirty, must have been feeling more lonely, more unsure of himself, than ever. His distress shows up in the notebooks. Whenever he started a new pen, he was

in the habit, after trimming it, of scribbling something on the corner of a page, to try it out—usually disconnected phrases and almost always starting with the same words: *Di, di.* "Tell me . . ." "Tell me whether . . ." "Tell me how things are . . ." "Tell me if there was ever . . ."[27] As an assiduous reader of the *Divine Comedy,* he may perhaps have picked up this invocation from Dante, who often whispers to Virgil, "Tell me, master, tell me, lord," as they travel through the Inferno.[28] Later, in 1485, Leonardo seems to be asking after a certain Caterina, who might be his mother: "Tell me how things are back there, and can you tell me what la Caterina wishes to do?"[29] Then, satisfied with the pen, he returns to the work in hand.

But one day, on a page covered with drawings of machines, more or less contemporary with the Saint Jerome, instead of the imperative *Di* (Tell me), there appears the patronymic suffix *di: "Bernardo di di di Sim . . . di di di Simone."*[30] The end of the quill was not quite right, or perhaps he was particularly inclined to daydream on that occasion, for still thinking of Bernardo di Simone (who is thought to have been a falconer, one of the Contrigiani family of Florence), he tried again, this time writing: *"Ber, Bern Berna."* Was he expecting a commission from Bernardo? Or did he have closer links with this important man? The latter is probable, since on the same jumbled page, which also carries a mention of his uncle Francesco and a reference to the winter, Leonardo writes, in very ornate characters, "friends." Perhaps he was preparing to write a letter to the falconer. Further on, among other half-written words, there is an incomplete but coherent sentence that could well be the opening of a letter: "As I told you a few days ago, I am completely without . . ."[31]

Perhaps he felt deprived of so many things that he could not bring himself to write down any one of them and simply gave up.

At the bottom of the same text, he seems to make a play on words with the name di ser Piero (his father's grandfather); he abbreviates the name as follows: "di. s. p. ero," which, fused, reads *dispero*—I despair.[32]

Any autobiographical notes from this period are the harder to decipher because they are poorly preserved: the ink has faded and the paper is fragile. There is another page that might shed considera-

ble light on his frame of mind at this time, but there is a great blot in the middle, so that however one looks at it, most of the text is lost.[33] It is arranged in columns, with, on one side, a poem of sorts, not in Leonardo's hand, only a few lines of which remain legible; on the other side, there is a kind of response to the poem, recognizably in the artist's left-handed script. The foreign hand has written: "Leonardo, my Leonardo, why such torment?" Then comes something like "O Leonardo, why torment yourself with a vain love?"

Leonardo's reply is quite legible: "Do not despise me, for I am not poor. That man is poor who has great desires. Where shall I put myself? You shall know this soon."

The first two lines call for no comment: literary in character, they amount to an aphorism in the style of the day. The third sentence, however, *"Dove mi poserò,"* which some translate as "Where shall I settle?" may be a hint in poetic style at Leonardo's intention to leave Florence, as well as a need to rest, to recover, after some disapointment in love.

The intention became reality in 1481. Lorenzo de' Medici had escaped another assassination attempt; Ser Piero had left his house on the Via della Prestanza for a larger apartment in the Via Ghibellina; and Leonardo was no doubt hoping either to accompany Verrocchio to Venice (where Andrea had the commission for the great equestrian statue of Colleoni) or to enter the service of Pope Sixtus IV.

Now reconciled with Florence, the Pope had asked Lorenzo de' Medici—whose judgment in artistic matters was revered and whose territory was the most fertile nursery of talent in all Italy—to lend him some of his best painters in order to decorate the chapel he had just built—the Sistine Chapel, named after him.[34] Lorenzo, as we have noted apropos the visit of the duke of Milan, was quite willing to pursue a policy of artistic prestige (or, as André Chastel calls it, "cultural propaganda"). He had already lent the king of Naples the architect Giuliano da Maiano and had sent Verrocchio to Pistoia for the Forteguerri monument. Which artists would he send to the Pope, whose friendship he was anxious to cultivate? In 1481, the workshops of Florence were agog with excitement: the Vatican was the biggest building site in Italy; their own city was no longer carrying out works on this scale. Leonardo must have been as eager

as everyone else to participate. Perhaps he turned down the chance to accompany his master to Venice, having been misled by unfounded encouragement and believing that the road to Rome was open. We may imagine his disappointment and humiliation when, that October, he saw several of his former companions—Botticelli, Signorelli, Ghirlandaio, and Perugino—setting off for the Eternal City without him.

Why was he not included?

There is no question but that Lorenzo chose the painters he considered the best, since the whole affair was in his own interest, and their glory would enhance his own. Should we conclude that he did not appreciate Leonardo's work? Or did he have other plans for him?

We know of no painting by Leonardo directly associated with the name of Lorenzo de' Medici. The two men were about the same age and they had similar interests: music, horses, beauty, knowledge, intellectual games and riddles. Everything ought to have brought them together. The family of one had always patronized the master of the other: Lorenzo could not have failed to know about Leonardo. And yet he never offered him a full-scale commission. Was there between them one of those trifling quarrels which history rarely registers but which may be heavy with consequences?

The Anonimo Gaddiano states, as does Vasari after him, that Leonardo "in the days of his youth was admitted to the company of Il Magnifico, who paid him an allowance and had him work in the garden in the Piazza San Marco." Contrary to what Vasari believed, the garden did not at that time train any pupils and could not be considered a school or an academy (academies were the invention of the next century).[35] It was in fact a repository for marble, a sort of open-air museum. Lorenzo had installed his collection of antique statues here, with a workshop for restoration. It was the custom of the day to restore all mutilated statues: they were thought unacceptable if there was a hand or a leg or a nose missing. This explains the information in the Anonimo Gaddiano: Leonardo, who had been trained in all kinds of sculpture, was hired to restore (or copy) some Roman statue for the Medici, just as Verrocchio had been.

However, he could not have done so "in the days of his youth,"

since Lorenzo only acquired the garden of San Marco in 1480 (as a present for his bride).

In any case, a restoration was hardly a major commission. Perhaps the two men were less similar than they appeared. Rather than look for resemblances, perhaps one should consider what might have kept them apart.

Lorenzo was not a handsome man, as he himself said. We know what he looked like from the medal struck after the Pazzi conspiracy, from the portrait by Ghirlandaio, and from his tragic funeral mask. His mouth fell into a sort of twisted grin. He had a square, pale face, with large, skeptical eyes and a wide broken nose. At best one might describe him as interestingly ugly. He was a *grand bourgeois* who suffered (and would later die) from the gout inherited from his father. "Incredibly given to the pleasures of Venus," according to Machiavelli, he nevertheless spent more time playing with his children than entertaining his mistresses; he knew the value of things. The sobriety of his table astonished people. He was not carried away by fashionable crazes but dressed with ostentatious simplicity. If he sometimes wore diamonds, it was a calculated action. Prudent, cunning, "wise and prompt in decision" (Machiavelli again), by turns brutal and magnanimous, he never did anything that did not serve his own interests. Posterity gave him the reputation of a Maecenas; actually, he did not devote to the arts a quarter of the energy shown by his grandfather Cosimo, father of the state and active patron of Donatello, Fra Angelico, Masaccio, Brunelleschi, and Filippo Lippi. Lorenzo very quickly spotted the genius of Michelangelo, to whom he opened his house, but in practice he offered remarkably few commissions to artists. He was more likely to offer work to bronzesmiths, stucco ornamentalists, medal engravers, and marquetry experts. What he loved above all were books, antiques, objects of curiosity such as cameos and intaglios (of which he had five or six thousand), and precious vases. It was quite enough to impress his contemporaries. He built relatively little (a few villas) and that only late in life. Rather than employ painters himself, he preferred to send them abroad as ambassadors.[36] Those he appreciated most were Antonio Pollaiuolo, whom he described as *principale maestro della città*, who also went to Rome, and Botticelli. Both were close to the humanists and were

obsessed with mythology (from which their works borrowed many subjects). They encouraged Lorenzo's passion for *anticaglie* (antiquities). In the end, Lorenzo, whose classical education included training in history and philosophy (his four tutors had been a canon, a Byzantine grammarian, a Platonic philosopher, and a poet), was far more interested in literature than in art. He tended to admire artists who reflected literary tastes. His mother, the elderly Lucrezia Tornabuoni, improvised facetious sonnets and composed songs of devotion; Lorenzo's son was already quoting Virgil in his letters at the age of seven; and Lorenzo prided himself on being a writer. His entire court spent its time debating, composing verses in Tuscan or Latin, making up songs, epigrams, and elegies[37]—and he surrounded himself with writers.

To please Lorenzo, one had to be a scholar.

When Leonardo was introduced to this circle, he must have felt lost. He might perhaps have listened to the Hellenist Giovanni Argyropolo, who taught in Florence until 1475,[38] but since he did not even know Latin, what would he make of Greek? He had a good voice and was quite eloquent, as his friends testified. But he was ignorant of the subtleties of rhetoric and prosody. After all these years in Florence, and in part thanks to Verrocchio, he had acquired some "culture" (we have seen that he quoted from the poets). But his ideas, his personal tastes, did not take him toward the slightly pretentious forms of culture and the admiration of antiquity to be found in the Medici milieu. He was—and he openly said as much— an *omo senza lettere*, a man without literary culture.

He writes, for example: "I know very well that because I am unlettered [*non essere io litterato*] some presumptuous people will think they have a right to criticize me, saying that I am an uncultured man. What stupid fools! Do they not know that I could reply to them as Marius did to the Roman patricians: 'Do those who pride themselves on the works of other men claim to challenge mine?'[39] They will argue that my lack of literary experience prevents me from expressing myself as I ought on the subjects I treat. They do not know that these call less for other people's words than for experience, the mistress of the good writer. I have chosen her as my mistress, and I will not cease to refer to her."[40] Or elsewhere:

"Anyone who invokes authors in a discussion is using not his intelligence but his memory."[41]

Elsewhere again, he inveighs violently against those whom he describes as "reciters and trumpeters of the works of other men," even comparing them to a flock of sheep; and against the "abbreviators," that is, the authors of anthologies and textbooks. They are proud "to have stolen the mistress of their masters." The only people who counted in his eyes, he repeated, were the "inventors," *inventori,* who directly interpreted the world.[42]

He took the same line on art. He, too, had studied the art of antiquity by looking at Roman statues and bas-reliefs. He does not deny their merits or excellence; sometimes he refers to it, but he does not make it his touchstone. In his view, art, science, everything, including literature and philosophy, proceeded exclusively from nature. "No one should imitate the manner of another, for he would then deserve to be called a grandson of nature, not her son. Given the abundance of natural forms, it is important to go straight to nature rather than to the masters who have learned from her." And to those of his colleagues who were too anxious to conform to the taste of the day, Leonardo, who knew that fashions passed, said: "I am addressing not those who wish to make money from art but those who expect honor and glory from it."[43]

One had to be bold, as Leonardo was well aware, to brave the authority of the ancients—or to contradict the educated men who believed they represented that authority.

Was it an overassertive show of independence that barred his road to Rome? (Unlike Michelangelo, who agreed to be advised by the poet Poliziano when in 1493 he sculpted his *Combat of the Centaurs and Lapiths,* Leonardo was not prepared to submit himself to the guidance of a humanist.)

One argument against this view might be based on another sentence from the Anonimo Gaddiano, according to which Lorenzo not only employed Leonardo in the garden of San Marco but intervened in his favor, sending him to his most powerful ally. "It is said that when Leonardo was thirty years old, the Magnifico sent him to present a lyre to the duke of Milan, with a certain Atalante Migliorotti, for he played upon this instrument exceptionally well."

But sending him to the Lombard court as a musician seems to suggest that he did not think very highly of him as an artist.

It was normal at the time for scholars to set their verses to music (music being regarded as a liberal art, whereas the plastic arts seemed to them to be closer to craftsmanship, or the "mechanical arts"). Although Lorenzo did not, apparently, sing in tune, he liked to improvise concerts with his friends, who included composers like Squarcialupi and Cardiere, rather as Louis XIV liked to dance in Lully's ballets. Paolo Giovio and Vasari both claim that Leonardo sang to perfection, accompanying himself on the *lira*. If we are seeking common ground between Leonardo and Lorenzo, perhaps it can be found here. To the lord of Florence, Leonardo was not conspicuous for any of his numerous other talents.

And yet in the months before his departure, Leonardo was working on a project that should have brought him much praise—a great altarpiece representing the *Adoration of the Magi,* for the main altar of the convent of the friars of San Donato at Scopeto, just outside Florence.[11] The picture is almost two and a half meters across. This was not a portrait or a small-scale Madonna but one of those great paintings that the age most valued, containing dozens of figures. It offered Leonardo at last the chance to try his hand at the "grand style."

Ser Piero, who handled the legal affairs of the San Donato monks, may have said a word to them in favor of his son. But he let Leonardo sign a very odd contract in the month of March 1481. The monks intended no money to change hands at all. A merchant who had taken religious orders had left them an estate in the Valdelsa, on condition they provide a dowry for his daughter Lisabetta, a seamstress by trade. As remuneration, Leonardo was to receive a third of this estate, which would remain inalienable for three years and could be bought back at any time by the abbey for three hundred florins (quite a handsome sum). But it was Leonardo who had to provide the one hundred fifty florins dowry for the daughter, and contrary to usual practice, he was to pay for his own paints and gold leaf as well. Moreover, a clause committed him to finishing the altarpiece within twenty-four to thirty months, on pain of forfeiting the work done up to that point.

One had to be sorely in need of work to sign an agreement like

this. Leonardo accepted the conditions, probably knowing that he could not comply. And indeed, he never did fulfill them—most likely assuming that the contract would not be enforced.

He no doubt began by looking again at some of the studies he had carried out in 1478 for the *Adoration of the Shepherds* in the San Bernardo chapel in the Signoria—his first personal commission, never honored.[45] Some of these pen-and-ink sketches have survived: in the Musée Bonnat in Bayonne, the Accademia in Venice, and the Kunsthalle in Hamburg. Kenneth Clark remarks that they follow the sort of traditional composition taught by Verrocchio, to which Lorenzo di Credi and Perugino remained wedded: the figures arranged in a square around the Virgin. Leonardo was not content with this, however. Looking for movement and depth, he extended the scene into the background, arranging the composition on several planes and deepening the perspective.[46] One drawing in the Louvre and another in the Uffizi reveal the different stages of his thought: how he gradually moved away from the conventional formula, correcting, experimenting, organizing, and eventually—on a subject that was one of the most well worn of the century—inventing his own vision. He gradually converted the static square into two triangles, their apexes meeting at the center of the picture, the head of the Virgin Mary. Then he duplicated the triangles, moved them slightly, and interrupted them with verticals, so as not to fall into the pompous emptiness of oversymmetrical design. He probably did hundreds of sketches and drafts, to judge by the number that have been preserved (in the Musée des Beaux-Arts in Paris, the Fitzwilliam Museum in Cambridge, etc.). Depicting the homage of the kings to the Holy Child meant rendering intelligible all that the birth of God's son represented. He wanted the viewer to grasp instinctively the consequences, the universal significance, of the event: hence the liberties he took with the biblical account. In the sketch preserved in the Louvre, we see the ox, the ass, and the structure of the stable; the artist is still following classical iconography. But they are missing from the final version, as are most of the traditional elements in the Epiphany. In Leonardo's picture, the Magi (one of whom, Balthasar, was usually shown as black, and all three of whom were normally portrayed with conspicuous Orientalism: turbans, golden kaftans, ornate crowns) appear as three iden-

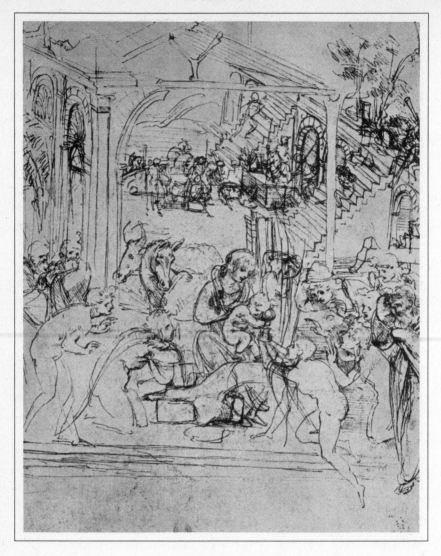

Study for the *Adoration of the Magi*.
LOUVRE, PARIS.

———

tical old men, three sages, weary, modestly clad, and humble, keep-
ing a respectful distance from the Savior as if they were afraid to
come too close. I find fascinating the novelty of the dark space, the
no-man's-land separating the central group of the Virgin and Child
from the swarming mass of worshipers and witnesses. Once more,

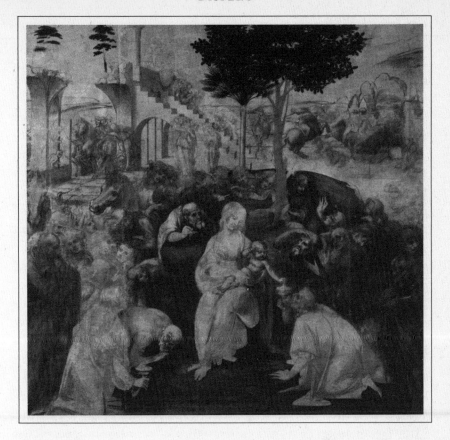

Adoration of the Magi.
GALLERIA DEGLI UFFIZI, FLORENCE.

Leonardo has eliminated unnecessary circumstantial detail. The offerings are reduced to incense and myrrh. He originally drew a camel in the background; in the end it became a man on horseback. There is no improbable exoticism here: this is a timeless scene, which might have been set anywhere. True, a palm tree still survives (a symbol of peace), and what appears to be a carob tree—the tree of Saint John, but also the tree from which Judas hanged himself. But one looks in vain for any other canonical symbols. Guillaume Durand, bishop of Mende, said in the thirteenth century: "In church, the paintings and ornaments are readings for the laity." But Leonardo reworks the Gospels. In the upper third of the picture, the

horsemen killing each other amid ruined cities portray the confusion of the ancient world, already doomed since it is ignorant of the coming of the Redeemer; while in the lower part of the painting, bounded by the outline of a rocky outcrop, are gathered all those who have, with amazement, delight, or perplexity, recognized that with this coming a new era was beginning. This is the Gospel according to Leonardo.

The monks of San Donato might be aware that they were patrons to an exceptional work of art, but they would have liked to see the painter work more quickly. In June, the contract was revised to grant him a small advance to buy pigments from the apothecary of the Ingesuati, as if to encourage him. Leonardo must have been pitifully short of resources, since the monks got him to paint the convent clock yellow and blue, and paid him with one load of fagots and one of large logs. The dowry was still not forthcoming. How could a young artist produce such a sum? So in July they also entered on his account—with bad grace, because they said his slow progress was causing them inconvenience—the sum of twenty-eight florins. But the picture was taking shape and must have been coming along well. Toward the end of the summer, a carter from the abbey delivered a bushel of wheat to Leonardo; then, on 28 September 1481, a cask of red wine (for his personal consumption?). But this is the last mention of da Vinci in the monks' register. It appears that as winter approached, he disappeared to try his luck in Milan. Like the *Saint Jerome,* which is probably contemporary with it, the *Adoration of the Magi* remained unfinished.

The incompletion of this picture has always perplexed historians, even more than that of the *Saint Jerome.* Leonardo had put a great deal of work into the *Adoration,* which some consider, even as it stands, to be one of the most extraordinary pictures of the century. "Truly a great masterpiece and perhaps the quattrocento produced nothing greater," says the usually cool Bernard Berenson.[47] In it, one can find most of the themes that were to obsess Leonardo all his life. The Magi prefigure the apostles in *The Last Supper;* the combat on horseback would reappear twenty-five years later in the *Battle of Anghiari;* the figure pointing an index finger to the sky and leaning against the largest tree prefigures the smiling *John the Baptist,* which was to be a kind of last will and testament. (This characteris-

tic gesture occurs twice in the *Adoration:* on the left, between two horses, another character is raising his finger heavenward.) If further proof were needed of the importance of this work, one has only to look at the reactions it provoked in contemporary artists. Filippino Lippi,[48] Ghirlandaio, and Botticelli all took inspiration from it— but timidly, without drawing on all its force. Raphael stood awe-struck in front of it and reproduced elements from it in his frescoes in the Stanza della Segnatura. Michelangelo himself seems to have borrowed from the hallucinating faces caught up in the swirling ring of darkness around the Virgin some of the grand elements he put into the ceiling of the Sistine Chapel. Why did Leonardo never finish the painting?

Several explanations have been suggested. Vasari provides the most simple: Leonardo was "capricious and unstable," he said, and did not finish the *Adoration* because he was incapable of finishing anything. As a kind of justification, he adds: "His intelligence of art made him take on many projects but never finish any of them, since it seemed to him that the hand would never achieve the required perfection." According to Vasari, Leonardo conceived of problems that were "so subtle, so astonishing," that he could not resolve them despite his skill. Certain modern critics, following Vasari's line of thought, have suggested that the ambitious *Adoration* might not have benefited from being carried through to the end. "Finish is only of value when it is a pure medium of expression," according to Kenneth Clark, who thought that the "finished" quality called for by the Florentine ideal would no doubt have shattered the magical charm of the picture. For other critics, the *Adoration* in its present state (sometimes anachronistically described as Rembrandt-esque) is perfect and complete. "At this stage," wrote Spengler, "the supreme achievement and the clarity of intention have been reached."[49] Such writers refer to the *non finito* effects of Donatello and quote Vasari when he says in his *Life* of Luca della Robbia that "rapidly made sketches in the first flush of inspiration express the idea marvelously in a few lines; whereas excessive labor and too great meticulousness deprive the works of all force and character, and the artist does not realize when to stop." Others again believe that Leonardo left the *Adoration* half complete because as he developed its composition, his art was itself progressing and evolving, so

that after seven or eight months spent on this work he was no longer happy with it and was eager to move on to another.[50]

Like Kafka, whom he resembles in many ways, Leonardo certainly found it hard to finish his works: he did not complete the Sforza monument, the *Musician* in the Ambrosiana, the *Battle of Anghiari,* the *Virgin with Saint Anne, The Last Supper,* or the *Mona Lisa.* I do not, however, believe that in the case of the *Adoration* and *Saint Jerome* the reason for abandoning them was necessarily "aesthetic."

We should note for one thing that the monks of San Donato did not keep the picture after the painter had left, contrary to the final clause in the contract; according to Vasari, it was Amerigo de' Benci,[51] a relative of Ginevra, who inherited it. So it is not impossible that it was the monks, rather than the painter, who failed to honor the contract—and that the latter broke off his work because the patrons, for one reason or another, had defaulted. It would not be the first time. Note that the monks brought no legal action against him. Second, how can one fail to consider the misfortunes, the emotional and material disappointments, with which the year 1481 was punctuated for Leonardo? (He was obsessed with a "vain love," humiliated at not being invited to the Vatican, reduced to painting a convent clock.) Perhaps this year marked the lowest point of his fortunes. To obtain salvation, he had to leave Florence.

We shall never know the truth. But it seems to me that arguments in favor of the latter theory can be seen in the picture itself. While the figures gravitate around the Virgin like moths around a flame, crushing each other in their desire to contemplate the Child, two peripheral characters, on opposite sides, remain oddly apart. They are not worshiping. They take no part in the movement of exaltation, the fever that has gripped everyone else. Their withdrawal would look almost discourteous if it were not that they are clearly outside the scene. The first is a massive old man in the Masaccio style, chin on hand, skeptical if not unbelieving, the very image of ancient philosophy. The other is a young man, possibly in armor, frowning slightly, his eyes firmly turned away from the center, looking out of the picture. This is supposed to be the famous idealized self-portrait of Leonardo. The doubts of the old man seem to relate as much to the mystery of the Child as to the young man

positioned opposite him; but are they doubts or reproaches? The young man may be turning away to hide a tear (the condition of the picture makes it hard to be sure). But is the emotion he betrays inspired by the proximity of the Savior or by the antagonistic old man, standing as stiffly and gloweringly as a judge? Or is he feeling sorry for himself at being excluded from the great movement of redemption? Are these tears of shame? Would he, too, like to be carried away, to be part of the family, to be lost in adoration? Something is holding him back. Such is his destiny. Like the old man, he appears primarily to represent the excluded.

A sentence from Kafka's *Journal* seems to me to express the ambiguous feelings suggested by this set of attitudes: "Much hope, an infinite quantity of hope . . . but not for us." The young man turns away; he looks elsewhere. In his mind, he has already left.

VI

Pen
and Penknife

*One can have no smaller or greater mastery
than mastery of oneself.*

—LEONARDO[1]

Design for a Gun with an Array of Horizontal Barrels.

CODEX ATLANTICUS.

IN HIS THIRTIETH YEAR Leonardo arrived in Milan, accompanied by his friend Atalante Migliorotti and bringing a musical instrument for the duke, according to the Anonimo Gaddiano. Vasari adds that the instrument, devised by Leonardo himself, was a sort of lute, made mostly of silver, "in the strange and unusual form of a horse's head, with a view to obtaining powerful harmony and perfect sound." Leonardo is supposed to have played it in a competition in Florence, surpassing all the other musicians and winning the favor of Lorenzo, who was "a great music lover."

Vasari mistakenly gives the year of his arrival in Milan as 1476: Leonardo cannot have left Florence before the winter of 1481. But the lute in the shape of a horse's head may really have existed. On one page of the notebooks, alongside some conventional musical instruments, is a drawing of a composite animal head, combining elements of wolf, goat, horse, and parrot, and most resembling some kind of devil or dragon. The lower part seems to be a soundboard, with three strings and some perpendicular divisions, which could mark fingering positions.[2] Fanciful musical instruments were very fashionable at the time, and the lute, along with the *lira da braccio* (the hand lyre, played by angels in pictures by Bellini, Carpaccio, Raphael, and Mantegna[3]) was then the most favored accompaniment to a singer.

The contest, too, may really have taken place. A note by Leonardo fifteen years later reads: "Tadeo, son of Nicolaio del Turco,

was nine years old on Michaelmas Eve, 28 September in the year 1497. The child went that day to Milan and played the lute and was judged one of the best players in Italy."[4]

Leonardo's interest in music is quite evident from the notebooks, which record his research into acoustics as well as the instruments he improved or invented (the *viola organista,* a recorder with *glissando,* a drum and bell with keyboard; he is even thought to have invented the violin[5]). He could both read and write music, which he describes felicitously as "the representation of invisible things."[6] No score in his hand has survived, for he was chiefly an improviser;[7] but he often used staves and notes in the many riddles and acrostics he liked to make up.

There are several pages of these riddles in his notebooks. Two from his first Milan period—the happiest in his life—stand out. On one stave, after the clef, he drew a fishhook (*amo* in Italian), then the series of notes *re sol la mi fa re mi,* followed by the letters *rare;* a bar line, then *la sol mi fa sol* and the letters *lecita.* This gives: *Amore sol la mi fa remirare, la solmi fa sollecita* (Only love makes me remember, it alone stirs my heart).[8] Another works out similarly: "Love gives me pleasure."[9]

He seems to have been introduced fairly quickly to musical circles in Milan, frequented at the time by musicians of repute such as the Frenchman Josquin des Prés. A portrait, now in the Ambrosiana Library, that Leonardo painted soon after his arrival was long thought to be of the duke but is actually of a musician. When the painting was cleaned in 1905, it was revealed that the sitter is holding a sheet of music, on which can be seen a stave and the faintly visible letters "Cant. Ang." This might mean *Canticum angelicum,* the title of a composition by Franchino Gaffurio, known as Gafurius, choirmaster at Milan Cathedral. So it is possible that Gafurius was the sitter[10] and therefore that he was friendly with the painter. (According to Gerolamo Adda, Leonardo also illustrated Gafurius's *Practica musicae,* a theoretical treatise that was the first to analyze the notion of harmony.)

Leonardo also came to know Lorenzo Gugnasco of Pavia, a manufacturer and dealer in *organetti,* organs, harpsichords, lutes, viols, *lire da braccio,* and other instruments, who was in the service of the courts of Milan, Ferrara, and Mantua. Leonardo may have

Riddle Using Musical Notation.
ROYAL LIBRARY, WINDSOR.

benefited from his advice and used his workshop for his own experiments in sound and to work on his various musical instruments.

Finally, there was Atalante Migliorotti, his traveling companion and pupil (on the *lira*), according to the Anonimo Gaddiano. He is thought to have been a Florentine, about ten years younger than Leonardo and, like him, illegitimate. The painter, who may have felt more than friendship for this youth, noted that he had sketched his portrait, "with head held high."[11] We know nothing of Atalante's career in Milan—it was probably devoted to singing and playing the lyre, since he played the title role in Poliziano's *Favola d'Orfeo* at the palace in Mantua in 1491. (He and Leonardo seem to have lost touch thereafter but met again in Rome in 1513, where the singer, who had probably found a powerful protector, held the enviable position of inspector of architectural works at the Vatican.)

We might reconstruct the following sequence of events: Having received some training in goldsmithing from Verrocchio, Leonardo made a silver instrument, whose unusual appearance caught the fancy of Lorenzo de' Medici, prompting him to think of offering this "curiosity" to his Milanese ally, Ludovico Sforza. Eager to

leave Florence, Leonardo seized the opportunity to deliver the instrument to the duke in person; on arrival, he and his pupil-companion demonstrated the instrument's range, thus gaining admission to Milan's musical circles. But Leonardo had no intention of making a career in music, leaving that to young Atalante. He continued to play to entertain his friends or sometimes the court, but his ambitions lay elsewhere. The lute in the shape of a horse's head merely served as a passport, gaining him entry to the city.

We know that he had other things in mind, for he had written (perhaps on the way to Milan) a long letter offering his services to its powerful ruler—on matters quite unconnected with music. All that survives of the letter is a much-corrected draft, not in Leonardo's own hand, as if perhaps, feeling doubtful about his spelling and style, he had asked a friend more practiced with the pen to help him catalogue his skills. We must imagine him agonizing over every word, calculating every effect, revising every turn of phrase.

This astonishing letter, consisting of eleven or twelve points (the order altered by renumbering) reveals a Leonardo one would never have suspected from our knowledge of his early years. It deserves to be quoted in full.

Most Illustrious Lord, having by now sufficiently considered the experience of those men who claim to be skilled inventors of machines of war, and having realized that the said machines in no way differ from those commonly employed, I shall endeavor, without prejudice to anyone else, to reveal my secrets to Your Excellency, for whom I offer to execute, at your convenience, all the items briefly noted below.

1. I have a model of very strong but light bridges, extremely easy to carry, by means of which you will be able to pursue or if necessary flee an enemy; I have others, which are sturdy and will resist fire as well as attack, and are easy to lay down and take up. I also know ways to burn and destroy those of the enemy.

2. During a siege, I know how to dry up the water of the moats and how to construct an infinite number of bridges, covered ways, scaling ladders, and other machines for this type of enterprise.

3. *Item.* If because of the height of the embankment, and the strength of the place or its site, it should be impossible to reduce it by bombardment, I know methods of destroying any citadel or fortress, even if it is built on rock.

4. I also have models of mortars that are very practical and easy to transport, with which I can project stones so that they seem to be raining down; and their smoke will plunge the enemy into terror, to his great hurt and confusion.

9. And if battle is to be joined at sea, I have many very efficient machines for both attack and defense; and vessels that will resist even the heaviest cannon fire, fumes, and gunpowder.

5. *Item.* I know how to use paths and secret underground tunnels, dug without noise and following tortuous routes, to reach a given place, even if it means passing below a moat or a river.

6. *Item.* I will make covered vehicles, safe and unassailable, which will penetrate enemy ranks with their artillery and destroy the most powerful troops; the infantry may follow them without meeting obstacles or suffering damage.

7. *Item.* In case of need, I will make large bombards, mortars, and fire-throwing engines, of beautiful and practical design, which will be different from those presently in use.

8. Where bombardment would fail, I can make catapults, mangonels, *trabocchi,* [12] or other unusual machines of marvelous efficiency, not in common use. In short, whatever the situation, I can invent an infinite variety of machines for both attack and defense.

10. In peacetime, I think I can give perfect satisfaction and be the equal of any man in architecture, in the design of buildings public and private, or to conduct water from one place to another.

Item. I can carry out sculpture in marble, bronze, and clay; and in painting can do any kind of work as well as any man, whoever he be.

Moreover, the bronze horse could be made that will be to the immortal glory and eternal honor of the lord your father of blessed memory and of the illustrious house of Sforza.

And if any of the items mentioned above appears to anyone impossible or impractical, I am ready to give a demonstration in your park or in any other place that should please Your Excellency—to whom I recommend myself in all humility, etc.[13]

Did he ever deliver to the duke this request for work—so presumptuous about the machines of war and so modest in the few lines relating to his art? I am not sure he did. But even if he did not seriously envisage sending it, Leonardo certainly conceived the text and dictated its main outlines, so it is worth pausing over.

It gives the impression of a self-imposed program rather than of a genuine offer of services. Leonardo was to devote much time to military inventions: he would fill notebooks with countless sketches of weapons—hand arms, projectiles, fire throwers—as well as machines of destruction and plans of fortification. He would design everything he lists here for the duke and more besides, but in 1482, he does not seem to have advanced very far in this direction. A memorandum in which he lists various studies he had made (possibly the list of everything he was taking to Milan) speaks of drawings of nudes, flowers, trees, angels, faces, old men, the head of a gypsy, portraits (Atalante included), two Virgins, eight Saint Sebastians, and so on—but mentions no more than three technical subjects, and all are of civilian application: designs for a furnace or kiln; instruments of navigation, and "certain instruments for water" *(cierti strumenti d'acqua)*. [14] Only a few sketches of cannon and crossbows predate his journey to Milan.[15] So how did he suddenly come to be posing as a military engineer?

The war Florence had waged against Rome, Naples, and their allies, or rather the panic-stricken preparations within the city, had certainly provided an opportunity to become familiar with the arms and machines necessary to launch or withstand a siege. What Leonardo had seen in the armorers' workshops and arsenals of Florence had stimulated his intelligence and given him ideas. He had probably studied the inventions of the leading military engineers, as he says in his letter, and read the available treatises on the subject (Taccola, Valturio, or indeed the 1476 edition of Pliny). He then imagined ways of improving existing weapons and devised new ones.

Mechanized Military Drum.
CODEX ATLANTICUS.

Curiously, all these inventions and improvements are in the same mold as his excursions into the world of musical instruments: his method was always to organize, assemble, and mechanize any given activity, limiting the role of human intervention and trying to achieve with a single machine what was normally the work of several. For example, he invented a drum struck by five sticks attached by cogwheels to carriage wheels,[16] so that as the carriage moved, the drum automatically played complicated rhythms. In much the same way, he designed a gun battery arranged like a set of organ pipes mounted on wheels: eleven barrels would fire, then as the carriage advanced, another set of barrels would move automatically into position, and so on.[17] He also designed a system to push away scaling ladders from a wall, three or four at a time;[18] and he thought of linking several gun barrels to a single carriage—prefiguring the machine gun[19]—just as he envisaged a bell to be struck by four hammers activated by a keyboard, so that, as he said, one bell would "produce the effect of four bells."[20] To a mind like his, so preoccupied with efficiency, there was perhaps not much difference between an innocent carillon and an artillery battery vomiting a continuous stream of flame and metal.

It is also possible that the workshop of Verrocchio, the leading bronzesmith in Florence and an experienced metal founder (as we

know from the ball on the cathedral), had been asked to participate in some manner in the manufacture of cannon or cannon balls. Whether bells, cannon, or statues, the casting process was the same.[21] Leonardo had undoubtedly learned the techniques of metal casting from his master, along with various recipes for alloys.

When Leonardo arrived in Milan, peace in Italy seemed more precarious than ever: the Turks had landed in Apulia, Rome had formed an alliance with Venice, Venice had its eye on Ferrara. A league was being formed against the city of the doges, which was nevertheless pressing ahead with its plans. Although this meant losing the friendship of the Pope and turning the entire peninsula against it, Venice continued to advance, hiring mercenaries, fighting near Argenta, besieging the marquess of Este, sending troops into Lombardy. Milan, having hitherto assumed that its intervention in this conflict would be merely diplomatic, was now obliged to take up arms.

Leonardo therefore assumed—rightly, no doubt—that for the moment the duchy had more need of military engineers than of artists: circumstances dictated the first part of his letter. The "peace-time" referred to in the latter part was not the time being.

Whether or not he sent the letter, he was evidently tempted to give his career a new direction, one that took advantage of the situation. The arms industry had long been a Milanese specialty: in the Via degli Armorari and its surrounding streets, there were dozens of armorers' shops, some as famous as those of Toledo, forging and decorating swords, pikes, halberds, helmets, and shields, to be sold far from home. But these were all traditional weapons. The *ars militaria* was not very highly developed in Italy, compared with its northern neighbors or the Turks. Leonardo stresses the novelty of the machines he has designed. If he could make only one of these, his fortune would be assured.

His letter corresponded to the needs of the hour. He claims to be able to build bombards both sturdy and light: those in use at the time were difficult to handle because of their weight—and they often exploded. He claims to be experienced with mines, catapults, and other siege machines: the Italians avoided pitched battles as much as possible, preferring wars of attrition. He proposed to provide ships with cannon and armor—an odd suggestion when one

considers that Lombardy had no outlet to the sea—but Venice, being a maritime power, had assembled a large fleet on the Po, with which it hoped to attack Milan's ally, Ferrara.

Having been passed over for the trip to Rome, having left unfinished both the *Adoration* and *Saint Jerome,* Leonardo was likely to be feeling out of humor with painting. He was anxious to make a fresh start. So why not choose the path that led to the highest honors, rather than vegetating in the "mechanical arts"? When he lists his "peacetime" capabilities, he does not boast of being Verrocchio's pupil, or of having seen the late duke Galeazzo Maria (brother of the reigning duke) on his visit to Florence in 1471; there is not a word of his having helped decorate the Medici Palace for the visit, nor of the suit of armor *alla romana* offered to the visitor; nor does he mention any of his completed works.[22] He describes himself above all as an architect, although there is no evidence of his having any experience in building, and he claims that he can "conduct water from one place to another" (there was talk of linking the Adda to Milan by a canal at the time); then he mentions sculpture, and only lastly says that he is a painter. He was listing his talents in the order in which they would be valued in his day.

Leonardo was by nature passionately interested in technical problems, but here passion coincided with self-interest. The social status of the engineer, especially the military engineer, was the highest to which he could aspire.[23] For a prince seeking glory, frescoes and painted panels were but fragile decorations; bronze and marble had a better chance of surviving down the centuries; a great building made it even more likely one would remain in people's memories; but all that was nothing unless one possessed the political and military might that enabled such things to be created and maintained.

Giotto was appointed to public office with a generous annual allowance—but only in his capacity as an architect; he was commissioned to build the campanile of Santa Maria del Fiore and to erect fortifications. Leonardo saw the esteem in which Lorenzo de' Medici held Giuliano da Sangallo, his military engineer. How good it would be to have all the advantages of an official position![24]

There is one paragraph in the request for employment that stands out not only for its content but also for its style and position in the

letter. It concerns the last thing Leonardo offers to make. Whereas for everything else he states "I can . . . I know how to . . . I will make," here he uses the conditional and passive: "Moreover, the bronze horse could be made . . ." *(Ancora si potrà dare opera al cavallo di bronzo)*.

Why does this boastful catalogue of Leonardo's talents end suddenly on a timid and impersonal note, with courtly formulas of politeness ("the lord your father of blessed memory")?

If the entire letter looks like the dream of an expatriate in search of work, these three lines seem to me to refer to something real. Leonardo must have heard in Florence that the wealthy tyrant of Milan wished to put up a grand equestrian statue in memory of Francesco Sforza, his father; and he had gone to Lombardy in the hope of obtaining this commission. Leonardo's imagination had had time to build castles in the air on the way to Lombardy—hence the extra ambitions he had dreamed up. Affirmative statements mark the dream; the conditional refers to the real world. From what I can surmise of his cast of mind, Leonardo concealed his true plan in the last paragraph of the letter. His real reason for going to Milan was the bronze horse.

Whereas quattrocento Florence has come down to us almost unchanged, Milan has undergone such upheavals and alterations over the centuries that it is now difficult to imagine the city as it was in Leonardo's day.

Since Milan was founded by the Celts—in other words, by barbarians—Tuscans, who tend to be snobbish about this sort of thing, regard it as lacking prestigious origins. Livy calls it Mediolanum, a corruption of *in medio plano* (in the middle of the plain). The Germanic invaders later called it Mayland, perhaps a further corruption of the same name. It is surprising that it developed so successfully, being located neither on a river or lake, nor on a hill, but on an open site, damp, unhealthy, and inconvenient, far from the river Ticino, the Adda, or the Po (although attempts were made in the fifteenth century to link it to them). It must have been an unavoidable staging post between Rome and the countries north of the Alps, since it very quickly became a vitally important strategic and commercial center—thus the fierce quarrels over its possession.

The Carthaginians invaded it, the Romans occupied it; it was the imperial capital under Diocletian; the Goths seized it, followed by the Lombards, who gave their name to the surrounding region. Barbarossa razed the walls and reduced it to ashes; it rebuilt itself, revived its industries, and took off once more. The *signoria* of the Visconti became established there, and with this family in power for a hundred thirty years (albeit often by means of poison and the sword), the city expanded and grew rich, so that by Leonardo's time it was one of the largest, most populous (100,000 inhabitants), and most powerful cities in Europe. Still greatly coveted, it was later to fall into the hands of the French, Spanish, Austrians, and Germans—and much of it was destroyed by air raids in 1943. Five times it was ruined, and five times revived. Few Italian cities have suffered so much in the way of war and occupation.

Milan is an almost circular city, built of tawny brick and gray stone, dotted with islands of greenery. Leonardo drew a plan of it, indicating the general outline and drawing the gates, the major thoroughfares, and the chief buildings in perspective.[25] In the center appear the cathedral and the Corte Vecchia; lower down, the church of San Lorenzo and the Ticina gate; on the right, surrounded by water, on the edge of town, is the great mass of the Castello Sforzesco, the duke's residence. One of its particular features was that it was more fortified on the side facing the city, as if the ruling family feared an uprising by its subjects more than external aggression.

If Leonardo obtained the favor of a ducal audience to offer the horse's-head lute, or perhaps to deliver his letter, this is where he would have come: past the cliff-like ramparts, flanked by towers, across a drawbridge guarded by archers, past the remarkable keep built by Filarete (it looks rather like a pagoda), and onto the parade ground (capable of accommodating 3,500 men-at-arms, according to de Brosses). Here he would have discovered the fortress within a fortress: La Rocchetta, the color of dried blood, protected by strong artillery and reputed to be impregnable. Its treasury tower concealed wealth that would have made the kings of France and England pale with envy, it was said: chests full of rubies, diamonds, and pearls, armfuls of gold, and a pile of silver coin so high, said the ambassador from Ferrara, that a stag could not have leapt over it.

This intimidating castle (which was to inspire the architecture of the Kremlin) set the tone for the city during these years. Less than two hundred miles separated Milan from Florence; but the Lombard capital, often wreathed in mist, must have seemed another world to Leonardo, to belong to northern Europe—or perhaps to another century. No town planners had supervised building here: huddled together higgledy-piggledy, medieval houses made up a labyrinth of streets, noisy, narrow, dirty, and full of variety, interrupted here and there by canals (the *navigli*), where frogs chorused nightly. Leonardo might have glimpsed an occasional "modern" building in the style of the quattrocento—designed by Florentine architects— such as the fine Ospedale Maggiore by Filarete, or the Medici bank, with its porch by Michelozzo. But the great majority of palaces and churches, whether or not they dated from previous centuries, were in the Romanesque or Gothic style, especially that exaggerated Gothic sometimes described as "flamboyant."

With its courtyards and secret gardens, this anarchic, prosperous city has its own special charm, extremely engaging but hard to define. Much is usually made of the indolent sensuality of its inhabitants, as well as of its extraordinary business life and the refinement of its cuisine. The Milanese, says the storyteller Bandello, "think that one does not know how to live if one does not live and eat well in company"—a remark faithfully relayed by Goldoni a hundred years later. Stendhal thought that the streets of Milan were the most convenient in Europe for conversation ("the most comfortable streets" was what he actually wrote, in English). Alberto Savinio admired the city for having named a street after a nonexistent person, Randaccio Nicola, just as Athens had a temple dedicated to the Unknown God.[26] But none of this explains the persistent pleasure certain individuals have found within its walls.

Today as in the past, the visitor either loves Milan or hates it. Leonardo, perhaps in reaction against Florence, which had not understood him properly, felt that in Milan he could breathe at last, that he was a new man; he stayed there seventeen or eighteen years, before being forced by circumstances to leave. What was more, he would return. He suffered none of the usual homesickness felt by Tuscans abroad, not even the famous *malattia del Duomo;* unlike

Dante, who pined for the sight of the Baptistery, he would never murmur, "Oh, my fair San Giovanni."

Vasari wrote of Leonardo's arrival in Milan: "the prince, hearing his marvelous discourse, was incredibly moved by his talent. He begged him to paint an altarpiece representing the Nativity, which he sent to the emperor."[27]

Like the Anonimo Gaddiano, Vasari creates the impression of a brilliant debut at court, followed by immediate success. No trace of this Nativity survives. Nor did Leonardo win favor at court quite so quickly. It was a long time before he received the commission for the bronze horse or set out to use his engineering gifts (the title *ingeniarius* was not conferred on him until nine years later, in 1490). He had to prove himself first.

By the spring of 1483, he was staying in the house of a family of artists named Preda or Predis, near the Porta Ticina.

Artists often collaborated, to evade protectionist measures, to share the expenses of a studio, or the work of a commission too large for an individual to complete. Donatello and Michelozzo, Masaccio and Masolino, Fra Bartolomeo and Albertinelli, Andrea del Sarto and Franciabigio—there are plenty of examples in the fifteenth and sixteenth centuries of painters or sculptors working together. Since his projects had not met with any immediate response, Leonardo had to fall back on painting to make his way in the Lombard capital.

"The pen," he writes on the cover of one of the notebooks, "must of necessity be accompanied by the penknife; a very useful alliance, since one can do little without the other."[28]

The Predis family consisted of six brothers, born of three marriages. Their talents were modest but varied, and above all they were well connected at court. Evangelista was a woodcarver; Cristoforo, a deaf-mute, was a miniaturist; Bernardino, the eldest, did medals and cartoons for tapestries; Gian Ambrogio, a painter, seems to have been the most successful. He had started by engraving coins and illuminating books of hours. Then the prince asked him to paint his portrait; other commissions followed, notably a portrait of the duchess of Ferrara; later still, he did portraits of the emperor Maximilian and of Bianca Maria Sforza.

We do not know how Leonardo met the family or on what basis their collaboration began, but a contract dated 25 April 1483 links his name with those of Ambrogio and Evangelista de Predis, for the execution of an altarpiece destined for the recently formed Confraternity of the Immaculate Conception of the Blessed Virgin Mary, whose chapel was in the church of San Francesco Grande (now destroyed).

Leonardo was the only one to be described in the document as a master. And it was specified that the central panel (of the requested triptych) "would be painted by the Florentine, in oils," while Ambrogio would do the side panels and Evangelista (one supposes) the gilding. It looks as if Ambrogio engineered the affair astutely, guaranteeing the commission by vaunting the talents of his lodger.

Three years earlier, the prior of the Confraternity had asked for a large wooden frame for the altarpiece of the brand-new chapel. The panels ordered from Leonardo and the Predis brothers would have to fit the dimensions of this triple frame, decorated in relief and not yet complete. But the demands of the Confraternity were not confined to matters of format; the contract, which covers several pages, half in Latin, half in Italian, drawn up by the priors with the help of their lawyers, also settles in detail the subject and composition of the work. It specifies, after various invocations and a long legal preamble, that the Virgin Mary, flanked by two prophets, will occupy the center of the painting. "Portrayed to perfection," she will wear a gown of gold brocade and deep blue, lined with green, and the gold will be applied over a fine layer of red lacquer. God the Father, overhead, will be similarly clad in blue and gold,[29] while the angels, with gold haloes, will be painted in oils "in the Greek manner." The Child will be posed on a kind of golden platform, and the mountains and rocks in the background, also executed in oils, will display various colors—and so forth. Finally, it states that the panels must be ready by 8 December, the Feast of the Immaculate Conception. The artists were to receive eight hundred imperial lire or two hundred ducats among them—provided that their painting stood up to the passage of time (people were suspicious of the new techniques: the priors were effectively asking for a ten-year guarantee). One prudent clause provided for the eventuality of Leonardo's leaving Milan before his share of the work was com-

plete; another established the possibility of a bonus, after examination by experts.

The Confraternity was so particular because it was defending a new dogma—the Immaculate Conception of the Virgin Mary—which was at the time a matter of passionate debate.[30] In the eyes of the Confraternity, an artist had no business meddling in theology; he was being asked to illustrate a thesis, rather as an advertising agency might today ask a photographer to provide an image for an idea.

We should also try to understand Leonardo's point of view. He respected the doctrine but wanted to translate it his own way. As an artist, he aspired to being more than a skilled worker: such a position was humiliating. He had his personal contribution to make, the product of reflection, and he could think of more effective forms and symbols than those his patrons sought to impose on him. (No doubt, too, the son of the notary thought contracts were made to be broken.) We may be sure that from the very start, Leonardo had no intention of bowing to the dictates of an outmoded style the "Greek manner"—which he had never practiced.

There would be no gold leaf in the *Virgin of the Rocks* (a name it was given later, for Leonardo never bothered to title his works)—not even the traditional haloes attached to divine figures. Leonardo omitted such accessories as being both archaic and superfluous.[31] Nor would there be brocade or precious fabrics. The Madonna had no need of these trappings to appear in all her glory. There would be no prophet and no chorus of chubby-cheeked cherubs. Against a background of rocks, four figures—the Virgin, a single angel, whose wings are concealed in shadow, the infant Jesus, and the infant John the Baptist—would suffice to portray the moment in the Virgin's life chosen as the subject. It was a far cry from the overloaded icon the Confraternity had in mind.

When Herod learned from the Wise Men that the "king of the Jews" had been born in Bethlehem, he ordered all the newborn boys in the area to be killed. Forewarned by the angel Gabriel, Mary, Joseph, and the Child left at night to take refuge in Egypt, where they lived in the desert until the tyrant had died. An apocryphal legend, based on Saint Luke and divulged in the fourteenth century by the Dominican Fra Pietro Cavalca, says that in their exile, they

met the infant Saint John with his mother, Saint Elizabeth, under the protection of the angel Uriel, for John, too, "was in the deserts till the day of his shewing unto Israel."[32]

This is the subject of Leonardo's painting. The Virgin, seated at the entrance to a cave (a mountain opened miraculously to shelter the Holy Family, tradition said), seems to be presenting her son to the boy who would later baptize him. Here the roles are reversed: Jesus is blessing John, the precursor, who kneels with hands together in prayer while the angel points toward him. Their position seems to echo the words of John: "This was he of whom I spake. He that cometh after me is preferred before me, for he was before me." The water running through a cleft in the rock in the foreground is an allusion to the baptism. The archangel and the saint replace the prophets mentioned in the contract: their presence and their gestures indicate that the prophecy has begun to be accomplished.

The rocks and the cave, traditional symbols of untamed nature in Florentine art,[33] may have had special significance for Leonardo—as would the child in exile, whose father does not appear. As in the *Adoration,* a dark gap opens up between Jesus and his worshiper. Once more, Leonardo has contrived to introduce into a religious painting his own memories and feelings. He portrays an ideal mother, of radiant beauty, still not much more than a child herself, whose only care is for the safety and happiness of her son. She has found him shelter and a playmate; dusk is falling; nothing will now disturb their night.

This painting, like most of Leonardo's works, poses many problems, both of chronological and iconographical character, which will probably never be resolved. Why does the infant Saint John, at whom the angel is formally pointing his finger, to draw him to the spectator's attention, occupy such a predominant position in an altarpiece dedicated to the Immaculate Conception? Saint John was the patron saint of Florence. On this account, and because the Virgin, still a little in the style of Verrocchio, recalls the Virgin in the *Adoration,* because the background reminds one of *Saint Jerome,* because the style of the preparatory drawings and the dark tones of the painting itself (alas, altered by its transfer to canvas and too much retouching) seem to belong to Leonardo's early period, some critics have suggested that he began the work in Tuscany, not in

Milan. In other words, the *Virgin of the Rocks* was not originally conceived for the Confraternity's chapel but was brought with him by Leonardo to Lombardy. I find it hard to believe that he would have encumbered himself with a wooden panel covered in plaster, about six feet long and weighing at least 150 pounds, as fragile as it was unwieldy: no mule could have carried it, so it would have had to be wrapped in cloth and transported by cart. And why bring this one rather than the *Adoration* or *Saint Jerome?* The work commissioned in Milan had to fit into the frame sculpted by Giacomo del Maino: it is all very well to say that this sort of composition was usually about the same size, but it would be an extraordinary coincidence if Leonardo happened to have about him a painting of the Virgin of just the right measurements and with the particular feature that this one has, an arched top—uncommon in Florence. Lastly, it was not usual at the time for a richly endowed confraternity to decorate its chapel with what would amount to a secondhand painting.

It is, however, quite probable that Leonardo had already been thinking about a Madonna with Jesus and Saint John as infants, a very unusual subject;[34] and that by the time he reached Milan, the work was already composed in his head and perhaps on paper—or, if one prefers, that he used a Florentine schema for his first Milanese painting. Changing cities did not necessarily mean changing his "manner." This would also explain why he felt able to sign a contract (assuming minimum good faith on his part) that committed him to finishing the work by 8 December 1483, within eight and a half months. Leonardo's well-known slowness and the small number of his works were the result not so much of a technique that required lengthy waits between applying many coats, or—at this period at least—of any unwillingness to paint, so much as of the trouble he took over the conception of each work. He never began a painting until he had thoroughly mastered his subject. He was incapable of repeating what had already been done by someone else, and only took up his brushes once a revolution in the mind had been accomplished. A radical innovator, a thinker and a perfectionist, he left infinitely more studies and notes than any other Renaissance artist.

The confusion and arguments provoked to this day by the *Virgin*

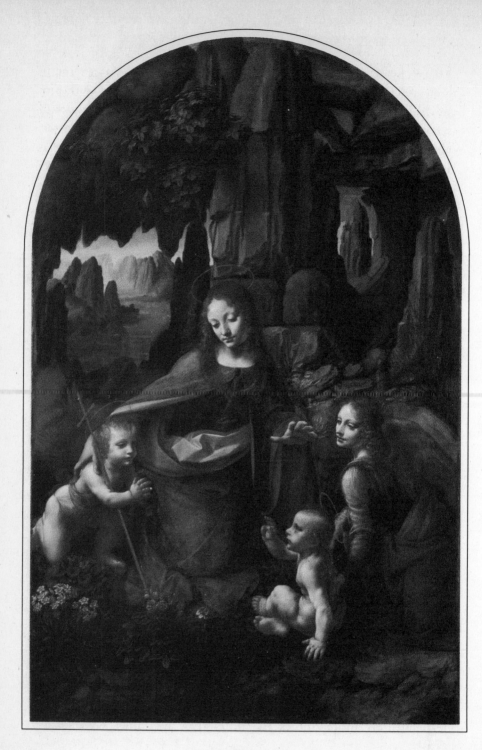

Virgin of the Rocks.
NATIONAL GALLERY, LONDON.

188

of the Rocks largely result from there being two versions of it, one in the Louvre, the other, painted at a later date and in which one detects the hand of Ambrogio de Predis more than that of Leonardo, in the National Gallery in London. Some critics[35] have suggested that there may have been a third version, now lost. The problem also arises from the contradictory and incomplete documents relating to the lawsuit between Leonardo and his collaborators and the Confraternity of the Conception—a lawsuit that went on for over twenty years.

There must have been some delay, though we do not know how serious it was. Above all, it seems that the priors were dissatisfied with the work of the artists they had engaged. Leonardo asked for a supplementary payment of a hundred ducats but received only twenty-five. Experts were consulted, as was usual at the time, and the case was brought before the duke, who seems to have taken his time delivering judgment.

In a spirit of emulation, and having absorbed Leonardo's style to the best of his ability, Ambrogio de Predis had also taken some liberties with the contract: instead of the two angel musicians requested for each of the side panels, he provided only one, "in large format" and without halo or gold leaf.[36] The priors may have resignedly settled for this, but how could they have been satisfied with Leonardo's strange Madonna?

To my mind, Leonardo did make a number of concessions—which give a slightly Gothic air to the painting. For example, the vegetation depicted on the rocks obeys the symbolism of tradition. It tells a *story,* in language that was perfectly intelligible at the time: the ivy in the background stands for fidelity and continuity; the palm and the iris in the foreground evoke both the incarnation of the Word and the peace it would bring to mankind. The blood-red anemone, the flower of sadness and death in antiquity, foretells the Crucifixion. The Confraternity wanted the Virgin to be surrounded by prophets. Leonardo, perhaps out of a concern for realism, preferred to set her in a field of prophetic signs, surrounded by clear symbols of the Passion.

But not everything in this picture can be read so easily; far from it. It is quite likely that when Leonardo unveiled his work, his contemporaries were just as puzzled as we are today by the expres-

sion on the face of the angel Uriel (at whom is it directed?). Just as intriguing is the extraordinary pattern of hands: the spectacular ranging within the same vertical plane of the infant Jesus' fingers raised in benediction, the pointing index finger of the angel, and the outstretched hand of the Virgin, foreshortened, with fingers in a grasping position, both protecting and perhaps threatening; sanctifying—yet reminiscent of an eagle's talons.

Consciously or not, Leonardo composed the *Virgin of the Rocks* around one organizing principle: that of contrast, of opposition, which is likely to disturb the spectator. The peaceful group of the mother, the children, and the *almost smiling* angel is surrounded by a confused background that suggests the end of the world—a chaotic and inhuman landscape, full of hostility. The plants are flowering from a barren rock. The Immaculate Conception, Leonardo seems to be saying, paves the way for the agony on the cross. What ought to be a source of joy carries the seeds of Calvary. The Virgin was born miraculously, was impregnated by the Holy Ghost, and saved her son from the wickedness of men, only to offer Him up to a tragic destiny.

"When I thought I was learning to live, I was learning to die," Leonardo was later to write, paraphrasing Socrates.[37]

The light in the painting, too, provides a contrast to reinforce the logic. Warm sunshine bathes the mouth of the cave in golden light, while all around, the darkness deepens, the shadows become black and threatening. Here chiaroscuro finds a meaningful function.

Might it not also be said that the gestures of the figures are part of the same economy? Those ambiguous hands, greeting, pointing, blessing, and protecting, seem to me to mark the four extremities of a horizontal cross hanging over the head of Jesus like the sword of Damocles: the prophecy is repeated in the sibylline wordless play of signs.

If too many subtle effects are included in a work of art, there may be a risk of irritating the spectator, who turns away vexed at failing to understand it. The public prefers clearly stated emotions; it would rather not make an effort, but if it must, the effort should be quickly rewarded. Curiously enough, in an age when theological questions are losing importance and when a painter is

no longer expected to deliver a message, Leonardo seduces us by his hermeticism, his strangeness. As Julien Green writes of the *Mona Lisa,* "I have heard it said that this painting creates the illusion of life. It does much more; it creates the illusion of dreaming." The *Virgin of the Rocks* similarly transports us into an unreal space and time, defying analysis.

Nothing survives of the reception of the *Virgin of the Rocks* at the time it was painted. But the Milanese cannot have failed to admire Leonardo's impeccable technique, by comparison with the painters they knew. The picture must have caused a certain sensation in *botteghe* and in intellectual circles, as well as in the ducal castle. In fact Leonardo soon obtained a commission from the court.

One must also take into account the state of painting in Lombardy at the time. Whereas Florence could export artists and hardly notice, Milan had not a single great master to its name. Its wealth had attracted first-rate musicians, as well as poets in large numbers if not always with commensurate talents. It had a brilliant university in Pavia, where ninety distinguished professors taught law, medicine, philology, and mathematics. It is significant that the first book in Greek to be printed in Italy, Lascaris' grammar, appeared in Milan in 1476. But the city had hitherto failed to distinguish itself in the fine arts. What is generously known as the "Lombard style" was in fact a hybrid manner, dominated by the influence of Giotto and Pisanello, and later by Tuscan, Venetian, and Flemish influences. Vincenzo Foppa (born in Brescia in about 1420) was probably its best and most typical representative; he was inspired by Jacopo Bellini, before discovering French-Provençal art in Genoa and later visiting Flanders. His undeniable talent flowered rather late in life, when he came into contact with Bramante and above all with Leonardo, his junior by some thirty years. Da Vinci was effectively the founder of the short-lived Lombard school.

At last, it could be said, the city had found its painter.[38]

It is true that Milan already had Bramante: trained in the school of Melozzo da Forli and Piero della Francesca, he was engaged at the time on the frescoes in the hall of arms in the Casa Panigarola.[39] But Bramante's genius found its most forceful expression in architecture; he painted primarily as a decorator, specializing in trompe l'oeil effects. Painting was not his favorite occupation—and it

would hardly be charitable to compare, say, his *Christ* in the Brera museum with the versions by Giovanni Bellini. Although he had a few disciples (Bramantino, Cesariano), Bramante would soon be hanging up his brushes of his own accord.

He was then about forty years old. Vasari, who describes him as a new Brunelleschi, remarks on his genial and kindly character. He had a reputation for bohemianism and composed sonnets more remarkable for their rather black humor than for their elegance and poetry. Portraits of him show a man with a round, powerful face and scant but disheveled hair.[40]

Born near Urbino, of modest parentage, Bramante had studied at the court of Federico da Montefeltro; he traveled to Ravenna, then to Mantua, and in 1477 decorated the facade of the *podestà*'s palace in Bergamo. Then he came to seek his fortune in Milan, arriving three or four years before Leonardo.

Just as da Vinci put his hopes in the bronze horse, so Bramante hoped that the duke, who was thought to have ambitious building schemes, would give him some major architectural project.[41] The two artists quickly became good friends.

In a note about drawbridges dating from the 1490s, Leonardo refers to Bramante, whose real name was Donato di Angelo, by the affectionate diminutive "Donnino."[42] They had much in common. They were in the same position vis-à-vis the city and the duke; they were both interested in mathematics ("He who does not know the supreme certainty of mathematics is wallowing in confusion," wrote Leonardo[43]) and they both admired Alberti.[44] Da Vinci had ambitions as an architect, while Bramante, according to Vasari, liked to improvise on the lute and to listen to music. They could exchange theories and gossip about acquaintances: no doubt they spent many evenings setting the world to rights.

The future designer of St. Peter's in Rome—who was highly esteemed by the court poets, as we know from their verses—was completely free from professional jealousy; he would later introduce his compatriot Raphael to the Vatican, and he may have contributed to the success of his new friend in Milan by praising his talents in high places.

But the time had not yet come for major building enterprises. In

1484, a treaty signed with Venice lessened the chance of war, but a much more alarming scourge—plague—declared itself in Milan. Originating in the east, it had cut swaths through the European population in the fourteenth century and continued to break out at intervals, particularly in the towns and in times of famine. The often heroic efforts of the medical profession were powerless to stop it. Victims were isolated and their clothes and bedding burned after death, but beyond that, people simply resorted to prayers and vows. Gravediggers demanded high wages at such times, so the corpses of the poor lay rotting for days, like those of animals, until the municipality arranged for them to be buried. Plague was thought to be "a foul vapor, the enemy of the heart," produced by infected air, so people thought they would be protected by breathing through a perfumed handkerchief or by holding a posy of herbs or spices to their noses. In fact, the best way to avoid the plague was the remedy made famous by Boccaccio and which the sensible Cosimo de' Medici pithily expressed as "Drop everything and run": to retreat to the countryside, as far as possible from the outbreak, preferably to a high place where the air was purer, and to stay there until the epidemic seemed to be over. "Brother left brother, uncle left nephew, wife often left husband," we read in the *Decameron*. Doomed houses echoed with the desperate cries of the dying, abandoned to themselves. Sometimes the "black death" disappeared after a few weeks, as was the case in Florence in 1479. This time in Milan, the epidemic raged for two long years; the victims ran into tens of thousands, and possibly as many as one in three townspeople died.

The duke left town. Taking his astrologer's advice, he ate no more oysters or other perishable food, kept all his visitors at a distance, and did not open any letters until they had been "purified" with strong perfumes.[45] Leonardo says nothing of the horrors of the plague; but just as war had excited his curiosity about weapons, so the sufferings of the Milanese focused his mind on problems of hygiene and town planning. At first this was a theoretical interest, inspired by the treatises of Alberti, Vitruvius, and Filarete: it is also possible that the idea first came to him in conversation with Bramante or Francesco di Giorgio Martini,[46] who was to redesign the great ducal piazza of Vigevano.

Leonardo jotted down a few notes on paper: he was by now in

the habit of writing everything in his notebooks. He envisaged an ideal city, built along the banks of a river, from which all risk of plague would be eliminated. Before long he was drawing up the plans, illustrating the principal aspects, and developing details.[47]

Starting from the premise that overcrowding in cities was the cause of the evils that befell them, he imagined dividing Milan into ten towns of five thousand houses, each town providing thirty thousand dwellings. "In this way," he wrote, "you will disperse the mass of people who are now herded together like a flock of goats, filling every corner with their stench and spreading pestilential death."[48] There was to be horizontal as well as vertical reorganization: in the new cities, crisscrossed by canals, which would provide transport as well as irrigating kitchen gardens and washing the streets by means of mills and locks, life would be lived on two levels. The upper zone, a sort of pedestrian area, would be reserved for "gentlemen" and noble buildings; the lower level, directly communicating with the canals, which were partly underground (although Leonardo firmly distinguishes them from the sewers), would be reserved for the circulation of beasts and merchandise, and for the dwellings of shopkeepers and artisans, as well as of the ordinary people.

Though to our eyes a terribly elitist project, it claimed to "relieve the infinite hardships" of the poor *(poveraglia)* and improve the quality of everyone's life by calculating the width of the streets from the heights of the facades, by bringing as much light as possible inside the houses, and by inventing a system of chimneys that would disperse smoke high above roof level.

He devised gutters along the pavements and was particularly concerned with the disposal of waste, which he wanted to be discreet and regular. For public buildings, he advised spiral staircases, since he had observed that people had the irritating habit of using the dark corners of square staircases to relieve themselves. He wanted to provide more lavatories; since he left nothing to chance, he designed his own model, which is astonishingly modern: "The seat of the latrine," he wrote, "should be able to swivel like the turnstile in a convent and return to its initial position by the use of a counterweight; and the ceiling should have many holes in it so that one would be able to breathe."[49]

Drawing for a City on Two Levels.

When the authorities decided to improve the poorest (and there-fore most plague-stricken) quarters of Milan, in the early 1490s, Leonardo was able to apply his theories to actual conditions. He began by calculating the dimensions of the city, its suburbs, and its *navigli,* in order to draw up a very large-scale plan. He sought out maps, researched the subject, and wrote in his notebook (as if in a diary) that there was "a book about Milan and its churches in the last bookshop going toward Cordusio."[50] Reasonably enough, he proposed to try out his notions in a district that ran between the old and new fortifications from the Porta Romana to the Porta Tosa (now the Porta Vittoria), representing about a tenth of the city's surface area.[51] Pedretti describes it as a "pilot scheme."[52] One of the sketches, later inked over, shows a central piazza, surrounded with

arches, on which Leonardo has written "market." This square dictates the symmetrical arrangement of streets and canals; on one corner of the page is a sort of residential unit. But the most remarkable aspect of his program was the novel concept of splitting up the city, the "decentralization" he proposed. If it had ever been realized, his ideal city would have consisted of a string of separate settlements, freed of the usual straitjacket of city walls and (topographically at least) independent of castle or church, with each sector organized around a civil and commercial center, the town square, and the market or *forum*—as modern towns are.

This futuristic town planning does not seem to have caught on; it was not followed up, and I can find no evidence of the plans' influence on architects either at the time or in the years ahead. Did Leonardo even show them to anyone in authority? In about 1493, writing legibly from left to right in red chalk, he drafted salutations for a memorandum: "To the most illustrious and excellent . . . To my most illustrious Lord Ludovico . . ." He did not finish the letter but instead agonized over how to sign: "Leonardo da Vinci of Florence, etc." or just "Leonardo"?[53] He thought a good deal about the means of financing the project and rehearsed the economic, political, and social advantages it might bring the duke: "profit," "eternal renown," and so on. One gets the impression that this memorandum, like the earlier one about military engineering, never got beyond the draft stage. When he develops his arguments in these documents, Leonardo cannot prevent himself from addressing his interlocutor, as was his usual way, in the second person singular *(tu):* "You will receive revenue from these dwellings. . . . The community of Lodi will build a customs house and receive from it the sum of money it will annually send you. . . . The receipts will increase with the fame of your greatness."[54] This was not how one spoke to princes. Once more, we do not know how serious Leonardo's intentions were or whether he really believed in what he was proposing. That he was serious and indeed passionate about the designs, there can be no doubt. But I have the feeling that he was often building castles in the air—and was well aware of it.[55]

The plague seriously disturbed the city's activity but did not paralyze it: people quickly learned to live with death. Florentine

moralists declared that the plague allowed incredible fortunes to be made overnight and that it encouraged licentiousness rather than piety.[56] In the seventeenth century, Samuel Pepys was to note: "This sickness makes us more cruel to one another than if we were dogs."

In 1484–85, Leonardo no doubt continued to work as usual, perhaps still in the Predis *bottega*. He was painting, studying, and preparing a sort of "portfolio" in order to obtain the commission for the bronze horse. According to Sabba de Castiglione, he devoted sixteen years to this sculpture;[57] he certainly appears to have begun thinking about it very early and to have been sketching horses and considering ways of casting a large-scale work in bronze from the moment of his arrival in Milan. He was probably not the only artist to be chasing the contract. Others must have been in the running— from the day in 1472 or 1473 that the Sforzas decided to raise a statue honoring the founder of their all-too-recent dynasty.[58] The Mantegazza brothers of Lombardy had already been approached, as had the Pollaiuoli, who were famous throughout Italy. If he was to be chosen, Leonardo would have to produce a particularly origi nal and convincing portfolio.

At the time, the problem of the equestrian statue was occupying the minds of many artists, just as that of the bronze door had fascinated the generation of Ghiberti, Brunelleschi, and Jacopo della Quercia.[59] It was thought that the art of casting a large horse with its rider had been lost during the Dark Ages. Could any contemporary possibly rival the statue of Marcus Aurelius on the Capitol (4.24 meters high) or the magnificent *Regisole* in Pavia? The subject had been tackled in paint, by Paolo Uccello and Andrea del Castagno in the cathedral at Florence, but the real difficulty was in the molding and casting, not in the design: the sculptors were held up by lack of technology. Donatello, taking the *Marcus Aurelius* as inspiration, had made the first monumental bronze equestrian statue since antiquity: the *Gattamelata* in Padua, 3.20 meters high, erected in 1453.[60] Verrocchio was at this very moment trying to outdo him with his *Colleoni* in Venice. Leonardo's imagination was fired equally by the subject, since it involved a horse, and by the technical problem. At the same time, it provided a splendid occasion for him to rival his master.

He began to win the confidence of Ludovico, it seems, by paint-

ing the portrait of the duke's mistress of the moment, Cecilia Gallerani (a picture now thought to be the *Lady with an Ermine* in the Czartoryski Gallery in Cracow[61]). This was probably good tactics.

The Sforzas, "those heroes of patience and cunning who built themselves up from nothing," as Michelet called them, had always been much given to sexual adventures. Muzzo Attendolo, the soldier ancestor who had given the ducal dynasty its name[62] (*sforzare* = to force; he was said to have had Herculean strength), passed on to his descendants three pieces of advice: never touch another man's wife; never strike a servant or a companion, but if this should ever happen, get rid of him as fast as possible; and never ride a horse with a hard mouth or inclined to cast its shoes. His successors respected the last precept a good deal more than the first. His natural son Francesco (the one to be immortalized in bronze) had a special secretary to handle his vast amorous correspondence and left as many bastards as legitimate children. The oldest of the latter, the brutal and prodigal Galeazzo Maria, inherited power and may have poisoned his mother, *"donna di animo virile—troppo virile."* It was said that "he did things too shameful to write down."[63] He bought wives from their husbands, with money or estates, sometimes in front of a lawyer. When he was tired of them, he frequently ceded his conquests to friends: the conquests concerned apparently did not object. This was the man who during his visit in 1471 had both dazzled the Florentines and shocked them by his impiety. His cruelty and wickedness, as well as his vices, finally led to his assassination: "three students, inflamed by reading stirring passages in Livy," as Stendhal put it, "stabbed him to death in front of the church of Santo Stefano on the day after Christmas, 1476." On his death, the heir to the dukedom, Gian Galeazzo, was only eight years old. His mother stood regent for a while but made the mistake of falling in love with the palace steward, whom she elevated to various dignities, thus bringing about her ruin. Ludovico Sforza, the fourth son of Duke Francesco, took advantage of her indiscretion to assume guardianship of the young prince and become master of Milan *de facto* if not *de jure* (he was still only duke of Bari). He declared with some hypocrisy: "I take up the burden of power and leave the honors of it to my nephew."

Ludovico Sforza.

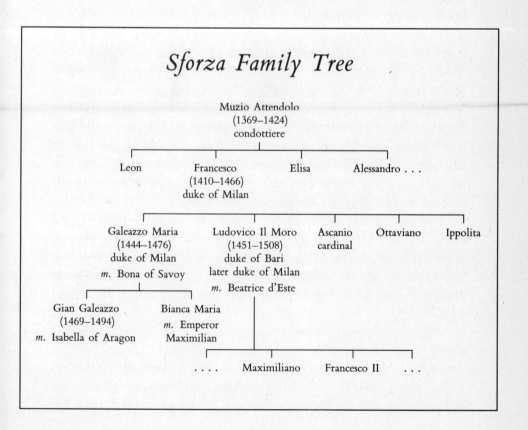

Sforza Family Tree

Muzio Attendolo
(1369–1424)
condottiere

Leon Francesco Elisa Alessandro . . .
(1410–1466)
duke of Milan

Galeazzo Maria Ludovico Il Moro Ascanio Ottaviano Ippolita
(1444–1476) (1451–1508) cardinal
duke of Milan duke of Bari
m. Bona of Savoy later duke of Milan
 m. Beatrice d'Este

Gian Galeazzo Bianca Maria
(1469–1494) *m.* Emperor
m. Isabella of Aragon Maximilian

. . . . Maximiliano Francesco II . . .

Ludovico had been born at Vigevano in 1451, so he was only a few months older than Leonardo. Nicknamed "the Moor" (Il Moro)—less because of his dark hair and skin than because one of his given names was Mauro—he put on his coat of arms a Moor's head and a mulberry tree[64] (*moro:* these puns were much appreciated at the time). The nickname did not really help his fortunes; rather, it promoted a reputation of being cowardly, harsh, and treacherous. Leonardo, who served him for thirteen or fourteen years, himself wrote of "the justice of the Moor, as black as himself."[65]

Ludovico was not, however, a cruel man. Unlike his late brother, the duke of Milan, he took no pleasure in bloodshed, nor did he have his enemies hanged, drawn, and quartered. When there was an attempt on his life, he had the chief culprit executed without the usual excesses and sent his accomplice to prison with the instruction that every year on the feast of Saint Ambrose he was to receive two lashes of the rope: for the time, this was incredible magnanimity, bordering on weakness.

He was a complex man, this new patron of Leonardo's. Apparently thoroughly self-satisfied, pragmatic, and superstitious, he had the fleshy face of the *bon vivant;* with age, he developed heavy jowls and a double chin. At the same time, one senses in the darting eyes and greedy lips insatiable ambition. This, combined with overweening confidence in his own intelligence and good fortune, made him gamble with the destiny of his state as if speculating on the futures market. A few profitable operations encouraged him to take greater and greater risks, to try ever more impossible combinations. In his fall, he would drag all Italy down with him.

A popular song attributed the following words to him: "I said there was one God in heaven / And on earth one Moor / At my good will and pleasure / I made peace or war." Did he derive this impudent vanity from his father's official poet, Filelfo, the venal author of a mythmaking *Sforziad,* who compared himself to Virgil or Cicero?

Ludovico's ambitions were not confined to politics. Comparatively well educated (he knew Latin and prided himself on his oratory) and having spent some years of exile in Tuscany, he invited to his court the Florentine writer Bernardo Bellincioni, so as to refine (as he put it) "the coarse speech of the Milanese." He took

as his secretary a distinguished Hellenist scholar, who founded two schools at his own expense.[66] In seeking to turn his city into a new Athens, he was striving to imitate the Medici (after the fall of that family, he tried in vain to buy Lorenzo's fabulous collection of intaglios). Hence the prefabricated and artificial character of his "cultural policy": all the Milanese poets seem to have made it their prime concern to flatter his family.

The Moor had seduced "a young Milanese girl of noble blood, as honest as one could desire," soon after taking power, when she was only fourteen years old. By now Cecilia Gallerani was seventeen. She played the lute and composed a little poetry, so the courtiers called her a "modern Sappho," into which not too much should be read. She was very pretty, and people admired her for having kept the favor of the inconstant Ludovico: one by one, she eliminated all her rivals, moved into the palace, obtained from her lover an estate out toward Saronno, and despite her youth managed to secure her place as first lady of the duchy.

In Leonardo's notebooks there is a fragment of a letter beginning "Magnificent Cecilia, my beloved goddess . . ."[67] Some interpreters have read these words as addressed to Ludovico's mistress and thereupon invented a highly romantic scenario in which the painter falls in love with his model. The problem is that the words were written by a right-handed person, probably in Rome in about 1510 (the writing is rather like Raphael's).

Some critics have refused to recognize Cecilia in the portrait in Cracow (which bears a misleading eighteenth-century inscription: "La Bele Feroniere / Leonard d'Awinci" [sic].)

But plenty of factors allow us to identify the *Lady with an Ermine* with Gallerani. First, the slim oval face, just on the point of smiling, recalls the angel Uriel in the *Virgin of the Rocks:* they seem to belong to the same period. Second, the poet Bellincioni is known to have composed some verses about Leonardo's portrait of the Moor's mistress, in which he says, "nature herself is jealous, since the beautiful young woman is so lifelike that she seems to be listening and only lacks speech." The attentive air of the model for the Cracow picture could fit this description. What is more, she is holding an ermine or a marten, an animal kept since antiquity to chase mice.

The ermine was one of the innumerable emblems of the duke. Finally, the Greek for ermine is *gale,* allowing a play on words with the name Gallerani: as we have seen, Leonardo used the juniper to symbolize Ginevra de' Benci.

The painting is in poor condition: it is hard to imagine what it must have looked like originally. The background is too dark and has been crudely painted by a restorer, who damaged the lines around the head, shoulder, and hand. The smooth hair looks as if it is tied under the chin: originally this was a transparent veil, now clumsily retouched. The left hand has probably been painted out, and examination under X-ray has revealed that a door or window was planned behind Cecilia's shoulder. It is possible that Ambrogio de Predis collaborated in the painting: the ermine and the flesh of the sitter seem indisputably to be by Leonardo, but perhaps not the clothes and hair.

It may seem extraordinary to us that artists of dissimilar and often unequal talents should collaborate on a work. But in Leonardo's time, a painting was sold in advance, and the painter was working not for himself but on commission. The artist was not yet inspired by an irresistible desire to express himself, his work was not the flesh of his flesh, however great the effort or the passion he put into it: it only half belonged to him. In this case, Leonardo was continuing to use his Milanese colleague to make his way at the Lombard court. He was always less concerned with the finishing of a picture than with its conception. His ideal would consist of imagining the picture and getting someone else to paint it: invention was what mattered most to him. Painting was above all "a thing of the mind."[68] As he clearly put it, "To reflect is noble, to realize is servile."[69]

Another possible fruit of collaboration with Ambrogio may be the *Lady in Profile* in the Ambrosiana in Milan,[70] an attractive portrait that contains no surprises. The *Madonna Litta*[71] in the Leningrad Hermitage—so often copied by Lombard painters—and the *Portrait of a Milanese Lady* in the Louvre (also erroneously known as *La Belle Ferronnière*[72]) are in all likelihood collaborative works as well. The overall design and the intention suggest the master; certain weaknesses (stiffness and academicism) or shortcuts suggest the pupil. In later years, Leonardo would entrust to disciples

the entire execution of certain paintings. It seems that he gave them a cartoon (a drawing ready for transfer to a panel), or sometimes only a sketch, and let them work on it as they pleased, being content to advise from a distance. Critics have not failed to note that Ambrogio de Predis, Leonardo's first emulator in Milan, surpassed himself during these years, whereas his talent seems to have vanished as soon as he no longer had Leonardo at his side. The pupils were not "ghosting" for Leonardo, and no deception was being practiced. He never signed their works: unlike Corot, he did not do favors for friends in need, nor was he their victim. The Renaissance was an age of copies and imitations, but forgery was practically nonexistent, except perhaps of antiquities. Today, we attach a far more clear-cut—and therefore narrowly proprietorial—notion to the work of art. There was no such thing as artistic property in those days, and I do not think that Leonardo would have minded at all that his style and his "concepts" were divulged to others. He himself invokes the image of the military leader: "It is his soldiers, not he, who have won the victory, but they were following his instructions, so he merits the laurels."[73] I would say that Leonardo, who retained much of the spirit of Verrocchio's *bottega* (the latter, after all, behaved in much the same way), was something like a famous dress designer in our day who designs for both *haute couture* and the ready-to-wear market; he may grant licenses to use his name but is not always protected against plagiarism. Some designs are essentially in his hand, others are produced by a team of associates working directly under him, while others again may emerge from different fashion houses entirely, with or without permission. At the end of the day, Leonardo would have been perfectly satisfied: his followers would be helping to make his vision known, promoting his reputation, even "advertising" his work; and I imagine that his immediate disciples paid him part of their earnings. Faced with the innumerable pictures "after Leonardo" found in museums, instead of praising or blaming the work of the executor we ought rather to try to rediscover the conception of the master, since that has not always survived. Leonardo painted very little—and consequently did not repeat himself. ("Always attentive to nature, consulting it constantly, he never imitates himself," as Delacroix wrote in his *Journal* on 3 April 1860.) He left this thankless task to others; their hybrid

works, in spite or because of their faults, illumine, continue, amplify, and reinforce his own.

We have almost no information about Leonardo during the 1480s. It is thought that on 16 March 1485, when the plague was at its height, he observed the total eclipse of the sun recorded by the chroniclers, since on one page of a notebook[74] he draws a device for studying it without damaging one's eyes. Numerous documents testify that in 1487, he participated in a competition for the design of the crossing dome for Milan Cathedral. But that is all: we know nothing about how he lived. From this gap in the records, some historians have concluded that throughout these years Milan remained closed to him, that he waited in vain, in poverty and obscurity, for the devious Ludovico to take some interest in him. But the *Virgin of the Rocks* and the portrait of Cecilia Gallerani (not to speak of other possible but missing works) are sufficient to tell us that Leonardo was in favor at court by 1485. He would certainly have left the city if its promises to him had not been kept one way or another. My feeling is that while he started almost from scratch and did not have the good fortune to become successful overnight, he nevertheless slowly and steadily improved his standing. Leonardo was not given to hurrying things, nor did Ludovico grant his confidence easily. By the end of the decade, however, Leonardo was numbered among the most prominent artistic personalities at court.

If one looks closely at the details of his design of the cathedral crossing dome, or *tiburio,* one finds that by 1487, he had become fully integrated into Lombard cultural life—which seems to indicate a degree of success.

Nothing is dearer to the heart of a Milanese than the city's cathedral, so unjustly underrated. This enormous white marble building is like nothing else in the world—this "sublime folly," as Taine described it, bristling with spires, pinnacles, and statues, which foreigners all too often describe in terms reminiscent of lace or wedding cakes. No other building has taken so long to complete: work began in 1386, refinement after refinement was added, and it was still receiving finishing touches at the beginning of this century. The French and German master builders who erected it were the first to be perplexed by the strange proportions requested by their pa-

trons. They criticized the plans and were dismissed; Italians took their place. One could fill a page with the names of the contractors alone. The architecture is hybrid, entirely subordinated to decoration—in fact, to an orgy of decoration, as its fiercest defenders would probably have to allow. Personally, I have a soft spot for this neo-Gothic monstrosity. The monstrous can sometime verge on the divine.

The ground plan of the Duomo is simple enough, but the building, especially the apse, is composed of such extraordinary inclined planes that no one could work out how to finish it off without spoiling its overall coherence. At the period that concerns us, the facade was not even begun. It was thought desirable to demolish the temporary cupola on top of the building, since it was threatening to collapse, and to build over the meeting of the transepts an elegant and solid *tiburio*. Luca Fancelli, a former disciple of Alberti, who was called in as a consultant by Ludovico, predicted that since the cathedral was "lacking in framework and measurements, this would not be easy."[75] The structure would have to be built at a height of over fifty meters from the ground and balanced on four slim pillars.

The competition was open to all comers: entrants included Leonardo, Bramante (who withdrew from completing Santa Maria di San Satiro to participate), the great Francesco di Giorgio Martini, and other renowned architects from the various Italian states.

Leonardo had been considering the problem since his arrival in Lombardy;[76] it was a subject of debate for everyone in Milan. As usual, he studied the data carefully, then imagined every possible solution, before concentrating on one in particular and moving from theory to practice.

On 30 July 1487, the joiner Bernardo di Abbiate received an advance for the construction of Leonardo's model. It took thirty-four days' work to complete it. To cover his expenses, Leonardo himself received sixteen imperial lire, paid in two installments (8 August and 30 September), and another forty on 11 January 1488. This is surely evidence that those in charge of building the Duomo recognized him as an architect.

The draft of a letter to them has survived. He explains that the "sick cathedral" needs above all a physician-architect, that only perfect knowledge of the causes will make it possible to erect a

tiburio both durable and in accord with the rest of the building. "My model," he goes on, "possesses this symmetry, concordance, and *conformità* appropriate to the building in question. . . . Do not allow yourselves to be influenced by any passion, but choose either me or someone who has succeeded better than I in demonstrating what a building is, and what the rules of correct building are, and the number and nature of the parts into which it is divided."[77]

We might be tempted to think that Leonardo was bluffing again, but no: he was by now fully versed in the science of masonry, and it was as a professional that he spoke of stonework and buttresses or compared the relative merits of various kinds of arch (he had a nice expression to describe the arch: "a strength springing from two weaknesses"[78]). He still had no building to his name, but during the preceding years he had never ceased reading, observing, and asking questions, learning and thinking. Some of his sketches remind us that he had grown up on the teachings of Brunelleschi, from the time when Verrocchio was making the ball for the Duomo in Florence. Others indicate that he had examined a number of new buildings right down to their foundations, compass or lead line in hand. And some of his sketches propose quite original solutions—ones his colleagues would adopt some ten or fifteen years later.

In his letter, Leonardo compares the Duomo to a living organism—which he diagnoses as sick. This was no mere figure of speech: Alberti and Filarete, following Vitruvius, had developed the idea of anthropomorphic and proportional architecture: the pillars and ribbing of a building were compared to human ribs, the transepts to arms, the apse to the head. In between Leonardo's sketches for the *tiburio,* we find drawings of legs[79] and reflections on health and sickness that repeat what he had written to those in charge of the works,[80] as well as sketches of the human skull (which he called "the house of the mind"), seen in section as if in an architectural design. If architecture was to be in the measure of man, the architect should know "what a man is, what life is." His first personal anatomical works date from this period.[81]

I am not suggesting a direct cause-and-effect relationship— Leonardo must have studied anatomy since his apprenticeship. Rather, his interest in the art of building led him to renew his acquaintance with anatomical study. In his view, all branches of

Sketch for the Tiburio.
TRIVULZIO MANUSCRIPT, MILAN.

knowledge were connected and interdependent, and man was always at the center. "Man is the model of the world," as he put it.[82] Meditating on the *De Architectura* of Vitruvius, in which it is stated

that the human body is constructed on the basis of the square and the circle, Leonardo produced his famous Venice drawing, known as "the Vitruvian man," showing a nude figure with outstretched limbs in various positions, inscribed within the square and the circle. He could have dictated the following sentence from the *De Divina Proportione* by his friend Luca Pacioli: "The Ancients, having taken into consideration the rigorous construction of the human body, elaborated all their works, and especially their holy temples, according to these proportions; for they found here the two principal figures without which no project is possible: the perfection of the circle, the principle of all regular bodies, and the equilateral square."

At this time, Leonardo devised all sorts of buildings based on a centralized plan, in which all the parts are symmetrically developed around radii passing through their centers, as in a rose window or in the drawing of Vitruvian man. This human geometry was the utmost expression of the unity and perfection of the universe. Bramante may have been inspired by these drawings in his *tempietto* of San Pietro in Montorio and in his original plans for St. Peter's in the Vatican. Meanwhile, Leonardo would gradually come to imagine that the earth itself was made in man's image: "The earth," he wrote, "has a vegetative life; its flesh is the soil, its bones the disposition and assembly of rocks that form the mountains; its cartilage is limestone, its blood the living streams."[83]

Similarly, he established a relation between the movements of the eye and the mind and the rays of the sun.[84] Nothing could be born, he thought, "where there exists no sensitive fiber or rational life."[85] His idea of the human machine spilled over into his engineering projects, and vice versa. He discussed botany with the vocabulary of an embryologist or gynecologist,[86] while he tackled anatomy in the spirit of a geographer. "The cosmography of the *mondo minor* [minor world or microcosm] will be revealed to you in twelve entire figures," he writes, "in the same order as Ptolemy followed in his cosmography. Thus I shall divide the limbs as he divides the earth into provinces; then I shall speak of the functions of each part of the body in its own place, putting before your eyes a representation of the whole form and substance of a man, and every local movement by means of its parts. May the Creator grant that I be

Study for a Centralized Church.

Vertical and Horizontal Sections of the Head.
ROYAL LIBRARY, WINDSOR.

capable of revealing the nature and customs of man, just as I can describe his figure."[87] Everything is in everything, he seems to be saying here, and everything refers back to the circle and to man.

This approach was to lead him into error more than once—for example, when his geology and physiology became confused, allowing him to believe that rivers come from underground watercourses originating in the depths of the sea, instead of from the rain and snows of the mountains.[88]

The entrants presented their models for the crossing dome in 1488 or 1489. Those in charge of the works took their time in judging. Finally, on 13 April 1490, they made the prudent and politic decision to entrust the execution to two Lombards, Giovanni Antonio Amadeo[89] and Gian Giacomo Dolcebuono, asking them to prepare a model that took account of all the submitted designs.

The whole affair was quite complicated. On 31 May, the architects met to try to devise a compromise. They discussed it at length without managing to agree. Yet Bramante claimed that it would have taken less than an hour, "taking a bit from one model and a bit from another," to produce an ideal version. Ludovico then summoned Francesco di Giorgio, Giovanni Antonio Amadeo, and Leonardo to Pavia (because he wanted their opinion on the cathedral of the latter town). Finally all the competitors met for one last discussion, on 27 June, in the Castello, in front of Ludovico himself, the archbishop of Milan, and the elders of the council of works.

On 11 September, the archbishop laid the foundation stone of the *tiburio* (which would be completed in 1500). But who had won the competition? Giovanni Antonio Amadeo conducted the site work without taking any notice of the solutions proposed by Francesco di Giorgio, although these had been officially adopted. The final design was an all Milanese one: perhaps the whole thing was a foregone conclusion.

Since Leonardo's name does not figure in the last report of the committee, several historians have thought that he must have withdrawn from the contest in early June. But one should remember that the final design was only an amalgam of all the entries submitted. It is possible that Francesco di Giorgio (who had the backing of the duke) worked out the final design in conversation with Leonardo during their journey to Pavia or in the inn, the Osteria del Moro, where they stayed. I suspect that da Vinci did not put forward any plans on 27 June (or send his model to the council of works, as he ought to have done) not because he was dissatisfied with his

work, but because his model had already been taken into considera-
tion and his ideas already incorporated into those of his more
famous colleague—and perhaps because he had a shrewd idea what
would happen in the end.[90]

I do not think Leonardo would have been particularly disap-
pointed at not being chosen by the cathedral churchwardens. The
role of consultant or adviser (which he would play again, like
Alberti, his role model, for the building of Pavia Cathedral and for
various palaces and villas) entirely suited him, and he acquitted
himself honorably in such circumstances. He would have been
somewhat embarrassed in any case if he had had to take over the
management of a building site at this point, because at last (we do
not know exactly when or how) he had secured his heart's desire,
the commission for the bronze horse. Moreover, he was being asked
to carry out several works for the ducal palace; he was passionately
pursuing his interests in twenty or more subjects; and his life had
taken a new turn: he was about to "adopt" a young boy. One
wonders how he found time to fit everything in.

VII

Thoughts Turn to Hope

When fortune comes, seize her firmly by the forelock,
for, I tell you, she is bald at the back.

—LEONARDO[1]

Study for the Sforza Monument.

I N 1490, with the coming of peace, the whole of Italy was going through a phase of extraordinary prosperity. All the Italian states witnessed a degree of political stability. In Milan, as people recovered from the horrors of the plague, they began, according to the chroniclers, to think of nothing but getting and spending, in some cases to excess. "Pomp and voluptuousness were given free rein. . . . Our prince's court was dazzling, full of new fashions, new costumes and delights," wrote the honest Corio, who, in the picture he drew of this age of plenty, admitted that morals declined once more, while the arts progressed.[2]

Moralists, from Machiavelli to Montesquieu, have always warned against these ages of felicity, when, they warn, societies grow soft and virtue is corrupted. But it was during this time of general exaltation, when any fancy seemed capable of realization, that Leonardo's many talents finally came into their own.

With the granaries full and arms laid aside, the duke now set about embellishing his capital, which stood in great need, as did the nearby towns of Pavia (the cultural center of the state) and Vigevano (his birthplace and therefore dear to his heart). Some buildings were demolished, others rebuilt and enlarged; gardens were laid out, streets paved, and facades decorated. Hence the prominence of architecture and town planning among Leonardo's preoccupations during these years. A Renaissance artist had no choice:

once more, he adapted his anxieties and aspirations to the desires of the prince.

But architecture was a calling with frontiers even less clearly defined than those of painting. The term "architect" hardly ever appears in the documents: the preferred term was "engineer"— which may have reflected reality more accurately. Leonardo's name, like Bramante's, usually appears with the label *ingegnero* in the ducal archives (sometimes, more officially, as *ingeniarius ducalis,* or *ingeniarius camerarius*).

How did one become an engineer-architect? In the same way that one became a painter, although theory played a greater part in the training: one learned on the job, assimilating by example traditional techniques, studying the achievements and writings of one's contemporaries—and then, paradoxically, those of the ancients, if one wanted to be up to date.

In Pavia, Leonardo asked the workmen questions about consolidating walls;[3] he redesigned a paleo-Christian church (Santa Maria alla Pertica);[4] he sketched the ruins of a Roman theater, whose acoustic qualities inspired him to design a "place for preaching,"[5] then a "theater for hearing mass."[6] At the same time, he was always on the lookout for any learned book of which he had heard: "Messer Fazio[7] owns the *Proportions* of Alchino with the commentaries of Marliano," he notes; or "A nephew of Gian Angelo the painter has a book on waterworks which belongs to his father."[8] He also had the run of the very rich library of the University of Pavia.

The exemplary career of Francesco di Giorgio Martini, from whom Leonardo took much inspiration, well illustrates what was expected of an engineer-architect and all the various tasks he might be set. Born in Siena in 1439, Francesco di Giorgio trained as a painter and sculptor, before being put in charge of the waterworks (in other words, the drains), fountains, and aqueducts of his native city. Later, in Urbino, he was employed as military architect by Federico da Montefeltro, whom he served during his many campaigns: he knew not only how to build fortresses and fortify towns but also how to besiege and destroy them. Much in demand, he was constantly on the move; while never abandoning painting and sculpture, he also designed several civil buildings—palaces and churches. Lastly, he wrote the obligatory treatise that established

Stretching Device and Volute Gear.

one's reputation. His was in three parts: the first devoted to architecture in general, the second to fortifications, and the third to machines, *ingegni,* for civil or military use: transmission systems, gears, flyball governors, cannon, "self-propelling" vehicles with wheels that were both propulsive and directional, drainage pumps, clocks, paddle boats, and diving suits for underwater attacks.[9]

The list ought not to surprise us. The architect, like the painter, made his "tools" himself: in order to erect a column, he had to devise some way of carrying it and then setting it up on its base. Since there was only a limited range of energy sources (animal, human, wind, or hydraulic), the machines devised, usually made of wood, all obeyed simple principles: they used the screw, the windlass, the cogwheel, and the spring, and every engineer tried to increase their efficiency and reliability. Even for someone like Leonardo—who was plunged into a kind of ecstasy by devising never-

ending systems of cogwheels and screws—it was less a matter of discovery than of perfecting other inventions and finding novel uses for them. He himself said: "Nothing can be described as the result of new research."[10]

The engineering profession, with its origins in military works, had called for versatility in its practitioners since antiquity. According to Vitruvius, who wrote in the time of Caesar, the engineer's trade encompassed mills, bridges, temples, excavators, cranes and hoists, battering rams, scorpions and other siege machinery, as well as industrial machines such as might be used in sawmills, dikes, hydraulic installations, pumps, fountains, canals, locks, even water clocks—in short, practically anything that could be built or was used for building or demolishing. In fifteenth-century Italy, the words for "machine" and "building" were practically interchangeable.[11]

So it was quite normal that Leonardo should tackle very disparate works while hoping for the post of engineer to the duke—and *a fortiori* when he had obtained it. But with Leonardo, versatility took on particular dimensions—and gradually came to look as if it conformed to some master plan.

In 1489, Leonardo reminds himself in a long memorandum[12] to take the measurements of the Castello Sforzesco and other buildings in the city; to ask a certain Master Antonio "how to install bombards and ramparts by day and by night"; to explain to Giannino, a manufacturer of bombards, "how they built the tower of Ferrara without loopholes"; to study the "crossbow of Master Gianetto"; to consult various mathematical books and to have demonstrated to him "the squaring of the triangle"; to seek out a hydraulics expert and to find out about "dams and their cost"; he notes that a stonemason, Pagolino, known as Assiolo, is a skillful hydraulic engineer, and so on. From this text, we discover that Leonardo was in touch with various artisans, with a monk from the Brera convent, and with academics, notably the family of the professor of medicine and mathematics Giovanni Marliano, to whom he refers frequently and from whom he wishes to borrow "a bone,"[13] for unspecified reasons, as well as a "fine herbal."[14] A few lines indicate that he was as enthusiastic as ever about astronomy: he writes on the same page

that a Frenchman[15] has promised to reveal to him the dimensions of the sun and that a treatise by Aristotle on the heavenly bodies has just been translated into Italian. Finally, in the midst of these serious preoccupations, he reminds himself to ask the rich Florentine merchant Benedetto Portinari "how they run on the ice in Flanders." Was he thinking of going skating?[16]

Although I have grouped the entries in his memorandum by theme—armaments, architecture, hydraulics, mathematics, astronomy—Leonardo writes things down in no order at all—and even these headings do not cover half his activities at the time. One should really set them down just as he does, to convey the flavor of his life in these years, when he had apparently abandoned painting but was enjoying better material prospects. They were years in which his curiosity and obligations took him in so many different directions that it becomes almost impossible to trace his steps in any sort of chronological order.

The notebooks he was now filling contain observations on optics (reflections on light and shade), anatomy, watchmaking, acoustics, mechanics, and general physics. At the same time, without forgetting the equestrian statue, he was no doubt executing a number of small commissions for the duke: perhaps the delicate fountains with spiral plinths of which the designs have survived;[17] or the device to "raise and lower the curtains concealing the duke's silver" (probably the curtains of a display case in which Ludovico kept gold and silver plate), a record of which appears among the plans for the *tiburio* of the cathedral.[18]

At later dates, he designed, among other things, an olive press;[19] counterweights to make a door close automatically;[20] candelabras[21] (proving that he had not forgotten the teaching of the ex-goldsmith Verrocchio); a variable-intensity table lamp[22] and another which would produce a very bright light;[23] some folding furniture;[24] locks for chests;[25] mirrors (in particular the octagonal mirror that would multiply indefinitely the image of a man standing inside it, which he may have used for his self-portrait[26]); a therapeutic armchair;[27] a bathhouse and a washhouse;[28] a crane for emptying ditches.[29] I believe that it was essentially for work of this kind (as well as on account of the bronze horse) that he was eventually promoted to the rank of ducal engineer.[30] His "ingeniousness" and good taste,

Machine for Emptying Ditches.

CODEX ATLANTICUS.

and particularly his fertile and inventive mind, led to an increasing role in staging the various feasts that were held for the court's entertainment. This was all in the day's work for the engineer. In the same year, 1489, he probably helped with the preparations for the marriage to Isabella of Aragon of Ludovico's nephew Gian Galeazzo Sforza, legitimate heir to the duchy of Milan. And the following year, while the cathedral commissioners were still scratching their heads over the choice of the architect of the *tiburio,* he devised the decorations and controlled the production of a spectacle that gave him the reputation of being the most skilled engineer in Italy: the grand Masque of the Planets, also known as the "Feast of Paradise."[31]

Much has been written about the Moor's reasons for giving this feast in honor of the ducal·couple. Reigning in his nephew's stead and having small intention of giving up the power to him, Ludovico, who was still only duke of Bari, not of Milan, was preserving appearances by allowing the young duke to preside over

entertainments. Not that anybody was fooled. According to the detailed reports by ambassadors at the ducal court, the Moor took great pains to fill the leisure time of Gian Galeazzo, who was about twenty years old, distracting him from affairs of state by encouraging his vices, the better to weaken him and undermine his resolve. His nephew was imprisoned in a constant round of drinking, luxury, and debauchery.

The wedding of Gian Galeazzo to Isabella was celebrated in February 1489; but as the duchess of Ferrara wrote to the queen of Hungary, nine months later the bride seemed to be as "virginal and chaste as she had been on her arrival; and from what one sees and hears, the chances are that she will long remain so." The bride's grandfather, King Ferrante of Naples, threatened to withhold the two hundred thousand ducats of the dowry as long as the union was not consummated. There was talk of "nervous debility" or of the Moor's having bewitched his nephew. The young prince had to explain himself in public to committees of lawyers, doctors, and clerics.

The Masque of the Planets, held on 13 January 1490 in the Castello Sforzesco, was intended to help dispel disagreeable rumors, which were spreading abroad.

Ludovico himself chose the theme, probably on the advice of his physician and astrologer. This was Ambrogio da Varese, whom he had made count of Rosate (a title accompanied by land and a castle) in gratitude for his having miraculously saved the Moor's life during a serious illness two years earlier—since then, no one had higher standing at court.

While Leonardo seems to have had some respect for astrology (almost indissociable from astronomy in those days) and to have believed that the planets had some bearing on human behavior,[32] he had scant regard for astrologers, who grew fat, he said, on the credulity of the foolish. I imagine he found it hard to get on with the ubiquitous Ambrogio da Rosate (who calculated everything by the stars, including the hour at which the spectacle should begin), but he had no choice but to submit to the whims of his master. And the theme chosen for the masque could not fail to attract him.

The libretto was by Bernardo Bellincioni. It began with introductions, dancing, a masked procession, and a Turkish cavalcade. A

dome of greenery concealed the ceiling of the hall. Painted panels (by Leonardo?) displayed episodes of ancient history and the "many great deeds" accomplished by the Sforzas. When midnight struck, the Moor, clad in Oriental costume, stopped the music, and the curtain went up on a vast hemisphere representing the celestial vault—a "sort of half-egg," wrote Trotti, the ambassador from Ferrara, "gilded on the inside, in which many torches imitated the stars; it was furnished with niches in which the seven planets were placed according to rank. On the edge of the half-egg, behind a window, illuminated with torches, were the twelve signs of the zodiac, which afforded a marvelous sight." The planets, represented by actors "costumed according to poetic descriptions," rotated slowly in their orbits, while "numerous melodies and soft and harmonious songs" arose to cover the noise of the invisible mechanism. Then the stellar divinities came down from their pedestals as if by magic, to deliver from the stage compliments to the duchess Isabella, composed by Bellincioni: Jupiter thanked God for having created such a beautiful and virtuous woman, Apollo displayed jealousy that there should be a more perfect creature than himself, the three Graces and the seven Christian Virtues bowed in turn before the most exquisite of sovereign ladies—and so on.

The Feast of Paradise bore fruit. Some months later, the envoy from Ferrara could at last write that "the duchess is pregnant—and the duke is sick to the stomach from having overtilled the ground." Moreover, the feast brought Leonardo fame. Nothing pleased him more than creating illusions, and from then on, he would devise ever more ingenious inventions for court festivities.

We know about the Masque of the Planets only from descriptions left by contemporaries. Leonardo himself makes no reference to it. The craftsmen who received his plans had no special reason, I suppose, to hold on to them once the work was finished. And the stewards of the castle similarly would have disposed of the wooden scaffolding, the painted backcloths, and other props—probably the very next morning. How many ephemeral designs by Leonardo vanished this way?

I do not know whether his automatic spit[33] or his water-powered alarm clock[34] ever saw the light of day. Such things are unlikely to be mentioned in the Lombard archives or in contemporary

correspondence, which is generally more concerned with palace gossip than with arts or technology. The servant would be referred to only in relation to the master. So one should not evaluate Leonardo's work as an engineer—that is, as inventor, architect, stage director, and designer—without remembering that what the notebooks contain are essentially *studies,* not finished projects; and that many of his "creations," precisely because they were put into practice, will undoubtedly have perished without trace, unless by chance some drawing survives.

On the fifteenth folio of the large notebook that Leonardo devoted to study of light and shade are these words: "23 April 1490, I began this book and began again on the horse." Then just below: "Giacomo came to live with me on the feast of Saint Mary Magdalene [22 July] of the year 1490. He is ten years old."[35]

There follows a list of the boy's misdemeanors, with various dates which show that Leonardo (who was now thirty-nine years old) was not jotting things down as they happened but looking back over the past year. It takes the account as far as April 1491 (by the old calendar, the year ended on 20 March).

So it was a sort of summing up. Leonardo had embarked upon work in optics, which was of the highest importance to him (he was developing his theory of vision, and this notebook was the first one to be devoted to a single theme, the others being random collections of notes);[36] he had made a fresh start on the *cavallo* (the bronze horse); he had taken in a young boy—and this child, unpredictable, wayward, and badly behaved, had thrown his life into such turmoil that Leonardo, somewhat chastened by the experience, felt the need to set down his feelings. We see him working out on two thirds of a page how much his protégé had cost him "during the first year." He would never write again at such length about any other human being. The pretext is a transparent one: since he was not used to setting down his private thoughts, he channeled them into an excessive preoccupation with lire and soldi. Money can be a good catalyst. Here the notary's son was translating his feelings into the stern medium of accounts.

The child cannot have owned any decent clothes. "The second day," says Leonardo, "I had tailored for him two shirts, a pair of

hose, and a jerkin; but when I had put aside the money to pay for them, he stole this money from the purse. Although I have not been able to get him to admit it, I am absolutely sure that he did."

Expenses: four lire. And immediately after comes a categorical judgment in the margin: "Thief, liar, obstinate, greedy."

The first lines are written very small; as Leonardo's indignation seems to grow, the letters double in size.

Two days later, he goes on, while they were dining in company of Jacomo Andrea di Ferrara, Giacomo behaved badly at table, ate for two, made mischief for four, broke three bottles, knocked over the wine, and went to finish his meal in the place where . . . The sentence is unfinished; we may imagine the worst.

Then Giacomo stole from the studio a silverpoint pencil worth twenty-two soldi, belonging to one of Leonardo's pupils, Marco (probably Marco d'Oggione). The pen was hunted for high and low, and found in the child's box.

Next, during preparations for a costumed tournament held by Galeazzo da Sanseverino, the Moor's military commander and son in-law, when the grooms undressed to try on the "disguises of savages"[37] designed by Leonardo, Giacomo took the opportunity to steal a purse left on a bed among the clothes, containing two lire four soldi.

When a painter from Pavia, Agostino Vaprio, offered Leonardo a piece of Turkish leather to make a pair of boots, Giacomo took the skin and sold it to a shoemaker; he eventually confessed that with the money (two lire) he had bought some aniseed sweets.

Then he stole a silverpoint pencil from Giovanni Antonio Boltraffio, another of Leonardo's pupils: one lira four soldi.

His master ended his grievances by noting in red chalk what he had spent in 1490 on clothing for the boy: he had provided him with a generous wardrobe: "One cloak: 2 lire; 6 shirts: 4 lire; three jerkins: 6 lire; 4 pairs of hose: 7 lire 8 soldi; a lined suit: 5 lire; 4 pairs of shoes:[38] 6 lire 5 soldi; a cap: 1 lira; thongs for belts: 1 lira."

Oddly, he does not work out the total: the page ends with the recipe for "powder to make medals," followed by three diagrams displaying the workings of light and shade (*"luminoso,"* the artist writes after each diagram).

Leonardo does not say in what capacity the boy entered his household. He simply says "Giacomo came to live with me," as if it was something independent of any wish on his part, as one says: "I won in the lottery" or "I found a gray hair this morning."

Officially, Giacomo must have been some kind of servant: it was not uncommon to "go into service" at the age of ten. J. P. Richter imagines that the list and the figures were intended for the child's father, Giovan Pietro Caprotti, of Oreno, a penniless *contadino* (peasant), it seems, or perhaps for the boy's legal guardian. Leonardo would be setting them down to justify his paying no wages, or perhaps simply to draw attention to the boy's behavior in the first few months. But one would hardly keep as a servant—let alone lavish presents on—such a little rascal, whom one knew and admitted to be obstinate, greedy, mendacious, and dishonest. Leonardo had no intention of dismissing him. He complains but never indicates that he is about to get rid of him, or even to punish or scold him. In fact, he was immensely fond of Giacomo and would never part company with him, taking him everywhere: Rome, Florence, and even France, where he remembered him in his will.

But the boy does not seem to have improved at all as he grew up: he could have come from a Pasolini film rather than from a suburb of fifteenth-century Milan. Six years later, Leonardo notes that he has once more stolen a few soldi.[39] Then he "lost" "two towels."[40] What is more, his master christened him Salai—a Tuscan word meaning a demon or "limb of Satan" (possibly of Arabic origin and a corruption of "Allah"):[41] da Vinci may have found it in the burlesque epic *Il Morgante Maggiore,* by Luigi Pulci. Salai was a meaningful nickname, and it stuck.

Leonardo continued to spoil the boy and dress him in lavish clothes. In the inventory for a trunk, drawn up in 1505, we find, beside the master's famous pink garments, "a tunic laced in the French fashion, belonging to Salai; a cape in the French mode, once owned by the duke of Valentinois, belonging to Salai; a tunic of gray Flanders cloth, belonging to Salai," etc.[42] On other pages, Salai is mentioned in connection with buying a bow and arrows, a chain, a ring, ribbons, some silver brocade.[43] Elsewhere there is mention of a contribution to his sister's dowry.[44]

The Anonimo Gaddiano and Vasari politely describe Salai as a pupil. In the *Lives*, Vasari says: "Leonardo took as a pupil the Milanese Salai, of ravishing grace and beauty, with a mass of curly hair which his master loved: he taught him much, but in certain works thought in Milan to be by Salai, Leonardo's hand is present."

In drafts of letters,[45] the boy, sent on various errands, is referred to as "my pupil," although Leonardo treated him more often as a servant. The difference between the two may not have been very great at the time. Nevertheless, it was normal for pupils to pay for their apprenticeship: in 1494, for instance, the father of a certain Galeazzo undertook to pay Leonardo five lire on the fifteenth of every month for the upkeep of his son *(per le sue spese)*.[46] Above all, one did not dress a pupil in fine clothes from head to foot.

This was, one has to say, no ordinary pupil. He seems to have had no talent for art: when Vasari says that his master "taught him much," one should probably understand that Leonardo had great difficulty teaching him the rudiments of painting. He learned the technique but deceived no one and had to be given a helping hand. We can tell from Vasari's account that even in the sixteenth century, people found it hard to credit him with full responsibility for a work. The few pictures attributed to him today do not dispose one in his favor.[47]

A pupil without talent and an unreliable servant (to say the least), the little rascal did, however, have the face of an angel. "Of ravishing grace and beauty"—Vasari's evidence is particularly valuable on this point. Salai was a pretty child, and here we reach the heart of the matter. His comeliness must have been enough to make Leonardo notice him one day, in the street or on a country road, and think of using him as a model;[48] then perhaps to prompt him to rescue the child from poverty and take him into his service. This explains why he was ready to forgive him anything, the thefts and lies, and why he neither would nor could part with him. Finding Salai irresistible, he fell under his spell and sought to make him look even more beautiful by dressing him in velvet and ribbons. Walking about in his company was no doubt a source of vanity to Leonardo.

Leonardo indicates what he thought of this intoxicating beauty by drawing it: the angelic boy with curly hair, light-colored eyes,

Profile of an Adolescent.
ROYAL LIBRARY, WINDSOR.

and slightly sulky mouth who appears many times and at different ages in the drawings must surely be Salai.

It is hard to imagine the relationship of a man of Leonardo's age with a child of ten. Or rather one wonders how far it went. Near the obscene drawing referred to earlier concerning the bicycle, an unknown hand has written the name of Salai. When the writer Lomazzo made Leonardo the speaker of a long tirade in favor of homosexuality, Salai was mentioned in connection with the "Florentine game."[49] Leonardo obviously had a weakness for bad boys with pretty faces (Saltarelli may have been another). I cannot help thinking that his indignation over the child's bad behavior—the thefts, the terrible table manners, and the greed—may conceal af-

fection and amusement; he must surely have had to suppress a smile when he wrote about the aniseed sweets. The irrepressible Salai both amused and disturbed, in every sense of the word, the orderly Leonardo. Sentences in the notebooks such as "I fed you with milk like my own son"[50] may indicate innocent paternal affection, but they can also be interpreted as reproaches, as emotional blackmail, as fragments in an amorous discourse where there is room for every variety of feeling. More than twenty years later, around 1508, it seems that relations between the master and his handsome page had not yet settled down, if the words written under a shopping list are any indication:

Fish 8
Wine 8
Bran 108
Bread 4

Salai, I want to make peace with you, not war. No more war, I give in.[51]

Leonardo said that he had made a fresh start on the horse in that crucial year of 1490. So he must have begun it at some earlier point.

This is confirmed in a letter the Florentine envoy to Milan wrote to Lorenzo de' Medici. Dated 22 July 1489, it informs us that Leonardo had finally obtained the commission for the statue: "Lord Ludovico has plans to provide a worthy tomb for his father, and he has already given orders that Leonardo da Vinci should make a model for it, that is to say an enormous bronze horse carrying Duke Francesco clad in armor. And since his excellency wishes to make a work that will be extraordinarily fine and without compare, he asks me to tell you that he would like you to send him one or two Florentine artists skilled at this kind of work; although he has entrusted the task to Leonardo, it does not seem to me that the latter is capable of bringing it safely to completion."

The letter was not followed up. Lorenzo sent no sculptor from Florence; and the Moor did not ask again. Da Vinci began work on the bronze horse a few months later. We may wonder why Leonardo, who had been developing his project for six or seven

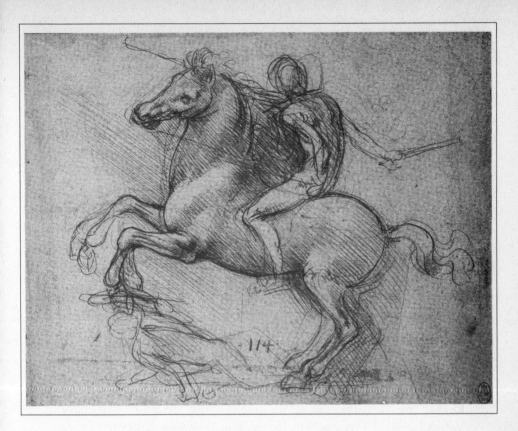

Study of Horse with Nude Rider.

years, to whom the commission was certainly not granted without good reason, and who had already proved himself as an engineer-architect, should suddenly be regarded as incapable of completing the enterprise.

I can see some technical reasons. Leonardo had originally imagined a rearing horse, like those in the background to the *Adoration of the Magi*. One of his first studies shows a horse up on its hind legs, carrying a nude rider brandishing a general's baton.[52] Another shows a jumping horse in section, so as to indicate the inner structure of the mold.[53] He made some small wax models on these designs;[54] and some may even have been cast in bronze. Several equestrian statuettes, thought to be by or more probably after Leonardo, still exist: the one in the museum in Budapest in particular displays

admirable power and movement.[55] Pollaiuolo had also envisaged a
horse rearing up.[56] But while this solution worked splendidly on
paper or in small-scale models, it became virtually impossible to
create once it called for a certain weight of metal. How could a
horse weighing several tons be made to stand on two legs (or even
two legs plus tail)? It would of course be possible to provide extra
support by having one of the forelegs resting on a tree trunk or the
shield of some vanquished enemy—a design seen on cameos and
medals of antiquity. And Leonardo thought of this, as did Pollai-
uolo. But how was such a group to be cast and balanced? And
whatever the solution, Ludovico certainly wanted the monument to
his father to be giant-sized, *grandissimo,* as the letter to Lorenzo
makes perfectly clear.

Originally, the duke may have wanted a mere life-size statue (it
was certainly all that Galeazzo Maria had requested[57]). Then, since
the prosperity of the day encouraged grandiose schemes, he may
have asked instead for a statue three or four times life-size—which
had never been attempted, either in antiquity or by contemporaries.
In that case, a horse rearing up or galloping would be impossible.
When Leonardo returned to the problem, he was thinking in terms
of a horse walking. Was he so disappointed by having to abandon
his first idea that he went off in a sulk? Or did he simply give up
for a while because of the enormous technical difficulties?

There may have been another explanation: Verrocchio, his for-
mer master, had died a few months earlier in Venice, just as he was
completing the casting of the horse for his equestrian statue of
Colleoni.

The *Colleoni* had been commissioned from Verrocchio in 1480.[58]
He had made a wax model in Florence when Leonardo was still
there.[59] Vasari tells us that he was about to cast it, when another
sculptor, Bellano of Padua, managed—by scheming behind Ver-
rocchio's back—to obtain the commission for the rider, leaving
Verrocchio only the horse. In a moment of anger, Vasari says,
Verrocchio cut the head off his model, whereupon the doges bade
him never to dare show his face in Venice again on pain of behead-
ing. To which Verrocchio replied that he would certainly not
return, "for it was not in their power to stick heads back on,
especially one like his own, as he would have been able to do in

the case of the statue, replacing the one he had broken with an even finer head."[60] The letter was so well received, Vasari tells us, that Verrocchio was recalled to Venice at twice the pay. He repaired his model and set to work on the casting: this was well advanced when, coming out of the furnace, he caught a chill. He was fifty-three years old. "His death," says Vasari, "infinitely distressed his friends and many disciples."

Leonardo had embarked upon the *cavallo* project at least in part to measure himself against or identify with the man who had taught him all he knew. One can easily imagine his distress at the news of Verrocchio's death. The horse had killed him; perhaps remorse or even superstition paralyzed Leonardo's progress.[61]

Then, since threats were made of calling in some Florentine sculptor (still Pollaiuolo?), he took the project up again. On the page where he recorded his decision, he also announces that he has taken in Giacomo and mentions incidentally for the first time the names of his pupils (Marco and Giovanni Antonio, from whom the little *diavolo* stole the silverpoints). I have an idea these incidents are all linked: the master is dead; long live the master! In 1489–90, Leonardo set up his own workshop, reconstituting a spiritual family, in which this time he played the role of father. He had received much; now it was time to give something back. The image of the sage of the Turin self-portrait begins to take shape.

He returned to the equestrian statue with renewed energy and intentions. This time, the work would proceed quite rapidly, although he was constantly being called on to lend his talents as decorator and organizer of spectacles for the procession of princely marriages that took place in Milan during these years. Following Gian Galeazzo's marriage to Isabella of Aragon, Ludovico arranged for his illegitimate daughter Bianca, aged eight, to marry Sanseverino, the commander of his armies, who seems to have been a friend of Leonardo's; and for his niece Anna Sforza to wed Alfonso d'Este; then Ludovico himself decided to marry his cousin Beatrice d'Este, the younger daughter of the duke of Ferrara, to whom he had been betrothed ten years earlier, when she was only five years old. Finally, he pulled off a masterstroke in marrying his other niece, Bianca, the sister of Gian Galeazzo, to the emperor Maximilian. Each of these weddings was the pretext for a celebration more

dazzling than the last. Once Beatrice d'Este's influence took hold in the Lombard court, barely a month went past without the presentation of "some idyll, comedy, tragedy, or other new spectacle," as the duchess's secretary remarked in wonder.

Leonardo found models for the statue in the princely stables; he must have come to some arrangement with the grooms. He drew from life and from every angle a thoroughbred known as "the Sicilian,"[62] noting its dimensions. He also writes of a jennet belonging to the same owner;[63] of the black Florentine horse owned by Messer Mariolo, a splendid animal, remarkable for its neck and head; of the "falconer's white stallion" with its perfect flanks, which could be seen at the Porta Comasima; and of the "great courser from Cermonino owned by Signor Giulio."[64] It seems that he was once more carried away into a major program of study, leading to a treatise on the anatomy of the horse—a treatise that really existed, according to Vasari and Lomazzo. (What was more, visiting the stables of Milan inspired him with an idea for model stables, "clean and well ordered, unlike present habits," where the mangers would be automatically replenished with fodder stored in the attic and distributed down vertical conduits in the walls, while pumps would keep troughs full of water and liquid manure would run off down inclined planes to underground channels. The project is summed up in a perspective drawing in section: twenty-five years later, it would provide the basis for the Medici stables in Florence.)[65]

In Pavia, Leonardo considered the *Regisole,* an equestrian bronze statue of Odoacer, king of the Goths (it was destroyed during the insurrection of 1796; Petrarch has left a description of it).

Leonardo notes it "is above all admirable for its movement. . . . It almost seems to be trotting like a freely moving animal."[66] He recommended working from life rather than from antique models, but nevertheless added that it was better to be inspired by the ancients than by the moderns. To judge by his sketches, the colossal horse that he was building out of clay was striding, like the *Regisole* horse, with alternate fore and back legs moving in synchrony—a less stiff and more realistic stance than that chosen by either Donatello or Verrocchio.

At last a model was ready. It is thought that Leonardo displayed it on the occasion of the betrothal of Bianca Maria Sforza, in

November 1493,[67] possibly on the immense square that recent excavations have revealed in front of the Castello. The horse alone was twelve *braccia* high, over seven meters (the entire monument—horse, rider, and plinth—must have been about double that).[68] It is possible that this statue, as tall as a building, was also represented on canvas under a triumphal arch in the cathedral.[69] We do not know exactly under what circumstances the gigantic work was revealed to the public; but we do have many witnesses to the great stir it caused. In honor of the *gran cavallo,* the court poets (Pietro Lazzaroni, Giovanni da Tolentino, Piattino Patti) composed verses of greater or lesser felicity, but all were unstinting in their praise. "Neither Greece nor Rome saw anything greater," cried Baldassare Taccone. The name Vinci lent itself, as may be imagined, to many plays on the word to conquer *(vincere): "Vittoria vince e vinci tu vittore"* (Victory to the victor, and you, Vinci [or victor], have the victory), as Bramante put it in a long poem dedicated to his friend, which appeared anonymously in Rome.[70] All those who saw the great model that Leonardo made out of clay, Vasari says, declared that they had never seen anything finer or more magnificent. Soon the fame of the sculptor was sweeping Italy.

Poets of those days were inclined to extravagant periphrasis; only Paolo Giovio actually tells us something about the clay horse, which he describes as a colossus, and refers to its "panting and impetuous aspect."

Leonardo had won the first round; now came the hardest part—casting the model in bronze.

Between 1491 and 1493, he had thought a great deal about the problem of casting, putting down all his observations and copying old notes into a little book.[71] No doubt he spent whole days in the arsenals and cannon foundries of the city (the Royal Library in Windsor owns a fine pen-and-ink drawing of an artillery park in which soldiers are heaving a giant gun onto its carriage).[72] He noted recipes for alloys, methods of controlling the temperature in the furnaces, of adding tin to copper "when the latter has melted," of polishing the metal with a kind of broom made of wire "of the thickness of string."[73] In 1492, as the fires of the Inquisition were being kindled in Spain, and as Columbus was discovering a new continent, Leonardo held long conversations about casting with

Giuliano da Sangallo, engineer to the Medici, who had built the Gondi Palace in Florence, on the site where Ser Piero had once lived. Leonardo had come to the conclusion that his horse would have to be cast in one piece, modifying the traditional *cire perdue* (lost wax) process.

Until then, sculptors had had to divide the work to be cast into smaller pieces, so as to reduce the technical difficulty. A mold was made of every piece: torso, leg, head; the interior was lined with a thin layer of wax, which represented the thickness of the bronze, and then a core of fireclay was constructed. Alternatively, a layer of wax was sculpted over a crude core, then covered with a layer of clay. Openings known as runners and risers were made in the mold, then the whole thing was locked into a brace. The first firing melted the wax, which disappeared, to be replaced by hot metal poured through the runners into the mold. After cooling, the pieces were removed from the mold, cleaned, trimmed, and welded together. Finally, the work was rubbed smooth, chiseled, and polished.

This process had disadvantages: the welding lines never completely disappeared after rubbing; the wax proof had disappeared in the firing, so it could not be referred to for adjusting the cold metal; and it was rarely possible to make all the pieces of uniform thickness and thus to estimate their weight, in order to establish the overall balance of the work in advance.

Leonardo, because of the extraordinary size of his *cavallo* and the particular problems it posed, therefore intended to try to cast his statue in one piece, from the clay model, using molds that could be preserved.[74] His notes enable us to reconstruct the method he developed. He began by taking an impression of the statue, piece by piece; then, in the female or concave molds thus obtained, he applied with a brush a coating of equal parts of wax and clay, which he called *grossezza* (thickness). (Cellini would call it *lasagne*.) Next, he made the core of heat-resistant fireclay, filled with rubble. This corresponded to what in the finished statue would be a hollow center, reducing the overall weight. He unmolded the wax, checked and corrected the accuracy of the impression and the uniformity of the *grossezza;* the volume of wax used could give him a reasonably exact measure of the amount of bronze he would need. Then he assembled the core, strengthened with crossbars and struts, which

was to make up the male or convex mold: all the female molds were now attached on the outside and enclosed within a casting hood, strengthened with iron straps. The bars and struts holding the inner mold were bolted to the external casting hood; thus screwed together, Vasari explains, they gave each other mutual support.[75] The bronze was to be poured into the gap determined by the *grossezza,* about two fingers' width at most, through a very large number of holes, so that it should be quickly distributed and would cool at constant speed throughout.

Leonardo tried out one by one all the materials he proposed to use. "First of all, test every ingredient and choose the best," he writes.[76] For the inside of the mold, "a mixture of coarse river sand, ash, crushed brick, egg white, and vinegar together with your clay. Try it first."[77] He also imagined a series of dress rehearsals and experimented with the process on reduced scale models: "with a little piece and little furnaces."[78]

His original idea had been to dig a huge pit, in which the mold would be buried upside down, so that the bronze could run in through the animal's belly, with the air escaping upward through the feet.[79] But in December 1493, he realized that the size of his horse would mean digging a pit so deep as to reach the water table. Milan was a city full of canals, so "the mold would be only a couple of feet away from the water," and any dampness would ruin the casting.[80] Next he envisaged casting the animal on its side; but this solution also had drawbacks, which he lists.[81] We do not know which of the two positions he opted for in the end. But he did leave very detailed diagrams for the iron framework of the hood and core, and others showing the wooden frame he had designed to transport the huge mold from his workshop to the foundry, as well as the block-and-tackle machine with which it could be maneuvered.[82]

Evidence indicates everything was ready for the actual casting by early 1494. A start may have been made on digging the pit and building the four specially designed furnaces around it (two square, two rectangular, "built between pillars resting on solid bases"), from which the molten metal would flow to the holes in the mold by a series of pipes. Leonardo had planned everything down to the smallest detail. He wrote: "for the casting, let every man keep his furnace closed with a red-hot iron bar and let the furnaces be opened

Device for Casting Horse's Head.

simultaneously; and let fine iron rods be used to stop any of the holes becoming blocked by a piece of metal; and let there be four rods kept in reserve at red heat to replace one of the others if they should be broken."[83] He had also planned a trapdoor on the animal's back (where the rider would eventually sit), through which the debris of the core could be extracted after cooling; and he had plans to cast a separate panel to close this hole, "with hinges."[84]

The *cavallo* was both product and symbol of the Sforza dynasty in its heyday. How could Leonardo possibly have guessed the fate that awaited his statue?

The Milanese people had accepted without undue grumbling their heavy burden of taxation. The blast furnaces of Como, Sondrio, and Brescia were sending up continuous smoke; rice was growing in the plain. The arms, wool, and silk industries had never

been more prosperous. There were a few disturbances at the University of Pavia, but they were soon quelled, and a generous reform package calmed things down.

Destiny seemed to be smiling on Ludovico, even in his private life. He already had one son by his mistress. He now discovered—to his surprise—that he loved his young bride, the exuberant Beatrice d'Este, who crowned his joy by giving him another son, Ercole, later rebaptized Maximilian in honor of the Holy Roman Emperor.[85]

The regent's good fortune was celebrated with the most extravagant festivities held to mark this child's birth in January 1493. The cradle was gilded with fine gold; Beatrice's apartments at the Rochetta were redecorated in great luxury; Bramante composed a "fantasy"; the church bells rang all day; debtors were released from prison; and at the hour fixed by Ambrogio de Rosate *(in punto d'astrologia)*, the entire nobility in gala costume went to thank God at Santa Maria delle Grazie.

Cecilia Gallerani had retired gracefully, provided with a husband and laden with gifts.

There was but one cloud on the horizon: Three years after her marriage to the inadequate Gian Galeazzo, Isabella of Aragon wanted to be duchess of Milan in more than name. Her legitimate claims were increasing in intensity. Dark, embittered, a little too thin for the taste of the Milanese, the duchess Isabella concealed beneath her fragile appearance indomitable pride and determination. She was, people said, the unhappiest person at court; Galeazzo, who trembled in front of his uncle, beat her when he was drunk and humiliated her by openly preferring a boy known as Il Bozzone (the Rustic). Above all, she was jealous of her lively, flirtatious, and happy cousin Beatrice, on whom Ludovico was spending extravagant sums of money, whose wardrobes were crammed with eighty-four pearl-encrusted and embroidered dresses, and who played the role of first lady of Milan. Having no ally at court, spied on by her servants (who were in Ludovico's pay), Isabella had no choice but to write to her family. She begged her father, Alfonso of Calabria, and her grandfather, Ferrante of Naples, to urge, by arms if necessary, the granting of her husband's true rights. With her tears,

Guicciardini tells us, "the courageous princess" begged that at the very least she be rescued "from the unworthy slavery in which she was maintained."[86]

These letters poisoned the already tense relations between Milan and Naples. The old king sympathized, became angry, and sent two ambassadors. Admittedly, Isabella's interests coincided with his own: he would not be unhappy to see Ludovico's exit, and to lay hands on Lombardy through the intermediary of his granddaughter.

Unmoved by the ambassadors, Ludovico accused Isabella of pride and of running up debts. According to the chronicler Corio, "the Moor lent the same ear to all things." If denounced as an oppressor and usurper, he smiled. He had already made his preparations and thought he had nothing to fear from Naples.

But Florence, which had previously acted as a bulwark against Naples, could no longer protect Lombardy. Lorenzo de' Medici, the Sforzas' faithful ally, architect and guarantor of peace, had died in 1492. Pope Innocent VIII followed shortly afterward. The alliances were reversed. In Florence, Piero, Lorenzo's eldest son, who was as imprudent and vacillating as his father had been wise and resolute, had gone over to Naples, having married a Neapolitan bride. In Rome, a cardinal of Spanish origin had been elected to the Holy See, after bribing the curia with money and promises. People were becoming acquainted with, and therefore wary of, the Borgia Pope, Alexander VI. He was already known to be cruel, greedy, without scruple or piety, affectionate only toward his own offspring. And he had some more unpleasant surprises up his sleeve.

In fact, every participant was playing a double if not triple game. Ludovico moved his pawns about in the shadows, activated diplomatic missions, and approached his traditional enemy, Venice. Cardinal Ascanio Sforza, his brother, tried to put in a word for him at the Vatican. Ludovico extended handfuls of gold to the Holy Roman Emperor, and above all he consolidated his ties with the king of France, who had for several years nursed designs on the kingdom of Naples. In the agreement struck with France, Milan obtained permission to annex the duchy of Genoa. Ludovico did not yet see the dangers of his policy; like everyone else, he was simply thinking in terms of keeping and if possible consolidating his power. He had neutralized the Neapolitan threat simply by brandishing the

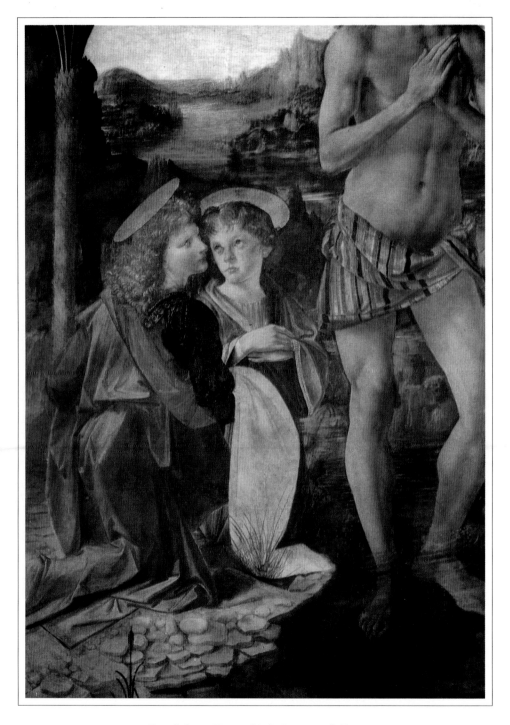

Detail from Verrocchio's *Baptism of Christ;*
angel at left painted by Leonardo

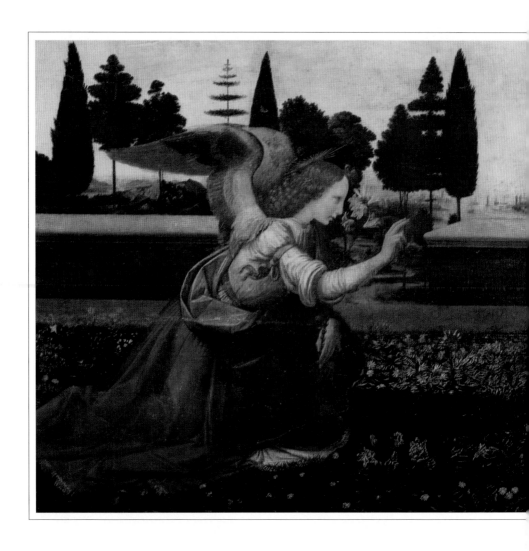

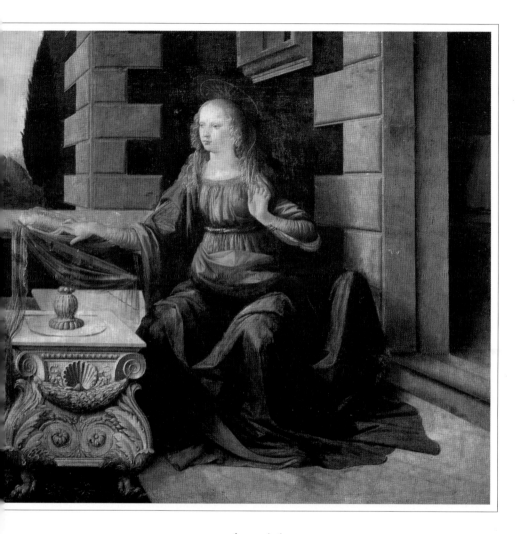

Annunciation.
GALLERIA DEGLI UFFIZI, FLORENCE.

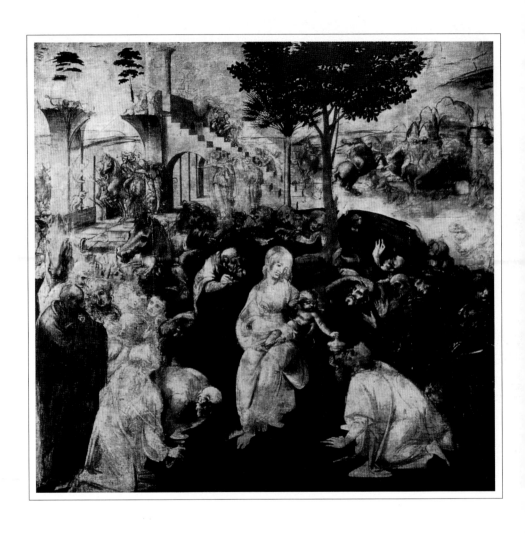

Adoration of the Magi.

GALLERIA DEGLI UFFIZI, FLORENCE.

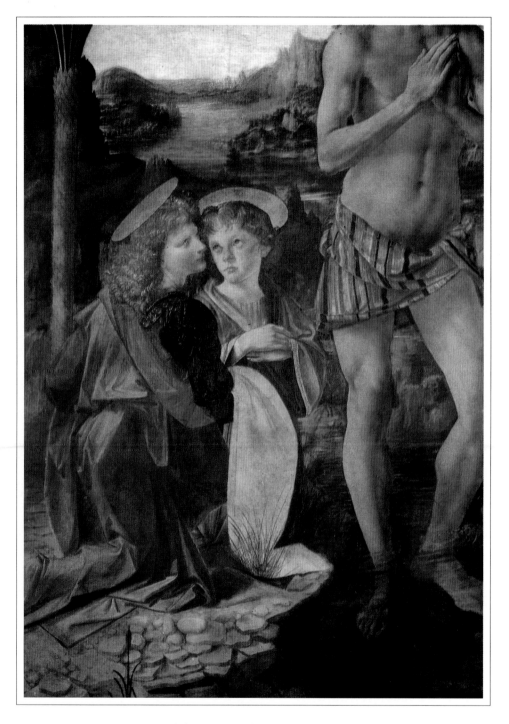

Detail from Verrocchio's *Baptism of Christ;*
angel at left painted by Leonardo

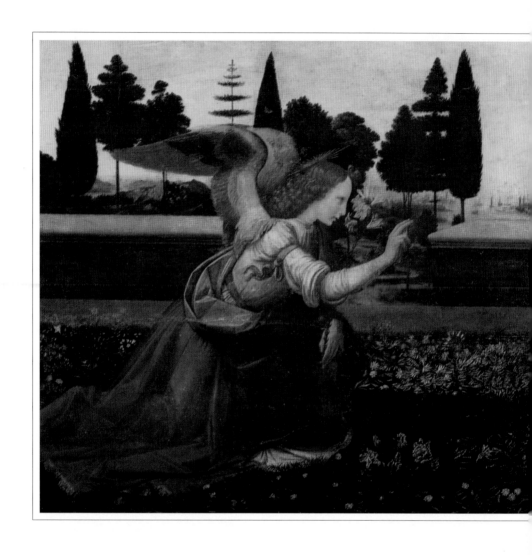

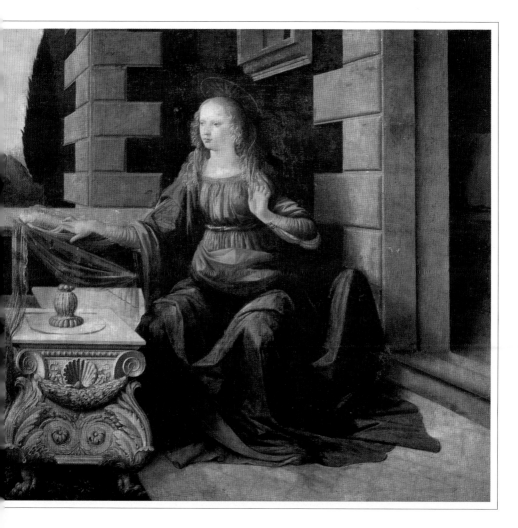

Annunciation.
GALLERIA DEGLI UFFIZI, FLORENCE.

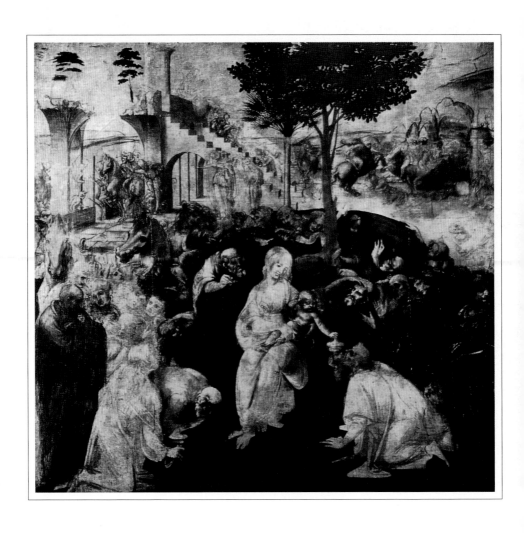

Adoration of the Magi.

GALLERIA DEGLI UFFIZI, FLORENCE.

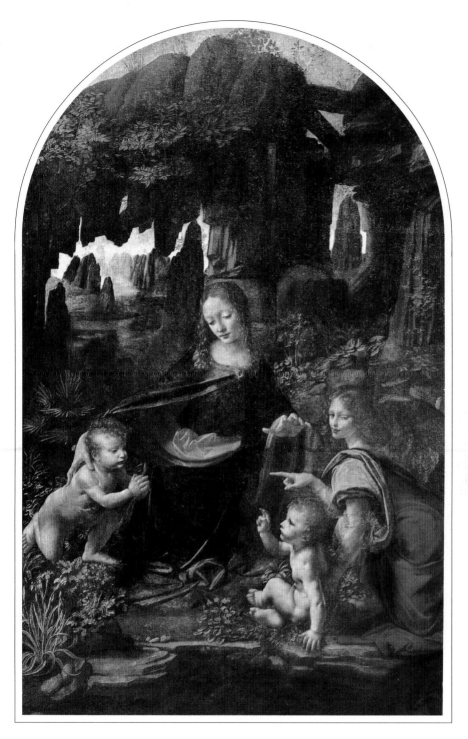

Virgin of the Rocks.
LOUVRE, PARIS.

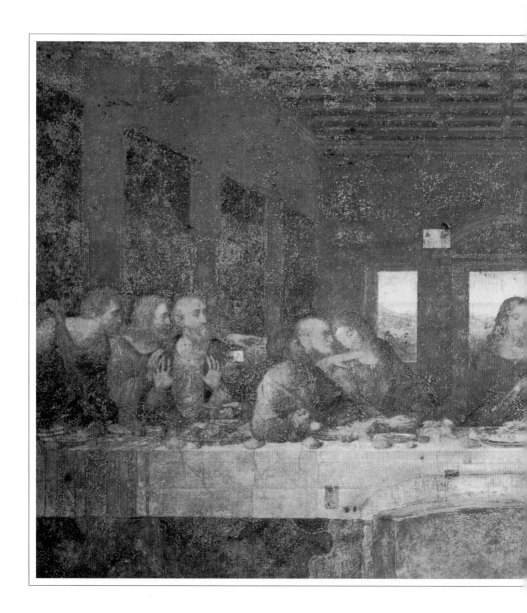

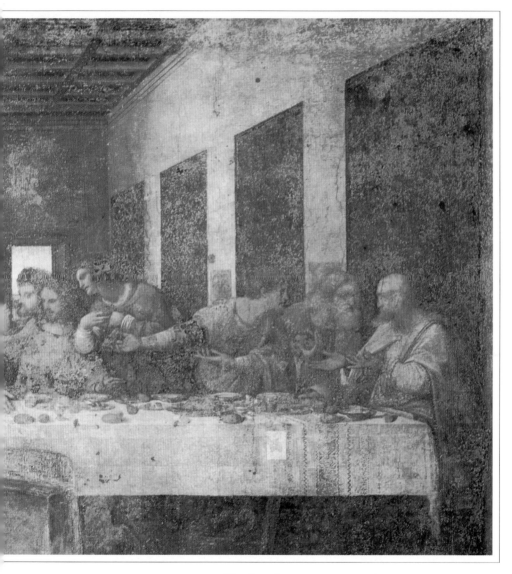

The Last Supper.

SANTA MARIA DELLE GRAZIE, MILAN.

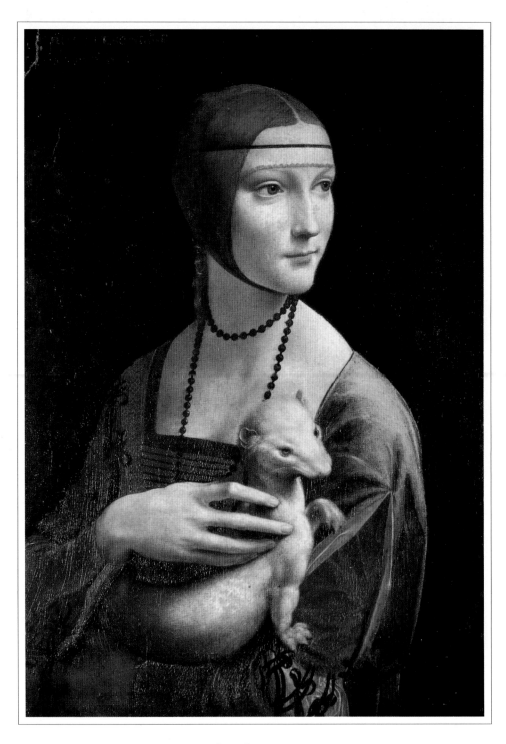

Lady with an Ermine.
CZARTORYSKI MUSEUM, CRAKOW.

threat of his backers, France and the Holy Roman Empire—a brilliant combination, he imagined, which would enable him to return to his life of pleasure with peace of mind. He did not levy any troops. He is said to have declared (it sounds too good to be true): "Pope Alexander is my chaplain, the emperor my *condottiere,* Venice my chamberlain, and the king of France my errand boy." How could anyone imagine that Il Moro, whom Bernardo Bellincioni described as "part fox, part lion," had put his foot into a machine that would crush him?

If fortune turned against the prince, everything he had commissioned would go down with him. But Leonardo showed little political awareness about his patron's situation. It has indeed been said of him that for someone who was passionately interested in mankind, who wrote that man was the model of the world, he cared very little for men in the real world, his contemporaries in particular.

In 1493, Leonardo, like all his colleagues, joined in the chorus of praises that the Moor so enjoyed. He worked hard to satisfy the regent's taste for emblems, designing complex and flattering allegorical images in which could be seen the dove of the Sforzas, the viper of the Visconti, the imperial eagle, and the brush *(scopetta)* that Ludovico had included on his coat of arms, with which he proposed to "clean up the face of Italy." These allegories may have been intended for decorative panels. Sometimes the invention takes a literary turn: in the following sentence, the name of the Moor is mentioned five times: *"O Moro io moro se con tua moralita non mi amori, tanto il viver m'e amaro"* (O Moor, I shall die if with your goodness you love me no more, so bitter is life for me).[87]

It appears that during these happy years, Ludovico was indeed good to Leonardo. We do not know quite how much he was paid, but he was granted large premises—for setting up a workshop and perhaps for living quarters—in the Corte Vecchia, the old ducal palace whose gates opened onto the cathedral square.[88]

Leonardo must have been leading quite a grand life at this time. "Although without fortune," Vasari tells us, "he always had many servants and horses, which he loved dearly, as well as all sorts of animals, which he tended with extreme patience and care." Leonardo loved animals so much, it seems, that he had turned vegetar-

ian. He asked with horror how nature could permit her creatures to live by the death of their fellows;[89] he would not let his body become a "tomb for other animals, an inn of the dead . . . a container of corruption."[90] In 1515, the traveler Andrea Corsali wrote to Giuliano de' Medici that the Hindus respected all animate creatures, even insects, "like our Leonardo da Vinci." There cannot have been many vegetarians in Renaissance Italy.

The domestic accounts to be found in Leonardo's notebooks several times mention purchases of meat, but this must have been for his pupils. The master dined off salad, fruits, vegetables, cereals, mushrooms, and pasta: he seems to have been particularly fond of minestrone.

On one large page, he copied out some rules of hygiene, turned into verse:

> *If you would be healthy, observe this advice:*
> *Eat only when hungry, and let light fare suffice.*
> *Chew all your food well, and this rule always follow:*
> *Well cooked and simple be all that you swallow.*
> *On leaving the table, a good posture keep,*
> *And after your luncheon do not yield to sleep.*
> *Let little and often be your rule for wine,*
> *But not between meals or when waiting to dine.*
> *Visits to the privy should not be postponed . . .* [91]

Leonardo seems not to have done anything without first thinking about it and justifying himself. He refused to accept the world and its ways unthinkingly. To him, everything was food for thought. As an anatomist, he protested against the practice of clipping the noses of horses,[92] as well as against that of swaddling newborn children in such tight wrappings that the poor babies expressed their loss of liberty "in tears, sighs, and lamentations."[93] The most insignificant things, to Leonardo's mind, deserved fresh and thoughtful attention.

He had imagined the ideal workshop, just as he had the ideal town and the ideal stables, and drew a diagram of it. He preferred small rooms, "which arouse the mind," rather than large ones, "which distract it."[94] But he wanted large windows, since small

ones, he had observed, produced too great contrasts between light and shade, "and that is not good for work."[95] He imagined his large windows as provided with adjustable blinds, which could be raised or lowered so as to throw the desired amount of light on the work or the subject, at the right height. Similarly, a system of pulleys and weights would make it possible to raise and lower the platform *(cassa)* on which the work was placed, "so that it would be the work, not the master, that would move up and down." The *cassa* could be lowered through the floor to the story below. "Every night," Leonardo explains, "you would be able to put your work away and close it, like those chests that can be used as seats when they are closed."[96] He probably arranged his studio in the Corte Vecchia along these lines.

He must have had an entire wing at his disposal, and either a courtyard or a shed, for this was where he developed his inventions, sculpted the great horse, and prepared the molds: *"la mia fabrica,"* he called it.

Apart from decorative elements, it seems that he was also painting—or perhaps supervising the painting of—portraits (of the duchess Isabella, of Bianca Maria Sforza, of the duchess Beatrice?).[97] He was certainly not short of work, for the studio expanded to take in new helpers and apprentices. In 1493, Master Tommaso (no doubt Zoroastre da Peretola) joined him; then came Giulio, a German. One was a goldsmith, the other an ironsmith. Master Tommaso made six candlesticks, and Master Giulio worked partly on his own, partly for Leonardo (he made him a vise, and some locks, notably for the studio). Then Galeazzo came as a pupil.[98]

In the month of July the same year, there entered Leonardo's household a woman named Caterina. This mysterious woman has puzzled historians: can it be true that she was Leonardo's mother, rather than simply a domestic servant?

Freud did not doubt for a moment that this Caterina was indeed the woman abandoned by Ser Piero.

K. R. Eissler, in his psychoanalytic study of Leonardo, acknowledges that Caterina was a very infrequent baptismal name at the time; but he decides, following Bérence, and being well aware of "the archaic meanings of names, the irrepressible emotions they may reveal, the superstitions attached to them, and the magic powers

with which they are credited," that Caterina may indeed have been a housekeeper, hired by the painter precisely because of her name, and that her name, her age, perhaps her physical appearance, and her functions in the household may have made her a sort of "mother substitute." Various historians take different sides on whether or not Caterina was actually Leonardo's mother, and many rather pusillanimously ignore the problem altogether.

There is no incontrovertible evidence either way.

A few years earlier, Leonardo had written: "Can you tell me what la Caterina wishes to do"; and a little higher on the same page occur these words paraphrasing lines from Ovid's *Metamorphoses:* "O Time, consumer of all things! envious old age, which gradually consumes everything with the sharp teeth of the years in a slow death! When she looked in her mirror and saw the wrinkles that age had laid on her face, Helen wondered, with tears in her eyes, why she had been twice ravished. O Time, consumer of all things! O envious old age, by which everything is consumed!"[99]

Leonardo seems to be associating Helen of Troy, the "fairest of all mortals," carried off by Paris, with his mother, seduced by Ser Piero. The link is made with Helen in her old age, doubly "ravished."

By 1493, his mother must have been about sixty-six years old. The tax register enables us to keep track of her until 1490: she had four daughters and a son and lived all her life, in humble circumstances, near the village of Vinci. There is no further mention of the Accattabriga family until 1504. By this time, there were in the village only two daughters, both widowed, and three grandchildren, with whom the line would die out. Two other daughters had either died or left the district. According to an addition to the census of 1487 (made sometime after 1490), the son had been killed by a crossbow bolt in Pisa.[100] Leonardo's mother and stepfather had disappeared from Vinci, but no document tells us where to or when.

There is no intrinsic reason why Caterina, possibly widowed and having lost her legitimate son, should not have come to spend her last years with her illegitimate son, who was doing so well in Milan. "What la Caterina wishes to do"—Leonardo may be referring to

an earlier invitation to her to come and join him in Lombardy.[101]

The entry in the notebook, on two separate lines, reads: "16 July/ Caterina came, 16 July 1493."[102]

When referring to his pupils, Leonardo generally says "So-and-so came to live with me" *(venne a stare con meco)*, and he does not repeat the date (in fact, he rarely noted this kind of thing on a day-to-day basis).

Repeating a date is not common in Leonardo's manuscripts: but he does on one occasion repeat the time of day—when recording his father's death.[103]

Such "overdetermination" of a detail, to use psychoanalytic jargon, may be a tiny but telling clue as to the identity of Caterina, betraying an emotion Leonardo did not openly refer to. Was Leonardo opening his door to his now elderly mother?

Meetings summon up memories. On the other side of the page is a list of names from Leonardo's childhood: "Antonio [his grandfather]; Bartolomeo [a village elder? a relative of Accattabriga?], Lucia [his grandmother], Piero [his father], Leonardo."[104] Is this just one more coincidence?

The name of Caterina recurs in his papers six months later, among some topographical data about the Castello:

<center>

29 January 1494

Material for hose	4 lire	3 soldi
Lining		16 s.
Making up		8 s.
For Salai		3 s.
Jasper ring		13 s.
Stone with brilliants		11 s.
For Caterina		10 s.
For Caterina		10 s.[105]

</center>

After this, there is nothing, no further mention of Caterina— until the day of her funeral, perhaps a year or two later. Leonardo on this occasion (as when he set down the first exploits of Salai) simply gives a column of figures. He does not describe the event (it has to be dated from the context); he merely calculates the expenses he paid for the burial:

Expenses of Caterina's Burial

For 3 pounds of wax	27 soldi
For the bier	8 s.
Pall for the bier	12 s.
Carriage and erection of cross	4 s.
For the bearers	8 s.
For 4 priests and 4 clerks	20 s.
Bell, book, sponge	2 s.
For the gravediggers	16 s.
For the dean	8 s.
For official permission	1 s.
	106 s.

(Earlier expenses)

Doctor	5 s.
Sugar and candles	12 s.
	123 s.[106]

The expense seems excessive for a housekeeper or servant who had been with him only two or three years. On the other hand, it seems a little ungenerous for a beloved mother, rediscovered after years of estrangement. Twenty years later, Leonardo asked in his will that his own funeral be celebrated with much greater pomp. While he bought only three pounds of wax (for candles) for Caterina, he ordered forty pounds for himself, divided among four churches; and he wanted a procession of sixty poor persons, each carrying a taper.

If Caterina was his mother, would he not have given her a more impressive funeral? And would he not have betrayed some sign of sorrow on the page?

Against this, one could argue that Leonardo was as reluctant to speak of his origins as of his feelings. It is possible that he chose a form of mourning that, while respectable, would also be discreet, so as not to damage either his mother's memory, by revealing that she had had a child out of wedlock, or of course his own reputation, by disclosing his illegitimacy.

Caterina took her secret to the grave. We shall probably never know the truth about her. But I am quite ready to believe that Leonardo, as soon as he had the means to do so, invited his mother

to join him in Milan, knowing her to be in straitened circumstances and possibly already unwell, so that he had at least the pleasure of offering her a comfortable old age. Verrocchio similarly supported various female members of his family.

"Each part of an element separated from the mass," Leonardo writes, "desires to return to it by the shortest route, to escape its own imperfection."[107] If Caterina really was his mother, and if we can assume that Leonardo would find fulfillment in some kind of reconstitution of the family unit, then it seems a very plausible move—especially if we remember his mixed feelings about his father, whose responsibilities he was thus assuming, *redeeming* him, so to speak.

There are many signs of some such sense of fulfillment. At this period, Leonardo, like the prince he served, was filled with that enthusiasm which Pasteur called "the inner god, which leads to everything." It seemed that nothing was impossible for him, that he could attempt anything—and *understand* anything. He composed treatise after treatise; with supreme self-confidence, he sought to penetrate the secrets of art, water, air, mankind, the world (he was now interested in geology, in fossils, and in mountain formation[108]); he investigated the origins of milk, colic, tears, drunkenness, madness, and dreams; as if it came under the senses, he talked of "writing what the soul is";[109] he dreamed of flying like an eagle or a kite and began to draw plans of "flying machines." Alongside a drawing of a bird in a cage, he wrote: "the thoughts turn to hope."[110]

The giant horse that he intended to cast in one piece is another product of the exaltation, passion, and enormous creative energy that now propelled him.

Just as Leonardo had apparently accomplished all the necessary conditions for casting the *cavallo*, so Ludovico Sforza had apparently taken all precautions to thwart his enemies' plans and to maintain his regency. But now the unexpected happened. Ferrante of Naples died in January 1494, and Charles VIII, king of France, at the head of the largest army in Europe, crossed the Alps and marched into Italy.

In his *Memoirs*, the French ambassador Commynes relates that Ludovico had painted for the young king a picture of "the fumes and glories of Italy," in order to tempt him, reminding him of the

right "he had to the fine kingdom of Naples, which he knowingly praised and glorified for him."[111]

The Most Christian King of France, brought up on tales of chivalry and Roman history, dreamed of making his name by playing Sir Lancelot in the land of the Caesars. He saw himself as launching a crusade: reclaiming his Neapolitan fief was equivalent in his eyes to acquiring a staging post (a legitimate and necessary one) on his way to the Holy Land, for he would have liked next to subjugate the Turk. In his mind's eye he was king of Jerusalem as well as of the "Two Sicilies" (the domain of the kings of Naples).

Charles was a little man, only twenty-two years old, good-natured, nervous, delicate, and ugly. He had a bony face, too large for his body, thick lips, large watery eyes, a short red beard, and an aquiline nose, "much bigger than was fitting," according to the Venetian ambassador Contarini, who furthermore did not consider him a man of great intelligence.

Nobody had thought he would cross the Alps so soon; people reckoned on his hesitation, inexperience, inadequate finances, and the pusillanimity of most of his princes.

Only the monk Savonarola, gloomy and fanatical, was aware of the imminence of the invasion, thanks to repeated visions. From the pulpit in Florence, he cried: "I saw in the heavens a sword suspended, and I heard these words: *Ecce gladius, Domini super terram cito et velociter!* And the sword fell straight away and, with its falling, brought wars, massacres, and troubles without number." He later added: "I did not name [Charles VIII] in my prophecies, but it was of him that I was thinking."

Naples was thrown into a state of panic by Ferrante's death. His son Alfonso, father of Isabella of Aragon, the Moor's bitterest enemy, hired a *condottiere,* regrouped his forces, and sought to attack Milan, via Genoa. When that failed, he would later—with papal approval—implore help from the Turks.

Ludovico hoped that the Holy Roman Emperor would descend on Italy at the same time as the French king and that the activities of the two powers would cancel each other out. He was expecting a war of influence rather than real hostilities.[112] But Maximilian remained behind his frontiers; the danger from Naples increased (there was talk of Alfonso's hired killers being on the loose in

Lombardy), and Ludovico neither could nor dared turn back.

On 29 August 1494, Charles left Grenoble; by 5 September, he was in Turin; a few days later, to the sound of drums and preceded by impressive artillery forces, he entered Asti, where Ludovico, along with Ercole d'Este, marquess of Ferrara (his father-in-law) awaited him with no great peace of mind. The French King then proceeded to Vigevano and Pavia.

Leonardo wrote these prophetic words: "The fleur-de-lis came to settle on the banks of the Ticino; and the current carried away both lily and banks."[113] We do not not know whether he took part in the festivities in honor of the French king, arranged by Ludovico for the sake of appearances. In reality, there were cracks in the entente. "Suspicions and discontent increased every day," says Guicciardini.

Two members of the French entourage particularly worried the Moor: Gian Giacomo Trivulzio, a Milanese in exile, an opponent of the Sforza regime, and a Guelph dispossessed of his property; and above all Louis, duke of Orleans, the future Louis XIII, grandson of a Visconti, who had serious designs on Milan, much as Charles had designs on Naples.

At this juncture, Gian Galeazzo Sforza most opportunely died. It was whispered that his uncle had had him poisoned by the court astrologer; the doctor Theodore of Pavia said so, and everyone believed him.

In any event, the succession was open. Now, at last, Ludovico could obtain for himself and his heirs the coveted title of duke of Milan. The city acclaimed him, either spontaneously or under pressure. But his rights remained precarious; and he found that the French were advancing through all Italy with dangerous ease. First Florence opened its doors to them, then Pisa and Rome; Naples, weary of the tyranny of the Aragonese, welcomed them as liberators in February 1495. Tacitus remarks that nothing is so weak and unstable as a sovereignty with no force of its own to support it. Ludovico had gotten rid of Alfonso but could not control his now out-of-hand French allies. When Louis of Orleans took Novara, the duchy of Milan was more seriously threatened than before; so the Moor had to give a new twist to his policy: turning against Charles VIII, he joined the league being formed by the emperor Maximilian

and by Ferdinand of Spain (who was equally preoccupied by French hegemony), along with the Pope and Venice—in order to "save Italy."

The league did eventually get the better of Charles VIII, at the battle of Fornovo. But in the meantime, the twists and turns of fate and policy cost Leonardo his horse.

The French artillery—serpentine cannon, double courtauts, colubrines, falcons, and other bombards of modern design—had caused the Italian generals powerfully to reflect. They had seen it overcome the fortress of Mordano, near Imola, in less than three hours. They needed to equip themselves with comparable cannon: the seventy-two tons or so of bronze destined for the *gran cavallo* were therefore loaded onto barges and dispatched to the arsenals of Ludovico's father-in-law, Ercole d'Este.

The Sforza coffers were thought to be bottomless; but the French alliance, Bianca's dowry (paid to the emperor), the purchase of the ducal title, the levying of troops and recruitment of mercenaries, not to mention all the new building in Milan, Vigevano, and Pavia, had practically exhausted them. Ludovico had even pledged his personal jewels in Venice. Bronze was a precious metal, especially in war-time. None was left for Leonardo's statue, and there would be no more ducats to buy any. And perhaps now that he had obtained his investiture, the duke was less anxious than before to honor his father's memory.

Leonardo did not despair of finishing the statue; he continued to work on it, waiting for better circumstances (which never materialized). In about 1496, he noted: "About the horse I will say nothing, for I know what times these are."[114]

The molds were never used. The giant clay colossus praised by the poets would crack, crumble, and decay, either in the Corte Vecchia or perhaps on the site where it had been displayed in triumph a few years earlier.

Since Francesco Sforza's statue was never cast, one wonders whether Leonardo was really capable of casting it. Skeptics are numerous—starting with Michelangelo—and they blame the artist himself for the failure. Even Vasari writes: "He proposed to make a bronze horse of extraordinary stature. He began it and made it so big that he could never complete it." Vasari imagines that Leo-

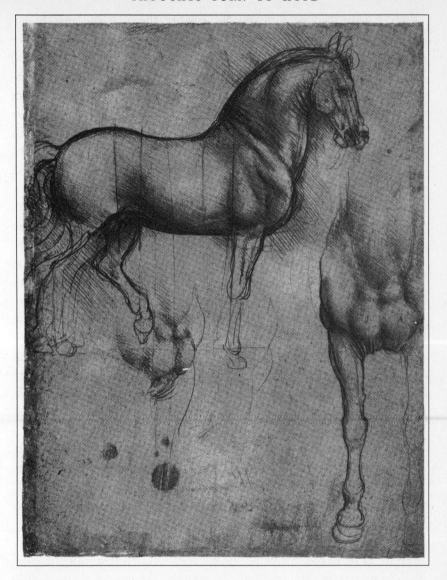

Study of a Horse.
ROYAL LIBRARY, WINDSOR.

nardo's mind was "paralyzed by the excessive nature of his ambi-
tion"; and he adds elegantly, quoting Petrarch: "The work was
delayed by desire." Political circumstances were not taken into

consideration in contemporary judgments: the quattrocento tended to reduce everything to individual *virtù*.

In favor of Leonardo's technique, one might cite Cellini, who seems to have known Leonardo's writings on casting and the techniques he invented, and to have derived useful inspiration from them. It also appears, from Brugnoli's description, that the enormous equestrian statue of Louis XIV (6.82 meters high) made in Paris two hundred years later by François Girardon was cast following a procedure very similar to that devised by Leonardo. "The same use [was made] of bars to brace the mold, strengthening the whole, and for the insertion of the core; the same method of handling the core and making the mold of regular detachable sections; the same method of casting in one piece; the same position was chosen for the mold, upside down in a pit."[115] Even the stance of the horse was the same, and by remarkable coincidence, the same bad luck attended the statue: it was destroyed during the Revolution, so we cannot see it. But the fact that it was cast at all shows that the method was sound.

All the same, a document left by Leonardo does prompt some doubts. It is the draft of a long letter to the council of works of Piacenza Cathedral,[116] reminiscent in some ways of the letter addressed some years earlier to the churchwardens of the Duomo of Milan:

"Magnificent commissioners of the works, having learned that Your Excellencies have decided to erect certain great works in bronze, I propose to offer you some advice about this. First of all, take care not to entrust the commission so hastily as to fail to make a good choice both of master and subject." The works in question were the bronze cathedral doors, which Leonardo would have liked to make. Since he speaks of himself in the third person in the last paragraph, one assumes that he was not writing in his own name but rather counting on some influential acquaintance to sign and send the letter on his behalf[117]—not a very honest tactic, but a common one at the time, and employed here with some humor.

"I cannot help feeling some irritation," Leonardo has his protector say, "when I think of the individuals who have conveyed to you their desire to embark on such an enterprise without bothering to

ascertain whether they are really capable of doing it, to say the least. One is a potter, another an armorer, a third is a bell founder and another a maker of bell clappers; there is even a bombardier among them; while one, a retainer of the duke, boasts of being the close friend of Messer Ambrosio Ferrere, a very highly placed man who has made promises to him. If that will not do, this man will jump on his horse and seek out his lordship, from whom he will obtain letters, so that you will be unable to refuse him the commission. But consider the distress of the poor masters who have acquired by their studies the necessary knowledge for the execution of such works, when they have to compete with creatures like this. Open your eyes and try to assure yourself that your money will not serve to buy your own shame." And the letter ends with this equivocal sentence: "No one is qualified—believe me—apart from Leonardo the Florentine, who is now making Duke Francesco's bronze horse, and whom one need not suggest, since he has enough work for a lifetime; and I even doubt, so huge is his enterprise, that he will ever finish it."

Leonardo was dissatisfied with the end and rewrote it: "There is the man his lordship called from Florence to do this work,[118] who is a worthy master, but he has so much to do that he will never finish it."

This is an odd kind of job application—what is one to make of it? Leonardo says, or has it said, that he is the only man capable of building the bronze doors for Piacenza Cathedral; yet he announces that he is too busy to take them on. He speaks of the horse as being to his credit but immediately admits to doubts whether he will ever finish it. Was he hoping for the commissioners to beg him to enter their service? Did he want to suggest that his commitments prevented him from applying personally? That he had work and to spare but that if pressed he just might act as consultant or even more—since as things stood, with small hope of ever completing his *magnum opus,* taking on extra work would not make much difference?

The ruse seems rather transparent; at all events, it did not work, or else the project fell through; Leonardo was not invited to Piacenza.

Nevertheless, he does not blame political circumstances for his

inability to finish the horse. Like Vasari, he says he is held back by the size of the work: *"si grande opera."*

Technically, it seems clear, he could have solved the problem of casting. It is true that he often hesitated in a kind of anguish before the irremediable: the completed work. But one wonders what his feelings were as he watched the barges laden with the metal for his statue disappear toward Ferrara in the winter of 1494.

VIII

The Absolute Man

Miserable mortals, open your eyes.

—LEONARDO

To create the appearance of life
is more important than life itself.
The works of God are never better appreciated
than by other creators!

—Anonymous hand on a page
of Leonardo's notebooks[1]

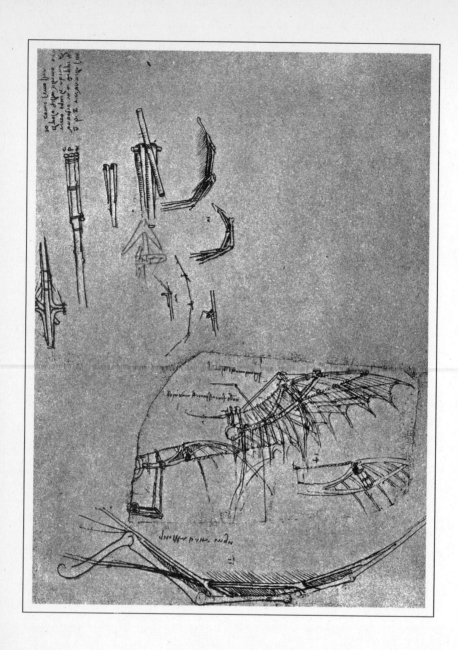

Design for Wing.

CODEX ATLANTICUS.

A LL OUR KNOWLEDGE proceeds from what we feel," Leonardo wrote.[2] To experience the world through the senses (first among which he placed sight), to discern, judge, and reflect—these were for him the essential prerequisites for knowledge and wisdom.

"What one acquires in youth," he wrote, "enables one to fight against the miseries of old age; and if you wish your later years to be nourished with wisdom, take steps while you are young to see that you do not lack resources in old age."[3]

Just as an athlete develops his muscles, Leonardo trained his own senses, educating his observant faculties. We know from his notebooks the kind of mental gymnastics he put himself through.

One must first of all learn, he wrote, to separate the parts from the whole: "Seeing is one of the most rapid operations possible: it embraces an infinity of forms, yet it fixes on but one object at a time." To read a text, one has to consider the words one by one, then the sentences the words make up, not the total number of letters written on the page. In the same way, Leonardo says, "if you wish to gain knowledge of the forms of things, begin with the detail and only move from one detail to another when you have fixed the first firmly in your memory and become well acquainted with it."[4]

Four centuries before Bertillon, Leonardo had imagined a sort of anthropometric system and advised the beginner to learn by heart "many heads, eyes, noses, mouths, chins and throats, necks and shoulders," so as to retain physiognomies in the mind. For example,

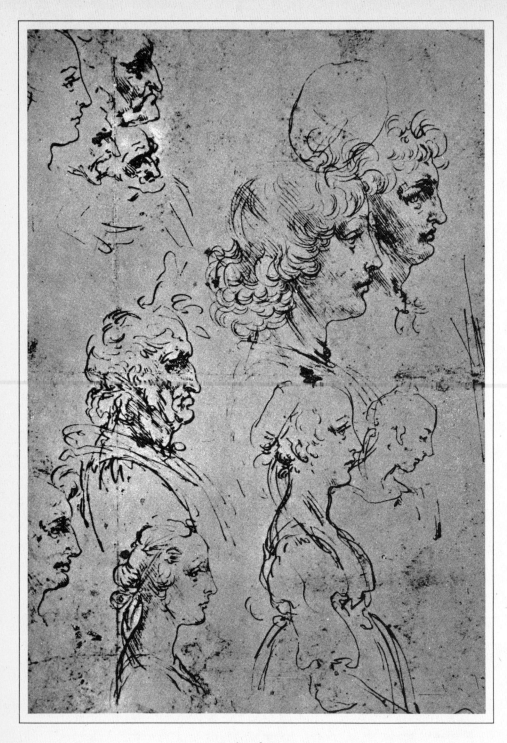

Study of Faces.

he distinguishes ten different types of nose in profile ("straight, bulbous, concave, jutting above the midpoint or below it, aquiline, regular, snub, round, and pointed") and twelve seen from the front. He advised drawing such generic features in a sketchbook—lips, eyebrows, shapes of head, etc.—as if in a catalogue, and learning to spot them immediately in any face, recognizing how much or how little the features of a given individual resembled them. "I will not speak of monstrous faces," he adds: "one remembers them without difficulty."

He did the same for bodies, plants, and all natural forms—for one should strive to be universal. Thanks to his method, he said, universality was easily acquired.[5]

One could improve one's perception by playing games: he listed "profitable recreations" whereby one could train oneself "to recognize the length and width of things," to compare proportions and estimate distances.

He did not disdain the use of drawing machines or perspectographs and even designed one,[6] which Dürer would study in detail some years later. It consisted of a frame and an eyepiece: the frame held in a vertical position a pane of grid-marked glass. The user applied his eye to the eyepiece (fixed about thirty centimeters from the center of the pane) and traced what could be seen in real perspective through the glass. The grid could then be used to reproduce it. There were several variants of the apparatus.[7]

Leonardo condemned this invention, however, "when those who use it do not know how to do without it nor how to think for themselves, for by such sloth they destroy their minds." But he did regard it as useful for correcting one's work. "Try to reproduce an object without the model," he recommends, "after having drawn it so often that you think you know it by heart. Then put over this drawing from memory the tracing obtained with the perspectograph. Find out the places where the tracing and your drawing do not match and where you have made a mistake, and remember it, so as not to fall into the same error again."

Human memory could not contain "all the forms and phenomena of nature." But one should nevertheless try to study and memorize as many of them as possible: the wider one's knowledge, the less difficulty one would have in tackling a new subject. Leonardo tried

to picture them for himself at night before going to sleep. "I know from experience," he writes, "the interest there can be when you are in bed in the dark, in going over in your imagination the contours of the forms already studied or other remarkable objects conceived with subtle speculation; this is an exercise to be recommended, very useful for imprinting things on the memory."

Leonardo may have picked up some of these practices from his master, who was a skilled pedagogue. Verrocchio excelled in the art of drawing, as is admitted even by Vasari, who is generally hard on him: "I have in my portfolio," he writes, "some of his drawings, done with great patience and admirable judgment, among which are heads of women, charming in their grace and the arrangement of their hair, which Leonardo, because of their beauty, imitated all his life. I also have [drawings of] two horses with a measured grid for making an exact and proportionate enlargement, and a relief in terra-cotta representing a horse's head copied from an antique original, of rare beauty."[8] Here at last Verrocchio receives some justice.

"From the dawning of the day," Leonardo writes, "the air is filled with countless images for which the eye acts as magnet."[9] He did not want to miss a single one. In such a frame of mind, how could he respect the religious calendar? He speaks with the greatest scorn of the bigots and hypocrites "that censure the man who examines the works of God by working on holy days." The study of nature, he continues, reveals the grandeur of Him "who invented so many marvelous things"; it is by knowing Him through his works that one learns to love Him.

The artist had to perceive (or conceive) form but also to preserve, analyze, and transmit it: there was no better method than drawing. "With what words can you, a writer, equal in your description the complete face that is reproduced by a drawing?"[10] A single image could be the equivalent of a book.

Observing and drawing (and imagining or reflecting) were operations that very soon for Leonardo became much the same thing. Hand, eye, and brain became coordinated through determined training. He gradually turned himself into a sort of living, thinking, and inventive camera (he wrote of "becoming like a mirror"—an intelligent and critical mirror).[11] Drawing seems to have been almost second nature to him. He saw to perfection, then judged and repro-

duced the subject, seemingly without an intermediary between retina and paper: his thought was formed in the movement of his hand as his hand interpreted his vision. He could work so fast that one sometimes feels one is looking at a form of shorthand. "Keep a sharp lookout," he writes, "for figures in movement, in the streets, in the squares, in the countryside, and note down the main lines quickly: that is to say, putting an O for the head and straight or bent lines for the arms and the same for legs and trunk; then when you get home, look back at your sketches and give them finished form"; and "Tomorrow make some silhouettes out of cardboard in various forms and throw them from the top of the terrace through the air; then draw the movements each makes at the different stages of its descent."[12] For many years, he preferred to work with silverpoint pen on tinted paper, for this did not allow any second thoughts; the same was true of pen-and-ink. In his studies of flowers, bodies, machines, and whirlpools, depicted in the minutest detail, or of birds in midflight, he finally achieved a mastery comparable to that of Zen archers who have come to identify so closely with their weapon and its target that their arrows hit it without their having consciously taken aim. (Some of Leonardo's sentences are in fact strangely reminiscent of *koans,* the statements by which Japanese Buddhism provokes "awareness": so when he writes, "The sun never sees the shadow" or "The moon, dense and grave—what is the moon like?"[13] one is reminded not so much of problems of perspective and astronomy as of some disquieting Oriental riddle.)

Leonardo had recipes for everything; he even gives one for stimulating the imagination. Almost with an apology, since it seems so "petty and ridiculous," he advises: "in order to excite the mind to various inventions" ("invention" is a frequent word with him), one should contemplate "walls covered with shapeless stains" or made of ill-assorted stones: one can find in them mountain landscapes, trees, battles, "figures with lively movements," faces, and "strange costumes." The colored patches on the walls, or the clouds in the sky, he adds, are like a carillon of bells, "which contains all the sounds and words that you could imagine." (André Chastel notes that in the 1920s, Max Ernst discovered the surrealist technique of *frottages* in this "teaching of Leonardo."[14])

Leonardo writes: "Surely there is no one who would rather lose

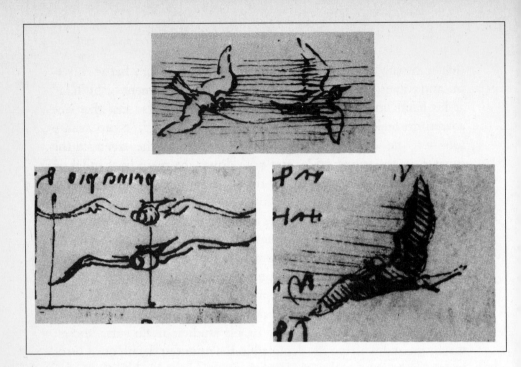

Birds in Flight.
CODEX MADRID.

his sight than his hearing or sense of smell." And: "To lose one's sight is to be deprived of the beauty of the universe, and to be like a man buried alive in a tomb. . . . Do you not see that the eye embraces the beauty of the entire world?"

He explains at length, sometimes with specious arguments, why sight is the most important of our senses, "the best and most noble," and consequently why painting, "a divine science," far from being a "mechanical activity," towers over all the other arts.

"Through its foundation, which is drawing," he explains, "it is as indispensable to the architect and the sculptor as it is to the potter, the goldsmith, the weaver, or the embroiderer." Drawing teaches them beauty and plastic harmony; it has invented characters that allow us to write; "it has given arithmeticians their figures; it has taught geometers the shape of their diagrams; it has instructed opticians *(prospettivi)*, astronomers, machine builders, and engineers."

Drawing is the first instrument of every science; and its extension, painting, or knowledge through form, comes closer to the truth

than philosophy itself—for, says Leonardo, the eye makes fewer mistakes than the mind: *"perchè l'occhio meno s'inganna."* [15]

As a sort of introduction to a major treatise on painting, he amused himself by drawing parallels *(paragone)* between the various arts—it was a fashionable subject for discussion in the late fifteenth century. Was painting of more value than literature or than that "blind painting," poetry? Yes indeed, Leonardo categorically replied: "If the poet describes the beauties of a lady to her lover, and the painter paints her portrait, you will see which way nature will incline the amorous judge." Was it of more value than music? Unquestionably. Music, although creator of harmonies, is but "the younger sister of painting": since sounds do not last, music dies the very instant it expresses itself; and it is exhausted by repetition—which renders it "unworthy and vile." Sculpture? Nothing endures so well as marble or bronze. But sculpture is essentially concerned with mass, and its "summary discourse" cannot rival that of painting, "a miraculous thing," far more intellectual and based on ten principles, "light, darkness, color, mass, figures, position, distance, proximity, movement, and repose," so that there is nothing it cannot represent. And besides, sculpture is a manual occupation, which wears a man out and makes him dirty: the poor sculptor, sweating and out of breath, his face encrusted with marble dust, looks like a baker, or as if it had been snowing on him. His lodgings are ankle deep in stone rubble, [16] whereas the painter, "seated comfortably before his work, elegantly dressed, dips a light paintbrush into agreeable colors . . . lives in a clean dwelling, and can often have himself accompanied by music or the reading aloud of beautiful and varied works, to which he listens with pleasure, without being interrupted by the sounds of hammers or other noise."

Leonardo's lively polemics are above all the expression of his ardent wish to elevate his art, long dismissed as inferior and a mere craft, to the level of the seven liberal arts. He wanted to prove that painting, *"cosa mentale, maggior discorso mentale,"* based on the study of natural phenomena, deserved to be considered a science—a *qualitative* science, cognizant of beauty and capable of capturing and reflecting "the decoration of the world."

And by portraying the painter in a luxurious and refined atmosphere, Leonardo was producing a "portrait of the artist as noble-

man." Before either Titian or Rubens,[17] he was rising above his station, laying claim to a social status to which none of his colleagues had yet dared aspire: this was something quite unprecedented. It struck his contemporaries and astonished the next generation, that of Vasari, inspiring admiration that continued down to the nineteenth century. Vasari, who often relied on eyewitness accounts, tells us apropos the famous smile of the *Mona Lisa,* that during the sittings Leonardo filled the studio with musicians, singers, and clowns, as if to amuse a prince. Later, when painters such as Bertini depicted Leonardo at work, they always picked up this image: he is shown richly clad, in a studio full of fine furniture as if in a literary or aristocratic salon, seated at the center of a veritable court.[18]

From 1490 on, Leonardo's research seems to progress in a more spiral fashion: as if it were obeying a certain order and logic, if not exactly a plan. For example, while at work on the horse and on courtly festivities, he sought to understand the functioning of the eye, "the window of the soul." From that followed the mechanics of vision, the nature of light, and the way the heavenly bodies reflect or produce this light. This in turn led him to consider the movement of water and the propagation of sounds, as if he perceived analogies between sound waves, the waves on the surface of a lake, and the rays of the sun. At this time, he experimented with a camera obscura and with shadows, thus returning, on a different plane, to the problems of representation.

It is not always clear with Leonardo whether one should speak of rational discoveries or of blinding intuitions. His methods, like his formulas, were rarely orthodox. In any case, the deductions in his notebooks are dazzling. Whereas men of his age thought that vision was created by particles *(spezie)* projected by the eye, Leonardo understood that the eye did not transmit anything but received rays of light. Studying the anatomy of the eye, he discovered the lens, or crystalline humor, as it was then called, and distinguished peripheral from central vision; he also perceived that the eye registered a reversed image.[19] He worked out the causes of farsightedness (from which he may have suffered himself) and envisaged a sort of contact lens (though he would have had great difficulty actually

making one).[20] He was the first to note the principle of stereoscopic vision—that is, the perception of three-dimensional relief. He had the notion that light traveled (whereas his age believed that it filled the world in a single instant), and he may even have tried to calculate its speed. Explaining how light is diffused, he uses the word *tremore*—trembling—to express what we would today call oscillation. A century before Fermat he formulated this fundamental law based on Aristotle: "Every natural phenomenon is produced by the shortest possible route."[21] Some of his experiments anticipate Rumford's photometer.[22] He even explained why the sky is blue: "I say that the azure that the air makes us see is not its proper color, but this color comes from warm, damp air, evaporated into minuscule and imperceptible particles, which, being struck by the light of the sun, become luminous below the obscurity of the mighty darkness which covers them like a lid."[23]

This is a glance at Leonardo's work on optics. It needs to be examined in detail, as do his related studies of acoustics, water, movement, percussion, force, and weight; or his work in geology, botany, and phonetics. Not for an instant does one lose the feeling that one is in the presence of an extraordinary genius who by his "discoveries" seems unbelievably—almost abnormally—ahead of his time. Merejkovski compares him to "a man who wakes too early, while it is still dark and all around are sleeping." Scientists today, though still amazed by Leonardo, nevertheless hesitate about the exact value one should place on his discoveries—or potential discoveries.

Sometimes these fit into a line of descent. When he writes: "Where a flame cannot live, no animal that breathes can survive,"[24] he seems to be reaching forward to modern chemistry. But he could simply be repeating a commonsense observation, which any underground miner could have formulated. He had no idea what oxygen was. Leonardo may point the way to Lavoisier, but he does not jump the centuries between them. Similarly, he observed the laws of refraction—but did not formulate them, since he did not know enough trigonometry. He was interested in the properties of steam; but he was a long way from the steam engine. He seems to have invented some kind of telescope a century before Galileo. He writes: "Make glasses to see the moon enlarged."[25] He assembled lenses, but

even if he built an instrument (which I rather doubt), he never made anything of it. What he had devised was too rudimentary to revolutionize astronomy. And apparently he never suspected that the planets orbit the sun.[26]

The history of science, against which we measure his discoveries, tends to both minimize and exaggerate our appreciation of Leonardo's scientific achievements. Personally, I am as amazed by the countless results that Leonardo obtained (limited though they may be) as by his extraordinary need to understand, that obstinate compulsion which drove him ceaselessly toward so many kinds of research, making him ask questions nobody had ever asked before. And finally, I am quite amazed by the fact that this autodidact, with absurdly limited resources at his disposal, exploring the universe in his spare time as a sort of hobby, should have succeeded in the end, chiefly thanks to analogies and correspondences, in developing a general theory of the world—solid, compelling, and coherent. Quoting Aristotle, he himself said, "Man merits praise or blame solely in consideration of what it is in his power to do or not to do."[27]

We have all amused ourselves at one time or another throwing stones into water. But how many of us have ever noticed that two stones thrown into calm water will produce two sets of concentric rings that, as they expand, will meet and intersect without breaking? And how many of us, finding this surprising, would deduce a principle from it? Leonardo observed that the water, which seems to be moving, is in fact not moving at all. Rather, he writes, there are "as it were little wounds, which, opening and closing suddenly, impart to it a certain reaction that has more to do with trembling than with movement." If the series of rings do not break when they meet, it is because "water is homogeneous in all its particles, and this trembling is transmitted to its particles without the water itself moving." Having thus defined the principle of waves, Leonardo *sensed* that sound and light spread through the air in the same way.[28] Does it really matter if, after that, he lost his way somewhat?

Nature was his laboratory; he was his own most finely tuned instrument of investigation. Open your eyes, he says. You have only to *see things properly* to understand.

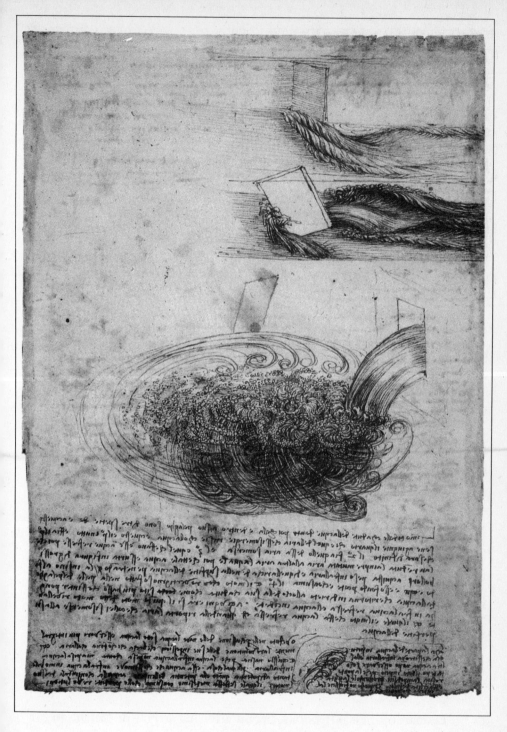

Motion of Waves and Current.

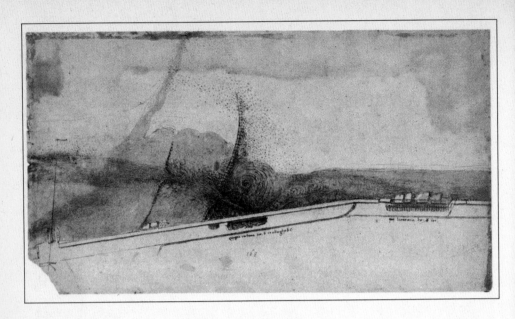

Motion of Waves and Current.
ROYAL LIBRARY, WINDSOR.

He examined the hollows in rocks, the gravel rolled down by rivers, mud and sediment. Shells and fossilized seaweed found in sedimentary mountains revealed to him that oceans had once covered the earth.[29] He arrived at the most stupendous conclusions using candle ends, the eye of a needle, a funnel, a bucket, and a metal box. A glass ball filled with water served as a convergent lens. By moving a sheet of paper pierced with a tiny hole in front of a white wall, he was able to define the trajectory of rays of light. A torch waved about rapidly in the dark, seeming to trace lines of fire, or a knife embedded in a table and vibrating so that it gave the illusion of being two knives, told him that the eye finds it hard to distinguish images following each other in quick succession. He noted this phenomenon several times: when a lute string oscillates, he remarked, it seems to be doubled. The eye does not immediately assimilate visual impressions—is this not further proof that it has a purely receptive function and that light is traveling toward it at great speed?[30]

Leonardo's first notebooks, begun after his arrival in Milan, are essentially concerned with machines: they show us the progress of the engineer. It was only gradually, and in part thanks to contact

266

with the learned men of the University of Pavia, that the engineer became a scholar himself. Exploring technical problems led him into the methodical analysis of motion, the elements, and so on. The artist had found his way at last: he began to challenge everything, as the gaps and errors of traditional science became clear to him. "So many things," he haughtily remarks on several occasions, "have remained unknown or misinterpreted for centuries!"[31] His own findings often seem contradictory. His method was to set out from received opinion, then to try to verify whether it was correct; finding counterevidence suggesting the opposite, he would repeat the experiment many times in order to have irrefutable proof, before making a personal pronouncement. Since he wrote down his results in any old order, often on the first piece of paper that came to hand, and since he rarely had the time or patience to classify them properly, it is difficult to identify his final conclusions.

He was, after all, learning almost from scratch. He had not been to a university; he hadn't even received what we would call a "secondary education." He had not completed an apprenticeship for all his work (architecture, for instance). He learned through chance meetings, by observation, or by reading and asking questions. Very quickly, however, he realized that he would never get far without expanding and consolidating his basic knowledge, and whatever the virtues of hand and eye for drawing, he needed to be able to set things down in writing, to define them properly in words: the world belongs to those who can describe it.

In about 1490, at the age of thirty-seven or thirty-eight, he therefore turned his hand to composing a sort of great lexicon, filling page after page with various words. One notebook (the *Codex Trivulzianus*) contains nine thousand or more, arranged in closely written columns, mostly learned or foreign words or neologisms, though there are also, surprisingly, some popular terms. At one point over four pages, the words appear in alphabetical order, accompanied by a brief definition:

arduous: difficult, painful
Alpine: of the region of the Alps
archimandrite: leader of a group
ambition: rivalry and presumption

. .

syllogism: suspect way of talking
sophism: confused way of speaking
schism: division
stipendio: soldiers' pay[32]

More often, the words succeed each other without any logic or explanation, so that some writers (such as Stites, who treats Leonardo as if he were under analysis[33]) have studied them at length using the Freudian principle of free association. It is certainly tempting: at the top of one of the first lists, for instance, in the right-hand column (with which Leonardo began, since he wrote mirrorwise), we read:

to suspect
to propose
suspicious
public
advice
feeling
wise

Is this another sign of his persecution mania and passion for secrecy? On the same page, one reads:

fixed
rooted
found
pleasure
union
operation
introduced
renounced[34]

This might hint at his tortured and nagging sexuality. Or perhaps he actually devised the method in order to explore his own mind. But it is equally possible (and does not necessarily rule out any psychoanalytic examination) that he simply copied out words as he

met them in his reading: every time he found a word that intrigued him or seemed useful, he noted it systematically in his lexicon, so as not to forget it. Soon he could proudly declare: "I possess so many words in my native language that I ought rather to complain of not understanding things than of lacking for words to express my thoughts properly."[35]

The extent of his reading increases during the 1490s. Leonardo makes various allusions in his notebooks to the authors he was reading. Having a mania for lists, he twice catalogued his personal library, in 1497 and again in about 1505.[36] So we know the titles of over one hundred seventy books he had read. They range from the Bible to Albertus Magnus, by way of Ovid's *Metamorphoses*, Alberti's *Architecture*, various mathematical treatises, a *Rhetoric*, a *Chiromancy*, a *Chronicle of Saint Isidore*, a textbook on surgery, a brochure on urine, Livy's *Decades*, an *Art of Memory*, Burchiello's *Sonnets*, Pliny's *Natural History*, Aristotle's *Physica*, a medieval *Fior di Virtù*, and several collections of fables (of which he copied out whole pages).[37]

On the first folio of the Codex Trivulzianus, between a bill and some caricatures, occur the following words, like an agonized sigh, expressing the passionate thirst for culture of this man who called himself "unlettered" but owned more books than many scholars of his time: "Ammianus Marcellinus says that seven hundred thousand books were burned during the conquest of Alexandria, in the time of Julius Caesar."

But many of the scientific treatises that did get passed down from antiquity existed only in manuscript, such as the Latin translation of Archimedes' *Treatise on Floating Bodies*, which Leonardo spent years trying to obtain.[38] And many more were not available in Italian.

So in order to pursue his studies, Leonardo began learning Latin. He was over forty. He started a little notebook—the very moving manuscript H—by conjugating *amo, amas, amat*, like any schoolboy. He must already have had a smattering of the language of Cicero, but only a vague one. Earlier, he had tried to translate simple sentences and got very mixed up: thus he renders *Caelidonium auctores vocant ipsi falcastrum* as "Celidonio calls *auctores* a crescent-shaped weapon."[39]

Conjugations, declensions, then grammar (he copied out almost the whole of Niccolò Perotti's) and Latin vocabulary (from Luigi Pulci) were all noted. New words entered his lexicon. And finally, he could tackle unaided the science of the ancients.

Leonardo did his reading pen in hand, noting down vocabulary and in particular copying out word for word long passages from books that interested him. Since he read critically and with imagination, he commented on what he was noting and drew images of what he imagined.

Studying the *De re militari* of Roberto Valturio (written in 1450, published in 1472, reprinted in 1483), he noted the technical names of complicated weapons and reproduced and refined the illustrations (the originals were naive woodcuts). The weapons whose designs he copied—with improvements and modifications of his own— inspired him to design new types, sketches of which he may have sold to Milanese armorers. This was normal practice: Valturio had himself borrowed much from Taccola ("the Archimedes of Siena"), from the German Konrad Keyser, and from Vegetius, a Latin writer of the fourth century.

Leonardo's astonishing assault vehicle,[40] which looks like a flying saucer with its four wheels turned by a crankshaft, owes much to the various engines designed by his predecessors (one of them invented by Guy de Vigevano in particular, powered by wind vanes). But when one sets side by side Leonardo's impeccable designs and the crude efforts of his forerunners, the difference is blindingly obvious: while his assault car, clear and precise, drawn in three dimensions, in section, and in motion, has an independent existence and an evident function, the others look like improbable medieval contraptions. Although they are all similar in principle, one has the sense of comparing highly sophisticated technology with machinery still in its infancy. When he later perfected his self-propelling tank, providing it with a spring-powered "motor" and a differential transmission system, or when he tried to reduce the friction resistance of every moving part,[41] Leonardo was far ahead of the engineers of his century. His acute and well-informed graphic sense, combined with an unparalleled talent for layout and that instinctive style of his, which translated thoughts into pictures so impressively

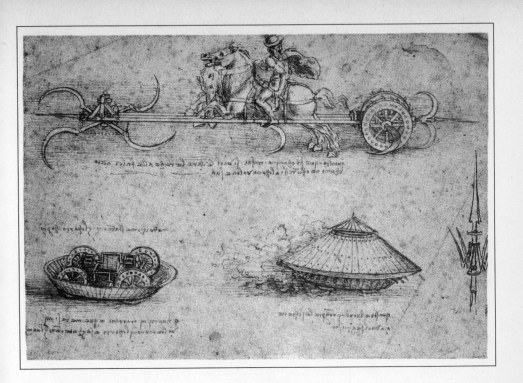

Assault Vehicles.

that modern advertisers are still imitating him, often creates a convincing illusion.

At the same time, the dimensionality, clarity, and precision of his diagrams (which may have replaced experiment), the unusual attention he pays to detail by dissecting his machines, showing the mechanism from various angles, in section, or broken down into elements (he studied the parts of a machine as he learned the features of the face, eyes, nose, etc.), were in themselves major innovations. There have been virtually no better technical drawings until the coming of computer-assisted draftmanship. Leonardo might be copying an existing machine, but he was already innovating in his manner of representing it.

Since Leonardo scarcely ever gives his sources, various scholars[42] have tried to distinguish between borrowings (literary, technical, and scientific) and the original ideas with which they are inextricably tangled. They have shown, for instance, that a sentence we may

271

think is his own is actually a transcription from Pliny or Aesop, that a certain "discovery" is in fact the work of Pecham or Alhazen, or that an "invention" was well known to his contemporaries. But in order to judge properly the thousands of pages he left, one would have to have an encyclopedic knowledge of the entire culture of his age, to read all the books he read, and to examine in detail everything he might have seen or heard of. Then one would have to find out how aware his own contemporaries were of his works, and to what use they were put, or who actually read any of his writings. Vasari, for example, was aware that Leonardo had designed "mills, fulling machines [for sizing fabric], and water-driven mechanisms," as well as others intended "to raise heavy weights." Such machines have of course disappeared: so how is one to estimate the influence, the importance, or the novelty of Leonardo's designs?

One may be a little disappointed to find that his diving suit and webbed gloves are already to be found in Archimedes and Alberti and that his submarine resembles one that Cesariano (a pupil of Bramante's) tried out in the moat of the Castello Sforzesco. On the other hand, it may be a relief to learn that Leonardo is simply copying a thesis like the following because its naïveté amuses him: "Men born in hot countries enjoy the night because it brings them cool, and hate the light of the sun, which makes them too hot. That is why they are the color of the night, which is black; and in cold countries it is the other way around."[43]

His contribution to technical progress was eventually absorbed into the technical advances of his age. But there are some spectacular inventions (or improvements in design) that cannot be taken away from him, in particular his textile machines (which seemed to him to be more useful, profitable, and perfect than the printing press): machines for spinning, weaving, twisting hemp, trimming felt, and making needles. He was unquestionably a mechanical genius—and indeed a prophetic one—anticipating the industrial revolution in the sense that his "machines" (including tools, musical instruments, and weapons) all aspired toward systematic automation.

In the end, much as one may reduce them by revealing their limitations, or diminish their originality by placing them in context, Leonardo's scientific and technical achievements undeniably possess

a greatness and an exceptional character that derives essentially from the conception and the determination behind them. From 1490 on, Leonardo sought to assimilate and rigorously classify (according to what he called "my mathematical principles") the whole of human knowledge, by *structuring* it, correcting it if necessary, and enlarging it if possible.

It was a desire both irrational and unreasonable if ever one was (and he said so himself[44]). Such a plan was not made in a day: it must have taken shape as Leonardo developed his knowledge.

He writes with feigned modesty, covering great irony: "Seeing that I cannot choose a particularly useful or pleasant subject, since the men born before me have taken for themselves all the useful and necessary themes, I shall do the same as the poor man who arrives last at the fair, and being unable to choose what he wants, has to be content with what others have already seen and rejected because of its small worth. I will load my humble bags with this scorned and disdained merchandise, rejected by many buyers, and go to distribute it not in the great cities but in poor villages, receiving the price for what I have to offer."[45]

Leonardo began by exploring indiscriminately a number of precise areas; then he investigated with enthusiasm ever more numerous, extensive, and fertile fields of inquiry, finally coming to the conclusion that the earth was of a piece, in the image of man, and that everything was interconnected.[46] He soon realized that he had garnered a rich harvest in his notebooks—but to what purpose?

An emulator of Alberti and a great reader of Aristotle and Dante (whose *Divine Comedy* was a sort of poetic catalogue containing the culture of an entire age), Leonardo thought of classifying the fruits of his research and in turn giving the world a "comedy" of his own, in the form of a treatise, a universal encyclopedia. He expresses several times the desire to order his notes and rearrange them for publication. "When you put together the science of the movements of water,"[47] he writes hopefully at one point; and again, picturesquely: "The order of your book must follow a plan: first the simple beams, then the ones held up from below, then those that are partially suspended, then those that are entirely suspended. Then the beams that will bear weight."[48] He had worked out a coherent

plan for his shorter treatises too: "The book on the science of mechanics must precede the book of useful inventions. Get your anatomy books bound."[49]

Some days he must have dreamed, even though he rejects the thought, of discovering the single law governing all the other laws of the universe. He was already writing: "Motion is the principle of all life"[50] and had established that every physical phenomenon depended on four powers *(potenze):* motion, weight, force, and percussion.[51]

This unreasonable desire to penetrate and expose in all its glory the entire sum of knowledge accorded well with Leonardo's aspirations as a painter—who "represents in fiction an infinity of forms, animals, plants, and places," who in the tiny space of his pictures encloses all the images of the universe and who alone can "dispute and rival nature."

The painter, Leonardo writes, is "the master of every individual and every thing." If he wishes to see "beauties capable of inspiring him with love, he has the faculty of creating them, and if he wishes to see monstrous things, inspiring fear, or comical things to make him laugh, or sights capable of arousing pity, he is their master and their god." He has the power to create idyllic landscapes, mighty mountains, raging oceans, and even mythical forms, shapes that nature does not know: "The divine character of painting," declares Leonardo, "means that the mind of the painter is transformed into an image of the mind of God."

Vasari accuses Leonardo of heresy, of obeying no religion, of placing "scientific knowledge [higher than] Christian faith." He might rather have accused him of the sin of pride, if not blasphemy. In the late 1490s, Leonardo, who was thinking more and more seriously of flying through the air like a bird or swimming under water like a fish, was measuring himself against the Almighty, just as the Titan Prometheus, father of civilization and benefactor of humanity, had defied Zeus.

Leonardo despised the antics of priests, who "produce many words, receive much wealth, and promise paradise." "Many are those," he wrote, "who trade in tricks and simulated miracles, duping the foolish multitude; and if nobody unmasked their subterfuges, they would impose them on everyone."[52]

Of the commercial exploitation of pious objects, he wrote: "I see Christ once more being sold and crucified and his saints martyred."[53] He protested against the sale of indulgences, criticized the exaggerated pomp of churches, obligatory confession, and the cult of the saints. He mocked those redundant prelates who claimed "to be pleasing God" by lounging all year round in sumptuous residences.[54] The seeds of the Reformation were being sown all over Europe: such opinions were common coin in intellectual circles; indeed, these examples seem moderate alongside the thunderings pronounced in the pulpit (and published) by the uncompromising Savonarola.

Leonardo's flagrant anticlericalism certainly did not lead him toward an atheistic position. He believed in God—though not perhaps a very Christian God; rather, one closer to the ideas of Aristotle or the German theologian Nicholas of Cusa, and prefiguring the God of Spinoza. He discovered this God in the miraculous beauty of light, in the harmonious movement of the planets, in the intricate arrangement of muscles and nerves inside the body, and in that inexpressible masterpiece the human soul. He was almost jealous of the Creator, whom he called the *primo motore*: the *inventor* of everything was a better architect and engineer than he himself would ever be.

"O admirable necessity!" he writes of the eyeball. "O powerful action! What mind can penetrate your nature? What language can express this marvel? None, to be sure. This is where human discourse turns toward the contemplation of the divine." This sense of the marvelous in fact dictated Leonardo's moral philosophy, which was based on a single axiom: Respect all life. I cannot think of a wiser one.

Painting, he says somewhere (or, indeed, science as he saw it), the daughter of the visible world, is "the granddaughter of nature and related to God." He constantly links things together by family ties—music is the younger sister of painting, flame is the mother of metals, truth is the daughter of time, etc. In search of a family, Leonardo attached himself to the whole of nature, imagining a sort of genealogical tree for his art, which would link him to the Creator. His personal cosmology made him a legatee of the universe, outside human society yet at home everywhere, hence the

legitimately wide scope of his scientific inquiries.

Leonardo was probably not a practicing worshiper; or rather he practiced in his own way. His art, although dispensing with gold and azure, as he would have liked the Church to do (his elimination of haloes shows Reformation tendencies), remained essentially religious through and through. Even in a profane work, Leonardo was celebrating the sublime creation of the Almighty, which he sought to understand and reflect.

He had already painted several pictures of the Virgin Mary: an Annunciation, an Adoration, several Virgin and Child paintings. But he had never represented Jesus *as an adult*. In 1495, as the political situation became (momentarily) more stable, Ludovico il Moro commissioned him to paint the Last Supper, the crucial moment of the Passion, which would offer him the chance to apply his pictorial (and to some extent scientific) theories, as well as to express his religious feelings more deeply than before.

The Last Supper still exists in the refectory of Santa Maria delle Grazie in Milan. It is the only work by Leonardo that one can visit *in situ*. The convent archives have been destroyed, but we know that this Dominican monastery was favored by Duke Ludovico: he came here often to meditate; he wished to be buried here with his wife, Beatrice, and their family. He had demolished both the choir and the apse of the church (begun by Guiniforte Solari, the architect of the cathedral, in about 1465) and had appointed Bramante to enlarge and complete the building. In 1495, the pulpit, a sort of vast cube supporting a cupola with sixteen vaults, was still under construction (it would not be finished for another two years).

At the same time, the Moor was having the monastery building alongside the church refurbished. He had already asked the Lombard painter Montofarno for a Crucifixion on the north wall of the refectory. To Leonardo he assigned the opposite wall, 8.8 meters long.[55]

The Last Supper depicts the final meal that Jesus took with his disciples, when he instituted the communion service. This was a traditional subject for the decoration of convent refectories. The earthly tables of the monks echoed the sacred table of the Gospels; the temporal world met the eternal, so that the words of Jesus "I

shall be always among you" should be fulfilled. The idea could not fail to appeal to da Vinci. Goethe believed that he took as his model the monks' actual trestle table, "even their tablecloth with its regular folds, its embroidered border, and its fringe," as well as the plates, dishes, and glasses that they daily used.[56] Above all, Leonardo made his fictional space prolong the real space of the dining room. Using all the resources of perspective—that is, theatrical perspective, for, as in a stage set, he designed a misleading architecture so as to increase the impression of depth[57]—he was to devise what is surely the most ingenious composition in the history of art. Significantly, his earliest studies for *The Last Supper* appear among geometrical drawings, on a page where he demonstrates how to turn a circle into an octagon.[58] The circle formed by the vault and the floor[59] of the refectory determined the secret geometry of the great rectangular painting: its center provided both the vanishing point of the perspective and the position of the head of Christ. Leonardo was, in the first instance, honoring a Euclidian God whose mystery could be celebrated with a ruler and a pair of compasses.

He chose to represent not Jesus' institution of the Eucharist (although the bread and wine are there in front of him) but the moment when he tells the disciples that one of them will betray him.

"Now when the even was come," says the Gospel according to Saint Matthew, "he sat down with the twelve. And as they did eat, he said: 'Verily I say unto you that one of you shall betray me.' And they were exceeding sorrowful and began every one of them to say unto him, 'Lord, is it I?' And he answered and said, 'He that dippeth his hand with me in the dish, the same shall betray me.'"

Painting, according to Leonardo, was "silent poetry." His task was to transpose the Scriptures, to tell the story—the drama—through the gestures, attitudes, and physiognomies of the characters.

He organized their "action" like a theater director. He noted the apostles' names and distributed roles: "One who has just been drinking," he writes in his notebook, "has put down his glass and turned his head toward another, who is speaking. Another, entwining his fingers together, is turning with a frown toward his neighbor. Another displays the palms of his hands and shrugs his shoulders up toward his ears, struck dumb with amazement. Another whispers in the ear of his neighbor, who turns toward him and inclines his ear,

while holding in one hand a knife and in the other a bread roll partly cut."[60] And so on.

Note the prime importance of the ear and the mouth: the word provokes and carries the "action," while the hands translate and underline the words exchanged and the speakers' reactions.

Thus we can "read" into the work surprise, incredulity, fear, anger, denial, suspicion: which of the disciples has betrayed? Thomas the skeptic naturally challenges his master's words; Philip has risen to his feet, dismayed by the foreseeable consequences of the treason; Bartholomew, too, has jumped up and is questioning Simon, who indicates that he knows nothing. Some ask questions and react with shock; others are angry and protest their loyalty and innocence. It is as if two human waves are unfurling and rolling this way and that on either side of the equilateral triangle formed by the figure of Jesus—whose calm contrasts with the agitation in the assembly. Only John, the disciple whom Jesus loved sitting beside him like a mirror image of his master, eyes closed and face tilted, seems to understand that the Son of Man must go to meet his fate—"as it was written," Saint Luke says.

Leonardo divides the apostles into four groups of three. But one of the disciples, although he enters (or pretends to enter) into the general movement, is distinguished from his peers: the dark Judas, in the shadow of John, his hand almost touching that of Jesus: in another moment they will be putting their hands into the dish, and the gesture will give him away, as has been prophesied.

In order to indicate Judas clearly to the spectator, quattrocento painters usually deprived him of a halo and isolated him by placing him to one side; indeed, he is often seen from the back, sitting on the other side of the table. This was the approach of Signorelli, Ghirlandaio, and Andrea del Castagno.[61] In so doing, they also hoped to break the monotony of thirteen people all sitting in the same plane. Leonardo once more breaks the rules, scorning facile devices. He uses shadow, expression, attitude (Judas is shrinking backward, nervously clutching the bag of silver to his bosom). We recognize the traitor at first glance. In fact, in his concern for verisimilitude and faithfulness to the text, Leonardo broke the rule so effectively that after him, no self-respecting painter dared separate Judas from Christ and the disciples with the width of the table.

In his notebooks, Leonardo writes almost obsessively of the sins of envy, jealousy, calumny, lies, falsity, and betrayal. He says that words can kill like arrows or poison; he knows from experience what they can do. He writes that "the memory of benefits is fragile compared to ingratitude" and that "from little cause there often springs great ruin"; also that "the ermine, symbol of purity, prefers death to becoming soiled."[62]

The theme of betrayal had haunted him ever since the Saltarelli affair. Perhaps it had haunted him ever since he became aware of his father's wrongs toward Caterina. At various times in his life, Leonardo seems to have discovered odious plots directed against him and believed himself to be the victim of denunciation. He complained bitterly of the hypocrisy and malice of his fellowmen. We find among his papers a draft of a letter to the Moor dating from a year or two before *The Last Supper:* "There is a man who was expecting to receive from me more than his due, and being disappointed in his presumptuous desire, he has tried to turn all my friends against me, but since he found them forewarned and proof against his will, he has threatened to make accusations that would deprive me of my benefactors. (I am informing Your Lordship of this, so that this individual who wishes to create scandal will find no soil on which to sow the seeds of his wickedness) and that if this man should try to make Your Lordship the tool of his iniquitous and malicious nature, he will be thwarted in his desire."[63]

Unfortunately, Leonardo does not name this mischief-maker, nor does he clarify the circumstances in which he made such an enemy or, more important, with what he could be reproached. But another text in his hand seems to relate to this affair and to the same individual: "All the evils that exist or have ever existed, if he could bring them about, would still not satisfy the desires of his treacherous soul. And I could not, however long I tried, paint his true nature to you; but I conclude"[64]—here the text breaks off.

Virtue persecuted: Leonardo would readily have taken these words for his epitaph. I believe he identified with the Savior, so unworthily betrayed and handed over to the priestly authorities by the kiss of Judas. In *The Last Supper,* he was once more painting a subject that came close to his heart: purity confronted and opposed by the evil and unworthiness of men.

It seems to me that, unlike Socrates, Leonardo did not believe that men were fundamentally good. Some individuals did not even seem to him to deserve the bodies the Creator had given them. He says, speaking of bone structure, muscles, and organs: "I do not think that rough men, of bad habits and little intelligence, deserve such a fine instrument and such a variety of mechanisms."[65] Their "bad nature" meant that they did not appreciate the marvel of human life (or, as Leonardo would say impartially, *animal* life), and thus they did not feel obliged to respect it. Accordingly they killed each other, tore one another apart, devoured one another—and betrayed. Stupidity, mediocrity, meanness, cupidity, malice: these failings inspired a sort of rage in Leonardo. "How many people there are," he writes, "who could be described as mere channels for food, producers of excrement, fillers of latrines, for they have no other purpose in this world; they practice no virtue whatsoever; all that remains after them is a full latrine."[66]

And alas, these made up the majority of men, so that the human race should always be described as stupid and deranged ("*o umaline sciochese o viue pazze queste due epiteti vanno nel principio della preposizione*"[67]).

Thus, according to him, humanity was rushing unwittingly to destruction. At about the same time that he painted *The Last Supper,* Leonardo composed this prophecy (in the form of a riddle): "There will be seen on earth creatures fighting each other without pause and with very heavy losses and frequent deaths on both sides. Their malice will know no bounds; in the immense forests of the world, their savage members will cut down an immense number of trees. Once sated with food, they will want to assuage their desire to inflict death, affliction, torment, terror, and exile on every living thing. . . . O Earth! why do you hesitate to swallow them up into the deep crevasses of your great abysms and caverns and never show again to the face of heaven a monster so cruel and horrible!"[68]

As against the unassailable geometrical purity of Christ, Leonardo would therefore place in *The Last Supper* the infinite malice of Judas—the common mortal, the representative of mankind—a malice at which the wisest recoil, except for John, the preferred disciple.

"He was in the world, and the world was made by him, and the world knew him not," wrote Saint John. Leonardo writes: "If you

meet someone virtuous and good, do not drive him far from you but honor him, so that he will not have to flee you and be reduced to hiding like a hermit or taking refuge in a cave or other solitary dwelling to shelter from your perfidy."[69] Of whom was he thinking when he wrote this sentence?

Leonardo began *The Last Supper* in about 1495. Legend, or rather Vasari, states that he painted it with infinite slowness and never finished the head of Christ. In reality, the work seems to have been quite finished some two or three years later, if we can credit the testimony of Luca Pacioli, although Leonardo was dividing much of his time during these years among a variety of tasks. All in all, he did not spend an overlong time on the painting.

Since he was working directly on the refectory wall, instead of in the privacy of his studio, he could hardly conceal his activity from onlookers—who included nobles and court personalities. There is no sign that he disdained his audience; indeed, he encouraged it to express its views. As a result, we have several eyewitness accounts of his manner of working: notably from Giovanni Battista Giraldi and from the writer Matteo Bandello, nephew of the prior of the convent.

In one of his novellas (*Lucca,* 1554), Bandello tells how as a boy he would see the painter arrive in the refectory early in the morning, climb up onto the scaffolding (*The Last Supper* is a good two meters above the ground), and immediately start work. "He sometimes stayed there from dawn to sundown, never putting down his brush, forgetting to eat and drink, painting without pause. He would also sometimes remain two, three, or four days without touching his brush, although he spent several hours a day standing in front of the work, arms folded, examining and criticizing the figures to himself. I also saw him, driven by some sudden urge, at midday, when the sun was at its height, leaving the Corte Vecchia, where he was working on his marvelous clay horse, to come straight to Santa Maria delle Grazie, without seeking shade, and clamber up onto the scaffolding, pick up a brush, put in one or two strokes, and then go away again."

To what further task was he going, unheeding of the midday sun? Was he returning to the *cavallo?* Was he in a hurry to finish some

other commission for the duke? Was he hastening to the *fabrica,* where some experiment was awaiting him or where his team was working on some ingenious machine? Or had he perhaps already begun to paint the picture of Lucrezia Crivelli, Ludovico's mistress of the moment?[70] Was he working on a float, or the costumes for a carnival or tournament[71] he had been asked to oversee?

We know that he devised the sets and the production for a *Danaë* (by the poet Baldassare Taccone, the duke's chancellor), which was performed on 31 January 1496, in the palace of Galeazzo da San-severino's older brother, the count of Caiazzo. A few notes and studies for the spectacle have survived: they show a *trompe l'oeil* city scene, anticipating that of Palladio's Teatro Olimpico at Vicenza; an animated heaven, as in the Feast of Paradise; and a theatrical machine in the form of a cylinder, from which an actor could emerge swathed in a sort of flaming cloud.[72]

Leonardo may have taken some part in decorating the sumptu-ous palace that Cecilia Gallerani was having built (it was com-pleted in 1498) or in the perpetual refurbishment of the Castello Sforzesco. And he designed a house for an unknown patron as well as one or two villas. Some notes and sketches of this period survive relating to the building of various dwellings inside and outside Milan—which might also be part of a projected treatise on civil architecture.[73]

For the duchess Beatrice, we know that he built a collapsible wooden summerhouse in the middle of a living maze[74] and that he decorated several of the rooms, or *camerini,* of her apartments in the castle. This was the occasion of one of Leonardo's rare outbursts. "The painter who is working on the *camerini* today caused a certain scandal, after which he left," the duke's secretary notes on 8 June 1496, without further details. His patron threatened to replace Leo-nardo with Perugino (who never came), as he had previously threat-ened to call in a Florentine sculptor for the *cavallo.* Failure to pay him was probably the reason behind the outburst: the ducal coffers were empty, and artists were the last of the "tradesmen" one thought of paying—like tailors in the nineteenth century. Leonardo more or less energetically claimed his due. "I regret being in need," he writes in a draft of a letter to Ludovico, "and I regret even more that this prevents me from conforming to my desire, which has

always been to obey Your Lordship." He goes on: "I regret very much that, having called upon me, you find me in need and that the necessity of providing for my subsistence has prevented me from"—he breaks off here, failing to find the right words, then continues: "I much regret that the need to provide for my subsistence obliges me to occupy myself with trifles, instead of continuing the task Your Lordship asked of me; but I hope I shall soon have earned enough money to be able, with peace of mind, to satisfy the wishes of Your Excellency, to whom I recommend myself; and if Your Lordship had thought I had money, Your Lordship was mistaken: I have had to feed 6 persons for 56 months and have received only 50 ducats."[75]

There survives another draft plea to the Moor—unfortunately torn in two down the middle, so that only scraps of it are readable—in which Leonardo speaks of the *cavallo,* of "changing his art," of eternal glory, of his present poverty, and of the decoration of the *camerini* of the duchess.[76]

Leonardo was apparently under pressure. These fragments of letters date from around the time of Caterina's death and of Leonardo's warnings against the individual of "treacherous soul" who was wishing him harm.

We do not know whether Messer Gualtieri, the treasurer of the castle, did in the end receive instructions to pay Leonardo, nor do we know whether the latter—claiming to be paying for the upkeep of six dependents—was as short of money as he said. He no doubt had several sources of income. And indeed, fewer complaints on this score come from Leonardo than from Bramante or Bellincioni (and "who is not familiar with the laments of the artists and humanists of the Renaissance?" as Muntz puts it). Bandello says that Leonardo was paid two thousand ducats a year for *The Last Supper,* not to mention various gifts and presents from the Moor.

At any rate, we do learn from these texts that Leonardo could not reply to some summonses by the duke because his time was taken up with trifling tasks *("alcuni picoli")* and that he soon hoped to be earning enough to be able to return to work with peace of mind.

The very remunerative "trifles" could have been the bronze doors for Piacenza Cathedral, or a painting for the high altar in the church

of San Francesco in Brescia,[77] or, more likely, some invention of which Leonardo hoped to sell the design: his weaving machine, the machine for making needles, the rolling mill,[78] or even his flying machine. For while working on *The Last Supper* and the *camerini,* as well as putting final touches to the horse he did not pause for a moment, if Bandello can be believed, in his scientific and technical explorations.

"Tomorrow morning," he noted on 2 January 1496, "I shall make the strap and the attempt."[79] It may have been his first attempt to fly.

The idea of flying had preoccupied Leonardo since his time in Florence—perhaps since his adolescence. It appears for the first time on a page of drawings, preserved in the Uffizi, dating from the period when he was painting the *Adoration of the Magi;* and we may also remember the special care he took over the wings of the angel in the *Annunciation.* From 1482 in Lombardy, his notebooks explore further the possibility of a man's being able to fly like a bird of prey. In the early 1490s, he carried out observations of birds, establishing a sort of theory of flight (based on the "force" of the air), and sketched the designs for several flying machines. "The bird," he wrote, "is an instrument functioning according to mathematical laws, and man has the power to reproduce an instrument like this with all its movements."[80] In 1495 or 1496, he seems to have moved on to practice and physical experiment: he says himself that the roof of the Corte Vecchia, where he had his *fabrica,* was the "most suitable place in Italy" for trying out his device and that by placing himself in a "sheltered corner behind the tower," he would be invisible to the workmen finishing off the *tiburio* of the cathedral: the experiment was intended to be a secret.[81]

This project haunted him. A few years later, in 1505, he would claim to have been in some sense *predestined* to study flight, when he described his famous childhood memory of the kite flying down onto his cradle.

But the ambition to provide man with wings went back to antiquity. Florence was well acquainted with the myth of Icarus which Giotto and Andrea Pisano included on one of the marble octagons decorating the Campanile. The dream persisted with medieval engineers, both Christian and Arab. In the thirteenth

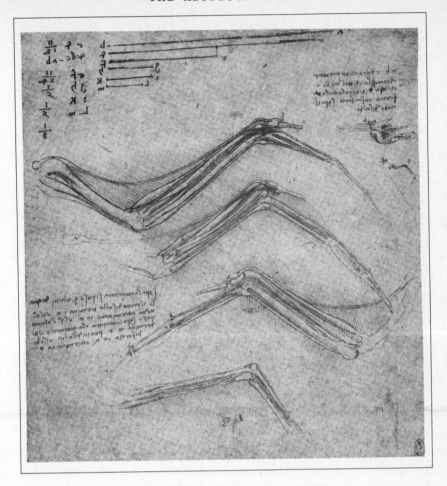

Anatomical Study of a Bird's Wing.
ROYAL LIBRARY, WINDSOR.

century, in his *Epistola de secretis operibus,* the English philosopher Roger Bacon, establishing a sort of program of technical research, had spoken of great ships without oarsmen, which a single man could sail; of "incredibly swift" self-propelled vehicles; cranes with immense capacities; bridges spanning rivers without ropes or supports; machines for exploring the bed of the sea—and a "flying machine in the middle of which a man could be seated and make an engine turn to activate artificial wings that would beat the air

like those of a bird." Bacon concludes: "All these machines were built in antiquity, and they have certainly been achieved in our own time, except perhaps the flying machine, which I have not seen, nor do I know anyone who has seen one, but I know an expert who has developed a way of making one."

Leonardo was aware of the writings of the Englishman (whom he called Rugieri Bacho) and notes that they are or soon will be in print.[82] But he did not need to read them to be acquainted with them. His friends the professors at the University of Pavia cannot have failed to discuss them in his presence. The master craftsmen whom he frequented must also have had their stories of flying machines. And other Italian engineers were trying to fly—Giovan Battista Danti of Perugia, for instance, whose machine was to crash onto a church roof in 1503.

Leonardo no doubt started his research from existing machines or descriptions of them. In the notebooks of the medieval engineer Villard de Honnecourt, we find a sketch of an articulated bird able to beat its wings, and in a manuscript of the British Library in London, there is a drawing of a parachute very like Leonardo's—and just as ineffective: anyone who tried to jump from a clifftop with one of these would certainly end up with broken bones, for the surface area of the canopy is not enough to bear the weight of a man.[83] But the articulated bird and parachute may have worked perfectly well on a reduced scale, as toys. This was doubtless how Leonardo first experimented with his various machines connected with flight. When he describes his helicopter ("if this instrument in the shape of a screw is properly made, that is, in linen cloth, sized with starch, and if it is made to turn fast, it will be found that the screw creates a helix in the air and rises rapidly"), it is clear that he envisages trying it out with "a little model made of paper, whose axis will be made of a fine steel blade, placed under strong torsion, and when released, it will turn the helix."[84] The same was true of the apparatus he thought of launching secretly from the roof of the Corte Vecchia: "Barricade the top room," he begins, "and make a large and tall model."[85]

Perhaps these first attempts were crowned with success. There was indeed no reason why he should not make small flying models, spring-operated like the steel blade of the helicopter, or perhaps

gliders put together out of reeds and silk. Even if weighted with a dummy, these would be light enough to rise into the air and stay there briefly. But Leonardo was determined to adapt them to the proportions and weight of a man. For the helicopter, he thought of a canvas spiral about ten meters in diameter; his plans for "airplanes" (or *ornitotteri,* as he called them) specify wings about the same size: one of them measured twenty *braccia,* or about twelve meters. How could he hope to propel such machines, which surely must have weighed more than a hundred kilos when loaded—and how could he produce the sustained "force" necessary for a human flight?

This problem led him to study the relationship between wing area and weight in birds. It seemed to him that there was no fixed rule, since some large birds, like the pelican, have quite short wings, whereas bats, say, have very long ones for their size. Regarding these calculations as too approximate, he tried out some life-size experiments: on one drawing in manuscript B,[86] we see a man using a lever to move a large wing, rather like that of a bat, to which is attached a piece of wood weighing 200 pounds (a pound of the time being about 380 grams). From this Leonardo deduced a load threshold.

Inspired by the various flying creatures he dissected, he envisaged various kinds of wing in turn, the most sophisticated being articulated. Thanks to a system of strings and pulleys, they could be bent and stretched and could beat in such a way as to rise from the ground or travel horizontally.[87] He also sought out the lightest, strongest, and most supple materials: pinewood strengthened with lime, sized silk, canvas covered with feathers, leather treated with alum or smeared with grease (for lanyards and straps), raw silk, young pine laths or reeds for the chassis, steel and horn for the springs. Finally, he had to resolve the questions of balance and statics. Should the pilot be seated, lying, or standing in his machine? And how could one arrange for him to move all four limbs at once, enabling him both to propel and steer the apparatus?

Under Leonardo's pen, the *ornitottero* took many shapes, successively looking like a canoe with a balancing mechanism, an indoor rowing machine, a large butterfly with four wings, or a calabash shell crossed with a windmill. It was variously equipped with pedals,

a rudder, stirrups, a sail, handles, a harness, a gondola, platforms, steering cables, and a retractable undercarriage made up of ladders and buffers.[88]

Full of faith, Leonardo spent endless hours on his invention. Others might have tried to fly before him, but no one had pursued this dream with such patience, ingenuity, daring, and tenacity.

He must have given up in the end the idea of jumping from the roof of the Corte Vecchia (to land in the cathedral square?). Perhaps he used the roof only to test the load his wings could bear, or to try out his models. Prudently, he decided: "You will experiment with this machine over a lake and you will wear attached to your belt a long wineskin [as a sort of life buoy], so that if you fall in, you will not be drowned."[89]

Many historians doubt whether he ever risked himself in the air. I do not share their skepticism. But since he changed his mind many times over the plan, it is not impossible that what he ended up with was a sort of kite (not unlike a modern hang glider), such as appears on a page of the Madrid manuscript,[90] rather than an engine with mobile wings: the former seems less likely to drop like a stone. A sentence by Girolamo Cardano, whose father, Fazio Cardano, was friendly with Leonardo, indicates that some attempt at flight was made, and that it failed, as might have been foreseen: *"Vincius tentavit et frustra"*—Vinci tried in vain (*De subtilitate,* 1550).

To my mind, Leonardo confirms the existence of his enterprise, and its failure, when he writes in the last years of the century, in the middle of his long prophecy about the cruelty of men: "Because of their ambition, some men will wish to rise to the sky, but the excessive weight of their limbs will hold them down."[91] Here he confesses his pride and the vanity of his ambition. When one knows of his hopes and the pains he had taken, one imagines that he must have been disappointed, humiliated, and discouraged. And so he was for a while—but it did not last. A few years later, in Florence, he was back working on flying machines, more enthusiastically than ever.

In 1496, an important figure arrived in Milan: the Franciscan monk Luca Pacioli.

Fra Luca, born in Borgo San Sepolcro, in Tuscany, and aged

about fifty (a few years older than Leonardo), was a disciple of Alberti and Piero della Francesca, who earned his living by teaching mathematics. He had made his name with his *Summa de arithmetica geometrica proportioni et proportionalita,* and the duke had invited him to come and teach in Milan. Vasari said Pacioli "gave himself fine feathers" by appropriating ancient texts,[92] for he intended to bring together all mathematical knowledge, from Euclid to Regimontanus, from the square of the hypotenuse to commercial book-keeping.

Leonardo was immediately attracted to the mathematical monk and studied his treatise (from which he copied many pages).[93] He mentions him often in his notes, calling him *maestro Luca.*

The Museo Nazionale di Capodimonte in Naples has a magnificent portrait of Pacioli with his pupil Guidobaldo da Montefeltro. On the green tablecloth in front of the monk lies a slate showing a Euclidian figure, a geometrical manuscript, a pentahedron, a large closed book, and a compass, set square, and portable inkwell of the kind Leonardo must have used. The heavy cylinder in which pens were stored allowed the inkwell itself to hang open over the table on the end of the strings used for carrying it.[94] A large regular shape, apparently made of glass, seems to float in the air on the left.

The monk has a broad, strong face, an assured, learned, and persuasive eye—he looks like someone who can convince and impress. He certainly impressed Leonardo. We may be surprised to learn this, knowing the latter's scorn for those "who trumpet and recite the works of others"—he himself only borrowed in order to move on to fresh discoveries. But we should remember that his own mathematical knowledge was not great. When Leonardo writes: "Let no one read me who is not a mathematician,"[95] he is essentially using the word to convey notions like rigor, coherence, and logic. He had a thorough understanding of practical geometry, as did most painters, architects, and engineers of his time. But for theory, he required a guide who could offer advice and explanations: in his own words, he liked to have things "demonstrated by a university man." Algebra in particular remained a closed book to him; and he was not very good with figures: one regularly finds him going wrong, even in simple additions (perhaps out of absentmindedness). For example, when he catalogues his writings in 1504, he calculates:

"25 little books, 2 bigger books, 16 bigger again, 6 bound in vellum, 1 book bound in green chamois: total 48."[96]

Pacioli seemed to him to be the guardian of incommensurable knowledge compared to his own. There is nothing so obscure as an abstraction to which one does not hold the key. Friendship with this man would stimulate Leonardo's natural appetite for mathematics. From 1496, he suddenly begins feverishly filling his notebooks (as he had once filled them with Italian and Latin vocabulary) with square roots, multiplications, fractions, and dizzying figures (taking large numbers to the power of three or four), with postulates, axioms, intoxicating theorems, and enthusiastically recorded geo-metrical games,[97] in which triangles, squares, hexagons, circles, and spheres are dissected, split, and subdivided to infinity.[98]

Leonardo and Pacioli were fascinated by one another. While one explained Euclid and Archimedes, the other showed his inventions, opened his notebooks, demonstrated his mechanics, gave his views on art and his personal conception of proportions and harmony.

Soon the idea was born of a book, *De divina proportione,* to be written by Pacioli and illustrated by Leonardo. It would eventually be published in 1509 in Venice, after splendid manuscript versions were presented to Ludovico Sforza and Galeazzo da Sanseverino in 1498.[99] In his preface, Pacioli pays tribute to his friend, "the most worthy of painters, perspectivists, architects, and musicians, the man endowed with all the virtues, Leonardo da Vinci, the Florentine," whose "sublime left hand" had drawn the five regular bodies defined by Plato, first as solids *("solidi"),* then as "skeletons" *("vacui"):* the tetrahedron, the hexahedron, the octahedron, the dodecahedron, and the icosahedron, as well as their derivatives (there are over sixty illustrations in all, including numerous decorated letters).[100]

Vasari accused Pacioli of having plagiarized the treatises of Piero della Francesca in his *Summa;* and Geoffroy Tory, printer to Fran-çois I, said he stole from Leonardo for the *De divina proportione:* "I have heard that all that he put in it he took from the late Leonardo da Vinci, who was a great Mathematician, painter, and image maker." This is no doubt going too far. Leonardo would never be a "great Mathematician"; his greatest achievement in this field was probably his construction of mathematical instruments: propor-tional, parabolic, and elliptical compasses—for which he has left the

DVODECEDRON ELEVA
TVS VACVVS

Illustration from *De divina proportione*.

plans.[101] Rather, the two men encouraged and stimulated each other—with Pacioli perhaps putting the finishing touches on his friend's scientific education. Their views were close and became practically identical, as did Leonardo's with those of Bramante on architecture. The fact remains, however, that a number of the propositions advanced by Fra Luca (especially those concerning art) seem to be an echo of the painter's voice: Leonardo found in Pacioli both a mentor and a mouthpiece.

This fruitful collaboration between artist and mathematician probably influenced the composition of *The Last Supper*. But this work was not inspired by geometry alone: it developed into what amounted to a discourse on the emotions. The dramatic poet Gio-

vanni Battista Giraldi, in a text published in 1554, argued that even the authors of novels or comedies ought to seek inspiration from the way Leonardo built up his figures. "That great painter," he writes, "when he had to introduce a person into one of his pictures, first asked himself about the quality of that person: whether he ought to be of noble or vulgar type, of joyful or severe humor, caught in a moment of anxiety or serenity. . . . He would then go to the places where one might ordinarily find such persons. He closely observed their customary movements, their physiognomy, and all their habits. And every time he found the least characteristic that might serve his purpose, he drew it in a little book that he always carried with him. When, after many visits, he thought he had collected sufficient material, he finally picked up his brushes."

Giraldi obtained this information from his father, who often went to see da Vinci at work at Santa Maria delle Grazie. The artist's notebooks provide even clearer evidence of his habit of discovering models in certain disreputable places in Milan. "Go every Saturday to the public bathhouse [*alla stufa*]," Leonardo notes in the cover of manuscript F; "you will see nudes there." He also noted that "Cristofano da Casti, who is at the Pietà, has a fine head"; "Giovannina has a fantastic face; she is in the Santa Caterina hospital."[102] In order to discover "interesting" physical types, he ventured into taverns, haunts of ill fame, and the occasional brothel. (He was even inspired to draw plans for a utopian bordello; it had three separate entries, with their own staircases and corridors, providing maximum discretion for the customer.[103]) A few years later, he observed that in the Porta Vercellina district, "the women of Messer Jacomo Alfeo" (the keeper of a bawdy house?) might serve as models for *Leda*. [104]

On occasion, Vasari tells us, Leonardo would follow someone with unusual features around all day, in order to study him. According to Bandello, he observed the contortions of criminals under torture. Grotesque faces, deformed bodies, and amputated limbs particularly intrigued him. "The doctor Giuliano Maria has an assistant with no hands," he noted.[105] He would often make lightning caricatures of the unfortunate faces that caught his attention: in the middle of his most serious reflections, there suddenly appear drawings of corpulent old men with toothless grimaces, apparently

Caricatures.

ACCADEMIA, VENICE.

consumed by leprosy, crazed or clownish faces, a withered old woman, weirdly adorned, who could have been drawn by Goya.[106] These caricatures were highly prized in the eighteenth and nineteenth centuries: collectors searched them out avidly, and engravers published books of them. Various explanations have been offered for this morbid curiosity on Leonardo's part. Some see it as the counterpart of his pursuit of perfection: Victor Hugo argues in his preface to *Cromwell* that one can tire of everything, even beauty. Others think it was merely a casual pastime: the misfortunes and

deformities of his fellowmen were a distraction from his everyday work. I believe that this interest was primarily determined by the taste of the time: we know, for instance, that the Moor was a collector of unusual forms and had a dwarf brought to his court from Chios, at great expense. Further, these exceptional figures, which broke the rules and proportions Leonardo sought to establish, fitted into his universal scheme: they were, after all, part of reality. Lastly, the grotesques demonstrate in exaggerated form the expressions common to all human beings. Leonardo writes on one occasion: "The good painter has essentially two things to represent: a person and that person's state of mind. The first is easy, the second difficult, for one has to achieve it through the gestures and movements of the limbs; and this may be learned from the mute, who express themselves better this way than other men."[107]

Leonardo probably found the faces of the apostles in *The Last Supper* in the surrounding streets of Milan—the reader may be reminded of Fellini and his painstaking casting. Cristofano da Casti, mentioned above, may have inspired the head of Saint John or another disciple; a certain Count Giovanni, in the entourage of Cardinal di Mortaro, seems to have served as a model for Christ (one of whose hands is thought to have been painted from that of a certain Alessandro of Parma).[108]

Giraldi, like Vasari, relates that by about 1497, Leonardo had completed the eleven apostles and the body of Judas but could not find a satisfactory model for Judas's face. "The prior of the convent," Giraldi says, "impatient at having his refectory still cluttered with the painter's equipment, went to complain to Duke Ludovico, who was paying Leonardo very handsomely for this work. Ludovico had him summoned and expressed his astonishment at such delay. Da Vinci replied that he had occasion to be astonished himself at his excellency's words, for the truth was that not a day went past without his working two full hours on this picture." (Confirmation of this conversation survives in a document preserved in the Lombardy archives following a letter from the Moor: "Put pressure on Leonardo the Florentine to finish the work he is doing in the refectory of Santa Maria delle Grazie, so that he can start work on the other wall of the refectory.[109] If not, the agree-

ments formerly signed by him concerning completion within a certain time will be cancelled.")

In spite of the warning, no progress was made, so the prior returned to the duke. "There is only the head of Judas still to do," he said, "and for over a year now, not only has Leonardo not touched the painting, but he has only come to see it once." The duke, annoyed, had the painter summoned again. Leonardo declared that the fathers knew nothing about art and that a painter did not work like a laborer with a pickax. He admitted that he had not been near the convent for months but reaffirmed that he was working on *The Last Supper* at least two hours a day. How can that be, asked the duke, if you do not go there? According to Giraldi, Leonardo replied: "Your Excellency is aware that only the head of Judas remains to be done, and he was, as everyone knows, an egregious villain. Therefore he should be given a physiognomy fitting his wickedness. To this end, for about a year if not more, night and morning, I have been going every day to the Borghetto, where Your Excellency knows that all the ruffians of the city live. But I have not yet been able to discover a villain's face corresponding to what I have in mind. Once I find that face, I will finish the painting in a day. But if my research remains fruitless, I shall take the features of the prior who came to complain about me to Your Excellency and who would fit the requirements perfectly. But I have been hesitating a long time whether to make him a figure of ridicule in his own convent." (Vasari, in his version of the incident, has Leonardo say, typically: "It is at the moment that they are working the least that higher minds achieve the most; they are then mentally in search of the unprecedented and find the perfect form for the ideas, which they afterward express by tracing with their hands what they have conceived in their minds.")

Ludovico, delighted by his reply, came down on Leonardo's side, Giraldi says. The painter finally found the evil face he was looking for, combined it with features he had already collected (including, no doubt, the "treacherous" being whom he thought to be persecuting him), and rapidly finished the painting.

So great has been the deterioration of *The Last Supper* that it is hard for us today to appreciate as we should its extraordinary

combination of physiognomies: one has to look at the preparatory sketches of the faces, mostly in red chalk, to get any idea of them.[110] One is still transported by the rhythm of the composition, and stupefied by the ingenious perspective and the expressiveness of the gestures, but the faces in this picture that Proudhon described in a letter as "the most beautiful painting in the world and the masterpiece of all painting" have lost their outlines and flaked and crumbled away, as if swallowed by the wall—"the shadow of a shadow," as Henry James says (*Italian Hours,* 1870).

The Last Supper had already begun to deteriorate in the sixteenth century. By Vasari's time, it was said to be no more than "a dazzling stain." By 1624, according to the Carthusian friar Sanese, "there was hardly anything left of it to see." A door leading to the priory kitchen was cut in the wall at this time, removing the part of the picture that depicted the feet of Christ and part of the tablecloth. Two strenuous attempts were made in the eighteenth century to restore the work as a whole, but the restorers, Belloti in particular, did more harm than good: they pulled off damaged portions and repainted whole sections of the painting themselves. In 1796, despite express orders to the contrary from Bonaparte, French troops stored their horses' fodder in the now disused refectory, and it is said that republican dragoons amused themselves by throwing bricks at the apostles' heads. *The Last Supper* was restored three times between 1820 and 1908. At the end of World War II, a bomb fell on the refectory roof, but Leonardo's work, protected by sandbags, survived almost unscathed. Between 1946 and 1953, an attempt was made to return it to its original condition; the bright red of Christ's robe, the symbolic color of the Passion, finally reappeared. Yet another restoration, utilizing the most advanced scientific methods, is being undertaken at present, by the Istituto Centrale del Restauro.

The painting is known to have suffered damage during floods on two occasions, in 1500 and in 1800—when the water, according to Goethe, filled the refectory to a depth of sixty centimeters. It is also said that the hastily built convent walls were made of porous material, which retained the damp, salt, and acid exuded by the lime in the mortar. But in that case, why has Montofarno's *Crucifixion,* on the opposite wall, not suffered the same damage? It seems that

the untried technique used by Leonardo (strong tempera on a double layer of plaster) may have been partly responsible for the picture's decay.

It is not in fact a fresco in the true sense of the word: it was not executed *al fresco,* straight onto fresh mortar, with colors diluted in water. This procedure, which resulted in lasting pictures, required much "vigor, certainty, and promptness in decision," as Vasari stresses. Giotto finished frescoes in about ten days. Leonardo, who was always repainting his figures and liked to take time to think, was not well suited to this technique. He seems to have made the mistake of experimenting with a compromise between a traditional tempera and oil. In Verrocchio's studio, one learned everything except how to paint large murals: the pupil had to invent what his master had not taught him. If da Vinci had known the recipe for "oil painting on a dry wall," which Vasari gives in the introduction to the *Lives,* the chances are that *The Last Supper* would have survived better over the centuries.

If it is today no more than "a famous invalid" (Henry James again), the countless copies[111] made of it in the sixteenth century, some by Leonardo's direct disciples (Boltraffio, Marco d'Oggione, and Cesare Magni), do at least allow us to guess more or less what it looked like originally (in particular the detail and the color) and at the same time to appreciate its incredible influence. The art of painting took a new direction—as the artists of the time were well aware—with this work by Leonardo.

Neither Vasari nor Giraldi, neither Bandello nor indeed Leonardo himself, tells us why Ludovico was in such a hurry in June 1497 to see *The Last Supper* and the other murals at Santa Maria delle Grazie finished. The reason is simple: his wife, Beatrice, had died during the winter. He wanted everything to be ready in the convent to receive the double tomb he had ordered from Cristoforo Solari, so that "if it please God, we shall lie together until the moment of resurrection."[112]

Beatrice had died as she had lived. Several months pregnant, she could not resist going to a ball on 2 January 1497, and danced until she was seized by labor pains. She gave birth to a stillborn child, then died herself during the night.

She was only twenty-two years old. Her childish features had thickened, and the courtiers whispered that she was beginning to resemble the dowager duchess. She had taken to wearing striped dresses in order to look slimmer. Ludovico had tired of her and taken a mistress, Lucrezia Crivelli, but Beatrice was still a precious ally to him, remaining associated with all affairs of state and consulted as often as the duke's astrologers. When she died, her husband fell to worshiping her. The letter to the marquess of Mantua in which he announces the news betrays genuine grief and distress. Additionally, his natural daughter Bianca, who had been married very young to Galeazzo da Sanseverino, had succumbed to a *"passione de stomacho"* the year before.

The superstitious Ludovico sensed that his good fortune was deserting him and turned pious. Leonardo was probably consulted about Beatrice's funeral ceremony. He was also commissioned to carry out some devotional work—possibly an *Assumption* for the gatehouse of Santa Maria delle Grazie, now disappeared—and the decoration in the Castello of a "black room" *(saletta negra)* dedicated to the memory of the duchess.

Beatrice's funeral was held with great pomp, described for us by the ambassadors to Milan: "There were so many wax tapers," the envoy from the d'Este family remarked, that "it was marvelous to behold." The duke fasted and offered the Dominican friars jewels, silver, and his estates in Vigevano. "The court, which was once a divine paradise, has become a sinister hell," wrote the duchess's secretary.

But six months later, when Lucrezia Crivelli gave birth to a boy, Ludovico returned to his old ways. Furthermore, events obliged Ludovico to engage once more in his ruinous and complicated diplomacy. From April 1498, seeking to reinforce his alliances, he set in motion urgent and unrewarding intrigues in Venice, Pisa, Florence, Germany, and even Turkey. Charles VIII had died after hitting his head on the lintel of a doorway, and his cousin Louis of Orleans had succeeded him. The new Louis XII declared himself duke of Milan and claimed the inheritance of his Visconti grandmother. The French army, which Ludovico had first called in against Naples, was now preparing to conquer Lombardy.

Rounds of ambassadorial meetings began again in the Castello.

Leonardo was called upon for the decoration. Some wall paintings commissioned from him were uncovered in 1901, when the plaster was removed from the vault of the large room known as the Sala delle Asse. There is a reference to the paintings in a document dating from Wednesday, 23 April 1498: a request is made that the scaffolding be removed (it had perhaps given the room its name, since *asse* means "wooden boards") except for one section so that Master Leonardo of Florence, *ingegniere camerale,* may finish his work by September.

An effort has been made to restore the Sala delle Asse to its original appearance (it, too, has been the victim both of time and of clumsy and overenthusiastic restoration, by one Bassani). The decoration consists of greenery spreading around the walls of the room, with the Sforza arms on the vaulted ceiling. Tree trunks rise from rocky strata, which have been fractured by the roots. The trees stand like columns, and their branches mingle, masking and covering the features of the masonry. One can see (or rather one ought to be able to see) the blue of the sky through the foliage. This gigantic tracery of leaves, painted with the precision of a botanist, makes up a tangled, leafy labyrinth. The luxuriant growth is deceptive: gradually one perceives an order, a methodical composition, and a harmonious coordination that Leonardo would no doubt have described as *mathematical.* The coordination is provided, or underscored, by a golden ribbon winding in and out of the branches. Its ends are hidden, and it runs uninterrupted around the grove of foliage. Leonardo had painstakingly wound and knotted a single endless ribbon around the walls of the Sala delle Asse.

The grove of trees, crowned with the duke's coat of arms (which included a tree), no doubt represented the strong ties between the people and the prince.[113] But Leonardo gave his own particular significance to the paintings in the Sala delle Asse: he made them into both his own symbolic device and a plastic representation of his philosophy.

We have seen that emblems based on wordplay were common at the time: Lorenzo de' Medici was represented by a laurel, Ludovico Mauro Maria Sforza by a mulberry tree or a Moor's head. Poets connected da Vinci's name with conquering *(vincere).* But *vinco* also meant a reed or rush in Italian, and *vincolare* or *vincere*

Detail from the Sala delle Asse.
MILAN.

———

could mean to bind. Leonardo cannot have failed to know the famous line from Dante: *"che mi ligasse con si dolci vinci"* ("who might have confined me in such sweet bonds"—*Paradiso* XIV). The knots in the ribbon were a sort of signature.

Knots and scrolls, known at the time as *fantasie de vinci,* appear in many of Leonardo's sketches: in studies for ornaments, embroidery motifs (for Beatrice's robes?), designs for parquet floors or porcelain tiles, stucco and marquetry.[114] They are to be found on the sleeves and the hair net of the *Portrait of a Milanese Lady* in the Ambrosiana, in the intricate braided hairstyle of *Leda,* [115] on the handle of a ceremonial sword or the flap on a lady's bag.[116] Vasari says: "Leonardo spent much time designing a pattern of knots, so interlinked that the thread could be followed from one end to the other, describing a circle. There is an engraving of one of these beautiful and complicated designs, with the inscription *'Leonardus Vinci Academia.'* " These complex interweavings are also in evidence in a series of engravings with a white line describing endless garlands and curlicues inside a black disk. Either by Leonardo or, more probably, after drawings by him, they all bear the words *Accademia Leonardo Vinci* (with variations in the spelling), either in a central medallion or in several peripheral medallions. Indeed, they have started a legend: for a long time, it was thought that Leonardo really ran an academy on the model of the Platonic Academy of Florence. In his preface to *De divina proportione,* Pacioli refers to an "excellent scientific competition" held in the Castello on 19 February 1498, bringing together clerics, theologians, "skillful architects and engineers and inventors with fertile new creations." Leonardo, he says, "conquered" all *(vince).* Pacioli mentions only one such such intellectual joust, but from his text there grew a legend, fostered in 1616 by Borsieri's *Nobilità di Milano,* of regular meetings presided over by Leonardo. It was, naïvely, thought that he conducted the debates and taught the pupils. In 1904, Joséphin Péladan even published a short work entitled *La Dernière Leçon de Léonard de Vinci en son Académie de Milan,* in which he supposed that the engravings of knots were some kind of diploma or certificate that the master gave to deserving pupils. The idea of an academy run by Leonardo is today completely discredited: academies in the sense of schools did not appear until the following century. The exact function of the interwoven garlands remains a mystery. It has been suggested that they were potential frontispieces for an edition of Leonardo's treatises that never materialized. The word "Academy" might simply

be a pompous name for Leonardo's *bottega,* in which case they were ornamental designs bearing his trademark, engraved and sold (to embroiderers, jewelers, and marquetry workers) by the master's team.

But the engraved *fantasie dei vinci,* like the knots in the ribbon twined around the foliage in the Sala delle Asse, do correspond to a fundamental truth reached by the philosopher and man of science. One might compare them with paving stones of certain Gothic cathedrals: Symbols of both the infinity and the unity of the world, they proclaim that there must be a rule governing everything. The roots painted by Leonardo thrust between the rocks. The trunks full of sap rise *forcefully* toward the sky, where they explode in a labyrinth of leaves and branches. Yet the chaotic torrent of life follows the proportions set by the artist. He bends, corrects, *dominates* nature. Leonardo had once hesitated to plunge into the terrifying darkness of the cave: the luminous and domesticated exuberance of the Sala delle Asse seems to indicate that he had—temporarily—overcome his demons.

O N I APRIL 1499, Leonardo noted with some satisfaction that he was in possession of 218 lire.[2] Toward the end of the same month, Ludovico Sforza granted him outright a piece of land outside town, on the Porta Vercellina side, "16 perches wide" and planted with vines. Either the Moor was particularly satisfied with the artist, or else the ducal coffers were exhausted and he could afford to pay only in kind.

While Leonardo was thinking of building himself a house, the new king of France, Louis XII, had purchased from the Borgia Pope the divorce that allowed him to marry his predecessor's widow and his own niece, Anne of Brittany. Plain and crippled she might be, but she provided control of the kingdom. Dazzled in his turn by the "fumes and glories" of Italy, the king formed a secret alliance with Venice against Milan and obtained the neutrality of Florence (under duress).

Ludovico, hearing of the military preparations beyond the Alps, seeing doors closing to his ambassadors, and finding himself abandoned by all except Ferrara and Mantua, prepared to contain the *furia francese* single-handed, hiring mercenaries and arming his forts.

In the early summer, while Louis's army began to cross the Alps, Leonardo, as if all these events were of no consequence to him, devoted himself to experiments on motion and weight. He also carried out some plumbing works for the unfortunate widow of Gian Galeazzo Maria, Isabella of Aragon, who was now confined

to a wing of the Corte Vecchia, where Leonardo had his studio. He devised a mechanism "for her stove and her bath," he said, thanks to which the duchess had as much hot water as she wanted. Several pages of his notebooks show designs for boilers and piping: we learn that the ideal temperature was obtained by mixing three parts hot to one part cold water. In August, as the French besieged Arazzo, the citadel overlooking the Tanaro River, Leonardo was still imperturbably occupied with "the duchess's bathhouse."[3]

Louis XII's troops seized in quick succession the fortress of Annone (where the garrison was put to the sword, according to Guicciardini), Bassignano, Voghiera, and Castelnuovo. The Venetians attacked Lombardy from the east, singing *"Ora il Moro fa la danza!"* (Now it's the Moor's turn to dance!). Galeazzo da Sanseverino shut himself up in his castle, then beat an inglorious retreat, while his brother, the count of Caiazzo, surrendered unconditionally to the French. Ludovico, despite promises and fine speeches, failed to rally his city behind him. A Milanese mob lynched his treasurer. Sensing that the wind had changed, his generals deserted him. Panic stricken, the duke sent his children and the remains of his fortune to the emperor in Germany (who was too preoccupied with a war against the Swiss to come to his aid), before joining them himself in Innsbruck, by secret routes.

Milan capitulated on 14 September, without a single cannon shot being fired. On 6 October, Louis made a triumphal entry. Since he announced immediate tax reductions, the people welcomed him as a liberator. The richest state in Italy had fallen into French hands in less than a month.

Many of the Moor's courtiers had fled the capital. Leonardo hesitated about his course of action. The comte de Ligny, commander of the French troops, may have invited Leonardo to enter his service and study the fortifications of Tuscany,[4] for the French envisaged marching down to Naples, which they had not managed to hold since their previous expedition. We do not know to what extent Leonardo committed himself to the count: the latter's name certainly appears in a curious memorandum in which the letters of some words are reversed. "Go and find *ingil* [Ligny] and tell him you will wait for him at *amor* [Roma] and that you will go with

him to *ilopan* [Napoli]."[5] Why did Leonardo, who wrote mirror script, feel it necessary to use code too? It cannot have been guilt at crossing over so speedily to the enemy: such scruples were unknown at the time. I think rather that he was taking care to keep secret a plan he had not quite fixed upon.

Another sentence in the same memorandum shows him in contact with the French: "Get from Gian di Paris the method for dry coloring [*a secco*] and the recipe for making white salt and tinted paper." Gian di Paris was probably Jean Perréal, a painter in the royal service, who was in Milan at this time.[6] We also know from Paolo Giovio that Louis XII was so entranced by *The Last Supper* when he saw it at Santa Maria delle Grazie that he asked whether it was possible to remove it from the wall for transport to France. It would have been very odd if the king had not attempted to meet the artist, if not to invite him into his service.

But Leonardo did not yet attach himself to the French. Indeed, the latter were beginning to make themselves obnoxious to the population of Milan; looting had been followed by killing. The painter may have seen some of his friends molested by invading soldiers.[7] It was time to leave town.

The memorandum containing Ligny's name tells us about Leonardo's preparations. His first thought was to protect the vineyard he had received from the duke ("the donation"—*enoiganod al,* as he wrote backward, which suggests the need for intervention by Ligny or some other high French official). He made a note to take certain books—Vitelone, *De ponderibus,* etc.[8]—and to have "two boxes packed up and ready for the muleteer—some bed coverings will be best." He had three boxes altogether, but intended to leave one at Vinci, where Uncle Francesco was still living. He reminded himself to collect a small stove from Santa Maria delle Grazie, and something (the word is illegible) that had been stolen from him; to sell what he could not take (notably scaffolding planks, perhaps those on which he stood to paint *The Last Supper*); and to buy "tablecloths and towels, a hat, shoes, four pairs of hose, a greatcoat of chamois skin, and more leather to make new ones." He mentions reams of paper and a box of colors that may have belonged to "Gian di Paris"; he also wanted to take various seeds (lily, watermelon),

for purposes that remain obscure; and finally, before leaving Milan, he urgently wished to learn how to level ground and "how much earth a man can dig out in a day."

With these words, a chapter of his life ends. Having put his affairs in order, at the end of 1499, as the century came to a close, Leonardo sent most of his savings to the Monte di Pietà in Florence (the Santa Maria Nuova hospital, serving as a bank, where his family had always deposited its money) and set off, accompanied by Luca Pacioli and his beloved Salai. He considered joining Bramante in Rome, where the latter had been for some time, but decided to take the long way around, via Mantua, Venice, and his native Tuscany.

Leonardo had not stayed in Milan seventeen or eighteen years without ever leaving the city. His notes provide evidence of visits to Pavia, Vigevano, Lake Como, Chiaravalle (where he closely studied the working of a clock[9]), and Genoa, where, in April 1498, he was present with the duke during a tempest so severe that the harbor wall was breached.[10]

He describes in detail the Val di Chiavenna and the Trozzo and Sasina valleys.[11] I imagine he was particularly fond of these mountain landscapes, which must have reminded him of childhood expeditions around Vinci. On one occasion, in mid-July, he even undertook to climb a high peak in the heart of the Alps: at 4,634 meters, this was no mean feat. Along with Petrarch and Cardinal Bembo, Leonardo was among the earliest mountaineers in European history. On reaching the summit (if he really did so) Leonardo was stupefied by the sight before him: having dreamed of flying, he was now above the clouds; the sky was an intense blue—giving him some notions about the atmosphere; glaciers sparkled at his feet; deep in the valleys he could see the silver threads of the streams: he declared that he was looking down on the "four rivers that water Europe."[12]

Some people think he also went to Sardinia, but the Sardinia mentioned three times in his notes is more likely to be a small place on the banks of the Arno near Florence. Leonardo mentions several sea voyages; distant countries excited his curiosity. But when he writes of the coast of Sicily, or of Hungary, Spain, and England, it is almost certain that he is not speaking from experience but reporting travelers' tales he has heard.[13] Some of the accounts, which

mystified researchers at first, are entirely imaginary—exotic fantasies or literary exercises. One of them takes the form of a letter to the Florentine merchant Benedetto Dei, who really did explore distant lands. Leonardo gives him "news from the East," narrating how "in the month of June a giant appeared from the Syrian desert," provoking panic and dealing death. The many crossings out and additions betray the intention to tell a good story. Another, addressed to the "Devatdar of Syria, lieutenant of the sacred Sultan of Babylon," describes Mount Taurus and the river Euphrates. To make the story convincing, Leonardo illustrates it with maps and drawings. (This lengthy "letter" seems to have been the draft of a novel: Leonardo introduces it with the heading "Divisions of the Book," under which he indicates twelve chapters. There is a prophecy, a flood, the destruction of a city, despair, devastation; in the end, "the new prophet"—himself?—shows that "all these misfortunes occurred as he had foretold."[14])

In fact, Leonardo had hardly been farther than the frontiers of Lombardy in all his years in the Moor's service. It is thought he may have returned once or twice to Florence, but there is no firm evidence. Since exoticism was fashionable—the court was wild about things Turkish,[15] and it was the age of the great discoveries—he dreamed above all of marvelous voyages, which became pretexts for him to depict the apocalyptic visions that haunted him at certain times of his life.

Leonardo did not linger long in Mantua, despite his very warm welcome there; the marchioness Isabella d'Este, Beatrice's elder sister and Ludovico's sister-in-law, had long wished him to paint her portrait. She had already met the painter several times on her many visits to the court of Milan. Two years earlier, in 1498, she had written to Cecilia Gallerani, the Moor's former mistress, asking to borrow the portrait by Leonardo: she wished to compare it with certain works in her possession—such were her words. Cecilia declined, explaining that the portrait was not a good resemblance, but "Your Highness should not imagine that this is the fault of the master, for I do not think he has an equal. It is merely that the portrait was painted when I was extremely young, and since then my face has changed so much that if it were to be compared with

the picture, one would not believe it had been painted for me."

Contemporary reports described Isabella as the most accomplished woman in Italy—"first lady of the world," wrote Niccolò da Corregio. Poets never ceased praising her virtues, her courage, her wit, her learning, and her taste. She was a patron of the arts and had her private apartments *(studiolo)* decorated with works commissioned from the best artists of the day: Mantegna, who was her official painter, Perugino, Giovanni Bellini, Lorenzo da Costa, and later Raphael and Titian. At first sight she might have seemed an ideal protectress for Leonardo: she had already attracted to her court the singer Atalante Migliorotti, with whom he had made his debut in Milan. But da Vinci quickly discovered the marchioness had a tyrannical and interfering temperament, with which he must have found it difficult to get on. He could not have failed to learn how she had harassed Bellini, even taking him to court to obtain exactly the picture she wanted. And there are no fewer than fifty-three vehement letters from her to Perugino, trying to persuade him to finish an allegory of her own invention, praising her merits: a *Combat of Love and Chastity.* Truth to tell, Isabella was interested only in pictures painted in her honor and to her specifications.

Leonardo appeared to obey: he drew her in profile, in black lead and red chalk with pastel highlights. From this drawing, now in the Louvre, he probably made a copy, which he offered to the sitter.[16] Keeping the original in order to transfer it to a panel and paint it, or at any rate making noises to this effect, he left Mantua for Venice, where Pacioli had many contacts.

From Venice, on 13 March 1500, the musical-instrument maker Lorenzo Gugnasco, a friend of Leonardo's, sent Isabella a precious lute "in the Spanish fashion," accompanied by a letter informing her that the painter had shown him the drawing of her, "which is in every point a perfect likeness. In fact, it is so good that one could not do better. That is all I shall say of it in this letter." The two last sentences surely reflect Leonardo's intentions concerning the portrait: he was not about to pick up his brushes for the demanding Isabella. Apparently, an official portrait commission did not interest him: he seems to have replied to princely caprice by artistic license.

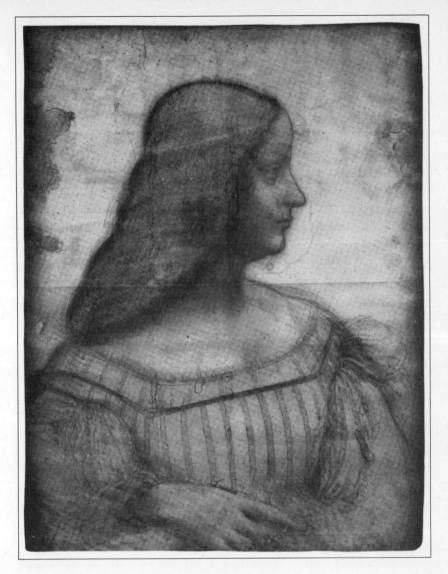

Portrait of Isabella d'Este.
LOUVRE, PARIS.

Upon his arrival in Venice early in 1500, Leonardo learned that the Moor was trying to reconquer Milan, where a group calling for his return had formed. Ludovico had called in the Sultan Bayezid

against Venice and spent all his money to mount a mercenary army composed of eight thousand Swiss and five hundred men-at-arms from the Franche-Comté. While the Turks ravaged Friuli, he recaptured his capital city—as easily as he had lost it. But the French cornered him in Novara: they, too, had Swiss mercenaries, and all his hired troops, whether on a sudden impulse or because the French paid them to do so, suddenly decided that they could not fight their fellow countrymen and returned home. On 10 April, the Moor had to escape by hiding in their ranks disguised as a foot soldier. He was recognized and betrayed, captured by Louis de Ligny, and taken to France under guard. Louis XII had him paraded through the streets of Lyon "like a wild animal," as Michelet puts it, before imprisoning him in the keep of Loches in Touraine. Never pardoned, he died in captivity eight years later, going down in history as the man who called foreign troops into Italy. The French and Spanish meanwhile fought first over Naples, then over Lombardy; after driving out the French, the Spanish were themselves expelled by the Austrians. Italy would be liberated from foreign occupation only upon unification in the nineteenth century.

Until the betrayal at Novara, Leonardo may have been hoping to return to his protector. Ludovico had been a convenient patron, allowing him plenty of leisure and employing him on a variety of tasks. To whom could he now turn? On the back cover of one of the notebooks (manuscript L), a few curt sentences refer to the recent events, not always clearly. Leonardo writes of a "little room above the apostles" and of "buildings by Bramante" (to regret that they were unfinished?); he notes the fate of various people known to him: the governor of the Castello, "taken prisoner"; a certain Visconti, "arrested and his son killed"; the astrologer Ambrogio della Rosa (da Rosate), "deprived of his money"; the administrator Bergonzo Botta, ruined. His last words refer to the Moor and perhaps indirectly to the bronze horse: "The duke lost his states, his personal fortune, and his freedom; none of his projects came to fruition."

Leonardo did no painting in Venice, although his work had made a great impression on the artists there. Vasari says that the "muted and dark" style of Leonardo so pleased the young Giorgione that he would stick to it all his life and "use it widely in his

oil painting." Palma Vecchio was also influenced by him, according to Vasari.

The Turks had responded so energetically to the Moor's request (to keep the Venetians busy defending their frontiers) that their advance guard was encamped on the banks of the Isonzo, less than fifty miles from the Doges' Palace. The circumstances revived Leonardo's ambitions as a military engineer. He went to Friuli and studied on the spot the topography of the threatened valleys. At Gradisca, he apparently[17] made suggestions for installing bombards. Returning to Venice, he put to the Senate a plan for halting the Ottoman advance: his idea consisted of building a mobile wooden lock on the river Isonzo, which the Turks would have to cross to get any farther into Venetian territory. The device would enable a handful of men to flood the valley and drown a whole army in a very short time.[18] No trace of the project survives in the Venetian archives: like so many other plans dreamed up by da Vinci, this one must have remained a dead issue.

Some historians think that he put to the Senate his plan for an underwater raid to liberate the many Venetians who were captives of the Turks, or indeed to wipe out the sultan's powerful fleet.[19] For several years, following in the steps of Alberti and Taccola, Leonardo had been thinking of sending divers in combat against enemy ports. The divers, he said, would wear glass goggles; they would be equipped with wineskins full of air and armed with very sharp cutlasses, in case they were pursued with nets. They would sink the enemy flagships by piercing their hulls with drills below the waterline, then they would set fire to the other ships. A sketch shows a rather convincing diving suit, made of watertight leather. This "invention" filled him with scruples. "How and why is it," he asked, "that I do not describe my method for remaining underwater and how long I can remain there without coming up for air? I do not wish to divulge or publish this because of the evil nature of men, who might use it for murder on the sea bed."[20] On the other hand, he imagined that his scheme might put an end to a murderous war without causing too many victims, since he envisaged issuing an ultimatum: "If you do not surrender in four hours, I will send you to the bottom." It would also be a means of rescuing from vile slavery those Christians whom the Turks refused to hand back—so

Diving Apparatus.
CODEX ATLANTICUS.

it might bring him considerable wealth, since he would collect a share of the ransoms promised by the captives' families. Alongside his drawing representing the underwater attack, Leonardo writes: "Do not teach anyone, and you alone will excel," and: "first draw up a legal contract [before a notary] so as to obtain half the ransom, with no other fee or exception."[21] The precaution was unnecessary: the underwater attack met the same lack of response as the flooding of the Isonzo valley. It is not certain that the project ever got further than the drawing board. Before long, Venice had signed a treaty with the Sublime Porte. By April 1500, Leonardo was back in Florence.

By now da Vinci was forty-eight. His hair must have been beginning to thin and turn gray. The city he returned to had changed too. Florence had expelled the Medici and become a republic once more. It had been won over by the fanatical teachings of the monk Fra Girolamo Savonarola—experiencing the exaltation and excesses of four years of theocratic dictatorship—until Savonarola was forced by the Pope to retract under torture and was ignominiously burned at the stake. After his death, the influence of his sermons, reinforced by his martyrdom (which he had predicted), continued to exert great sway over people's minds. Among artists, Botticelli, Lorenzo di Credi, Baccio della Porta (who became a monk under the name Fra Bartolomeo), and Michelangelo would bear to the end of their days the heavy imprint of the words of the Dominican friar. Some had enthusiastically taken part in the great "bonfire of the vanities" of 1497, committing to the flames works of art, musical instruments, playing cards, antiques, books, rare manuscripts deemed insufficiently Christian, mirrors, and women's jewels. Some refused ever after to paint profane subjects.

Leonardo saw his father once more. Ser Piero, by now seventy-four years old, was living in his new house on the Via Ghibellina with his fourth wife, Lucrezia di Guglielmo, a notary's daughter, and his eleven children, of whom the oldest was twenty-four and the youngest scarcely two years old. One presumes that father and son wrote to each other regularly while Leonardo was in Milan; but of this correspondence, only a draft of one letter survives: "Dearly beloved father, on the last day of last month, I received the letter that you wrote me and that in the space of an instant gave me pleasure and sadness. I had the pleasure of learning that you are in good health and give thanks to God; and I was unhappy to learn of your trouble."[22] The letter is very brief. Probably Ser Piero had been ill; we do not know what the "trouble" was—the death of his third wife? the loss of a friend, a business deal, or an important customer? (Bankruptcies were frequent under the austere rule of Savonarola.)

Leonardo withdrew fifty florins from his account at Santa Maria Nuova. If he was nursing any hopes in connection with Louis de Ligny, he was to be disappointed. The latter did not travel to Naples

but left Lombardy suddenly and returned to France, where he died three years later. While looking for a patron, Leonardo had to find lodgings. He learned that the Servite friars wanted a painting for the high altar of the Annunziata, and let it be known that he would be willing to do it. Filippino Lippi had already signed a contract for it, but he courteously withdrew in favor of his illustrious colleague—da Vinci's reputation had reached Florence before him. So the master took up residence in the convent, with Salai. But for the first few months, he did not paint (Vasari says that he kept the monks on tenterhooks, "without beginning anything"). He took part in the restoration of the church of San Salvatore, which was threatened by subsidence, and the campanile of San Miniato al Monte—after all, he had become something of an expert since the contest for the *tiburio* of Milan Cathedral. A treatise on the causes of the collapse of buildings and the resistance of building materials was still in progress in his notebooks. Then he either designed or copied the plans for a Florentine villa for Francesco da Gonzaga, marquess of Mantua. While the Servites were becoming restive and urging him to start work (they had already ordered the frame for the picture from Baccio d'Agnolo), Leonardo gives the impression that he was calmly carrying out experiments on weight and percussion, as well as studying mathematics and geometry with Pacioli.

Meanwhile, Isabella d'Este, hearing no news about her portrait, was determined to get a picture out of him. In March 1501, she wrote to her Florentine contact Fra Pietro da Novellara: "Most Reverend Father, if Leonardo the Florentine painter is at present in Florence, we pray you to inform us about the life he is leading, that is, whether he has some work in progress, as we have been told, and if so of what kind, and whether he is likely to remain long in the city. Would you have the goodness to ask him, as if the request came from yourself, if it would be convenient for him to paint a picture for my apartment? If he agrees, we will leave to him the choice of date and subject. If he is reluctant, try at least to persuade him to paint us a little Madonna full of faith and sweetness, as it is in his nature to paint them."

The reverend father went to the Servite convent to inquire. A few days later, on 8 April 1501, he replied to Isabella that "the existence of Leonardo is so unstable and uncertain that one might

say he lives from day to day." The letter goes on to describe a certain cartoon which the painter had at last begun for the monks, based on a sketch apparently made in Milan, of the *Virgin and Child with Saint Anne*.[23] The writer adds that Leonardo is not working on anything else, "except that he sometimes puts touches to portraits being painted by two of his pupils."

Isabella was not the sort of woman to be fobbed off with vague excuses; so her correspondent continued his inquiries. He questioned Salai "and other persons in the painter's entourage," whom he managed to find, not without difficulty, on Good Friday. Taking up his pen once more on 14 April, he reported this time that because of the mathematical research in which he was deeply immersed, Leonardo was "weary of the paintbrush" and—rather in contradiction to this news—that he would do no more until he had finished a little picture for Florimond Robertet, the favorite of the king of France: a *Madonna with a Yarn-Winder*.[24]

Isabella was to try again several times with Leonardo, asking him to value for her some precious vases that had belonged to Lorenzo the Magnificent (letter dated 3 March 1502[25]); sending him her agent Angelo del Tovaglia to tempt him with a large salary (14 May 1504); and writing to him herself at the same time as the last offer. "Master Leonardo, learning that you have settled in Florence, we have formed the hope of achieving our desire. . . . When you came to see us, you drew our portrait in chalk and promised one day to paint it in color; but understanding that it would be hard for you to keep your promise, since it would mean your returning here, we pray you to be good enough to discharge your commitments to us by replacing our portrait by a picture of Christ as a child of about twelve years old, that is, when he disputed with the doctors in the Temple, and to execute it with the charm and sweetness which are to such a high degree a feature of your art. If you agree to our desire, as well as the payment, which you may fix yourself, we should be so obliged to you that we should not know how to repay you."[26] She wrote again on 30 October 1504. In 1506, she asked Ser Piero's first wife's brother, Canon Alessandro degli Amadori, whom Leonardo had met again in Fiesole in spring 1505, to intercede on her behalf. Perugino, Raphael, and Titian, being similarly pursued by Isabella, all gave in to her in the end. But not Leonardo, although it was to him that she held out

the most enticing offers and used the humblest of tones. To Perugino she had written: "In this picture, you will not be allowed to add anything of your own invention." To da Vinci she wrote: "I think it a good thing to send you these few words to ask you to paint us a little canvas as a distraction." Leonardo remained unmoved. He does not even seem to have troubled to reply.

In April 1501, according to Isabella's correspondent, Leonardo was working on the picture commissioned by the Servites. Vasari tells us that the cartoon for the *Virgin and Child with Saint Anne* astonished all the painters who came to see it, and when it was finished, a crowd of men and women, young and old, filed past it for two days in the room where it was displayed, as if they were going to "a solemn festival." Everyone, he says, was "stupefied by its perfection." Florence had ignored Leonardo in the days of his youth; times had changed, and he was now universally respected. One imagines that Ser Piero was rather proud at last of his bastard son.

On the basis of this cartoon, modifying and lightening the composition so as to give it greater dynamic force, Leonardo at last began painting the picture, which is today in the Louvre.[27] The Virgin is seated on the knees of her mother, Saint Anne, at the same time leaning forward and catching in her arms the Infant Jesus as if to pull him away from the lamb with which he is playing. (The lamb, the sacrificial victim, symbolizes the Passion and sufferings of Christ.) Art critics have admired the unity of the three figures, the freedom of movement, the sweet and melting quality of the faces, and the hallucinatory mountains in the background. Freud, on the other hand, expressed surprise at the theme Leonardo had chosen, "the glorification of motherhood," and at the fact that the Virgin and Saint Anne seem to be about the same age, with their two bodies merging almost into one. "Leonardo gave the child two mothers," he writes, "both graced with the blessed smile of maternal happiness." He reminds us that the painter's childhood had been divided between his real mother and his stepmother (Ser Piero's first wife) and suggests that he may have united them in his mind as he did in his picture, a picture that no one but he could have painted. (In

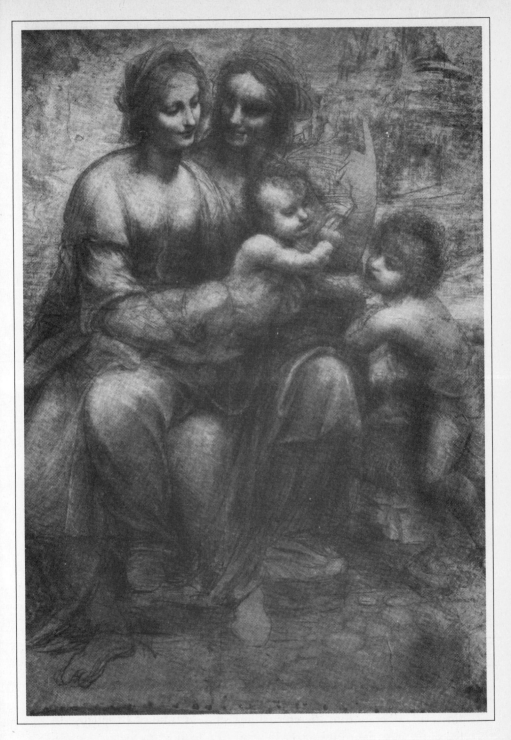

Cartoon for *Virgin and Child with Saint Anne.*

NATIONAL GALLERY, LONDON.

a note to the second edition of his work, Freud mentions that one of his pupils had discovered something: the "vulture" of the childhood memory appears "like an unconscious hidden image" in the contours of the Virgin's blue robes.[28])

Freud is mistaken about the theme's being unusual. The Virgin and Child with Saint Anne was a subject quite frequently painted in Renaissance Italy (by Masaccio and Gozzoli among others). Indeed, there is a special phrase in Italian for the subject: *Santa Anna Metterza*—Saint Anne as the Third. This kind of composition corresponded to the growing cult of the Virgin Mary and of her Immaculate Conception, a cult that therefore included the grandmother of Christ, Saint Anne, the third element in a sort of trinity taken from apocryphal writings. From the pyramidal construction to the fact that only three feet belonging to the figures are visible, everything in the picture seems to be threefold. In fact, in this painting, Leonardo was pursuing a theological meditation on the destiny of Christ, which had begun with the *Virgin of the Rocks,* if not earlier. Christ was predestined to die on the cross from long before his birth—from the time of the Immaculate Conception of the Virgin. How could one depict this mystery in plastic terms, without the use of anecdote? This explains the complex genesis of the painting, the many preliminary cartoons and drawings, the time taken, and the difficulty with which the eventual composition was developed. Leonardo started with the two women seated almost alongside each other and the Infant Jesus playing with John the Baptist (as in the cartoon in the National Gallery in London). But this did not adequately convey his idea; so he replaced Saint John with a lamb and had the Virgin stretch out her arms to pull her son away from this symbolic beast, while Saint Anne seeks to restrain her daughter, knowing that her gesture is futile since it is Christ's destiny to expiate the sins of men (another cartoon, now lost, described by Fra Pietro da Novellara). Finally, in the painting in the Louvre, Saint Anne, motionless and smiling, carries on her knees, as if in her womb, the Virgin, who is anxious about the fate of the Child. The two women look about the same age because this is a story outside time, or rather within the eternal and endless time of prophecy. In the same way, paintings of the descent of Christ from the cross often depict Christ looking older than his mother—the *Pietà* by Mi-

chelangelo in the Vatican, for instance. Leonardo is thus once more revitalizing in his own way the religious iconography of the period, and in this sense Freud is right to say that this picture could be the work of no other painter: this *Santa Anna Metterza* is very distant, both in form and in subject, from its predecessors. And we may be sure that Leonardo's reflection was inspired by events in his own life: but it seems to me equally important to note how the artist chooses to express himself, to see how he is perpetually concerned with theology: one can follow the movement of his thought from one painting to another, as in the pages of a book.

The painting in the Louvre is unfinished. Leonardo worked on it at intervals for many years—possibly eight or nine. But he never completed the landscape or the robes, although some of this work was apparently delegated to pupils. (They did, on the other hand, copy the picture many times.[29]) To explain this now habitual defaulting, we may remember the words of Fra Pietro da Novellara, the correspondent of Isabella d'Este: Leonardo was weary of the paintbrush *("impiacentissimo del pennello")*—although I suspect the priest of exaggerating a little so as not to hurt Isabella's feelings. In my view, one must think of Leonardo's main necessity—entering the service of a prince who suited his needs and his tastes. This search would continue to occupy him, taking him away from Florence and back to Milan, then to Rome.

In 1502, he thought he had found an ideal protector in the person of Cesare Borgia, who offered him the post he had always dreamed of. At fifty years of age, Leonardo was at last appointed military engineer.

The name Cesare Borgia is nowadays a synonym for infamy. It immediately suggests cruelty, deception, impiety, lust, and incest. The illegitimate son of Pope Alexander VI and a Roman courtesan, a cardinal at sixteen and unfrocked at twenty-two, Cesare Borgia seems to embody the dark side of the Renaissance. He is supposed to have had a liaison with his sister Lucrezia and to have arranged her marriage (for gain) to other princes, whom he then summarily dispatched—one of them with dagger and noose. He is supposed to have had his own brother stabbed to death in order to replace him as captain-general of the armies of the Church. He is thought to

Anonymous, *Portrait of Cesare Borgia*.
CARRARA ACADEMY OF FINE ARTS, BERGAMO.

have murdered and despoiled those whom he could not deceive or corrupt. The imaginative nineteenth century in particular went to town on his crimes. His own contemporaries (and historians) have left more mitigated judgments on his career. Guicciardini does indeed describe him as "a bloodthirsty barbarian," "a public brigand," and "more execrable than the Turk," but that was after his fall, and Guicciardini was hardly neutral. Others fell under his spell and spoke of him rather as an adventurer of genius. He inspired fear, respect, and astonishment—which was enough for many to admire him and to credit him with *virtù*. In fact, the period witnessed tyrants just as terrible, who had no pretext of a long-term policy— and it was against such men that Cesare pitted himself. He reminds one of the French king Louis XI. He did not hesitate to murder—

but only to some purpose, as his biographers take care to point out, not for pleasure or for petty ends. He frankly loved power and did not hide his personal ambition behind lofty ideas and empty words, bombastic manifestos, or a political party. He played his game quite openly, with none of the hypocrisy of modern politicians. And since his aggression was directed against despots whose chief concern was to oppress their subjects, since he suppressed feudal privileges, established a civil magistrature, and brought comparative peace, the people (the bourgeoisie, at any rate) acclaimed him as a hero.

At twenty-seven, he thought he was near his goal: the subjugation of central Italy, which he would unite under the banner of the Church—that is, of his father, Pope Alexander. The conquest of the rest of the peninsula, still being fought over by France and Spain (with the latter now claiming Naples), would have to wait a little. His baptismal name had gone to his head, people said, and he admitted as much in his motto: *Aut Caesar aut nihil* (Caesar or nothing) and in the inscription on his sword: *Cum nomine Caesaris omen* (With the name of Caesar as a prophecy).

Leonardo had no doubt met him in Milan with Ligny in 1499, for Cesare accompanied the French when they captured Lombardy. For services rendered (in particular, helping to obtain the papal dispensation that enabled the French king to marry Anne of Brittany), Louis XII offered him a small army, an income, and a title: he was given French nationality and made duke of Valentinois—the name by which Leonardo addressed his new master.

The two men must have taken an instant liking to each other. The boldness of the artist-engineer corresponded in some ways to the extreme audacity of the prince. I imagine that these two bastard children, having created their own lives, respected each other for their intelligence, independence of mind, and scorn for convention. Leonardo must also surely have been susceptible to Cesare's boisterous elegance and superb bearing. Portraits of him show a proud and handsome face (Andalusian, according to the chroniclers, in a reference to his origins), bearded and full of strength and energy: he resembled the leopards he used for hunting. The painter needed the protection of such men: enterprising, powerful, and strong—like Ser Piero, a psychoanalyst might say.

Leonardo took up his post as military engineer in the early

summer of 1502. His notes enable us to follow his movements almost step by step. In July, he was at Piombino on the Tuscan coast, concerning himself with fortifications and the draining of marshes. He relaxed by looking at the sea—that is, studying the movements of the waves and the mechanisms of storms and tides.[30] Then he went to Siena, where he examined a bell;[31] next to Arezzo, along with the captain Vitellozzo Vitelli, for whom he drew a map of the region.[32] He was probably present during the rebellion by this Tuscan town and then at the siege of the fortress where troops loyal to the republic had retreated—they held out for two weeks. Vitellozzo soon afterward attacked Borgo San Sepolcro, the native city of Pacioli. Leonardo asked (perhaps as his share of the spoils) for a treatise by Archimedes that he had long been seeking, that must have been kept there.[33] In the last few days of July, the painter joined Cesare Borgia, who had captured Urbino by a ruse, without firing a shot. In Urbino, he drew (as a tourist might) an imposing staircase designed by Francesco di Giorgio Martini, noting its dimensions; he did a rapid sketch of the fortress; and was much taken with a dovecote.[34] Cesare seized the city's gold and its artistic and cultural treasures and sent them off for safekeeping on muleback. Perhaps regretting the departure of rare manuscripts he would have liked to see, Leonardo wrote: "Many treasures and great wealth will be entrusted to quadrupeds who will carry them to various places."[35] After Urbino, he went to Pesaro on the Adriatic,[36] then to Rimini, where he was entranced by the harmonious sounds produced by a "musical fountain."[37] A few days later, he was on his way north, toward Cesena, capital of the Romagna.

On 18 August, from Pavia, where he was plotting with the king of France, Cesare sent Leonardo a passport confirming his appointment:

To all our lieutenants, castellans, captains, *condottieri,* officers, soldiers, and subjects who read this document: We order and command this: that to our most excellent and dearly beloved architect and general engineer Leonardo da Vinci, bearer of this pass, charged with inspecting the places and fortresses of our states, so that we may maintain them according to their needs and

on his advice, all will allow free passage, without subjecting him to any public tax either on himself or his companions [presumably Leonardo was accompanied by Salai and other pupils], and to welcome him with amity, and allow him to measure and examine anything he likes. To this effect, provide him with the men he requests and give him any aid, assistance, and favor he asks for. We desire that for any work to be executed within our states, each engineer be required to confer with him and to conform to his judgment. Let no man act otherwise unless he wishes to incur our wrath.

Thus armed with full powers, Leonardo involved himself in the various fortification works ordered by Cesare Borgia in the Romagna, in particular at Cesena and Porto Cesenatico: in the former, both civilian and military buildings; in the latter, a canal between the town and the harbor. His notebooks contain only brief and indirect references to his activities. Alongside a map, there is a mention of cisterns; on 6 September, at nine o'clock in the morning, he notes an idea he has had to protect the ramparts from artillery fire; elsewhere he remarks that the workmen digging moats group themselves in a pyramid.[38] Any plans and reports he may have presented to Borgia's builders have not survived.

Sometimes he went walking in the country, taking an interest in local customs or thinking about a new kind of mill, powered by the wind, which prefigured the so-called Dutch mills that appeared fifty years later. Since the carts he saw on the roads seemed to him to be designed in a manner contrary to common sense, he corrected them mentally and declared the Romagna to be the "capital of all the stupidities."[39]

On 12 October, Cesare Borgia sacked the little town of Fossombrone,[40] near Urbino. He then took up winter quarters at Imola. Several of his *condottieri,* including Vitellozzo, had formed a league against him and threatened to deprive him of the benefits of his most recent conquests. He was also afraid that the French were about to abandon him.

Leonardo rejoined him that month. Imola had to be fortified as a matter of urgency. Leonardo gave instructions for the citadel;

drew a beautiful circular map of the town, in color, possibly invent-
ing on this occasion an original method and instrument for map-
making.

Various embassies presented themselves at the Borgia court. From
the Ottoman delegation, Leonardo learned that Sultan Bayezid was
looking for an engineer who could build a permanent bridge across
the Golden Horn, linking Istanbul to Pera. Several artists, Gentile
Bellini in particular, had already traveled among the Turks, who
were said to be very openhanded. Leonardo considered the offer
attentively. During his travels around the Romagna, he seems to
have studied the single-span bridge at Castel del Rio then under
construction. Having informed himself of the topography of the
city that had once been Byzantium, he used this model to design
a gigantic bridge,[41] with pure and amazingly modern lines: the arch
was to be 240 meters long. Then he wrote to the sultan. In 1952,
a Turkish copy of a letter sent to Bayezid by "an infidel named
Leonardo" was found in the Topkapi archives in Istanbul. In this
letter, which is full of Arabic turns of phrase and invocations to
God, the artist claims to be able to build windmills, an automatic
bilge pump for ships, and, "at little cost," the colossal bridge that
would link Europe to Asia. Certain improbable passages in the
document may be imputed to the translation. But it does seem that
Leonardo really did think briefly of putting his talents at the service
of the Sublime Porte. He was by no means the only artist to be
tempted: we know from Vasari that Michelangelo, a few years later,
following a quarrel with the Pope, also applied to build the bridge
over the Golden Horn. In Leonardo's case, his plans do not appear
to have been taken seriously by Bayezid's advisers—at any rate, no
more is heard of them.[42]

While he was accompanying Cesare, Leonardo made the ac-
quaintance of a little man with malicious eyes, thin lips, and short
hair. Niccolò Machiavelli, the secretary of the Florentine Republic,
had been sent to Romagna as an observer. Confined to deciphering
and transmitting to the Tuscan authorities the intentions of the
enigmatic Cesare, he was dying to enter the game himself—that is,
to negotiate, advise, and plot, with the aim of allying the hesitant
Florentines to the destiny of this unbeaten warrior, brilliant leader
of men, and sublime tyrant, for whom no praise was too strong.

Santi di Tito, *Portrait of Machiavelli.*

Cesare Borgia's personality and actions were the inspiration for the masterpiece *The Prince.* Machiavelli's thought has been travestied to the point that his name and the adjective derived from it give off a strong whiff of sulfur. *The Prince* was put on the Index and banned in various ages; Voltaire condemned it, as did Montesquieu, reproaching its author for too greatly admiring "the duke of Valen-

tinois, his idol." In the eyes of Napoleon, it was "the only book worth reading"—which did not help its reputation. Machiavelli deserves respect, however, not only for his lucidity and impartiality when faced with the sad and repetitive realities of history—which he analyzed as ruthlessly as Laclos did the ruses of seduction—but for his psychology and deep knowledge of the human heart. "There is no political doctrine in Machiavelli," said Jean Giono, who kept a copy of *The Prince* at his bedside. "It is the first and perhaps the only objective study of mankind: the study of the passions conducted dispassionately, as if dealing with a mathematical problem." These were qualities that Leonardo could appreciate. Machiavelli, who was also a poet of some wit, spent over three months (October 1502 to January 1503) in Cesare's entourage. The long winter evenings, traditionally a time of rest and truce, encouraged conversations: one would like to have overheard the fireside chats between the aging artist and the young secretary of the Republic (who may have met each other at Pistoia some months earlier). One was laying bare the mechanisms of power as the other was those of nature, and with the same scientific rigor. Although neither mentions the other in his writings, some sentences of Leonardo's could almost be by Machiavelli, whereas the latter seems to be drawing on da Vinci's personal memories in several pages of his *Istorie Fiorentine*.

Until this point, Leonardo had played no part in his master's crimes, nor had he even witnessed them. He had drawn up plans and maps, had armed and reinforced towns, usually moving about independently of the army. The only action in which he was more or less involved was the capture of Borgo San Sepolcro, which had been achieved "by agreement," according to Guicciardini—that is, without bloodshed. But what about the massacres and murders that attended Cesare's progress? Leonardo can hardly have failed to be aware of what was public knowledge: the fate, for instance, meted out to Remiro dell'Orco (or Ramiro di Lorqua), governor of the Romagna. Cesare had ordered him to impose order on this occupied territory, by *any available means*. The excesses to which this kind of order could lead are obvious, and Remiro obeyed with chilling efficiency. Once "normalization" had taken place, Cesare, who knew how much the governor was detested, arranged that he be found, one fine morning after a ball, "cut in two pieces and exposed

in the town square with a wooden cudgel and a bloody knife alongside him." In this way, Cesare was signaling that if there had been cruelty, it had not come from him "but from the wicked nature of the minister, to whom justice was done." Machiavelli, who reports this incident in *The Prince,* applauded it thoroughly. The people, he concluded, "will remain satisfied and none the wiser." But we do not know what Leonardo thought. The artist, who claimed to have an absolute respect for life (nobody in those days talked about the rights of man), nowhere reveals his thoughts.

Was he present at Sinaglia with Machiavelli in the last days of December 1502? In this little fortified town on the Adriatic coast, the duke of Valentinois carried off what many think was his master-stroke. Rather than challenge his rebellious *condottieri* on the field of battle, he pretended to be reconciled with them; he forgave them, restored them to their commands, and offered them gold. With a small escort and a smile on his lips, he went out to meet them at the city gates, "with embraces," says Guicciardini. He invited them to meet informally in his rooms, then had them arrested and strangled, ignoring their pleas, without further form of trial.

By such murders, which astonished the king of France and which Paolo Giovio, by now bishop of Nocera, described as "a magnificent deception" *("bellissimo inganno"),* Cesare Borgia recovered for a while control of central Italy. Did he lose his "architect and general engineer" as a result of this affair? We do not know. At any rate, by March 1503 Leonardo was back in Florence and taking money out of his account in Santa Maria Nuova, perhaps an indication that he was not paid for his work in the Romagna. His notebooks do not tell us when he left Cesare or, above all, the reasons for his departure. Was he resigning his post because he sensed the imminent fall of the Borgias? Because he was no longer needed and had been dismissed? Was he responding to an invitation from the Florentine Republic conveyed by Machiavelli? Or was it, as one would like to think, because the blood shed by Cesare Borgia disgusted and repelled him? Leonardo knew personally at least one of the murdered conspirators, Vitellozzo Vitelli, from whom he had requested the Archimedes manuscript.

The notes dating from early 1503 do not mention the problem; they relate to his old friend Attavante the miniaturist, to whom he

lent four gold ducats on 8 April; to the usual expenditures on Salai—three gold ducats for a pair of pink hose the same day, and some fabric to make a shirt on 20 April;[43] and to a monk of Santa Croce who had written to him about a holy relic on 17 April.[44] And that is all. The only reference to Cesare Borgia in all Leonardo's writings, at the top of an undated memorandum (concerning boots, various friends, boxes held by the customs office, porphyry, knots, a nude, a square, some bags to be sent back, and a "frame for spectacles"—since it seems that failing eyesight obliged him to wear glasses), is this simple question: "Where is Il Valentino?"[45]

Once more, Leonardo provides no explanation. And yet if one examines his activities in the following months, one sees evidence of reconsideration of his work as a military engineer: during the summer, he initiated the digging of a canal intended to put an end to a war; and from October, he was to paint an immense fresco depicting the horrors of battle.

Both commissions appear to have been obtained as a result of Machiavelli's intervention.

The war was that between Florence and its former dependency Pisa, which had taken advantage of the first French expedition of 1494 to seize its independence. The Florentine Republic was prepared to make major sacrifices to regain this coastal town, which possessed the principal port in Tuscany: numerous troops had been levied, and ships had been hired to prevent Genoa's supplying the rebel city by sea; armed soldiers had been posted in the countryside to prevent the peasants from sowing corn for the next year. But despite the blockade and the threat of famine, the Pisans refused to capitulate.

With his experience in Romagna to his credit, Leonardo was among the engineers consulted about the siege. In June, he visited the region and drew detailed maps of it.[46] It seems likely that on this occasion he proposed to the Florentine authorities a scheme to divert the Arno some distance above Pisa, so as to deprive the town of both its water supply and its harbor (the estuary of the Arno), thus forcing it to yield without bloodshed; or at least that he suggested something of the sort to Machiavelli, who enthusiastically put the plan to the city fathers.[47] The Venetians had not listened to

Leonardo when he suggested drowning the Turks by damming a valley in the Friuli. We do not know what arguments he used this time, but either he was very persuasive[48] or the situation was desperate, for despite considerable misgivings, a decree was voted and the work began on 20 August 1503.

One of Machiavelli's assistants, Biagio Buonaccorsi,[49] followed the matter closely. It had been thought that by employing two thousand workmen a day (the site foremen reckoned in *opera,* or days of work per head), it would be possible by October to erect a wooden barrage on the Arno and to have dug two channels through which the river would reach a lake and a torrent leading to the sea some distance from Pisa. But these calculations soon proved too optimistic, and unexpected obstacles were encountered. There was a shortage of manpower, since the pay arrived irregularly. And a thousand soldiers were scarcely enough to protect the laborers from Pisan attack. The river began to flood, ruining some of the work accomplished, and the banks of one canal collapsed under the initial impact of the water. The generals grumbled and threatened to resign. Extra workers, foremen, and two *maestre d'acque* from Lombardy were taken on. Despite the considerable sums sunk in the scheme (over seven thousand ducats), delays piled up; the river continued to flood but refused to flow into its new channel. After six months, less than half the work was complete. Public opinion became impatient; Machiavelli pleaded with the Grand Council in vain; and the scheme was abandoned, amid much opprobrium. Buonaccorsi says that it was decided to "inflict damage on the Pisans some other way, chiefly by confining them within their city walls."

Leonardo had never been in charge of the works; in fact, once the initial discussions were over and the project officially adopted, his name disappears from any of the documents. Buonaccorsi does not mention him at all. He seems to have withdrawn to the position of consultant engineer, as usual, so one wonders whether the ambitious plan eventually chosen (a double diversion about twelve kilometers long, to be carried out in record time—for strategic reasons—in enemy territory) really corresponded to what he had in mind. The original idea of diverting the river may have come from

him, as a way of resolving armed conflict by technology rather than by battle, but it may then have been modified and its execution entrusted to other engineers.

In his own notes on the Arno valley, some of which go back to his Milanese period—that is, to the early days of the Pisan problem[50]—Leonardo had envisaged another ambitious solution, much more complex and costly than that supported by Machiavelli. Leonardo favored building a navigable waterway all the way from Florence to the sea: a canal that would provide irrigation for land that was always parched, bringing prosperity to the farmers. Above all, it would free the Tuscan capital from dependency on a politically unreliable port for its Mediterranean trade.

While the laborers were trying to "dry Pisa out," Leonardo continued to travel in the region, creating more maps and topographical sketches, pursuing his dream of a canal. On his own initiative, it seems, he concentrated his efforts on finding an intelligent, humane, peaceful, and lasting solution to the conflict. As he had for his ideal city, he thought long and hard about finance—which reveals the extent and implications of his scheme. He intended to submit it to the various guilds who might benefit from the hydraulic energy his canal could provide. Along the waterway he dreamed of seeing saltpeter mills, fulling mills, and silk mills, mills for paper, mills to power potters' wheels, sawmills, and mills to sharpen or polish metal.[51] The industries involved would contribute to the expenses—this would be a better source of income than a weak and divided government, and the benefits of technology would reconcile the enemy cities. "The canal," he wrote, "would increase the value of the land; the cities of Prato, Pistoia, and Pisa, as well as Florence, would gain thereby an annual income of two hundred thousand ducats, so that they will not refuse their assistance for such a useful scheme, and the same will be true of the inhabitants of Lucca."[52] "If one were to divert the course of the Arno," he claimed, "from top to bottom, all those who wished to would find a treasure in every plot of land."[53]

These ideas, which Leonardo was to develop—in vain—for years, had naturally first occurred to him when he embarked on his career as an engineer in Milan, which possessed the largest network of navigable waterways in Italy. He had closely observed the many

Map of the Arno and Proposed Canal.
ROYAL LIBRARY, WINDSOR.

Lombard schemes: the Martesana canal (dug in about 1460 between Milan and Lake Como), the locks at the Naviglio Bereguardo, the dams near Pavia, the irrigation works at the Sforzesca, and a model farm created by Ludovico the Moor at Vigevano. In about 1490, after much reading and countless experiments (on the speed of the currents at various points in a river, on whirlpools, on the resistance of the bank, on the silting up of canals, etc.), he had begun a treatise on hydraulics.[54] He does not seem to have been asked to carry out any hydraulic engineering by the Moor, but he had unquestionably become an outstanding *maestro d'acque,* and it was natural that he try to apply his knowledge to a region lacking in waterways, especially if circumstances seemed to be conducive to experiment. Leonardo did not see himself as confined to theory on such matters. "May I be deprived of the faculty to act before I tire of serving," he repeated. "I would prefer to lose the power of movement than that of usefulness. I would prefer death to inactivity. . . . I never tire of being useful."[55]

But Leonardo's fascination with water went beyond science and technology. He described it as the "vehicle of nature" *("vetturale di natura")*. Water is to the world, he said, as blood is to our bodies—perhaps more: it circulates according to fixed rules, both within and without the earth; it falls as rain or snow, it springs from the ground, runs in rivers, then returns to those vast reservoirs the seas, which surround us on all sides. As indispensable to mankind as it is to plants and animals, it is also the most terrible instrument of destruction that can be imagined; nothing resists its might. Leonardo had seen the damage caused by storms, had recognized the ceaseless motion of waves and currents, and seems to have been the first person to discover the principle of erosion. "Water gnaws at mountains and fills valleys," he writes. "If it could, it would reduce the earth to a perfect sphere."[56] As an essential element of life, water had to be tamed in order to play its role usefully, just as any vital drive had to be channeled. Leonardo would have liked to subjugate nature, to tame it, to bend it to his will, as he had bent the exuberance of the foliage in his paintings in the Sala delle Asse.

One of his youthful memoranda had referred to "various instruments for water." In Milan, he had thought of washing the streets automatically, using a system of locks and paddle wheels, so as to expel the miasma of the plague. At the very end of his life, he was still thinking of controlling waterways, digging canals, draining marshes. The obverse of this obsession is to be found in the many literary descriptions of floods, storms, and terrible inundations in which Leonardo indulged throughout his life. Although fascinated by cataclysms in general, he seems to be particularly gripped by panic at the sight of swirling waters. They seem to him more destructive than wind, earthquakes, and volcanic eruptions, or at least they frighten him more. There is nothing more terrifying, he says, or more *inhuman,* than a river in spate breaking its banks: it sweeps away houses and trees and washes people, animals, and even the land itself down to the sea. Perhaps he never expressed his feelings so strongly on this matter as in his "letter" to Marshal Benedetto Dei, in which he describes the appearance in Libya of a giant arising from the depths of the sea, where it has fed on "whales, cachalots, and ships"; its blows rain "like hail." This nightmare, like the unknown demons of the dark cave, paralyzed Leonardo: "I do

not know what to say or do," when he realizes the monster is going to swallow him. "I seem to be swimming headfirst into those mighty jaws, and, rendered unrecognizable by death, I am engulfed in that mighty maw."[57]

An obsession this forceful must have had origins in the painter's early childhood. There is nothing in his own writings about it, but Machiavelli, in his history of Florence, describes a hurricane that ravaged the Val d'Arno, and therefore the Vinci district, in 1456, when Leonardo was four years old. Machiavelli had not yet been born, and the cataclysm does not have much importance in the history of Florence, since it affected only the countryside, not the city; yet he devotes two pages to it. "By this example," he concludes, "God wished to bring back into men's hearts the memory of his might." Was this text (or another, deploring the decline in morality in Tuscany after the visit of the duke of Milan) inspired by conversations with Leonardo? Ten years after the hurricane, on 12 January 1466, the river Arno burst its banks, causing immense havoc. There were more floods in 1478. Leonardo must surely have witnessed these disasters: had he been the powerless observer of some tragedy? What vision of horror was so deeply stamped on his memory that he keeps returning to it with a sort of morbid pleasure? All his life, he tried to exorcise the images that haunted him by writing of and drawing them. He tackled them by inventing machines and structures intended to stop the nightmare from recurring in real life, seeking to control the blind power of the elements, in some sense to take revenge on nature. It is a pity that Freud was unaware of these matters.

The dream of a navigable canal linking Florence to the sea was long-lasting. Leonardo drew countless maps, some of them neatly rendered and colored, others more violent, in which the waterways seem to be nerves and flayed muscles, heaving and tossing against a background of dark patches.[58] Since the Arno wound its way west of Florence through steep hills, he imagined the canal as running by Prato and Pistoia, on the other side of Monte Albano, and thus describing a large curve. It would have to be cut through the heights of Seravalle: he hesitated between boring a tunnel through the rock (this has now been done for the motorway) and cutting a series of

giant steps, water races with locks, enabling ships to sail up into the hills, with the water being raised from one level to another by a huge siphon. "Thanks to the principle of the pump," he wrote, "one can move any river to the highest mountains."[59] He also dreamed of transforming the unhealthy marshes of the Val di Chiana into an artificial lake, which would act as a reservoir, and of attaching this to Lake Trasimeno, the level of which would be stabilized by a system of sluices. Leonardo took precise measurements, drew diagrams, covered his notebooks with figures and complicated calculations. He drew plans for two giant excavators, as if to compare them: one of traditional design, the other his own invention, a revolutionary machine mounted on rails and powered by a windlass, which enabled hundreds of laborers to work at the same time on various levels.[60] Then, little by little, he returned to reality.

Pope Alexander VI died in August 1503; some said he was poisoned inadvertently by his own hand. His son Cesare Borgia was driven into exile, first in Naples, then in Spain. Dispossessed of his territories and enlisted as a *condottiere* for the king of Navarre, he died in a skirmish "at the corner of a wood," as Michelet puts it.

While the war with Pisa continued, Leonardo, who had re-registered in October in the painters' guild of Florence, began to paint a battle scene. The commission came from the Signoria, which wanted Leonardo to "leave a memento" of his passing through, says Vasari. He was asked to decorate one of the walls of the Grand Council Chamber in the Palazzo Vecchio, illustrating some noble episode from the annals of the city. Since this immense room, fifty-three meters long and twenty-two meters wide, was still under construction,[61] premises were provided at Santa Maria Novella: an apartment for himself and, presumably, for his pupils, and the so-called Room of the Popes, which became the workshop. He received the keys on 24 October.

The Grand Council Chamber, built on the initiative of Savonarola, symbolized the Republic triumphant. The idea was to decorate the walls with a patriotic scene: some great feat of arms likely to fire the imagination. The subject chosen in the end was the battle between the Florentines and the Milanese at Anghiari, near Borgo San Sepolcro, in 1440. We do not know who chose the subject, but Leonardo's notebooks contain a detailed description of

the battle, apparently the work of one of Machiavelli's secretaries, a certain Agostino Vespucci. The names of the principal antagonists are listed at the top of this memorandum, which takes up three quarters of a large folio folded in four (Leonardo, who was always short of paper, used the rest to draw plans for the hinges of the wings of a flying machine). Vespucci describes the battlefield ("mountains, meadows, a valley watered by a river") and lists the forces present (forty cavalry squadrons, two thousand foot soldiers, artillery). He goes on to give a chronological narrative of events: from reconnaissance of the site by the generals at dawn to the collection of the dead at dusk, including a blow-by-blow account of every incident in a battle that long hung in the balance, featuring the heroic defense of a bridge and even a miraculous appearance by Saint Peter in the clouds. Even if one discounts the celestial intervention, this account does not seem to correspond to reality; Machiavelli, in his *Istorie Fiorentine,* records only one death, the result of an accidental fall from horseback, whereas Vespucci had described "great carnage." No doubt an "official" version was elaborated for the artist.

Leonardo took little notice of it, in any case. He had long held views on how to represent a battle and would apply them to this work. "You will first paint the smoke of the artillery, mingling in the air with the dust raised by the commotion of horses and combatants," he had written in about 1490.

> . . . You will give a reddish tinge to the faces, the figures, the air, the musketeers, and those around them, and this red glow will fade the farther it is from its source. . . . Arrows will be flying in all directions, falling down, flying straight ahead, filling the air, and bullets from firearms will leave a trail of smoke behind them. . . . If you show a man who has fallen to the ground, reproduce his skid marks in the dust, which has been transformed into bloody mud. And all around on the slippery ground you will show the marks where men and horses have trampled it in passing. A horse will be dragging behind it the body of its dead rider, leaving traces of the corpse's blood behind in the dust and mud. Make the vanquished look pale and panic-stricken, their eyebrows raised high or knitted in grief, their faces stricken with painful lines. . . . Men fleeing in rout will be crying out with open

mouths. Have all kinds of weapons lying underfoot: broken shields, lances, stumps of swords, and other such things. . . . The dying will be grinding their teeth, their eyeballs rolling heavenward as they beat their bodies with their fists and twist their limbs. You could show a warrior disarmed and knocked to the ground, turning on his foe, biting and scratching him in cruel and bitter revenge; there could also be a riderless horse galloping away into the enemy lines, mane flying in the wind, causing great injury with its hooves. Or perhaps some wounded man, lying on the ground and trying to protect himself with his shield, while his enemy bends over him to deal the fatal blow. Or a pile of men lying on the corpse of a horse. Several of the victors are leaving the field; they will move away from the melee, wiping their hands over their eyes and cheeks to remove the thick layer of mud caused by their eyes watering on account of the dust. . . . Take care not to leave a single flat area that is not trampled and saturated with blood.[62]

The first preliminary sketches for the *Battle of Anghiari* (those preserved in the Accademia at Venice, for example) correspond to this very realistic vision of a battlefield: men and horses clashing confusedly in a cloud of dust and smoke. The nervously drawn lines collide in disorder; one can scarcely distinguish a few figures: a foot soldier brandishing an ax, two men struggling violently, the twisted corpse of a horse. From this anarchic turmoil, without sacrificing his original idea of a furious melee, Leonardo gradually extracted his composition—a central motif and its peripheral elements. In the center of the fresco, he placed a mass of cavalrymen fighting for a standard (their turmoil owes much to his studies on the movement of water and storms). All around, as if drawn in by the power of this maelstrom, were hundreds of combatants, on horseback and on foot, furiously intent on slaughtering one another. The formula in some ways returns to that of the *Adoration of the Magi,* twenty years earlier. Unfortunately, only traces of the painting remain—in the lines quoted above, in a few of Leonardo's sketches (in Windsor Castle and the British Library), and in partial copies of the fresco by Raphael and Michelangelo.

Cavalry Battle.

In February 1504, Leonardo ordered from the joiners an apparatus described by Vasari as "very cunning"—a movable scaffold with a platform, which enabled him to work in comfort on the great cartoon for the *Battle,* measuring about twenty by eight meters: the largest painting commission he had ever been offered.

A report by the Grand Council tells us that Leonardo had already begun his sketch on 4 May 1504. After some deliberation, he was given an advance of thirty-five florins and was to receive from April a monthly salary of fifteen florins. In return, he promised to finish the composition of the *Battle* by the following February (in the event of default or delay, he would have to repay the money

received and let the Signoria keep the cartoon, whatever its condition). After examination of the completed cartoon, a more detailed contract would be drawn up for the painting itself. Naturally, the commissioners paid the artist's expenses: the document ends with references to the purchase of plaster, white lead from Alexandria, a ream of paper, sketchbooks, flour to glue the paper together, and a bed sheet "three measures wide" for the border of the cartoon.

The petty accounting irritated Leonardo. According to Vasari, when the cashier of the Signoria one day paid the artist's monthly allowance in small change, he refused the money, declaring, "I am no penny painter." He had no desire to be treated as an artisan, a petty official, or a municipal employee.[63] Piero Soderini, *gonfaloniere* of Florence—the chief magistrate, elected to the post for life—who was an honest but a rigid and uninspired man, took it very badly. He denounced the painter's insolence, whereupon Leonardo, supported by his friends, sent back all the money he had been paid, no doubt remembering with nostalgia the openhandedness of Ludovico. The conflict of wills ended to his advantage: he was begged to keep his money and to return to work.

The battle for the standard, the central subject of the picture, figures neither in Vespucci's text nor in Machiavelli's account; it was an invention by Leonardo, an interpretation of the patriotic theme he had been asked for. Vasari understands it in this sense when he says: "This composition was immediately considered to be full of lessons because of the admirable intentions that had guided it." While Leonardo had met the Signoria's request, his fresco also exposed in the crudest of terms the horror of war, which Leonardo described unhesitatingly as *"una pazzia bestialissima"* (a most bestial folly). Indeed, Vasari's description of the painting opens with the words: "Fury, hate, and rage are as visible in the men as in the horses." Apart from Poussin's *Massacre of the Innocents,* Goya's *Tres de Mayo,* and Picasso's *Guernica,* there has probably been no picture in the history of art as violent, brutal, and terrible as the *Battle of Anghiari.* As Leonardo saw it, the painter had to reach the onlooker's heart, move him, force him to think, and edify him. He hated war and in his fresco sought to communicate to others the horror it inspired in him.

Between this sentiment and his ambitions as a military engineer there is a contradiction, which cannot but perplex us. In his application for work with Ludovico Sforza, Leonardo had presented a very martial program, claiming to be prepared to build the most murderous of devices. When one looks at his notebooks, one is obliged to admit that he spent a great part of his time pondering machines of destruction—bombards, bombs, explosive cannonballs (prefiguring shells), versions of a machine gun, giant catapults and crossbows, chariots carrying great scythes intended literally to cut the enemy to pieces.[64] Many pages in manuscript B are devoted to study of the weapons of antiquity, whose fantastic names seem to have fascinated him: *falaricus, rhomphea, scorpion, murex* or *tribule, scalpre, vervine, soliferrum, danore, fragilici,* etc.[65] He appears to have taken as much pleasure in drawing sharp blades, iron bars, and the points of the cruelest weapons imaginable as he did in representing the gears, windlasses, and springs of useful and peaceable machines. Many of his discoveries are not very practical, like the cross between a shield and a wolf trap in a drawing preserved in the Louvre: when a sword strikes the shield, a sort of trapdoor opens and grabs it. But my impression is that while some of his drawings of swords and ornamental armor may have been intended for armorers, most of his military inventions never left the drawing board; that is why so many of them have survived—on paper. Engines of destruction fascinated him, just like natural cataclysms such as tornadoes and floods. Nevertheless, he remained a sworn enemy of violence and thus incapable of genuinely providing new instruments of destruction for his fellowmen, who were already all too inclined to massacre each other. "A truly disdainful man, he was peaceable," writes André Suarès. As Leonardo wrote about his "method for remaining underwater" to sink ships: "I do not wish to divulge or publish this because of the evil nature of men." One could hardly make oneself more plain. Unlike Einstein, he seems to have been assailed by remorse *before* he provided the military leaders with the plans of his inventions. In my view, the weapons in the notebooks are merely the secret, innocent games of a mind with a morbid bent—they remind one of the "bachelor machines," pseudo toys, and "supremely ambiguous" fictions elaborated by Marcel Duchamp.[66]

As an engineer to Ludovico il Moro, Leonardo had never accompanied the Lombard generals. As engineer to Cesare Borgia, for six or seven months he was essentially occupied, as his passport indicates, in advising the architects of the Romagna. As engineer to the Florentine Republic, he proposed a canal that would eliminate the need for a bloody conflict and the construction of a navigable waterway that would reconcile the combatants. During the autumn of 1504, while developing the great antiwar statement the *Battle of Anghiari,* he was once more at work on fortifications, in Piombino for Jacopo IV Appiani. He designed some low-profile fortresses, which prefigure Vauban, but they were all *defensive* structures[67]: his efforts went into defending and preserving. I cannot find any evidence of his participation in an offensive action. Vasari, who mentions several of Leonardo's technical "projects and models" and is well aware of the scope of his scientific work, does not seem to know anything—no doubt for good reason—about his career as a military engineer.

Leonardo was to spend over three years on the *Battle of Anghiari*—years marked by a death, by fresh hopes, and by an equal number of disappointments.

Ser Piero died during the summer of 1504. Leonardo noted his passing twice in his notebooks, both times repeating the time of death in almost identical terms. In a manuscript now in the British Museum, he wrote: "On 9 July 1504, a Wednesday, at seven o'clock, died Ser Piero da Vinci, notary to the Palace of the Podestat, my father—at seven o'clock, aged eighty years, leaving ten sons and two daughters."[68] And in the Codex Atlanticus, we read: "On Wednesday at seven o'clock died Ser Piero da Vinci, on 9 July 1504, a Wednesday, at about seven o'clock."[69] This odd double repetition (was he afraid of forgetting it?) is all that survives of whatever emotion he felt—unless we interpret as further signs of distress the error in his father's age (Ser Piero was seventy-eight years old) and the insistence on Wednesday, whereas the ninth of July in 1504 actually fell on a Tuesday. In any event, I do not believe Leonardo was as hard-hearted as some have claimed. His notebooks, we must always remember, are working books, in which only very occasional personal items appear; they are certainly not intimate diaries

or confessionals. The feelings Leonardo had for his father were certainly ambivalent; were they not therefore all the more intense?

This personal loss was compounded by a professional problem. Originally, no other artist was slated to decorate the Council Chamber. But Leonardo soon learned that the wall facing his fresco was to be given over to Michelangelo, the protégé of the *gonfaloniere* Soderini and the rising star of Florentine painting and sculpture. The younger man was to paint a fresco of similar dimensions, also depicting a major battle scene: the *Battle of Cascina,* which took place after the Pisan army launched a surprise attack on Florentine soldiers who were bathing in a river. Some historians read the decision to divide the work as related to the failure of the diversion of the Arno. Certainly Michelangelo was riding higher in the government's favor than da Vinci.

Michelangelo Buonarroti was twenty-nine years old. A disciple of Ghirlandaio for one short year, he had practically been brought up in the house of Lorenzo the Magnificent and had already made a name for himself in both Florence and Rome. In 1501, he sculpted, from a damaged block of marble that no one else wanted, a colossal statue of David—arrogant, nude, and dazzlingly white—alongside which the previous *David*s, by Donatello and Verrocchio, look almost wishy-washy. Leonardo had probably met Michelangelo for the first time in February 1504, when he was asked—along with Perugino, Botticelli, Filippino Lippi, Il Cronaca, Andrea della Robbia, and other well-known artists—to sit on the committee that would decide the site for this statue. The whole city took sides in the debate, with passions running so high that there were injuries from stone throwing. Leonardo, like most of his colleagues, favored a site inside the Loggia dei Lanzi, where the statue would be protected from the weather. Michelangelo, on the other hand, wanted his *David* to stand "proudly in the blaze of the piazza," in a prime site outside the Signoria. He got his way in the end, but no doubt felt some resentment against those who had opposed him.

One could not imagine two beings more different than Leonardo and his young rival. Their respective admirers would themselves later seem to be defending irreconcilable causes, as if favoring one inevitably meant despising the other. Leonardo, it might be said, sought to condense into deep inner spaces the mysterious light of

life, whereas Michelangelo unfolded against the immensity of heaven and hell the tragic grandeur of existence. The former, preferring painting, sought depth, while the latter, essentially a sculptor, handled great mass and volume.

But the dissimilarity was not confined to their art: these were two men separated by character, convictions, even physique. Michelangelo was born into the middle bourgeoisie and had pretensions to nobility, claiming to be descended from one of the counts of Canossa. Untidy in appearance, hunchbacked but stocky, quick and forceful in both manner and speech, he had the fiercely proud eyes of his *David*. Describing himself as "mad and wicked," tormented by anxiety, irascible and intolerant, he often picked quarrels with his fellow artists. Indeed, he was prepared to do battle with all comers to make his arguments prevail: his nose had been broken during a fistfight with the sculptor Torrigiano, and he insulted Perugino so grossly that the latter took him to court for libel—unsuccessfully. Having fallen under the influence of Savonarola, Michelangelo was by turns elated and tormented by a burning faith. "My delight is in melancholy," he wrote in Sonnet LXXXI. Although he eventually became wealthy, he always led an ascetic life, dressing and eating like a mendicant friar and working like a galley slave. He never removed his dogskin underboots, did not wash, slept in the studio dust alongside his work, and was content with a crust of bread and a jug of wine a day. A homosexual, he was torn between his passions and his religion. How could he fail to envy and detest the easy charm, the elegance, refinement, amiable sweetness of manner, dilettantism, and above all the skepticism of Leonardo, a man of another generation, said to be without religious faith, around whom there constantly strutted a crowd of beautiful pupils, led by the insufferable Salai? The two men no doubt respected each other's talent. Michelangelo copied a fragment of the *Battle of Anghiari,* and da Vinci's influence can be detected in several places in his work. Leonardo in turn made in the corner of a page a connoisseur's drawing of the monumental silhouette of the *David.* [70] But it was inevitable that these two larger-than-life personalities would one day meet head-on in the little world of Florence.

Their clash seems to have resulted from a literary quarrel. One day Leonardo, accompanied by the painter Giovanni di Gavina, was

Study of Michelangelo's David.

crossing the Piazza Santa Trinità, in front of the Spini Palace, when a group of people chatting on the benches stopped him and asked his opinion of some obscure lines by Dante. It so happened that at that moment Michelangelo appeared in the square. Perhaps from modesty, perhaps to flatter his colleague, or more probably because the subject did not interest him and he had better things to do, Leonardo said, "Here comes Michelangelo; he will explain it to you." The sculptor reacted angrily to this remark, thinking that he was being mocked, and retorted: "Explain it yourself, you who made a model of a horse you could never cast in bronze and which you gave up, to your shame." Upon which, he turned on his heel. Flushing at the insult, Leonardo was left standing at a loss for words. Michelangelo threw over his shoulder a final taunt: "And the stupid people of Milan had faith in you?"

Leonardo writes: "Patience protects from insult as clothes protect from the cold; if you put on more as it grows colder, it will not harm you; so, too, you should increase your patience in the face of great insults, and they will not reach your spirit."[71] But he had blushed with shame: Michelangelo's taunt had hit home. Leonardo had already left so many works unfinished. How many times had he bitterly scribbled, while trying out a new pen: "Tell me if anything has ever been achieved; tell me"; "Tell me if I have ever done anything that . . ."; "Tell me, tell if ever . . ."?[72]

And the failures had been repeated over the years, as they would continue to be to the end of his life. Unable to succeed in his plan to render the Arno navigable, he persisted in hopes of improving the course of the river east and west of Florence: there are sketches of hydraulic machines among his preparatory drawings for the *Battle of Anghiari*. Once more, however, no one was interested. Nor did the mathematics and geometry in which he was immersed lead anywhere. One November evening, by candlelight, taking up Archimedes' imperfect solution, which Pacioli must have explained to him, he made strenuous efforts to square the circle, covering pages and pages with beautiful geometrical diagrams. As the day dawned, he realized that he had discovered nothing. In the margin of the book, he wrote with a weary hand: "St. Andrew's night, I am through with squaring the circle; and this was the end of the light, and of the night, and of the paper I was writing on; this conclusion has come to me at the end of the last hour."[73] Neither would he outdo Archimedes—nor would he succeed in flying. In 1503, he had started his experiments once more: between March and April, in Fiesole, he assiduously studied the flight of birds, noting in a new book[74] the way they took off, hovered, or swerved with the wind, and how they flapped their wings at different stages in flight. Imagining that he had discovered the secret principle that would enable him to fly through the air, he believed success was within reach. On the inside of the notebook's cover, underneath some household accounts and architectural drawings, he wrote this strange prophecy: "The great bird will take its first flight from the back of the great swan, dumbfounding the universe, overwhelming with its renown all writings, and bringing eternal glory to its birthplace." On another folio, he wrote: "From the mountain bear-

ing the name of the great bird, the famous bird will take flight that shall fill the world with its great renown."[75] Historians have tried to identify the mountain known as the "great swan." As it happens, there is a high hill outside Florence that in the sixteenth century was called Monte Ceceri. Leonardo probably tried once more to defy gravity from the top of "Mount Swan." But the universe was certainly not dumbfounded. The silence surrounding the enterprise suggests failure. A century later, Descartes wrote: "One can from a metaphysical point of view make a machine that would stay up in the air like a bird, and birds themselves are such machines, or so I believe, but it is not possible from a scientific or a practical point of view, because it would require forces at once too subtle and too great to be manufactured by men." Given the technology available at the time, Descartes's arguments were reasonable, but they make all the more remarkable Leonardo's stubborn hopes of a century before.

Nor would Leonardo complete the *Battle of Anghiari*. While Michelangelo was working on his cartoon, over at San Noferio, the dyers' hospital, da Vinci finished his own at Santa Maria Novella, within the time limit, and prepared to transfer the drawing to the wall he had been allocated in the Council Chamber. He had his scaffolding taken over there. In February 1505, the Signoria settled his bills for purchases of plaster, linseed oil, Greek pitch, Alexandrian white, and Venetian sponges. Several assistants helped him to prepare and smooth the wall: among them Raffaelo d'Antonio di Biagio (who spent only two weeks in his service), the Spaniard Ferrando Llanos, Riccio della Porta, possibly the German Jacopo, who was enrolled in August 1504, and from 14 April a certain Lorenzo, who gave his age as seventeen.[76] Tommaso di Giovanni Masini, also known as Zoroastre, whom Leonardo warmly described as *mio famiglio,* mixed the paints. A blacksmith or mechanic from Milan, he was an odd individual, the team's jack-of-all-trades. Finally, the moment came to lay on the first brush stroke. "On 6 June 1505," Leonardo recorded, "a Friday, at the thirteenth hour [9:30 A.M.], I began to paint in the palace. I was just picking up my brush when the weather took a turn for the worse and the church-bells rang the alarm, calling people together. And the cartoon [made of pieces of paper stuck together] began to come apart, water went

everywhere, for the vessel in which it was being carried broke. Suddenly the weather grew worse still, and it poured with rain until evening; the day had been transformed into night."[77] It was a dark omen, especially since Friday was an unlucky day in popular folklore. I do not think that Leonardo was superstitious, but perhaps his friend Zoroastre da Peretola took it on himself to interpret the signs. In August, the registers of the Signoria mention more purchases: more plaster, white lead, and walnut oil, thirteen ells of canvas to protect the scaffolding, wax. The payments continued until the winter: then nothing. Leonardo apparently stopped painting in the Council Chamber. In May 1506, abandoning his fresco, he returned to Milan.[78]

The Anonimo Gaddiano says that he abandoned it "out of dissatisfaction, or some other reason." Paolo Giovio more explicitly states that this latest in a row of failures was the result of technical difficulty and blames the poor quality of the coating applied to the wall, which he says was "irremediably resistant to paints prepared with walnut oil." According to the *Libro di Antonio Billi* of about 1518,[79] the oil was made from linseed and of extremely poor quality. A text appended to the Anonimo Gaddiano, on the other hand, says that Leonardo had taken from Pliny the Elder a recipe for colors, which he used without having perfectly understood it. He experimented with it for the first time in the small Room of the Popes, in which he was working; in front of the wall, he made a great coal fire, which was supposed to dry the paint. When he began to paint in the Council Chamber, however, it appeared that the fire was too far away from the upper section to dry the colors. Not being fixed, they began to run.

This explanation sounds quite plausible. Leonardo, wishing to paint in oils, the only medium suited to his methods, tried the ancient recipe on a small surface—as he had tested casting processes on a small scale for the *cavallo*. The experiment had seemed to work, so he had confidently embarked on his painting on the larger scale of the Council Chamber wall. The "coal fire" reminds us of the stove he had collected from Santa Maria delle Grazie, mentioned in the "Ligny memorandum." Perhaps he had already tried to dry his paint when working on *The Last Supper*. In any case, by the end of 1505, he was unable to repair the damage caused by a faulty

Study for the *Battle of Anghiari.*
SZEPMUVESZETI MUSEUM, BUDAPEST.

technique, or, perhaps, by defective materials, and did not have the heart to clean it all off and start again. He had been invited by the French to return to Lombardy, so he simply gave up, leaving the painting in outline only. Anonymous copies made at the time (in oils, such as the *Tavola Doria,* now in a private collection in Munich; or in engravings, such as that in the Palazzo Rucellai in Florence) show that he had stopped after completing the central portion, the battle for the standard.

It may be small consolation, but Michelangelo never painted his *Battle of Cascina,* either; when he finished the cartoon, he left for Rome, where Pope Julius II had asked him to design his tomb and to paint the frescoes in the Sistine Chapel.

Michelangelo's cartoon and the fragments that remained of Leo-

nardo's painting were displayed for a long time in the Room of the Popes and the Council Chamber. Benvenuto Cellini said that they were regarded as "the school of the world." From the first announcement of the "battle of *Battles,*" artists flocked from every workshop in Italy to learn from these works, out of which both classicism and the Baroque would later emerge. Imagine all the artists who might have rubbed elbows in Florence early in the sixteenth century: apart from Leonardo and Michelangelo, there were Perugino, Botticelli, Filippino Lippi, Lorenzo di Credi, Piero di Cosimo, Andrea del Sarto, Baccio della Porta, the two Sangalli, Il Cronaca, and a twenty-year-old native of Urbino, who, according to Vasari, was so impressed by Leonardo's style that he decided there and then to try to forget everything else he had learned in order to imitate it: Raphael, a former pupil of Perugino. There are few other examples of such a concentration of talent in such a small space. It was in front of this exceptional audience that Michelangelo's nude warriors and Leonardo's frantic horses competed for attention. According to Cellini, there was no winner: "Neither ancients nor moderns ever produced anything more fair," he writes.

The cartoon of the *Battle of Cascina,* a fragile artifact, disappeared during an uprising in 1512, possibly falling victim to the jealousy of the sculptor Baccio Bandinelli. The following year, the city fathers had a wooden frame made to protect Leonardo's fresco, now almost ruined. As late as 1549, in an artistic guide to Florence couched in terms of a letter to a friend, Anton Francesco Doni could still say: "When you have climbed the staircase to the Great Chamber, look carefully at a group of horses, which will seem a marvelous thing to you." Rubens was later to copy the battle for the standard (Stendhal described the result as "Virgil translated by Madame de Staël"), but this was already only a copy of a copy. The Medici, having taken power once more in Florence, had ordered Vasari to remove from the Signoria walls all traces of works commissioned by the Republic. By 1560, he had plastered over what was left of the *Battle of Anghiari,* before painting on top of it the uninteresting frescoes that are still to be seen today. He does not boast about this in his *Lives.* Recently, the walls were tested with ultrasonic devices to see whether anything can be recovered of Leonardo's work—in vain.

X

Like a Well-Filled Day

Amor omnia vincit. Et nos cedamus amori.

—VIRGIL,

QUOTED BY LEONARDO[1]

Nude *Mona Lisa*.

MUSÉE CONDÉ, CHANTILLY.

L EONARDO DEPARTED FLORENCE for the first time in about 1482, leaving unfinished both his *Saint Jerome* and the *Adoration of the Magi*. He left the city again twenty-four years later, having completed neither his *Virgin and Child with Saint Anne* nor the *Battle of Anghiari*. Perhaps the city of his youth exerted an unfortunate influence on him.

The city fathers took the news of his departure badly. They consented to it, in May 1506, because they had no choice: Florence was too deeply committed to the French (an ally in the war against Pisa) to refuse a request from the governor of Milan, Louis XII's powerful lieutenant Charles d'Amboise, comte de Chaumont, who had peremptorily summoned the artist to his court. But Leonardo was only granted leave for three months, on pain of a heavy fine, one hundred fifty florins, for any delay.

One supposes Leonardo agreed to the condition with a shrug of the shoulders. From now on, he would do as he pleased, with the encouragement and aid of his new protector, the *gran maestro,* as he called him. On 18 August, Charles d'Amboise courteously asked the Signoria of Florence to extend the painter's leave of absence until at least the end of September. The *gonfaloniere,* Soderini, replied angrily that da Vinci had not behaved well toward the Republic: "He received a large sum of money and has only made a small beginning on the great work he was commissioned to carry out [the *Battle*]. We do not wish further delays to be asked for on his behalf,

for his work is supposed to satisfy the citizens of this city. We cannot release him from his obligations—having committed ourselves in this matter—without exposing ourselves to serious damage."

Leonardo turned a deaf ear to this reply. Threats were powerless to make him finish a fresco that had brought him nothing but bitterness and disappointment. He was happy in Milan, where he had always felt at home, where he had many friends and plenty of work. Ambrogio de Predis had at last resolved the lawsuit in which both of them had been embroiled since 1483 with the Confraternity of the Immaculate Conception: together they now painted, or completed, a second version of the *Virgin of the Rocks* (the one that is today in the National Gallery in London), the first one having perhaps been sold to the French king. They were granted permission to remove the original picture from the church of San Francesco Grande in order to make their copy.[2] Meanwhile, Charles d'Amboise had commissioned from Leonardo plans for a large palace that he wished to build near the Porta Venezia. A few drawings and notes have survived of the project—in particular, the description of a garden worthy of the *Thousand and One Nights:* The sails of a windmill will create an artificial breeze in summer, Leonardo suggests; murmuring and fish-haunted waters, "in which wine can be put to cool," will circulate among orange, lemon, and citron groves and other sweet-smelling trees; the perfumes of the flowers will be matched by the sweet singing of many birds, sheltered in an immense aviary made of woven copper wires. Musical instruments, powered by the mill, will play automatically; and to crown it all there will be "places where water will spray out to drench passersby, for instance if one wanted to sprinkle the ladies' dresses for fun"[3]— for the high-spirited Charles d'Amboise was "as fond of Venus as of Bacchus," according to the chronicler Prato. Leonardo was also asked to organize masks and entertainments[4] such as he had arranged for Il Moro—apparently there had never been as many diversions put on at the Castello as there were now: circuses were useful distractions in times of foreign occupation.

The now elderly master was at the center of this round of pleasures; he had no wish to withdraw from them, especially since he was treated with consideration fit for a prince, he was receiving

a more than generous pension, and the vineyard given him by Ludovico had been restored to him. Far from binding him to a single commission, his new patrons consulted him on all manner of works, and he became once more the arbiter of taste he had been under the Sforzas. People jostled for his company and his services— to the French he represented as no other man could the splendors of the Renaissance, everything that had attracted them into the Italian wars. Every important person at court wanted a picture by him; he may have been asked to design a church.[5] And since he must have expressed the desire, he was allowed to concern himself with hydraulic matters: he improved the Lombard system of locks and dams and did so to such good effect that he was promised an income—a tax levied on "twelve ounces of water" in the Naviglio San Cristoforo (probably one of the canals he had redesigned), which brought in an enviable sum.

A further letter from Charles d'Amboise to the Florentine city fathers, dated 16 December 1506, gives some idea of the undivided admiration the French felt for Leonardo: "The excellent works accomplished in Italy and especially in Milan by Master Leonardo da Vinci, your fellow citizen, have made all those who see them singularly love their author, even if they have never met him. ... For ourselves, we confess that we loved him before meeting him personally. But now that we have been in his company and can speak from experience of his varied talents, we see in truth that his name, already famous for painting, remains comparatively unknown when one thinks of the praises he merits for the other gifts he possesses, which are of extraordinary power. ... If it is fitting to recommend a man of such rich talent to his fellow citizens, we recommend him to you to the best of our ability, assuring you that everything you can do to increase either his fortune and well-being or the honors to which he is entitled would give us as well as himself the greatest pleasure, and we should be much obliged to you."

Geoffroy Carlos (or Jofredus Karoli), vice-chancellor of Milan, poet, scientist, and enlightened connoisseur of art, intervened in turn to ask Soderini to stop pestering Leonardo. The king of France himself joined in. In Blois, where he had been residing for a year, Louis XII informed a Florentine envoy that finding himself entranced by a small painting by da Vinci (was it the *Madonna with*

a Yarn-Winder, belonging to Florimond Robertet?), he ardently desired the artist to remain in Milan, for he wished to obtain some work from him. As if that were not enough, he had Robertet write to the *gonfaloniere* and priors of the Signoria in January 1507: "We have necessary need of Master Leonardo da Vinci, painter of your city of Florence. . . . Write to him that he should not leave the said city [Milan] before our arrival, as I told your ambassador." Leonardo was becoming the object of a diplomatic tug-of-war. The Florentines must have found it hard to understand why the French were making such a fuss about an *artist.* Reluctantly, Soderini bent to the will of the king, but he continued to call for the repayment of the money the Republic had spent on the *Battle.* Obliged to visit Florence in 1507 because of a disputed inheritance, Leonardo may have purchased his freedom by paying back the money; at any rate, he cleared his account in Santa Maria Nuova in June 1507.

At the time, he had on his hands a double battle over a legacy. Ser Piero had died intestate; the children of his fourth marriage had united against those of the third to obtain the larger share of the estate, and they all combined to disinherit the notary's illegitimate eldest son. On 30 April 1506, a committee of lawyers reached a temporary settlement, from which Leonardo was excluded. When, a few months later, his uncle Francesco died in turn, without heirs, he left his entire estate to his favorite nephew, as if to correct an injustice. The family challenged the will.[6] This time, Leonardo was determined not to give up his rights, especially because he appears to have lent Francesco some money shortly before his uncle's death. Since his stepfamily was treating him like a stranger (*alienissimo* was his word), he made it a matter of principle, if not of emotion.

A small property known as Il Broto seems to have been at the center of the dispute. Ser Giuliano, the youngest of Ser Piero's legitimate sons, who had recently qualified as a lawyer, took up the case.[7] Certain of support from the judges, who were his colleagues, and banking on the general ill will of the Signoria toward Leonardo, he assumed he would quickly be able to invalidate his uncle's will.

Leonardo hoped to enlist his protectors to his side. He managed to get the French king to exert some influence (he had brilliantly organized the monarch's solemn entry into Milan—with triumphal

arches, antique chariots, and various machines—in May 1507, only a few weeks before leaving for Florence[8]). Louis XII took up his pen once more on behalf of the artist, who was now promoted to the rank of royal painter and engineer and whom he called "our dear and well-beloved Léonard da Vincy." He wrote to the Signoria: "We singularly desire that this lawsuit be brought to a conclusion in the best and swiftest rendering of justice possible; we have willingly written in support of this cause." Charles d'Amboise wrote to the magistrates in the same vein: let the judgment be soon, for the king has great need of his painter. But the French were far away in Milan, this was a private suit, and everyone knows how slow the law can be. Nothing happened. So Leonardo had to seek help from another quarter, Cardinal Ippolito d'Este, who was benevolently inclined toward him and who had connections with Raffaello Hyeronimo, the prior in charge of the case. The letter to the cardinal has been found in the State Archives at Modena. It is not in Leonardo's own hand, since once more lacking confidence in his writing or his style, he has found a friend to write it. But the document is signed with his name, "Leonardus Vincius pictor." This is the only one of his letters that we *know* to have been sent, all the others being drafts in the notebooks. "Although right is on my side," Leonardo explains, "I do not wish to neglect my interests in a matter about which I care greatly. . . . I beg Your Highness to send a few words to Ser Raffaello, in that skillful and affectionate manner which is yours, to recommend your ever humble servant, Leonardo da Vinci."

The judgment was nevertheless a long time coming. Obliged to stay in Florence to plead his case, Leonardo, accompanied by Salai, was living in the house of the rich patron Piero di Braccio Martelli, an accomplished mathematician, who was already accommodating the sculptor Giovan Francesco Rustici. Leonardo seems to have been very fond of Rustici. About thirty, he was a former member of Verrocchio's *bottega*. His studio looked like Noah's ark, according to Vasari: it contained an eagle, a crow "who could speak like a man," snakes, and a porcupine trained like a dog, which had the annoying habit of pricking people's legs under the table. An amateur alchemist and occasional necromancer, Rustici belonged, with Andrea del Sarto, Aristotile da Sangallo, and other artists of his genera-

tion, to a mock confraternity baptized the Company of the Caldron. They were in the habit of holding feasts of a noisy and eccentric nature, using a large cooking pot or caldron, during which all the guests might compose a picture—a portrait, landscape, or mythological scene—not with paints but out of chickens, jelly, sausages, lasagne, Parmesan cheese, roast meat, and other edible goods: compositions that could have served as models for Arcimboldo. Leonardo, himself much given to jokes of all kinds and perhaps the first among artists to possess many animals, must have felt particularly at home in the free and easy atmosphere of the Casa Martelli. Judging by his associates at this time, his tastes had not changed regarding unconventional friends. In Milan, one of his disciples seems to have been the extravagant Il Sodoma, whose nickname speaks for itself, and who kept a virtual menagerie, including a monkey and pygmy donkeys. Another faithful associate was the solitary Piero di Cosimo, who sometimes imitated Leonardo's works: he acted "like a savage," prized the oddities of nature above all else, and painted a monster in the manner of Leonardo. According to Vasari, Piero would make extraordinary remarks, which rendered his companions speechless with laughter.

In March, Leonardo took advantage of his free time to try to put his notebooks in order.[9] Rereading them, he was dismayed by the chaotic character of his notes and the number of repetitions. It had become unmanageable, beyond his control. Perhaps he ought to confine himself to a few treatises (on water, on painting, on anatomy) if he wanted to see any of this writing published.

As a diversion, when not pursuing his studies in mathematics and anatomy, he helped Rustici model his *Saint John the Baptist Preaching to a Levite and a Pharisee,* a life-size group of statues for the Baptistery, which was commissioned by the Company of Merchants. Vasari says that all the time the sculptor was working on this group, he would let no one come near him except Leonardo, right through to the casting, so one imagines that the maestro may have had some hand in the execution. While the statue of Saint John is pointing a finger heavenward in a vaguely Leonardesque gesture, it is nevertheless executed in the ordinary, not particularly graceful, style of Rustici. The other figures, however, far surpass in quality anything else the sculptor ever did. The three bronze statues are still

over the north door of the Baptistery: one of them is reminiscent of the pensive old man in the *Adoration of the Magi.* To my mind, these are the only sculptures still in existence in which Leonardo's hand can be seen with any certainty.[10]

The French were becoming impatient with their painter-engineer's long stay in Florence. He seems to have become indispensable to them in a short space of time. Leonardo (who may have traveled more than once between Lombardy and Tuscany during the year the lawsuit lasted) wrote to his protector in the early months of 1508 to say that the end was in sight and that he expected to be back in Milan by Easter, bringing "two pictures of Our Lady," which he had painted for the king or for anyone else who would be a suitable recipient. In this letter, which was sent with Salai, he expressed concern about his lodgings, since he did not want to trouble the governor of Milan (which seems to indicate that he had previously been his guest), as well as about his allowance and income from the canal, which he had been promised but had not yet received.[11] Another letter, addressed to the superintendent of canals, whom he calls "Magnificent President," is more closely concerned with the "twelve ounces of water" he had been allocated by the king. "Your Worship knows that I did not enter into possession of this," writes Leonardo, "for at the time they were granted me, there was a great shortage of water in the canal, partly because of the drought of that season and partly because the sluice gates had not yet been regulated. But Your Excellency assured me that when the regulation was finished, my hope would be fulfilled. Hearing that the canal was now in working order, I have written to you several times, as I have to Messer Gerolamo da Cusano, who has the act of donation . . . but without receiving a reply. I am sending as bearer of this letter my pupil Salai, to whom Your Worship may tell *viva voce* everything that has occurred concerning the matter on which I am soliciting Your Excellency."[12]

At last the verdict of the lawsuit was pronounced. The priors found against the younger brother and declared Uncle Francesco's will valid; an acceptable settlement was reached, and Leonardo seems to have set off at once for Milan, in the summer of 1508.[13]

He would return several times to Florence—in 1509, 1511, 1514, 1515, and 1516—but only for comparatively short spells.

Rustici, *Saint John the Baptist Preaching to a Levite and a Pharisee.*
BAPTISTERY, FLORENCE.

"I shall bring with me two pictures of Our Lady."

It is not easy to identify these two Madonnas, "of different sizes," which Leonardo had painted in his "spare time," according to his letter to Charles d'Amboise, and which were almost finished *("condotte in assai bon porto").*

Either they have disappeared or they are paintings he began himself, then turned over to his pupils. This was increasingly his practice whenever a work did not seem greatly important to him— when it did not pose problems sufficiently complex to engage his imagination and intelligence or, much the same thing, if in the

course of creating it he had extracted all the "juice" from it, so that the execution no longer interested him. No benefit can be derived, he writes, from food eaten without appetite. There is no shortage of Madonnas painted by his disciples on his instructions or from a drawing or cartoon by the master: *Madonna Playing with the Child, Madonna with a Pair of Scales, Madonna with a Lily* . . . Any of these paintings "after Leonardo," as catalogues sometimes describe them, might correspond to one or another of these so-called lost paintings that he took to Milan.

One might imagine that at this stage, "weary of the paintbrush," as Isabella d'Este's correspondent had reported, disappointed by the failure of the *Battle of Anghiari,* deeply absorbed in his studies in anatomy and geology, and kept busy by the various hydraulic or architectural commissions offered by the French, Leonardo had lost the urge to paint. On the contrary, it was during these years (between 1505 and 1515, apparently) that he produced not only the *Leda* but the *Mona Lisa* and *Saint John the Baptist,* the last two indisputably by his hand alone.

No documentary evidence enables us to date any of these paintings with certainty. We do not even know who commissioned them, if commissioned they were. Their history consists of a string of hypotheses. It is scarcely possible even to rank them chronologically: it is believed that the *Mona Lisa* predates *Leda* and that *John the Baptist* (which is prefigured by a studio composition, *Bacchus,* now in the Louvre) was the last thing Leonardo ever painted. In all likelihood, the composition of these paintings overlapped. There is nevertheless a continuity running through them, and if we wish to understand them, we must find the connecting thread.

Raphael made a pencil drawing in Florence either of the *Mona Lisa* itself or of the cartoon for it. His drawing, now in the Louvre, shows the famous three-quarter pose, the folded hands lightly resting on the edge of a piece of furniture or a balustrade, the hint of a smile, the misty landscape behind the sitter. This formula, which Raphael would use many times himself (in his *Lady with a Unicorn,* his portraits of *Maddalena Doni,* of *La Fornarina,* and of his friend *Baldassare Castiglione*) and which became the classic portrait format, was so new at the time that Raphael can only have borrowed it from Leonardo when they were both in Tuscany—in about 1505.

Vasari tells us that Leonardo undertook to paint for a certain Francesco del Giocondo the portrait of his wife, Monna Lisa, but that after four years of effort, he left it unfinished, and "it now belongs to the king of France." Research in the Tuscan archives has shown that Francesco di Bartolomeo di Zanobi del Giocondo was a wealthy man, who had made his money in the silk trade and held certain public offices. His family were connoisseurs of the arts, and several of his relatives had commissioned pictures from leading artists. Twice widowed, he took as his third wife, in 1495, a young woman from a more modest background, Lisa di Gherardini. They had one child, who died in infancy. No more is known, except that in 1505, Monna Lisa must have been about twenty-six or twenty-seven. None of this contradicts the account in Vasari (nor indeed the evidence of the painting itself). Consequently the portrait, to which Leonardo never gave a title, is known as *La Gioconda* in Italy, *La Joconde* in France, and *Mona Lisa* in English-speaking countries.

However, the Anonimo Gaddiano refers to a portrait of Francesco del Giocondo, not of his wife. And a few months before Leonardo's death in France, the cardinal of Aragon claimed to have seen "the portrait from life of a Florentine lady, painted on the orders of the late Magnifico, Giuliano de' Medici" (Lorenzo's son, something of a ladies' man and a protector of Leonardo), which appears to correspond to the painting we now call the *Mona Lisa.* Lomazzo thought that the sitter was Neapolitan. And the earliest royal inventories in which the picture is listed call it either "a courtesan in a gauze veil" or, on the contrary, "a virtuous Italian lady" (the view of Father Dan, keeper of the king's pictures in the seventeenth century).

Vasari gives a detailed description of the *Mona Lisa.* But he had never seen it for himself, knowing of it only by hearsay, since by the time he wrote his *Lives,* it was in France. There is no eyewitness account or document to confirm his version. He is the only source to give the name Monna Lisa, so a number of historians have expressed doubts and explored other avenues of inquiry. Today, there are about a dozen possible identifications of the sitter, all more or less defensible. She might be the favorite of Giuliano de' Medici, a certain Pacifica Brandano; or a "Signora Gualanda,"[14] or one of the mistresses of Charles d'Amboise; or even Isabella d'Este, suppos-

ing the painter to have given in to her in the end; or she might be the duchess of Francavilla, Costanza d'Avalos, since a poem mentions an "unknown" portrait of her by da Vinci.[15] Some people have suggested that there was no model at all, that Leonardo was painting an ideal woman. The most farfetched theory is that this is a portrait of a man, or indeed a self-portrait by the artist: Leonardo, some suggest, depicted himself in the guise of a woman, omitting the beard and the wrinkles of old age. It is true that the sitter is not portrayed in the usual manner for a bourgeois portrait: Leonardo took great pains and applied much art to make her look like a Madonna or a princess, giving her monumental stature. But in the end, since no one has unearthed any incontrovertible evidence, people have fallen back on Vasari and continued to call the picture *La Gioconda* or *Mona Lisa*.

If this really was a portrait, why was it never delivered to the man who commissioned it? To judge by Vasari's account, the unfinished state of the painting after four years' work, when Leonardo left Florence for Milan, explains why he kept it with him to the end of his life, taking it to France as he did the *Saint Anne*. But the painting in the Louvre does not appear unfinished. If Leonardo completed it in Milan or Rome, why did he not send it to Francesco del Giocondo, as he should have if he wanted to be paid? Had Monna Lisa perhaps died in the meantime (we do not know the date of her death)? Was it, as some romantically suggest, because he had fallen in love with his painting? Or because the final touches were added only in France? If the sitter was a mistress of Giuliano de' Medici, which is an arguable possibility, the reason might be that when Giuliano married Philiberta of Savoy in 1515, he refused to take delivery of a work that reminded him of his dissolute youth. In that case, if Raphael made his sketch in 1505, Leonardo would have spent ten years on a commission that a moral about-face eventually rendered redundant. To muddy the waters even further, some historians have suggested that the libertine Giuliano de' Medici originally ordered a "nude *Mona Lisa*," which must have existed, since there are copies of it (in the Musée Condé in Chantilly, for example). Or else reference is made to various other paintings and drawings, close to the *Mona Lisa* but of earlier date and now lost. Some historians have tried to combine two theories

by imagining quite gratuitously that Francesco del Giocondo's wife, rather than Pacifica Brandano or Signora Gualanda, was the mistress of Giuliano de' Medici. Another suggestion is that Leonardo never got rid of the painting because it was not a portrait but the image of a dream woman, in front of a phantasmagorical landscape, painted entirely for his own pleasure (and therefore without collaborators). He gave her a smile that (in Freud's view) reminded him of his mother, as well as all the qualities and virtues he looked for in a woman: gentleness, understanding, indulgence, patience, constancy. If so, the *Mona Lisa* would be the first painting in the world to be perfectly pure in intention.

Some claim the *Mona Lisa* resembles its painter. Could it have been a posthumous portrait of his mother? If this was the case, Leonardo never revealed the identity of the original, or else sent contemporaries off on false trails, since he had always been extremely discreet about Caterina.

Generations of art historians have racked their brains over the mystery. There is not the slightest allusion to this painting, or to the man assumed to have commissioned it, in any of the artist's writings; not even a preliminary sketch among his papers. The *Mona Lisa* has kept its secret. In fact, the mists surrounding its origins are perfectly matched to the sibylline character of the portrait. Leonardo employed the *sfumato* effect not only in his painting and writing but in his manner of drawing a veil, or so it seems, over certain circumstances in his life, as if he were leaving a trail of smoke behind him. This was his style, his manner, and the way his mind worked.

Leonardo was well aware that things might be more beautiful for being indistinct, and he skillfully wove the threads of his enigma— the true subject of his painting—first in his use of light. "In the streets when night is falling, in bad weather," he wrote in his *Treatise on Painting,* "observe what delicacy and grace appear in the faces of men and women."[16] The golden shades of dusk pick out the smile of the *Mona Lisa.* "You may paint your picture at the end of the day," Leonardo goes on, "when there are clouds or mist, and this atmosphere is perfect." Since it was impractical to work at this time of day, he had devised a method for creating artificial dusk: "You will have, O painter, a courtyard specially arranged, with

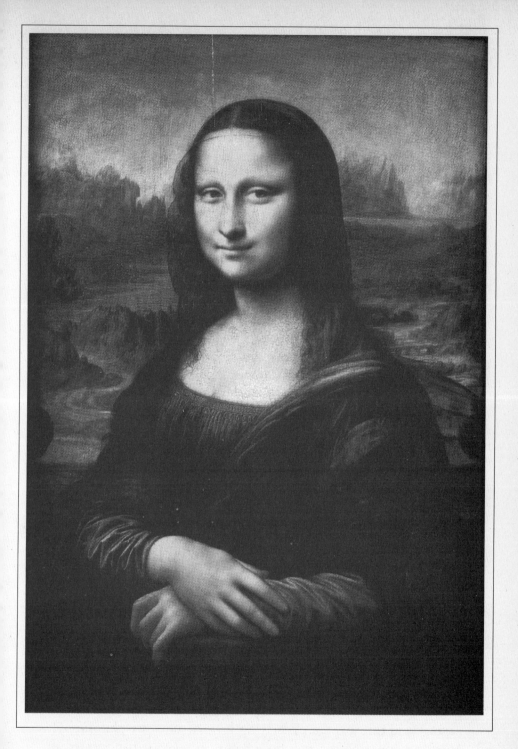

Mona Lisa.
LOUVRE, PARIS.

———

walls painted black and a roof jutting out a little over the wall; the yard should be ten *braccia* wide, twenty long, and ten high; and when the sun shines, take care to hang it with drapes." Elsewhere he speaks of an "atmosphere free of all sunlight" and of those streets that run between walls so high that even at midday people's cheeks "reflect only the darkness around them," so that the front of the face alone is illumined. "And to this is added the grace of the shadows, which have no harsh contours but blend harmoniously into one another."[17]

The *Mona Lisa* fits well with this sense of failing light, of a damp and misty atmosphere, at the very end of the day, when shapes emerge miraculously from a "darkening shadow." One feels that the daylight is fading, in a moment night will have swallowed up the gentle scene—and yet this woman is smiling. Vasari tells us that Leonardo obtained the *Mona Lisa*'s smile by having the sitter surrounded by musicians, singers, and clowns. It is a fleeting smile, nothing to do with happiness. Nor is there any question of seduction. One thinks: This woman is smiling, yet the rest of the picture speaks of annihilation—the absent sun, the desolate and grandiose landscape threatened by darkness, the dark clothes, the black veil around the woman's hair, which might be a sign of mourning. (If the sitter really was Monna Lisa, she might still be mourning the child she had lost; but according to Venturi, the duchess of Francavilla had not long been widowed.) "Hers is the head," writes Oscar Wilde, "on which all 'the ends of the world' are come, and the eyelids are a little weary." (*Intentions,* 1891). She is no longer young, by the standards of the time. Her smile is that of the wife, the eternal mother, who has experienced all pleasure and all pain, and who even in affliction remains all-knowing, full of compassion. A womanly equivalent of Christ, she sits with hands quietly folded, peacefully defying time, the "consumer of all things." Leonardo had learned very early the effect to be obtained from such contrasts. He had already made use of them in the *Virgin of the Rocks* and in the *Portrait of Ginevra de' Benci,* which was a kind of prototype of the *Mona Lisa.* Beauty, the permanent prodigy of life, he seems to be saying (and this was the underlying basis of an entire philosophy), never has more power and attraction than when it is presented in an emotive setting, surrounded with signs of doom.

Like most of Leonardo's paintings, the *Mona Lisa* has suffered over the centuries. The panel has lost a strip of about seven centimeters from each side: we can no longer see the two pillars that originally framed the landscape, which appear in old copies and in Raphael's drawing. There has been some overpainting. A glaucous varnish has replaced the light gloss that originally covered the face. Vasari, who had surely obtained a detailed eyewitness description of the painting, tells us that "the clear eyes retained all their natural luster; surrounded by rosy and shadowy tints, they were fringed with lashes rendered with the utmost delicacy. The eyebrows, growing thickly in one place and thinly in another, following the pores of the skin, could not have been more lifelike. The nose, with its ravishingly delicate pink nostrils, was life itself. The shaping of the mouth, where the red of the lips merged with the skin tones of the face, seemed not to be made from colors but from living flesh. In the hollow of the throat, the observant onlooker could see the pulsing of the veins." The extraordinarily lifelike impression survives, but now the skin has a sad greenish tinge and nothing remains of the pink, the pulsing veins, the delicate eyebrows: they were no doubt in the upper layers of paint, removed by some zealous restorer.

Yet it is not the deterioration of the painting that prevents sophisticates from appreciating the *Mona Lisa* at its true worth today. Above all, the painting suffers from being too famous, from having appeared on too many postcards, chocolate boxes, and cheap tin trays, from having been too insistently pressed upon the public. It is fashionable to disparage it. How can one look at it now with fresh eyes? A Chinese poet of the Sung dynasty, Li Chi Lai, remarked that the three most distressing things in the world are to see youth damaged by a poor education, to see good tea wasted by bad handling, and to see a magnificent painting devalued by the uncomprehending stare of the multitude. The *Mona Lisa* is without question a pinnacle of art. But the unbearable fame it has acquired—often for reasons quite unconnected with its intrinsic qualities[18]—means that one has to overcome one's own resistance in order to perceive its greatness.

While still working on the *Mona Lisa, Leda,* and the *Virgin with Saint Anne* in Milan, Leonardo again turned his hand to hydraulic

engineering. His letter to Charles d'Amboise ends by saying that he hopes on his return to make "instruments and other things that will please his most Christian majesty." This probably refers to devices for measuring the flow of water; the government, which had the monopoly of water, sold it "by the ounce," a quantity hitherto calculated very approximately. Leonardo's notebooks[19] contain various plans and notes for a hydraulic "counter" of previously unknown design. But he did not stop there. Developing his study "of the science and movements of water" from a theoretical perspective,[20] always thinking of ways to improve existing dams and locks, he envisaged digging a large canal that would complete the network of navigable waterways in Lombardy: he planned a dike about thirty meters in length, a long tunnel through the mountain, and a single great lock between the Adda valley and Milan[21]—a most ambitious project, which would be realized, but on a more modest scale, late in the sixteenth century (when it was known as the "French machine").

He had already traveled in the region, collecting topographical data, and must have been taken with the landscape: here the hills rose steeply, their sinuous contours picked out by bright green vegetation; torrents tumbled down the deep gorges, while on the gentler slopes, planted with orchards, the red-tiled roofs of the square-built houses emerged here and there, and in the distance towered the blue heights of the Alps. Sometime in 1506 or 1507, his travels brought him into contact with Francesco Melzi, a Lombard aristocrat aged about fifteen, whose parents owned an estate at Vaprio. Melzi was a *bellissimo fanciullo*—a beautiful boy—according to Vasari. A portrait of him attributed to Leonardo's pupil Boltraffio shows a light-skinned oval face with almond-shaped eyes, surrounded by a mass of thick shoulder-length hair. The youth and the elderly artist seem to have taken to each other at once and to have seen each other frequently, since Leonardo, during his lawsuit, wrote to Francesco from Florence in a tone that suggests they were already on intimate terms. He addresses his young friend as "Messer Francesco" on account of his noble rank, but immediately after this polite formula, we read: "Why in God's name have you not replied to any of the letters I sent you? Just wait till I get back, and by God I will make you write till you are almost sick of it."[22]

Boltraffio, *Portrait of Francesco Melzi.*

Since this letter (or rather the draft for it) comes immediately after the one addressed to the superintendent of the Lombard waterways, it is highly likely that Salai was entrusted with delivering both. By now, Salai must have been twenty-seven or twenty-eight. One wonders how he viewed his master's friendship with this wealthy, presentable, and highborn youth—as different from himself as day from night. It cannot have been easy for him; nor would he have greatly relished sharing lodgings in Florence with Rustici. At any rate, it was at about this time (in 1508 or so) that apparently after some scene, Leonardo wrote in a notebook, under a shopping list, that he wished to make peace with Salai: "No more war," he begs. "I give in."

Harder to understand are the reactions of the Melzi family. Young Francesco soon announced that he wished to follow da Vinci

as a pupil, to be initiated into the art of painting. How would his parents take it? His father, Girolamo Melzi, was a captain in the service of Louis XII. It was quite unprecedented for the son of a good Lombard family to soil his hands with paint. Strangely enough, the family raised no objection: perhaps they were open-minded and above the conventions; perhaps they, too, were won over by Leonardo's famous charm. Francesco Melzi was never to leave Leonardo's side, nursing him when he was ill, handling studio affairs (surpassing Salai), taking all sorts of notes from his dictation. Later, he would attempt to put Leonardo's writings into some kind of order. Nor was he without talent as a painter: several pictures and drawings are attributed to him, mostly copies of Leonardo but also, if the experts are right, such original works as the *Pomona* in the Staatliche Museen in Berlin and the *Flora* in the Hermitage, which prove that he assimilated to some effect the manner of his master.

By this time, the clay model of the *cavallo* was probably irremediably damaged. According to Sabba di Castiglione and Vasari, it had in fact been destroyed during the French entry to Milan, when Gascon archers used it for target practice.

In 1507 or 1508, Marshal Gian Giacomo Trivulzio, one of Louis XII's leading generals, who must have seen the *cavallo* before it was destroyed or damaged, asked Leonardo to design a tomb for him, surmounted by a life-size equestrian statue, in a chapel in San Nazaro.[23] Da Vinci once more embarked upon a series of studies of horses—rearing up, trampling fallen enemies, trotting, walking.[24] Unlike his sketches for the Sforza monument, the drawings showed the rider, either in armor or as a naked youth brandishing a commander's baton. (These figures were not portraits of Trivulzio, a burly man of no great beauty, but rather ideal representations of a military leader.) Leonardo also designed several possible bases for the statue, in the form of a triumphal arch or as an ancient temple containing the sarcophagus, flanked by slaves in chains, not unlike Michelangelo's designs for the tomb of Julius II.

This commission was a second chance to acquire fame by a great work in bronze, and Leonardo did not intend to let it pass him by. He drew up plans, correct to the last centimeter, to present to his

patron and calculated the price of the metal, of the clay model, of the molds and their supports, of building a smelter, and of the charcoal to fuel it. He added the wages of the workmen who would polish the bronze and carve the marble for the plinth, as well as the cost of the stone for the pedestals, columns, frieze, architrave, cornices, and the slab on which the effigy of the departed would lie. The calculations are written with a firm hand: "To square off and finish the pedestals, numbering eight, at 2 ducats each: 16 ducats; and for six tablets with figures and trophies, at 25 ducats each: 150 ducats; and to make the stone cornices for the slab under the effigy: 40 ducats; and to make the effigy, and make it well: 100 ducats; to make six harpies, holding candlesticks, at 25 ducats each: 150 ducats."[25] The estimates filled an entire page. Leonardo worked to the tightest of budgets, intending to recover the wax after melting it, in order to sell it,[26] and granting himself only a very modest fee. The total worked out at 3,046 ducats, a sum well within Trivulzio's means.

Thus, as in the past, Leonardo found himself, aged almost sixty, caught up in a tangle of obligations, commissions, and personal research—into which he seems to have retreated instinctively, as if it made him happy. In some sense he needed to have a number of activities in hand, as if his mind functioned best when it was called upon to consider a variety of different tasks at the same time: they overlapped, complemented, and encouraged one another like the branches in the Sala delle Asse, bringing him to a state of perfect equilibrium. Painting, sculpture, architecture, hydraulic works, mathematics (the squaring of the circle was back on the agenda[27]), as well as the study of heaven and earth—all of these were but a single field of observation to him. Everything was connected, like the long echoes in Baudelaire's poem, "in a deep and dark unity."

On Monday, 21 October 1510, Leonardo and other engineers were consulted by the council of works for Milan Cathedral about the building of the choir stalls. Although this was really a matter of joinery, he willingly participated; it must have reminded him of the *tiburio* competition. A few months later, he showed interest in a quarry of white stone "as hard as porphyry," of which his friend the sculptor Benedetto Briosco promised to bring him some samples.[28] Nor had he abandoned the idea of making his fortune by

marketing his inventions. For some time he had considered manufacturing various artificial substances: a substitute for unpolished amber (made from black pudding skins, boiled with egg white);[29] pearls "any size you wish," made with mother-of-pearl dissolved in lemon juice.[30] Now he was writing about some form of plastic material (*"vetro pannjchulato*—plastic glass—which I have invented"),[31] obtained by boiling together eggs, glue, and vegetable dyes: saffron, poppy dust, whole lilies. The formula for the *misstura* seems incomplete: no doubt he wanted to keep it a secret. He explains briefly how to shape, scrape, and polish (with a dog's tooth) this substance, which he claims resembles agate, jasper, or some other hard gemstone, and he gives a list of possible uses for it: knife handles, chessmen, saltcellars, penholders, boxes, vases in the antique style, necklaces, lamps, candleholders, "encrusted" jewel caskets.[32]

One might imagine that such a variety of occupations would have taken up all his time. Not at all. With the enthusiasm of a young man, Leonardo was simultaneously pursuing the anatomical studies begun twenty years before. He had gradually moved from the mechanical to the organic and was growing daily more interested in the nature of life. Methodically, braving the prejudices of the day, he sawed his way through bones and skulls, or flayed bodies to analyze the structure of nerves and muscles. When he was working on the cartoon for the *Battle of Anghiari* in Florence, his workshop had been in the Santa Maria Novella hospital, where he had been able to watch and practice dissection. He recounts performing autopsies on a very old man and a young child: "A few hours before his death, this old man told me that he had lived a hundred years and that he felt no physical pain, only weakness; and thus, seated on a bed in the hospital of Santa Maria Novella, without any movement or symptom of distress, he gently passed from life into death. I carried out the autopsy to determine the cause of such a calm death and discovered that it was the result of weakness produced by insufficiency of blood and of the artery supplying the heart and other lower members, which I found to be all withered, shrunken, and desiccated. . . . The other postmortem was on a child of two years, and here I discovered the case to be exactly opposite to that of the old man."[33] Leonardo thus produced the first description of arteriosclerosis in the history of medicine. One wonders what it felt

like, as someone without any training for the job, to plunge a knife into the thorax of an old man one had been speaking to not long before, and to dissect the body of a small child. Elsewhere he describes dissecting "the corpse of a man who had grown so thin as the result of a disease [cancer?] that his muscles were consumed and reduced to the state of a thin membrane";[34] and the cadaver of a hanged man, whose penis was engorged. Needless to say, the notes were accompanied by drawings.

His early studies had been primarily concerned with the architecture and mechanics of the human body (its appearance, movements, and functions). Encouraged, perhaps, by his meeting with the brilliant young doctor Marcantonio della Torre,[35] he devised a larger and more ambitious program for himself. He extended his research to animals—bears, monkeys, cows, frogs, birds[36]—in order to compare their anatomy with that of man. What he desired to understand above all, in its very deepest essence, was the nature of animate life; to discover the relation of every part of an animate being to the whole, the development of every member and organ, from the formation of the fetus to the age of adulthood, and to be able to reveal to his fellowmen "the origin of the first and perhaps the second cause of their existence" (that is, the human origin, the sperm produced by the testicles, and the "divine" origin, the soul, transmitted, according to Hippocrates, in the spinal fluid).[37] This was a long way from the artistic anatomy practiced by several of his contemporaries—Michelangelo, for example. "I want to work miracles!" Leonardo declared, at the risk of ending up in poverty, like the alchemist blinded by the mirage of gold, or those who exhausted themselves chasing the dream of perpetual motion, or necromancers and magicians of all times.[38]

Reading his notes, one feels that he is feverish with excitement, transported by the joy of discovery, full of pride in his achievement. The more organs he dissected—lungs, hearts ("kernels from which grows the tree of the veins"), brains, livers, intestines, necks, and faces—the more fascinated, overwhelmed, and amazed he was by the subtle work of the Creator, "who creates nothing superfluous or imperfect."[39] And yet the work itself was repugnant. Addressing an imaginary pupil drawn to dissection, he admits: "If you have a love for this, you may be turned from it by disgust in your stomach;

and if that does not deter you, you may be afraid to stay up at night in the company of corpses cut to pieces and lacerated and horrible to behold."[40] Cadavers, he explained, did not last long; they decomposed in less time than it took to examine and draw them properly. And often several corpses were necessary "in order to discover the differences." When he drew up his program, he foresaw that the bloody mass of flesh, viscera, and muscles inside the body would be so entangled that at least three dissections would be necessary in order "to discern properly the veins and arteries, discarding the rest; three for the tendons, muscles, and ligaments; three for the bones and cartilage; three for the anatomy of the bones, which must be sawn through to find out which ones are hollow and which not, which are full of marrow and which are spongy," etc. Moreover, he writes, three dissections would be necessary "for a woman, who conceals a great mystery—that is, the matrix and the fetus." Finally, every feature was to be shown from three separate angles, "as if you were holding it in your hand and turning it over and over."[41]

Once the scalpel and saw had done their work, Leonardo, taking care not to damage the organs he had laid bare, washed them in running water or a solution of lime, or injected them with liquid wax from a syringe in order to reproduce their internal shape, then, with pen or pencil, he drew exactly what was in front of him.[42] The result is a series of some two hundred illustrations, for the human body alone, as admirable for their beauty as for their scientific value—for no one had done anything like them before and they would remain unrivaled until the end of the eighteenth century. He made some mistakes; but one should remember that each of the discoveries he made—in osteology, myology, cardiology, neurology, etc.—flew in the face of the conceptions of the ancients, of Arab physicians, and of the doctors of his own time (who believed, for example, that the liver governed the vascular system). One should also not forget how difficult it was to procure human cadavers; he did obtain that of a fetus of about seven months gestation but never managed to acquire the cadaver of a pregnant woman, and all his studies in embryology are based on the uterus of the cow.

Together with the circulation of the blood, of which he dimly perceived the principle, the genitourinary functions and the devel-

Anatomical Study.

opment of the fetus were the areas whose secrets Leonardo would have most liked to discover: they held the keys to existence, the "great mystery." While he was still working on muscles and tendons of the limbs, he noted: "I hope to finish all this anatomy in the course of winter 1510." In fact, he would go on pursuing his investigations into the soul, the vital spark, the origin of existence, for several more years, as long as he still had the strength and means to do so, while still studying the earth and water. What did he hope to find? His last anatomical observations concerned (more modestly?) the respiratory system and the vocal cords. One senses a growing anxiety about the delay in fulfilling his program, a thwarting of his expectations. He writes: "I did not allow myself to be held up by avarice or by negligence, only by time. Farewell [*vale*]!" And elsewhere he sighs: "I have wasted my hours."[43] Alongside a hasty sketch of dominoes toppling over, he has written: "They are chasing each other; these rectangles symbolize the life and studies of men."[44]

He had proposed to "write down what the soul is"; now he left the question to be answered by the "clerics, the fathers of the people, those who discover all secrets through divine inspiration."[45] Doubt had entered his mind; there was a threshold that the intellect could not cross. He who had once thought that experience, the mother of wisdom, could never lead one astray, who had hoped to understand everything through the mediation of experience, one day came to admit that "nature is full of infinite causes that experience has never demonstrated."[46] He was succumbing to the weight of necessity, the rule and limit of everything.[47] He would venture no further into the dark cave. So overwhelmed and (as he often says) dumbfounded by the mysteries he could contemplate but not penetrate, bowing to the majesty of the divine and contenting himself with declaring it, he set aside his scalpel, compass, and pen, and he took up his paintbrush once more.

The *Virgin and Child with Saint Anne,* the *Mona Lisa, Leda,* and *Saint John the Baptist* are contemporary with Leonardo's late work in anatomy, hydraulics, and geology. Each subject's smile seems an attempt to express the ineffable, as if Leonardo were putting into these paintings not only his science but his metaphysics—that which lies beyond the frontiers of the natural sciences.

His *Leda,* for instance, summarizes, continues, and in a sense completes his approach to "animal" reproduction and embryology. According to the legend, Zeus took on the shape of a swan in order to seduce Leda, the wife of Tyndarus, king of Sparta. The result of this illegitimate and unnatural union, the bizarre nature of which would have appealed to Leonardo, was that Leda produced two eggs, containing two sets of twins: Castor and Pollux, Clytemnestra and Helen. Did Leonardo in some way connect the Olympian swan and the "Mount Swan" from which he hoped to fly in his great bird? We have already noted that he seems to have linked the image of his mother to that of Helen of Troy in old age, "twice ravished." These correspondences may have played some part in the choice of this pagan motherhood, so far removed from his usual subjects. *Leda* is the only female nude that can definitely be attributed to Leonardo; and it is also his first picture inspired by a myth of antiquity—as if he had always resisted it hitherto. It is possible that the scholar-poet Antonio Segni,[48] for whom he had designed a Neptune fountain at the time of the *Battle of Anghiari,* encouraged him to take up this theme, but he may also have been attracted to it from his own reading: we know that he was an admirer of Ovid's *Metamorphoses.*

His *Leda* is now lost: either destroyed by one of Louis XIII's ministers or burned, like a witch at the stake, in about 1700 on the orders of Madame de Maintenon, in the bigotry of her old age.[49] We have some idea of the *Leda* from the many copies made, by both Italian and Flemish painters, and there is also a drawing by Raphael, now in Windsor Castle. Only a few of Leonardo's preparatory drawings survive, dating from the time of the *Battle of Anghiari* and from the beginning of his second stay in Milan: in these, Leda appears first kneeling, then standing.[50] Several are of the head only or simply of the hairstyle, with its intricate braiding in whorls and loops,[51] like the *fantasie dei vinci.*

The Leda theme introduced by Leonardo was to inspire a number of painters and sculptors in the sixteenth century, including Michelangelo, whose painting *Leda,* now lost, is closer to the original myth than Leonardo's. It shows the monstrous coupling of the swan with the queen of Sparta, as does a Greek marble statue preserved in Venice (though in Michelangelo's version, the queen appears to

Study for Leda.

be consenting, while in the antique statue she is resisting): Michelangelo's version depicts passion and the voluptuousness of the embrace, not an allegory of triumphant fecundity. This is in contrast to Leonardo's painting, where the supple curves and rounded forms of the young woman's body and the swan's phallic neck (echoed in the meanders of the vegetation and in the twists and curls of the hair) are in no way evocative of desire or amorous ecstasy. The large broken eggs shock our sensibility: we think of their being laid and

wonder with what suffering they were brought into the world. This *Leda* no more appeals to the delirium of the senses than the *Mona Lisa* does; it speaks of the obscure mechanisms of childbirth, of genetic aberration, of the imperious and primitive surge of life in the depths of the body and the entrails of the earth. Some critics admit to finding the contents of this work terrifying. Looking at it, one senses only too well the transcendence of science: one feels how the painter, in conceiving his picture, had studied the relentless growth of plants, whirlpools of water, and abdomens dissected by flickering candlelight: One grasps above all the fascination, unease, and irrational anguish aroused by the "hideous" idea of procreation and the "great mystery" of woman. If his *Leda* perished in flames on the orders of the aged de Maintenon, it was not because of its lascivious character. With its idolatrous and tormented naturalism, the painting outraged not so much virtue as Christian reason.

Cardinal Georges d'Amboise, uncle of the governor of Milan, minister of the French king, and persistent but unsuccessful candidate for the papacy, offered Leonardo work redesigning his château at Gaillon, not far from Paris. The French court would also have been glad to see him on the banks of the Loire. But Leonardo declined the invitations.[52] He was willing to end his days in studious endeavor in the service of the French, but only on condition that he remain in his beloved Lombardy. One of his best disciples, Andrea Solario, went in his stead.

Da Vinci had entered that unhappy phase of life when one seems surrounded by death. He had lost his father and his uncle; Ludovico Sforza had died in captivity; in 1510, Botticelli died in Florence (as did the very young Giorgione in Venice). In the same year, Cardinal d'Amboise succumbed during an epidemic of what the doctors evasively called whooping cough. The following year, on 10 March, Charles d'Amboise died, rumor had it, of a broken heart upon being excommunicated by the Pope, with whom France was at war. (The real cause of death was malaria.) Marcantonio della Torre, the professor of medicine who had assisted Leonardo in his anatomy studies, died of plague; and finally, the new governor of Milan, Gaston de Foix, nephew of Louis XII, was killed in Ravenna on Easter Day, 1511. It is not surprising, then, to find Leonardo

anxious about the lot of those near to him and wondering in a note whether Messer Alessandro Amadori, his uncle by marriage, the canon of Fiesole, was "alive or dead."[53]

France, at this time openly embarking on an expansionist policy in the Italian manner, signed the treaty of Cambrai with the Vatican, the Holy Roman Empire, and Spain, in the hope of annexing a large slice of Venetian territory—the Turks as usual providing a convenient alibi. But invading a country did not mean absorbing its ethos: the king of France was naive enough to believe the treaty would hold. In Italy, it was advisable to play two or, better still, three games. Otherwise one was likely to lose any advantage gained. The French lashed out blindly, scored victories on the field of battle, then waited politely for the next blow to fall before sending in the cavalry and cannon. Ranged against them were Pope Julius II, who wielded with equal skill guile, the sword, and the ultimate weapon, excommunication; the Venetian Republic, with centuries of experience in this kind of warfare; and Germany and Spain, who had nothing to lose by pushing their pawns about the board. Louis XII failed to realize that the real conflict was taking place elsewhere. While he was being crowned with laurel, Venice was sending envoys to Spain and Rome and making the necessary concessions. So the Pope lifted the interdict he had placed on the city and turned his divine thunderbolts on those who the moment before had been his allies. Although he was by now a sick man, he formed a Holy Alliance to drive the French *barbari* out of the peninsula.

Once more politics and the emergencies it created interrupted Leonardo's work. He would never build the princely residence at the Porta Venezia, nor the aviary and windmill he had hoped to install in the magic gardens. Neither would he make the equestrian monument for Trivulzio: work began on the chapel in 1511, under the direction of Bramantino, but Leonardo never even received the blocks of marble he needed. And his payment was delayed; he noted: "even if I do not receive the marble for ten years, I do not intend to wait while they put off again the payment due to me for my work."[54] Nor would the long-dreamed-of hydraulic works on the Arno see the light of day in his lifetime.

He may have briefly followed the king or his generals in the early stages of the campaign against Venice, but he took no part at all

in the operations. His ambitions as a military engineer had vanished for good. The only notes he took on the way concerned rivers, canals, locks, and pumps, or else geology and the atmosphere. It is also my impression that since he carried out practically no work for Charles d'Amboise, who had after all summoned him to Milan and taken his part against the *gonfaloniere* Soderini, he must fairly soon have distanced himself from this protector, a man of war and an administrator who used debatable methods.

Early signs of the French debacle were becoming visible. By increasing the going rate, the Pope succeeded in stirring up the Swiss—who were the mercenaries of Europe and redoubtable soldiers—against Louis XII. Their poverty-stricken mountains could not support them; all they had to export were their muscles, their blood, long acquaintance with arms, and a "Roman discipline" that was the admiration and the fear of all. Julius II tempted them with promises of profitable looting. They came down from their cantons as far as Varese; and by the following year they were at the gates of Milan. Leonardo noted in red chalk: "On 10 December 1511, at the same time, a second fire has been started by the Swiss at a place called Desio" (a suburb of Milan).[55]

The Swiss and the emperor were pushing forward on the Italian checkerboard young Maximilian Sforza, Ludovico's legitimate son. Their first encounter with French forces gave them the advantage; they lost it, then recovered it with the aid of Venice during the following months, and Maximilian seated himself firmly on the ducal throne previously occupied by his father. Outwitted all along the line, the French crossed back over the Alps with their tails between their legs.

During these events, Leonardo had prudently absented himself from the Lombard capital, where supplies were beginning to run short. He retired to Vaprio, to the estate of the Melzi, the parents of his young protégé, and spent most of the year 1513 there.[56] He may have helped to fortify the castle of Trezzo, whose ruins are still visible. He walked in the nearby hills, sketched the dramatic landscape of the Adda valley, and designed for his hosts plans for enlarging and improving their villa.[57] He completed his anatomical studies, dissecting animals in the absence of any human "material." On the same sheet of paper, dated 9 January 1513, there are architec-

tural plans ("the chamber in the tower at Vaprio") and various studies of the diaphragm and the digestive and respiratory organs, surrounded by a schematic thorax, almost like a stage set engraved in a cartouche or in a cameo.[58]

At last, unable to remain unemployed any longer and in need of a powerful and established protector, he packed his bags (now the heavier by several pictures and thousands of pages of manuscripts) and took to the road once more. On a new notebook, he recorded in his usual laconic style: "On 24 September, I left Milan for Rome, in the company of Giovan Francesco Melzi, Salai, Lorenzo [the pupil who had joined him in 1505 in Florence], and Il Fanfoia" (probably a servant).[59] He was sixty-one years old. It was at this period and in these circumstances that he drew the red-chalk self-portrait now in Turin.

The year 1513 was particularly eventful in terms of political change. While the French were evacuating Lombardy, Julius II died in Rome; he was succeeded by the younger son of Lorenzo de' Medici, who took the name Leo X, thus enabling the Medici family, now strengthened by the secular power of the Vatican and the support of the Spanish, to recover power in Florence after twenty years of disgrace. The Republic collapsed, and Soderini was driven into exile.

The new Pope was a plump man, fond of good living, with fleshy lips and delicate hands. His father had advised him in his youth to eat less and to take "plenty of exercise," advice he did not heed until too late, by which time his health (and his pocket) had been damaged by Lucullan feasts. Forced to be a glutton by proxy, he enjoyed watching his courtiers eat what now was forbidden to him. He also took pleasure in hunting, cards, dice, music, and the company of clowns, whom, it was said, he asked to debate the immortality of the soul at the dinner table. Not illustrious for his piety, he raised the singer Gabriel Merino to the dignity of archbishop. Still, widely read and traveled, having tasted exile, the horrors of war, and captivity (he had been a prisoner of the French), Leo X handled the temporal affairs of Rome with moderation and wisdom. He was a great aesthete, curious about everything, and he encouraged the arts, literature, and science—at least as much as his predecessors. His

prodigality attracted to the Eternal City a throng of artists. Flatterers declared that thanks to him, the reign of Apollo had succeeded that of Mars: the iron age had turned into the age of gold.

It was not with the intention of joining the glittering court of Leo X that Leonardo took the road to Rome. He had been bidden by the Pope's brother, Giuliano de' Medici, commander in chief of the papal troops and according to some historians the man who had commissioned the *Mona Lisa*. A restless and unhealthy soul, prey to both melancholy and debauchery, Giuliano had the disillusioned features of an old man, even though he was not yet forty-five; he had written a sonnet in praise of suicide. Vasari says that he was interested in natural sciences and chemistry. We do not know when Leonardo made the acquaintance of his new protector—possibly on an earlier visit to Rome with Cesare Borgia, or perhaps at the court of Milan. In any case, Leonardo had long maintained his contacts with the Medici family.

Leonardo and his companions appear to have met up with Giuliano in Florence in October 1513 (when the painter deposited three hundred florins of his savings in his bank), and they traveled the rest of the way together.

One of Bramante's assistants, Giuliano Leno, prepared apartments for the master and his pupils at the Belvedere, a villa inside the Vatican, near the papal palace. The bill for the work has been found: it lists repairs to the ceilings and floors, the erection of internal partitions, the enlargement of windows, and the decoration of several bedrooms, a kitchen, and a studio, as well as the purchase of furniture: cupboards, benches, chests, stools, and tables, one of which was "for mixing colors."

Leonardo met some of his old friends again: the singer Atalante Migliorotti, now a supervisor of works for the Vatican, and Donato Bramante (who had only a few months to live). He also renewed acquaintance with Il Sodoma, the engineers Fra Giocondo and Giuliano da Sangallo, the pious Fra Bartolomeo, and Raphael, at the height of his fame and now the Pope's favorite painter. Leonardo also must have met Luca Signorelli and Michelangelo, who had now finished the Sistine Chapel and was chafing to carry out his plans for the tomb of Julius II.

Most biographers have come to the conclusion that the years in

Rome—the city that Lorenzo the Magnificent described as the "meeting place of all the vices"—were the unhappiest of Leonardo's life. No longer in fashion, an elderly man with a long white beard, he could play only the role of venerable predecessor, one of the last survivors of the heroic age, left to wander in solitary gloom through the corridors of the Vatican. His reputation was eclipsed by those of his younger rivals, rapid and zealous workers, laden with commissions. Compared with the exorbitant sums being spent all around him on painters, poets, and musicians, his stipend of thirty-three ducats a month seems almost insulting. (Raphael was paid twelve thousand ducats for each of the *Stanze*.) Leonardo was unable to carve out a place for himself in this venal milieu, teeming with hangers-on, where great genius was elbowed aside by charlatans. He had never been very competitive, nor was he much given to currying favor, or else he had lost the habit. (In Milan, adulated by the French, he had had few serious competitors.) More seriously, age had reduced his creative talents—he would paint no more major works. Finally, he suffered from the tumult and intrigues of the court.

As evidence of his bitterness in this situation, some words from the notebooks are often quoted: *"i medici me crearono edesstrussono."*[60] Since Leonardo practically never used capital letters for proper names, this is frequently translated as "the Medici created me and destroyed me." In fact, it is hard to see how the Medici, who had hardly given him any help in his youth, could be perceived as having created him; and since they were now his patrons (the Florentine philosopher Benedetto Varchi tells us that Giuliano treated the painter "like a brother"), they could not be regarded as harming him. *Medico* is also the Italian for "doctor," and it is my belief that Leonardo is here inveighing against doctors, whom he elsewhere describes as *"destruttore di vite,"* destroyers of lives.[61] He was certainly not fond of them: "Try to keep in good health," he writes; "you will do so better if you avoid doctors, for their drugs are a kind of alchemy, which has produced as many books as remedies."[62] The sentence quoted earlier could therefore mean that they brought him into the world, but unable to heal his ailments, they prescribed an exhausting treatment. There are several hints in the notebooks that he might indeed be ill. Above the sentence about the *medici* is some hygienic advice ending with a warning against

apothecaries' potions. He also repeats that one should keep warm at night, a concern that suggests either rheumatism (in Milan he had bought a fur-lined jerkin[63]) or that he had caught a chill. On another page, a foreign hand has written out the name and address of a doctor in Rome for him.[64] Finally, he says himself during the summer of 1515, in a draft letter to Giuliano de' Medici, that he has "practically recovered from his illness" ("io quasi ho / riavuto la sanità mia / sono all'ultimo del mio male"). We do not know exactly what was wrong with him, but his health was undoubtedly failing during these years. He must have had eye problems as well: he had already mentioned spectacles on his return to Florence and again when he was in the service of Cesare Borgia. Now we find reference in a memorandum to blue eyeglasses ("ochiali azurri").[65] In his self-portrait, the eyelids look heavy and half-closed, as if light pained his eyes.

But it would be wrong to imagine that physical decline confined him to inactivity or even slowed down his capacities. Leonardo continued to pursue a wide variety of studies with undiminished energy and inventive power.

Hardly had he settled into the apartment in the Belvedere than he threw himself into the study of motion, percussion, weight, air, geometry, mathematics,[66] botany (the Vatican possessed a garden full of exotic plants), anatomy, in particular the lungs (comparing the rhythm of respiration to that of the ebb and flow of the sea[67]), and the emission of sound by the larynx, since he was now writing a treatise on the voice. Before long, he was producing plans for machines capable of making rope[68] and of minting coins.[69] Above all, in the three years he spent in the service of Giuliano de' Medici, he was occupied in mirror building, architecture, and hydraulics.

The Pope, upon his election, had expressed the wish to drain the Pontine marshes, the vast area on either side of the Appian Way, where "lethal fevers" bred. In 1514, he entrusted this difficult undertaking to his brother, "at his own risk," according to a document, in exchange for which some of the reclaimed land would be assigned to him. One master Domenico de Juvenibus drew up the plans, apparently in consultation with Leonardo, who made a map of the region with the help of Melzi.[70] Da Vinci had already considered draining marshes in 1503 at Piombino. Here, too, it was a matter

of digging drainage canals to carry the water from the swamps to the sea. His map shows clearly how he intended to proceed. Work began a few months later, under the direction of the monk Giovanni Scoti from Como. But a strange fatality seems to have attended all Leonardo's grand schemes. The work was stopped after a few years and not subsequently attempted with success until the end of the nineteenth century.

Since the fortunes of the Medici and indeed of Florence depended in great part on the textile industry (hence the machines for making rope), Leonardo proposed to his master the use of solar energy, captured by a huge parabolic mirror, to boil the water in the dyers' vats. We know little of this work on mirrors, made of glass or polished metal, except that they kept him busy a long time and would soon be the source of trouble. He had already been thinking, back in the 1490s, of machines capable of producing concave mirrors[71]—possibly burning glasses for welding operations, and others to laminate and polish metal. This time, he hoped to build an enormous reflector, which might also enable him to view the stars.[72]

He had been assigned two German assistants, a smith and a mirror maker, Master Giorgio and Master Giovanni of the Mirrors, as they were called, at wages of seven ducats each per month.[73] Before long he was complaining bitterly about them. He was afraid these men wished to steal his inventions; moreover, one was lazy and insolent, while the other, who thought only of his stomach, spread gossip. We are informed in detail of all his grievances about the "German idlers," thanks to a draft letter to Giuliano de' Medici (who had gone to Bologna).[74] Trembling with rage and indignation, Leonardo scribbled out no fewer than six drafts of the letter, black with crossings out, additions, and corrections. He himself, he declared, had always behaved correctly toward Master Giorgio, paying him "before the due date," as he could prove with receipts signed "in the presence of the interpreter." In the early days, he invited him to sit at table and asked him to "work with his files" alongside him; this would have been economical and profitable and would have enabled the German to learn Italian, so as to be able to express himself "without an intermediary." But the rogue *("ingannatore")* simply criticized the work in hand and went off to eat dinner with the Swiss from the papal guard, "among whom idlers abound," then

amused himself shooting birds with muskets in their company until evening. This massacre of birds, within the ruins of ancient Rome, was particularly odious in Leonardo's eyes. Matters stood thus for two months. One day, Leonardo sent his pupil Lorenzo to bring Giorgio back to work. The German claimed to be busy with his excellency's armory. Leonardo made inquiries and found this to be untrue. When Master Giorgio worked at all, it was on his own business or that of his compatriot Master Giovanni of the Mirrors. Giovanni was jealous of the favors his excellency had shown him, Leonardo, since his arrival. He could not bear having a competitor at court and above all was trying to steal his secrets (notably an apparatus he calls *"la mia cientina"*); he was forever snooping around Leonardo and spying on him; he was encouraging Master Giorgio to make wooden models of devices that were to be fabricated of metal, "in order to take them to his own country." Leonardo refused to countenance this and now only entrusted to his assistant plans indicating the "width, height, depth, and contours of what he was supposed to be making." Indeed, Leonardo no longer dared even to indicate clearly the ingredients of the alloys he had developed: he used code, or else borrowed the vocabulary of the alchemist, refer- ring to Jupiter, Venus, or Mercury,[75] describing a metal as having to be "returned to its mother's breast" when he meant it had to be returned to the fire. So we know next to nothing about the mold, or the form *(sagoma)* from which the great parabolic mirror was to emerge.[76] But worse was to come: in order to discredit Leonardo at the Vatican, Giovanni accused him of practicing necromancy; from then on, Leonardo was forbidden to carry out the anatomical work he had been doing at San Spirito hospital.

The great solar reflector never saw the light of day. No doubt Leonardo did not have the time to finish it, for he was often on the road, traveling to Parma, Piacenza, and Milan,[77] or to Florence, where he was summoned by his protector or by Giuliano's nephew Lorenzo di Piero de' Medici, the new governor of the city.

He was also consulted about various town planning or architec- tural projects. It may have been suggested that he replace Bramante, who had died on 11 April 1514, and complete the harbor at Civita- vecchia.[78] In 1515, he seems to have entered the competition for the facade of San Lorenzo[79] in Florence and also to have proposed plans

for the rebuilding of the Medici district, including a new palace on the Via Larga. Apparently the only designs ever realized were those he made for the stables—accommodating 128 horses—a reworking of the model stable designed in Milan years before. The building is still standing: today it houses the Istituto Geografico Militare.[80]

While the tasks Giuliano assigned Leonardo indicate his esteem, we know little about the Pope's attitude. Leo X, who was always on the lookout for fresh amusements, must have been entertained by the tricks Leonardo liked to play on the courtiers at the Vatican. According to Vasari, Leonardo obtained a large lizard and fixed on its back wings made of scales from other reptiles and painted with quicksilver. He also attached to this creature big eyes, horns, and a beard, then tamed it and carried it about with him in a box. People ran away screaming when he loosed his "dragon" on them. He also fashioned, out of a wax-based paste, hollow animals, very light in weight, which flew when he blew into them. Another time, he cleaned and scraped the intestines of a bullock so carefully that they could be held in the palm of a hand. Fitting the extremities of these tubes to a blacksmith's bellows concealed in the next room, he activated the bellows when visitors arrived, and the intestines were inflated to such a monstrous size that they filled the room, "which was, moreover, a very big one," forcing the people into the corners. According to Vasari, Leonardo compared these "transparent objects full of air," which occupied "so little space at first and so much in the end," to personal virtù. Did this attract the admiration of the Pope? If Vasari is to be believed, Leonardo painted for one of the papal notaries, Baldassare Turini of Brescia, a Virgin and Child and the portrait of a boy, works described as "perfect" but never identified. When Leo X in turn commissioned a painting from him, Leonardo made the mistake of wanting to start by distilling the oils and plants for the varnish, so that the Holy Father exclaimed: "Here is a man, alas, who will never do anything, since he is thinking of the completion of his painting before he has started." Did these remarks reach Leonardo's ears? After the disaster of the *Battle of Anghiari,* his intention must have seemed eminently prudent. It was also his habitual practice—a few years earlier, he had written as a sort of motto: "Think carefully about the end. Consider first the end."[81]

Unless he accompanied Giuliano abroad, Leonardo must have been at something of a loose end when his patron was away. The aggressive practical jokes with the lizard and the bullock's guts do not suggest someone with complete peace of mind. He had few friends and protectors in the Vatican. In December 1514, he received a visit from his half-brother Ser Giuliano, with whom he was now reconciled, and the notary showed him a letter from the family in Florence. A postscript asked for regards to be conveyed to Leonardo, "an excellent and singular man," and informed Ser Giuliano that his wife, Alessandra, was going mad *("la lesandra a perduto el cervello")*. Leonardo kept the letter, on the back of which he did some geometrical diagrams and noted that he had given a book (he does not say what: possibly a treatise in his own hand) to Monsignor Branconio dell'Aquila, the "secret chamberlain of the Pope."[82] I do not know whether he was gratified by the visit of his half-brother, but he cannot have been insensible to the plight of his sister-in-law. His own distress was no doubt increased by the news. Deprived of the protection of his patron (who was by now far gone with tuberculosis—was this why Leonardo was investigating the functions of the lungs?), having only young Melzi and Salai to comfort him, banned from the dissecting rooms on account of the German mirror maker, physically diminished, looking back on the wasted hours and failed projects, contemplating a career damaged by circumstances and his own fault, he became subject to morbid thoughts. The demons of his childhood resurfaced and inspired images of the darkest of fiction, the most terrifying catastrophes.

He had often written, as if to exorcise nightmares, about earthquakes, floods (the Syrian giant), and volcanoes. He had drawn, from nature, raging waves and a mighty storm in the Alps.[83] While at the Sforza court, he had imagined a surreal deluge of objects: rakes, caldrons, stools, compasses, lanterns, helmets, and whips falling down through a dense mass of cloud.[84] As if he, too, had been transfixed by the millenarian prophecies of Savonarola (whose sermons he may have read—they were published in thousands of copies—even if he had never heard them), he depicted a series of cataclysms, either for diversion or in a spirit of misanthropy and anguish. This time, as if to deliver himself once and for all from

the visions that obsessed him by precisely defining them, he was to describe the end of the world as he envisaged it: he would narrate and draw the Flood, as we might imagine Hiroshima. He may have been thinking of a large fresco (to stand against the paintings of Michelangelo?), since his text, reminiscent of his advice on battle scenes, is called "Of the Flood and its representation in painting." As it stands, a film director could use it as a screenplay: it has a strong dramatic line, with cuts from one scene to another and exemplary camera movements.

"One will see," he writes, "the dark and nebulous air tormented by contrary winds whirling incessant rain mingled with hail, and an infinity of broken branches entangled with countless leaves. All around, one will see ancient trees uprooted, torn to pieces by the fury of the storm. One will see whole mountainsides, already ravaged by foaming torrents, collapsing and filling the valleys, sending up the level of the captive waters, which will unfurl to cover great plains and their inhabitants." Once the scene has been set, very scientifically, since Leonardo was here reasoning as a geologist and a hydraulic engineer, the animal and human element is introduced. "Moreover, on many mountaintops, one will see all kinds of animals, terrified and reduced to a domestic state, as well as men who have taken refuge there with wives and children." Then we enter the detail of the action: "the submerged fields will display waters carrying tables, beds, boats, and other improvised craft, out of both necessity and fear of death; on them, men, women, and children, huddled together, will be crying and lamenting, terrified by the furious tornado that whips up the waves and with them the corpses of the drowned. No object floats past that is not covered with various animals, brought together in a truce and fearfully crouching against one another: wolves, foxes, snakes, and creatures of all kinds, fleeing death. The waves strike against them and repeatedly buffet them with the bodies of the drowned, and these impacts destroy those in whom a breath of life still pulses."

Leonardo then moves from the general to the particular, inventing the most atrocious scenes: "You will see some groups of men, weapon in hand, defending the refuge that remains to them against lions, wolves, and savage beasts seeking shelter. . . . Oh, how many people will you see stopping their ears with their hands, so as not

Deluge of Objects.
ROYAL LIBRARY, WINDSOR.

to hear the mighty noise with which the violence of the winds, mingled with the rain and the thunder, and the cracking of thunderbolts fills the darkened air! Some, not content with closing their eyes, put their hands over them, one on top of the other, the better to cover them and spare them the sight of the implacable carnage that the wrath of God is visiting on the human race. . . . Others, losing their reason, commit suicide, despairing of being able to bear such torture: some hurl themselves from the top of ridges, others strangle themselves with their own hands, others again seize their

Deluge.

children and kill them with a blow. Oh, how many mothers bran-
dish their fists against the heavens and weep for the drowned sons
they hold on their knees, howling curses on the wrath of the gods."
This narrative, which Leonardo wrote in several versions,[85] carries
on for two or three pages. Animals, panic-stricken, trample one
another to death, birds exhausted with flight perch on people's heads
for want of a resting place, the waters rise further, hunger causes
ravages, ships are shattered on reefs, corpses are washed in every
direction like bundles of seaweed. The mountains, the vegetation,
beasts and humans, nothing resists this delirium of the elements.
Leonardo was no doubt inspired by the Scriptures (in one of his
notebooks, he refuted the explanations and the figures in the Bible,
in the name of scientific logic[86]). But as in Dante's *Inferno,* which
one enters abandoning all hope, no one will survive the raging

392

torrents. Leonardo allows no Noah's ark for his Deluge, only total annihilation.

A dozen extraordinary drawings in black lead, sometimes picked out in ink and wash, accompany this literary description. These also depict trees, horses, and riders carried away by the fury of the winds, monstrous waves engulfing ships and crews, others crashing against reefs, tumults of water bursting into a valley, washing away whole mountainsides, submerging towns and huge buildings, which crumble like decks of cards.[87] Leonardo seems to want to precipitate the entire universe with him into the abyss.

And yet at the same time as he was elaborating this series of apocalyptic visions (the order of which remains unclear), he was completing his painting of the smiling John the Baptist now in the Louvre:[88] the prophecy of the coming of the Redeemer.

Certain formal analogies link this painting with the drawings of the Deluge. The spiral starting with the saint's lips, continued in the incline of the head and developed in the curve of the arm, leading to the upward-pointing index finger, suggests the whirlpools with which Leonardo was obsessed—except that here the movement is mastered and controlled, its strength completely subordinated to an intention. Similarly, the helical lines formed by the long ringlets of hair (hard to see today, because of the thick varnish that obscures the picture) recall the way Leonardo usually depicted currents moving through water. And there is, of course, the chronological parallel: just as the original idea of the Deluge came to Leonardo when he was drawing the dramatic landscapes of the Adda valley (in Vaprio, when he was staying with the Melzi), *Saint John the Baptist* is in a sense the prolongation and completion of a train of thought beginning in Milan with the *Bacchus,* now also in the Louvre.

The *Bacchus* is a studio work. It must have been executed by pupils (Melzi, Marco d'Oggione, Cesare da Sesto, Bernazzone?) after a cartoon or sketch by Leonardo, possibly the drawing in the Museo del Sacromonte in Varese, of about 1510. Bacchus is an ambiguous figure, with a delicate, almost feminine, face atop a large male nude body. Since the image was considered unedifying in the late seventeenth century, some say that this is when the figure was provided with a leopard skin and a vine-leaf crown, and the cross

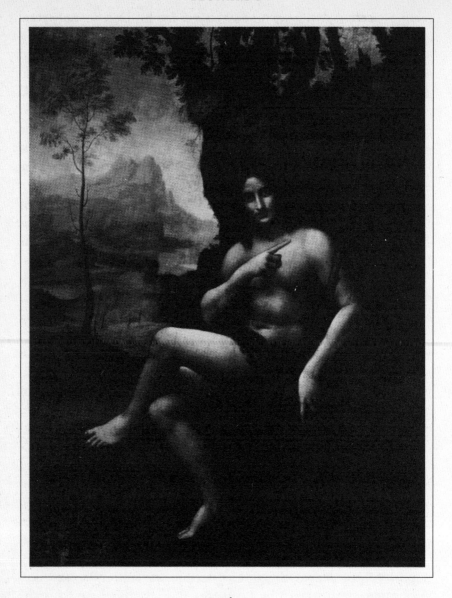

Bacchus.
LOUVRE, PARIS.

———

was converted into a shepherd's crook, so as to indicate more clearly its pagan aspect. This is by no means proved. Leonardo was, as we know, attracted to the idea of prophecy, and most of his paintings

are concerned with birth and predestination: he may deliberately have combined the god of wine and liberating ecstasy and the prophetic saint. His was an age that strove to reconcile antiquity with Christianity. Already Dante had placed in purgatory, not in hell, the souls of the ancient poets and philosophers he admired. The preacher Ficino looked for Christ in Plato. And the writer Pierre Bersuire in his *Ovid Moralized,* successfully published in 1509, presented the myth of Bacchus as a prefiguration of the Passion: Bacchus, the son of Jupiter and Semele, was killed and resurrected. Like the Baptist, he wandered in the desert and announced the coming of the Saviour. Leonardo's French friends or the erudite Antonio Segni might have put a copy of *Ovid Moralized* into Leonardo's hands. But at any rate the painter seems to have absorbed this correspondence, since it confirmed his idea of the unity and permanence of certain truths.

When he later painted his *John the Baptist,* I believe Leonardo incorporated into it elements of the *Bacchus.* One of the shoulders is draped in a panther skin; the saint has the androgynous beauty of the pagan gods. At the same time, accessory details and anecdote are reduced to a minimum: a dark background replaces the landscape, and there is no color apart from the transparent gold of the lighting on the face: one can appreciate the painting without being obliged to decipher it—the beauty, the smile, and the gesture immediately appeal to the emotions. There is nothing to *read.* Nothing in it suggests the terrestrial life of the saint who lived like a hermit on the banks of the Jordan and who is usually represented as gaunt and wild in aspect; this work asks simply to be experienced emotionally. Leonardo had discovered very early on, when painting the *Adoration of the Magi,* the expressive power of a particular gesture: an index finger pointing heavenward—or at least to something outside the picture—and he employed it often. The smile, on the other hand, appeared only later on in his work, not—as some psychoanalysts have maintained—after the the death of his father but a few years earlier, in the cartoon for the *Virgin with Saint Anne* (or possibly there is an even earlier hint at it on the lips of Saint John in *The Last Supper*). It recurs in more obvious form in the *Mona Lisa,* the *Leda,* and the *Bacchus* and attains its full development and meaning, as the painter's manner reaches its most refined and somber state, in

the beguiling face of *John the Baptist*—the "witness of light" and the "messenger of God," as he is described in the Gospels.

Much has been written about this smile: it has been compared to that of an angel in Reims cathedral, or to Khmer divinities. The Buddhist ethic would no doubt have appealed to Leonardo, who would have subscribed willingly to sayings such as "Only love can overcome hate" or "If one man triumphs over a thousand men in battle, he has won less of a victory than the man who has triumphed over himself." But his figures, unlike representations of Buddha, are not smiling the smile of inner peace. They are smiling in order to bewitch. One recognizes what Michelet means when he writes, of the *John the Baptist:* "This canvas attracts me, overwhelms me, absorbs me; I go toward it in spite of myself, like the bird toward the snake." It is the object of the painting, Leonardo would reply, to stir the onlooker in this way. One should not be astonished by the excessive reactions his work can provoke.

Leonardo's paintings are the most vandalized in the entire history of art. They have been attacked with stones and knives (which is why they are all now behind strengthened glass). Recently someone fired a revolver at the *Saint Anne* cartoon in the National Gallery in London. One of the attendants in the Louvre fell in love with the *Mona Lisa,* which it was his duty to guard. He talked to her and was jealous of tourists who came too close, claiming that she sometimes smiled back at them. He was encouraged to take early retirement. Leonardo sets out to disturb and trouble the emotions. He had progressively purified the syntax of his work throughout his career, finally reaching one supreme emotion that contains all others—and since some element of his sexuality crept into it, reason cannot always resist the overwhelming impression it conveys. *John the Baptist* leads to every temptation. I like to think that this was Leonardo's last work—in some sense his final will and testament. His subject has ceased to be "a voice crying in the wilderness." He has reached the ultimate limits of human knowledge; he smiles and points at the source of everything, which amazes him but which is unfathomable. Yet while he was working on this painting, Leonardo was also producing the terrible sequence of drawings of the Deluge. We do not really know what his final message was— possibly it was a double one. The fear and desire experienced before

the mouth of the dark cave must have divided Leonardo's mind to the end.

"Giuliano de' Medici, il Magnifico," Leonardo notes, "left Rome on the ninth day of January 1515, at daybreak, to take wife in Savoy. The same day the news reached us of the death of the king of France."[89]

While da Vinci's protector, despite his poor health, bowed to *raison d'état* and married Philiberta of Savoy, François I acceded to the throne vacated by his cousin and father-in-law, Louis XII. Like the latter in similar circumstances, François thought first of Milan. He had no sooner been crowned than the French army was crossing the Alps again. In July at Marignano, his artillery massacred the Swiss mercenaries of Maximilian Sforza. A few days later, he was entering the Lombard capital in triumph.

Six feet tall—a giant by the standards of the time—with massive shoulders, small, laughing eyes, a powerful nose, and crimson lips surrounded by a short beard, François I was not yet twenty. Clad in gilded armor, he struck the Italians as a hero from one of the romances of chivalry. His mother, Louise of Savoy, and his highly educated sister, Marguerite d'Angoulême, had brought him up to think so of himself. His knightly armor came from the valiant Bayard, "without fear and without reproach," whom François hoped to imitate. He enjoyed war so much that he fought with his gentlemen in the front line of the troops. Plumes flying, he went into battle as if entering a tournament. (As a result, he would later be taken prisoner at Pavia.) He was as magnanimous as he was imposing: instead of throwing Maximilian Sforza into a dungeon, he pensioned him off and welcomed him at his court, as a cousin. Affairs of state, it was said, never occupied him later than noon. During the midday meal, he had classical authors read aloud to him. The rest of the day was given over to hunting and the evenings to worldly delights—poetry, dancing, and above all women, to whom he was attractive and not only because he was king.

Pope Leo X was as embarrassed by this remarkable personality, who bewitched all hearts ("the sovereign is so attractive that it is impossible to resist him," wrote the Venetian ambassador), as he was by the French victory at Marignano. Troubled by the king's attitude

toward the Church, he had sent his own troops into the battle, on the wrong side. Peace talks were held at Bologna in October 1515. Leonardo was very likely present; it must have been on this occasion that he met the man who was to become his last protector. According to Vasari, da Vinci had made a mechanical lion, able to walk several paces, with a chest that opened to show, instead of a heart, a bunch of fleur-de-lis. The lion, the symbol of Florence (the *marzocco*), was thus expressing in somewhat grandiose style the attachment to France of Florence and of the Medici. Lomazzo confirms that Leonardo made several articulated animals, lions and birds, activated by a system of "wheels" (probably some kind of spring-powered clockwork mechanism). Some of the artist's notes even suggest a sort of robot. A no doubt improved version of the lion would reappear in 1533 for the wedding of Catherine de' Medici. It cannot have been a very complicated machine, since it could walk only a few steps (Leonardo had devised it in a hurry, under pressure of events). But it produced its effect, since it was far more advanced than anything else of the kind.

Whatever offers were made to him—or rather reiterated, since he had already been invited to France under Louis XII—Leonardo did not yet enter the service of François I but remained faithful to Giuliano de' Medici. (Perhaps he wanted to finish his great parabolic mirror or some of the architectural designs asked of him.) He did not make up his mind to emigrate until after the death of his Medici patron in Florence, on 17 March 1516. In August that year, he was still in Rome, taking the measurements of the basilica of St. Paul-Without-the-Walls.[90] But failing to find any Italian prince to whom he could turn, since Raphael, Michelangelo and Titian now reigned supreme, and knowing from experience the political instability of Milan, he put his affairs in order and set off to end his days beyond the Alps, where he was best appreciated, in the Loire valley to which François had returned.

Leonardo left Italy either in the autumn of 1516 or the following spring. He traveled via Florence, Milan, the valley of the Mont-Genèvre, Grenoble, and Lyon; thereafter he must have taken the route by Vierzon, along the Cher. He arrived in Amboise after a journey of about three months. Accompanying him were Salai,

Melzi, and a new servant, Battista de Villanis. The party included several mules laden with chests and trunks, for knowing that he would never return, Leonardo took everything with him to France: objects, pictures, drawings, and manuscripts.

With flattering attention, François I installed Leonardo and his companions in the little manor of Cloux,[91] belonging to the queen mother and adjoining the château of Amboise. An underground tunnel connected this house with the royal palace. The king could therefore visit his "favorite painter, engineer, and architect" whenever he wished—quite frequently, according to Benvenuto Cellini, who says that François took "great pleasure in hearing him converse." He also granted Leonardo an exceptional income: an annual pension of a thousand écus soleil plus 400 ordinary écus for Melzi ("the Italian gentleman who is with the said Master Lyenard," the register says) and a hundred écus "in a single payment to Salay, the servant of Master Lyenard de Vince" (French officials had their own spellings for foreign names).

Leonardo inspected his new domain, about two and a half acres of gardens, sloping meadows, and a vineyard, a dovecote, fine trees, and a fishing stream. The house, made up of two adjoining buildings, one with a chapel, consisted of a ground floor, upper floor, and attic. The large downstairs room could be used as a studio, and a spiral staircase in the central tower led to the bedrooms. It is traditionally supposed that the largest bedroom was Leonardo's: it has a fine stone fireplace and looks out onto the grassy slope where the king's château stood. Melzi drew the view from the window; it has hardly changed to this day.[92] A local woman, Mathurine, saw to the cooking and cleaning. Leonardo could not have hoped for a more comfortable or independent retreat. He would enjoy it for less than three years.

The only information about his residence at Amboise is in the travel diary of Don Antonio de Beatis, secretary to the cardinal of Aragon. On his way to Blois, the prelate paid a visit to the "very famous" painter in the first week of October 1517. Leonardo, who appeared to be "over seventy years old" (he was sixty-five), first showed his visitors three paintings "executed to great perfection": "the portrait of a certain Florentine lady," which must be the *Mona Lisa; John the Baptist,*[93] and the *Virgin with Saint Anne.*

By this time, Beatis says, the artist could no longer paint, "for he is paralyzed in the right arm," but he had a very well trained pupil from Milan, who worked to excellent effect under his instruction. And although the master could no longer work in color with the delicacy for which he was renowned, he could at least do some drawing and supervise the work of others. The pupil can only have been Melzi. Salai did not work "to excellent effect." Was the paralysis the same illness from which Leonardo had been suffering in Rome and the reason why he tried to keep warm? The secretary must surely have been mistaken about which arm it was: it would have had to be the left for the painter to be unable to hold a brush.

Next, Leonardo opened some of his folders of drawings. The prelate owned to being very impressed by the contents of the folios, which Melzi must have been been turning. Don Antonio de Beatis, who described Leonardo as a "gentleman," so grand did the old man appear, writes that he had "composed a work on anatomy, especially as applied to the study of painting, whether the members, the muscles, nerves, veins, joints, intestines, and everything that can be explained, both in the bodies of men and in those of women. Such a thing has never been done before. He showed it to us and also told us that he had dissected over thirty bodies of men and women of all ages." The words "everything that can be explained" seem very telling to me: Leonardo, like Kant after him, was fully aware of coming up against the limits of human reason.

The cardinal's secretary continues: "Messire Leonardo has also written a quantity of volumes on the nature of waters, on various machines, and on other subjects, which he pointed out to us. All these books, written in Italian, will be a source of pleasure and profit when they appear." So there was a plan to publish them, and arrangements were being made. The artist had, however, only *pointed* to them: he had not pulled out for the visitors all the notes he was engaged in sorting and copying. Nor did he allow them to examine in detail his book of useful inventions, his treatises on hydraulics, his book "on the transformation of one body into another without increase or decrease of matter," or his treatises on the voice, on the horse, on the flight of birds, on the eye and vision, on ballistics, the collapse of buildings, the air, the stars, painting, or casting—for the good reason that they were not in presentable

form. The ambitious plans for these works were rarely put into practice. Leonardo had set himself daunting timetables, listing the chapter heads in advance. But he never wrote the promised collections. His notebooks merely contain drafts of texts, scattered versions, the product of incomplete and irregular research, elements that could not be used as they stood, buried in the great mass of his manuscripts. Leonardo no more completed his scientific, technical, and literary projects than he had the *cavallo,* the *Adoration of the Magi,* or the *Battle of Anghiari.* He admitted to himself in a moment of despair: "Like a kingdom divided, which rushes to its doom, the mind that engages in subjects of too great variety becomes confused and weakened."[94]

One might wonder what François I could expect from this old man, hired at immense cost on the strength of his reputation but now paralyzed and unable to paint, much less sculpt, who had practically abandoned his technological studies, to judge by his notebooks. The answer is that the king enjoyed his conversation, judging him to be the most cultivated man alive and "a great philosopher," according to reports by Benvenuto Cellini and Geoffroy Tory. Was the king content to have works painted by Melzi, ersatz Leonardos, while he simply listened to the master talk? (And in which language did they converse? Had Leonardo learned French at the court of Charles d'Amboise, or did the king speak Italian, as many of his ministers and his sister did?) François may have been gratified by Leonardo's mere presence at court: he was a jewel in the crown. But I do not believe that Leonardo can have been content not to be useful in some way. "Iron rusts when it is not used," he wrote; "stagnant water loses its purity and freezes over with cold; so, too, does inactivity sap the vigor of the mind."[95] He was still able to draw, Beatis observed; and above all he could think, advise, dictate, direct, and enable others to profit by his taste and his experience. On the corner of one page in about 1518, he wrote plainly: "I shall continue."[96] He never gave up: during the months left him to live, he would play Merlin to the chivalrous young king.

Leonardo had a model in mind. "Alexander and Aristotle," he wrote one day, "were teachers of one another. Alexander possessed the power that allowed him to conquer the world. Aristotle had great learning, which enabled him to embrace all the learning

acquired by other philosophers."[97] One would like to know what teachings Leonardo imparted to the young monarch. He must have told him about the entertainments in Milan and amazed him by explaining the powers of water, the blue of the heavens, the movement of the blood, the origins of the earth. He had seen and studied so many extraordinary things, from the Siamese monsters that a Spaniard had put on display in Florence in October 1513, to the bones of a great sea creature discovered by the laborers digging a canal. "How many changes of state and circumstances have succeeded one another since there perished in some deep and sinuous crevice the marvelous form of this fish!" he wrote in a notebook. "Now destroyed by time, it has been waiting patiently in this cramped space, and with its bones stripped bare, it has become a prop and support for the mountain rising above it."[98]

A note in his handwriting[99] indicates that shortly after his arrival in France, he went with the king to Romorantin. François wanted to build a château for himself and his court in this town in the exact center of France where his mother was living. Leonardo viewed the site, the region, the streams crossing it and the rivers to which they might be connected, and he revived the plans for an ideal city he had devised in Milan, developing, revising, and adapting them. First, various canals would have to be dug. The royal residence would be at the center of a star-shaped network of waterways linking the new capital to the rest of the country, from the Channel to the Mediterranean—the king would then truly be at the heart of France. The gardens and the castle, built on the plan of Caesar's camps, and the surrounding town, would themselves be crisscrossed with canals, which would supply the fountains and a great lake for aquatic spectacles. They would also be used for irrigation, for cleaning the streets and alleyways, and for removing rubbish. This was probably the grandest, most revolutionary town planning conceived in Europe at the time. Leonardo drew up plans for the castle, which should really be described as a palace, since the building is more like Louis XIV's Versailles than the usual feudal dwelling; he drew plans for the canalization and drainage of the Sologne; he designed an octagonal pavilion for the park (halfway between a circle and a square, the octagon was a perfect form in his view), as well as other pavilions, which could be taken down and re-erected

when the court moved about; and he designed an immense stable block. Finally, he may have returned to old drawings he had made of staircases: did he inspire those at Blois and Chambord? Staircases—double, triple, and quadruple—fascinated him as much as waterways, veins, and arteries and indeed anything to do with circulation: movement was after all the principle of life.[100]

He very likely submitted his plans to the king's architects and contractors, and perhaps to his compatriot Domenico Barnabei da Cortona, also known as Il Boccador, who is credited with the early designs of Chambord and the Hôtel de Ville in Paris. If any of Leonardo's ideas were taken up (and they do seem to have had some influence on French architecture in the sixteenth century), it must have been by this intermediary, since the Romorantin site was abandoned after a few years' work, when an epidemic ravaged the labor force.

Da Vinci was still concerned with court entertainments. Although as usual no official document mentions his name, he probably organized or oversaw a ball at Argentan in early October 1517 (the mechanical lion was trotted out once more); then, at Amboise, the double celebration of the baptism of the Dauphin and the marriage of Lorenzo di Piero de' Medici, governor of Florence and nephew of the Pope, to Madeleine de la Tour d'Auvergne. The festivities lasted from 15 April until 2 May 1518 and included "the finest jousting ever done in France or Christendom," according to one chronicler. Then on 18 May 1518, he laid on another version— in a tent "of celestial color," lit *a giorno*—of the Masque of the Planets produced long before in Milan for the duchess Isabella.

We do not know who Leonardo's friends were at Amboise, apart from Melzi. No doubt he met once more Galeazzo da Sanseverino, the son-in-law of the Moor's captain, now steward of the royal stables. Salai had returned to Milan, either on an impulse or at Leonardo's bidding. But there were plenty of Italians at court with whom he may have conversed.

He was still spending much time on what he called his "geometrical games," inscribing all sorts of figures within circles, and sometimes these abstract designs led to architectural drawings of rose windows or lunettes. He seems, with age, to have recognized these pastimes for what they were. On one page, where he had been

Abstractions.

CODEX ATLANTICUS.

404

endeavoring to divide triangles into proportionately equal ones, he ends a paragraph of commentary with an abrupt "et cetera," followed by words that explain why he is breaking off: "because the soup [*la minestra*] is getting cold." He went back to the exercise after dinner.[101]

On 23 April 1519, a few days after his sixty-seventh birthday, "considering nothing to be more certain than death and nothing more uncertain than the hour," as the saying had it, he asked a notary in Amboise, Guillaume Boreau, to record his last will and testament before witnesses.

Vasari says that toward the end of his life, having been ill for many months, Leonardo "desired scrupulously to be informed of Catholic practice and of the good and holy Christian religion, then, after many tears, he repented and confessed. Since he could no longer stand upright, he had himself supported by his friends and servants in order to receive the holy sacrament in piety outside his bed." The will appears to confirm this return to religion. Leonardo commends his soul to Almighty God, to the Blessed Virgin Mary, to Saint Michael and all angels and saints in paradise. The first wishes he expresses are pious arrangements for his burial. He asks to be interred at the church of Saint-Florentin in Amboise; that his coffin be carried by the chaplains of this church and followed by the prior, the curates, and minor friars of the church; that three high masses be celebrated by the deacon and subdeacon, and thirty low Gregorian masses at Saint-Florentin and Saint-Denis; that sixty poor men, to whom alms will be given, should carry sixty tapers at his funeral; that ten great candles be lit while prayers are said for his soul; that seventy *sous tournois* be distributed to the poor at the Hôtel-Dieu and at Saint-Lazare in Amboise. But all this may simply have been observing convention. Vasari always has a tendency to moralize heavily. In fact, Leonardo was asking for nothing out of the ordinary: the king's chief painter could hardly settle for less regarding his funeral. Da Vinci nowhere indicates that he believes in life after death: for him, death was the "supreme evil"—*sommo male*.[102] And of the soul he wrote simply: "It is with the greatest reluctance that it leaves the body, and I think that its sorrow and lamentations are not without cause."[103] Did sickness and physical suffering, which he had always dreaded above all else, bring a

change of mind? The odd thing is that he gives no instructions for his burial, not even for the inscription on the tombstone; he simply does not mention it—a sign, perhaps, of the small importance he accorded to the hereafter? If one could choose an epitaph for him, one might be tempted to use the sentence he had written thirty years earlier in Milan: "Just as a well-filled day brings blessed sleep, so a well-employed life brings a blessed death."[104] But was this true for him anymore?

In return for kind and loyal services rendered, Leonardo left to his servant Battista de Villanis the water toll that Louis XII had granted him on the San Cristoforo canal and half of the vineyard given him by Ludovico Sforza. The other half he left to Salai, as well as the house that the latter had built and was now living in. To Mathurine, his serving woman, he left a robe "in good black woolen cloth lined with fur, a woolen cloak, and two ducats payable at once"; to his half-brothers, he left the four hundred *écus soleil* in his account at Santa Maria Nuova in Florence and the small property inherited from Uncle Francesco;[105] to Messire Francesco Melzi, whom he named as his executor, he left all the rest: his pension, his property, his clothes, books, writings, and "all the instruments and portraits concerning his art and trade as a painter." It is surprising how little he left to Salai: either they had quarreled—which would explain why he left Leonardo before the end—or else he had been richly rewarded before he left, hence the house he had built for himself.

Having dictated his last wishes and commended his soul to God—with or without fervor—Leonardo died, in the manor of Cloux, on 2 May 1519.

Vasari says that the king, "who was in the habit of making frequent affectionate visits to him," entered his chamber just as the priest who gave him extreme unction was leaving. Leonardo then summoned up the strength to raise himself up on his bed "with deference," to explain to François what his sickness was and what the symptoms were, before recognizing "how much he had offended God by not working on his art as much as he should have." Then he fell silent and had a last spasm, upon which the king came near, held up his head, spoke tenderly to him, and tried to relieve his suffering. So Leonardo had the honor of dying a few moments later

in the arms of the king of France. In 1850, Léon de Laborde cast doubt on this story by reproducing an act of François I dated 3 May 1519 and written at Saint-Germain-en-Laye. Since it took two good days on horseback to reach Saint-Germain from Amboise, the king could not have been at the painter's deathbed the day before. Most modern historians have accepted this argument. However, as Aimé Champollion pointed out in 1856, the act of 3 May 1519 is not signed by the king himself but by his chancellor, in the king's absence: it bears the inscription "Par le Roy." So it is possible that François I did assist Leonardo in his last moments.[106] While I do not really believe that the artist repented for having offended God by not spending enough time on painting, I can well believe that he spent his last minutes explaining his illness to the king and describing the symptoms. If he had had pen and ink at hand and the strength to write, he would surely have recorded in his notebook with what reluctance and suffering the soul leaves the body that has harbored it.

XI

The Traces

Truth alone was the daughter of time.

—LEONARDO[1]

Anatomical Studies of Skulls.

ROYAL LIBRARY, WINDSOR.

LEONARDO'S FAME spread so far, says Vasari, that although he was highly esteemed in his lifetime, he was even more celebrated after his death.

In the first edition of the *Lives,* Vasari had put it even more strongly: "Heaven sometimes sends us beings who represent not humanity alone but divinity itself, so that taking them as our models and imitating them, our minds and the best of our intelligence may approach the highest celestial spheres. Experience shows that those who are led by chance to study and follow the traces of these marvelous geniuses, even if nature gives them little or no help, may at least approach the supernatural works that participate in this divinity." Why did he suppress these lines in the 1568 edition? Was it to give greater prominence to Michelangelo?

He does not mention all the names of Leonardo's immediate pupils, probably deeming them (not without reason) lacking in that innate grace which is the source of true greatness. Paolo Giovio also said of Leonardo that he "left no disciple of talent." Was this because he chose them primarily for their good looks or entertainment value, then kept them on for their devotion to him, rather than for their abilities?[2]

On 1 June 1519, Francesco Melzi wrote to Leonardo's half-brothers to inform them of the artist's death. "He was like the best of fathers to me," he wrote, "and the grief that I felt at his death

seems to me impossible to express; as long as there is breath in my body, I shall feel the eternal sadness it caused and with true reason, for he gave me every day proof of a passionate and ardent affection. Each of us must mourn the loss of a man such that nature is powerless to create another."

These last words—*"quale non è più in podestà della natura"*—engraved themselves, no doubt, in the memory of one of Leonardo's brothers, Bartolomeo, a son of Ser Piero's fourth marriage. Bartolomeo tried to disprove them. Vasari says that he married a girl from near Vinci—in other words, someone very like Caterina—and goes on: "Bartolomeo wished to have a son. He spoke endlessly of the great genius his brother had been and prayed to God that he would be found worthy of engendering another Leonardo, the first having died at about this time [actually about ten years earlier]. When presently a fine boy was born, as he wished, he wanted to call him Leonardo, but his relatives advised him to name him after his own father, so he called the child Piero." This child, who was as fair as his uncle had been, soon displayed "astonishing vivacity of mind." An astrologer, Giuliano del Carmine, and a chiromantic priest predicted a dazzling career for the boy—brilliant but short. He was taught his letters and learned by his own efforts to draw and to model clay figures; he appeared to be incredibly gifted, so Bartolomeo thought that he had not prayed in vain "that his brother should be rendered to him in his son." God had heard his plea, and the miracle had happened.

He sent the boy, now known as Pierino da Vinci, to study in Florence with Bandinello, who had known Leonardo, and later with the sculptor Tribolo. Pierino amazed his master and his fellow pupils, showing a talent above all for sculpture: he made a fountain and a marble Bacchus, some bronze *putti* for a pool, and various other things, which excited universal admiration. Unlike his uncle, he seemed to be quite prolific. He traveled to Rome, where he assimilated the manner of Michelangelo. Alas, the prediction of the astrologer and the chiromancer came true: in 1553, just as his reputation was beginning to spread through Italy, Pierino died of a fever in Pisa. He was twenty-three years old. A few of his sculptures have survived (a *Water God* in the Louvre, a *Samson and a Philistine* in the Palazzo Vecchio in Florence), which allow us to guess what he

might have achieved had he lived. In a sonnet composed in his memory, one of his friends, Benedetto Varchi, grieved that an unhappy destiny had removed from the world, "oh, misfortune, the second da Vinci."

An unhappy destiny did indeed continue to pursue Leonardo beyond the grave. The copy of the burial certificate in the royal collegiate church of Saint-Florentin in Amboise, dated 12 August 1519, suggests that there was a provisional interment, followed three months later by a more ceremonial burial. In 1802, a senator was appointed by Napoleon to restore the monuments at Amboise, which had suffered both from the ravages of time and from revolutionary vandalism. The chapel of Saint-Florentin did not seem to him to be worth preserving. Finding, as he said in his report, that this ruin obscured the view "in a shocking manner," he had it demolished and ordered the gravestones and tombs to be used to repair the château. The lead coffins were melted down, and children played skittles with the bones abandoned in the rubble, until a gardener, distressed at such a sight, buried them in a corner of the courtyard. Not all the tombs had been opened; but no one knew where Leonardo's remains were buried. It is possible that wanton boys kicked his skull to pieces, just as Gascon archers had demolished his *cavallo*. In 1863, the poet Arsène Houssaye undertook to excavate the site on which Saint-Florentin had stood. He found one whole skeleton (some people claimed it had three femurs) with its arm bent and the skull resting curiously on one hand; not far away were fragments of a slab with the incomplete inscription: EO DUS VINC— Leonardus Vincius? He thought the skull large enough to have housed an exceptional brain. ("We had not before seen a head so magnificently designed by or for intelligence," he wrote. "After three and a half centuries, death had not yet been able to reduce the pride of this majestic head.") He took an impression of it, for Parisian phrenologists to examine; and a subscription was launched to erect a monument. The bones themselves were collected in a basket, lost, then rediscovered by the comte de Paris, who had them buried in the chapel of Saint-Hubert in the château, with a plaque on which he scrupulously recorded that these were *thought* to be the remains of Leonardo da Vinci. The monument and the stone are still

visible, but the fragments of the inscribed slab, which might have been able to give us some clues today, were not preserved. All that remains of them is an engraving in the Bibliothèque Nationale. Uncertainty and fatality marked Leonardo's path to the very end.

Every human being is an enigma, becoming more complicated as time goes by. When it comes to Leonardo, the infinite alchemist of chiaroscuro, how can one ever hope to have said the last word? Determined efforts by generations of researchers can at best produce a coherent story. That is already an achievement: it enables us to perceive a reflection or an echo of the marvelous "celestial spheres," as Vasari called them, and one can have a sense of being bathed in their harmony and light.

Epilogue

FRANCESCO MELZI did not return immediately to Italy. One document tells us that on 20 August 1519, he was still at Amboise, receiving a pension from the king, and that he had taken Villanis on as his manservant. It seems likely that (unless this had been done earlier) he now handed over to François I the paintings Leonardo had brought to France. Then, having conscientiously executed the last wishes of his master and friend, Melzi set off for Milan in 1520 or 1521, taking with him the vital inheritance: thousands of pages of notes and all the drawings, objects, and instruments of which Leonardo had made him sole legatee.

By 1523, he was back in Lombardy—as was Salai, who seems to have been killed the following year by a bolt from a crossbow. A room in the villa in Vaprio was set aside for the master's manuscripts, and Francesco willingly showed them to visitors. Alfonso Benedetto, an envoy of the duke of Ferrara, told his master that Melzi possessed "books on anatomy and many other fine things." He proudly opened up notebooks and folders; Lomazzo, Luini, and Vasari in turn consulted them. Melzi was trying to classify the notes and to copy out some of them with a view to publication (copies of the treatises on art had probably been begun in France, which would explain why Cellini, living at François I's court in midcentury, was acquainted with them). To this end, Melzi hired two scribes; under his guidance, they put together the work known today as the *Trattato della pittura*. But for some unknown reason,

they, like Leonardo before them, never finished the compilation. The unfinished manuscript fell into the hands of an obscure Milanese artist, then was acquired by the dukes of Urbino, and finally by the Vatican, which catalogued it by the name of the previous owners: Codex Urbinas Latinus 1270. It was not published until 1651.

Melzi died in 1570. He had married, but his son Orazio, having different tastes, and perhaps irritated by the cult of Leonardo his father no doubt maintained, consigned all the manuscripts randomly into chests in an attic at Vaprio. Lelio Gavardi, the family tutor, had no difficulty in obtaining thirteen large volumes, which he passed on to the grand duke of Tuscany. The Milanese Barnabite monk Mazenta took them back, wishing to restore them to the Melzi family, but the latter, saying that they had plenty more, for which they had no use, let him keep them. The story became known, and before long souvenir hunters were turning up at Vaprio, where they were allowed to take anything they wanted. A certain Pompeo Leoni of Arezzo, sculptor to the king of Sardinia, obtained many manuscripts and also managed to acquire, in two lots, ten of the thirteen volumes held by Mazenta. Of the others, one fell into the hands of Cardinal Borromeo (manuscript C plus one other, now lost); one went to an obscure painter; and the other to Charles-Emmanuel of Savoy. The last two are now lost. And the dispersal went on down to the nineteenth century.

Leoni, finding Leonardo's scattered papers to be of varying dimensions and on the widest range of subjects, sorted and arranged them according to his own tastes and pasted them on large folios, which he had bound into two large volumes—or more, according to some reports. He entitled his first collection "Drawings of Machines and Secret Arts and Other Things by Leonardo da Vinci, collected by Pompeo Leoni." Because of the paper size, known as *atlantico* (it was used for atlases), this manuscript was given the name Codex Atlanticus. The second found its way to Windsor, where the pages were detached and mounted individually. As for the intact notebooks in his possession, Leoni negotiated the sale of some of them to Spain. After his death, in 1608, his heir ceded the rest to Count Galeazzo Arconati.

Arconati was therefore in a position to leave eleven notebooks to the Ambrosiana Library, including the Codex Atlanticus. Some

of them quickly disappeared, probably stolen. And pages were torn from others. The Codex Trivulzianus (named after the Trivulziano Library) originally had sixty-two pages; Arconati counted fifty-four; and there are only fifty-one now.

From the early eighteenth century, da Vinci drawings were much sought after, in particular by English collectors. Lord Arundel acquired a large quantity for himself and for King Charles I. Some notebooks ended up in Vienna, where Lord Lytton purchased them in the late nineteenth century, before selling them to a certain John Forster (hence their current name: Forster I, II, and III)—who in turn offered them to the Victoria and Albert Museum.

During the Italian campaign, Napoleon picked up many works of art, manuscripts, and precious objects: he had all the writings of Leonardo still in the Ambrosiana transferred to Paris. The Codex Atlanticus was given back in 1815, but the other notebooks (designated by the initials A, B, E, F, G, H, I, L, M, plus those known as B[ibliothèque N[ationale] 2037 and 2038, or Ashburnham I and II, which originally formed part of manuscripts A and B) remained in the Institut de France. From this period on, people began to be as interested in the artist's writings as they were in his drawings. Venturi began the study, then Ravaisson-Mollien undertook the difficult task of transcribing them. Apart from the *Treatise on Painting* (and a little anthology of writings about water), none of Leonardo's texts had ever been published. Over three centuries after his death, a new image of the man was thus created—and as his writings were deciphered and commented on, the architect, engineer, scholar, thinker, and writer began to emerge.

Today, Leonardo's manuscripts—the notebooks of all sizes, still in their original covers, the artificial collections, the isolated folios that the artist sometimes folded in order to carry them about, the pages torn from notebooks (by one Guglielmo Libri in particular), the drawings cut out by unscrupulous collectors—are dispersed among the Ambrosiana and Trivulziana libraries in Milan, the Institut de France in Paris, the Royal Collection at Windsor, the British Museum and the Victoria and Albert in London, Christ Church Library, Oxford, the Accademia in Venice, and the ex–Royal Library (Biblioteca Reale) in Turin. There are still pages of notes and drawings in the Uffizi in Florence, in the Louvre and the

École des Beaux-Arts in Paris, the Bonnat Museum in Bayonne, the Metropolitan Museum in New York, the Schloss Museum in Weimar, the Municipal Library in Nantes, and in private collections. The only important notebook in a private collection is the Codex Leicester, named after its previous owner, which was sold by public auction at Christie's in London to the Hammer Foundation for over two million pounds.

This immense jigsaw puzzle has not yet yielded up all its secrets—especially since a great many manuscripts have disappeared. It is estimated that less than two thirds of Leonardo's manuscripts have survived—perhaps seven thousand of the thirteen thousand original pages. Some will no doubt reappear one day, just as paintings can sometimes emerge from the shadows. For example, the important notebooks that were part of Pompeo Leoni's hoard and had been lost since 1866 turned up in 1965 in the labyrinth of the stacks in the National Library in Madrid (Madrid I and II), and their transcription has considerably increased what we know about Leonardo's Milanese period.

Notes

INTRODUCTION

1. Giorgio Vasari, *Le Vite de' più eccellenti architettori, pittori e scultori italiani,* Raghianti ed. (Milan, 1942–50). The 1550 edition has recently been reissued in one volume (Turin: Einaudi, 1986). The most convenient edition in English is the Penguin Classics selection, *Lives of the Artists,* ed. George Bull. Most extracts quoted here have been retranslated, since some of the author's points refer very closely to the Italian text.

2. Kenneth Clark, *Leonardo da Vinci: An Account of His Development as an Artist* (Cambridge, 1940).

3. Anonimo Gaddiano, in *Codice Magliabecchiano,* ed. Carl Frey (Berlin, 1892).

4. G. P. Lomazzo, *Idea del tempio della pittura,* Milan, 1590, ed. R. Klein (Florence, 1974).

5. In L. Beltrami, *Documenti e memorie riguardanti la vita e le opere di Leonardo da Vinci* (Milan, 1919).

6. Cf. André Chastel, *Marsile Ficin et l'art* (Geneva, 1975), and P. Monnier, *Le Quattrocento* (Paris, 1931).

7. The same gesture, with the index finger pointing upward, is to be found in *The Last Supper,* in the cartoon of the *Virgin with Saint Anne,* in *Saint John the Baptist,* the *Adoration of the Magi,* and the *Bacchus.* When Raphael painted the *School of Athens,* he had no doubt seen not only the cartoon of *Saint Anne* and the *Adoration* but probably a reproduction of *The Last Supper.*

8. In the preparatory study for the *School of Athens,* which is in the Ambrosiana Library in Milan, the Heraclitus-Michelangelo figure in the foreground does not even exist. There is nothing and nobody in front of the Plato-Leonardo figure: an empty space is at his feet, as if no one else deserved to stand in his way; all the lines of the composition converge on the philosopher's head.

9. Benvenuto Cellini, *Opere* (Milan, 1806).

10. Baldassare Castiglione, *Il Libro del Cortegiano* (Turin ed., 1964).

11. Paolo Giovio, in *Storia della letteratura italiana,* ed. Tiraboschi, 1781, vol. IX.

12. Pierre-Jean Mariette, *Recueil de testes de caractères et de charges dessinées par Léonard de Vinci* (Paris, 1770).

13. Treatise compiled by the Dominican Fra Luigi Maria in a manuscript in the Vatican Library (*Barberini Latin,* 4332) and published in a collection of writings about hydraulics in 1826.

14. E. MacCurdy, *The Notebooks of Leonardo da Vinci* (London, 1938).

15. In Bertrand Gille, *Les Ingénieurs de la Renaissance* (Paris, 1964).

16. P. Duhem, *Études sur Léonard de Vinci: Ceux qu'il a lus, et ceux qui l'ont lu* (Paris, 1906–13).

17. The Milan exhibition was sent for propaganda purposes to America and then to Japan, where it was destroyed in an air raid.

18. Giovio, *Storia della letteratura.*

19. Don Antonio Beatis, *Voyage du cardinal d'Aragon* (Paris ed., 1913).

20. Sigmund Freud, *A Childhood Memory of Leonardo da Vinci (Ein Kindheitserinnerung des Leonardo da Vinci)* (Vienna, 1910).

21. Cf. Baudelaire, *Les Fleurs du Mal (Les Phares):*

> *Léonard de Vinci, miroir profond et sombre*
> *Ou des anges charmants, avec un doux souris*
> *Tout chargé de mystère, apparaissent à l'ombre*
> *Des glaciers et des pins qui ferment leur pays.*

22. *1990, le Complexe de Léonard de Vinci* (Paris, 1983).

I: A CIRCLE OF MIRRORS

1. MS 2038, Bibliothèque Nationale, Paris, 29*v.* (Hereafter B.N.)

2. While most experts now agree that the Turin drawing is a self-portrait by Leonardo, some skeptics continue to think that it is simply a drawing of an unnamed old man. I do not share their view. But there are practically no works by Leonardo that do not inspire some doubts. The almost illegible inscription on the Turin drawing, for instance, reads according to J. P. Richter, *"Lionardo it . . . lm* [or *lai*] *fatto da lui stesso assai vecchio."* I have given here the transcription in A. E. Popham, *The Drawings of Leonardo da Vinci* (London, 1946).

3. *Codex Atlanticus,* 71r a. (Hereafter Cod. Atl.)

4. According to Kenneth Clark, another hand may have worked on the lines around the nostrils. Retouching of this kind is not uncommon in Leonardo's drawings.

5. On Calamatta's engraving of the *Mona Lisa,* see *Gazette des Beaux-Arts,* 1859, vol. I, p. 1633.

6. In about 1490, Leonardo had designed (for what purpose? some celebration?) a kind of cabin, octagonal in shape and lined with mirrors, of which he said: "If you make eight flat mirrors, each two *braccia* high and three *braccia* wide, and set them in a circle, they will make up an eight-sided figure with a circumference of sixteen *braccia* and a diameter of five. He who positions himself inside will be able to see himself an infinity of times in every direction" (*Manuscrits,* Ravaisson-Mollien edition, B 28r). A set of mirrors like this would make it perfectly possible to see oneself in three-quarters profile without meeting one's own eyes—as in the Turin portrait.

7. Windsor, 12726.

8. Ambrosiana Library, Milan, F 263 inf., no. 1 b.

9. For example, in the album *I, Leonardo,* written and illustrated by Ralph Steadman (London, 1982); or in *Leonardo da Vinci* (a book for children), by Alice and Martin Provensen (Paris, 1984).

10. Although the Coriolano engraving shows Leonardo in profile, it does not in any way reproduce the mild and fluid lines of the Windsor drawing. The expression is much closer to the Turin self-portrait: it is difficult to imagine the heavy, arched eyebrows, for example, as having any other source; but Coriolano may have been inspired by some other drawing, now lost.

11. In *Opus chronographicum,* by Pierre Opmer (Antwerp, c. 1611); and Isaac Bullart's *Académie des Sciences et des Arts* (Amsterdam, 1682); *Abrégé de la vie des plus fameux peintres* (Paris, 1745). *Leonardo e l'incisione* (Milan, 1982) contains reproductions of many of the various engravings made after portraits by Leonardo.

12. Piero Sanpaolesi, *Bolletino d'Arte,* May 1938.

13. One could also mention the so-called self-portrait of Leonardo in the Esterhazy collection in Vienna, where the sitter is holding a letter bearing the words: *"A Maria Ant. della Torre."*

14. Giovanni Nesi, *Poema Visione,* canto XII; in Beltrami, op. cit.

15. Eugene Müntz, "Les portraits de Leonard de Vinci," in *L'Encyclopédie,* 15 October 1894; Luca Beltrami, "Il volto di Leonardo," in *Emporium,* January 1919.

16. He was detected, for example, in Luini's *Marriage of the Virgin,* in the Sanctuary at Saronno; as Joseph in an anonymous *Holy Family* in Florence; in a drawing by Michelangelo in which an old man is holding a skull in his hands Hamlet fashion (in the British Museum); and in the Vatican *Moses,* sculpted in about 1513. He was also seen in the *Dispute of the Holy Sacrament* by Raphael (as David, playing the lyre) and in the hooded old man in Giorgione's *Three Astronomers* (Vienna); in various Lombard sculptures of Aristotle (always wearing a cap); in a miniature in a treatise on music by Florenzio (the Codex Attavantiano, in the Trivulziana Library in Milan); in a miniature by Jean Perreal (in the Bibliothèque Nationale in Paris), and so on. I would personally add to this list the *Saint Jerome* by Cesare da Sesto. But even if we accept all these identifications, none of these works can be considered a portrait done from life.

17. Yielding to the arbitrary temptation of resemblance, they have recognized him in the Saint Michael of Francesco Botticini's *Toby and the Archangels,* or alongside Lorenzo the Magnificent in Botticelli's *Adoration of the Magi* (both in the Uffizi).

18. Dürer took this practice to excess; Masaccio put himself into a fresco *(Saint Peter Preaching)* in the Carmine and Filippino Lippi did the same in a companion work *(The Dispute of Saint Peter and Simon Magus Before Nero).*

19. The young man looking to the right in Leonardo's painting may not be taking part in the action, from his expression, but he is perfectly integrated into the composition, with a counterpart on the left: the meditative old man who seems to be looking at him. Cf. Chapter V.

20. It is very tempting to see the young man in the *Adoration* as a self-portrait; but his apparent age does not quite fit that of the painter when he was working on the picture: in 1481, Leonardo was twenty-nine.

21. Popham, *Drawings,* nos. 24, 40 A, 49, 127, 131 B, 132, etc.

22. Cf. Raymond S. Stites, *The Sublimations of Leonardo da Vinci* (Washington, 1970), who confidently asserts that drawings nos. 446 in the Uffizi and 11039 in the British Museum, for example, are portraits of Leonardo's father.

23. A 23r.

24. MS 2038, B.N., 27r.

25. On several occasions, Leonardo insists on the need for an artist to diversify his figures, not to fill a large painting with a single type (e.g., G 5v).

26. We can dismiss, in my view, the so-called scientific argument that in the *Mona Lisa* Leonardo was painting himself: Mona Lisa "resembles" him in the same way that many of his works do. See Chapter X.

27. The drawing showing the proportions of the full face is in the Biblioteca Reale in Turin, the profile in the Accademia in Venice.

28. The profile with the grid measurements is to be found echoed exactly in a chalk drawing in the British Museum (Popham, *Drawings,* no. 140 B), dating from about 1490. The old man in this sketch does not have a shaved head but is bald, with one or two tufts of hair.

II: LOVABLE AS A LOVE CHILD

1. Ser Guido, notary of the Republic in 1413, had two sons: Piero, Leonardo's great-grandfather, and Giovanni, also a notary, who married Lotteria Beccannugi and died in Barcelona.

2. Gustavo Uzielli, *Ricerche intorno a Leonardo da Vinci* (Florence, 1872).

3. Monna Lucia's father was a Florentine notary, originally from the Monte Albano region, not far from Vinci.

4. Pierpaccini, *Leonardo da Vinci, Istituto de Medicine sociale* (Rome, 1952). Leonardo does not prefix his grandfather's name with the title, either; when giving his own name, he says *Leonardo di ser Piero d'Antonio.*

5. The Via della Prestanza, the street on which the house was located, is today the Via Gondi. Nothing remains of any of the houses where Leonardo lived, either in Florence or in Milan.

6. Renzo Cianchi, *Leonardo e la sua famiglia* (Milan, 1952).

7. The mathematician Girolamo Cardano (Cardan) was similarly banned from the College of Physicians in Milan on account of his illegitimacy.

8. For example, Bérence (1938), Vallentin (1938), and Douglas (1944).

9. They recall the surprise expressed by the Frenchman Philippe de Commynes—ambassador to Italy on behalf of Louis XI, Charles VIII, and Louis XII of France—at the number of bastards in Italian courts and the rights they enjoyed. In his *Mémoires,* he noted, "they make little distinction in Italy between a bastard child and a legitimate one."

10. "Some men bear at their birth the stain of an error committed by their parents and do their best to cover it by their modest conduct, agreeable conversation, and the excellence of their actions and works"—this moralizing prologue to the *Life* of Filippino Lippi, the son of Fra Filippo Lippi, was cut by Vasari from the 1568 edition.

11. The entry reads as follows: "1452. There was born to me a grandson, son of Ser Piero my son, on 15 April, a Saturday, at the third hour of the night. He bears the name Leonardo. It was the priest Piero di Bartolomeo, of Vinci, who baptized him, in the presence of Papino di Nanni Banti, Meo di Tonino, Piero di Malvotto, Nanni di Venzo, Arrigo di Giovanni the German, Monna Lisa di Domenico di Brettone, Monna Antonia di Giuliano, Monna Niccolosa del Barna, Monna Maria, daughter of Nanni di Venzo, Monna Pippa (di Nanni di Venzo) di Previcone." This document, in the Florence Archives, was discovered by Emile Möller in 1939.

12. No trace of Caterina's family—and alas, we do not know her patronymic—has yet been found in the Tuscan archives. Among the women named Caterina figuring on the *catasto* (see note 18) in the Vinci region at the time, none seems to fit. Was she perhaps too poor even to figure on the *catasto?*

13. Quoted in Ludwig, *Das Buch von der Malerei* (Berlin, 1882), paragraph 404.

14. This remark by Leonardo figures on an anatomical plate now in Weimar Castle. It no doubt reflects folk wisdom and some popular saying about "love children," as Stendhal calls them.

15. Indeed, was it in honor of this Antonio *di Lionardo* that the child received his baptismal name? Leonardo was not, so far as I can ascertain, a name borne by anyone in the family. In Tuscany, it was usual to baptize children in the name of a deceased ancestor: the first legitimate son of Ser Piero (who was himself named after great-grandfather Piero) was christened Antonio after his grandfather.

16. The da Vinci family estate was producing, a few years before Leonardo's birth, 50 bushels of wheat, 26.5 measures of wine, 2 jars of olive oil, and 6 bushels of buckwheat. This is not a great deal.

17. The nickname Accattabriga—Quarreler or Troublemaker—was common at the time among mercenaries. Had Caterina's husband begun his career in the army? His son, at any rate, was killed by a shot from an arquebus in Pisa; perhaps there was some military tradition in the family. But I am more inclined to see it as the sign of a precarious income: men usually enlisted in the army as a last resort.

18. The equitable *catasto* system, proposed in 1285 by a certain Borgo Rinaldi, had been established throughout the Florentine territory in 1427. This provided for a complete census of all real estate and land, all income from commercial and professional activities, all liquid cash, investments, etc. From the total "wealth" thus determined, each family could deduct the value of its dwellings, of any shop or business, any debts, plus 200 florins per person (or *bocca*) deemed "necessary for the requirements of life"; the rest, deemed surplus, was taxed at 1 1/2 percent. In the year 1457, the da Vinci family paid the sum of seven florins in taxes.

19. Leonardo later refers to one of Albiera's brothers, Alessandro, a canon at Fiesole. "Is Messer Alessandro Amadori alive or dead?" he wonders in about 1512 (Cod. Atl., 83*r*). Was it to this brother of Albiera that Leonardo entrusted the cartoon (now lost) of the *Adam and Eve* mentioned by Vasari, which may have inspired Raphael's *Original Sin* in the Vatican (see Chapter V)? Vasari writes: "This work is at present in Florence in the blessed house of the magnificent Ottavio de Medici, to whom it was given not long ago by Leonardo's uncle." Did Leonardo continue to consider Alessandro degli Amadori as his uncle, long after Albiera's death? It is not impossible.

20. According to M. Cianchi, Leonardo designed and built at Vinci in about 1500 a mill for crushing dyestuffs, which was still working in 1910.

21. Relations between the da Vincis and Caterina's husband's family were strengthened, it seems, over time: in 1469, Antonio rented the kiln on the Empoli road where Accattabriga had previously worked; in 1498, Ser Piero arranged the marriage of the daughter of a deceased uncle to a certain Domenicho di Vacha, a close relative of Accattabriga—indeed, it almost looks as though this family provided a useful supply of spouses for difficult occasions.

22. Cod. Atl., 71*r* a.

23. Quaderni III, 8*r*.

24. At the time when Leonardo was composing his prophecies, his mother, after a long separation, may have joined him in Milan (see Chapter VII). Codex Forster II, 9*v* (hereafter Forster); Cod. Atl., 370*r* a, 145*r* a; British Museum, 212*v*.

25. Letter from Freud to Jung, 17 October 1909.

26. Cod. Atl., 66*v* b.

27. It was a learned reader of the *Burlington Magazine* (in which a long article had appeared on Freud's essay) who first pointed out in 1923 the mistake in translation that had misled Freud. But this was not generally realized until much later.

III: ARTIUM MATER

1. See in particular the famous *Lettera a' Veneziani,* by the Florentine Benedetto Dei, agent to the Medici, in which all the "marvels" of the city are catalogued with passion.

2. Now in Berlin Staatlichen Museen; so called because it has a chain *(catena)* around it like a frame.

3. In the 1300s, two branches of the Cancellieri family of Pistoia were engaged in a dark vendetta over some futile incident. One of the branches was descended from a certain Bianca (white) and took the name Bianchi. The others therefore began to call themselves the Blacks (Neri). The quarrel of the Blacks and Whites soon reached Florence, where it led to a thoroughgoing civil war. (See Machiavelli's *Istorie Fiorentine.*)

4. San Gimignano still has that "bristling horizon" that once existed in Florence. Seen from a distance, the tower houses of the town remind one of the Manhattan skyline.

5. "The officers of the Tower and of rebel property," a municipal body created at the time of the Black Death, was in charge of estates, the upkeep of public monuments, the administration of bridges and highways, etc.

6. Today the Via Cavour.

7. The Rocca of the counts of Guidi, which now houses a museum, where one can see models built to the technical specifications of Leonardo's drawings.

8. David Berliben and Christiane Klapisch-Zuber, *Les Toscans et leurs familles* (Paris, 1978).

9. Cf. Monnier, *Le Quattrocento.*

10. The *Incredulity of Saint Thomas,* a life-size bronze, is still displayed at Or San Michele. Commissioned in 1463, finished in the 1480s, it was described by Landucci as "the most beautiful work one could find, the finest head of our Lord ever sculpted." André Chastel regards it as Verrocchio's masterpiece.

11. Before 1500, Ser Piero's name figures on the account books of at least eleven convents. In Leonardo's youth, his father was already working for the convent of the Servites, the Sisters of Santa Chiara, etc.

12. Vasari refers to a visit Verrocchio made to Rome, but seems to be mistaken about this.

13. Sculptors and architects were also trained in joinery and marquetry workshops; examples are Giuliano da Sangallo and Giuliano da Maiano.

14. Works now lost, described by Vasari.

15. Verrocchio must surely have been influenced by others besides Donatello. (The Anonimo Gaddiano says that he was his colleague, whereas Gauricus describes them as rivals); other possible influences are Desiderio da Settignano or Antonio Rossellino.

16. In a novella written around 1550, Anton Francesco Grazzini locates Verrocchio's workshop in the Via del Garbo. It seems that workshops in quattrocento Florence changed premises quite often. Moreover, Verrocchio may have had a metal foundry (which required more space) located apart from the main workshop.

17. See, for example, the engravings by Baccio Baldini or Maso Finiguerra, or the frescoes by Vasari, etc.

18. Masaccio was the first Italian artist to put an inscription at the foot of a painting (he dated the Cascia triptych in Roman figures, 23 April 1422). Fra Filippo Lippi signed a work in 1440

and Mantegna in 1448. But the practice of putting one's name to a painting or sculpture did not really begin to spread until the late fifteenth century; it was more common in northern Italy than in Florence, and then often on the inner edge of a *cartellino,* a trompe l'oeil label. Leonardo never signed his work: if any work of his is signed, one can be sure that the signature at least is not genuine.

19. Quoted here from the French edition, Cennino Cennini, *Le Livre de l'Art; ou Traité de la peinture,* ed. with notes by the Chevalier G. Tambroni (Paris, n.d.).

20. Forster I. 43r.

21. MS 2038, B.N., 23r.

22. Cod. Atl., 200r.

23. Codex Trivulzianus, 84v. (Hereafter Cod. Triv.)

24. Forster III, 66v.

25. In 1467, Verrocchio, who no doubt had his own foundry, supplied to Lucca della Robbia and Michelozzo the bronze destined for the door of the sacristy of the Duomo. On this occasion, he was simply acting as a contractor.

26. Vasari, Life of Brunelleschi.

27. Luca Landucci describes the installation of the ball on top of the cathedral in his *Diario Fiorentino.* It is also mentioned in Billi and the Anonimo Gaddiano. The ball withstood wind—but not lightning, which struck it on the night of 17 January 1600 and knocked it down into the street, to the great consternation of the local people. The present ball, bigger than Verrocchio's, was put in position in March 1602.

28. Cod. Atl., 295r b; 349r a.

29. G 84v.

30. Lorenzo de' Medici owned a "very ancient" *Marsyas* in red marble, of which only the bust and torso remained. Verrocchio "restored" it, i.e., he completely rebuilt the missing arms and legs (Vasari, Life of Verrocchio). Lorenzo placed it in the courtyard of his palace in Florence, and it is now in the Uffizi.

31. "Andrea also made, for the fountain of Lorenzo de' Medici's villa at Careggi, a bronze statue of a child strangling a fish; Duke Cosimo had it placed in the fountain in the courtyard of his palace, where it is today" (Ibid.).

32. Ugolino Verino, *De Illustratione Urbis Fiorentiae,* book II.

33. Verrocchio's style is echoed in particular in Botticelli's early Madonnas, such as the *Madonna with the Rose Tree* in the Uffizi, and in works of Perugino such as the *Virgin and Child* in the Jacquemart-André Museum.

34. Alberti, *De Statua,* in Anthony Blunt, *The Theory of the Arts in Italy from 1450 to 1600* (Oxford, 1940).

35. Cod. Atl., 181r a.

36. Ibid.

37. Leonardo, like Vasari, does not take into account a factor that seems more important to me: the ravages of plague, which first appeared in 1348 as the Black Death but recurred regularly, wiping out much of the European population. Moreover, one may wonder what either Leonardo or Vasari knew about the paintings of antiquity, Greek or Roman: they based their judgments on literary descriptions or what one might imagine from rediscovered sculptures and bas-reliefs. In fact, practically nothing was known about ancient painting before the excavation of Pompeii in the nineteenth century.

38. Cod. Atl., 181r a.

39. Forster III, 55r. Leonardo also wrote: "That science is the most useful whose results can be communicated."

40. Work now lost, described by Antonio Manetti in his *Vita del Brunellesco,* which was Vasari's source.

41. I 30r.

42. G 8r.

43. *Ostinato rigore; destinato rigore:* these mottoes accompanied allegorical drawings (a plow, a windmill or water mill) in cartoons, possibly subjects for intaglios (W 243).

44. Vasari, Life of Verrocchio.

45. Vasari, Life of Leonardo.

46. These studies of draperies occupy the first seven plates in Popham's anthology (originals in Corsini Gallery, Rome; Louvre; British Museum; Uffizi; etc.). In later years, Leonardo would criticize this method and the use of fabric weighed down with clay. (MS 2038, Bibliothèque Nationale, 17v.)

47. Ashburnham I, 26 r.

48. MS 2038 B.N., 2r.

IV: FEAR AND DESIRE

1. Cod. Triv., 23 b.

2. H I 16 b.

3. "The manuscripts . . . are fragments of a larger purpose, charted, defined, explored, but never fulfilled, of which the treatises containing the sum of his researches in anatomy, physiology, and geology form component parts, fragments of a vast encyclopedia of human knowledge" (MacCurdy, *Notebooks).* These remarks are echoed by Kenneth Clark in *Leonardo da Vinci.*

4. Codex Arundel, 148v. (Hereafter Cod. Arun.)

5. Paul Valéry, preface to the French translation of MacCurdy, *Notebooks* (Paris, 1942).

6. Cod. Atl., 765v, 766r. The description of the mill is on the back of folio 766. See Chapter II, note 20.

7. Map on scale 1/230,000 of northwestern Tuscany (Windsor, 12685). The name of Anchiano, two kilometers from Vinci, where Leonardo was born according to local legend, figures only once in his writings and then is crossed out—which might be a hint that it was significant.

8. Uffizi, Drawings Collection.

9. This castle has also been identified as Montelupo, Montevettolini, etc. See Alessandro Vezzosi, *Toscana di Leonardo* (Florence, 1984).

10. The inscription reads: *"di di Santa Maria della neve / addi 5 d'aghosto 1473."* The signature "Leonardo" at the foot of the drawing is neither in the artist's own hand nor from his century.

11. Since the site has never been identified and since, for Tuscan artists of the time, naturalism did not mean very much when it came to landscapes, I am inclined to read it as an idealized, adapted lanscape—at least as far as the castle is concerned. Why did Leonardo see fit to introduce a castle (in rather poor perspective) into a drawing connected to his mother? Over to the psychoanalysts.

12. This view was advanced for the first time by Heydenreich in *Die Sakralbaustudien Leonardo da Vincis* (Leipzig, 1929). It has been much repeated since. Some later writers, whose names

had better not be quoted, even suggested that Leonardo dated this drawing *because* he knew it was the earliest landscape drawing in Western art.

13. Windsor, 12395.

14. Leonardo's handwriting varies considerably over time, which often helps us to date texts. The writing in this case is that of his years in Florence; but the passage is very hard to decipher.

15. British Museum, 155 a.

16. See J. P. Richter, *The Literary Works of Leonardo da Vinci,* 3d ed. (London and New York, 1970), paragraph 1339.

17. Ibid.

18. In any case, he was always intending to copy them out properly, which would have meant censoring them. In one notebook, begun in 1508, Leonardo wrote: "This will be a random collection made up of many folios I have copied out in the hope of classifying them later into the right order and place, according to the subject matter" (British Museum, 1*r*).

19. Angelo Poliziano, *Stanze cominciate per la Giostra di Giuliano de' Medici* (Turin, 1954).

20. André Rochon, *La Jeunesse de Laurent de Médicis* (Paris, 1963).

21. A work now lost. There is no evidence that Leonardo contributed to it, as Möller suggests.

22. Rochon, *La Jeunesse.*

23. Officially, Duke Galeazzo Maria was visiting Florence to thank Lorenzo de' Medici for agreeing to act as godfather to his son in Milan in July 1469. In fact, the purpose was to demonstrate to the rest of Italy the strength of their alliance, directed notably against the Pope, who was trying to press both of them to launch a crusade against the Turks.

24. S. Ammirato, *Istorie Fiorentine.*

25. Vasari, Life of Brunelleschi.

26. Cod. Atl., 231*v* a.

27. Machiavelli, *Istorie Fiorentine.*

28. Clark, *Leonardo da Vinci,* p. 18.

29. The entry reads: *"Leonardo di ser Piero da Vinci, dipintore"* (painter). Some writers (e.g., Stites in *The Sublimations of Leonardo da Vinci*) have disputed its authenticity; the company of Saint Luke, they argue, had been defunct since 1431, the writing apparently corresponds not to the previous entries but to those dated after 1502, and oddly enough the guild of painters enrolled no members between 1472 and 1502—the year when Leonardo, returning to Florence, was occupied on various official tasks. Was the entry forged, backdated to legalize an official standing? Since the Arno floods of 1966, there is no way of telling.

30. Botticelli received, on 18 August 1470, an order for two *Virtues,* for the back of the bench of the *Tribunale di Mercanzia* (C. Gamba, *Botticelli,* Paris, n.d.).

31. Vasari, *Life* of Leonardo. Although some experts think they have identified a few of these youthful sculptures by Leonardo (a terra-cotta Virgin in the Victoria and Albert Museum in London, another in the state museum in Berlin), all the others seem to have disappeared. Even the proposed identifications do not relate to any major work.

32. Leonardo also executed a Medusa's head in the same vein as the monster on the shield, but it is now lost (unless Vasari was confusing the two works). The painted buckler was a normal object for the time; only the subject was unusual. Even in the late sixteenth century, when Caravaggio painted (in imitation of Leonardo?) his shield with the Gorgon's head now in the Uffizi, his contemporaries found the idea most bizarre.

33. Codex Urbinas Latinus, 135 a. (Hereafter Cod. Urb.)

34. Other extraordinary creatures would later spring from da Vinci's brush; among them a potbellied elephant man, whose trunk is a sort of flute (MS 2038, Bibliothèque Nationale 29r), and a creature with two heads and four arms (Windsor, 12361; Oxford, 107 v). Unlike his contemporary Hieronymus Bosch, in Leonardo's case his leaning toward the fantastic and grotesque found more expression in reality than in fiction: his anatomical drawings, his designs for weapons, are cloaked in rationality but in fact seem to have more to do with dreams—they seem to me to represent an intelligent waking nightmare.

35. Strangely (or significantly?), Vasari attributes the *Battle of Nude Men* to Verrocchio.

36. Several panels of his *Hunts* and *Battles* have disappeared.

37. Uccello is thought to have painted himself alongside Brunelleschi, Donatello, and Manetti in the *Five Florentines* in the Louvre, but the attribution is contested. Vasari himself originally attributed the work to Masaccio (first edition of the *Lives*).

38. I do not share the view of those who think that by the 1470s Alberti's work, or rather his message, was already failing to find an audience. True, new formulas were beginning to appear, which outdated his theories. But it was precisely from the foundation provided by Alberti that the new writings sprang. His work remained in contemporary minds because it was criticized; one does not criticize a man's work if it is forgotten.

39. He was responsible not only for the church of San Andrea in Mantua, the facade of Santa Maria Novella in Florence, and the Tempio Malatestiano in Rimini, but also for experiments with the camera obscura; a stage play; the first free verse in Italian poetry; the first grammar of the "vernacular tongue"; a kind of secret writing, which the curia in Rome used for many years; a curious kaleidoscope in which the moon and stars look down on a rocky landscape; instruments to be used for topography and underwater diving; considerations on the manufacture of pocket watches; and above all a tremendous body of theoretical work, written in the form of dialogues like those of the ancients, in which there is no lack of humor: *De familia* (1437–41), *Della Pittura* (1436), *De re aedificatoria* (1485, dedicated to Lorenzo de' Medici), etc.

40. *Self-Portrait* by Alberti, Bibliothèque Nationale.

41. Leonardo contradicts Alberti on several technical points: e.g., he refutes his method of calculating the speed of ships.

42. Baldovinetti "loved to paint landscapes and copied them on the spot, exactly as they appear. . . . At the Annunziata, he represented . . . the crumbling stones of a ruined house, eaten away by rain and frost, and a great ivy plant which covered part of the wall. . . . He even took the trouble to make the upper side of the leaves a certain green and the underside a different green, as they really are" (Vasari, *Lives*). Leonardo, too, wrote of the different shades of green to be found in leaves.

43. Verrocchio's influence on Perugino is particularly noticeable in the *Virgin and Child* in the National Gallery in London, for example. The influence of Perugino on the painters in Master Andrea's studio is most evident in those works of which Lorenzi di Credi executed a large share, as if the latter were divided in allegiance to his elders. Another Umbrian, Fiorenzo di Lorenzo from Perugia, also seems to have been working in Verrocchio's studio in about 1470.

44. Cod. Atl., 262r e.

45. Forster I, 40r.

46. Forster I, 43r.

47. Ibid.

48. Ibid. The "amber" was probably what would today be called *baume de Venise*. There was a legend that Van Eyck had succeeded in dissolving actual amber—fossilized resin—while conserving all its qualities; this probably explains Leonardo's note.

49. Cod. Atl., 4v b.

50. Ibid., 70 b; 207 b.

51. The *Baptism of Christ* was handed on from San Salvi to the Sisters of Vallombroso of Santa Verdiana; in 1810, it found its way to the Academy of Fine Arts in Florence, and it was placed in the Uffizi in 1914.

52. Only the angel holding the garment is by Leonardo; the other is in an intermediate style midway between that of Verrocchio and that of Leonardo at the time. It is almost as if Verrocchio painted it from a drawing by his pupil, or perhaps they really did collaborate on it (as a sort of exercise?).

53. John Ruskin, *Modern Painters,* 1851 (quotation retranslated).

54. Walter Pater, *The Renaissance,* 1893 (1980 ed., p. 80).

55. See the article by Magdeleine Hourse, head of laboratory services in the Louvre, "La Peinture de Léonard vue au laboratoire," in *Connaissance de Léonard de Vinci* (1953).

56. Leonardo was very particular about the preparation of the wooden panels on which he was going to paint. He writes: "The wood should be cypress, pear, rowan, or walnut, and you will first apply to it mastic and double-distilled turpentine and whitewash or lime. Put it in a frame so that it can stretch or contract according to the degree of humidity. Then cover with a double or triple solution of arsenic or corrosive sublimate in alcohol. Next a layer of boiled linseed oil, working it well in, and before it is cold, wipe the panel thoroughly with a cloth so that it looks dry. Then apply liquid varnish and white lead, and when it is dry, wash it with urine. Lastly, polish it and trace your drawing finely onto it. Then apply a coat of thirty parts verdigris and two of egg yolk." (A Ir.) At the end of all that, Leonardo obtained a surface as smooth as marble. For further information see Jean Rudel, "Le Métier du peintre," in *Connaissance.*

57. Of all the Italian painters of the fifteenth century, Leonardo is surely the closest to Van Eyck in technique. When one compares Van Eyck's unfinished Saint Barbara to Leonardo's unfinished paintings such as the *Adoration of the Magi* or *Saint Jerome,* one can see that they proceeded in similar manner: by building up the shadows and color without overloading. The white of the underlying coating acts as a screen; the layer of paint is always very transparent, oil paint acts as a kind of varnish, and the colors have the depth of lacquer.

58. See *Connaissance.*

59. Cod. Urb., 224 a.

60. MS 2038, Bibliothèque Nationale, Ir.

61. Leonardo also writes: "the first task of the painter is to make a flat surface give the appearance of a body standing out from that surface—and whoever outstrips others in this respect is most worthy of praise. This science, or rather this peak of our knowledge, depends on light and shade." We should not forget that Leonardo was originally the pupil of a sculptor.

62. Vasari, *Life* of Masaccio.

63. Vasari makes it clear that before Masaccio, feet did not seem to be touching the ground: the figures in paintings appeared not to be standing firmly but "to be on tiptoe." Masaccio was the first to foreshorten feet, showing them firmly balanced and even varying the angle.

64. Windsor, 12363.

65. Ibid., 12331.

66. Ibid., 12326r.

67. Quaderni IV, 17r.

68. Cod. Atl., 119v a.

69. Alberti, *Della Pittura* (c. 1436).

70. Cod. Atl., 11 b; 37 b. Leonardo writes: *"maestro pagholo medicho."*

71. The comet of 1472 was observed and described at length by Ragiomontano.

72. A theory suggested by Stites in *Sublimations.*

73. A line in Leonardo's notebooks—"Talk about the sea to the man from Genoa" (Codex Leicester, 26r [hereafter Cod. Leic.])—has engendered the theory that Leonardo met and "advised" Christopher Columbus, who was Genoese. It is far more reasonable to think that the line refers to the time when Ludovico Sforza became ruler of Genoa and called representatives of the city to his court.

74. In 1406, the Florentine merchant Palla Strozzi bought a Greek manuscript of Ptolemy (second century B.C.) and had it translated into Latin. The Ptolemaic system for calculating distances and drawing maps, which had been forgotten in the West until then, was now adopted in Italy.

75. A list of names, in the form of a memorandum, appears at one point in the notebooks. It includes Carlo Marmochi (another astronomer, owner of a quadrant that Leonardo seems to have coveted); Francesco Araldo, Ser Benedetto d'Accie Perello, Domenico di Michelino (a painter, pupil of Fra Angelico), Giovanni Argiropolo (professor of Greek, translator of *De Cielo* and of Aristotle's *Physica*).

76. In the Uffizi. An inscription higher on the page gives the date 1478. Once more, the text referring to Fioravante is hard to decipher. Some translators read it as "love . . . like a young girl," which would singularly illumine Leonardo's love life. I do not myself believe this kind of confession possible, especially at this date, and prefer Richter's transcription.

77. We do know a few of them: Attavante di Gabriello, for instance, who was the same age as Leonardo, and Gherardo di Giovanni, whom Vasari describes as a man "of tortuous mind." Both were miniaturists who illuminated precious manuscripts, like the *Aeneid*s commissioned by Filippo Valori. They probably had their *botteghe* in the Via dei Librai, the street of booksellers (today's Via della Condotta), a few yards from Ser Piero's house. In two missals that he illustrated in the 1480s, Attavante quite shamelessly copied Leonardo's angel from the *Baptism of Christ.*

78. Cod. Triv., I a.

79. Cod. Atl., 120r d.

80. *Treatise on Painting,* Chapter LX.

81. G 5v.

82. Giovanni Santi, *Verse Chronicles.*

83. Vasari, *Life* of Perugino.

84. M 58v.

85. Cod. Atl., 380r b.

86. Here is another example: "Close up all the exits from a room, have a brass or iron brazier full of hot coals, sprinkle on it two pints of eau-de-vie (a little at a time) so that smoke rises. Then have someone come in with a lantern, and you will see the whole room full of flames—like a bolt of lightning—but no one will be hurt." (Forster I, 44v.)

87. Stendhal, *La Peinture en Italie,* 1854.

88. Ludwig, *Buch der Malerei,* paragraph 404.

89. F 96v.

90. Cod. Atl., 287r a.

91. B 3v.

92. Forster III, 741r.

93. Cod. Atl., 76r.

94. K 112 (32)v.

95. There are many allusions in Leonardo's writings to precious or semiprecious stones and to working or engraving on them: "jasper ring—13 s. / gem—11s" (H 64v); "Chalcedony" (H 94r); etc. From the ex-goldsmith Verrocchio, Leonardo would have learned various jewelry techniques. François van Heesvelde has devoted to the question of Leonardo's jewels half of an extremely farfetched book, which at least has the merit of giving the subject an airing (*Les Signatures de Léonard de Vinci,* privately published, Antwerp, 1962).

96. MS 2038, B.N., 27v.

97. Uzielli, *Ricerche.*

98. G. Séailles, *Léonard de Vinci* (Paris, 1892).

99. Cf. Popham, *Drawings,* nos. 230–242.

100. Quaderni III, 1r.

101. Quaderni III, 7r.

102. Quaderni III, 2v.

103. Ibid., 3v.

104. Cod. Atl., 48v a, b. On the claim that Leonardo invented the bicycle, see the chapter by Marinon in L. Reti, ed., *Léonard de Vinci* (Paris, 1974).

105. Quaderni III, 3v. This drawing is commented on at length by Freud in his essay on Leonardo.

106. A 10r.

107. Cod. Atl., 202v a. Did Leonardo really send this letter—it seems uncharacteristically unkind—to Domenico, Ser Piero's fifth son? Perhaps it was simply a reflection, jotted down in the form of a letter.

108. Cod. Atl., 78v, 78r.

109. Cennini, *Livre de l'Art.*

110. H 118 (25r) v.

111. Windsor, 12351 a.

112. Cod. Atl. 313r b; Folio (1292); Windsor, 12351.

113. B 2v.

114. B 13r.

115. "Lust is the cause of generation" (H 32r). In fact, it is always hard to separate a personal opinion from views traditionally held at the time. In an allegorical drawing in the Albertina Institute in Vienna, Pisanello depicts a rabbit as the attribute of lust, and Leonardo may here be doing no more than that.

116. Petrarch, *On Love.*

117. Oxford II, 7.

118. Plato, *Phaedo.*

119. Windsor, 12349v. In Milan, Leonardo devised a special kind of alarm—to cure himself of sleeping late in the morning?

120. Cod. Atl., 320v b.

121. Cod. Triv., 9 a. Leonardo says "the object of love," which is obscure and could mean the object of study, the artist's work. But it seems to me to be ambiguous and of wider meaning, as if Leonardo was, like the Old Testament, using the word "know" to mean "love"

and as if he thought physical and intellectual love could be conceived in similar terms or serve as symbols for each other.

122. Ibid.

123. Oxford II, 6.

124. Ibid.

125. F. Bérence, *Léonardo de Vinci, ouvrier de l'intelligence* (Paris, 1947).

126. Cod. Atl., 284 a. The complete sentence, an extremely hermetic one, is: "When I did well, a child, you put me in prison; now I do the same, an adult, you will do worse to me." Leonardo wrote these words in about 1505. Some people have tried to interpret them as "the time when I painted Christ as a child" and "now that I have painted him as an adult." According to C. Pedretti, *Commentary* to J. P. Richter's edition of *The Literary Works of Leonardo da Vinci* (Oxford, 1977), Leonardo might have depicted Christ as a child, using Jacopo Saltarelli as a model. Traditionally, Saltarelli is supposed to have been an artist's model at the time of the charges. I have found no evidence that he was ever a model—the charge sheet does not say so. But it is hard to see when else Leonardo might have been in prison.

127. Cod. Leic., 90v.

128. Cod. Atl., 394r b.

129. Ibid., 9v b.

130. Pedretti thinks that these drawings may correspond to an episode that figures in Vasari's *Life* of Caparra, a Florentine blacksmith. Some "young citizens," of whom it is not impossible that Leonardo was one, came to Caparra one day to ask him to manufacture a contraption of their own design to break or tear iron bars with a vise or jack. The blacksmith sent them away in indignation, imagining some scheme for a burglary or kidnapping to be afoot. C. Pedretti, *Léonard de Vinci et l'architecture,* Milan, 1978.)

131. It might also be remarked that Lorenzo di Credi's *Self-Portrait* in the Uffizi shows a very girlish face.

132. Quoted by K. R. Eissler, *Leonardo da Vinci* (Paris, 1980).

133. H 5v.

134. Ibid.

135. H 12v.

136. H 14r.

137. H 22v.

138. H 22r.

139. H 63v.

140. H 6r.

141. Quaderni II, 14r.

142. Cod. Atl., 76r. Most of the passages quoted, especially in manuscript H, date from the 1490s. So they are from twenty years after the Saltarelli affair. But history seems to have repeated itself in these years: Leonardo was afraid of the effects of another "denunciation" (see Chapter VIII) and a change of heart on the part of his protector—Ludovico Sforza, now playing the part of Ser Piero.

143. H 16v; Cod. Atl., 170r b.

144. South Ken., M III 85 a.

V: DISPERO

1. Ashburnham I, 27v.

2. *Opere di Lorenzo de' Medici,* ed. Molini (Florence, 1825).

3. Cod. Atl., 175v.

4. The rallying cry of the Medici was a reference to the roundels—*palle*—on their coat of arms.

5. Verrocchio, who had already made the marble bust of Giuliano de' Medici, was commissioned after the latter's murder to make waxworks of Lorenzo. Vasari writes of these as "votive offerings to God for saving him"; but they were also used as political propaganda. Assisted by the wax modeler Orsino, who initiated him into the craft, Verrocchio made three life-size statues: the face, hands, and feet were made of wax, painted with oils, while the body was simply a wooden frame laced together with cane and covered with waxed cloth. The first of these figures, exhibited in the church of the Sisters of Chiarito, showed Lorenzo in the clothes he was wearing just before the attack; the second, at the Annunziata, showed him dressed in the *lucco,* the civic robe of the Florentines; and the third, probably identical, was sent to Assisi and placed in front of a statue of the Virgin at Santa Maria degli Angeli. Vasari says that these extraordinarily lifelike figures did not seem to be statues at all but living beings. They have not survived.

6. Carlo Gamba, *Botticelli* (Paris, n.d.).

7. Leonardo's drawing of the hanged man was exhibited in the Paris École des Beaux-Arts in 1879. The catalogue described it as follows: "A hanged man, dressed in a long robe, his hands tied behind his back . . . Bernardo di Bendino Barontigni, seller of trousers." Richter corrected this in his transcription of Leonardo's writings.

8. The study for the arm of the angel of the *Annunciation* (now in the Ashmolean Museum) was published in 1907 by Sidney Colvin.

9. Clark, *Leonardo da Vinci.*

10. Leonardo writes "companions at Pistoia" on the torn sheet (in the Uffizi) where the reference to his friend Fioravante occurs.

11. The Louvre possesses two terra-cotta angels (former Thiers collection) very similar to the marble angels on the Forteguerri monument. Passavant attributes the right-hand one to Leonardo, while Valentiner thinks he did both. In fact, they seem to be in the style of Verrocchio.

12. Cod. Atl., 71v a.

13. Despite what the Anonimo Gaddiano says, Filippino Lippi's painting, now in the Uffizi, does not look much like one of Leonardo's compositions.

14. The beginning of the sentence is missing: all that remains is ". . . bre 1478." So Leonardo apparently began the Virgin Mary paintings between September and December that year; this is on the same sheet as the references to Pistoia and to Fioravante (see note 10).

15. The *Benois Madonna* was not bought from a traveling musician, according to some historians, but from a Prince Kurakin. A recently discovered register belonging to the Sapojnikov family seems to suggest that the picture, already considered to be by Leonardo, was transferred to canvas in 1824 by a certain Korotkov and that it had previously belonged to General Korsakov. That still does not explain how the picture came to be in the province of Astrakhan in the early years of the nineteenth century.

16. Bernard Berenson, *The Study and Criticism of Italian Art,* 1916. The *Benois Madonna* became known in Europe after being put on show in Saint Petersburg in 1908. Berenson had seen only a photograph of it, which may explain his harsh judgment.

17. Among the many replicas of the *Benois Madonna,* one might mention that attributed to Filippino Lippi in the Colonna Gallery in Rome, that in the Magdeburg Museum, that in the Toscanelli *sale* (Florence, 1883) "in the style of Botticini," etc. Both Raphael and Lorenzo di Credi copied parts of it (either the Virgin or the Child).

18. There are three studies for a Madonna with cat (or lamb?) in the British Museum in London.

19. The *Madonna with a Flower* may have found its way to Holland (the Louvre has a Flemish copy of it dating from the late sixteenth century) before surfacing at a public auction in a little town in Bavaria in 1889. It was sold for twenty-two marks, then resold to the Pinakothek for about a thousand marks.

20. The portrait of *Ginevra de' Benci* is as highly protected as the *Mona Lisa:* it is behind bulletproof glass and surrounded by alarms and security guards; one cannot just walk up to it.

21. The drawing of the hands (in Windsor) was first connected with Ginevra de' Benci by Müller-Walde. Vasari says that the painting was done toward the end of Leonardo's life, which seems to be wrong. Since it was usual at the time to commission a portrait of a woman for her wedding, some critics have put the date as 1474, the year when Ginevra married Luigi di Bernardo. That is not a conclusive argument: for stylistic reasons, I would be inclined to put it in 1478. Lorenzo di Credi also painted the young woman's portrait (now in the Metropolitan Museum in New York), but it was as a widow wearing mourning clothes, ten years later.

22. Hands are included in a few earlier portraits, by Pollaiuolo or Antonello da Messina, but they are timid and without expression—"in the Flemish manner"—and mostly in portraits of men. Leonardo wrote: "It is in the body's extremities that grace is revealed."

23. MS 2038, B.N., 20r.

24. André Suarès, *Voyage du condottiere* (Paris, 1931).

25. The *Saint Jerome* appears in an inventory for the first time in the mid-eighteenth century. It was originally in the Vatican, then belonged to the painter Angelica Kaufmann, before being rediscovered by Cardinal Fesch and restored to the Vatican.

26. A 109v.

27. In his *Commentary* on Leonardo's notebooks, Pedretti notes about thirty sentences beginning with *"Di"*—Tell me.

28. Dante, *Inferno,* IV, 46.

29. Cod. Atl., 76r a.

30. What Leonardo actually wrote was: *"dj . . . djmmj . . . essapimimj djre,"* since in written Italian in his day *i* and *j* were interchangeable. He wrote on this occasion: *"bernardo dj sim(one) / dj dj djsimon / dl dj . . ."*

31. Cod. Atl., 4v a.

32. The reference is to Leonardo's great-grandfather, not to his father: he is in fact writing about his uncle Francesco: *"franco dantonio / dj s(er) p ero."*

33. Cod. Atl., 71r a.

34. The chapel was built in 1473 by Giovanni de Dolci. The reference is of course to the wall frescoes in the Sistine Chapel, some of which were later lost, not to the ceiling paintings by Michelangelo (1508–12) or to the latter's *Last Judgment,* painted on the back wall between 1536 and 1541.

35. André Chastel, *Art et humanisme à Florence* (Paris, 1982).

36. The services of the following painters were not called upon by Lorenzo de' Medici at this time: Baldovinetti, Ghirlandaio, Luca della Robbia, Perugino, Mino di Fiesole, Benedetto da Maiano, Giuliano da Sangallo.

37. Monnier, *Le Quattrocento.*

38. Giovanni Argiropolo (Argyropoulos), whom Leonardo calls Messer Giovanni Arcimboldi in the memorandum referred to earlier.

39. Richter could not find the source of this quotation. According to Chastel, it comes from Sallust's *Bellum Jugurthinum.*

40. Cod. Atl., 119*v.*

41. Ibid., 76*r* a.

42. Ibid., 117*r* b.

43. Cod. Urb., 39*v.*

44. The rich convent of San Donato, which housed works by Botticelli and Filippino Lippi, was destroyed, as a precautionary measure, before the siege of Florence of 1529. It was outside the city walls near the Porta Romana.

45. This is a widely accepted supposition. But there is no evidence that the subject intended for the *pala per l'altare maggiore* of the chapel in the Signoria was an *Adoration of the Shepherds,* apart from these sketches, done at about the same time as the commission. Would the altarpiece not have included a figure of Saint Bernard, to whom the chapel was dedicated? We do not know. Some nineteenth-century critics similarly suggested that the painting Leonardo began for the friars of San Donato was not the *Adoration of the Magi* but *Christ Bearing the Cross,* for which a few studies survive; but this theory has been rejected.

46. "The theme of the *Adoration of the Magi* is the apotheosis of movement," Marcel Brion wrote. The subject does indeed suppose a journey: the kings have come from distant lands, following the star that led them to the place of the Christ child's birth. Painters saw this as an opportunity to depict broad landscapes and brilliant processions (there are almost always horses in an *Adoration*): good examples are the *tondo* by Fra Angelico and Filippo Lippi (National Gallery, Washington, D.C.) and Gozzoli's famous fresco in the chapel of the Ricardi Palace.

47. Bernard Berenson, *The Italian Painters of the Renaissance,* 1930.

48. About fifteen years after Leonardo's departure for Milan, the monks of San Donato asked Filippino Lippi to do their altarpiece. He took up the major elements of Leonardo's composition but without exploiting all its adventurous ideas. Filippino Lippi seems to have specialized in executing or completing commissions originally given to other painters.

49. Oswald Spengler, *The Decline of the West,* 1918–22.

50. Just as there were doubts about the picture's destination, it was also thought that Leonardo worked on it at different times, adding or transforming certain figures after his return from Milan in 1501: there is no evidence for this.

51. Leonardo seems to have been connected in some way with the Benci family, especially with Tommaso and Giovanni, cousins of Ginevra. Leonardo entrusted to the latter his globe and possibly some books, instruments, and precious stones (Cod. Atl., 120*r*). By Vasari's time, Giovanni's son Amerigo was in possession of the *Adoration.* The painting then turned up in various Florentine palaces before entering the Uffizi in 1794.

VI: PEN AND PENKNIFE

1. H 119*v*.

2. MS 2037, B.N., C *r*.

3. Winternitz cites many examples of the *lira da braccio* in paintings of the period, as well as a contemporary instrument by the Venetian lutemaker Giovanni d'Andrea, held by the Kunsthistorisches Museum in Vienna. The French lutemaker François Curty has recently reconstructed a *lira da braccio* in maplewood. Like the lyre of antiquity, the *lira da braccio* had seven strings; five were played with a bow and two plucked with the thumb to provide the beat. Mersenne speaks of a "sweet and enveloping sonority."

4. Madrid, I O*v*.

5. The invention of the violin is attributed to a certain Gasparo Diuffoprugcar, among others. This oddly named instrument maker is thought to have been summoned to France by François I, on the recommendation of Leonardo. Some historians have assumed, without any evidence, that a violin was therefore built to Leonardo's specifications or from his design. There are absolutely no grounds for the suggestion.

6. Cod. Urb., 6*v*.

7. In this context, the reader should be warned that Leonardo had a namesake, Leonardo Vinci (1696–1730), an Italian composer and follower of Scarlatti and the Neapolitan opera.

8. Windsor, 12697.

9. Windsor, 12692*v*.

10. The *Musician* in the Ambrosiana is the only portrait of a man by Leonardo that has come down to us. It is unfinished but, perhaps for that very reason, in very good condition. Many names have been suggested for the sitter. "Cant. Ang." might mean Cantor Angelo, since there was a singing master in Milan in 1491 called Angelo Testagrossa. But the identification with Gaffurio is more convincing for chronological reasons. The work was briefly attributed to Ambrogio de Predis rather than to Leonardo.

11. Cod. Atl., 324*r*.

12. I am not sure what the siege machines were that Leonardo designated as *trabocchi*. *Trabocco* means "overflow" and *traboccheto* means "trap."

13. Cod. Atl., 391*r* a. The authenticity of this letter to Duke Ludovico has been much discussed. See Richter, *Literary Works,* paragraph 1340, and the *Commentary* by Pedretti.

14. This memorandum (Cod. Atl., 391*r* a) contains thirty-four entries. The column of text is surrounded by diagrams, two of which seem to be of lodgings, and by caricatures of very sad faces: the downcast eyes and mouths may reflect Leonardo's feelings on his arrival in Milan.

15. These were simply sketches of existing weapons; I can see no particular improvement made by Leonardo.

16. Cod. Atl., 306*v* a.

17. Ibid., 56*v*. Leonardo has written alongside his design: "Piece of artillery on organ-pipe principle. On the gun carriage, there should be thirty-three barrels, arranged in groups of eleven." He perfected his engine (on paper) by increasing the number of barrels (Cod. Atl., 3*v* a).

18. Cod. Atl., 49*v* b.

19. Ibid., 340*r* b.

20. Madrid II, 75*v*.

21. Significantly, artillery made of bronze (not cast iron) was first used to powerful effect during the siege of Constantinople in 1453, the very year when Donatello succeeded in casting at Padua the largest bronze sculpture since Roman times.

22. The reigning prince, Ludovico il Moro, was also on this journey. Did Leonardo meet him? He could also have approached Ludovico when the latter, at the time in exile in Pisa, came to offer his condolences to Lorenzo de' Medici after the assassination of his brother by the Pazzi. Did some chance meeting of the kind encourage Leonardo to leave for Milan? We do not know.

23. Leonardo might also have started his Milanese career as a musician because musicians had higher status than painters and, in Milan, earned far more money.

24. Leonardo may have heard on his voyage that the duke was looking for someone to replace his military engineer, the elderly Bartolomeo Gadio. Leonardo seems to have made a careful study of Milan's needs. But I do not believe he was presumptuous enough to seek this elevated position (which went to Ambrogio Ferrari).

25. Cod. Atl., 73v.

26. Alberto Savinio has listed all the qualities of Milan (as they have been identified over the ages) in his fine book *Ville j'écoute ton coeur* (Paris, 1982).

27. This unknown *Nativity* mentioned by Vasari is also referred to by the Anonimo Gaddiano. According to Chastel, it has no connection with the sketch in the Metropolitan Museum, New York, done in Florence in 1480.

28. MS L., cover.

29. The figure of God the Father was supposed to appear in bas-relief at the top of the frame and to be painted in colors.

30. The doctrine had been admitted by the Pope only five years earlier, was sanctioned by the Sorbonne only in 1496, and was not officially proclaimed until 1854. The doctrine of the Immaculate Conception does not refer to the birth of Christ (engendered by the Holy Ghost) but to the miraculous birth of the Virgin Mary. Saint Anne, her mother, is supposed not to have had carnal relations with her husband, Joachim, before giving birth: a chaste kiss was enough. This doctrine was intended to reinforce the holiness of the Virgin Mary and by the same token to confirm the importance of her cult.

31. Leonardo was probably the first painter to omit haloes from the heads of figures from the Scriptures; very early in his career, he had stopped giving them even to Jesus or the Virgin. Haloes appear in the works he executed in Verrocchio's studio, but as soon as Leonardo left, he abandoned them. The haloes in the *Benois Madonna* were most likely added by another hand.

32. Luke 3:1–18.

33. The rocks, which seem to be characteristic of Leonardo's paintings, are rather rudimentary, still reflecting the biblical notion of the wilderness to be found in painters as early as Duccio and Giotto.

34. This theme, the meeting of the infant Jesus with the infant John the Baptist, was virtually confined to Florence before Leonardo's *Virgin of the Rocks,* and then only to a few paintings (notably Nativities by Filippo Lippi). But many Lombard pupils and followers of Leonardo took it up: Boltraffio, Luini, Cesare Magni, Cesare de Sesto, Marco d'Oggione, etc.—which proves that the theme could easily be exported: in the end, it became more popular in Milan than in Florence.

35. All commentators agree that the version in the Louvre stylistically predates the other; but there is no agreement about the destination of either painting or about the date (and consequently place) of execution. Some have suggested that Leonardo painted a third version, on

which the existing two are based. It has been suggested that this might be the painting in the Affori church in Milan—to my mind, a sixteenth-century copy. My remarks here refer only to the *Virgin of the Rocks* in the Louvre, which most closely corresponds (after a fashion, at least) to the 1483 contract.

36. The angel musicians painted by Ambrogio de Predis are in the National Gallery in London; one of them is playing the *lira da braccio.*

37. Cod. Atl., 252r a.

38. I do not want to give the impression that the Italian painters submitted meekly to the authority of painters from northern Europe. It was simply the technique, *la maniera,* of their Flemish counterparts that they envied: the use of oil paint. In other respects, the Italians deemed themselves to be infinitely superior to the Flemish, in particular as regards that untranslatable word *proporzionalità,* to which they laid claim and which referred both to "proportions" and to "harmony." Michelangelo summed up the general view, I think, when he said that Flemish art was painting "without music."

39. Bramante's frescoes are preserved in the Brera museum in Milan.

40. See in particular Raphael's portrait of Bramante in chalk (in the Louvre).

41. One of Bramante's first buildings was the oratory of Santa Maria presso Santo Satirio, in about 1482. The enlargement of the little church (into a basilica) was only a plan at that date.

42. M 53 b.

43. Quaderni II, 14r.

44. Bramante had probably met Alberti at the court of Federico da Montefeltro, who honored him with his friendship: *famigliare diletissimo,* as he put it.

45. The perfumes for which Leonardo gives the recipes (see Chapter IV) may have been for this very purpose: to protect against "pestilence" and the "corruption of the air," which was a source of disease.

46. The painting of an ideal city in the *studiolo* of Federico da Montefeltro is attributed to Francesco di Giorgio; certainly the theme of the ideal city was typical of the artists at the court of Urbino. But their ideal was an aesthetic one, whereas Leonardo's utopian city was supposed to be above all healthy, practical, comfortable, and pleasant to live in.

47. MS B; Cod. Atl.; Forster III.

48. Cod. Atl., 65v b.

49. B 53r.

50. Cod. Atl., 225r b.

51. Forster III, 23v; Cod. Atl., 65v b.

52. C. Pedretti, *Léonard de Vinci architecte* (Paris, 1983).

53. Forster III, 64v.

54. Cod. Atl., 65v b.

55. Leonardo did, however, write: "Would it please you to see a model that would be as useful to you as to me, and would be equally useful to those who will be the cause of our usefulness?" (Forster 68r). But if these words do refer to the "new Milan" (and if they were ever copied and sent), they seem to me to be addressed to the promoters of the project rather than to the duke.

56. See the opinions of Boccaccio or Villani. It seems that religious feelings triumphed only after years of suffering and then might turn into fanaticism.

57. Sabba de Castiglione, *Ricordi* (Venice, 1555).

58. The Sforzas, who were not of Lombard origin but came from the Romagna, had held power in Milan for only three generations and the title of duke for only two. Galeazzo Maria decided to put up a life-size equestrian statue to his father with the idea of consolidating in bronze the might of the dynasty. In November 1473, he asked the architect Bartolomeo Gadio to find him "a master capable of realizing it," Lombard or foreigner, for he wanted an "excellent" artist. Presumably no one could be found, or perhaps the project was postponed. Ludovico il Moro revived it when he came to power in 1480.

59. André Chastel, *Le Grand Atelier* (Paris, 1965).

60. The first equestrian statue to be cast in bronze since antiquity (or at least since the reign of Theodoric in Ravenna) was in fact one of the marquess Niccolò III of Ferrara. The municipality held a competition to find an artist capable of executing it, and the Florentine Niccolò di Giovanni won it from Antonio di Cristoforo by only a single vote. So he was given the task of making the horse (the more difficult part), while Cristoforo made the rider. Alberti designed the plinth, in the form of a Roman arch. The statue was erected on Ascension Day, 1451, two years before Donatello's *Gattamelata*—but it was not as large as the latter.

61. Prince Adam Czartoryski no doubt acquired the *Lady with an Ermine* during the French Revolution. The painting returned to France from 1830 to 1867 and was hung in the Hôtel Lambert, the Czartoryskis' dwelling in Paris, before returning to Poland.

62. Most of the *condottieri* were known by nicknames: Gattamelata (the Dappled Cat), Facino Cane (Facino the Dog), Tartaglia (the Stammerer), etc. Italians were particularly fond of nicknames: Muzzio Attendolo, aka Sforza, who came from a family of landed gentry, first distinguished himself under the command of Alberic de Barbiano. He then fought as a mercenary for the Milanese, the Perugians, the Florentines, the papacy, etc. His son Francesco inherited the nickname and carried on the family tradition: he hired his services to the highest bidder before seizing the duchy of Milan.

63. See *Storia di Milano* by the chronicler Corio.

64. The mulberry was thought to be the wisest of all trees, since it is the last to put out leaves but the first to bear fruit.

65. *"E la giustitia nera pel Moro"* (H 40 b).

66. Bartolomeo Calco.

67. Cod. Atl., 297*v* a.

68. Cod. Urb., 18*r*.

69. Cod. Atl., 109*v* a.

70. Experts still disagree about the true paternity of this painting: is it a minor work by Leonardo; is it Ambrogio de Predis's masterpiece; or is it the product of their collaboration? And if the latter, what did each contribute? They also disagree about the identity of the sitter (seven names have been suggested, including Bianca Maria Sforza and Beatrice d'Este).

71. This *Madonna* belonged to the Counts Litta, noblemen of Milan, hence its name, before being purchased by Czar Alexander II in 1865. We have some studies by Leonardo for the Virgin's face, for the body of the Child, but not for the head, which, significantly, is the weakest part of the painting. Kenneth Clark thinks that this work was painted at least twice: the first time by someone completing a sketch by Leonardo, the second time by a nineteenth-century restorer.

72. The model for this portrait has never been firmly identified. The painting entered the French royal collection very early, belonging to François I and possibly to Louis XII.

73. Forster II, 15v. Marcel Duchamp, whose work contains certain echoes of Leonardo, one day said to Man Ray that his ideal, too, was to get his pictures painted "by coolies."

74. Cod. Triv., 66.

75. Letter from Luca Fanelli to Lorenzo de' Medici, 12 August 1487.

76. Some of Leonardo's earliest Milanese notes are on sheets of paper torn from a blank register from the cathedral administration (Cod. Atl., 333v; 346v a). He would not have been able to obtain this if he had not been quite closely associated with the cathedral.

77. Cod. Atl., 270r c.

78. A 50r. From his observation of arches, Leonardo also drew the following conclusion: "Two weaknesses leaning on each other create a strength. That is why half the world leaning on the other half is the more solid." (Cod. Atl., 244v a).

79. Windsor, 12632.

80. Leonardo writes: "Medicine is the restoration of harmony between unbalanced elements; illness is the disharmony of elements present in a single living body" (Cod. Triv., 7v).

81. On Leonardo's earliest anatomical works, there is a date: 2 April 1489, followed by these words: "Book entitled *On the human face*" (Quaderni I, 1 a).

82. British Museum, 156v.

83. Leonardo also writes, "The ocean is the reservoir of blood surrounding the heart; the ebb and flow of the sea correspond to its breathing and the beat of the pulse. The warmth of the human soul is the fire that penetrates the earth; and the seat of the vegetative soul the fire that spurts out from several parts of the globe, in hot springs, in sulfur mines, in volcanoes, in Mount Etna in Sicily, and many other places." Cod. Leic., 34r. And, "Water which rises in the mountains is the blood that keeps the mountain alive. If one of its veins should open, inside or on its side, Nature, which is anxious to help her organisms and to make good the loss of the liquid that has flowed, brings diligent assistance, as she does also to the place where a man is wounded; as help arrives, one sees the blood flowing under the skin and forming a swelling so that the infected part may burst" (H 77 29r).

84. Cod. Atl., 204v a.

85. Cod. Leic., 34r.

86. Leonardo: "All seeds have an umbilical cord, which breaks when the seed is ripe. They also have a womb, a reproductive apparatus, as we can see in those that come in pods. With those that have a shell (hazelnut, pistachio), the umbilical cord is long and appears from their infancy" (Quaderni III, 9v).

87. Quaderni I, 2r.

88. "The body of the earth," we read in his notes, "is, like that of living beings, traversed by a network of interconnected veins and intended to provide life and food to the earth and its creatures. They come from the depths of the sea and after many cycles must return thither by the rivers that these veins form when they come to the surface." Later on, however, he did come to question some of these parallels. Cod. Leic., 33v.

89. Milanese by birth, Giovanni Antonio Amadeo had married the daughter of Guiniforte Solari. The Solari family had been architects to the cathedral for three generations (and they also worked on the charterhouse of Pavia).

90. On the relations between Leonardo's model and that proposed by Francesco di Giorgio Martini, see Pedretti, *Léonard de Vinci architecte*, op. cit.

VII: THOUGHTS TURN TO HOPE

1. Cod. Atl., 89*v*.

2. Corio, *Storia di Milano*.

3. "I have seen sections of the old walls of Pavia being strengthened, on the banks of the Ticino" (B 66*r*). There follow on the next pages illustrations and developments (e.g., on preparing and laying mortar).

4. Santa Maria alla Pertica particularly interested Leonardo, since it was a church built on a centralized plan (B 55*r*).

5. Ashburnham II, 8 a.

6. B 52*r*.

7. Fazio Cardano, professor of law and medicine at the University of Pavia, was the father of the famous Girolamo Cardano.

8. Andrea Gian Angelo was an engineer and painter in the service of Ludovico. No work that can be attributed to him has survived (Cod. Atl., 22*r* b).

9. Francesco di Giorgio Martini, *Trattato dell'Architettura civile e militare* (Turin, 1841 ed.).

10. Cod. Triv., 53 a.

11. During the Renaissance, as in antiquity, the word *aedificio* was often applied to some engine of war or hydraulics whose frame gave it the appearance of a building. The word *macchina*, conversely, could also be used for works of architecture: people spoke, for example, of the "machine of the Duomo of Milan, or the machine of the dome by Brunelleschi, etc." (Pedretti, *Léonard de Vinci architecte*).

12. Cod. Atl., 22*r* b.

13. The "bone" belonging to the Marliani is a complete mystery. Leonardo also wrote about "the bone that Gian Giacomo da Bellinzona pierced and from which he easily extracted the nail," and we are no wiser about that one.

14. According to Solmi, this might be a *Herbarius* that had appeared in Pavia in about 1485 (Forster III, 37*v*).

15. Leonardo says "Maestro Giovanni Franceze": this may have been Jean Pélerin Viator, the author of a *De artificiali perspectiva*, who mentions a Leonardo among his Italian friends and colleagues.

16. Leonardo notes elsewhere: "Example of running on the ice" (B 36*r*).

17. These were known as "heron" fountains, meant as ornaments for tables (Cod. Atl., 293*r* b).

18. Cod. Triv., 3*v*.

19. Under the design for his oil press, Leonardo writes: "I promise you that the olives will be so well pressed that the residue will be almost dry" (Cod. Atl., 14*r* a).

20. B 23*v*.

21. Cod. Arun., 283*v*.

22. A desk lamp furnished with a large oil holder and a shade (Windsor, 12675*v*).

23. Leonardo calls it "a system for lighting at night." His lamp consisted of a large glass ball full of water, to act as a lens, inside which a glass cylinder protected the flame (B 13*r*).

24. Madrid I, 172*r*.

25. Cod. Atl., 292*v* a.

26. Ibid., 291*v* a.

27. B 28r.

28. B 14v.

29. B 65v.

30. There were thirteen *ingeniarii ducali* in Milan in the early 1490s. Four of them seem to have held senior status: Bramante, engineer and painter; Giovanni Battagio, engineer and builder; Giovan Giacomo Dolcebuono, engineer and sculptor; and Leonardo, engineer and painter.

31. Bernardo Bellincioni, the author of the libretto, explains the name *Paradiso* in the first lines of the printed text: "Feast or representation of paradise, staged on the orders of Ludovico il Moro in honor of the duchess of Milan, and so called because Master Leonardo da Vinci of Florence, with ingenious art, made the seven planets turn in their orbits for us."

32. Leonardo: "One may speak of the influence of the stars and of God" (the stars being considered a sort of "second cause") (Cod. At., 203v a).

33. Leonardo's automatic spit was moved by hot air; as it rose, the air turned large fins, which then turned the spit. "This is a good way to cook meat," Leonardo writes, "since the roast will turn slowly or quickly depending on whether the fire is strong or weak."

34. "A clock for those who are miserly with their time." Water ran during the night into a receptacle. When it was full, it tipped over, pouring all the water back into the original container. "The latter," Leonardo reports, "thus doubles in weight, violently jerking upwards the feet of the sleeper, who wakes up and goes about his business" (B 20 v°).

35. This page, no. 15 of manuscript C, may originally have been the first in the book.

36. Manuscript C ("the least rewarding to read," according to Péladan) essentially contains notes on light and shade; but there are also some reflections on force and on water; Leonardo found it hard to stick to one subject.

37. We have no other evidence of Leonardo's participation in preparations for the tournament given by Galeazzo da Sanseverino on 26 January 1491 in Milan.

38. Leonardo, referring to shoes bought for Salai, writes *"e 4 para"*; since his *e* looks like a *2*, some transcribers read this as "24 pairs," which would be extravagant indeed.

39. "Salai's expenses: 1497

Coat for Salai, fourth day of April 1497			
4 *braccia* of cloth of silver	15 l.	4 s.	
Green velvet for trim	9 l.		
Ribbons		9 s.	
Little rings		12 s.	
Making up	1 l.	5 s.	
Ribbon for the front		5 s.	
Punching holes			
13 *grossoni* [old Tuscan currency] for him			
Salai stole some soldi" (L 94r).			

40. Forster II, 60 c.

41. In Abbé Alberti de Villeneuve's Italian-French dictionary (1772), the following definition is given for *Sala:* "commonly said for Allah, Turkish word meaning God." Leonardo may have given his protégé a nickname because his baptismal name, Giacomo, echoed that of Jacopo Saltarelli, the cause of his court case.

42. Madrid II, 4 b.

43. Cod. Atl., 312 b; 949 b; Windsor, 32.

44. "One day in October, having thirty crowns, I lent thirteen to Salai for his sister's dowry, leaving me seventeen" (F cover 2r).

45. "I am sending you my pupil Salai as the carrier of this message" (Cod. Atl., 373v a). "I recommend to you Salai to explain to Your Lordship" (Cod. Atl., 317r b).

46. H 41r.

47. Salai is generously credited (though without any certainty) with a *Virgin with Jesus and Saint John* (Milan, private collection), a *Virgin and Child* (Rome, collection of the Villa Albani), and the sentimental *Saint John* in the Ambrosiana. Various other poor pictures in the general style of Leonardo might be by him, for he probably continued painting after his master's death. In some exhibition catalogues, he is sometimes listed as Andrea Salai or Salaino.

48. Leonardo: "You will choose someone of good posture, who has not been brought up to wear a doublet, whose body has therefore preserved its natural ease, and you will make him execute graceful and elegant movements. It does not matter greatly if the muscles do not jut out clearly from the outline of the limbs" (MS 2038, B.N., 27r). Could these words refer to Salai as a model?

49. See Chapter IV.

50. Cod. Atl., 220v c.

51. Ibid., 244v a.

52. Silverpoint drawing on blue paper, Windsor, 12358r.

53. Windsor, 12349r.

54. Alongside his sketches of horses and riders, Leonardo writes: "Make a little model of this in wax, a finger length in size."

55. There are other bronzes representing horses, rearing up or not, which have "something of Leonardo" about them, in the Metropolitan Museum and the Frick Collection in New York, in the Rijksmuseum in Amsterdam, in the museum in Berlin, in the Castello Sforzesco in Milan, etc. They may be related to the Sforza statue or to the Trivulzio one (of 1508): it seems undeniable that Leonardo's models were much copied during the Renaissance.

56. Vasari was the first to speak of "a design and model" by Pollaiuolo for the Sforza equestrian statue. Two studies of this project have survived (Engravings Collection, Munich, and Lehman Collection, New York). They show a horse rearing and trampling a fallen enemy and seem to date from the early 1480s. Whether Pollaiuolo would have been able to cast a large-scale bronze is not known.

57. Galeazzo Maria had written that he wanted to raise a "life-size statue [to his father] in an open place somewhere in our castle." See Chapter VI, note 58.

58. Like Il Gattamelata, Bartolomeo Colleoni was a *condottiere* better known for the statue in his honor than for his martial victories. He was very rich, owning 231,983 ducats in cash when he died. In his will, he left much of his fortune to the Republic of Venice on condition that an equestrian statue of him be erected in St. Mark's Square. The Venetians decided that it would be a bit much to place him opposite the Doges' Palace and got around the will by deciding in July 1479 that the statue would stand by the Scuola di San Marco (Campo SS. Giovanni e Paolo); nobody protested.

59. Verrocchio's model was ready in 1481: a letter from the ambassador of Ferrara to Florence, dated 12 July 1481, asks his master to give permission for a life-size statue representing "Bartolomeo da Bergamo" to travel across his territory en route to Venice.

60. Once more, it seems, Vasari is mythmaking. According to Maud Cruttwell, Venice had launched a competition for the Colleoni sculpture, in which Verrocchio, Vellano of Padua,

and Leopardi of Ferrara were contestants. The Dominican Fabri describes how he admired three models for the statue in Venice in 1483, one made of wood, one of terra-cotta, and one (Verrocchio's) of wax.

61. Another hypothesis is possible. A few days before his death, Verrocchio requested that his pupil Lorenzo di Credi, heir to his workshop, should finish the statue. Lorenzo accepted but hired a Florentine brass founder, Giovanni Andrea di Domenico: no doubt he did not feel capable of handling the casting himself. In 1490, the Venetian authorities took the commission from him and gave it to Leopardi. Did Leonardo for a brief moment envisage himself taking over the Colleoni statue? It does not seem very likely: by this time, he was too much in demand to finish off someone else's work.

62. Cod. Atl., 291v a; Windsor, 12294, 12317.

63. Windsor, 12319.

64. Forster III, 88r. Leonardo also dissected horses, hence his studies of the osteology and myology of the pelvic area of the horse (K 102r, v).

65. The plans for a model stable are found in the Codex Trivulzianus (fol. 21, 27). The most detailed plan takes up a double page in manuscript B (38v–39r); and the proportions of the "stables of Il Magnifico" (Lorenzo de' Medici) are sketched on a page in the Codex Atlanticus (96v a).

66. Cod. Atl., 147r b; Windsor, 12345. Leonardo said that when a man walked, his movements were like those of a horse trotting: "he moves his limbs alternately, that is to say, if he moves his right foot, he also moves his left arm, etc." (Cod. Atl., 297r b).

67. We do not know where the foundry Leonardo hoped to use was located, or the site for which the statue was intended. Galeazzo Maria's idea of putting it in one of the castle courtyards was probably abandoned because of its size: probably the new square in front of the castle was envisaged (today the Piazza Castello), a square that may have been laid out according to plans by Leonardo.

68. Before Luca Pacioli, Leonardo himself gives this height of twelve braccia (Madrid II, 151 b): "perche essendo esso chavallo braccia 12."

69. Beatrice d'Este, in a letter to her sister on 29 December 1493, speaks of a painting representing Francesco Sforza on horseback, which was displayed under a triumphal arch in Milan Cathedral. Is there any connection between this painting, of which no trace survives, and the miniature in the Chronicle of the Sforzas by Bartolomeo Gambagnola (Bibliothèque Nationale), in which Francesco is seen on a courser, suggesting Leonardo's model?

70. The Antiquarie prospetiche romane (Rome, Casanatense Library), dedicated to Leonardo, are today generally agreed to be by Bramante. The punning on the name Vinci was often imitated. On a drawing of Neptune, which Leonardo is thought to have offered to his friend Antonio Segni, according to Vasari, a poet composed the following quatrain:

> Virgil, after Homer, depicted Neptune
> Driving his horses over the foam.
> The poets saw him with the mind's eye,
> Vinci with the body's and he is victorious.

Giovan Battista Strozzi wrote in similar vein:

> Vinci vanquishes alone
> All the rest; he vanquishes Phidias and Apollo
> And their victorious crew.

71. Madrid II, "On the casting of the horse."

72. Windsor, 12647.

73. Cod. Triv., 47, 49, 50, etc. We should remember that Leonardo was well acquainted with furnaces: his stepfather, Accattabriga, worked in a limekiln.

74. We do not know how far Leonardo departed from his predecessors at this stage. While Verrocchio's model was made of wax, the other contenders for the Colleoni statue produced models in wood and terra-cotta, which were therefore capable of being preserved.

75. The method indicated by Vasari, in the introduction to his *Lives,* for making "large figures out of bronze" seems to have benefited from Leonardo's work. Pompeo Gaurio, on the other hand, describes the traditional practice in his *De Sculptura,* despite its late date (1542).

76. Madrid II, 143 a.

77. Ibid., 144 a.

78. Ibid.

79. Leonardo never speaks of the rider in his notes: presumably the rider posed no problem, and he no doubt intended to model and cast it after the horse was finished.

80. Madrid II, 151 b.

81. Leonardo: "Proof and Conclusion That One Should Not Cast the Horse Lying on Its Side: If the horse were cast lying on its side, the legs, which must be especially solid, would need more molten bronze than the jets can provide. The empty jets would already have cooled while the legs would still be liquid. As bronze shrinks in volume as it cools, there would be no way of filling the gap left by the shrinkage; the legs would be imperfect and to some extent weakened along all their length." (Madrid II, 148 b).

82. The device he had invented to transport and maneuver the horse looks much like the one used to hoist a massive artillery piece that he had seen and drawn in the arsenal (Cod. Atl., 216 a; Madrid II, 154r).

83. Madrid II, 143 a.

84. Ibid., 149r. This page shows the general arrangements Leonardo made for the casting. In the center is the horse, upside down, in a pit, surrounded by four furnaces. At the top of the page is a sketch of a furnace in section and a plan showing the trapdoor through which the core would be extracted. At the bottom, Leonardo has drawn the horse in profile with the jets displayed. So on this diagram, the horse is indeed being cast upside down: perhaps Leonardo had found a site dry enough to bury his mold in this position.

85. Changes in baptismal names were not infrequent. Ludovico himself had been christened Ludovico Mauro, then rechristened Ludovico Maria, to put him under the protection of the Virgin.

86. Francesco Guicciardini, *Storie d'Italia,* 1535–61 (posthumous).

87. Madrid II, 141r. Leonardo may not always have been as uncritical as he seems; possibly some of the allegories contained veiled criticism: how, for example, are we to take his remark about "justice as black as the Moor"?

88. The Corte Vecchia was originally (1138) the seat of the city fathers (Broletto Vecchio); it became the ducal palace of the Visconti after 1310. The Sforzas abandoned it when they built their castle at the Porta Giovio, rather as Louis XIV abandoned the Louvre for Versailles and for much the same reasons. Later, the Spanish governor and the Archduke Ferdinand of Austria lived there. The building has been so altered over the ages that it is not now possible to find the place in the present "royal palace" where Leonardo had his studio.

89. British Museum, 156v.

90. Cod. Atl., 76v a. Leonardo believed that all creatures capable of movement could feel pain—that they had been granted movement precisely because of, or together with, that faculty. So he wanted to eat only what could neither move nor suffer: vegetables (H 60-12r).

91. Cod. Atl., 78*v* b.

92. Leonardo· "The practice of clipping horses' nostrils should be laughed to scorn. Imbeciles observe this custom as if they thought nature had not done its job properly and needed to be corrected by men. . . . The nostrils are needed when the mouth is busy masticating." (Cod. Atl., 76*r* a.)

93. Cod. Atl., 143*r*. Even in seventeenth-century paintings, one can see babies tightly swaddled up to the neck like mummies.

94. A 96*r*. Leonardo also remarked that "Small bedrooms or lodgings keep the mind on the right track, large ones cause it to be diverted" (MS 2038, B.N., 16*r*).

95. A 112*v*.

96. A 84*v*. The ideal studio described by Leonardo could have served for a painter, a sculptor, or a "mechanic." The stand he calls a *cassa,* because it was both a chest and a bench, reminds one of what he said of the molds for the statue: "Make and assemble them yourself in secret" (Cod. Atl., 83*r* b), or of one of his inventions: "This wheel and all the other mechanisms will be hidden under the floorboards, so as to make them secret and incomprehensible" (document in the Uffizi). Leonardo put his work away every night to protect it—from dust and accidents as much as from inquisitive eyes.

97. Elsewhere in the notebooks are notes corresponding to an altarpiece—a work he apparently never began. They may refer to a *palla* for the cathedral in Brescia; in the center of a diagram, Leonardo has put the Virgin surrounded by the names of saints and that of the duke: "Ludovico with three lilies on his chest and the crown at his feet" (I 107-59*r*).

98. South Ken., M III 1 a; II III 37 a, II I 41 a.

99. Cod. Atl., 71*r* a. See Chapter II.

100. While an addition in the margin to the 1487 tax census records that Caterina's son Francesco died of a *spingarde* shot, he is still included in the fiscal declaration for 1490, *("per la testa di Franc . . . soldi 3 dinari 2").* So he must have been killed after this date.

101. The last word of this sentence is hard to read (remember that Leonardo was trying out a new pen). Did he write *"sella chaterina vuole fare"* or *"stare"*? (Cod. Atl., 71*r* a.)

102. Forster III, 88*r*.

103. British Museum, 272*r* a.

104. Gerolamo Calvi, *I Manoscritti di Leonardo da Vinci* (Busto Arsizio, 1982).

105. H 2 64b.

106. South Ken., M II 95 a.

107. Cod. Atl., 273*r* b.

108. Leonardo: "One can see in the mountains of Parma and Piacenza a multitude of shells and corals full of holes, still attached to the stone; and when I was working on the *gran cavallo* of Milan, peasants who had collected them in those regions brought me a big sackful to my studio" (Cod. Leic., 9 b).

109. B 21*r*.

110. Cod. Atl., 68*v* b.

111. Louis XI had inherited by testament the possessions of the house of Anjou (on the death of the last duke, in 1481), which included purely theoretically the kingdom of Naples and the quite imaginary kingdom of Jerusalem. Louis XI wisely refrained from laying any claim to these territories. But his son Charles VIII thought of doing so as soon as he succeeded to the throne. The encouragement of Ludovico il Moro and the death of King Ferrante, whose

son Alfonso, father of Isabella of Aragon, was hated by the Neapolitans, finally persuaded him to cross the Alps in 1494.

112. In a letter of March 1494 to his brother, Cardinal Ascanio, Ludovico confessed that he had no wish to see the French capture the kingdom of Naples: he simply wanted them to distract Alfonso from his Milanese projects and cut him down to size. Ludovico was well aware that the balance of power in Italy would be seriously disturbed by the presence of a foreign power.

113. H 44r.

114. Cod. Atl., 335v. These words are found in a fragment of a draft letter to Ludovico, undated, in which Leonardo complains that he has not been paid: "Since at present my wages are two years in arrears . . . and having two masters [working for me] whose wages and upkeep I have always provided."

115. Maria Vittoria Brugnoli, "Il Cavallo," in *Léonard de Vinci, L' Humaniste, l'Artiste, l'Inventeur* (Paris, 1974). The author of this article even suggests that the French casters of the statue of Louis XIV had read Leonardo's notes on the process.

116. Cod. Atl., 323v b. The letter to the churchwardens of Piacenza Cathedral has been studied in detail by Solmi.

117. Leonardo was in touch with various highly placed persons at court: Galeazzo da Sanseverino, Marchesino Stanga, Gualtieri da Bascape, Bergonzo Botta, and the Ambrogio Ferrario (or Ambrosio Ferrere) whom he mentions. But we do not know who was meant to sign the letter of introduction.

118. Leonardo writes: *"uno il quale il signore per afre sua opera a tratto di Firenze"* (the man the lord had brought from Florence). These words confirm that the prime reason for Leonardo's coming to Milan was to make the bronze horse. Was he actually invited to come?

VIII: THE ABSOLUTE MAN

1. Cod. Triv., 17 b. *"Fingere nam similem vivae quam vivere plus est./ Nec sunt facta Dei mira sed artificis":* among the studies for *The Last Supper* (Cod. Atl., 298rt b).

2. Cod. Triv., 41 a.

3. Cod. Atl., 109v a.

4. The following quotations, unless otherwise indicated, come from the *Treatise on Painting*, a compilation of various writings by Leonardo, consulted here in the French edition by André Chastel (Paris, 1987).

5. Leonardo's famous sentence *("Facil cosa è farsi universale")* has been so often misrepresented that it may be useful to put it back in context. Leonardo simply says, speaking of the proportions of the body: "The painter must attempt to make himself universal"; then he goes on: "For anyone who knows how to represent a man, *it is easy to make oneself universal,* since all land animals resemble each other in the parts of their body, that is, muscles, nerves, and bones, and differ only in size and length, as will be shown by anatomy. There are also aquatic animals, of which many species exist, but for these I would not advise the painter to follow a fixed rule, for they are of almost infinite variety; and the same is true of insects." (G 5v.) Vasari almost reproduces these words in his introduction to the *Lives* ("Nature uses the same measures everywhere . . .").

6. Cod. Atl., 1a r a.

7. In some perspectographs, the frame does not contain a pane of glass but is "divided into squares by threads"; this "trelliswork," as Leonardo calls it, gives guidelines for establishing the proportions of the subject: one can reproduce them on a sheet of paper that has also been

squared off (MS 2038, B.N., 24r). Leonardo's feelings about these devices seem to have changed over time: at first enthusiastic, he later criticized their use.

8. Some of these drawings by Verrocchio, mentioned in Vasari's *Life* of him, have been identified: e.g., the *Studies of Horses* in the Metropolitan Museum, New York, and the Musée Bonnat, Bayonne; the *Head of a Woman* in the Louvre, which is indeed very like a Leonardo drawing; or the *Madonna with a Carnation* in Munich.

9. Cod. Atl., 109v a.

10. Quaderni II, 1r.

11. Leonardo: "The painter who works routinely and by instinct, without explaining things to himself, is like a mirror reflecting everything in front of it but not having knowledge of it" (Cod. Atl., 76r). One had to "reflect" the world, then, but at the same time "reflect on it." Leonardo also wrote that "the painter who does not doubt himself will never achieve much."

12. Cod. Atl., 375r.

13. Some of Leonardo's drawings also have the beauty of tantric diagrams: these are his geometric "exercises" or plans for machines.

14. " 'On 10 August 1925,' writes Max Ernst, 'an unbearable visual obsession led me to discover the technical means that enabled me to put into practice this precept of Leonardo's on a large scale. . . .' The technique in question was taking rubbings of uneven surfaces, which had irresistibly attracted and held his attention." (Chastel, introduction to *Treatise on Painting*.)

15. Leonardo: "Painting relates to the surfaces, colors, and shapes of everything created by nature; and philosophy penetrates inside these bodies, considering their intrinsic properties; but it does not have the reward of that truth which the painter attains in grasping their essential truth, for the eye makes fewer mistakes" (Cod. Urb., 4v).

16. Leonardo is here mocking the sculptor of stone; he himself seems to have practiced mainly clay modeling followed by casting in bronze, neither of which presents quite the degree of inconvenience referred to here. People have often read this passage as a dig at Michelangelo, who preferred marble to everything else. See Chapter IX.

17. Mantegna and Perugino were at this period amassing much greater fortunes than the few goods collected by Leonardo. He was scarcely becoming a rich man, since he spent all he earned, and had no special status; but he displayed an attitude of detachment from his art and adopted in every way an extremely aristocratic mode of behavior, inspired by Alberti, unlike his colleagues. ("The man who seeks to make money in a day will be hanged before the year is out," Windsor, 12351r; "As for property and material goods, you should always beware of them; they often plunge their owner into ignominy, and if he should lose them, he is mocked," MS 2038, B.N., 34v).

18. Bertini's painting *Leonardo at the Court of Ludovico the Moor,* now lost, is known to us only through a photograph (Civiche Raccolte d'Arte, Milan). Eighteenth- and nineteenth-century engravings, like those of Cunego *(Leonardo in His Studio)* or Gandini *(Ludovico Sforza and Leonardo),* also popularized an image of the painter as grandee.

19. Leonardo was, however, mistaken about the way the image righted itself inside the eye (his error went uncorrected until Kepler). And he was also mistaken about the form of the lens. In order to study the latter, he had to set it firmly, so he boiled the whole eye with white of egg before dissecting it. By so doing, he altered the form of the lens (which is normally globular) and detached it from the iris—hence the errors in his diagrams.

20. Leonardo discovered the principle of the contact lens while trying to simulate the function of the eye with glass instruments (D 3v).

21. Quaderni IV, 16r; Cod. Arun, 85v.

22. Several sketches on manuscript C 22*r* remind one irresistibly of the light meter developed by Rumford in the late eighteenth century.

23. Cod. Leic, 4*r*.

24. Characteristically, Leonardo refers to the flame as "living," rather than "shining" or "burning" (Cod. Atl., 279*r* a); similarly, he speaks of the "wound" a stone inflicts when thrown into water; or uses the term "desire" of earthly magnetic attraction. He gives the impression of a psychological approach to nature. Indeed, his entire vocabulary expressed his idea that man and the earth were created in each other's image: "The Ancients," he writes, "called man a microcosm, and it is an appropriate formula, for man is composed of earth, air, fire, and water and so is the *body* of the earth" (A 55*v*).

25. Cod. Atl., 190*r* a.

26. Leonardo wrote: "The sun is immobile" (Quaderni V, 25*r*), a sentence that has misled many researchers: the context clearly indicates that he was not seeking to establish the theory that the planets move around the sun.

27. For once Leonardo cites his sources: "Aristotle, in the third volume of the *Ethics* . . ." (Cod. Atl., 289*v* c).

28. Cod. Atl. 61*r*. In another notebook, Leonardo establishes a parallel between waves of the sea, sound waves, and light waves (A 9*v*).

29. Leonardo: "And how will you explain the infinite number of kinds of leaves frozen into the high rocks of these mountains, among them *aliga,* seaweed that one finds mingled with shells and sand? And you will also see all manner of petrified things, such as sea crabs, broken into fragments, scattered and mingled with their shells" (F 80*v*). At this time, Leonardo seems to have thought that "the sea level fell during the course of time," rather than that the mountains were formed by the folding of the earth's crust.

30. C 15*r;* Quaderni IV, 12*v;* K 120 (40) *r*.

31. Cod. Atl., 119*v*. Leonardo also writes: "The eye, the function of which is so clearly demonstrated by experience, has been defined until the present time by a great many authors in a certain way—but I find it to be completely different" (Cod. Atl., 361*v*).

32. Cod. Triv., 12, 13. Some authors have maintained, mistakenly, that Leonardo was planning to compose a real dictionary for publication—or even a sort of treatise on philology.

33. Stites, *Sublimations*.

34. Cod. Triv., 4*r*. It might be thought that these word lists were meant for pupils, notably Salai, whom Leonardo must have had to educate. But in that case, would he have written them in mirror script? (Being ambidextrous, Leonardo could write perfectly well from left to right when he wanted to.)

35. Quaderni II, 16*r*.

36. The first "inventory" of Leonardo's books contains 40 titles (Cod. Atl., 559); the second contains 116, 102 under the heading "books left by me in a big locked chest" and 14 as "books left in a box in the monastery" (Madrid II, 2 b). He probably put his library in safekeeping before traveling. For a complete list of titles, see Richter and the *Commentary* by Pedretti.

37. Quite a few of the tales, prophecies, and notes on animals (found particularly in manuscript H) come straight from the *Fior di Virtù,* of which he owned a copy.

38. There are several references in the notebooks to this work by Archimedes, which was owned by the archbishop of Padua (British Museum, 135 a c) and also by Monsignor di Santa Giusta in Rome—but he had given it to his brother, who lived in Sardinia (Cod. Atl., 349*v*), etc.

39. On Leonardo's learning Latin, see Augusto Marinoni, "La philologie de Léonard de Vinci," in *Léonard de Vinci* (IGDA, Novara, 1958).

40. British Museum, B.B. 1030.

41. The most finished model of the tank by Leonardo is probably that on 296*v* of the Codex Atlanticus. But its system of springs allowed it to travel only a very short distance. According to specialists, Leonardo's most interesting research in mechanics lay in the elimination of friction (Cod. Atl., 209*v*), ball bearings (Madrid I, 20*v*), and articulated chains (Cod. Atl., 357*r* a; Madrid I, 10*r*). The transmission chain (to be seen, for example, on Leonardo's "bicycle") would not be *re*invented until the late nineteenth century.

42. Notably Adda, Duhem, Gilles, Grothe, Chastel, Pedretti, Marinoni.

43. Cod. Atl., 118*v* a. Another of Leonardo's notes helps us to see that he is hardly likely to have accepted this "solar" explanation for the skin pigment of black peoples: "The black races of Ethiopia are not the result of the sun," he writes, "since if a black man gets a white woman with child, the offspring is gray [*sic*], evidence that the mother's race has as much influence over the fetus as the father's (Quaderni III, 8*v*). Was this one more chance to minimize his paternal heredity?

44. Leonardo: "Supreme happiness will be the cause of misery and the perfection of wisdom the occasion of folly" (Cod. Atl., 39*v* c). He also noted: "Do not desire the impossible" (E 31*v*).

45. Cod. Atl., 393*v* a.

46. Leonardo quotes Anaxagoras: "Everything is born of everything, and everything becomes everything once more, since all that exists in the elements is made up of those elements" (Cod. Atl., 385*v* c).

47. F 2 b.

48. Cod. Atl., 146*v* a.

49. Quaderni IV, 167 a.

50. H 141 (2*v*) *r.*

51. Leonardo: "Nature cannot give movement to animals without mechanical instruments, as I have myself shown in this book, in the passages relating to the motion nature has created in animals; and that is why I have composed the rules of the four powers of nature, without which nature could not give local movement to animals" (Windsor, 19060).

52. F 5*v.*

53. I 66 (18) *v.* The pious Michelangelo also wrote of the Christ of crucifixes: "In Rome, they even sell his skin" (Sonnet V). And Dante had written: "In Rome, Christ is bought and sold every day."

54. C 19*v.*

55. Vasari and Lomazzo both attribute Montofarno's *Crucifixion* to Leonardo, but it was probably finished by the time da Vinci began to paint *The Last Supper,* in 1495.

56. Goethe, *Schriften und Aufsätze zur Kunst,* essay on Joseph Bossi and Leonardo (Abandmahl, 1817).

57. The perspective in *The Last Supper* has been studied in great detail by the architect Giovanni degl'Innocenti in particular (in Pedretti, *Léonard de Vinci architecte).* Several paragraphs of the *Treatise on Painting* seem to be directly related to the composition of *The Last Supper* (avoid painting groups of superimposed figures, bear in mind the spectator's viewpoint, unify the perspective and lighting, etc.). They seem to develop the formulas introduced by Masaccio.

58. Windsor, 12542.

59. The circle governing the composition is theoretically inscribed between the vault and (approximately, but probably deliberately so, for the sake of optical illusion) the former

pavement of the refectory; in fact, the floor has been raised about twenty centimeters since Leonardo's time.

60. Forster II, 62*v*; 63*r*.

61. It is not clear exactly how this habit of placing Judas across the table originated. We find it essentially in Florentine painters of the quattrocento: most of the primitives do not observe it, nor do Pietro Lorenzetti or Giotto, whereas Taddeo Gaddei does.

62. H 16*v*; H 100 (43 *v*) *r*: H 48*v*.

63. Cod. Atl., 380 a (1179 b). The words in brackets have been struck out.

64. H III, 89 a.

65. Windsor, 19060*r*. Leonardo also says: "He who does not attach value to life does not deserve it" (I 15*r*). He was no doubt speaking of his own life as well as of others.

66. Forster III, 74*v*.

67. C 19*v*.

68. Ibid.

69. Quaderni III, 214 a.

70. The Moor's latest mistress, married to a compliant bourgeois, Lucrezia Crivelli was a lady-in-waiting to the duchess. The portrait of her by Leonardo might be the one known as *La Belle Ferronnière* in the Louvre. There certainly was one: a court poet declared that this young woman not only was blessed by the gods with every gift and quality; she also had the good fortune to be loved by Duke Ludovico, "first among princes," and painted by Leonardo, "first among painters."

71. Many of Leonardo's notes and sketches refer to decorative motifs and to the preparation of scenic effects or costumes for carnivals. To take just one example: "To make a beautiful costume, take fine linen, cover it with a layer of sweet-smelling varnish, composed of oil and turpentine, and gloss it with Oriental scarlet, taking care that the model is perforated and dampened on the inside to prevent it from sticking; and the model should have bunches of knots, filled with black millet, and the hem with white millet" (I 49 [1] *v*).

72. On the *Danaë*, for which Leonardo did both the sets and the production, see *Le Lieu théâtral à la Renaissance* (Paris, 1968).

73. Pedretti thinks that he has identified the person who commissioned the decoration of this house, a sort of account book for which has been found among Leonardo's papers (Madrid I, 158*r* a): Mariolo de Guiscardi, chamberlain to the Moor. It seems that of all the villas that may have been built or decorated by Leonardo, none has escaped the demolitions and alterations undergone by Milan over the centuries. But Leonardo left dozens of pages (especially in the Codex Atlanticus) describing private residences in detail, with many original details for staircases, kitchens, the servants' quarters, the ballroom, the guest rooms, the gardens, the facades, etc. (See Pedretti, *Léonard de Vinci architecte*.)

74. B 12*r*.

75. Cod. Atl., 308 b; 939 a.

76. Cod. Atl., 335*v*. See Chapter VII, note 112.

77. I 107 (59) *r*. See Chapter VII, note 95.

78. Cod. Atl., 393*v* a; 397*r* a; 318*v* a; 2*r* a; I 48*v*. Alongside one of his sketches for a rolling mill, Leonardo noted that it made "very fine and regular sheets of tin."

79. Cod. Atl., 318*r* a.

80. Ibid., 434*r* (161*r* a).

81. Ibid., 361*v* b.

82. Leonardo: *"Rugieri Bacho fatto in istampa"* (British Museum, 71r). But Richter notes that the first edition of Bacon's works was in French and dates from forty years after Leonardo's death. Does this sentence correspond to a mere wish or to mistaken information?

83. Alongside the drawing of his pyramid-shaped parachute, Leonardo writes: "If a man has a *tent* made of well-primed canvas about 12 *braccia* across and 12 high, he will be able to throw himself from any height without harming himself" (Cod. Atl., 381v). I should say that the pyramid is much more convincing than the little cone shown in the manuscript in the British Library, where the man is holding a wooden frame.

84. Leonardo's "helicopter" does not have rotors but has a large spiral or screw, made of canvas on a frame: the principle on which it was meant to rise in the air was, however, the same as with a modern helicopter. Leonardo's inexplicable bicycle may also have been a toy. The Aztecs are supposed not to have invented the wheel; in fact, toys with wheels have been found in pre-Columbian tombs—but there was no other use for wheels if there were no draft animals available: horses and oxen were introduced to America by the Spanish. Similarly, many of Leonardo's inventions probably had no function except as toys in his own time.

85. Cod. Atl., 361 b.

86. B 88 and 89v. Oddly enough, Leonardo, who was at this time studying the bat, which he dissected, wrote of this creature: "Because of its unbridled lust, the bat does not follow natural law in its coupling: male unites with male and female with female, through chance encounter" (H 12r.)

87. Leonardo did many drawings of articulated wings; the most complete is on 341r of the Codex Atlanticus, accompanied by a long explanatory text. He indicates by letters (A, B, C) the articulations, moved by the heel and the hand, that enable it to function, and the rotation system that makes it possible to fly vertically or horizontally.

88. For his "undercarriage," Leonardo says he was inspired by the swift, "which is unable to lift itself directly from the ground since its legs are too short. When it starts to fly, it folds its *ladders,* as in my drawing." Leonardo also thought of making his retractable ladders with "folding wedges," which would act like springs or buffers, explaining that they would make it possible "to obtain the same movement as a person jumping on tiptoe, avoiding shocks to the heels" (B 89r).

89. B 74v.

90. The glider in the Madrid manuscript, shaped like a spearhead, carries a gondola in which a passenger could travel. On the same page, Leonardo envisages a sphere made of elmwood hoops and built according to the Cardano suspension principle, in which a man could stand upright (Madrid I, 64r).

91. C 19v.

92. Vasari, in his *Life* of Piero della Francesca, accuses Pacioli of failing to publish his master's essays (which are now lost), describing him as being "perfidious and impious."

93. Cod. Atl., 104r a. While Pacioli's *Summa* cost Leonardo 119 soldi, he paid only 68 soldi for the *Chronicle* and 61 for the Bible (which he may have used for *The Last Supper*). Several pages of the Madrid manuscript reproduce word for word passages from the *Summa*. But sometimes Leonardo flagged: when he copied the "family tree of proportions" invented by Pacioli, he reproduced only twenty of the forty categories (Madrid II, 78r).

94. Leonardo had designed an inkwell of this kind in a case bearing the initials B.T: we do not know who it was for—possibly Baldassare Taccone (Cod. Atl., 306r a).

95. Quaderni IV, 14r.

96. Madrid II, 3v.

97. Leonardo proposed in about 1503 to write a treatise entitled *De Ludo Geometrico,* in which he would show how to move from a circle or sphere to any other regular figure or solid (Cod. Atl., 45*v*).

98. Leonardo: "Proportion is found not only in numbers and measurements but also in sounds, landscapes, times, and places, and in any form of power at all" (K 49*r*). Thus he tried to define *proportion* in the growth of trees: he thought he could find a *relation* between the circumference of the trunk and the length of the branches. But this was only an abstract concept (Cod. Urb., 246*r;* M 78*v*).

99. Luca Pacioli, *De divina proportione,* 1st ed. (Paganinum de Paganinis, Venice, 1509). The manuscript copy dedicated to Ludovico the Moor is preserved in the University and Public Library in Geneva; the copy dedicated to Sanseverino is in the Ambrosiana in Milan; a third, dedicated to Piero Soderini, has been lost.

100. Leonardo's manuscript M contains the draft sketch for the five Platonic solids (folio 80 verso), accompanied by a tercet referring to them and copied by Pacioli: "The sweet fruit, so pleasant and refined / Has already encouraged philosophers to find / Our origin, to give food to the mind." Nowadays the *De divina proportione* seems a somewhat indigestible morsel rather than a sweet fruit. One of the work's aims was, via some very complicated calculations, to work out the "divine" or "golden" number: 1.618. Did Le Corbusier discover his identical Modulor in the treatise by Pacioli and Leonardo?

101. H. 108*v;* Cod. Atl., 394*r* a; 385*r* a; 295*r* a.

102. South Ken., III 94 a; II 78 b.

103. B 58*r*.

104. Windsor, 12281. Leonardo would not have had much trouble finding male sitters—there were the youths in his studio, for a start. But female sitters, if one wanted to draw nudes, could only be found in "places of ill repute."

105. South Ken., II 22 a.

106. Popham, *Drawings,* nos. 133–140. Had Goya seen Leonardo's "grotesques"? It is not impossible, for several of them had been published by his lifetime.

107. Lomazzo says that one day Leonardo amused himself by entertaining a group of peasants whose faces interested him: he offered them a banquet and made them roar with laughter. On going home, since he had made a mental note of every detail of their expressions, "he drew them in such a way that his drawing made the spectator laugh as much as he had made his models laugh during the feast." This might be one of the sheets preserved in Windsor (12495*r*).

108. Leonardo writes: "Christ / Count Giovanni [or 'the young count'], he of the Cardinal de Mortaro" (South Ken., II 786); and a little further: "Alessandro Carissimo of Parma, for Christ's hand." Both Lomazzo and Vasari, however, think that Leonardo was unable to find the right model for the Savior's head. Vasari says: "He gave up trying to find it on earth, having lost hope of imagining the celestial beauty and grace suitable for the image of God incarnate. . . . He left it unfinished." However, it seems that by 1498 the picture was quite complete. Does this mean that Leonardo resorted to the *non finito* (as Lomazzo seems to suggest) for the face of Jesus?

109. Leonardo is supposed to have painted, at the foot of Montofarno's *Crucifixion,* on the opposite wall, the figures of Ludovico and Beatrice, with their children, kneeling in profile. These paintings have deteriorated so badly that only the outlines remain.

110. Most of the studies for the faces of the apostles are in the Royal Library in Windsor. A watercolor drawing of Christ's head, possibly by a pupil, is preserved in the Brera museum in Milan. All of these reveal, sadly, how much *The Last Supper* lost during the early restorations.

111. Stendhal said he knew of over forty copies of *The Last Supper*. The picture was copied very early and all over Europe. Engravings were already making it known by the late fifteenth century. Louis XII, who wanted to remove the fresco from the wall to take it to France, according to Paolo Giovio, had a copy made. François I offered a reproduction of it in the form of a tapestry to Pope Clement VII in 1533. Rembrandt himself made a pencil copy of it (Metropolitan Museum, New York). In the late nineteenth century, it was one of the most reproduced works in the world (engravings, colored prints, plaster relief, pewter, silver, etc.). I was astonished recently, in the Lisbon flea market, to come across over thirty reproductions of all kinds in a single day. Clark says that *The Last Supper* "seems no longer to be the work of man but of nature."

112. The tomb of Ludovico and Beatrice, with their effigies by Solari, is now in Pavia.

113. Martin Kemp in *Leonardo da Vinci* (Cambridge, Mass., 1981) sees the Sala delle Asse, with its leafy branches and golden ribbons, as celebrating the union of the duke and duchess beyond the grave. It seems clear to me at all events that Leonardo combined the official emblem with his own.

114. H 32*v* and s; Cod. Atl., 358*v* a; 216*r;* 98*r*. It is possible that one of these interlaced motifs was intended for the parquet or paved floor of the Sala delle Asse.

115. Windsor, 12516.

116. Cod. Atl., 133*r* a; 372*r* b. Leonardo may have derived some of his income from these designs of bags and sword handles.

IX: LAURELS AND TEMPESTS

1. H 100 (43) *r*.

2. Cod. Atl., 248r.

3. The notes and plans for the bathhouse of Galeazzo Maria's widow are scattered through various notebooks (Cod. Arun., 145*v;* Cod. Atl., 104*r* b; 31*v;* I 28v; etc.). A device for controlling water flow appears on one page of the Codex Atlanticus, dated August 1499.

4. A note in the Codex Atlanticus, not in Leonardo's handwriting, mentions a promised report on the condition of the Tuscan fortifications (203*v* a).

5. The memorandum in which the Comte de Ligny's name figures (Cod. Atl., 247*r* a) was deciphered and provided with a detailed commentary by Calvi in 1907 (*Raccolta Vinciana,* III).

6. Jean Perréal, usually known as Jean de Paris, the name mentioned by Leonardo, was both a painter and an organizer of court entertainments for the king of France. He is thought to have depicted Leonardo (bearded, with long hair, aged about forty) in a miniature in a manuscript in the Bibliothèque Nationale in Paris (see the article by Léon Dorez in *Nouvelle Revue d'Italie,* Rome, 1919). The "dry coloring" technique that Leonardo wanted to ask him about, and the way of tinting paper, seems to correspond to pastel: Leonardo apparently learned this technique from the Frenchman and used it for the first time in his portrait of Isabella d'Este.

7. But Leonardo does not appear to have been in Milan at the time of the death of his friend Jacomo Andrea di Ferrara, at whose house Salai was so badly behaved at dinner one evening. The conspiracy in favor of the Moor, in which Jacomo took part and for which he was hanged, drawn, and quartered, had taken place in April 1500, when Leonardo was already in Florence.

8. The works cited in the "Ligny memorandum" are treatises on physics and perspective, and textbooks of architectural design. This seems to confirm that at this time Leonardo was intending to work as an engineer for the French and to draw up plans of fortifications for them. The *De Ponderibus* may be the work of the thirteenth-century mathematician Jordanus

Nemorarius (whom Leonardo calls Giordano); and what he calls "Vitelone" is an edition of the works of the Polish writer Witelo (thirteenth century).

9. Leonardo writes: "Clock in the tower at Chiaravalle, which shows the moon, the sun, the hours, and the minutes" (Cod. Atl., 399*v* b). When he starts calculating in order to explain the principle of the mechanism, he makes a mistake in the multiplication (arriving at a total of 9,760 hours instead of 8,760, which, divided by 24, would give 365).

10. Cod. Atl., 2*r* a.

11. Cod. Atl., 214*r* and *v* e.

12. The text in which Leonardo explains why the sky is blue opens his account of the ascent of the mountain (Cod. Leic. 4 *r*); the rest of the page is devoted to reflections on the atmosphere. Scholars have hesitated over the date of the ascent; it must have taken place either during the artist's first stay in Milan, in the 1490s, or during his second stay, in about 1507. I am inclined to the former. Would Leonardo have still been capable, at over fifty, of climbing a high mountain? The four rivers to which he refers are the Rhine, the Rhône, the Danube, and the Po.

13. Being passionately interested in geography, Leonardo mentions the Red Sea and the Nile in his notes, as well as Mount Etna, Greece, Gibraltar, and India. He seems to have made several journeys by sea, as indicated by a sentence like the following: "When I was at sea, at an equal distance from a flat shore and a mountain, the coast of the flat shore seemed much farther away than the mountain" (L 77*v*).

14. See Cod. Atl., 145*v* a, b; 145*r* b; 155*r* b; 311*r* a; 96*v* b, for Leonardo's "projected novels."

15. Renaissance Italy had many links with the East, though not close ones. Leonardo's personal taste for "things Turkish" appears both in his literary writing and in his architecture, e.g., in his centrally planned churches with their many domes buttressing each other like the domes of Byzantium. His vegetarianism and long beard also hinted at the East.

16. The *Portrait of Isabella d'Este* now in the Louvre is a cartoon of which the contours have been pricked out with a needle, in order to transfer them to another surface, the usual way of tracing a work. The holes were probably used to make another copy, which Leonardo left behind in Mantua and which is mentioned in a letter from Isabella to her agent in Florence: "Ask him [Leonardo] to send us another sketch of our portrait, since his highness our husband has given away the one we had" (27 May 1501). There are many copies of the drawing (in the Uffizi, in the British Museum, etc.). One of them, now in Oxford, shows that the drawing in the Louvre has been trimmed on three sides: originally the duchess's hands, the edge of a table, and a book were all visible. According to art historians, the monumental equilibrium of this head in profile on a body facing to the front considerably influenced the development of Renaissance portraiture.

17. In about 1515, Leonardo wrote: "Lyon artillery at Venice, the way I used it at Gradisca in Friuli and [illegible word]" (Cod. Atl., 79*r* c). Local legend claims that Leonardo played some part in designing the fortifications at Gradisca.

18. Cod. Atl., 234*r* c. In 1426, Brunelleschi had already considered flooding the town of Lucca, then at war with Florence, in much the same way, by building a dam.

19. On this point see E. Solmi, *Leonardo da Vinci e la Repubblica di Venezia* (Archivo Storico Lombardo, 1908).

20. Cod. Leic., 22 b.

21. According to Pedretti, the page on which Leonardo described his underwater assault (Cod. Atl., 333*v* a) dates from about 1487, not 1500. Solmi's version, which I have followed here, according to which the divers might have rescued Christian captives from the Turks, is debatable. It depends on a coincidence of names. The man with whom Leonardo hoped to come to some arrangement over "the ransom" was called Manetto: "The deposit of the prisoners is with Manetto," Leonardo writes, "and the payment might be into Manetto's hands." It so

happens that a secretary of the Venetian Republic named Alvise Manetti or Manetto was indeed sent as an envoy to the Turks in 1499, with the mission of negotiating the release of Venetian prisoners. The mission failed in February 1500. But was this the same man? And how can one reconcile this name with the probable date of composition of the project (which was never, so far as I know, presented)? One last obscure point: Leonardo talks of "ransoms" without making it clear whether these were for Venetians or for enemies who would be taken prisoner during the assault—Calvi suggests he was thinking of pirates on the Ligurian coast.

22. Cod. Atl., 62*v* a.

23. The Royal Academy in London, Burlington House, possesses a cartoon of the *Virgin with Saint Anne* (greatly admired by Berenson, who compared it to a Greek bas-relief), which apparently predates both the lost cartoon referred to by Fra Pietro da Novellara and the unfinished painting in the Louvre. It may have been done in Milan in the late 1490s. This cartoon was bought by the brother of the English ambassador to Venice in 1763 and had been acquired by the Royal Academy by 1791.

24. There are many versions of the *Madonna with a Yarn-Winder,* mentioned in a letter by Fra Pietro da Novellara: in the Louvre, in Drumlanrig Castle in Scotland, etc. None of them seems to be by Leonardo's own hand: some scholars believe that they are copies of a lost work, but as Chastel points out, there may never have been an original. Leonardo might well have drawn a composition of the *Madonna with a Yarn-Winder* (a red chalk drawing of a woman—Windsor, 12514—could be connected with it) and then left the execution to his pupils. Fra Pietro also says that at this period, the master sometimes added touches to the paintings of his pupils. The yarn-winder with which the Holy Child is playing is a symbol of the Cross and Passion. The fact that the work was intended for the favorite of Louis XII indicates that Leonardo was in close touch with the French.

25. On 3 March 1502, Isabella d'Este wrote to one of her correspondents in Florence: "It would be pleasing to us if you were to show these vases to some competent person such as Leonardo da Vinci, the Milanese painter, who is our friend." Leonardo examined the vases (which had probably been looted from the Medici collection in 1494) and found them very fine, but the high price deterred Isabella from buying them. It was not uncommon at the time for artists to be consulted as fine-art valuers.

26. As in the case of the *Madonna with a Yarn-Winder,* there are some studies by Leonardo for a *Christ Among the Doctors* or a *Christ Salvator Mundi* (Windsor, 12524, 12525) and various paintings related to them (in the Villa Borghese and the Spada Palace in Rome, in the Vittadini Collection in Milan), none of the latter by his own hand. Here again, I think the works were directly handled by his pupils. None of them seems to have been intended for the marchioness of Mantua.

27. The unfinished *Virgin with Saint Anne* in the Louvre seems to have been in the royal collection from a very early date: Leonardo may have brought the picture with him to François I's court. Giovio says that the king "bought it and hung it in his private chapel," but Vasari and the Anonimo Gaddiano contradict him on this point. Cardinal Richelieu certainly acquired the painting in 1628, and Louis XIII became its owner in 1636. The picture is in very poor condition.

28. Quoted by Freud: "One can see the head of the vulture, its neck and the beginning of its chest, in a very pronounced curve, in the blue robe draped around the Virgin, from the hip to the lap and the right knee" (letter from Oskar Pfister to Freud, written in 1913).

29. Like most of Leonardo's works, the *Virgin with Saint Anne* was much copied, *in toto* and in detail: the authors of the copies are often difficult to identify. Apart from those in private collections, there is the *Saint Anne* in the Uffizi and those in Budapest, in the Poldi-Pezzoli Museum and the Brera in Milan, in the University of California at Los Angeles, etc.

30. Leonardo: "Method for draining the Pontine marshes"; "Foaming waves in the sea at Piombino," etc. (Cod. Atl., 139*v* c; Windsor, 12665*r;* I 6*v*).

31. L 19 b; 33 b.

32. Windsor, 12682. Leonardo composed his "aerial" or bird's-eye view of Arezzo and the Val di Chiana in his imagination, of course.

33. L 2 a.

34. L 40 a, 78 b, 6 b.

35. L 91*r.*

36. Leonardo: "On 1 August 1502, the library at Pesaro" (LO.).

37. Leonardo: "There may be harmonious sounds produced by different waterfalls as you saw at the Rimini fountain on 8 August 1502" (L 78 a). There is another allusion to a musical fountain in the Madrid manuscript (II 55 a) and a diagram of a sort of water-powered organ in the Codex Arundel (136 a, 137 b). Leonardo may have built an instrument of this kind.

38. Windsor, 12666; L 66*r*, 77*r*. See L. Beltrami, *Leonardo e il porto da Cesenatico* (Milan, 1902).

39. K 2*r;* K 35*v;* L 72 a.

40. Leonardo, remembering the trick by which Cesare Borgia had taken the fortress of Fossombrone, later wrote: "Take care that the emergency exit does not run to the keep of the fort's commander, lest the fortress be captured by treachery, as happened at Fossombrone" (Cod. Atl., 43*v* b).

41. L 66 a.

42. The copy of a letter from Leonardo to Sultan Bayezid was found and published by F. Babingher in the *Nachrichten der Akademie der Wissenschaften in Göttingen* in 1952. The sultan's secretaries probably made only a partial and perhaps slanted translation of the original, hence the failure of the request.

43. British Museum, 229 b.

44. Under two anamorphoses, we find the opening sentences of a letter not in Leonardo's own hand: it concerns dealings with a certain Maestro Giovanni, regent of Santa Croce, and the meaning is unclear (Cod. Atl., 35*v* a). The back of folio 129 in the same collection contains an equally enigmatic note, signed by the same Maestro Giovanni and dated 17 April 1503, in Florence.

45. British Museum, 202 b. In fact, Leonardo does mention Cesare Borgia one other time in his notebooks: when inventorying the contents of a trunk, he speaks of a cloak that had belonged to Il Valentino and had been passed on to Salai. It was not uncommon for a prince to reward or pay an artist in this manner. But Leonardo, either out of pride or to give pleasure to his protégé, did not keep the cloak for himself.

46. Leonardo drew maps of Pisa and the region (Madrid II, 52*v*, 53*r;* Windsor, 12683). On 21 June 1503, he inspected the strategic fortress of Monte Veruca, then visited the Florentine camp outside the besieged city. One of his sketches of the Arno is dated 22 July ("Feast of Mary Magdalene," Madrid II, 1). It was at about this time that it was decided "after much deliberation and doubt, as a government report indicates, that the work [the dam and diversion of the river] would be a useful thing to do; and if one could really divert the Arno, or channel it into a canal, that would at least prevent our hills from being attacked by the enemy" (Francesco Guidicci).

47. Most of the information we have about the attempt to divert the Arno comes from the correspondence and memoirs of Machiavelli's secretaries. See P. Villari, *Niccolò Machiavelli e suoi tempi* (Florence, 1877–82).

48. We have already noted Leonardo's persuasive talents: the Anonimo Gaddiano and Vasari both speak admiringly of them. The latter writes, for example: "Among Leonardo's plans and models, there was one in which he proposed to the ingeniousness of the citizens governing Florence a way of raising the baptistery of San Giovanni and hoisting it onto a platform by degrees without harming it. He argued so convincingly that it seemed quite possible, even if everyone, when he got home, realized that this scheme was in fact quite unmanageable." (This project may certainly have existed, since the baptistery was regarded as being too low in relation to the cathedral; and it was not quite unthinkable: in 1455, the architect Aristotele Fioravanti in Bologna managed to move a church tower weighing several tons, over a distance of eighteen meters.)

49. Buonaccorsi's *Journal* (1498–1512) was published in 1568 in Florence.

50. The last words in the Ligny memorandum (see note 5, above)—"how much earth a man can move in a day"—may have concerned an early project to render the Arno navigable as far as Florence, which Leonardo intended to submit to the Republic when he arrived there.

51. Cod. Atl., 289r.

52. Ibid., 45r.

53. Ibid., 284r.

54. Leonardo was thinking of a treatise on water as early as manuscript A, dating from about 1491: there are notes on the nature of water and hydraulic machines in almost all the notebooks (F, H, Codex Leicester, etc.). It was certainly one of the subjects that mattered most to him and one of the areas he investigated most fully.

55. Windsor, 12700r. Leonardo may have felt slightly ridiculous at repeating that he was not tired of serving his fellowmen. In the margin, he wrote: "I am not tired of being useful is a carnival motto." But that did not prevent him from going on: "For the good of others, I shall never be able to do enough. . . . Nature made me this way."

56. Cod. Atl., 185v.

57. Cod. Atl., 96v b.

58. Windsor, 12279, 12679, 12680, etc.

59. Cod. Atl., 108v a.

60. Ibid., Iv a.

61. Vasari writes: "The great council chamber had just been rebuilt, its architecture having been designed according to advice from Leonardo himself, as well as that of Giuliano da Sangallo, Simone Pollaiuolo known as Il Cronaca, Michelangelo Buonarroti, and Baccio d'Agnolo." Today, it is regarded as being chiefly by Il Cronaca, with Filippino Lippi and Baccio d'Agnolo being responsible for the wooden decorations.

62. MS 2038, B.N., 30v; 31r.

63. See R. Lebel, *Léonard de Vinci ou la fin de l'humilité* (Paris, 1952).

64. Cod. Atl., 9v a; Cod. Arun. 54r, B 31 V; Cod. Atl., 51r; 54v a; British Museum, B.B. 1030.

65. According to Leonardo, the *falaricus* was a machine with a handle, which launched a barbed javelin; the *rhomphea* was a weapon halfway between a sword and a pike; the *scorpion* could throw stones, darts, or arrows; the *murex* was a mantrap with four spikes, etc. All these weapons and machines came from books by Latin authors, no doubt via Valturio.

66. The "bachelor machine," *la machine célibataire,* was the name given by Marcel Duchamp to the lower half of *The Bride Stripped Bare by the Bachelors.* Michel Carrouges compared this work to *In the Penal Colony* by Kafka, in a book entitled *Les Machines célibataires* (Paris, 1954), which was used as the basis of an exhibition in the Musée des Arts Décoratifs de Paris in

1976—including Leonardo, naturally. Carrouges wrote of the "bachelor machines" in words that could well be applied to Leonardo's technical drawings: "Supremely ambiguous, they affirm at once the power of eroticism and its negation, that of death and immortality, torture and wonderland, annihilation and resurrection. . . . It would seem that in this case the refusal of woman, and above all of procreation, appeared as the major condition for the break with the cosmic law, in the sense that both China and Kafka used this notion, and in particular the condition for illumination, freedom, and magical immortality."

67. Leonardo was no doubt sent to Piombino at Machiavelli's behest. He spent several months there in late 1504. Most of the works he was asked to do there are mentioned in manuscript II in Madrid (digging a trench, building a tower and a dike). These works, some of which may have been completed, led him to rethink entirely the principles of fortification (possibly in collaboration with Giuliano da Sangallo) and even to prepare a treatise on military architecture.

68. British Museum, 272 a.

69. Cod. Atl., 70 b (208 b)

70. Leonardo's drawing of Michelangelo's *David* is on a page in the Windsor collection (12591) alongside notes and plans for a princely residence.

71. Cod. Atl., 115*v*.

72. Pedretti in his commentaries on Leonardo's notebooks remarks that most of the incantatory phrases beginning "Tell me," when he was trying out a new pen, date from before 1500. But he gives the date 1505, the year of the *Battle of Anghiari,* for the words "Tell me if ever there was done . . ." (Cod. Atl., 368*v* b) and after 1508 for "Tell me if anything like this was ever done" (Quaderni IV, 15*v*).

73. Madrid II, 112 a.

74. Notebook known as *Codex on the Flight of Birds (Codex sul volo),* in the former Biblioteca Reale in Turin.

75. *Codex sul volo,* 18*v*.

76. Ibid.

77. Madrid, II, 2 a.

78. We do not know for certain what Leonardo did in the months before his departure. Perhaps he designed his Neptune fountain, a design Vasari calls "so elaborate that it sparkled with life; one could see the stormy sea, the chariot drawn by sea horses, with fantastic creatures, dolphins and winds, and exquisite heads of the sea gods." The final drawing for the fountain appears to be lost, but some idea of it is given by a black chalk drawing in the Windsor collection (12570). We might also place during this period of Leonardo's life the flight from Mount Ceceri, and the mill for grinding dyestuffs designed for Uncle Francesco. Finally, he may have begun work on two new paintings: the *Leda* (a first sketch for which appears among the preparatory drawings for the *Battle of Anghiari*) and the *Mona Lisa.*

79. The life of Leonardo by the Anonimo Gaddiano, and the accompanying text, follow a page in the *Libro di Antonio Billi* in which about thirty lines are devoted to Leonardo. The only important information they contain is the detail about the poor-quality oil apparently delivered to the painter for the *Battle of Anghiari.* 2

X: LIKE A WELL-FILLED DAY

1. Cod. Atl., 373*r* a. Leonardo himself translated the beginning of this line by Virgil from the Tenth Eclogue: *"Amor omni cosas vince"* (Love triumphs over all things), Cod. Atl., 344*r* b.

2. The second *Virgin of the Rocks* (which remained in the church of San Francesco Grande until 1781, arrived in England four years later, and was sold to the National Gallery in London in

1880) still divides art historians. When was it begun, and why was a second version required? (Did the French king want to take the original back to France?) And exactly who painted it? Leonardo seems to have helped Ambrogio de Predis with some parts of the painting, in particular the faces and hands, but was this before 1500 or in 1507? And who else worked on it? Above all, how is one to explain the differences between the painting in London and the one in the Louvre? No clear answer has ever been provided to these questions. In the London version, the rocks have been painted with a rather hard brush, the angel's face is in the mannerist style, and the infant Jesus has neither the molded quality nor the grace of the one in the Louvre. It also seems to be a *toned-down* version of the original: there are haloes around the heads, the infant John holds a cross, and the extraordinary gesture of the angel Uriel's pointing finger has disappeared. All these reasons incline one to think that Leonardo did not play much part in the execution of the painting—but some art historians would not agree.

3. Cod. Atl., 271*v* a; 231*r* b. Leonardo was probably inspired, in his plans for Charles d'Amboise's palace garden, by the musical fountain he had heard in Rimini, and perhaps by humanist descriptions of the Isle of Venus: in the later years of his life, he showed a growing interest in antiquity. Notes concerning the palace itself relate only to the dimensions of the entrance hall and stairway.

4. In particular, Leonardo seems to have directed a performance of Poliziano's *Orpheus* for the French. One of his notebooks, the Codex Arundel, mentions bills for the color and gold leaf (227*r*) as well as designs for a rotating stage (inspired by Pliny) in which a mountain opens to reveal the subterranean dwelling of the king of the underworld (231*v*; 224*r*).

5. In 1507, Charles d'Amboise ordered the construction, in the suburbs of Milan near the Porta Comasina, of the church of Santa Maria della Fontana, on the site of a miraculous spring. Did Leonardo design plans for this building—which still exists but is unfinished? Some of the sketches in the Codex Atlanticus seem to relate to it (352*r* b).

6. We do not know when Uncle Francesco died. His will, drawn up in the presence of the notary Girolami Cecchi on 2 August 1504 (a few weeks after Ser Piero had died intestate) was at one time in the state archives in Florence.

7. In the draft of a letter that Leonardo did not write himself but dictated in Milan, he calls him "My brother Ser Giuliano, chief of the other brothers" *("capo de li altri fratelli")*. We do not know to whom this letter is addressed (Charles d'Amboise? the marquess of Mantua?). The first paragraph describes a collection of semiprecious stones "good for making cameos" (Cod. Atl., 343*v* a).

8. The chronicler Jean d'Auton has left an account of the triumphal entry of Louis XII into Milan (the king had just put down a rebellion in Genoa). Between the cathedral and the castle, he says, along the "street of the Monte di Pietà," there were arches of greenery in which the arms of France and Brittany were displayed, along with images of the Savior and the saints; children carried torches; a triumphal chariot bore the cardinal virtues and the god Mars, holding in one hand an arrow and in the other a palm, symbol of victory.

9. "Begun in Florence, in the house of Pietro di Braccio Martelli, on 22 March 1508. This will be a collection without any order, made up of numerous sheets that I have copied in the hope of later classifying them in order and in a convenient arrangement relating to the subjects they treat; and I think that before the end of this book, I shall have to repeat the same thing several times; so, reader, do not blame me, for the subjects are many and memory cannot hold them all or say 'I shall not write this down because I have already written it.' " (British Museum, I*r*.)

10. The Bargello Museum in Florence also possesses a small terra-cotta group by Rustici, depicting a violent battle scene in which a horse is trampling enemies to the ground. The work is rather like the preliminary sketches for the *Battle of Anghiari*. Leonardo, who often made little models in three dimensions in order to draw them, may have helped his friend with this one.

11. Cod. Atl., 310 a; 944 a. The letter seems to be addressed to Charles d'Amboise, but the name Anton Maria Pallavicini, governor of Bergamo, and an ally of the French, appears on the same page.

12. Cod. Atl., 364 a; 1138 b. Messer Gerolamo da Cusano was the son of a doctor at the Sforza court, according to Solmi. He seems to have held quite an important post in the French administration in Lombardy.

13. Leonardo notes: "Record of the money I received from the king as my wages from July 1508 until April 1509: first 100 scudi, then 50, then 20; then 200 florins at 48 scudi to a florin" (Cod. Atl., 189 a; 565 a). So he must have been in Milan by July. The 200 florins no doubt correspond to a work of art completed and delivered—but which one? In October, Leonardo lent Salai some money for his sister's dowry.

14. Don Antonio de Beatis, the secretary of the cardinal of Aragon, refers to the "portrait of a certain Florentine lady painted life-size, some time ago, on the orders of the late Magnifico, Giuliano de' Medici" (which Leonardo showed the cardinal at Amboise in 1517), then goes on to call it the portrait of "la signora Gualanda" (Don Antonio de Beatis, *Voyage du cardinal d'Aragon* (Paris ed., 1913). There is no record of any such woman: did Beatis mishear Gualanda for Gioconda?

15. A poet at the Ischian court, Enea Irpino, celebrated in verse a portrait that Leonardo was supposed to have painted of his patroness, Costanza d'Avalos, duchess of Francavilla, widow of Federico del Balzo, "under a fine black veil." He adds: "this good and famous painter . . . has surpassed all art and has triumphed [*vince*] over himself." But Costanza must have been about forty-five at the time Leonardo began to paint the picture we call the *Mona Lisa*. (Note: The painting will here be referred to by the conventional name and spelling: *Mona Lisa;* the wife of Francesco del Giocondo will be referred to as Monna Lisa.)

16. A 110*v*.

17. Madrid II, 71*v*.

18. The *Mona Lisa* became famous immediately. It was imitated and copied from the start, in France, Italy, Flanders, and even Spain. Dozens of copies were painted between the sixteenth and the nineteenth centuries, and its fame was practically never eclipsed. Chasselieu reproduced it faithfully; Corot took it as his inspiration for the *Woman with a Pearl;* the symbolists believed they detected in it the spirit of a certain renewal. But its notoriety reached a peak in 1911, when it was stolen by a certain Vincenzo Peruggia, a housepainter who, he said, wanted it to be returned to its homeland, Italy. The theft and the subsequent restoration of the picture to the Louvre three years later were greatly exploited by the press (it was a distraction from the approaching war). And Mona Lisa madness was born of this exaggerated publicity, fanned by the reactions of the Futurist and Dadaist avant-garde. The *Mona Lisa* became the symbol of "museum art" as well as an international symbol when it was lent to the United States in 1963 and to Japan and the Soviet Union in 1974.

19. Cod. Arun., 241*r*. Leonardo built a model of his water meter for the wealthy Florentine Bernardo Rucellai. Perhaps he was hoping to sell the "patent" for it to the Tuscans as well as to the French in Lombardy.

20. In about 1508, Leonardo once more envisaged sorting out his notes in order to compose a great treatise on water and hydraulics. He divided the work into fifteen books (or chapters): "1. On water in itself. 2. On the sea. 3. On springs. 4. On rivers. 5. On the nature of depths. 6. On obstacles. 7. On gravel beds. 8. On the surface of water. 9. On the things that move in it. 10. On ways to repair [the banks of] rivers. 11. On conduits. 12. On canals. 13. On machines powered by water. 14. On the way to bring water uphill. 15. On the things that water destroys" (Cod. Leic., 15 b). Leonardo never completed this treatise (the plan of which was always being modified or extended), but he worked on it until the end of his life. Some of his notes were published in Rome in 1828 by Francesco Cardinali, under the title *De moto e misura dell'acqua.*

21. Cod. Atl., 335*r* a; 141*v* b.

22. There are two surviving drafts, one after another, of the letter Leonardo sent Francesco Melzi in 1507. The second (which probably corresponded to the letter sent) is both longer and more reserved: Leonardo was not used to expressing his feelings so openly.

23. Marshal Trivulzio requested (in two wills, dated 1504 and 1507) that a chapel be built for him against the basilica of San Nazaro, outside the city walls, and that a funeral monument be put up in it. The chapel was eventually built after 1511 to plans by Bramantino—plans in which Leonardo probably had a hand.

24. Windsor, 12353, 12354, 12355, 12356, 12360.

25. The estimate for "the monument of Messer Giovanni Giacomo da Trivulzio" takes up a whole page in the Codex Atlanticus (179*v* b). It is written mirrorwise, proving that it was merely a draft. It is our best source of information for details of what Leonardo had in mind.

26. Windsor, 12347 a.

27. On Sunday, 30 April 1509, "the eve of the calends of May," at the end of the afternoon, Leonardo really did think that after much work, he had solved the problem of the squaring of the circle (Windsor, 19145). He came back again to his complex and imperfect solution.

28. G 1 b.

29. Leonardo: "In a sausage skin, put white of egg and boil; when it is hard, paint over any marks, then coat again in white of egg and put it in a larger skin" (Forster III, 33*v*).

30. Leonardo first made a paste, by macerating small pearls or mother-of-pearl in lemon juice. Then he rinsed away the lemon with cold water. The paste then had to be dried, powdered, and mixed with egg white. Pearls made this way had to be polished for a long time with a lathe to make them shine. (Cod. Atl., 109*v* b.)

31. Windsor, 12677.

32. Cod. Atl., 313*v* b.

33. B 10*v*.

34. A 18*r*.

35. Marcantonio della Torre, born about 1480, was the son of a professor of medicine and seems to have taken over his father's chair while still very young. He was then appointed to Pavia. If Leonardo became friendly with him, as Vasari says, it must have been in Lombardy in about 1509: any collaboration must have been short-lived, since this brilliant academic died in 1511.

36. Leonardo speaks of dissecting the feet of various animals (A 17*r*), of describing "the tongue of the woodpecker and the jaw of the crocodile" (Quaderni, 13*v*), of studying the intestines of monkeys, birds, and a lion (B 37*r*). But the animals he appears chiefly to have examined were oxen, cows, and horses. He had also carried out experiments on frogs. "The frog dies immediately when its spinal marrow is pierced [with a needle]; before this, it continues to survive without a head, without bowels or entrails, or when flayed; it must be here, then, that the seat of life and movement lies" (Quaderni V, 21*v*).

37. Ibid. III, 3*v*.

38. Ibid. IV, 167 a.

39. Ibid. II, 3*r*.

40. Ibid. I, 6*r*.

41. Ibid. I, 2*r*.

42. "Make two air holes in the horns of the larger ventricle [of the brain]; take melted wax in a syringe, make an opening in the memory ventricle, and through this hole fill the three

ventricles of the brain. When the wax has set, dissect the brain, and you will clearly see the shape of the three ventricles" (Quaderni V, 7v).

43. Quaderni III, 12v.

44. G 89 a.

45. Windsor, 19115r.

46. I 18r.

47. "Necessity is the mistress and nurse of nature; necessity is the theme and the raison d'être of nature; it is the brake and eternal rule" (Forster II, 49 a). Was this his final thinking on the subject? In trying to give some account here of the various movements of Leonardo's thought, I have been obliged to reduce them to schematic outlines: in reality, his thought was characterized by uncertainties, outbursts, reversals, about-faces, and diversions, since he turned every idea and its opposite upside down before concluding—after a series of arguments and counterarguments—on one side or another.

48. Antonio Segni was the master of the Papal Mint; his relations with Leonardo were not confined to the order for the Neptune fountain, which was never realized; he seems also to have asked him for plans for a machine to mint coins and strike medals. Erudite and well versed in mythology, this was the man for whom Botticelli painted the *Calumny of Apelles.*

49. The suggestion that it was a minister of Louis XIII who destroyed the *Leda* seems to be entirely without foundation. On the other hand, Carlo Goldoni pointed out in 1775 that it did not figure, either, in the list of paintings burned by Madame de Maintenon. It is simply not known how the picture came to be missing from the royal collection.

Vasari did not know of the painting's existence, and the Anonimo Gaddiano was uncertain of it. But Lomazzo did know about it and described it as "a nude Leda, embracing the swan, her eyes chastely downcast." Commander Cassiano del Pozzo, a friend of Rubens and Poussin, claimed to have seen it at Fontainebleau in 1625: "Leda standing, almost entirely naked; at her feet are the swan and two broken eggs with four babies crawling from them. This painting, while somewhat dry in style, is very finely executed, especially the breast of the young woman. And the rest—the background landscape and vegetation—is rendered with the utmost care. Unfortunately, the picture is in poor condition, since it consists of three long panels with deep cracks at the joins, which much damage the painting." Inventories of the French royal household record it in 1692 and 1694, attributing it to da Vinci, but later inventories carry no mention of it. It looks as if it disappeared in the early years of the eighteenth century—but was this Leonardo's original or a copy? Indeed, did Leonardo ever complete with his own hand this elusive painting, whose trace seems to flicker in and out of existence?

50. Leda kneeling: Boymans Museum, Rotterdam; Chatsworth, Devonshire Collection; Windsor, 12337. Examples of Leda standing appear in tiny versions among geometrical studies or, barely visible, among sketches of ancient weapons and musical instruments (Cod. Atl., 423r; Windsor, 12642v; MS B, folio D). The study in the Louvre, once thought to be by Leonardo, may be a drawing by Melzi from either the painting itself or its cartoon.

51. Windsor, 12515, 12516, 12517, 12518.

52. Cardinal d'Amboise must have invited Leonardo to France in about 1507. It was once thought that the painter might have accepted the invitation, since a letter was addressed to him with the inscription "Monsieur Lyonnard, peintre du Roy pour Amboyse." This is now thought unlikely, but he may have sent to France plans for a château.

54. Cod. Atl., 83r a.

54. Ibid., 277v a.

55. Windsor, 12416.

56. By 25 March 1513, Leonardo must have been back in Milan, since he was once more being consulted by the council of works for the cathedral.

57. Cod. Atl., 395r b; 62r b; 153r d; 153r e; Windsor, 19107v.

58. On one page, dated 9 January 1513, there are some anatomical studies, and drawings of the Villa Melzi and the castle of Trezzo (Windsor, 19077v). Another page shows a bird's wing dissected and plans for a well and buildings. It seems that Leonardo's designs were realized in part.

59. E 1 a. D'Adda thinks that this Fanfoia was not a servant but the sculptor Bambaia. The Codex Atlanticus (400v) contains this note on the trip to Rome: "13 ducats for 500 lire, from here to Rome. 129 miles from Florence to Rome, 180 miles from here to Rome"—probably travel expenses.

60. Cod. Atl., 159r c.

61. F 96 b.

62. A 2r. Leonardo also says: "People choose as healers persons who understand nothing about the ills they treat" (British Museum, 147v).

63. Leonardo: *"un guardo cuore de pele"* (L 1 b).

64. Cod. Atl., 114r a.

65. Ibid., 83r a.

66. Ibid., 90r or v a. Leonardo wrote alongside some mathematical and geometrical problems: "Finished on 7 July, in the twenty-third hour, at the Belvedere, in the studio given me by the Magnifico" (Giuliano de' Medici).

67. Leonardo. "One must observe the respiratory movement of the human lung. the rhythm of the movement of water, attracted to the earth over 12 hours, in its ebb and flow, might help us find the dimensions of the lung of the earth" (Cod. Atl., 260r).

68. Cod. Atl., 12r, 13r.

69. G 43 a, 70 b, 71 a, 72 a, b; Cod. Atl., 3r a. Leonardo's work on the minting of coins and medals (possibly originally commissioned by his friend Segni—see note 48 above) does not seem to have led to any very new solutions.

70. Windsor, 12684; Cod. Atl., 167v a; 281r a. On the map of the Pontine marshes, the place names are in Melzi's handwriting.

71. Cod. Atl., 17v, 1957v.

72. Leonardo: "In order to observe the nature of the planets, open the roof and bring the image of a single planet onto the base [of a concave mirror]. Then the image of the planet reflected by the base will show the surface of the planet much magnified." (Cod. Arun., 279v.)

73. Master Giovanni of the Mirrors, according to Leonardo, claimed that his monthly wage was eight florins, whereas Giuliano de' Medici had promised him only seven. Leonardo got so worked up about his problems with the two Germans that we do not always know which one he is talking about.

74. The drafts of the letter to Giuliano de' Medici are in the Codex Atlanticus (243 b, 278 a, 729 b, 850 a, 179 b, 541 b). Leonardo found it equally difficult to describe his misfortunes and to find a correct formula of address.

75. G 46v. Leonardo must have picked up the tone and the language of alchemy from Verrocchio, who was also an adept of the great art, according to Vasari.

76. The notes concerning the mysterious *sagoma*, from which the parabolic mirror was to emerge, are mostly in manuscript G. It is here that Leonardo reminds himself to proceed as for the ball on Florence cathedral constructed by Verrocchio.

77. On 9 December 1515, Leonardo may have written to Zanobi Boni, his sharecropper, who was working the vineyard inherited from Uncle Francesco, to complain of the quality of that autumn's wine. The authenticity of this letter (bought in 1822 by a certain M. Bourdillon from a mysterious Florentine) is not proved. The text is cited in full by Pedretti in his *Commentary*.

78. There are several designs for the plans of Civitavecchia harbor in the Codex Atlanticus (271*v* d, 113*r* b, 12*r* b, 285*r* a). See A. Bruschi, "Bramante, Leonardo e Francesco di Giorgio a Civitavecchia," in *Studi Bramanteschi* (Rome 1974).

79. Vasari says that the competition for the facade of San Lorenzo in Florence was the occasion of another confrontation between Leonardo and Michelangelo, and indeed that Leonardo may have left Italy to avoid competing with the sculptor. In fact, Michelangelo had already started work on this facade in 1516, when Leonardo was still in Rome.

80. According to his notes and drawings, Leonardo wanted to enlarge the square of San Lorenzo by knocking down the church of San Giovannino and rebuilding it farther away. He would then have built the new Medici palace opposite the old one on the Via Larga. (Cod. Atl., 315*r* b.)

81. H 139 b.

82. Cod. Atl., 287*v* a.

83. Windsor, 12409.

84. Ibid., 12698.

85. Ibid., 12665*v*.

86. Leonardo, being anxious to discover how the world was made, looked for a logical explanation of the Flood: the figures given in the Bible ("a mile in 40 days": Cod. Atl., 18*v* a) seemed impossible to him. It was in the course of trying to work out how it happened, in rational fashion, that he was gradually drawn into imagining and then describing in detail, as if it were taking place in front of his eyes, his personal vision of the Deluge. Since he sometimes uses the future tense, sometimes the past, his account can be read as prophecy as much as "reconstruction."

87. Windsor, 12382, 12383, 12378.

88. *Saint John the Baptist* is supposed to have been in the collection of François I, then to have been exchanged, by one of Louis XIII's chamberlains, for Holbein's *Portrait of Erasmus* and a *Holy Family* by Titian, both owned by Charles I of England. There is no evidence for this. What is known is that Louis XIV bought it with the Jabach collection sometime before 1666.

89. The note of Giuliano's departure and of the death of Louis XII is on the verso of the cover of manuscript G; above it, Leonardo notes that he had stayed at the Bell Inn at Parma in 1514. Parma, a city under papal jurisdiction, was at the time a dependency of Giuliano de' Medici.

90. Cod. Atl., 172*v* b.

91. The manor of Cloux (now Clos-Lucé) still exists in Amboise. Of all the places where Leonardo lived, this is the one where his memory is best preserved. The house has, however, been considerably altered since the sixteenth century. A wing has been added and the staircase moved; the bed on display in "Leonardo's bedroom" is certainly not the one in which he died.

92. The sketch of the view from the bedroom window was once attributed to Leonardo himself but is probably by Melzi. Now in the Windsor Collection.

93. Beatis mentions a "youthful John the Baptist." He must have been surprised not to see the gaunt and severe John of tradition.

94. British Museum, 180 b.

95. Cod. Atl., 289*v* c.

96. Noted with the inscription: "24 June 1518, Feast of St. John, at Amboise in the palazzo of Cloux" (Cod. Atl., 249*r*).

97. Madrid II, 24 a.

98. This fossilized fish, apparently discovered during the digging of a canal, fascinated Leonardo and inspired several very literary texts, for example: "O powerful, once living instrument of constructive nature, your great strength was of no avail; and you had to leave your peaceful life to obey the law that God and time have issued for all procreating nature." Leonardo, who was probably thinking of his own destiny, always believed that animate beings had to die in order that others should be engendered—hence perhaps his fear and horror of procreation, as taking place on a heap of corpses; hence too, perhaps, his vegetarian diet.

99. "On the night of St. Anthony, I returned from Romorantin to Amboise; the king left Romorantin two days before" (Cod. Atl., 249*r*).

100. On the Romorantin project, see C. Pedretti, *Leonardo da Vinci: The Royal Palace at Romorantin* (Cambridge, Mass., 1972).

101. British Museum, 245 a.

102. "All evil leaves sadness in one's memory, except the supreme evil, death, which destroys memory along with life" (H 33*v*).

103. A 2*r*.

104. Tr. Tav., 28 a.

105. Leonardo does not mention in his will the land inherited from Uncle Francesco, but it figures in a letter from Melzi to the da Vinci half-brothers. The arrangement reached in 1507 must have been that Leonardo could keep the property until his death, after which it would revert to the brothers. This would explain the sentence quoted earlier: "Oh, why not let him have the use of it in his lifetime, since it will come to your children in the end?"

106. Historians have not as a rule noted Champollion's comment, but it was taken up by Jean Adhémar in an article in *Le Monde,* 25 July 1952.

XI: THE TRACES

1. M 58*v*.

2. Apart from Salai and Melzi, Vasari speaks of Giovanantonio Boltraffio and Marco Uggioni (d'Oggione). The Anonimo Gaddiano mentions Zoroastre da Peretola, Riccio Fiorentino, and Ferrando or Fernando de Llanos (all of whom helped Leonardo with the *Battle of Anghiari*). We also know the names of several other pupils—though without knowing when they entered his studio or how long they stayed. And to these can be added all those who were marked by his influence—who copied or imitated his work—without having actually worked alongside him. I have already noted some of their names: besides Cesare da Sesto, one of the most talented, there were Gianpetrino, Vincenzo Civerchio, Bernardino de' Conti, Cesare Magni, the Master of the Sforza altarpiece. Others, like Andrea Solario, Bernardino Luini, Il Sodoma, and Baccio Bandinelli, borrowed a great deal from Leonardo but had enough personal *virtù* to be able to resist his influence, successfully finding their own way without being crushed by his genius. Then there were those who retained something of his manner—of what he had invented in painting—and developed it without remaining bound by it: Piero di Cosimo, Raphael, Giorgione, Sebastiano del Piombo, even Pontormo or Bronzino. But space forbids any attempt here at analyzing Leonardo's influence throughout Europe and down the ages.

Leonardo's Paintings

WORKS ENTIRELY OR VERY LARGELY BY HIS OWN HAND

Annunciation, Uffizi, Florence
Benois Madonna, Hermitage, Leningrad
Portrait of Ginevra de' Benci, National Gallery, Washington
Adoration of the Magi (unfinished), Uffizi, Florence
Saint Jerome (unfinished), Vatican, Rome
Virgin of the Rocks, Louvre, Paris
Portrait of a Musician (unfinished), Ambrosiana, Milan
Lady with an Ermine (Cecilia Gallerani), Czartoryski Museum, Cracow
The Last Supper, convent of Santa Maria delle Grazie, Milan
La Sala delle Asse, Castello Sforzesco, Milan
Virgin and Child with Saint Anne and a Lamb (unfinished), Louvre, Paris
Mona Lisa, Louvre, Paris
Saint John the Baptist, Louvre, Paris

COLLABORATIVE OR STUDIO WORKS

The angel in Verrocchio's *Baptism of Christ,* Uffizi, Florence
Madonna with a Flower, Pinakothek, Munich
Portrait of a Lady at the Court of Milan, Louvre, Paris
Portrait of a Milanese lady, Ambrosiana, Milan
Madonna Litta, Hermitage, Leningrad
Virgin of the Rocks, National Gallery, London
Bacchus, Louvre, Paris

Leading Artists

OF THE QUATTROCENTO

FLORENCE	OUTSIDE FLORENCE
Giovanni Cimabue (c.1240–c.1302)	
Giotto (c.1270–c.1337)	
Filippo Brunelleschi (1377–1446)	
Lorenzo Ghiberti (c.1378–1455)	
Donatello (c.1386–1466)	
Fra Angelico (1387–1455)	Jan van Eyck (c.1390–1441)
	Francesco Squarcione (c.1394–1474)
Michelozzo (1396–1472)	Pisanello (c.1395–c.1455)
Paolo Uccello (1397–1475)	
Domenico Veneziano (1400–1461)	
Luca della Robbia (c.1400–1482)	
Tommaso Masaccio (1401–1428)	Rogier Van der Weyden (c.1400–1464)
Leon Battista Alberti (1404–1472)	
Fra Filippo Lippi (c.1406–1469)	
Piero della Francesca (c.1420–1492)	Dierik Bouts (c.1410–1475)
Benozzo Gozzoli (1420–1497)	Jean Fouquet (c.1420–1480)
Andrea del Castagno (c.1423–1457)	
Alesso Baldovinetti (1425–1499)	
Mino da Fiesole (1429–1484)	Cosimo Tura (c.1430–1495)
Desiderio da Settignano (c.1430–1464)	
	Antonello da Messina (c.1430–1479)
	Giovanni Bellini (c.1430–1516)
	Carlo Crivelli (c.1430–1495)
	Hans Memling (c.1430–1494)
	Andrea Mantegna (1431–1506)

LEADING ARTISTS OF THE QUATTROCENTO

FLORENCE

Antonio (1432–1498) and
 Piero (1443–1496) Pollaiuolo
Andrea del Verrocchio (1435–1488)
Sandro Botticelli (1444–1510)
Domenico Ghirlandaio (1449–1494)
Luca Signorelli (c.1450–1523)
Leonardo da Vinci (1452–1519)
Filippino Lippi (1457–1504)
Lorenzo di Credi (1459–1537)

Piero di Cosimo (1462–1521)

Michelangelo (1475–1564)

Andrea del Sarto (1486–1530)

Giorgio Vasari (1511–1574)

OUTSIDE FLORENCE

Francesco di Giorgio Martini (1439–1502)
Perugino (c.1445–1523)

Hieronymus Bosch (c.1450–1516)

Pinturicchio (c.1454–1513)
Vittore Carpaccio (c.1455–1525)
Matthias Grünewald (c.1460–1528)
Albrecht Dürer (1471–1528)
Lucas Cranach (1472–1553)
Giorgione (c.1477–1510)
Raphael (1483–1520)
Titian (c.1485–1576)
Correggio (c.1489–1534)
Hans Holbein The Younger (c.1497–1543)

Leonardo's Writings

FACSIMILES AND TRANSCRIPTIONS

Les Manuscrits de Léonard de Vinci, du manuscrit A au manuscrit M, ed. C. Ravaisson-Mollien, 6 vols., Paris, 1881–91. (There is also a more recent transcription of manuscripts **A and B**, Reale Commissione Vinciana, Rome, 1938 and 1941, and of manuscripts A to D, edited by A. Corbeau and D. Toni).

Les Manuscrits de Léonard de Vinci, manuscrits Ash. I et II, ed. C. Ravaisson-Mollien, Paris, 1881–91.

I manoscritti e i desegni di Leonardo da Vinci, Il Codice Arundel, Reale Comissione Vinciana, 4 vols., Rome, 1923–30.

Il Codice Atlantico di Leonardo da Vinci nella Biblioteca Ambrosiana di Milano, ed. A. Marinoni, 12 vols., Florence, 1973–75.

I manoscritti e i desegni di Leonardo da Vinci, Il Codice Forster, I, II, III, Reale Comissione Vinciana, 5 vols., Rome, 1930–36.

Il Codice di Leonardo da Vinci delle Biblioteca di Lord Leicester in Holkham Hall, ed. G. Calvi, Reale Istituto Lombardo di Scienze e Lettere, Milan, 1909.

The Manuscripts of Leonardo da Vinci at the Biblioteca Nacional of Madrid (Madrid I and II), ed. L. Reti, 5 vols., New York, 1974.

Il Codice di Leonardo da Vinci della Biblioteca del Principe Trivulzio in Milano, ed. L. Beltrami, Milan, 1891. (Another edition by N. de Toni, Milan, 1939.)

I manoscritti di Leonardo da Vinci, Codice sul volo degli uccelli e varie altre materie, ed. T. Sabachnikoff, G. Piumati, and C. Ravaisson-Mollien, Paris, 1893.

I fogli mancanti al codice di Leonardo da Vinci nella Biblioteca Reale di Torino, ed. E. Carusi, Rome, 1926.

I manoscritti di Leonardo da Vinci della Reale Biblioteca di Windsor, Dell'Anatomia, Fogli A, ed. T. Sabachnikoff and G. Piumati, Paris, 1898; and *Fogli B, idem*, Turin, 1909.

Quaderni D'Anatomia I–IV, Leonardo da Vinci, ed. O. Vangensten, A. Fonahn, and H. H. Hopstock, 6 vols., Christiana, 1911–16.

Treatise on Painting (Codex Urbinas Latinus, 1270) by Leonardo da Vinci, ed. A. P. MacMahon, 2 vols., Princeton, 1956.

ANTHOLOGIES IN TRANSLATION

J. P. Richter, ed., *The Literary Works of Leonardo da Vinci*, 3rd ed., 2 vols., London and New York, 1970.

Richter Commentary: C. Pedretti, *The Literary Works of Leonardo da Vinci*, ed. J. P. Richter, *Commentary*, 2 vols., Oxford, 1977.

E. MacCurdy, ed., *The Notebooks of Leonardo da Vinci*, London, 1938.

Selected Bibliography

D'ADDA. *Leonardo da Vinci e la sua libreria.* Milan, 1873.

ALAZARD, J. *L'Art italien au XVI^e s.* Paris, 1955.

———. *Le Pérugin.* Paris, 1927.

ALBERTI DE MAZZERI, S. *Léonard de Vinci.* Paris, 1984.

AMORETTI, C. *Memorie storiche su la vita, gli studi e le opere di Lionardo da Vinci.* Milan, 1804.

ASTON, M. *Panorama du XV^e siècle.* Paris, 1969.

Atti del Convegno di studi vinciani. Florence, 1953.

AUDIN, M. *Histoire de Léon X.* Paris, 1850.

BARATTA, M. *Curiosità vinciana.* Turin, 1905.

BEATIS, Don A. *Voyage du cardinal d'Aragon.* Paris, 1913.

BECK, J. *Leonardo's Rule of Painting.* Oxford, 1979.

BELTRAMI, L. *Documenti e Memorie riguardanti la vita e le opere di Leonardo da Vinci.* Milan, 1919.

BÉRENCE, F. *Léonard de Vinci, ouvrier de l'intelligence.* Paris, 1938.

BERENSON, B. *The Italian Painters of the Renaissance.* Rev. ed. Oxford, 1930.

BERLIBEN, D. and KLAPISCH-ZUBER. *Les Toscens et leurs familles.* Paris, 1978.

BLUNT, A. *Artistic Theory in Italy, 1450–1600.* Oxford, 1940.

BOLOGNA, G. *Leonardo a Milano.* Novara, 1982.

BOSSEBOEUF, L.-A. *Clos-Lucé, séjours et mort de Léonard da Vinci.* Tours, 1893.

BOSSI, G. *Vita de Leonardo da Vinci.* Padua, 1814.

BREWER, R. *A Study of Lorenzo di Credi.* Florence, 1970.

BRION, M. *Léonard de Vinci.* Paris, 1952.

BRION, M. *Léonard de Vinci,* avec des textes de Cocteau, Berl, Lebel. Paris, 1959.

BURCKHARDT, J. *The Civilization of the Renaissance in Italy.* New York, 1961.

BUSIGNANI, A. *Verrocchio.* Florence, 1966.

CALVI, G. *Contributi alla biografia de Leonardo da Vinci.* Milan, 1916.

———. *I Manoscritti di Leonardo da Vinci dal punto di vista cronologico, storico e biografico.* Bologna, 1925.

CARONE, S. *Una famiglia lombarda.* Milan, 1988.

CELLINI, B. *The Life of Benvenuto Cellini, Written by Himself.* Translated by Symonds. London, 1949.

CENNINI, C. *Il Libro dell'Arte.* Translated and edited by Thompson. New Haven, 1932.

CHASTEL, A. *Art et humanisme à Florence au temps de Laurent le Magnifique.* Paris, 1952.

473

————. *L'Art italien.* Paris, 1982.

————. *Fables, formes, figures.* Paris, 1978.

————. *Le Grand Atelier d'Italie.* Paris, 1965.

————. *Le Madonne di Leonardo.* Florence, 1985.

————. *Marsile Ficin et l'Art.* Geneva, 1975.

————. *Le Mythe de la Renaissance.* Geneva, 1969.

————. *Renaissance méridionale.* Paris, 1965.

CHAUVETTE, H. *Histoire de la littérature italienne.* Paris, 1906.

CIANCHI, M. *Les Machines de Léonard de Vinci.* Florence, 1984.

CIANCHI, R. *Ricerche e documenti sulla madre di Leonardo.* Florence, 1975.

————. *Leonardo e la sua famiglia, Mostra della scienza e technica di Leonardo.* Milan, 1952.

CLARK, K. *Leonardo da Vinci: An Account of his Development as an Artist.* Cambridge, 1939.

————. *The Nude; A Study of Ideal Art.* London, 1956.

————. and PEDRETTI, C. *Drawings of Leonardo da Vinci, at Windsor Castle.* London, 1968.

CLAUSSE, G. *Les Sforza et les arts en Milanais.* Paris, 1909.

COIGNET, C. *François Ier, portraits et récits du XVIe s.* Paris, 1885.

COLEMAN, M. *Histoire du Clos-Lucé.* Tours, 1937.

COLLISON-MORLEY, L. *Histoire des Sforza.* Paris, 1951.

COMMYNES, P. *Mémoires.* Les Belles-Lettres, 1965.

Connaissance de Léonard de Vinci. La peinture de Léonard vue au laboratoire. L'Amour de l'art, 67–68. Paris, 1953.

CRUTTWELL, M. *Verrocchio.* London, 1904.

DELUMEAU, J. *La Civilisation de la Renaissance.* Paris, 1967.

DUHEM, P. *Études sur Léonard de Vinci.* Paris, 1906–13.

EISSLER, K.R. *Léonard de Vinci (étude psychanalytique).* Paris, 1980.

ETTLINGER, L. *Antonio and Piero Pollaiuolo.* Oxford, 1978.

Etudes d'Art, 8, 9, 10. *L'Art et la pensée de Léonard da Vinci.* Congrès international du Val de Loire. Paris, 1953–54.

Les Fêtes de la Renaissance. Colloque du C.N.R.S. Études présentées par J. Jacquot. Paris, 1956–60.

FERRERO, L. *Léonard de Vinci ou l'œuvre d'art.* Paris, 1929.

FRANCASTEL, P. AND G. *Le Style de Florence.* Paris, 1958.

FREUD, S. *Leonardo da Vinci and a Memory of His Childhood.* Translated by Tyson. Harmondsworth, 1963.

FUMAGALLI, G. *Eros di Leonardo.* Florence, 1971.

FUNCK-BRENTANO, F. *La Renaissance.* Paris, 1935.

GAMBA, C. *Botticelli.* Paris, n.d.

GIACOMELLI, R. *I modelli delle macchine volanti di Leonardo da Vinci.* Rome, 1931.

GILLES, B. *Les Ingénieurs de la Renaissance.* Paris, 1964.

GOLDSCHEIDER, L. *Leonardo da Vinci.* London, 1959.

GOMBRICH, E.H. *New Light on Old Masters.* Oxford, 1986.

GUICCIARDINI, F. *Storia d'Italia,* Pisa, 1819.

GUILLERM, J.-P. *Tombeau de Léonard de Vinci.* Lille, 1981.

GUILLON. *Le Cénacle de Léonard de Vinci.* Milan, 1811.

HAUSER, A. *Histoire sociale de l'art et de la littérature.* Paris, 1984.

HEVESY, A. de. *Pèlerinage avec Léonard de Vinci.* Paris, 1939.

HEYDENREICH, L. *Leonardo da Vinci.* 2 vols. New York and Basel, 1954.

HOUSSAYE, A. *Histoire de Léonard de Vinci.* Paris, 1869.

HUYGUE, R. *La Joconde,* musée du Louvre. Fribourg, 1974.

KEMP, M. *Leonardo da Vinci: The Marvellous Works of Nature and Man.* Cambridge, Mass., 1981.

KLACZKO, J. *Jules II (Rome et la Renaissance).* Paris, 1898.

LACROIX, P. *Mœurs, usages et costumes à l'époque de la Renaissance.* Paris, 1873.

LEBEL, R. *Léonard de Vinci ou la Fin de l'humilité.* Paris, 1952.

LEBEY, A. *Essai sur Laurent de Médicis.* Paris, 1900.

Léonard de Vinci. Cercle du Bibliophile. Novare, 1958.

Léonard de Vinci. Nouvelle revue d'Italie. Edited by M. Migon. Rome, 1919.

Léonard de Vinci au Louvre. Paris, 1983.

Léonard de Vinci et l'expérience scientifique au XVI^e siècle. Colloques internationaux du C.N.R.S. Paris, 1953.

Léonard de Vinci, ingénieur et architecte. Exhibition catalogue. Musée des Beaux-Arts de Montréal, 1987.

Leonardo da Vinci. Conferenze Fiorentine. Articles by E. Solmi, M. Reymond, A. Conti, etc. Milan, 1910.

Leonardo da Vinci. Los Angeles County Museum, loan exhibition catalogue. Los Angeles, 1949.

Leonardo e il leonardismo a Napoli e a Roma. Giunti Barbera, 1983.

Leonardo e l'incisione. Leonardo a Milano. Milan, 1984.

Leonardo e Milano. Banca Populare di Milano. Milan, 1982.

Leonardo Nature Studies. Johnson Reprint Corporation. Malibu, 1980.

Leonardo's Legacy. An International Symposium, University of California Press. Los Angeles, 1969.

Le Lieu théâtral à la Renaissance. Colloque de Royaumont. Paris, 1981.

Les Machines célibataires. Musée des Arts décoratifs. Paris, 1976.

MALAGUZZI-VALERI, F. *La corte di Ludovico il Moro.* Milan, 1913–23.

MACHIAVELLI, N. *The Chief Works and Others.* Translated by Gilbert. Durham, N.C., 1965.

MARCEL, R. *Marsile Ficin.* Paris, 1958.

McMULLEN, R. *Les Grands Mystères de la Joconde.* Paris, 1981.

MEREZHKOVSKI, D. *The Forerunner: The Romance of Leonardo da Vinci.* London, 1926.

MICHELET, J. *Renaissance et Réforme.* Paris, 1982.

MICHELETTI, E. *Les Médicis à Florence.* Florence, 1980.

Milano nell'età di Ludovico il Moro. Atti del Convegno Internazionale. Milan, 1983.

MONNIER, Ph. *Le Quattrocento.* Paris, 1931.

MOTTA, E. *Ambrogio Preda et Leonardo da Vinci.* Milan, 1893.

MÜNTZ, E. *Histoire de l'Art pendant la Renaissance.* Paris, 1895.

———. *Léonard de Vinci, l'artiste: le penseur; le savant.* Paris, 1899.

———. *Raphaël.* Paris, 1900.

NÉRET, J.-A. *Louis XII.* Paris, 1948.

O'MALLEY, C.D. and SAUNDERS, J.B. *Leonardo on the Human Body.* New York, 1982.

PAGLIUGHI, P. *La Scrittura mancina di Leonardo.* Milan, 1984.

PASSAVENT, G. *Verrocchio.* London, 1969.

PATER, W. *The Renaissance.* London, 1893.

PEDRETTI, C. *A Chronology of Leonardo da Vinci's Architectural Studies After 1500.* Geneva, 1962.

———. *Léonard de Vinci architecte.* Paris, 1983.

———. *The Royal Palace at Romorantin.* Cambridge, Mass., 1972.

———. *A Study in Chronology and Style.* London, 1973.

PÉLADAN, J. *La Dernière Leçon de Léonard de Vinci.* Paris, 1913.

PERRENS, F. *La Civilisation florentine.* Paris, 1893.

———. *Histoire de Florence.* Paris, 1877.

POPE-HENNESSY, J. *Italian Renaissance Sculpture and Italian High Renaissance Sculpture.* Oxford, 1985–86.

POPHAM, A. E. *The Drawings of Leonardo da Vinci.* London, 1946.

Regard sur Léonard de Vinci. Cahiers du Sud, 313. Paris, 1952.

RETI, L. *Léonard de Vinci, l'humaniste, l'artiste, l'inventeur.* Paris, 1974.

REYMOND, M. *Bramante.* Paris, n.d.

———. *Verrocchio.* Paris, n.d.

RIO, A.-F. *Léonard de Vinci et son école.* Paris, 1855.

ROCHON, A. *La Jeunesse de Laurent de Médicis.* Paris, 1963.

RODONACHI, E. *La Femme italienne à l'époque de la Renaissance.* Paris, 1907.

ROLLAND, R. *Vie de Michel-Ange.* Paris, 1911.

ROSCI, M. *Léonard de Vinci.* Milan, 1976.

ROUCHETTE, J. *La Renaissance que nous a léguée Vasari.* Paris, 1959.

RUSKIN, J. *Le Val d'Arno.* Paris, 1911.

SAINT-HELME. *Léonard et la Joconde.* Paris, 1913.

SCAGLIA, G. *Alle origine degli studi tecnologici di Leonardo.* Florence, 1980.

SCHNEIDER, R. *La Peinture italienne des origines au XVI^e s. et du XVI^e à nos jours.* Brussels, 1930.

Scritti su Leonardo nelle biblioteche milanesi, Leonardo a Milano. Milan, 1982.

SÉAILLES, G. *Leonard de Vinci, l'artiste et le savant.* Paris, 1892.

SIRÉN, O. *Léonard de Vinci, l'artiste et l'homme.* Paris, 1928.

SIZERAINE, R. de La. *Béatrice d'Este et sa cour.* Paris, 1920.

SOLMI, E. *La festa del paradiso di Leonardo da Vinci.* Florence, 1904.

———. *Leonardo da Vinci e la Republica di Venezia.* Milan, 1908.

STEINITZ, K.T. *Pierre-Jean Mariette and the Comte de Caylus and Their Concept of Leonardo da Vinci.* Los Angeles, 1974.

STENDHAL. *La Peinture en Italie.* Paris, 1854.

STITES, R. S. *The Sublimations of Leonardo da Vinci.* Washington, D.C., 1970.

Studi per il Cenaclo dalla Bib. Reale nel Castello di Windsor. Olivetti, 1983.

SUARÈS, A. *Le Voyage du condottiere.* Paris, 1956.

TABORELLI, G. *Les Médicis à Florence.* Paris, 1981.

TAINE, H. *La Philosophie de l'art en Italie.* Paris, 1880.

———. *Voyage en Italie.* Paris, 1886.

TERRACE, C. *L'Architecture lombarde de la Renaissance.* Paris and Brussels, 1926.

THIIS, J. *Leonardo da Vinci: The Florentine Years.* London, n.d.

TODIÈRE, L. *Histoire de Louis XII.* Tours, 1857.

TOURETTE, G. de La. *Léonard de Vinci.* Paris, 1932.

Tout l'œuvre peint de Léonard de Vinci. Paris, 1950.

TRUC, G. *Léon X et son siècle.* Paris, 1941.

VALÉRY, P. *Œuvres.* Paris, 1957.

VALLENTIN, A. *Léonard de Vinci.* Paris, 1950.

VALENTINER, W.R. "*Leonardo as Verrocchio's Co-Worker.*" The Art Bulletin. University of Chicago, March 1930.

VASARI. *Lives of the Artists.* Translated by Bull. Harmondsworth, 1965.

VENTURI, L. *La critica e l'arte di Leonardo da Vinci.* Bologna, 1919.

VERDET, A. *Leonardo da Vinci, le rebelle.* Paris, 1957.

VERGA, E. *Storia della vita milanese.* Milan, 1931.

VEZZOSI, A. *Toscana di Leonardo.* Florence, 1984.

VULLIAUD, P. *La Pensée ésotérique de Léonard de Vinci.* Paris, 1981.

WEINSTEIN, D. *Savonarole et Florence.* Paris, 1973.

WINTERNITZ, E. *Leonardo da Vinci as a Musician.* New Haven, 1982.

YOUNG, G.F. *The Medici.* London, 1909.

ZERI, F. *Le Mythe visuel de l'Italie.* Paris, 1986.

———. *Renaissance et Pseudo-Renaissance.* Paris, 1985.

476

Index